ANCIENT EGYPTIAN FAIENCE

An Analytical Survey of Egyptian Faience from

Predynastic to Roman Times

carol strick

Alexander Kaczmarczyk

Department of Chemistry, Tufts University

&

Robert E M Hedges

Research Laboratory for Archaeology, The University of Oxford

With a Foreword by P. R. S. Moorey and an Appendix by P. Vandiver

ARIS & PHILLIPS Ltd
Warminster — England

 British Library Cataloguing in Publication Data

Kaczmarczyk, Alexander
 Ancient Egyptian faience.
 1. Faience—Egypt—Analysis
 I. Title II. Hedges, Robert E. M.
 738.3'7 NK3810

 ISBN 0-85668-221-7

Printed and published in England by Aris & Phillips Ltd., Teddington House, Warminster, Wiltshire.

ISBN 0 85668 221 7

Table of Contents

List of Figures

Figures to Appendix A follow page A-144

List of Tables

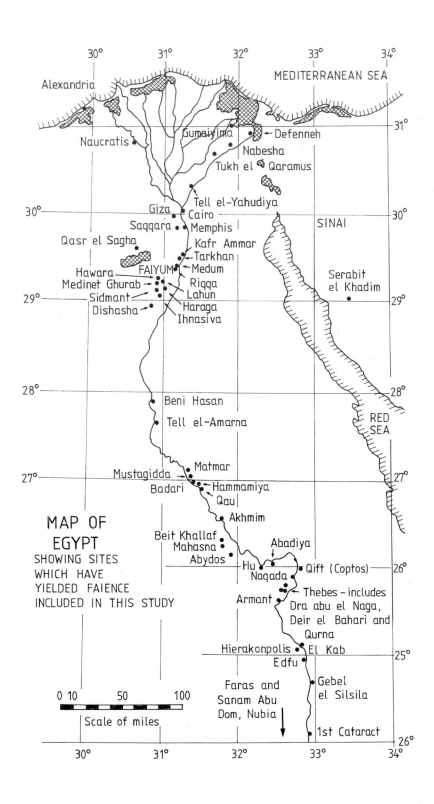

Foreword

In 1974 the Research Laboratory for Archaeology and the History of Art approached the Department of Antiquities to inquire if there was a range of Egyptian material in the collections suitable for a major programme of analyses to be undertaken in the laboratory by Dr. A. Kaczmarczyk, a chemist with an enthusiastic interest in Egyptology, from Tufts University, Boston, Massachusetts. As it was hoped at the time that there might also be a comparable study of Egyptian metalwork, upon which another scholar was then engaged, the choice of faience and related materials was almost inevitable. For reasons beyond our control the programme of research on metal never fully matured, although Dr. Kaczmarczyk is able to quote, for comparative purposes, some of the preliminary results. It gives us particular satisfaction, therefore, that his faience project, embracing almost twelve hundred analyses, should have been successfully carried through to publication.

Within the Museum, between 1974 and 1979, progress was greatly assisted by the detailed knowledge and hard work of Mrs. Joan Crowfoot Payne, who selected the objects for testing and at all times cross-checked the archaeological sources of excavated objects and provided dates for the unprovenanced ones. Her successor, Dr. Helen Whitehouse, has provided equally valuable assistance in the final stages of the work. We were also very happy to co-operate, when our resources failed, with our sister "Petrie Collection" in University College, London, where Mrs. Barbara Adams helped with the selection of suitable pieces for analysis to fill obvious gaps in our series. We were also fortunate, in the later stages of Dr. Kaczmarczyk's research programme, to be able to enlist the assistance of Mrs. Pamela Vandiver, of the Massachusetts Institute of Technology, in the technological study of selected objects, thereby broadening the basis of the work appreciably.

No single museum collection outside Egypt could hope to offer a sample of Egyptian faience fully balanced typologically, topographically and chronologically; but the Ashmolean Museum is in the fortunate position of being able to provide an unusually comprehensive range from controlled excavations. This was thought to be crucial in designing a research project of this kind, for past experience has shown how important it is that future students of the subject should know exactly which museum objects were tested.

They may then not only check on the dating, but also retest the object if they wish. It is no less vital, in what is still a pioneering stage of study, that the objects tested should be of known date and indisputably ancient. The distribution of the sites from which the material has been drawn inevitably reflects the pattern of British archaeological activity in Egypt in the last century of excavation. Happily this involves a sufficient number of key sites to provide an appropriate chronological framework, from the predynastic cemeteries of Naqada and Ballas down to major factories of the Roman period. They also offer a reasonable combination of objects from palace workshops and from lesser craft centres, as well as industrial debris from such sites as el-Amarna and Memphis.

The classic study of Egyptian faience and glaze composition, as of so much else in the Egyptian craft tradition, is that of Lucas, whose name is inevitably recurrent in the following pages. His data base was, however, very narrow and, although scattered additions have subsequently been made, it is still the source to which scholars instinctively turn. So long as they are primarily specialists in ancient Egypt, aware of the local conditions and the restricted nature of the evidence used by Lucas, this presents no unusual problems. But in the last twenty years there has been an upsurge of interest in the study of Bronze Age faience production in the Near East, in the Mediterranean and in Europe, including the British Isles. This has been directed particularly to the characterization of local production and to assessing the extent to which it was, or was not, dependent upon the Egyptian craft tradition. With so small a body of reliable Egyptian analyses it has often been difficult to state with confidence whether or not a particular composition, or trace element, was indeed indicative of Egyptian manufacture. This distinction became all the more significant as faience entered increasingly into a much wider debate over the relative roles of stimulus diffusion on the one hand, independent invention on the other, in the development of prehistoric technologies in Europe. The Egyptian analyses published and discussed here will greatly increase the confidence with which statements may now be made not only about the character of Egyptian faience and glazes in different periods, but also, though with more caution, in particular places and within specific categories of objects. They will further allow for much greater precision in any future attempts to define

those aspects of the history of faience, and related materials, that may be confidently attributed to the Egyptian craft tradition and those which derive from Western Asiatic workshops, whose ultimate origin is probably even earlier, but whose development and repertory of objects is far less well known.

Ashmolean Museum, Oxford P. R. S. Moorey
March,1982

INTRODUCTION

In this monograph we present the results of a comprehensive survey of the chemical composition of Egyptian faience produced from predynastic through to Roman times, and fabricated from Alexandria to the 3rd Cataract. Through the rapid non-destructive analytical technique of X-ray fluorescence we have been able to survey a representative sample of objects from each of the distinct periods of Egyptian history. The aim of this work is threefold: (1) to establish, on the basis of a very large number of analyses (over 1100 are recorded here), the definitive range of compositions to be found in Egyptian faience. This then allows one, for example, to identify unusual compositions and draw attention to objects that might have been manufactured outside of Egypt and imported in antiquity or made by modern forgers. (2) To understand the chemical technology involved in the controlled production of many types of coloured glaze, and to record the changes in this technology as it flourished for over 4000 years. These changes must be viewed in the context of Egyptian archaeology as a whole. (3) To examine, within the technical tradition inside Egypt, variations in composition primarily due to differences in geography, such as the availability of certain raw materials, or a particular regional cultural influence.

The analyses, together with brief descriptions of each object are gathered together in Appendix C. Over 90% of the objects analysed were selected by Mrs. Joan Crowfoot Payne from the Egyptian collection in the Ashmolean Museum, Oxford. The remaining objects were selected by Dr. Barbara Adams from the Petrie Collection at the University College, London. The elements measured by X-ray fluorescence spectroscopy (i.e. Si, S, Cl, K, Ca, Ti, V, Cr, Mn, Fe, Co, Ni, Cu, Zn, As, Sr, Ag, Sn, Sb, Ba, Pb, and Bi) with the exception of Na, Mg, and Al, cover all the technically relevant species, and include several trace elements. The three light elements (Na, Mg, and Al) have been determined by the method of Atomic Absorption Spectroscopy in over one third (53 specimens) of the analysed faience bodies and in seven specimens of glaze.

Complete quantitative analyses of Egyptian faience, have been published by A. Lucas[1] and more recently by K. Kuhne,[2] who published the results of his own very meticulous studies of 18th Dynasty faience. Though the published

data represent a mere handful of objects, where direct comparison is possible the results are consistent with each other. Since the composition of a glaze covering a single object may vary, as is evident to the eye from the colour range, significant deviations from a "typical" composition can only be discerned from a consideration of the statistical properties of the population of glazed faience objects, and with this in mind we have aimed at a sample of at least 10 pieces for each colour and period. In the case of blue and green faience the samples are considerably larger, while some of the other colours are completely unrepresented during certain historical periods.

In addition to the two sets of analyses noted above there have appeared several semi-quantitative analyses of Egyptian faience. In 1956 Stone and Thomas published the results of a spectrographic analysis of Egyptian and other ancient faience specimens.[3] Some of their left-over samples were re-examined by neutron activation analysis in 1972.[4] The main problem with the two sets of analyses is the fact that entire beads were ground up and no attempt was made to distinguish the body from the glaze. Since the proportion of glaze material depends on the thickness of the glaze and the surface to volume ratio of any one object, the results can only be used for a general discussion of the raw materials utilized in the manufacture of faience. McKerrell's 1972 analyses[5] were limited to three elements -- Sn, Pb, and Ag -- and the data for the first two were plotted as a ratio to the copper concentration. Dayton's 1978 book contains quantitative data for Egyptian frits (obtained by C. Lahanier at the Louvre Laboratories), but his XRF analyses of faience are tabulated so as to indicate only a rough order of magnitude of the concentrations.[6] Both McKerrell's and Dayton's publications give inadequate or no information about the experimental conditions, sampling procedures, etc., and thus make it impossible to estimate the expected precision of their XRF work. These limitations make a direct comparison between our results and those in the last four works cited above rather difficult.

In tabulating and plotting averages, medians and other composite composition values we grouped the glazes into **seven** colour combinations: white, yellow, green, blue, indigo-violet-purple, black-grey and brown-red. A secondary grouping was based on the generally accepted periods of Egyptian

history. A chronological listing of Periods and Dynasties may be found in Table I below. The dates are those compiled by John Baines and Jaromir Malek and published in their **Atlas of Ancient Egypt**, Phaidon Press, Oxford, 1980. In assigning the dynasties to specific periods we followed the divisions used by Alan Gardiner in his **Egypt of the Pharaohs**, Oxford University Press, Oxford, 1961.

A plentiful supply of well-documented New Kingdom faience allowed us to subdivide the period into three parts: Early 18th Dynasty to the reign of Amenhotep III, Late 18th Dynasty in which the Amarna period is most prominent, and the Ramesside Period made up of Dynasties XIX and XX. Limitations of space forced us to assign numbers ranging from 1 to 12 to indicate the historical periods in graphs representing chronological changes. The numbers given in the first column of Table I show which period corresponds to each number.

A third grouping involved geographical proximity and was based in part on the ancient division into Upper and Lower Egyptian nomes. A more detailed discussion of the geographical divisions and specific regions is postponed until Chapter V (see Table XXXVI), but a map showing the sites from which the faience included in this study came may be seen on page vii.

The monograph has been divided into several chapters. Chapter I deals with the scope of our survey and contains a discussion of the experimental procedures and the handling of analytical data. A discussion of the results taken one element at a time may be found in Chapter II. Since the analyses consist of over 22,000 individual numbers (all tabulated in Appendix C) the primarily technical discussion in this Chapter has the data summarized and reduced to intelligible proportions. The relationship of composition to such properties as glaze colour is treated in Chapter III. A separate chapter, Chapter IV, has been devoted to a discussion of faience body materials and unglazed frits.

Since the designated time periods (see Table I) often represent distinctly different economic and political conditions, one might expect corresponding differences in the state of ceramic technology. Considering the

T A B L E I

EGYPTIAN CHRONOLOGY: 4000-30 B.C.

Historic Period	Dates, B.C.
1. PREDYNASTIC PERIODS	
Amratian (Naqada I, S.D. 30-38)	4000-3500
Gerzean (Naqada II, S.D. 39-63)	3500-2900
2. ARCHAIC (PROTODYNASTIC) PERIOD	
Dyn. I-II	2920-2649
3. OLD KINGDOM	
Dyn. III	2649-2575
Dyn. IV	2575-2465
Dyn. V	2465-2323
Dyn. VI	2323-2150
4. FIRST INTERMEDIATE PERIOD	
Dyn. VII-VIII	2150-2134
Dyn. IX-X	2134-2040
5. MIDDLE KINGDOM	
Dyn. XI	2134-1991
Dyn. XII	1991-1783
6. SECOND INTERMEDIATE PERIOD	
Dyn. XIII-XIV	1783-1640
Dyn. XV-XVI (Hyksos)	1640-1532
Dyn. XVII	1640-1550
NEW KINGDOM	
7. Early Dyn. XVIII (to Amenhotep III)	1550-1391
8. Late Dyn. XVIII (partly Amarna Period)	1391-1307
9. Dyn. XIX-XX (Ramesside Period)	1307-1070
10. THIRD INTERMEDIATE PERIOD	
Dyn. XXI	1070-945
Dyn. XXII (Libyan)	945-712
Dyn. XXIII	822-712
Dyn. XXIV	724-712
Dyn. XXV (Ethiopian)	750-657
11. LATE PERIOD	
Dyn. XXVI (Saite period)	664-525
Dyn. XXVII (Persian rule)	525-404
Dyn. XXVIII-XXIX	404-380
Dyn. XXX	380-343
Dyn. XXXI (Persian rule)	343-332
12. PTOLEMAIC PERIOD	332-30

length and topography of the country and the different degrees of contact with
the outside world that one might expect in various parts of Egypt, it is also
essential to examine evidence for regional differences in the technology. The
historical and geographical implications of our analytical results are dealt
with in Chapter V.

A detailed treatment of the probable means of faience manufacture, as
deduced from the analytical data, Scanning Electron Microscopy and Optical
Microscopy may be found in Appendix A, written by P. Vandiver. A complete
description of the individual objects and their chemical compositions is
contained in Appendix C. The objects are listed in chronological order and
contemporary ones are ordered according to provenance in an approximately
north-south direction. Items of unknown provenance are listed last in the
geographical sequence. Each object is assigned a code number which reflects
the period, region, and notebook entry of the original analysis.

Finally, since the objects tabulated in Appendix C are arranged in
chronological order and are each assigned a sequential set of designated code
numbers, to make the data more accessible to future researchers we have
appended two sets of concordances. Appendix B gives the concordance between
museum accession numbers and the sequential code numbers of Appendix C.
Objects from the University College collection have accession numbers prefixed
by the letters UC; all other numbers represent faience from the Ashmolean
Museum.

In Appendix D one may find the concordance between the excavation sites
(listed in alphabetical order) and the code numbers of Appendix C. If one
wants to know the chemical composition of any object whose museum number is
known, Appendix B should be consulted first and the corresponding code number
will allow for quick retrieval of the desired information from Appendix C.
Similarly if one wants to know which sites are represented and what objects
from a given site have been analysed and what were the results, Appendix D
should be consulted first to obtain the appropriate code numbers.

I. THE OBJECTS AND THEIR ANALYSIS

1. Previous Work and Nature of 'Faience'

No analytical discussion of Egyptian faience can begin without reference to the pioneering work of Lucas.[1] His studies showed that while there were a number of distinct variations in the type of faience produced, the basic process consisted in fusing a core of granular quartz or sand with sufficient alkali and associated impurities to produce a rigid partly-vitreous structure with a coefficient of expansion similar to that for crystalline quartz, enabling low melting alkali-based glazes to be applied.

At a sub-millimeter scale, the core is inhomogeneous, consisting of largely unreacted quartz grains surrounded by reaction zones in which sodium/potassium, calcium and possibly magnesium and aluminum silicates are intermixed. If the sodium component is added as plant ash or as natron, in solution, the drying out process can lead to a higher concentration of soda at the surface, so that after firing there is a likelihood of forming a more continuous, more easily vitrifying layer with the appearance of a glaze.

The surface may be coloured by dusting with metallic copper or its corrosion products, or by any of several other methods proposed by recent investigators. [7-10] Except in a few unusual cases a definite interface between glaze and core is seen. Occasionally the interface is enlarged by the introduction of a separate layer of very finely ground quartz. The glaze may be applied as a frit, in which the components responsible for the glass phase have already been chemically fused in a previous firing and finely ground before application. Such frits usually include colourant elements as well. Examples of such frits have been recovered in excavations at Amarna, Memphis, and other sites, and several specimens which were analyzed by us will be discussed in Chapter IV.

Photomicrographs and chemical analyses of the individual layers in specimens of 18th Dynasty faience have been published by K. Kuhne.[2,11] The results obtained by Kuhne are in essential agreement with the faience making processes discussed by Lucas.[2]

The glass softens and flows at a much lower temperature than the core. Reduction in softening temperature is brought about by increasing the level of alkali, of calcium/magnesium (to a lesser extent), by the presence of colourant metal ions, and especially by the presence of large quantities of lead. Such changes in composition make for other changes in the glaze properties (e.g. of expansion coefficient and durability). They assume greater importance in the technically more demanding process of glazing pottery, where expansion coefficients between body and glaze are more disparate, and the softening of some clays must be considered.

It is therefore not surprising that glazed quartz-paste is found long before the first glazed pottery, and that, while the composition of the glaze is quite variable, no fundamental changes in composition were found to be necessary (for example, "lead glazing" is not found on faience throughout the period studied). What is perhaps surprising is the absence of any pottery glazing industry in Egypt, even after its development elsewhere (e.g. Mesopotamia), despite the long tradition of glazed "quartz paste". The latter word has occasionally been used as an alternative name to Egyptian "faience".

The general problems of the nature and specifically the glazing of Ancient Egyptian faience have been the subject of several studies spanning a period of 50 years. The conclusions of these studies[1,2,6-12] are often at variance with each other and the whole matter is reviewed in full in Appendix A.

2. Sampling and the Choice of Objects

Our general aim has been to analyse a representative sample of each colour from each of the traditional periods into which Egyptian history is divided. The material was grouped into seven colour classes and 12 periods. Table II shows the distribution of samples between colour and period. Since production is not uniformly distributed between different colours or different periods, average compositions integrated over all periods, or all colours, will not be truly representative of the historical output.

Despite our best efforts it proved impossible to assemble a geographically balanced distribution. No museum collection that we know of,

T A B L E II

NUMBER OF ANALYSES OF SPECIMENS OF VARIOUS COLOURS AND PERIODS

C O L O U R O F G L A Z E

TIME PERIOD	White	Yellow	Green	Blue	Purple and Violet	Black and Grey	Brown and Red	BODY MATERIAL (Core)	TOTAL
Predynastic	0	0	26	23	0	0	3	3	55
Dyn. 1-2	4	0	44	16	1	6	7	22	100
Dyn. 3-6	5	0	30	15	0	8	6	8	72
Dyn. 7-10	1	0	23	11	0	16	5	6	62
Dyn. 11-12	3	0	43	37	0	28	4	35	150
Dyn. 13-17	6	0	18	21	0	16	2	4	67
Early 18th	3	5	29	20	0	5	5	12	79
Late 18th	11	9	20	24	19	4	12	20	119
Dyn. 19-20	9	8	24	29	5	8	7	13	103
Dyn. 21-25	1	0	36	36	4	16	4	6	103
Dyn. 26-30	4	2	39	20	5	4	6	6	86
Ptolemaic	6	5	24	29	13	11	7	11	106
Total:	53	29	356	281	47	122	68	146	1102

with the possible exception of the Cairo Museum, has a collection of faience objects in which each geographical region is represented during each period of history. For example, after we analysed a representative sample of Predynastic beads from several sites, we found that those from sites other than Naqada were not made of faience but consisted of either steatite or of coloured minerals, such as amazonite. A similar problem arose with objects of the Ptolemaic period, where those from the Memphis area and the Delta greatly outnumber objects from sites in Upper Egypt. Thus some geographical selection with a potential regional bias is inevitable in certain instances. The subject of regional variability will be taken up explicitly in Chapter V.

Another possible bias stemming from the original selection of objects has to do with size, shape, and other physical features of the objects. It is not clear at the present time whether the same types of chemical formulations were used for small beads as for larger objects, such as models, statuettes or vessels. It is also not known whether multi-layered or polychrome objects required different proportions of alkali and other ingredients. We did make an attempt to have a good representation of every type of object that has ever been made from faience, and Appendix C shows that we have been quite successful on the whole. However, we could not obtain an even distribution of all the types of objects for each period or for each colour. For example, a search of the Ashmolean and University College collections yielded numerous beads but only one faience amulet from an excavated and documented prehistoric site. Similarly, ushabtis form the bulk of objects from the Third Intermediate Period. We tried to avoid objects which did not come from documented excavations, and only about 10% of our samples are of unknown provenance.

More subtle biases can also be present; for example, the distinction between blue and green or black and brown does not necessarily imply that a green or brown glaze was the result of a deliberate attempt to fabricate a green rather than a blue, or brown rather than black glaze. However, in general one can regard a particular colour as being a deliberate goal. Colour variations in polychrome objects, where several layers may be superimposed, present certain problems which will be discussed in Section 10 of Chapter III. The tendency for better preserved material to be analysed can also bias the

composition, although we do not think the effect is important in this survey. Though on the whole these effects may be minor, they should be considered when conclusions are drawn.

3. Method of Analysis and Numerical Results

3a. Summary

X-ray fluorescence (XRF) was the technique employed for the rapid, non-destructive analysis of the artifacts. The apparatus we used samples a small area (about 1.5 x 1.5 mm) at the surface of the object. It is therefore particularly well adapted for the analysis of glazes. The various questions concerning the validity and accuracy of such an approach are dealt with in full below. To determine the Na, Mg and Al contents, we took samples (20 mg) from the core and analysed them by Atomic Absorption Spectrometry (AAS), since these elements are not conveniently measured by XRF. The AAS analyses were performed by Miss Helen Hatcher at the Research Laboratory for Archaeology in Oxford.

Since both XRF and AAS measure the concentrations of <u>elements</u>, and it is a convention in ceramic analysis to quote composition in terms of <u>element oxides</u>, a convention must be made regarding the oxidation state for which the concentration of some of the elements is expressed. Thus 5% of Fe would be 6% of FeO or 7% Fe_2O_3. Often both oxides are actually present. Care must be taken in comparing analyses in different publications that the same conventional oxidation state be referred to. The difference is generally small, though especially significant for MnO_2 as compared with MnO. In addition to Fe and Mn the elements: Ti, Cu, As, Sb and S may also be found in several oxidation states in faience glaze.

The variability of individual elemental compositions must be expressed in a summarized form. We find the most convenient way to do this is to tabulate both the mean (arithmetical average) and the median (value midway between the highest 50% and lowest 50%). Since the mean may be strongly influenced by the presence of an abnormally large or small "atypical" value, the median by excluding extremes gives a much better idea of the "characteristic"

composition. Variability is conveniently indicated by quoting the
"interquintile" which is the composition range containing 60% of the objects
considered after the highest and the lowest 20% (one fifth) have been deleted.

3b. Technical Details of the Analytical Method and the Treatment of the
Data

The objects were analysed non-destructively by X-ray fluorescence using a
small (20kV) X-ray tube which was supplemented by a Am-241 source for the
excitation of elements fluorescing above 20 KeV. With tube excitation, 10-15
minutes were sufficient to provide determination of the elements Si-Sr to
0.02% levels in most cases. With the collimator used in most of our work the
X-ray tube irradiated an area of about 2 mm^2. The Americium source irradiated
a larger area (about 6 mm^2) and excited a much lower count rate, so that
determinations for Sb, Sn and Ba could take up to an hour or more. A
description of an early version of the apparatus and a discussion of the
technique may be found in a paper by Hall, Schweizer and Toller.[13] The
following elements could be measured with the apparatus operating in air: Si,
S, Cl, K, Ca, Ti, V, Cr, Mn, Fe, Ni, Co, Cu, Zn, Au, As, Pb, Bi, Sr, Ag, Sn,
Sb and Ba.

The absolute elemental concentrations were essentially determined by
interpolation from 24 known standards belonging to the Research Laboratory for
Archaeology, Oxford University. In addition to the well-known Corning A-D
standards[14] and standards prepared by the British Glass Research Institute
(Nos. 1-7), several other commercial standards and other specimens of Corning
glass of known composition were used. Each one of the elements reported in
this survey could be found in no fewer than three standards. Except for a
handful of objects with unusually high Mn, Fe and Cu concentrations, the
faience analyses fell entirely within the concentration ranges covered by our
standards. By using a large and diverse collection of reference standards we
reduced the interpolation and extrapolation distances, and ensured that none
of the analysed glazes had a matrix too different in composition from the
reference glasses.

The interpolation was indirect and based on the "Influence Factor" method

of analysis.[15] In this method the concentration of any element i is expressed
as a function of the experimental conditions and the concentrations of all the
other elements. The mathematical relationship is shown below.

$$C_i = A_i F_i (1 + \Sigma C_j a_{ij})$$

The variable C_j denotes the concentration of each of the elements present in
the object (including i), and a_{ij} is called the influence factor and
represents the effect of element j on the fluorescence spectrum of element i.
The factor F_i incorporates experimental variables such as radiation intensity,
counting rate of pure element i under the experimental conditions, and other
variables not explicitly dependent on the elemental composition of the matrix.
A_i represents the net integrated experimental counting rate (per second) under
the envelope of the emission band from element i. From the spectra of the 24
standards mentioned before we obtained values of F_i and of a_{ij} for each of the
elements of interest.

To eliminate, or at least, reduce, errors which an incorrect value of any
one of the elements in any of the standards might introduce into these
factors, the experimental estimates of F_i and of a_{ij} were plotted as a
function of the energies of the fluorescence maxima for the elements Si to Sr
(1.7-15 KeV). Both F_i and of a_{ij} (one curve for each j) should give smooth
and continuous curves, except for the discontinuities expected in the values
of a_{ij} at the absorption edges. The values of F_i and a_{ij} used in the final
computer program that calculated C_i were determined for each element i from
the curves that best fit the experimental values. The points chosen along
each curve were those corresponding to the energies of the K-alpha lines,
except for Pb, where the L-alpha line was used.

The same tube voltage and amperage, and total exposure times were used
with the standards as with the objects under investigation. Since certain
elements were found in trace quantities the advantages of "Fixed Time" over
the "Fixed Count" method are obvious.[15] In order to make the interpolation as
precise as possible the positioning of the object being analysed, relative to
the X-ray tube and the detector window, was rigidly controlled. With the aid
of a fine pointer the area being irradiated could be centered reproducibly
within the incident beam with an error of less than one-half millimeter in any

of the three dimensions.

The elements Sn, Sb, and Ba required a modified version of the "Influence Factor" method. The poor collimation and difficulties in centering the X-ray beam on the object, combined with the fact that the "Fixed Time" was impractical due to the very low intensity of the radiation emitted by the Am-241 source, forced us to replace the F_i factor in the equation shown above by a factor which relates the concentration of the element \underline{i} and its fluorescence count to those of some other element \underline{r} in the same object. The modified equation was

$$C_i = C_r F_r A_i (1 + \Sigma C_j a_{ij})/A_r (1 + \Sigma C_j a_{rj})$$

where F_r, a_{rj}, and a_{ij} are determined in the manner discussed above. The factors C_r and A_r represent the concentration, as determined from the X-ray tube radiation, and the total Am-induced fluorescence count of the element selected for internal reference, respectively. Since both A_i and A_r are recorded simultaneously it is not crucial that the same total counting time be used in all instances, nor is it absolutely necessary that the entire beam impinge on the object.

The elements Cu, Zn, Pb, and Sr proved most suitable for reference purposes, since they emit radiation falling within a very sensitive region of our detector. In this way, despite the low radiation intensity reasonable values of A_r and A_i could be obtained from most objects within one hour. Of course, any error in the value of C_r will introduce the same percent error into C_i.

The precision of the indirect "Influence Factor" method for the determination of Sn, Sb and Ba was checked in 1980 and 1981, when most of the standards and about 5% of the faience objects were reexamined with the aid of a new X-ray tube whose emission extended to over 40 KeV. The new values, obtained directly, rarely differed by more than 10% from those obtained earlier by means of the Am-241 source.

The same standards were used in deriving empirical parameters for the effective intensities of primary and secondary radiations and the miscellaneous geometric factors, which when combined with the known tabulated

mass absorption coefficients allowed us to compute percent compositions by the "Absorption Correction" method (ref.15a, p. 136). The analytical data tabulated in Appendix C represent the arithmetic average of concentrations computed by the two methods.

X-ray fluorescence clearly has its limitations; but we believe that in this application where the surface area composition is of primary interest they do not seriously compromise the results, while the benefits resulting from the analysis of a very large selection of objects are clear. Three possible sources of systematic error have to be recognized, however: a. the fact that only a surface layer is being analysed, to a depth dependent on the elements being measured (because of the different X-ray energies involved); b. the change in glaze composition, especially at the surface, resulting from the process of weathering; c. excessive scattering of fluorescence radiation from non-glossy surfaces.

If a high degree of precision is required from the XRF analyses the homogeneity and the thickness of the glaze have to be known, since allowance has to be made for any exciting radiation that failed to be absorbed and passed right through into the body or even beyond. The question of glaze thickness is a vexing one, as Kuhne clearly recognized,[2] when he pointed out that a very thin glossy layer gradually merges into a thicker still heavily-pigmented intermediate layer in even the simplest faience. In our discussion the term glaze will refer to the compact coloured layer clearly distinguishable from the underlying coarser body. We recorded the glaze thickness in over 250 objects and found the values to range from 100 to 1000 microns, with a median ca. 350. Glazes of the Amarna and Ptolemaic periods tend to be among the thickest. When experimental values were not available, as in the case of undamaged objects, a thickness of 350 microns was assumed in making corrections for the fraction of radiation penetrating beyond the glaze.

When allowance is made for the angle of incidence (which extends the path length) one can easily determine from the published mass absorption coefficients that X-rays of energies lower than 11 KeV will be virtually all (over 90%) absorbed by soda-lime silicate glazes 100 microns thick.[15] Consequently, only the values of Sn, Sb and Ba may be subject to significant

errors caused by the finite thickness of faience glazes. Fortunately, few glazes are as thin as that. It is also fortunate that many of the glazes rich in tin and antimony also tend to have appreciable amounts of lead and consequently very little radiation is transmitted, even through thinner glazes, because of the high mass absorption coefficient of Pb.

The reference standards were in most instances thick enough to allow for an assumption of infinite thickness. The same assumption is valid when percent compositions of faience bodies are computed. In dealing with glazes we made a correction for the finite thickness when such was known, whereas other objects were normalized to 350 microns. Consequently, values of Sn, Sb and Ba will be overestimated in thicker glazes and underestimated in thinner. Since the full dimensions of just about all objects had been recorded, a correction was also made for radiation excited on the reverse side of thinner objects. This was quite significant in small beads, which tend to have thinner glazes and consequently might yield most serious underestimates. After allowance is made for losses in the intervening body and for secondary radiation emanating from the other side, the combined thickness is usually quite close to the normalising 350 micron value.

Whereas it must be obvious that qualitative aspects of the information are not obscured by the finite glaze thickness, even the quantitative are only marginally affected. Sample calculations have shown that for the great majority of compositions a glaze several hundred microns thinner or thicker than the presumed 350 microns will not yield an error in excess of 10% of the computed tin or antimony concentration. This is particularly true if more than trace amounts of Sn, Sb, or Ba are present for these elements also have fairly high mass absorption coefficients.

Any change of glass or glaze composition caused by weathering depends upon a range of environmental factors, and also varies throughout the thickness of the glaze. Most severe and frequent changes are brought about through the leaching of such elements as Na and K. Because of the smaller depth of the surface layer sampled by the less penetrating fluorescence of the lighter elements, it is for these elements that the greatest change is noticed. This problem has recently been investigated in some detail by Cox

and Pollard.[16] However, serious chemical change, sufficient to distort the analysis of elements heavier than K to more than, say, 10%, is easily recognized from the weathered condition of the surface. Consequently, one can either avoid such objects or make special note of them.

In the case of Egyptian faience the state of preservation of the overwhelming majority of objects was extremely good, no doubt due to the very dry climate and other favourable burial conditions. We do know from excavation reports that many of the objects examined by us had probably never been exposed to water or even damp soil. This condition contrasts strongly with, for example, the high degree of weathering and other time-induced changes seen by us on Minoan and Mesopotamian faience. Favourable burial conditions are not the only factor, for Egyptian faience is famous for its resistance to attack by aqueous solutions. Kiefer and Allibert were amazed at how well some of the ancient specimens resisted attack by concentrated acids, for example.[9] For these reasons, we are confident that very few of our analyses are distorted by chemical weathering.

With regard to scattering from non-glossy surfaces the effects are only significant in the analysis of unglazed frit and faience body material (cores), since we tried to avoid objects on which there was not at least one spot of well-preserved glaze. We were fortunate enough to have several glass standards from which sections had been cut leaving behind a rough surface. Thus we could contrast the spectra of the glossy original polished surface with those from surfaces of various degrees of roughness. Only for elements below Ca did excessive scattering affect the fluorescence to any significant degree. The reduction in the intensity of the Si peak never amounted to more than 20% or to more than 10% in the case of K. From these measurements an appropriate empirical correction factor was derived and used in computing the compositions of frits, cores and the few glazed objects showing evidence of weathering.

We believe that such scattering is not a serious problem in our work, for we find no systematic difference between the analyses of extremely well preserved and the most questionable material. Moreover, as we will show in Chapter II the overall glaze compositions agree remarkably well with analysed

bulk glass compositions compiled by Lucas[18] and others.[19-25] Even in the case of body materials, where the effect is expected to be most pronounced, the K and Ca concentrations calculated from the fluorescence spectra of the core surface proved in most instances to be remarkably close to the values obtained for the same two elements from the Atomic Absorption Spectra of more homogeneous samples from the same objects(see Table XXXI in Chapter IV). Only in a few samples did the differences exceed the range of uncertainties we have allowed for these elements.

For elements heavier than Cr the analyses are expected to be within $\pm 5\%$ of the quoted value, except for Sn, Sb, and Ba where thinner glazes might increase the negative deviation for reasons discussed earlier. An uncertainty of $\pm 10\%$ in the values reported for elements in the Ca--Cr range, and $\pm 15\%$ for the K concentration is more than adequate to cover not only the potential systematic errors discussed above, but also the experimental accuracy found in repeated measurements of the same standards over a period of six years.

Since, with the exception of the 60 objects subjected to Atomic Absorption Analysis, the Na, Mg, and Al content of our materials is not known, the uncertainty in the Si value has to be raised to $\pm 20\%$ of the calculated value. The radiation emitted by Si, S and Cl is strongly absorbed by the three elements listed above, so in objects where Na, Mg and Al are found in excess of the average content of our standards Si, S, and Cl will be underestimated. The effect of Na is least important since its absorption edge is furthest removed from the Si emission line. This is quite fortunate, since an examination of the reported Egyptian faience and glass analyses[1-3,18-25] reveals that, whereas glasses have been found in which the soda content was as high as 30%, the concentration of either magnesia or alumina rarely exceed 5%. If the specimens in which the three elements were determined by Atomic Absorption Spectroscopy are assumed to represent a random sample, it would appear that in faience bodies, at least, only modest quantities of Na, Mg, and Al are to be expected in most instances. The data published by Lucas[1] and Kuhne[2] are in full accord with this conclusion.

It is important to note at this point that a very small absolute concentration of any element indicates a small fluorescent radiation count and

consequently greater inaccuracy in the experimental readings. For elements whose absolute concentrations fall below 0.5% the absolute errors may still be small, but the percent uncertainties quoted above will prove too optimistic. A particularly serious problem arises when the emission of an element found in small quantity overlaps that of a more plentiful component. In the presence of large amounts (above 5%) of iron and copper the values obtained for trace quantities (below 0.05%) of cobalt and zinc, respectively, may be in error by as much as ±100%. Similarly it does not take much lead to completely overwhelm and render almost undetectable small quantities of arsenic, and it is quite probable that more objects contain trace quantities of As than our results would indicate. Consequently, it is hoped that small absolute but large percent variations in the concentrations of elements present below 0.1% will not lead to unwarranted conclusions of the type well known in some archaeological literature.

In our description of each analysed specimen in Appendix C we have tried to describe the object and the spot where it was analysed as precisely as the space permitted. Such a description is particularly important in the case of larger and polychrome objects. Even on objects of one colour the composition of the glaze can vary from place to place, especially in the levels of colourant elements (e.g. Cu), and this generally is consistent with visual observation of changes in colour intensity. Some variations are quite extreme and objects have been seen where blue and green are found side by side on a continuous and homogeneous layer (for example, object No. 225-125-416 in Appendix C), or where small beads exhibited one blue and one green side. While these changes are random, rather than the systematic effects noted above, they limit the level of precision to which it is useful to make measurements.

Considering the low penetrating power of X-rays used in fluorescence analysis there is always the danger that the recorded data reflect, in part at least, the composition of a thin impurity layer. In dealing with museum objects, some of them of considerable value, one is seriously constrained in the choice of acceptable methods that might be used to clean the surface. In cases where particles of soil or other solid accretions were visible to the naked eye or under a magnifying glass, they were removed with the aid of a

wooden matchstick, a scraper that would neither contaminate nor scratch a glazed surface. Subsequent to this treatment, and in cases where no impurities were visible, the glazed area was wiped clean, first with a damp paper tissue then with one soaked in acetone. Contamination with lime or plaster ($CaSO_4$), found most often on restored objects in the vicinity of the breaks, is not as easily observed, but it does show up in excessive values of S and Ca. Whenever the concentration of either one of the two elements appeared too large, other areas of the same object were analysed and if they yielded significantly lower reproducible values only the latter would be accepted as the correct data. In one instance, for example, after a 19% Ca content was detected on one spot, analyses of adjacent areas yielded 3.1 and 3.4%, respectively. As a result of all these precautions it is unlikely that many cases of contaminated surface remain hidden among our analyses.

II. THE ELEMENTAL COMPOSITION OF FAIENCE GLAZES

In this section each element is considered in turn. Many elements are related together, technically or geographically, and such relationships will be brought out in subsequent chapters.

1. Potassium

Either potassia (K_2O) or soda (Na_2O) are essential ingredients in silica based glass. The combined concentration in glass would be expected to be 10-20%. The majority of analysed Ancient Egyptian glasses contain 15-25% alkali oxides.[18-25] In contrast, much lower values, in the 5-15% range, have been reported for faience glazes. For a specimen of greenish-blue 19th Dynasty and blue Roman period faience, respectively, Lucas reports 2.1 and 16.2% alkali content.[1] Kuhne has found 4.95 and 4.2% of soda (and no potassia) in a blue-green Amarna period ring and tile respectively.[2] Table III shows the median and mean levels of K_2O found by us in glazes of different colour at different periods.

Though experimentally determined soda concentrations are only available for six glazes and 52 faience bodies (Table XXXI) a reasonable estimate of the soda content of faience glazes can be made from the numbers tabulated under the "Other" heading in Appendix C. This column contains all the undetermined elements lighter than Si, and the reported glass analyses indicate that chief among them would be Na, with Mg and Al running a poor second. If one assumes that the relative amounts of magnesia, alumina and alkali are not too drastically different from those found in glass, one gets a range of values from 3-7% for the estimated combined alkali content of most faience.

No matter how one estimates the soda content, one inescapable conclusion is that in general potassia is the minor contributor to the total alkali content of Egyptian faience. This is borne out by the data presented in Section 20 of this Chapter. The impression that in most instances it is probably present as a contaminant is strengthened by noting that the darker colours on the right side of Table III contain more K_2O on the average. Here the purity of the original sand, which in some parts of Egypt is reported to contain over 1% of potash,[26,27] and of added components, such as plant ash, would be of lesser concern.

T A B L E III

VARIATIONS IN THE CONCENTRATION OF Potassium Oxide

IN GLAZES OF VARIOUS COLOURS

--

THE MEDIAN AND
AVERAGE PERCENT VALUES

TIME PERIOD	White	Yellow	Green	Blue	Purple and Violet	Black and Grey	Brown and Red
Predynastic	---	---	0.39	0.79	---	---	0.26
	---	---	0.48	0.90	---	---	0.27
Dyn. 1-2	0.75	---	0.46	1.34	0.00	2.31	1.29
	0.94	---	0.82	1.43	0.00	2.22	1.63
Dyn. 3-6	0.00	---	0.25	0.80	---	0.88	0.73
	0.07	---	0.40	1.28	---	1.15	0.65
Dyn. 7-10	0.00	---	0.42	2.49	---	1.33	1.23
	0.00	---	0.86	1.84	---	1.39	1.26
Dyn. 11-12	0.14	---	0.33	0.49	---	1.18	0.12
	0.15	---	0.58	0.92	---	1.48	0.18
Dyn. 13-17	0.21	---	0.69	1.62	---	2.68	0.98
	0.44	---	0.76	1.95	---	2.61	0.98
Early 18th	0.33	0.60	0.46	0.82	---	1.94	0.92
	0.41	0.59	1.20	1.34	---	2.33	0.92
Late 18th	0.02	0.82	0.60	0.65	1.12	0.35	0.77
	0.17	1.06	0.81	1.16	1.09	0.33	1.31
Dyn. 19-20	0.24	0.63	0.15	0.53	0.46	0.91	1.44
	0.28	0.60	0.22	0.85	0.49	0.86	1.47
Dyn. 21-25	0.66	---	0.32	0.92	2.55	0.97	0.56
	0.66	---	0.41	1.22	2.47	1.40	0.70
Dyn. 26-30	0.71	0.35	0.38	0.37	1.08	1.27	1.58
	0.65	0.35	0.40	0.53	1.29	1.30	1.40
Ptolemaic	0.63	1.72	1.20	1.26	1.49	1.55	0.72
	0.74	1.92	1.18	1.27	1.59	1.67	1.08

For several millennia plant ash has been, and in parts of the world still is, the principal source of alkali for everything from glazing to soap-making. In a group of 16 Middle Eastern plant ashes analysed and published by Brill,[28] all but one contained much more sodium than potassium. The one exception, a bush from the Egyptian Delta (specimen 653), yielded 18.2% K_2O and 7.75% Na_2O. As it was the only Egyptian specimen included in the study we do not know how typical it is of Egyptian plants in general. Since the great majority of our faience analyses and the published glass data show a considerable excess of sodium over potassium, it would appear that either most Egyptian plants resemble those from other parts of the Middle East, or that plant ash was not used extensively in the manufacture of glass and faience in Egypt. Only the analysis of a large number of plants from a wide geographical area will tell which is the correct conclusion.

If, as it appears, plant ashes were used only sparingly, it might have been because Egypt had a plentiful supply of an alternative source of alkali, namely natron. When natron, a mixture of $NaHCO_3$ and Na_2CO_3, is heated it decomposes to soda with loss of carbon dioxide. Only in the case of faience body materials do we have experimental verification of the proposition made above, that soda and not potassia was the principal alkali in Egyptian faience. Our own data reveal that in 90% of the analysed faience bodies Na_2O is in excess of K_2O (see Table XXXI).

2. Calcium

Lime (CaO) and to a lesser degree magnesia (MgO) are also essential ingredients in glass. Though some Egyptian sands contain appreciable amounts of $CaCO_3$, the quantity is so variable (0.2-35.0%)[26,27] that it would be most surprising if the Egyptians did not add a certain amount of lime routinely to ensure an adequate concentration. The levels of CaO shown in Table IV are, with few exceptions, at the lower end of the range expected in glass, but fall within the range of values reported for Egyptian faience.[1,2] If a substantial amount of CaO did originate in the raw sand, the observed range of lime concentrations is hardly surprising. As the glazing properties are quite insensitive to the CaO content, there would not be much incentive to control the lime intake through more careful selection and purification of sand.

T A B L E IV

VARIATIONS IN THE CONCENTRATION OF Calcium Oxide

IN GLAZES OF VARIOUS COLOURS

--

THE MEDIAN AND
AVERAGE PERCENT VALUES

TIME PERIOD	White	Yellow	Green	Blue	Purple and Violet	Black and Grey	Brown and Red
Predynastic	---	---	1.63	2.14	---	---	2.80
	---	---	2.14	2.63	---	---	2.79
Dyn. 1-2	2.02	---	1.98	5.46	1.89	5.82	3.40
	1.74	---	3.03	7.22	1.89	7.60	3.91
Dyn. 3-6	0.28	---	1.39	2.79	---	2.18	1.99
	1.14	---	1.94	5.28	---	2.58	2.92
Dyn. 7-10	1.80	---	1.40	2.27	---	2.46	1.55
	1.80	---	1.77	2.52	---	2.82	1.73
Dyn. 11-12	2.34	---	1.50	1.48	---	1.41	2.12
	2.32	---	2.41	1.93	---	2.46	2.39
Dyn. 13-17	1.08	---	1.03	1.29	---	1.61	2.13
	1.07	---	1.92	1.26	---	1.87	2.13
Early 18th	0.50	2.65	1.13	1.00	---	1.03	1.60
	0.79	3.16	2.28	1.78	---	1.10	4.12
Late 18th	2.19	2.10	1.15	1.03	1.29	1.40	1.51
	2.21	2.01	1.56	1.06	1.64	1.69	1.95
Dyn. 19-20	2.01	1.86	0.98	1.16	5.02	1.06	1.80
	2.17	1.95	1.49	1.66	5.60	1.16	1.88
Dyn. 21-25	1.64	---	1.11	0.99	1.18	1.38	2.03
	1.64	---	1.38	1.41	1.09	1.56	2.44
Dyn. 26-30	0.85	0.73	1.50	2.31	3.82	1.69	1.53
	0.77	0.73	1.86	2.98	4.52	1.63	2.26
Ptolemaic	3.31	3.77	2.74	2.88	3.93	3.56	2.56
	3.63	3.62	3.06	3.37	3.92	3.79	3.53

The concentrations of lime show no consistent historical trend. In most colours the highest average compositions are found in early and late faience. The reasons for this are not known, but if less thorough sand selection is responsible for the large amounts found in pre-Old Kingdom faience, preferential selection of calcareous sands or deliberate addition for technical reasons is more likely to be the cause of higher levels in Ptolemaic glazes. This conclusion is supported by the observation that the Ptolemaic faience exhibits a much smaller gap between the median and mean values, indicating a narrower range of values and hence greater deliberate control of the raw materials.

There is no systematic variation of CaO with colour, except that prior to the 18th Dynasty the darker colours tend to contain more calcium on the average. This parallels the behaviour of potassium and may presumably be attributed to a less thorough sand selection and washing. Why the colour dependence is less obvious in faience of the 18th and later dynasties is not clear. That there is no change in the mean CaO values from green, through blue-green to blue is interesting, because calcium is involved in the chemistry of the blue pigment "Egyptian Blue".[30,31] Table XXXI in Chapter IV shows that the CaO content of faience body materials, where instead of a developed glassy phase only a certain degree of cohesion is needed, generally resembles that found in most glazes. This supports the contention that a substantial portion of the lime comes from raw sand, which comprised the bulk of the core.

In addition to individual cases of high-lime content scattered randomly among our objects, we can single out certain classes of faience in which deliberate addition of substantial amounts of lime or limestone is clearly indicated. For example, the body materials of Variant D faience[1] and unglazed frits, both of which will be dealt with in greater detail in Chapter IV, show consistently high CaO concentrations (see Tables XXXI and XXXV), well above what one might expect from a random sand selection and far in excess of quantities encountered in contemporary glazes. Moreover, it is probably no coincidence that the only specimen of "glassy faience" that we had the opportunity of analysing (specimen 250-200-504 in Appendix C) should contain 5% CaO, the highest value of any object for the time period. The object, a

blue-green ushabti of the 25th Dynasty, stands out even more if the value is compared to the mean and median values of either blue or green faience of the same period. Since glassy faience is distinguished by a higher degree of vitrification,[1,32] the need for more lime is obvious.

Several cases of highly vitrified faience, where only a few quartz crystals can be seen floating in a nearly translucent glass matrix, also exhibit abnormally high CaO levels. Some of the vitrified faience antedates the appearance of glass by almost a millennium (for example, Old Kingdom beads 1924.339A/C from Badari) and might be considered as forerunners of glass. Since these objects also contain abnormal levels of K_2O (the specimens enumerated above contain about five times the median concentration for the period),it is tempting to see here some early experimentation in glassmaking.

3. Titanium and Vanadium

Neither titanium nor vanadium have any technological significance in producing a glass or as colourants at the concentration levels encountered in faience. (Though under suitable conditions glaze colours can be produced with either Ti or V).[33] Levels of TiO_2 and V_2O_5 are a reflection of the accidental circumstances leading to the incorporation of the elements. Since rutile (TiO_2) forms intergrowths with quartz, and ilmenite ($FeTiO_3$) is a fairly common mineral, most sands are expected to contain some titanium, and Egyptian sands are no exception.[26,27] Unfortunately we have no analytical data on the vanadium content of Egyptian sands, but glass analyses indicate the presence of V_2O_5 at the 0.01-0.03% level.[22,24]

Tables V and VI show that the concentrations of the two elements fluctuate within a very narrow range of values. No general trend is discernible, except that for most colours Ptolemaic faience shows the highest TiO_2 and lowest V_2O_5 concentrations. We have no explanation for this observation, but since most of the Ptolemaic material comes from Lower Egypt, Memphis specifically, the change in raw materials might be dictated by geographical rather than technical considerations. The five sand specimens in which TiO_2 was determined came from widely separated regions of Egypt and show a spread in values from less than 0.1% to 1.2%.[26,27]

T A B L E V

VARIATIONS IN THE CONCENTRATION OF Titanium Oxide

IN GLAZES OF VARIOUS COLOURS

--

THE MEDIAN AND
AVERAGE PERCENT VALUES

TIME PERIOD	White	Yellow	Green	Blue	Purple and Violet	Black and Grey	Brown and Red
Predynastic	---	---	0.02	0.03	---	---	0.06
	---	---	0.04	0.05	---	---	0.08
Dyn. 1-2	0.07	---	0.04	0.04	0.03	0.10	0.05
	0.08	---	0.06	0.05	0.03	0.16	0.06
Dyn. 3-6	0.00	---	0.01	0.08	---	0.01	0.13
	0.01	---	0.03	0.07	---	0.09	0.14
Dyn. 7-10	0.10	---	0.00	0.00	---	0.11	0.13
	0.10	---	0.01	0.04	---	0.11	0.13
Dyn. 11-12	0.04	---	0.04	0.00	---	0.00	0.11
	0.03	---	0.05	0.02	---	0.09	0.08
Dyn. 13-17	0.08	---	0.04	0.04	---	0.03	0.09
	0.08	---	0.05	0.04	---	0.03	0.09
Early 18th	0.01	0.02	0.05	0.04	---	0.00	0.04
	0.01	0.05	0.06	0.05	---	0.02	0.04
Late 18th	0.02	0.03	0.00	0.04	0.07	0.05	0.08
	0.03	0.08	0.03	0.04	0.08	0.05	0.11
Dyn. 19-20	0.03	0.04	0.06	0.05	0.04	0.07	0.12
	0.03	0.05	0.05	0.05	0.05	0.06	0.11
Dyn. 21-25	0.05	---	0.07	0.03	0.03	0.02	0.16
	0.05	---	0.07	0.03	0.02	0.04	0.16
Dyn. 26-30	0.04	0.04	0.07	0.09	0.07	0.07	0.12
	0.04	0.04	0.08	0.11	0.07	0.08	0.25
Ptolemaic	0.08	0.03	0.08	0.13	0.09	0.15	0.10
	0.09	0.04	0.09	0.12	0.08	0.18	0.14

T A B L E VI

VARIATIONS IN THE CONCENTRATION OF Vanadium Oxide
IN GLAZES OF VARIOUS COLOURS

--

THE MEDIAN AND
AVERAGE PERCENT VALUES

TIME PERIOD	White	Yellow	Green	Blue	Purple and Violet	Black and Grey	Brown and Red
Predynastic	---	---	0.00	0.00	---	---	0.02
	---	---	0.00	0.00	---	---	0.02
Dyn. 1-2	0.12	---	0.00	0.00	0.00	0.00	0.00
	0.13	---	0.03	0.00	0.00	0.01	0.03
Dyn. 3-6	0.06	---	0.00	0.01	---	0.00	0.07
	0.06	---	0.01	0.02	---	0.00	0.07
Dyn. 7-10	0.06	---	0.00	0.00	---	0.00	0.01
	0.06	---	0.02	0.01	---	0.01	0.02
Dyn. 11-12	0.05	---	0.00	0.00	---	0.00	0.00
	0.09	---	0.02	0.01	---	0.01	0.03
Dyn. 13-17	0.05	---	0.00	0.03	---	0.00	0.02
	0.05	---	0.01	0.03	---	0.01	0.02
Early 18th	0.00	0.00	0.00	0.00	---	0.00	0.00
	0.00	0.00	0.02	0.02	---	0.01	0.00
Late 18th	0.02	0.00	0.00	0.00	0.00	0.00	0.00
	0.02	0.01	0.01	0.01	0.01	0.01	0.01
Dyn. 19-20	0.02	0.00	0.05	0.02	0.00	0.02	0.00
	0.02	0.02	0.05	0.03	0.02	0.03	0.01
Dyn. 21-25	0.07	---	0.04	0.01	0.00	0.00	0.02
	0.07	---	0.04	0.02	0.00	0.01	0.02
Dyn. 26-30	0.02	0.02	0.02	0.00	0.00	0.00	0.00
	0.03	0.02	0.05	0.02	0.00	0.00	0.04
Ptolemaic	0.00	0.00	0.00	0.00	0.00	0.00	0.00
	0.01	0.01	0.01	0.00	0.00	0.00	0.00

Of all the colours, iron-rich brown and red of each period contain the most TiO_2, but whether the element is introduced with iron ore or simply reflects raw Egyptian sand, of which ilmenite ($FeTiO_3$) is a frequent component, [26] is not clear. That sand may well be the chief source of Ti and V is supported by the observation that with few exceptions the mean and median concentrations of the two elements in glazes are hardly distinguishable from values found in faience body material (see Tables XXXII and XXXIII). The similarity in the titanium content of glaze and body material can also be seen in the analyses published by Kuhne, who reports 0.02% for each of two specimens of blue-green Amarna glaze and 0.03% for the body material of one of the two objects.[2]

Glass analyses published before 1950 do not include titanium, and even many recent ones do not list vanadium. Recent spectrographic analyses published by Geilmann show TiO_2 in each sample and yield 0.11% for both the median and the mean.[34] Electron-beam probe microanalysis of three specimens of Amarna glass showed 0.1% TiO_2 in two of them.[25] Neutron activation analyses of 17 specimens of New Kingdom glass gave a median value of 0.08% for TiO_2 and 0.02% for V_2O_5.[22,24] We could not fail to note that among the 17 objects examined by Sayre black glass stands out in that it contains 0.48% TiO_2,[24] and since it also has the highest iron concentration, it lends support to our contention that additional TiO_2 comes with the iron.

Our faience analyses yield vanadium concentrations remarkably close to those found in glass and titanium concentrations halfway between the published glass and faience values. It should be pointed out that neither Ti nor V would appear to be suitable elements for the discrimination of geographical sources of raw materials, at least in Egypt. The published [17,20-22,25,28] and unpublished [24] data for Mesopotamian glass and faience give concentration ranges for TiO_2 and V_2O_5 which overlap those found in Egyptian materials.

4. Chromium

Chromium rarely occurs above the detection limit and even then the amounts are insignificant. Of almost one thousand glaze specimens analysed no more than a dozen contained Cr_2O_3 in excess of 0.01%, and in not a single case did the concentration exceed 0.06%. The element is seen more frequently on faience body material than on glazes, and often the amount found on the same object is extremely variable. Considering these observations and the low concentration levels there is a high probability that many (if not most) of the objects on which Cr_2O_3 was detected became contaminated with the element in antiquity through contact with clay or steatite moulds.

Of the trace elements found in Egyptian clays chromium is one of the most abundant. Tobia and Sayre, who recently analysed Egyptian pottery and clays from a wide geographical area, found Cr_2O_3 in the 0.01-0.05% range in each of their specimens.[35] Steatite also has to be considered as a potential source of chromium. We found substantial amounts (over 0.1%) of the element in a number of glazed steatite objects. In Egypt as in other parts of the world chromite is a common mineral in steatite deposits.

Only Stone and Thomas have reported finding chromium in Ancient Egyptian faience; in all but one case out of 28 the amounts were below 0.01%. [3] In Egyptian glass, Sayre found values ranging from 0.0005 to 0.0093% [22,24], so it is not surprising that earlier workers have not reported the element. Brill and Moll detected no Cr_2O_3 in blue or green glass, but found 0.1% in an opaque red specimen. [25] Our analyses give a concentration range similar to Sayre's, but only values over 0.01% are tabulated in Appendix C. In our opinion, any faience object containing over 0.05% Cr_2O_3 should be re-examined very carefully; if the figures are reproducible and the object definitely is not glazed steatite, one should consider the possibility that it is a foreign import or an outright fake.

5. Manganese

The element is most frequently found in the form of MnO_2 under the name of **pyrolusite**, or as a hydrated variant in minerals referred to as **psilomelanes** or **wads**. These minerals are black in colour. Above 535°C MnO_2 decomposes to black Mn_2O_3, which in turn decomposes to brownish black **hausmannite** (Mn_3O_4) above 870°C. Since only the lower oxidation states will be encountered in glasses and glazes, we have decided to express our manganese concentrations as % of MnO, a form nearest to Mn_3O_4. At moderate to low concentrations, particularly in the absence of iron, these lower oxidation states will impart a purple colour to a glass matrix.[33]

Egyptian sands have been reported to contain anywhere from only "trace" to 0.1% MnO;[26,27] this range falls within the wider range found in Egyptian clays.[35] Since the presence of manganese in either the raw materials or finished products would be quite obvious to the ancient glaze-maker, we believe that only values significantly in excess of 0.1% indicate intentional addition of the element for technical purposes.

Published glass analyses and our own results shown in Table VII support this belief. Examination of data published for colourless, white, yellow and green glass show few exceptions where the values exceed 0.1%. Thus Sayre reports a range of 0.016-0.035% for colourless and white glass, and 0.024-0.048% for yellow.[22-24] Farnsworth and Ritchie report 0.05% as the average of white and yellow specimens of New Kingdom glass, and give a range of 0.05%-0.1% for blue-green glass.[19] Similarly Neumann and Kotyga report only "trace" for all their specimens of colourless, white, yellow and green New Kingdom glass, and since the numbers are rounded off to the first decimal place the data indicate concentrations below 0.08%.[18,20] The three published analyses of blue-green faience glaze all show the manganese content significantly below 0.01% MnO.[1,2]

The median and average values in white, yellow and green faience are remarkably close to what one finds in contemporary glass. Since one or two objects unusually rich in manganese can distort the average, the median is a better criterion of the prevalent composition. In the few instances where the average does exceed 0.1% the median remains in the mainstream. The only case

T A B L E VII

VARIATIONS IN THE CONCENTRATION OF Manganese Oxide

IN GLAZES OF VARIOUS COLOURS

--

THE MEDIAN AND
AVERAGE PERCENT VALUES

TIME PERIOD	White	Yellow	Green	Blue	Purple and Violet	Black and Grey	Brown and Red
Predynastic	---	---	0.01	0.01	---	---	5.68
	---	---	0.02	0.02	---	---	5.73
Dyn. 1-2	0.10	---	0.02	0.03	0.01	3.05	0.87
	0.16	---	0.06	0.11	0.01	4.32	1.40
Dyn. 3-6	0.06	---	0.01	0.02	---	1.88	1.02
	0.05	---	0.06	0.08	---	2.64	1.32
Dyn. 7-10	0.09	---	0.03	0.06	---	2.10	3.35
	0.09	---	0.26	0.28	---	2.18	3.06
Dyn. 11-12	0.06	---	0.04	0.02	---	2.49	0.08
	0.14	---	0.06	0.04	---	2.70	0.49
Dyn. 13-17	0.09	---	0.02	0.02	---	2.50	1.85
	0.13	---	0.05	0.09	---	3.09	1.85
Early 18th	0.00	0.00	0.00	0.01	---	2.34	0.00
	0.00	0.00	0.04	0.03	---	2.19	0.00
Late 18th	0.02	0.06	0.00	0.13	0.32	2.01	0.01
	0.04	0.05	0.14	0.20	0.35	2.14	0.32
Dyn. 19-20	0.02	0.04	0.06	0.05	0.18	1.23	0.06
	0.03	0.04	0.05	0.11	0.15	1.81	1.55
Dyn. 21-25	0.04	---	0.07	0.04	0.76	2.44	1.61
	0.04	---	0.08	0.04	0.75	8.80	2.74
Dyn. 26-30	0.00	0.06	0.04	0.02	0.01	1.55	0.08
	0.01	0.06	0.05	0.03	0.07	1.70	0.57
Ptolemaic	0.02	0.03	0.02	0.04	0.06	0.33	1.88
	0.09	0.04	0.09	0.12	0.42	0.65	1.73

where the median exceeds 0.1% (First Intermediate Period white) has several off-white objects from the same Delta site and these may represent a regional factor in the choice of sand, since we cannot see why manganese-rich minerals would be added to what was intended as a colourless or white glaze. The few green objects responsible for the high averages (three instances) all have a greyish-green colour, and it is possible that MnO_2 was added deliberately to darken the colour.

However, the main interest of manganese is in its addition as a deliberate colourant. In such cases a table of averages and medians can be misleading, since often the distribution is bimodal. Under those circumstances the tabulated information can be clarified by a plot, such as in Fig. 1, of the concentration range of some fraction (middle 60% in our case) of each colour at each period of time. Examination of Table VII and Fig. 1 reveal that, except for the Amarna Period (Late 18th Dyn.), what was said about green applies to blue glazes. Only during the Amarna period does one find a significant fraction (over 50%) of objects with MnO in excess of 0.1%. If the Amarna blues are set aside, the fraction of blue glazes containing more than 0.1% MnO is not significantly different from the corresponding fraction of green and white glazes, i.e. under 20% for the total time span.

Just about all the manganese-rich blues of the Amarna and Ramesside Periods are also distinguished by the presence of significant quantities of cobalt and elevated amounts of several other elements. For example, if the New Kingdom glazes are separated into two classes: "Copper Blue" and "Cobalt Blue", using 0.05% CoO as the dividing line, we find two very distinct median values for MnO -- 0.02 and 0.28%, respectively. The correlations will be more fully discussed in Section 7.

New Kingdom violet faience is also very rich in manganese and cobalt, which explains why the colours border on indigo. The correlation between the two elements has also been noted in New Kingdom glass by Sayre, who recognized the need to distinguish between Cobalt Blue and Copper Blue glass. [22,23] As already noted, the similarity between the pigment concentrations in New Kingdom glass and faience is quite remarkable. The average concentration of manganese oxide in cobalt blue New Kingdom faience, 0.28% MnO, should be

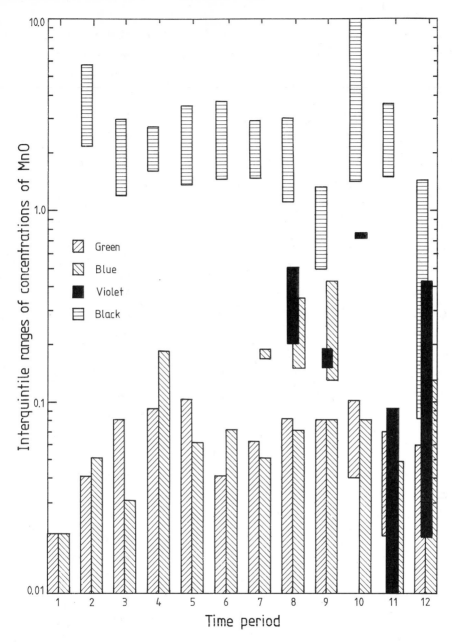

Figure 1. The interquintile ranges of concentrations of MnO in faience glazes of different colours at various time periods.

compared with the concentration ranges reported by Geilmann, 0.16-0.38;[34] by Farnsworth and Ritchie, 0.2-0.3%; [16] and by Sayre, 0.21-0.41%. [22-24]

For violet glass of the New Kingdom the last two groups of researchers report manganese ranges of 0.5-0.7% and 0.38-0.52%, respectively, which overlap the range found in New Kingdom violet faience, 0.0-0.5% MnO. The question of whether manganese was introduced as an impurity in a cobalt ore, or vice versa, has recently been discussed by Sayre,[23] and will be taken up by us in Section 7.

Only after the 20th Dynasty do we find clear evidence of deliberate use of just manganese to produce violet and purple glazes, since the quantities of cobalt are negligible in many of them. The apparent similarities in glass and faience technologies noted above is further underscored by the observation that one of the highest manganese concentrations listed by Lucas (No. 5 on p.480 of ref. 18) was found by Geilmann [34] in a cobalt-free violet glass of the 22nd Dynasty, a period of history in which violet faience has the highest mean and average values of manganese and little or no cobalt. Among the Ptolemaic violets and purples about half have a reddish purple colour which they owe to manganese solely, as they contain less than 0.02% CoO. The other half verge on indigo due to high cobalt concentrations and little or no manganese.

In black and brown glazes of most periods the MnO content is almost two orders of magnitude greater than what is expected from sand. The deliberate use of MnO_2 to produce oxidatively stable black is indisputable in most faience from the 2nd to the 26th Dynasty, when manganese begins to give way to reduced iron oxide. This is clearly seen in Table VII and will be discussed in greater detail in the next chapter. Unlike the black glazes of the Late and Ptolemaic periods in which the dominant iron is frequently quite free of manganese, the earlier glazes in which manganese dominates are seldom free of iron. Therefore, it is technically more correct to talk about a manganese-iron black pigment, as Noll has done in discussing very similar pigments detected on Ancient Egyptian clay ceramics. [36] Recent studies of decorated Ancient Near Eastern pottery have shown that the use of manganese oxides goes as far back in time as the use of reduced iron. [37]

The great variability observed among the numbers in the last column of Table VII is at least in part caused by the fact that both brown and red glazes are included. The proportion of each colour differs from period to period, and the red glazes tend to be lower in manganese. A discussion of the manganese concentrations of red as opposed to brown Egyptian glazes will be found in the next chapter. The published analyses of red and brown Egyptian glass exhibit a similarly wide range of values.[18,20]

Egypt contains many rich deposits of manganese,[38-41] mostly in the form of pyrolusite, but other ores, such as psilomelane, are also found in ample amounts. [40] That the Egyptians exploited many of the different deposits is attested by the discovery of specimens of pyrolusite, psilomelane and wad in tombs of the 12th and 18th Dynasties.[42] Whether these specimens were intended for the manufacture of pigments is uncertain since the oxides of manganese have also been used as cosmetics, as eye-paint. [43] The oldest specimens of glaze in which we found extravagantly high levels of manganese (4-7% MnO) were chocolate brown in colour and contained less than 0.3% Fe_2O_3 (beads from string U.C. 5021, Naqada, grave 661). They might represent the use of naturally-occurring brown ferruginous manganese ores,[38-40] which would not have required any additional iron.

6. Iron

Egypt has extensive deposits of pink granite, sandstone, and other iron-rich rocks, hence the wide range of values, 0.1-5.6%, reported[3,26,27] for the iron-content of Egyptian sands is perfectly understandable. A closer look at the published data reveals that very few sands contain more than 2%, and the majority less than 1% iron oxides. The few published analyses of faience glaze all show less than 1%, as do most of the analyses of body material. [1,2] None of the published glass analyses exceed the range of values reported for Egyptian sands, and if yellow and black glass are excluded, 95% of the reported specimens contain less than 1% Fe_2O_3.[18-25]

Plant ash, if used instead of natron as a source of alkali, is also a potential source of iron.[26,28] For example, Brill reports 2.76% Fe_2O_3 in the ash of an Egyptian Delta plant.[28] If we assume a glazing mixture containing 25-50% plant ash (within the range proposed by some workers[9,10]) this type of

plant could introduce over one percent of iron into the glaze. Ores of copper and other metals used for colouring purposes, such as those of ferruginous manganese referred to in the preceeding section, represent a third potential source of iron. For example, several copper sulphide deposits of the Eastern Desert contain substantial quantities of sulphides of iron.[38,39]

The median and average values listed in Table VIII show how similar is the iron content of Egyptian faience of all colours, except for early and late black, and brown glazes of most periods. Glazes other than those explicitly mentioned above fall within the range of values found in glass of similar colour, so it is safe to assume that most of the iron was introduced into Egyptian glass and faience unintentionally with sand and other ingredients. The minor fluctuations observed among the blue, green, and violet glazes of various periods result from regional biases in some instances (which affects the selection of sand) and variations in the amount of iron introduced with the alkali and mineral pigments.

Considering all the possible sources of iron, it is not easy to recognize all, or even most, of the cases where the element might have been added deliberately. And yet, these are the cases of greatest interest, for depending on its valence state and the nature of ions trapped in its vicinity, iron can impart a wide spectrum of colours to a glaze.[33] A more detailed discussion of these effects will be postponed to the next chapter.

In an attempt to see whether a concentration gap might exist between objects containing iron as an impurity and those into which it was introduced deliberately, the numerical distribution of specimens among various concentration ranges was plotted in Fig. 2. Two sets of histograms are plotted side by side. The first set represents combined green and blue glazes, the second set includes brown, red and black. The columns are placed at 0.2% intervals, and only values in the 0.2-5.0% Fe_2O_3 concentration range are shown.

Up to a concentration of about 2% the first set shows virtually exponential decline, fully consistent with all the other evidence suggesting that the great majority of green and blue glazes acquired the iron

T A B L E VIII

VARIATIONS IN THE CONCENTRATION OF Iron Oxides

IN GLAZES OF VARIOUS COLOURS

THE MEDIAN AND
AVERAGE PERCENT VALUES

TIME PERIOD	White	Yellow	Green	Blue	Purple and Violet	Black and Grey	Brown and Red
Predynastic	---	---	0.18	0.16	---	---	0.14
	---	---	0.20	0.21	---	---	0.17
Dyn. 1-2	0.37	---	0.26	0.48	0.16	3.75	0.98
	0.41	---	0.32	0.51	0.16	4.37	1.94
Dyn. 3-6	0.20	---	0.25	0.60	---	0.88	2.40
	0.22	---	0.75	0.61	---	3.28	2.44
Dyn. 7-10	0.32	---	0.20	0.49	---	0.86	0.54
	0.32	---	0.46	0.73	---	0.96	0.62
Dyn. 11-12	0.12	---	0.26	0.12	---	0.17	0.91
	0.24	---	0.48	0.15	---	0.51	1.81
Dyn. 13-17	0.27	---	0.20	0.22	---	0.38	0.41
	0.31	---	0.58	0.30	---	0.48	0.41
Early 18th	0.16	0.45	0.38	0.20	---	0.23	2.90
	0.18	0.48	0.80	0.33	---	0.34	2.75
Late 18th	0.13	0.37	0.24	0.27	0.52	0.19	3.77
	0.13	0.72	0.30	0.28	0.54	0.21	3.28
Dyn. 19-20	0.17	0.50	0.20	0.18	0.44	0.56	2.03
	0.15	0.71	0.22	0.25	0.36	0.51	2.66
Dyn. 21-25	0.14	---	0.30	0.18	0.44	0.21	1.70
	0.14	---	0.37	0.23	0.44	0.55	4.30
Dyn. 26-30	0.28	0.34	0.39	0.49	0.78	0.30	3.66
	0.34	0.34	0.53	0.91	0.85	0.59	8.40
Ptolemaic	0.53	0.55	0.69	1.05	1.13	2.69	0.62
	0.58	0.69	0.88	1.08	1.10	5.18	0.90

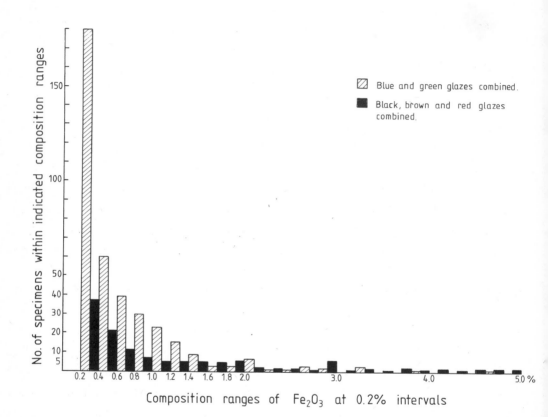

Figure 2. The distribution of iron oxide concentrations in faience glazes of various colours.

accidentally. Moreover, the data suggest that the cumulative contribution from all of the ingredients containing iron as an impurity has an upper limit somewhere between 2% and 3% Fe_2O_3. This does not preclude deliberate addition at levels below 2%, but simply suggests that intent may be safely presumed when the concentration exceeds 3%.

As expected, the black and brown glazes exhibit a less well-defined distribution, which trails off to concentrations of Fe_2O_3 in excess of 20%. Had the scale of Fig. 2 been extended it would show 16 specimens (8.2% of total sample) in the 5-20% concentration range. On the other hand only a single specimen of colour other than red, brown or black has been found to contain Fe_2O_3 in excess of 5%. As much as 7% has been detected in a Late Period cobalt blue glaze, but the object was atypical, since the second highest observed concentration was 2.3%; the maximum seen in green was 4.7%. It is particularly interesting to contrast the red and brown glazes, of which almost one third contained more than 3% Fe_2O_3, with the blue, violet and green, among which only one blue and a few green (1.7% of the analysed examples) had Fe_2O_3 in excess of the indicated value, 3%. Such contrasts are fully consistent with our contention that very few glazes other than brown, red, or black show evidence of deliberate and systematic use of iron.

The median and average values listed in Table VIII fail to indicate how wide a range of concentrations might be expected in a "typical" glaze of a given colour at a specified period of time. Such information may be found in Fig.3, where the range of values spanned by a clear majority (the middle three fifths) of specimens of a given colour and time period are shown.

We have failed to find clear evidence that iron was ever systematically and deliberately added so as to influence the formation of green versus blue glazes with copper. Whatever differences there may be between the average (or median) compositions of the respective colours, the overlap between the corresponding ranges in Fig. 3 is so great as to blur any clear intent. All one can say is that apparently greater care was taken in selecting low-iron sands for blue than for green glazes, since the range of values spanned by the former is much narrower than that of the latter and extends more frequently below 1%. Within the bar representing blue glazes those containing cobalt

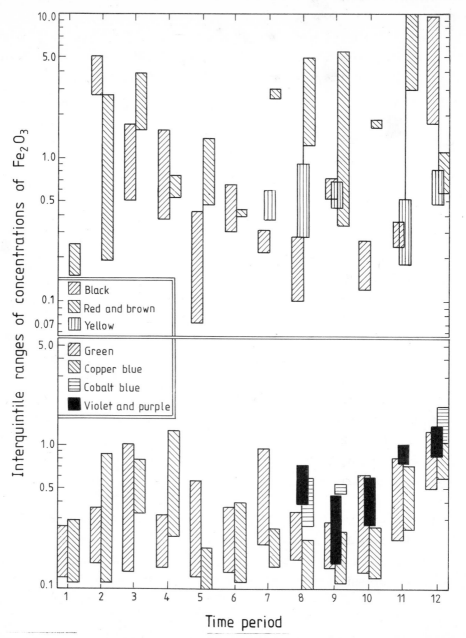

Figure 3. The interquintile ranges of iron oxide concentrations in faience glazes of various colours and time periods.

cluster near the top of the range. Violet and purple glazes of the New Kingdom have iron concentration ranges overlapping the upper half of those of contemporary blue or green. During the Ptolemaic period the range in violet and purple glazes is indistinguishable from that in blue or green.

Iron has been used since prehistoric times in Egypt and elsewhere to impart either red or black colour to pottery,[1,36,37] so its use for the same purpose in faience was not unexpected. No valid comparisons can be made between the concentrations on the surface of clay pots and those seen in early faience. However, as in the case of other elements, proper comparisons may be made between concentrations reported in glass and those found by us in contemporary faience. When such a comparison is made, the extraordinarily high concentrations of Fe_2O_3 encountered in a significant number of black and brown glazes (up to 20% Fe_2O_3) are difficult to explain, as nothing comparable has been reported for Egyptian glass.

During most of Egyptian history, though, the black glazes (in contrast with brown) contain only slightly more iron on the average than do the blue, green, or violet. The switch from iron to manganese and back to iron as the principal ingredient in black glazes has already been mentioned in the preceding section. However, the early decline and the sudden resurgence during the 26th Dynasty in the use of iron for the production of black colour, a break with a long tradition, is vividly illustrated in Fig. 3.

No such discontinuities are observed among brown and red glazes, which exhibit consistently broad ranges favouring high concentrations of Fe_2O_3. As a matter of fact the ranges are so broad (note the logarithmic scale in Fig. 3), that it is impossible to speak of a "typical" brown or red glaze.

7. Cobalt

No cobalt deposits of economic value have so far been discovered in Egypt. [38,44,45] Small quantities of the element have been reported in alum deposits of the Western Oases[46] and in the nickel deposits on St. John's Island. [47] There is no evidence that the latter were exploited in antiquity, but the oases show ample evidence of ancient occupation and mining activities. However, there is little doubt that alum was the mineral being sought and

cobalt would have been originally obtained as an unintended by-product. Cobalt is not distributed evenly and in no instance has it been reported to exceed 4% of the alum's weight.[48] The nearest rich deposits of cobalt may be found in the Caucasus and in present-day Iran.[45]

In his discussion of cobalt Lucas points out that small quantities of the element must have been present in the copper ores mined by the Ancient Egyptians, since it has been detected in a number of early copper objects and in Sinai copper slags.[41] The published analyses of these objects suggest that the cobalt content of the ores would have been too low for exploitation, as the Co:Cu ratio seldom exceeds 1:100. [49] High concentrations of cobalt (up to 2.9% CoO) had been reported for specimens of Ancient Egyptian glass as long as a century ago.[20] Yet, because subsequent investigators either failed to detect it or found only traces, the deliberate use of CoO as a pigment remained a matter of controversy until the late 1930's. The matter was laid to rest after Farnsworth and Ritchie subjected a large number of specimens of New Kingdom glass to a thorough spectrographic analysis and demonstrated beyond any reasonable doubt that the Egyptians had indeed been using cobalt in their glass. [19]

Subsequent studies amply confirmed the conclusions of Farnsworth and Ritchie and revealed that cobalt was also utilized in the blue paint on New Kingdom pottery. In 1974 Riederer identified cobalt aluminate ($CoAl_2O_4$) as one of the pigments on terracotta vases of the Amarna Period.[50] That the use of this pigment was not confined to the Amarna Period was shown by Noll and others who found it on Egyptian painted pottery of the 18th and 19th Dynasties, on objects recovered from sites all over Egypt.[36,51-53]

Neither Lucas nor Kuhne report cobalt in their faience analyses.[1,2] We have found traces of cobalt scattered among faience objects of just about all periods, but only from the 18th Dynasty on is there evidence of deliberate use of CoO, at first in blue and violet and later in black glazes. Though under suitable conditions colours as diverse as pink, purple, green, and blue may be obtained,[33] it would appear that the Egyptians and other people of antiquity used it almost exclusively for the production of blue, violet and indigo.

Out of about 400 specimens of pre-New Kingdom faience only 13 contained cobalt oxide in excess of 0.02%, and none had more than 0.08%. The low concentrations of CoO (ca. 0.04%, on the average) and the random distribution among blue, green, and black glazes are a clear indication that the element entered the glazes as impurity with one of the other transition metals, such as iron, copper, or manganese. This early cobalt correlates best with copper and the Co:Cu ratios come close to the corresponding ratios in Egyptian copper objects.[49] Early glazes containing cobalt tend to have elevated levels of zinc and tin. Such a combination of impurities has been found in several Egyptian copper ores, particularly in the deposits of Umm Samiuki. [54]

The median and average values in Table IX show that long after CoO came into regular use, rarely was any sizeable proportion of blue glazes of any period coloured by cobalt in preference to copper. Even specimens containing substantial amounts of CoO can seldom be found without a much larger amount of CuO. Among 25 specimens of cobalt-blue glaze (CoO above 0.05%) only 3 contained an excess of cobalt over copper. The median and average concentrations in Table IX represent combined values for both copper blue and cobalt blue glazes, in various proportions at different periods of time. To get a clearer indication of the levels of cobalt used in Egyptian faience we separated the blue and the indigo-violet glazes into high-Co and low-Co (CoO below 0.05%) specimens.

The data tabulated in Table X give some idea of the levels of CoO found in objects deliberately coloured by this pigment. It is interesting to compare our results with the concentration ranges reported for New Kingdom blue and indigo glass: 0.08-0.20%,[19] 0.075-0.33%,[34] and 0.11-0.22%. [22-24] The glass and faience figures, and the remarkable uniformity among the cobalt-rich blue glazes of all three periods comprising the New Kingdom, suggest a hitherto unexpected degree of quality control in the use of CoO, and re-emphasize a statement made by Farnsworth and Ritchie to the effect that: "...if its presence in XVIII Dynasty glass in optimum amount is intentional and not casual, this suggests that the glassmakers were well acquainted with its very strong colouring properties, for a high cobalt content results in almost black glass."[19] Unlike the blue glazes, those classified as indigo or violet range in colour from violet-purple to indigo-blue so that a wider range

T A B L E IX

VARIATIONS IN THE CONCENTRATION OF Cobalt Oxide

IN GLAZES OF VARIOUS COLOURS

--

THE MEDIAN AND
AVERAGE PERCENT VALUES

TIME PERIOD	White	Yellow	Green	Blue	Purple and Violet	Black and Grey	Brown and Red
Predynastic	---	---	0.00	0.00	---	---	0.00
	---	---	0.00	0.00	---	---	0.00
Dyn. 1-2	0.01	---	0.00	0.00	0.01	0.00	0.00
	0.01	---	0.01	0.00	0.01	0.01	0.00
Dyn. 3-6	0.00	---	0.00	0.00	---	0.00	0.00
	0.01	---	0.01	0.00	---	0.00	0.00
Dyn. 7-10	0.00	---	0.00	0.00	---	0.00	0.00
	0.00	---	0.00	0.00	---	0.00	0.00
Dyn. 11-12	0.00	---	0.00	0.00	---	0.00	0.00
	0.00	---	0.00	0.00	---	0.00	0.00
Dyn. 13-17	0.00	---	0.00	0.00	---	0.00	0.00
	0.00	---	0.01	0.00	---	0.01	0.00
Early 18th	0.00	0.00	0.00	0.00	---	0.00	0.00
	0.00	0.01	0.00	0.01	---	0.00	0.00
Late 18th	0.00	0.00	0.00	0.04	0.23	0.01	0.01
	0.00	0.00	0.02	0.08	0.22	0.01	0.03
Dyn. 19-20	0.00	0.00	0.00	0.00	0.08	0.00	0.00
	0.00	0.00	0.00	0.02	0.06	0.05	0.01
Dyn. 21-25	0.00	---	0.00	0.00	0.00	0.00	0.00
	0.00	---	0.00	0.00	0.01	0.00	0.00
Dyn. 26-30	0.00	0.00	0.00	0.00	0.09	0.00	0.03
	0.00	0.00	0.01	0.02	0.11	0.00	0.07
Ptolemaic	0.00	0.01	0.01	0.01	0.18	0.11	0.00
	0.00	0.01	0.03	0.10	0.53	0.22	0.00

T A B L E X

COBALT CONCENTRATIONS IN GLAZES COLOURED BY CoO

TIME PERIOD	Blue Glazes		Indigo and Violet Glazes	
	Average %	Range of Values	Average %	Range of Values
Early 18th	0.11	-----	--	-----
Late 18th	0.15	0.06-0.27	0.23	0.05-0.46
Dyn. 19-20	0.12	0.05-0.32	0.08	0.05-0.10
Dyn. 21-25	--	-----	--	-----
Dyn. 26-30	0.36	-----	0.11	0.07-0.21
Ptolemaic	0.34	0.10-0.62	0.75	0.14-1.59

of values was to be expected.

Both Tables IX and X point out the virtual disappearance of cobalt from post-New Kingdom faience, and its reappearance during the Late Period. The concentration range found in Ptolemaic and early Roman blues extends to higher concentrations which are reflected in the higher median and average values. The difference between the New Kingdom indigoes and violets and those of the Ptolemaic Period is less pronounced, but as was pointed out earlier, some of the latter are now manganese-free. The disappearance of cobalt after the 20th Dynasty is not confined to faience. A specimen of 22nd Dynasty glass analysed by Geilmann[34] contained no detectable amount of CoO or NiO but a lot of manganese (no. 5 on p. 480 of ref. 18). The disappearance of cobalt from 3rd Intermediate Period faience was also noted by Dayton, who unfortunately drew some unwarranted conclusions from the observation.[6]

When cobalt reappears, its use, formerly confined to the violet-blue range of the spectrum, is routinely extended during the Ptolemaic Period to the creation of a distinctive greyish-black glaze. For example, CoO is an important component of the greyish-black floral designs on bowls 1910.549(1), 1913.799 and 1913.800A from Memphis and of the black hair on the green female heads of the "Royal Oinochoe" fragments (1892.1025 and 1909.347). In the case of the Memphis bowls the cobalt-rich grey is juxtaposed to a similar design executed in cobalt-free brown.

There is no reason to doubt that black was the intended colour in the Ptolemaic cases cited above, where cobalt performs a function previously reserved for manganese. When CoO is seen in pre-Ptolemaic black glazes, deliberate use may be ruled out in just about all cases. In most instances the low concentrations of CoO and very high concentrations of iron, manganese, or copper suggest that cobalt entered the glaze as an impurity with one of the other elements. Concentrations over 0.05% are uncommon, and they are invariably confined to polychrome objects where the black is either adjacent to or placed over a cobalt blue layer. The same explanation may be provided to account for the occasional presence of CoO in green or brown.

A striking feature of the occurrence of cobalt in New Kingdom faience is its association with manganese, zinc, nickel and aluminum. A similar correlation has been noted by Sayre[22-24] on the basis of a more limited number of cobalt blue glasses, while Farnsworth and Ritchie noted an apparent connection between manganese and cobalt.[19] We have also found that cobalt-containing objects of the New Kingdom tend to have abnormally high concentrations of aluminum. This additional apparent correlation will be discussed more fully in Section 20 and in Chapter IV.

All of these correlations are only detected in faience made during the second half of the 2nd Millennium B.C. Among the earlier pre-New Kingdom faience objects containing CoO, only tin and zinc appear to be elevated above the values expected for the given colour and period. For example, the few Archaic Period green objects containing over 0.02% CoO yield a median value of 0.12% for ZnO, whereas the median for all other green objects of the same period is only 0.03% ZnO. The average concentration of MnO in these objects

is the same as the average for all Archaic greens.

In Table XI the concentrations of MnO, Fe_2O_3 and ZnO in high-Co glazes are contrasted with the corresponding values in glazes containing less than 0.05% CoO. The tabulated values not only make the correlation explicitly clear, but they also suggest that when CoO reappeared in Egyptian faience during the 26th Dynasty it must have originated from a distinctly different ore. In blue glazes the concentrations of MnO, NiO, and ZnO return to the average level of impurities, while among the purple and violet glazes only manganese recovers. The increased reliance on manganese (Mn_2O_3), often cobalt-free manganese, for the production of purple-violet glazes has already been commented on; it would seem that during the Ptolemaic Period the two ingredients were added separately.

Whether Egyptians imported a cobaltiferous ore rich in aluminum, manganese, zinc, and nickel or mixed the cobalt and manganese ores to create the blue and violet glazes of the New Kingdom cannot be proven unequivocally. To see how closely the elements are correlated we plotted the percentage of CoO versus that of MnO, NiO and ZnO, respectively, in Figs. 4-6. The cobalt and zinc show the best correlation while manganese and cobalt in blue glazes show the poorest. Still, the scatter is not extensive enough to rule out a single source for what could have been an asbolan type of ore. In such ores manganese is the principal ingredient and the Co:Mn ratios can fluctuate widely from one mine-site to another.

The scatter plots show little distinction between the blue and violet glazes, except that among the latter all the elements under consideration tend to have higher values. Since we are not certain whether the Egyptians would have gone to the trouble of restricting the ratios of several ores within such narrow limits, we are inclined to accept the premise that all five elements entered Egyptian faience together in one ore. However, there are some problems with this premise. Manganese is often associated with zinc, as is cobalt with nickel, but the presence of an almost equimolar quantity of zinc in a cobalt ore is very unusual.[44] This anomaly and the fact that manganese exceeds cobalt in blue glass objects of the New Kingdom has already been pointed out by Sayre.[23] Among the many blue, indigo and violet New Kingdom

T A B L E XI

AVERAGE CONCENTRATION LEVELS OF MnO, NiO, ZnO AND Fe_2O_3 IN THE PRESENCE AND ABSENCE OF COBALT

IN BLUE GLAZES

TIME PERIOD	% MnO in		% Fe_2O_3 in		% NiO in		% ZnO in	
	Cobalt Blue	Copper Blue	Cobalt Blue	Copper Blue	Cobalt Blue	Copper Blue	Cobalt Blue	Copper Blue
Early 18th	0.18	0.02	0.23	0.33	0.03	0.00	0.07	0.00
Late 18th	0.28	0.13	0.41	0.15	0.08	0.00	0.13	0.01
Dyn. 19-20	0.28	0.07	0.51	0.19	0.09	0.00	0.10	0.01
Dyn. 21-25	--	0.04	--	0.23	--	0.00	--	0.01
Dyn. 26-30	0.00	0.03	7.05	0.59	0.00	0.00	0.00	0.01
Ptolemaic	0.04	0.15	1.41	0.95	0.00	0.00	0.01	0.02

--

IN INDIGO AND VIOLET GLAZES

TIME PERIOD	% MnO in		% Fe_2O_3 in		% NiO in		% ZnO in	
	High-Co Glaze	Low-Co Glaze	High-Co Glaze	Low-Co Glaze	High-Co Glaze	Low-Co Glaze	High-Co Glaze	Low-Co Glaze
Late 18th	0.36	0.08	0.54	0.43	0.12	0.00	0.24	0.06
Dyn. 19-20	0.19	0.00	0.41	0.15	0.05	0.00	0.12	0.00
Dyn. 21-25	--	0.75	--	0.44	--	0.00	--	0.00
Dyn. 26-30	0.07	--	0.85	--	0.00	--	0.01	--
Ptolemaic	0.06	0.99	1.31	0.75	0.02	0.00	0.03	0.01

--

Note: Low-Co denotes glazes having CoO below 0.05%.

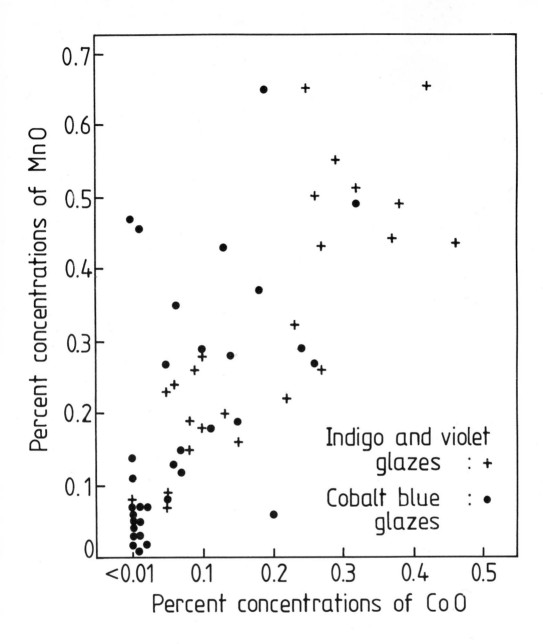

Figure 4. The correlation between the concentrations of MnO and CoO in violet, indigo and cobalt blue glazes of the New Kingdom.

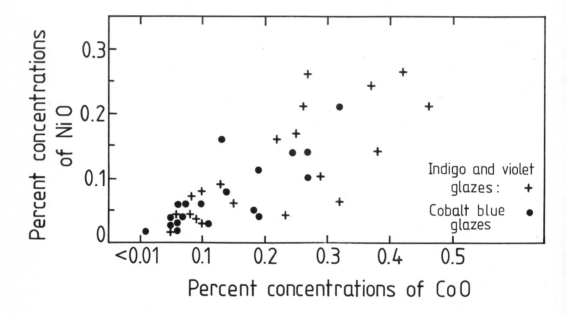

Figure 5. The correlation between the concentrations of NiO and CoO in violet, indigo and cobalt blue glazes of the New Kingdom.

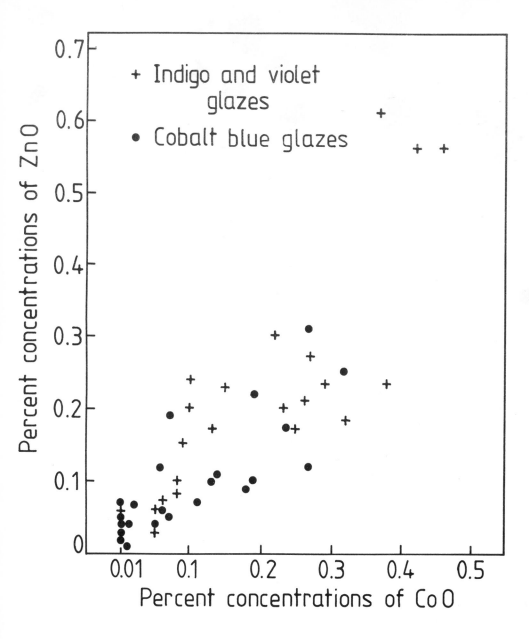

Figure 6. The correlation between the concentrations of ZnO and CoO in violet, indigo and cobalt blue glazes of the New Kingdom.

glazes containing cobalt in excess of 0.05% only four specimens were found in which MnO did not exceed CoO by a generous margin.

In addition to the elements mentioned above iron too seems to appear in above-average concentrations in cobalt-rich faience (see Table XI). However, as was pointed out in Section 6, the levels of iron exhibit such a wide range of values that the Co-Fe correlation may be illusory. There remains the possibility that salts of iron were added intentionally and separately to enhance the original violet or blue colour.

There has been considerable speculation in the last half century regarding the provenance of Egyptian cobalt. We have already dealt with the trace amounts encountered in a few pre-18th Dynasty objects earlier in this Section. It is the cobalt deliberately added to produce violet, indigo, and blue faience that is of primary interest to us. The speculation has gone as far as to suggest that some very remote mines in central Europe were the source of cobalt used in Egypt and other parts of the Mediterranean world.[6,55] On the basis of our own faience studies and data published for Egyptian glass and ceramic paint we feel that there is no need to postulate a place of origin further removed than the Great Western Oases (Kharga and Dakhla) and the Iranian plateau.

If the cobalt originated in the alums of the Great Oases then the elevated amounts of aluminum, iron and manganese would accord with the published analyses of cobalt-containing alums. One such specimen was reported to contain: 10.6% Al_2O_3, 1.63% Fe_2O_3, 4.23% FeO, 2.56% MnO, and 1.02% CoO.[48] As early as 1930, using some very simple calculations, Cottevieille-Giraudet pointed out that the cobalt content of the Dakhla and Kharga alum deposits was more than adequate to account for the CoO concentrations and Co-Al ratios encountered in Egyptian blue glass.[56] The published spectra[36,51,53] of the cobalt-containing ceramic pigments show Al, Mn, Ni, Fe, and Zn in proportions very close to those found in contemporary glass and faience coloured by cobalt. However, until more analyses of the alums are published and the presence of NiO and ZnO is also demonstrated one has to reserve judgment regarding the Great Oases as the primary source of New Kingdom cobalt.

It is more tempting at the moment to see Iran, or the Caucasus, as the place of origin for Egyptian cobalt. Geological surveys have shown that just about every type of cobalt ore may be found in Iran.[45] Thus two surveys, almost 50 years apart, revealed that the ancient cobalt works of Qamsar, in the vicinity of Kashan, contained cobalt bloom (erythrite, hydrous cobalt arsenate), earthy cobalt (asbolan, a cobalt-containing psilomelane), surrounded by sulphides of copper, iron, and nickel.[57] Since zinc occasionally replaces Co in erythrite while alumina has been found in many asbolans, [45] a mine such as the one noted above could have supplied cobalt containing all the elements needed to explain the observed correlations. The Qamsar mines show evidence of ancient workings and were already famous in the 14th century.[58] Another Iranian cobalt deposit, at Anarak, is discussed in Dayton's book. [6]

Whereas two possible sources may be proposed for the cobalt used during the New Kingdom, Iran seems to be the most logical source of the manganese-free cobalt seen in faience of the Late, Ptolemaic, and Roman periods. It is possible that sometime in the 1st Millennium B.C. the exploitation of asbolan became uneconomical or that newer and richer mines of sulphide and arsenide ores had been discovered. During medieval and later times Iran was most famous for its manganese-free arseno-sulphide ores, particularly cobaltite.[58] These were exported as far away as China where they were used in the production of the so-called "Mohammedan blue" porcelain pigment.[59] As a matter of fact, soon after 1400 A.D. the low-Mn cobalt in the Chinese blue-and-white porcelain was replaced by a high-Mn variety, and the change has been interpreted as indicating a switch from imported Iranian to native Chinese cobalt ore of the asbolan type.[60-62] The manganese-free cobalt continued to be the principal variety in Persian blue-and-white ceramics into the 20th century, [60] indicating that the ore was still available locally.

Analyses performed by W. J. Young have demonstrated the presence of arsenic in Mohammedan blue.[59] We have found a significant amount of arsenic (ca. 0.1% As_2O_3) in an indigo-blue bowl which has been dated on stylistic grounds and on the basis of the recovery site to the Roman period. The glaze of this bowl (1924.119) is coloured by about 1% CoO and is virtually free of manganese, nickel and zinc.

Whatever its source, cobalt must have been plentiful enough during the 18th and 19th Dynasties to have been used extensively, and it would appear wastefully, in the production of a distinct greyish-black body material of what Lucas would have characterized as variant D faience. The subject of variant D faience and of blue unglazed frit, in which no CoO has been found, will be dealt with in Chapter IV.

8. Nickel

Nickel is not reported in any of the published analyses of Egyptian sands, and only Geilmann[34] and Sayre[22-24] give quantitative data for glass. The faience analyses reported by Lucas and Kuhne do not mention the element either.[1,2] At the time Hume compiled his comprehensive geology book,[38] the only known Egyptian deposits of nickel were those of garnierite on the St. John's Island in the Red Sea,[47] but according to Lucas there is no evidence that these were worked in antiquity.[41] Since then, and too late to be included in Lucas' discussion of minerals (3rd edition of **Lucas**), a rich zone of copper-nickel mineralisation has been discovered at the ancient Abu Seyal copper mine, near the Sudanese border.[63] The ore consists of **violarite** (iron-nickel sulphide) mixed with **chalcopyrite** (iron-copper sulphide) and **pyrrhotite** (a complex sulphide of iron). A typical ore specimen contained: 3% Cu, 13% Fe, 2% Ni, 13% S, and less than 0.2% each of Cr, Mn and Co.[63]

The main ore body is penetrated by ancient shafts and the adjacent areas are littered with large dumps of rejected ore, slag heaps, extracted gossan, ancient furnaces and pottery fragments of pharaonic date. J.F. Wells, a mining engineer and metallurgist who surveyed the site at the turn of the century, made the following observations: "The ancient furnaces remain intact today, and it would appear that their process consisted in a preliminary roasting of the ore in the open, followed by a further roasting and subsequent smelting for high grade mat, followed by roasting and fusion of the mat for bean copper, which was further subjected to refining and then cast into ingots for shipment." (cited in ref. 38, p.842).

The properties of nickel are such that a normal metallurgical operation designed to extract copper would leave most of the nickel behind, in the slag. An indeed, the ancient slags at Abu Seyal do contain metallic globules

consisting of 61% Cu, 23% Fe and 15% Ni.[63] Consequently, copper metal originating in Abu Seyal would not contain much more nickel than the trace amounts detected in Ancient Egyptian artifacts.[49]

Except when it is found in conjunction with cobalt in blue and violet faience of the New Kingdom (Table XI) nickel is as uncommon as chromium. It shares with chromium the distinction of being often found in glazed steatite. The reasons for this are understandable. Garnierite and related nickel-magnesium silicates, are often found in conjunction with chromic iron in steatite deposits. In Egypt this is true at Fawakhir, near the ancient gold mines, and at the ancient peridot workings on St. John's Island. [47]

The correlation with cobalt has already been discussed in the preceding section, but one should note that among the objects plotted in Fig. 6 not a single one contains nickel in excess of cobalt. Even as an impurity nickel is seldom seen without cobalt. Of about 1000 low-cobalt specimens (CoO below 0.05%) only 14 contained NiO in excess of 0.01%, and none more than 0.11%. Our data accord with the results obtained by Sayre, who found the NiO concentrations in glasses not coloured by cobalt to fall in the 0.001-0.01% range. [22,24]

Since the copper-nickel ore at Abu Seyal was actively exploited in antiquity, one must conclude that very little of the raw or roasted ore reached Egyptian faiencemakers and glazemakers. Considering the remoteness of the site, it was obviously more economical to extract the the copper on the spot, or at nearby Kubban, as Hume believes (ref. 38, p.842), and ship the ingots north.

The average values for cobalt-coloured blue and violet glazes listed in Table XI are very low, since even in these glazes NiO is at times as low as 0.02%. Fig. 6 gives a truer picture of the range of values encountered in New Kingdom blue and violet glazes: 0.02-0.21% in blue, and 0.02-0.26% in indigo and violet. These figures may be compared with the ranges reported for cobalt blue glass: 0.03-0.075% and 0.050-0.141% found by Geilmann[34] and Sayre[22-24], respectively. Both nickel and cobalt disappear after the 20th Dynasty, but unlike the latter nickel does not reappear during the Ptolemaic Period.

On the basis of the published glass analyses and our own faience analyses we suggest that any object containing over 0.05% NiO in the absence of cobalt and manganese should be examined very carefully. If the glaze is intact so that the core does not show, the object may consist of glazed steatite, especially if chromium is also detected. On the other hand the object may be an ancient import of foreign origin or an outright fake. There is always a remote possibility that some of the nickel-rich Abu Seyal copper ore ended up in faience, but we have seen no evidence of it so far.

9. Copper

Only Stone and Thomas report copper among the elements detected in Egyptian sands, and mostly at concentrations below 0.01%.[3] The element is a common impurity in many glazes where its presence could not have been intended. For example, among white and yellow glazes almost 40% contain at least 0.1% CuO, though none have more than 0.6%. Concentrations near the upper end of this range are found on polychrome objects and reflect migration of the copper ions from adjacent or underlying blue or green glazes. Copper is notorious for its ability to migrate through a silicate matrix, and it is this property that makes the "self-glazing" of faience possible (see Appendix A). That such a technique was employed in Ancient Egypt has been postulated by several workers.[9,10]

Contamination through contact with copper or bronze containers, tools, etc., during the manufacturing process cannot be ruled out in cases where the CuO content is below 0.1%. Presumably unintentional contamination by copper is also apparent in the reported glass analyses. Though most of the analyses of white and yellow glass reprinted by Lucas[18] and Caley[20] report no copper, Sayre has found as much as 0.032% in some colourless, 0.093% in white, and 0.182% in yellow glass of the New Kingdom.[24] As will be seen in Chapter IV, a copper-free faience body material is not very common either.

The use of CuO for the production of a green or blue glaze (the colour depending on rather subtle changes in the chemical environment of the copper atom) was evidently known from the earliest times of faience making. In our survey, this means from ca. 4000 B.C., from the Naqada I period (see Table I). That this should be so is quite understandable considering the great number

and variety of copper ore deposits found in the Eastern Desert and in the
Sinai.[38,39,41,54] There are indications that some of the deposits have been
worked since Predynastic times, and the extent of mining and metallurgical
activity is attested by the great abundance of copper objects found in
predynastic sites. Contrary to some earlier, unfounded opinions, few of the
specimens were made of native copper.[41]

Table XII shows the median and average CuO levels in glazes of various
colours. As expected, white and yellow contain the least and blue and green
the most copper. The average copper content of blue faience is invariably
higher than that of contemporary green. The concentrations become less
haphazard with time, particularly among the blue glazes. The relative
levelling off is more apparent in Fig. 7, where we have plotted the range of
values encompassed by a majority of glazes of a given colour and period.
Unlike Table XII in which the column labelled "blue" included cobalt blue as
well as copper blue, Figure 7 is restricted to glazes containing less than
0.05% cobalt oxide.

In pre-Amarna blue glazes, where cobalt is seldom seen, the tabulated
medians and averages show the same trends as the plotted ranges, an undulating
rise. From the 18th Dynasty on, whenever a substantial number of glazes are
coloured by CoO, the average and median are weighed down somewhat, since such
glazes contain less copper on the average. That is why the sharp drop from
the Early to the Late 18th Dynasty (mostly Amarna material) and the sharp rise
after the 20th Dynasty is not reflected in the data plotted for copper blue
alone.

Unlike the blue glazes, the green show a steady uninterrupted decline in
the copper content from the 18th Dynasty on. A partial switch from pure
copper to a mixture of yellow lead antimonate and blue copper oxide for the
manufacture of green is responsible for some, but not all of the decline.
Even if only green glazes low in antimony and lead are compared the average
concentration of CuO still decreases steadily from the time of Amenhotep III
until it levels off in the Late Period. The reduced use of copper in green
glazes apparently reflects a change in taste. The preference for paler greens
is easily discernible among the many museum objects of late 18th Dynasty and

T A B L E XII

VARIATIONS IN THE CONCENTRATION OF Copper Oxides

IN GLAZES OF VARIOUS COLOURS

THE MEDIAN AND
AVERAGE PERCENT VALUES

TIME PERIOD	White	Yellow	Green	Blue	Purple and Violet	Black and Grey	Brown and Red
Predynastic	---	---	2.99	3.51	---	---	0.25
	---	---	3.23	3.77	---	---	0.26
Dyn. 1-2	0.14	---	2.33	2.39	1.79	1.81	2.89
	0.13	---	2.87	3.81	1.79	2.59	3.50
Dyn. 3-6	0.02	---	2.41	6.09	---	3.41	0.34
	0.11	---	2.62	6.20	---	3.28	0.41
Dyn. 7-10	0.15	---	3.29	5.85	---	2.91	4.20
	0.15	---	3.67	5.44	---	3.57	3.52
Dyn. 11-12	0.13	---	3.74	4.69	---	4.88	0.59
	0.23	---	3.93	5.51	---	5.30	0.70
Dyn. 13-17	0.07	---	4.00	4.05	---	4.43	3.81
	0.07	---	3.87	4.83	---	4.46	3.81
Early 18th	0.03	0.06	4.37	5.11	---	7.09	0.04
	0.04	0.15	4.66	5.52	---	6.06	1.73
Late 18th	0.06	0.17	2.82	3.99	0.94	0.19	0.13
	0.06	0.15	3.21	3.64	1.11	2.16	0.36
Dyn. 19-20	0.04	0.02	2.55	3.06	0.09	1.60	0.16
	0.05	0.03	2.84	3.24	0.74	1.88	0.39
Dyn. 21-25	0.19	---	2.27	4.70	2.58	2.93	1.72
	0.19	---	2.36	4.31	2.56	3.03	1.91
Dyn. 26-30	0.24	0.17	1.78	2.53	2.45	1.45	0.10
	0.23	0.17	1.94	3.18	3.00	1.71	0.53
Ptolemaic	0.13	0.58	1.35	2.37	1.32	1.35	0.32
	0.15	0.39	1.80	2.61	1.36	2.11	0.90

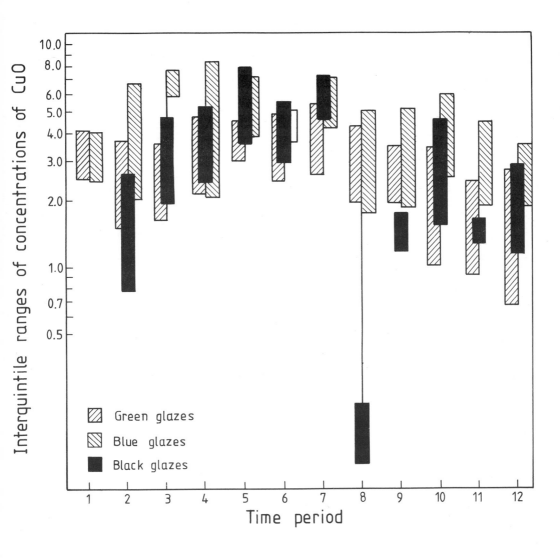

Figure 7. The interquintile ranges of concentrations of CuO in
in "cobalt-free" glazes of various colours and times.

subsequent periods. In contrast, dark blues remained fashionable into Roman times.

Examination of Fig. 7 reveals that the range of values spanned by CuO in the majority of blue and green glazes, particularly the green ones, is quite wide, much wider than that seen in the case of cobalt, for example. Moreover, if one looks at the total range instead of just that of the majority, the range and the individual variations this implies are truly staggering, with some blue and green glazes containing as much as 12% CuO.

Unlike cobalt, which may have been imported from the time it came into vogue, copper was readily obtainable from mines within Egypt proper or mines in neighbouring areas, such as the very rich deposits of Sinai and Timna in the Negev. Excavations at the latter site have yielded an interesting picture of Egyptian mining activities at a site quite remote from the Nile Valley.[64] Though copper is mentioned in lists of tribute from conquered Syria early in the 18th Dynasty,[65] as a commodity imported from a foreign land it is first noted in the Amarna Correspondence, in a letter from the King of Alasia, a land believed to be Cyprus.[66]

Consequently any restraint in the use of copper would be dictated by technical instead of economic reasons. Careful control would only be necessary to achieve pale colours for the more natural decorative styles of the Amarna Period and the subtle polychromatic scenes of the Hellenistic Period. For the great majority of beads, amulets, and ushabtis the exact shade of the object mattered very little. As we pointed out in Chapter I, several shades or even blue and green have been seen combined but not blended on a single object.

The invention of "Egyptian Blue", a crystalline double salt of the formula $CaCuSi_4O_{10}$,[30,31] gave the glaze-makers a reproducible blue. Yet glazes coloured by this double silicate can tolerate a wide range of CaO and CuO concentrations without any noticeable effect on the intense blue colour. This became apparent when we examined the Ca:Cu ratios in blue and green glazes. During some periods of Egyptian history the ratios in green glazes were higher than in blue, during other periods the reverse was true.

Moreover, the Ca:Cu ratios in both blue and green glazes were sometimes higher and at other times lower than 1:1. It is obvious that other factors, such as the nature and level of alkali, or the presence of iron or lead, appear to be more important in determining whether blue or green is obtained. The questions of chemical factors distinguishing green glazes from blue, and the quantitative aspects of the Ca:Cu ratio will be treated more fully at the beginning of the next chapter and when Egyptian blue is discussed explicitly in Section 6 of Chapter III.

The published analyses of Egyptian faience glazes give copper levels remarkably close to the average values found by us for contemporary time periods. Lucas reports 1.1 and 1.8% CuO for a pale green 19th Dynasty and blue Roman Period glazes, respectively.[1] Though the former is below the average we found in contemporary green faience (after all, it is described as "pale green"), the latter is indistinguishable from the average value found for Ptolemaic blues, 1.77%. The CuO concentrations reported by Kuhne for two specimens of blue-green Amarna faience glaze, 3.24 and 3.63%, respectively, [2] are surprisingly close to the average values found by us for the green (3.22%) and blue (3.64%) faience of the period.

The published analyses of blue and green glass also show considerable variability in the concentrations of CuO, but the range of values and average content tend to be distinctly lower than those found in faience. Analyses done in the first half of this century yield values ranging from "trace" to 2.7%.[18,20] Blue objects containing a "trace" or no copper were undoubtedly coloured by cobalt, which some workers did not report. For example the three blue specimens analysed by Geilmann[34] in which cobalt was present contained only 0.005-0.13% CuO; on the other hand, a blue-green specimen of the Third Intermediate Period contained 1.31% CuO, a value well within the range of green faience of the period (see Fig. 7). Sayre, who is the only one to have separated blue glass into "cobalt blue" and "copper blue", found very little CuO in the former (0.019 and 0.076%) and values in the 0.59-1.45% range in the latter, with an average of 0.93%. [22-24]

Since copper, unlike most other pigments, shows so much higher concentrations on the surface of faience than in contemporary glass, migration

to the surface is indicated. Either the self-glazing process[5] or the process
described by Kuhne[2] would result in the observed enrichment if frits of the
type analysed by us were used as pigment. As will be shown in Section 8 of
Chapter IV, the copper concentrations in Egyptian frits are usually several
times as large as in contemporary glazes.

It would appear that copper was seldom, if ever deliberately added to
produce faience glazes other than green and blue. Except for a handful of
cases, which will be dealt with in the next chapter, diffusion of copper from
adjacent or underlying glazes and accidental reduction during the
manufacturing process or in a subsequent tomb fire can account for the high
concentrations of copper, probably in the form of Cu_2O, found in some purple,
black, and brown glazes. For example, Table XII and Fig. 7 show that black
glazes tend to resemble contemporary green or blue. Entirely black objects
are quite uncommon, the overwhelming majority of black glazes investigated by
us represent black decorations painted over a blue or green ground. In such
cases the copper level tends to resemble that of the background. The
migration alluded to earlier makes this inevitable, but the extent of
migration depends on the alkalinity of the glaze and the length of time that
the two layers remained at elevated temperature.

Cuprous oxide (Cu_2O) and metallic copper have been used for over three
millennia in the manufacture of what is sometimes referred to as sealing-wax
red glass.[67,68] First Millennium B.C. examples of such glass are also
characterized by high concentrations of lead. In the 18th Dynasty specimens
the copper concentrations range from 4% to 12%,[21,25] while red glass of the
Ptolemaic Period tends to have Cu_2O below 5%.[18,20] We found no specimens of
red faience comparable in composition to the sealing-wax red glass. The few
objects where copper seemed to be the only pigment in a red or brown glaze
either showed evidence of unintentional reduction or were low in lead and high
in iron. Specific examples will be cited in the next chapter when the
manufacture of red faience is discussed explicitly.

From the earliest times green and blue glazes contained highly variable
though generally small quantities of zinc and lead. Thus among 28 beads from
a single Predynastic grave at Naqada (string U.C. 5022) almost half contained

detectable amounts of ZnO and two-thirds traces of lead (PbO below 0.04%). Since the copper objects of the period do not contain comparable amounts of the two elements, raw copper ore instead of the processed metal must have been used in the production of the blue glaze. This is in contrast with later practices, where copper and bronze scrap were used.[28]

If, as Lucas points out,[41] there is no evidence that the Egyptians exploited the emerald and copper mines of Western Sinai prior to the 3rd Dynasty, the craftsmen of the Predynastic and Archaic periods must have obtained their copper from the mines in the Eastern Desert. This is fully consistent with the observations made above, for the region contains a number of polymetallic deposits consisting of sulphides of copper, zinc, lead and iron.[38,39,54,69]

The use of such ores would also explain why trace amounts of tin, arsenic, and antimony have been detected in copper abjects and in faience produced long before the manufacture of bronze became well established.[49] The suggestion that the presence of arsenic and tin indicates that arsenical copper or bronze scrap were utilized in the manufacture of ceramic and glass pigments may be valid for objects made in the Second Millennium B.C., as we will show later in this chapter. However, unless one assumes that tin-bronzes were being produced in quantity as early as 3000 B.C., and so far no one has come up with any solid evidence to support such a contention, the small quantities of tin, arsenic, and antimony observed in a number of early blue and green glazes must have been introduced as impurities in the copper ore.

10. Zinc

All available evidence indicates that only in the last two centuries of our era did ZnO gain recognition as a pigment. We have found nothing to suggest that the oxide was ever added as a colourant or opacifier in ancient glass or faience, but its unintended presence in many instances had a considerable impact on the final colour of the glaze. For example, it can modify cobalt blue into a green pigment called Rinmann's green or convert nickel-containing brown into violet or blue. [33]

A neutron activation analysis of Egyptian sands from four sites gave ZnO

values in the 0.001-0.004% range.[4] By examining the correlation of zinc with
other elements we have been able to identify at least three sources of zinc:
1. copper ores of the Eastern Desert; 2. the manganese/cobalt pigment in use
during the New Kingdom; 3. Egyptian and foreign lead ores. Consequently, as
one might expect, the highest concentrations of ZnO are normally found in
yellow, green, and violet glazes of the New Kingdom (see Table XIII).

Until the 18th Dynasty the first source was about the only one
contributing to the random distribution of generally small amounts of zinc.
The randomness is reflected in the large discrepancies between the median and
average ZnO concentrations of early faience, for a handful of zinc-rich
objects has little impact on the median but can profoundly distort the
average.

Among pre-Old Kingdom objects, in particular, there is often a wide gap
between a single or a couple of glazes high in zinc and the great majority of
contemporary objects of the same colour containing less than 0.05% ZnO. For
example of 26 green Predynastic beads from Naqada all but one were coated with
glazes containing less than 0.07% ZnO, but the one exception (No. 7-117-732
in Appendix C) contained 3.1% CuO and 2.3% ZnO. Similarly, while one blue
Predynastic bead contained 0.35% ZnO, none of the remaining 22 had more than
0.04%.

Comparable variations are observed even when objects from the same grave
are compared and greater uniformity might have been anticipated. Thus, when
four randomly selected green beads from a 1st Dynasty grave (No. 678) at
Tarkhan were analysed, the glazes of two contained 1.7-1.8% CuO and about 1.5%
ZnO, while the others had 1.6-2% CuO and less than 0.03% ZnO. The remaining
40 green glazes of the Archaic Period had zinc concentrations in the 0.00 to
0.21% range.

The wild fluctuations among presumably contemporary faience beads from
the same excavated site make sense if one assumes that copper ores from
various sources, or from various sections of the same mining area, were mixed
before or after they entered the faience-makers shop. As has been noted
earlier in this chapter, the Eastern Desert is dotted with copper deposits

T A B L E XIII

VARIATIONS IN THE CONCENTRATION OF Zinc Oxide
IN GLAZES OF VARIOUS COLOURS

--

THE MEDIAN AND
AVERAGE PERCENT VALUES

TIME PERIOD	White	Yellow	Green	Blue	Purple and Violet	Black and Grey	Brown and Red
Predynastic	---	---	0.00	0.00	---	---	0.07
	---	---	0.10	0.02	---	---	0.07
Dyn. 1-2	0.01	---	0.02	0.00	0.00	0.01	0.00
	0.02	---	0.10	0.01	0.00	0.08	0.02
Dyn. 3-6	0.03	---	0.01	0.00	---	0.04	0.00
	0.03	---	0.07	0.01	---	0.15	0.00
Dyn. 7-10	0.12	---	0.00	0.00	---	0.01	0.00
	0.12	---	0.03	0.06	---	0.02	0.01
Dyn. 11-12	0.03	---	0.04	0.00	---	0.00	0.06
	0.03	---	0.09	0.02	---	0.04	0.07
Dyn. 13-17	0.03	---	0.01	0.01	---	0.01	0.03
	0.03	---	0.03	0.02	---	0.03	0.03
Early 18th	0.00	0.20	0.00	0.00	---	0.00	0.02
	0.05	0.23	0.02	0.01	---	0.01	0.02
Late 18th	0.03	0.30	0.13	0.04	0.20	0.08	0.00
	0.02	0.35	0.15	0.07	0.23	0.17	0.04
Dyn. 19-20	0.02	0.52	0.00	0.00	0.08	0.00	0.03
	0.02	0.56	0.01	0.02	0.10	0.05	0.04
Dyn. 21-25	0.01	---	0.00	0.00	0.00	0.00	0.02
	0.01	---	0.02	0.01	0.00	0.01	0.08
Dyn. 26-30	0.00	0.04	0.00	0.00	0.00	0.01	0.00
	0.00	0.04	0.01	0.01	0.01	0.04	0.00
Ptolemaic	0.00	0.00	0.00	0.00	0.00	0.05	0.00
	0.01	0.00	0.02	0.02	0.02	0.07	0.01

some of which consist of mixed sulphides of several metals. It is most
unlikely that the Egyptians of the Predynastic and Archaic Periods would have
expended too much effort on the separation and purification of such ores.
Consequently, no constant copper:zinc ratio is to be expected and none is
observed. The inhomogeneity of the polymetallic deposits is strikingly
revealed by the figures shown in Table XIV, where published assays of copper
deposits from Atshan[69] and Umm Samiuki[69,70] are reproduced. In addition to
the major components listed below, the ores of Atshan and Umm Samiuki contain
a rich assortment of minor components at low to trace levels.[54] There is
abundant archaeological evidence that both mining areas were worked in
antiquity.[38,41,69]

T A B L E XIV

THE COMPOSITION OF SOME EASTERN DESERT COPPER ORES

Site	Zn %	Cu %	Pb %	Fe %	Reference No.
Atshan	35	2.5	2.3	13.4	69
Umm Samiuki	7	2.4	11.1	5.0	69
" "	45.2	5.0	2.5	5.6	69
" "	17.5	2.1	6.5	6.1	69
" "	22	24.9	6.8	3.9	69
" "	12.7	1.33	2.1	4.9	70

Copper ores of the type discussed above can easily account for the
variable amounts of zinc encountered in many Egyptian copper objects,[49] and
for the two unusual specimens of early "brass" discovered by Petrie in the
Predynastic cemetery at Naqada. One, a pin from grave 218, contained 2% Zn,
1-2% Ni, 1% As, and lesser amounts of other metals; the other was quite

similar in composition and contained 1.55% Zn.[71]

The association of zinc with manganese and cobalt has been fully discussed in Sections 5 and 7 (see Table XI and Fig. 5). The relationship is confined to New Kingdom faience, in which the ZnO:CoO ratio shows a remarkable degree of constancy. Consequently, among glazes of low cobalt content (CoO below 0.05%) those containing ZnO in excess of 0.05% are a distinct minority.

From the 18th Dynasty onwards lead is often deliberately added to produce the yellow lead antimonate and copper-lead antimonate green. Most of the lead-rich glazes of the New Kingdom contain excessive amounts of ZnO, whereas similar glazes of the Late and Ptolemaic Periods are relatively free of zinc. This is dramatically illustrated in Table XIII by the sharp drop in the zinc content of 1st Millennium yellow glazes. Thus, the glaze-makers of the New Kingdom had access to lead ores which were either unavailable to or shunned by Egyptians of later periods. Some of the older lead deposits might have become exhausted by the end of the 19th Dynasty, for the low-zinc lead first becomes prominent in 20th Dynasty faience. However, since most of the material in question came from the Tell el-Yahudiya palace of Ramesses III we might be seeing here a case of regional bias. Even in faience of the 18th and 19th Dynasties the ZnO:PbO ratios fluctuate so much that several sources of lead ore must be assumed.

The association of zinc with cobalt and lead is not limited to faience, for Sayre obtained similar results for New Kingdom glass. Whereas as much as 0.36% ZnO was detected in cobalt-blue glass and 0.17% in yellow glass, no other specimen contained more than 0.025%.[22,24] Similar results are reported by Aspinall et al., who found 0.002-0.01% ZnO in Egyptian glass and 0.002-0.04% in low-Co faience.[4] As a matter of fact, if glazes containing over 0.05% CoO and over 0.2% PbO had been excluded from Table XIII, the average levels of ZnO in glazes made after the Old Kingdom would all fall in the 0.00-0.06% range.

Besides the polymetallic sulphides of the type mentioned above, Egypt has lead ores in which zinc is the only prominent additional component. For example, the mines of Gebel Rossas are reported to contain mixed lead and zinc

carbonates with the zinc content as high as 37%. [72] If one were looking for lead to be used with antimony and the desired colour were yellow instead of green, such ores would have been used in preference to the Umm Samiuki type.

Now, the fact that zinc-rich copper and lead ores exist in Egypt does not prove that they were the source of all the ZnO found in Egyptian faience, for it should be kept in mind that the association with copper and lead is not limited to Egypt or even to the immediate geographical area. To quote A. Bateman: "Despite chemical dissimilarity, geological conditions favour the formation of lead and zinc together. The world over, the companion sulphides galena and zinc blende, or their oxidation products, yield most of these important metals of modern industry. They are also associated with copper and other base sulphides; less commonly, lead and zinc occur separately."[73] Moreover, such deposits are independent of the surrounding igneous rocks. They may be found in limestones, dolomites, cherts, or calcareous shales.[74] Hence, it is the zinc-free lead in later yellow and green glazes that deserves closer scrutiny as possibly indicative of a specific source of lead. The possibility that lead might have been pre-processed and purified before being used in the pigment preparation can not be ruled out. It is doubtful, however, that if the high-zinc lead had been used, the methods employed in antiquity were capable of reducing the zinc concentrations to the levels seen in 1st Millennium B.C. Egyptian lead.

We have already pointed out that the presence of zinc in a cobalt ore is a rather unusual phenomenon,[44] encountered in only very few places, all of them far away from Egypt.[45] It is not unreasonable to assume that the association is actually with manganese, which accompanies and exceeds cobalt in almost all specimens of New Kingdom faience and glass. When in faience of later periods the manganese is absent from cobalt so is zinc, as can be seen in Table XI. Mixed manganese-zinc ores are not uncommon, but we know of no such deposits in Egypt. The reported analyses of Egyptian manganese ores show little zinc. The manganese found as natural impurity in Egyptian sands and clays is relatively free of zinc, as is the MnO found in the great majority of brown and black glazes. For this reason the black and brown glazes, despite the high concentrations of manganese, rarely contain any significant quantity of ZnO, unless either cobalt or lead are also present.

11. Arsenic

Very few of the faience glazes contain detectable amounts of arsenic and when present the element is rarely above 0.02%. As a consequence of low incidence and low concentrations no group of glazes of any period yielded a median figure above 0.007%, while only blue faience of the Old Kingdom yielded an average exceeding 0.01%, a modest 0.03% As_2O_3. Removal of just one object out of 15 would have reduced this average to 0.01%. Geilmann and Sayre both looked for arsenic in Egyptian glass. The former reports values in the 0.003-0.01% range in blue glass of the New Kingdom period, [34] while the latter simply notes that "few hundredths of 1%" were detected in some glass specimens.[23] Farnsworth and Ritchie explicitly note the absence of arsenic in all but a handful of analysed glasses.[19] When a selection of Egyptian glass, glassy faience, and ordinary faience was subjected to neutron activation analysis, fewer than one in ten had more than 0.01% As_2O_3, and none exceeded 0.02%.[4] Of the four Egyptian sand specimens analysed by Aspinall et al. not a single one contained more than 0.0003% arsenic.[4]

There is every indication that whatever arsenic is found in glass or faience it was not introduced there intentionally. That arsenates might have been used in antiquity as decolourizing agents with iron-rich sands has been proposed by Faider-Feytmans (cited in ref. 23). However, as Sayre points out,[23] and our data confirm his argument, the amounts of arsenic seen suggest that, even if allowance were made for losses through volatilization at elevated temperatures, there would not have been enough arsenic to perform this function. Moreover, one would then expect to see arsenic most frequently in white and yellow glazes, where dark impurities had to be suppressed. Instead, we found the most arsenic in high-copper blues and greens or 1st Millennium B.C. cobalt-containing faience, but hardly ever in pale colours.

Lead arsenate is used in the manufacture of modern opal glass, but no one has found evidence that its use as opacifier antedates the 18th century A.D. [68] Arsenic oxides were not used as opacifiers in the ancient Far East either. Werner and Bimson who have looked explicitly for the opacifiers in Chinese glass of the Han period failed to find a single specimen containing lead arsenate. [75] The absence of arsenate-based opacifiers from ancient glass makes their use in this capacity in faience even less likely. Unlike glass, faience

does not require an opacifier, since a clean white core, or a white intermediate layer of finely ground quartz, can always provide a suitable background to a transparent glaze or one of pale colour.

If the Egyptians failed to use arsenic in their glass and faience it was obviously a matter of choice and not necessity, because by the second half of the 18th Dynasty, if not earlier, fairly pure sulphide ores were available to them. This is attested by the recovery of realgar (AsS) and orpiment (As_2S_3) from sites as far apart as Thebes and Tanis.[76] The latter mineral has also been identified as pigment on a number of art works of the Amarna and Ramesside Periods,[76] including the famous Nefertiti head in the Berlin Museum. [77]

Lucas was of the opinion that the minerals were imports from Asia, since no deposits of importance have been uncovered in Egypt.[76] In commenting on the most frequently seen impurities in Egyptian copper objects (ref.41, pp.214,216), among which arsenic was included, he also expressed the opinion that: "All these impurities were derived accidentally from the ore employed,...". The question then remains, can the same be said of faience, can all the observed arsenic be accounted for in this manner?

We are inclined to believe that most, but not necessarily all, of the arsenic seen in faience was introduced not with the copper ore but as the secondary component of arsenical copper scrap. If the interpretation of the early 2nd Millennium B.C. Mesopotamian glassmaking (or glaze-making) recipes is correct, then we have documentary evidence that the use of metal scrap (pure or alloyed) in the production of copper-based pigments was an established practice by this early date.[28] The neutron activation study done by Aspinall et al.[4] and our own work show good correlation between arsenic and copper which, unfortunately, does not distinguish between arsenic derived directly from an ore and that from a copper alloy.

In many parts of the world minerals such as tennantite ($3Cu_2S.As_2S_3$) and enargite ($3Cu_2S.As_2S_3$) are found in association with chalcocite (Cu_2S) and covellite (CuS).[44] The latter two occur in several parts of Egypt, most prominently in the Sinai,[39,78] but they are relatively free of arsenic.

Equally insignificant was the arsenic content of the copper ores mined in antiquity at Timna.[64] As a matter of fact, about the only Egyptian ores known to contain even a modest quantity of arsenic are the galenas, sphalerites, and pyrites of Fawakhir and the arsenious wulfenite ($PbMoO_4$) of Umm Gheigh.[54] A recent neutron activation study of a number of Egyptian galenas detected the most arsenic in the ore from Fawakhir, 0.02% As.[79] The fact that we found no correlation between arsenic and lead in our faience study is not significant because of the low arsenic content of most galenas.

Until new evidence comes to light we must conclude that arsenic-rich minerals such as enargite and tennantite were not locally available, and any that reached Egypt probably came from Asia. It is believed that such ores were responsible for the production of the early arsenical coppers, which by demonstrating to the early metallurgists the superiority of alloys over pure metals led to the invention of bronze.[80-82] Egypt must have been at a disadvantage vis-a-vis its Asiatic neighbors, which might be one reason why its metal industry lagged behind that of Palestine and Syria, for example.

Recent studies have shown that by the end of the 4th Millennium B.C. arsenical copper objects were plentiful in Palestine, Syria, and Iraq.[83] For example, more than two thirds of the copper objects recovered from the Nahal Mishmar hoard contained well over 1% As.[84] Arsenic was also a prominent component of the overwhelming majority of copper objects excavated by Braidwood at Amuq in the plain of Antioch.[85] The most arsenic was found in objects of phase G (ca. 3100 B.C.), contemporaneous with the beginning of the Archaic Period in Egypt.[86,87] Egypt's lag behind the areas enumerated above and behind Anatolia,[88] is illustrated in surveys published by McKerrell which included old and new analyses.[89,90]

In order to see how extensive the use of arsenical copper scrap might have been, we decided to compare the temporal variations in the incidence of arsenic in Egyptian faience with variations in the fraction of copper objects containing more than a trace of As (As above 1%). The results are plotted in Fig. 8. Only blue and green glazes had enough arsenic (about 50 had at least 0.01% As_2O_3) to make such a comparison valid, so other colours were left out. Figure 8 reveals that arsenic shows up most frequently in New Kingdom faience,

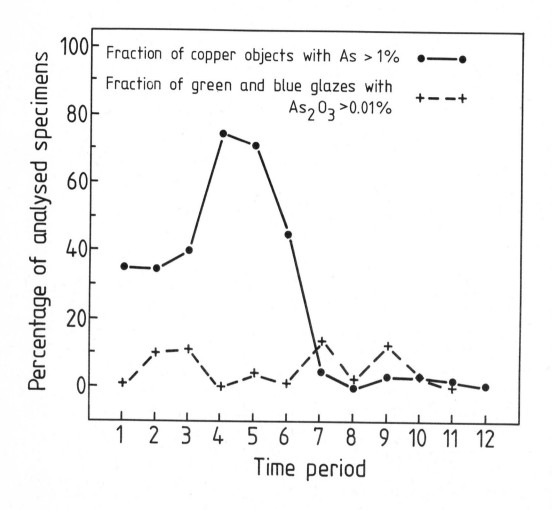

Figure 8. The relative abundance of arsenical copper objects compared with the abundance of blue and green faience containing at least 0.01% arsenic trioxide.

except for material from Tell el-Amarna. This and other instances of regional idiosyncracy will be discussed in Chapter V.

The metallic copper data, represented by the solid line in Fig. 8, are based on three sets of analyses: 1. pre-1960 assays compiled by Lucas and Harris;[49] 2. an analytical survey of Egyptian copper objects from the Ashmolean Museum carried out by H. McKerrell in 1974;[91] 3. a 1980 study of Egyptian copper artifacts at the British Museum.[92] Though the plotted figures represent the average of all three sets, the agreement between the last two, in particular, was amazingly good. Figure 8 indicates that arsenical copper was most popular during the Second Intermediate Period and the Middle Kingdom. A sudden and large increase in the number of high-arsenic specimens, as occurred in Egypt at the end of the Old Kingdom, has been interpreted by some as indicating that _intentional_ alloying of copper has replaced the fortuitous use of high-arsenic copper ores.

Since the periods of heaviest use of arsenical copper do not coincide with the periods of highest incidence of arsenic in faience, we decided to look for periods in which the highest As:Cu ratios are observed, particularly ratios above 1:100. Such ratios would definitely indicate copper with an initial arsenic content of over 1%. Here again a very peculiar asymmetry was observed. While the Archaic and Old Kingdom faience accounted for just about all the specimens having a ratio greater than 1% the majority of objects with the arsenic-copper ratio in the 0.1-1.0% range were dated to the New Kingdom. Not a single example of Middle Kingdom or First Intermediate Period date had a glaze with the As:Cu above 1:100.

Several explanations are possible for the lack of correlation between the arsenic in metals and arsenic in faience. The first that comes to mind is that we are only detecting a small portion of all the faience glazes that were originally coloured by arsenical scrap. When heated in the presence of oxygen, elemental As (or arsenides from an ore) are converted to arsenites and arsenates. At elevated temperatures the latter two decompose to a relatively volatile As_2O_3, which in its pure state boils at 465°C. The rate of loss of arsenic will depend on the partial vapor pressure in a particular medium (a function of the over-all composition of the glaze), the firing temperature,

and the length of time spent at elevated temperatures. Consequently, the higher the arsenical content of the copper the higher the probability that enough will survive to be later detected in the finished product. Nevertheless, the ultimate As:Cu ratio represents an unknown and highly variable fraction of the corresponding ratio in the original pigment. The much higher concentrations of As_2O_3 detected in Egyptian frits (see Sec.8, Chap. IV) is undoubtedly indicative of the use of lower temperatures in the preparation of frits.

The problem alluded to above is compounded by another random source of error, whose magnitude and seriousness we cannot even estimate. Considering the amount of faience manufactured in Ancient Egypt, would there have been enough scrap to fill the needs of the industry? It is most likely that scrap was used to supplement the normal supply of copper ore or for special cases where a particular shade of blue or green was desired. Such use of arsenical copper scrap would show up at random in various parts of Egypt, depending on the availability of scrap at a given site at a given time period.

The random manner in which high-arsenic and low-arsenic copper was apparently used is dramatically illustrated by a piece of wood from Abydos inlaid with blue faience. The inlays form an H pattern in which two blue-gray unglazed stripes are connected by a pale blue faience stripe. While the pale blue inlay contained 0.01% As_2O_3 (As:Cu = 0.001) the greyish blue had 0.63%, with As:Cu = 0.09, which corresponds to an 8% arsenical copper alloy. What makes the object (model coffin E.3519) truly unique is that no other frit or faience was ever found to contain more than 0.2% As_2O_3, and none with a ratio even half as large. If the blue-grey was the intended colour, and is not the result of subsequent chemical change, we might be seeing the deliberate use of the previously mentionsed arsenic ores selected because of their grey colours. Of course, the glaze-makers could not have known that the final oxides would still look grey, unless they had experimented with such ores at some earlier time. On the other hand, it is also possible that the silvery grey look of many arsenical coppers was the factor which led to the selection of such scrap in the manufacture of this unusual inlay.

Of the black and brown glazes only six contained over 0.01% As_2O_3. Since

all of them also had high copper concentrations it is difficult to tell
whether any additional arsenic was contributed by either iron or manganese
ores. However, in two instances where the black and the green were on
adjacent areas more arsenic was found in the black than in the green, although
the latter had a higher copper concentration. Moreover, all the black and
brown glazes containing As_2O_3 contained elevated amounts of BaO, a sub-
most frequently found in psilomelane-derived manganese. It would appear t.
arsenic is a minor component of some of the psilomelane used in Ancient Egypt.
Barium was also encountered in several of the arsenic-containing blue and
green glazes.

No As_2O_3 in excess of 0.01% was detected in any of the white or yellow
faience but it was found in two violet glazes. Of the two only the Amarna
fragment of the Roman period (bowl 1924.119) coloured by manganese-free
cobalt, which was probably derived from an Iranian cobalt arsenide ore (see
Section 7), contained amounts that could be termed significant (0.1-0.2%
As_2O_3) .

12. Strontium

A glance at Table XV or data in Appendix C should convince anyone that
strontium salts played no role in Egyptian faience. Even as an impurity Sr is
encountered only sporadically and rarely above 0.05%. Fewer than one in
twenty analysed samples contained more than 0.05% SrO. The strontium content
of Egyptian sands is reported to be 0.0007-0.023%. [4] The same study reported
somewhat higher values in glass and faience, 0.03-2.6% and 0.001-0.7%,
respectively. Sayre found strontium in all of his 18th Dynasty glasses at
concentrations ranging from 0.05 to 0.21%.[22,24]

Strontium may not be very abundant in nature (it constitutes about 0.019%
of the igneous crust) but it is closely associated with calcium in limestone
deposits, and limestone is the primary source of lime in glass and faience.
Calcareous sands, which are quite common in Egypt,[26,27] are another potential
source of the element. The third, a frequently ignored but in some cases
possibly the principal source of SrO are plant ashes. Brill reports 0.2% SrO
as the average concentration for a selected group of Near Eastern plant
ashes,[28] and such ashes may have constituted 25-50% of the total weight of the

T A B L E XV

VARIATIONS IN THE CONCENTRATION OF Strontium Oxide

IN GLAZES OF VARIOUS COLOURS

--

THE MEDIAN AND
AVERAGE PERCENT VALUES

TIME PERIOD	White	Yellow	Green	Blue	Purple and Violet	Black and Grey	Brown and Red
Predynastic	---	---	0.00	0.01	---	---	0.04
	---	---	0.01	0.01	---	---	0.04
Dyn. 1-2	0.00	---	0.00	0.02	0.00	0.00	0.00
	0.00	---	0.00	0.02	0.00	0.03	0.01
Dyn. 3-6	0.00	---	0.00	0.00	---	0.00	0.00
	0.00	---	0.00	0.03	---	0.01	0.01
Dyn. 7-10	0.00	---	0.00	0.00	---	0.00	0.05
	0.00	---	0.00	0.00	---	0.02	0.07
Dyn. 11-12	0.00	---	0.00	0.00	---	0.00	0.00
	0.00	---	0.01	0.00	---	0.01	0.00
Dyn. 13-17	0.00	---	0.00	0.00	---	0.00	0.00
	0.00	---	0.01	0.00	---	0.00	0.00
Early 18th	0.00	0.02	0.00	0.00	---	0.00	0.01
	0.01	0.02	0.01	0.01	---	0.00	0.03
Late 18th	0.00	0.00	0.00	0.00	0.00	0.00	0.00
	0.00	0.01	0.00	0.00	0.00	0.00	0.00
Dyn. 19-20	0.00	0.00	0.00	0.00	0.01	0.00	0.00
	0.00	0.01	0.00	0.00	0.01	0.00	0.02
Dyn. 21-25	0.00	---	0.00	0.00	0.00	0.00	0.00
	0.00	---	0.00	0.00	0.00	0.00	0.01
Dyn. 26-30	0.00	0.00	0.00	0.00	0.01	0.01	0.00
	0.00	0.00	0.00	0.00	0.01	0.01	0.01
Ptolemaic	0.00	0.00	0.00	0.00	0.01	0.02	0.00
	0.01	0.00	0.00	0.00	0.01	0.01	0.01

glazing mixture. [9,10]

As we have pointed out in our discussion of calcium, less lime is used on the average in faience glazes than in glass which explains why SrO is less frequently seen in faience than in glass. However, the upper limit of the range of values is almost identical to that found for glass, 0.25 vs 0.21%. [24]

With the strontium originating from several independent sources a very interesting distinction arises between black and blue (or green) glazes. We noted in the first section of this chapter that the highest potassium concentrations are usually seen in black glazes, suggesting freer use of plant ashes. Hence one would expect the ash to be the principal carrier of SrO in black glazes. This is borne out by our data.

We compared the K_2O and CaO concentrations in each specimen containing over 0.05% SrO with the median values of the same elements in all contemporary objects of like colour. If the strontium originated as an impurity in limestone it should most frequently be encountered among cases high in CaO, but if it came with the ash it should be seen most often among glazes high in K_2O, since ashes are also the major source of potassium. Over 80% of black specimens having SrO above 0.05% also contained K_2O well in excess of the median value for black glazes. No significant Sr-K correlation was detected among green or blue glazes, where a correlation with calcium is more dominant. Every specimen of blue or green glaze containing over 0.05% SrO also contained enough CaO to be placed in the upper quartile of the observed lime concentrations, i.e., it had CaO above 5%.

The correlations discussed above are those expected from the known chemistry of strontium compounds. We were surprised, though, not to find any clear correlation with barium, since the latter frequently accompanies strontium as an impurity in deposits of $CaCO_3$. No clear Ba-Sr correlation was seen in the 18th Dynasty glass analysed by Sayre either. [24] As expected from an impurity found in ingredients used over the entire length of Egyptian history, strontium shows no clear preference for any time period.

13. Tin

Very little tin is seen in objects anterior to the 18th Dynasty. If one considers anything over 0.05% SnO$_2$ significant, the examples are few and far between: 8 blue, 4 green, and 4 black glazes, out of over 400 analysed specimens. These early cases are invariably confined to a single or two related sites at any one historic period. We realized that such faience and the tombs from which it came were quite atypical of Egypt as a whole, when we examined the tin content of contemporary copper objects from the Ashmolean Museum collection.[91] Among 79 copper artifacts of the Archaic Period only two contained over 1% Sn and both came from the same site, royal tomb T at Abydos. This same tomb yielded a blue faience vessel (E. 3182) the surface of which contained as much as 0.3% SnO$_2$, in places, an impressive figure at any period, but truly extraordinary at this early date. Similarly, while only two out of 63 Old Kingdom copper objects had Sn in excess of 1%, one of them came from tomb K1 at Bet Khallaf, a site that yielded several of the few tin-containing faience objects of the period. Other such instances of regional aberration or unusual provenance will be cited in Section 2 of Chapter V.

The median and average values in Table XVI show that during the New Kingdom both the occurrence and the concentrations of tin oxide increase by a large factor. Moreover, the objects with significant amounts of tin are no longer confined to one or few isolated sites but come from widely separated areas. Except for a dip during the Third Intermediate Period, the concentrations in blue and green glazes, in particular, remain elevated with more than half the objects of any dynasty containing at least 0.10% SnO$_2$, and frequently more.

The distribution of tin oxide concentrations in blue and green faience is shown in Fig. 9. Concentrations over 1% are extremely rare in blue faience but are slightly more common in green faience, particularly of the Ramesside Period. Black glazes show a similar distribution. Tin oxide was least frequently seen in white glazes, of which only three contained over 0.05% SnO$_2$ and none above 0.12%. Seldom were significant amounts (over 0.05%) of tin oxide found in any glaze, regardless of colour, unless accompanied by a substantially greater amount of copper or lead and antimony. In most instances the ratio of any of the latter three to tin was greater than 10:1.

T A B L E XVI

VARIATIONS IN THE CONCENTRATION OF Tin Oxide

IN GLAZES OF VARIOUS COLOURS

--

THE MEDIAN AND
AVERAGE PERCENT VALUES

TIME PERIOD	White	Yellow	Green	Blue	Purple and Violet	Black and Grey	Brown and Red
Predynastic	---	---	0.00	0.00	---	---	0.00
	---	---	0.00	0.00	---	---	0.00
Dyn. 1-2	0.00	---	0.00	0.01	0.00	0.00	0.00
	0.00	---	0.00	0.09	0.00	0.00	0.00
Dyn. 3-6	0.00	---	0.00	0.00	---	0.01	0.00
	0.00	---	0.01	0.01	---	0.01	0.00
Dyn. 7-10	0.00	---	0.00	0.00	---	0.00	0.00
	0.00	---	0.00	0.00	---	0.00	0.00
Dyn. 11-12	0.00	---	0.00	0.00	---	0.00	0.00
	0.00	---	0.02	0.02	---	0.01	0.00
Dyn. 13-17	0.00	---	0.00	0.00	---	0.00	0.00
	0.00	---	0.00	0.01	---	0.01	0.00
Early 18th	0.00	0.04	0.02	0.06	---	0.00	0.00
	0.00	0.04	0.20	0.16	---	0.05	0.02
Late 18th	0.00	0.00	0.17	0.17	0.01	0.00	0.00
	0.01	0.02	0.21	0.23	0.10	0.09	0.01
Dyn. 19-20	0.00	0.00	0.41	0.30	0.01	0.07	0.01
	0.00	0.02	0.58	0.31	0.03	0.22	0.01
Dyn. 21-25	0.01	---	0.14	0.11	0.05	0.02	0.00
	0.01	---	0.20	0.20	0.05	0.08	0.08
Dyn. 26-30	0.00	0.01	0.25	0.17	0.13	0.17	0.00
	0.02	0.01	0.32	0.28	0.16	0.17	0.07
Ptolemaic	0.01	0.00	0.06	0.28	0.14	0.04	0.00
	0.03	0.03	0.12	0.24	0.18	0.24	0.08

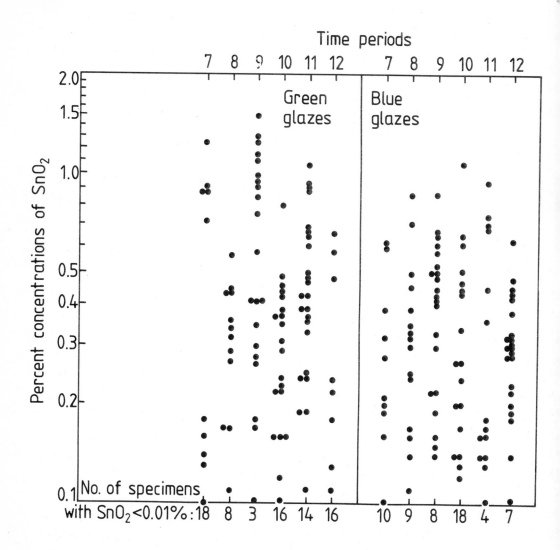

Figure 9. The distribution of tin oxide concentrations in green and blue faience glazes.

The virtual exclusion of tin oxide from white glazes and other faience glazes of low copper content (except for some yellows), combined with the relatively low concentrations in the great majority of others, after tin becomes relatively common, argue against any assumption that the Egyptians might have used tin oxide as an opacifier, or opacifier-colourant in lead-containing glazes, roles it has faithfully fulfilled in European and Oriental glass for over 1600 years.[67,93,94] The association between tin and lead, detected in certain yellow and green glazes, should not mislead anyone into assuming that yellow lead stannate was being deliberately manufactured, for without a single exception, such yellow glazes contained 5-100 times as much antimony as tin, making it eminently clear that lead antimonate was the intended product.

When one does find irrefutable evidence for the deliberate manufacture of lead stannate glazes, as in the case of the so-called "Egyptian" faience of Medieval Persia, the levels of tin and lead are not dissimilar, and the concentrations of SnO_2 are several-fold higher than the maximum found in any Ancient Egyptian faience. For example, after analysing a collection of early 14th century Persian faience objects from the Ashmolean Museum, Schweizer found that over half were high in lead and tin and the rest low in both elements.[95] A group of eight objects had glazes in which the SnO_2:PbO ratio averaged 8:10 and the concentrations of SnO_2 and PbO ranged from 7.5-11.5% and 4-20%, respectively. Fourteenth century faience was chosen, because we are fortunate enough to possess a treatise on the manufacture of pottery written by a Tabrizi Persian named Abu'l-Qasim ca. 1300 A.D.[58] It contains a recipe for the making of lead stannate faience glazes. The recipe, J. Allan's translation of which is quoted in ref. 95, is quite explicit on how much tin and lead oxide is to be mixed and how the mixture is to be processed to get the desired results. We might add, that the term "Egyptian" seems most inappropriate for glazes of this particular type, though the others in the group investigated by Schweizer and some 20th-century provincial products of Iran investigated by Wulff do resemble those of Ancient Egypt.[10,96]

Our conclusion, that tin oxide was not used as an opacifier are fully supported by the faience analyses published to date. Lucas reports no tin in any of his glazes, but Kuhne found 0.04 and 0.14% SnO_2 respectively, in two

specimens of blue-green Amarna glaze.[2] Stone and Thomas found no tin in pre-18th Dynasty faience, but among objects of the New Kingdom and later periods half had SnO_2 in the 0.01-0.1% range, a quarter above 0.1% and a quarter below the detection limit of 0.001%.[3] The highest value reported by Aspinall et al. was 0.4% SnO_2.[4] No suitable comparison with McKerrell's data is possible, since the author plotted just the approximate Sn:Cu ratios and not the absolute concentrations.[5] In contrast with the low concentrations reported for faience glazes, values in excess of 1% SnO_2 are common in Egyptian blue frit of the New Kingdom, as we and others have discovered (see Section 8 of Chapter IV).[97]

Variable but low levels of tin have been detected in Egyptian opaque glass, blue and green in particular. The highest reported value in pre-Roman glass is 0.6% SnO_2.[18,20] Neumann's analyses of 18th Dynasty blue glass detected no tin in half the samples and values ranging from 0.4 to 0.5 in the other half.[18,20] The mean of these analyses is remarkably close to the average composition of blue 18th Dynasty faience (0.27% SnO_2). Similarly, the majority of New Kingdom copper-blue glazes have SnO_2 in the 0.00-0.53% range.

Geilmann, however, reports only 0.01-0.1% SnO_2 in his samples.[34] Sayre found no SnO_2 in excess of 0.005% except in copper-blue and antimony-yellow glass. In the former group the concentration range was 0.0158-0.21%, in the latter 0.0048-0.055%.[22,24] Farnsworth and Ritchie report tin oxide in the majority of their glasses, but no precise figures are given.[19]

The use of tin as an opacifier and colourant in glass has been investigated extensively by Turner and Rooksby, who found no evidence of such use prior to the 4th c. A.D.[67,68,93,94] The earliest dateable glass in which they found an adequate quantity of crystalline SnO_2 or of the species responsible for the tin-yellow colour, Pb_2SnO_4 and $PbSnO_3$,[98] came from Spain and have been dated to ca. 330-350 A.D.[93,94] Sayre, who also looked for the opacifiers in over 300 specimens of ancient Near Eastern and European glass, found no evidence that tin replaced antimony as opacifier prior to that date.[23] Recently, however, intriguing exceptions have come to light which suggest that lead stannate might have been in use in Britain, at least, as early as the 1st c. A.D. The compound has been identified by X-ray

diffraction in specimens of yellow glass from Drummond Castle[99] and Welwyn Garden City.[100]

Of the people who have investigated ancient glass only Neumann was of the opinion that the Egyptians deliberately introduced tin oxide as an opacifying agent. Others who have closely examined glass of the same periods came to a different conclusion. The arguments against Neumann's thesis are summarized by Ritchie and Farnsworth in their 1938 study of Egyptian glass.[19]

While the inclusion of tin in pre-18th Dynasty faience can undoubtedly be considered the result of accidental circumstances, its presence in New Kingdom and later faience cannot be dismissed in the same manner. The sudden explosion in the number of glazes containing significant amounts of tin oxide and the remarkably narrow range of values within which the great majority of them cluster for over 1500 years (see Fig. 9), strongly suggest that tin was deliberately introduced as a desirable ingredient into many faience glazes. Whether it was introduced as tin, tin oxide, or in the form of bronze scrap may be uncertain, but the intent is unmistakable. We know of no copper deposits exploited in the Ancient Near East that contain as much tin in proportion to copper as would be required to produce some of the glazes seen by us. It is also unlikely that such ores, had they been mined, would have been mistaken for ordinary copper ores.

This is not the place to discuss the tin deposits of the Near East in general, and those exploited in antiquity in particular, as the subject has been reviewed by several authors in recent years. [101-104] It is noteworthy, however, that recent surveys have often failed to confirm the existence of tin mines reported by earlier travellers or have found their size and importance grossly exaggerated.[101-104] Particularly elusive have proved to be ores having tin in close association with copper and showing evidence of ancient workings. In this category belong the reported but unconfirmed placer tin deposits of Nahr Ibrahim discussed by Wainwright.[105,106]

The most common mixed copper-tin mineral is stannite ($Cu_2S.FeS.SnS_2$), and little of it has been found in Egypt. To date most of the tin discovered in Egypt has been in the form of cassiterite, [38,39,107,108] some of it of

remarkably high grade, as recent discoveries in the Eastern Desert have shown.[103,109] It has been reported that some of the chalcocite of West-Central Sinai, an area heavily exploited by the Ancient Egyptians, [41,110-112] contains traces of tin and bismuth. [54,78,113]

Sometimes copper and tin are brought together as a result of a geological accident. For example, in his extensive investigation of the tin-tungsten deposits of the Eastern Desert, Amin noted several instances where final supergene mineralisation deposited a variety of copper minerals, among them: chalcocite, chrysocolla, malachite, and azurite.[108] In places the supergene deposits fill deep fissures, so that if these or any other similar deposits had been mined for copper, contamination by varying amounts of tin would have been unavoidable. Undoubtedly, a search of Egyptian geological literature would reveal other sites where minor deposits of associated copper and tin exist, but the examples cited above suffice to explain the sporadic appearance and the low levels of tin in the pre-18th Dynasty faience.

When it comes to tin as an impurity, it is more often seen in Egyptian galenas and sphalerites,[54] minerals which at several sites (Umm Samiuki, for example) are deposited in close proximity to sulphides of copper. This may be one reason why, in general, tin is more often found in faience containing both lead and copper, than in glazes that contain an equivalent amount of copper without the lead. This can be demonstrated by dividing the green glazes, for example, into two groups: a low-lead group with PbO below 0.2% and a high-lead group with PbO above 0.2%. The frequency with which more than 0.1% SnO_2 shows up in the two groups is illustrated in Fig. 10. Except during the Ptolemaic Period, lead-containing faience is more likely to contain tin also. The tin data reinforce an earlier conclusion, based on zinc analyses, that Ptolemaic lead had a different origin from that of the New Kingdom lead.

Among some interesting early examples illustrating the relationship between lead and tin are two blue-green beads: Queens College Loan Nos. 1284A and B from grave D2 at Abydos. They are the only green pre-18th Dynasty faience specimens to contain SnO_2 in excess of 0.1% and they contain more lead than any other Middle Kingdom object from Abydos. In contrast, the levels of tin found in contemporary low-lead glazes are truly negligible. The absence

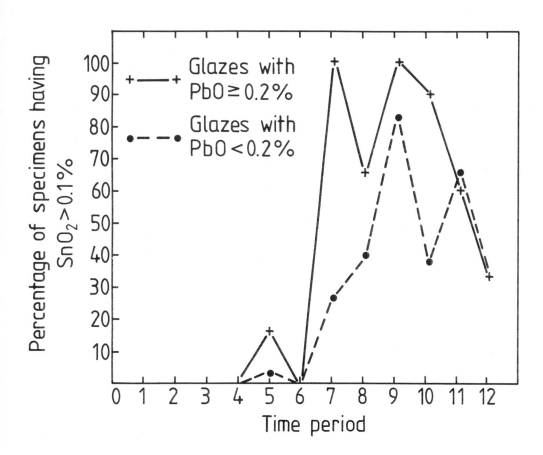

Figure 10. The occurrence of tin oxide in green glazes having PbO above 0.2% compared with occurrence in glazes with PbO below 0.2%

of antimony, and the high but similar SnO_2:PbO:CuO ratios (ca. 8:4:100) suggest that the beads might have received their tin from a mineral such as **teallite** ($PbS.SnS_2$), for example. Introduction of lead and tin into the pigment via a leaded bronze is most unlikely, since copper with this much lead and tin (8% Sn and 4% Pb) is quite uncommon till after the New Kingdom. [5,49]

Another way in which the lead-tin correlation can be demonstrated is to compare the average SnO_2:CuO ratios in high and low lead glazes of the same time period. From the Middle Kingdom until Ptolemaic times the ratios in the low-lead glazes are significantly lower than in those having PbO above 0.2%.

Starting with the 18th Dynasty, when tin and lead are found together they are more often than not accompanied by a substantial amount of antimony. This is most clearly seen among yellow glazes, where there is so little copper that the results cannot be obscured by any tin that might have accompanied the copper. In yellow glazes, where the use of bronze can be ruled out on the basis of low copper concentrations (or its virtual absence) which occasionally result in Sn:Cu ratios greater than 1:1 (almost 4:1 in one early 18th Dynasty yellow bead), the tin was probably introduced with lead ores containing minerals such as franckeite ($5PbS.3SnS_2.Sb_2S_3$), which accompany teallite in certain galenas.[44] We do not know of any Egyptian deposits of franckeite, but during the New Kingdom copper and lead ores were being imported from Nubia and Asia.[114] If allowance is made for transit trade, the tin-containing lead or antimony might have come from some very remote area of the Near East or from even farther away. During the Ptolemaic Period Alexandria was linked by trade with places as remote as Britain, India, and many other parts of Europe and Asia. Since the lead and antimony are also accompanied by excessive amounts of sulphur, we must be dealing with sulphide ores. For the objects containing antimony and tin, leaded bronze can be ruled out as the primary source of tin, since such bronzes rarely contain more than trace amounts of antimony. [49,115]

Minerals of the type discussed above are a direct but undoubtedly only a minor source of tin, so we still have to consider the use of bronze scrap, as we have done in the case of arsenic. On the basis of published[49,89,90,115] and unpublished analyses[91,92] we have constructed the plot shown in Fig. 11, where the fraction of copper objects containing more than 1% Sn is plotted as

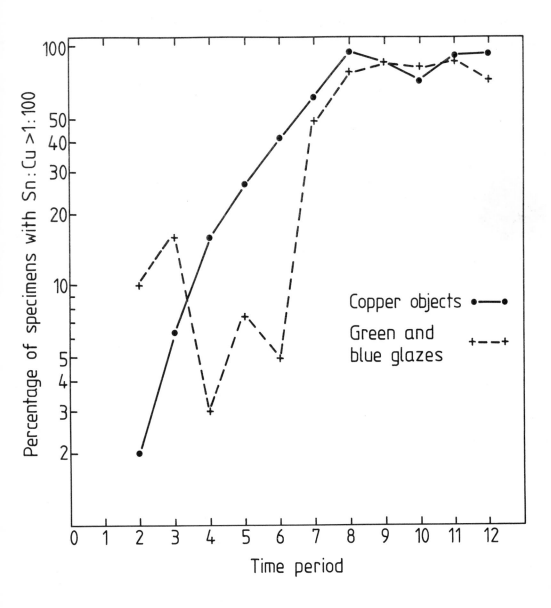

Figure 11. Fraction of copper objects and of green and blue faience glazes having a Sn:Cu ratio in excess of 1% at various periods of time.

a function of time (solid line). The actual fraction of copper objects that might legitimately be called bronze is not impressive until the Middle Kingdom (one in three),[49,89-92] but one cannot ignore the small but significant number of bronze objects recovered from Old Kingdom sites, be they of native manufacture or imports from Syria, explicitly Byblos, as some scholars believe.[106,116]

In the same Figure the fraction of blue and green glazes having a Sn:Cu ratio in excess of 1% is also plotted as a function of time (dashed line). Whereas for over 2000 years the fraction in either blue or green faience remained negligibly small (under 15%), it suddenly undergoes a most dramatic rise in the 18th Dynasty, a rise too great to be explained by anything except a deliberate switch from the use of plain copper ore to either bronze or copper supplemented by some tin compound. Some fluctuations are observed during subsequent time periods, but nothing to compare with the change during the 18th Dynasty.

The tin-copper ratios themselves undergo an even more profound change during the 18th Dynasty, with the average value changing by more than a factor of ten between the beginning and the end of the New Kingdom, as can be seen in Fig. 12. The ratios remain relatively high, except for a dip during the Third Intermediate Period (seen in glazes of all colours), which will be discussed in Chapter V. The high ratios are indicative of greater availability of tin and/or bronze, otherwise so much tin would not have been "wasted" on faience.

Figure 12 shows that the tin-copper ratios in green glazes are consistently lower than in blue. How much of this was deliberately planned is uncertain, because the green glazes contain more lead and lead is partly responsible for higher tin contents, as we noted earlier. Nowhere is this more dramatically illustrated than in the case of Amarna glazes, which have an average Sn:Cu ratio of 0.084, but if only samples containing less than 0.2% PbO are considered the average drops to 0.056. The Amarna material, however, is quite exceptional, since from a comparison of Sn:Cu and Pb:Cu ratios in low-lead and high-lead glazes of other time periods one gets an estimate of 0.01-0.02% for the amount of SnO_2 introduced with each percent of lead.

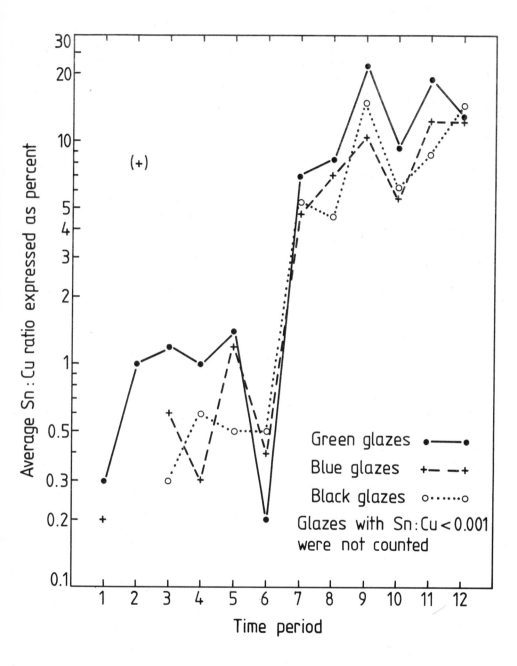

Figure 12. The average Sn:Cu ratios (expressed as %) in green, blue, and black faience glazes at various periods of time.

The averaged Sn:Cu ratios in bronze and in blue and green faience show some interesting parallels. From the published bronze analyses the following average Sn:Cu ratios may be computed: 7% for the 18th Dynasty and Ptolemaic bronzes; 8%, 4%, and 6% for the bronzes of the Ramesside, Third Intermediate, and Late Periods, respectively.[49,115] Recently analysed British Museum bronzes yielded a value of 9.3% Sn for the New Kingdom as a whole. Both the faience and the bronzes indicate a peak during Ramesside times, followed by a dip and gradual recovery during the Saite and Ptolemaic periods. Moreover, the average ratio of $SnO_2:CuO$ in combined blue and green faience of the 18th Dynasty is 0.068, which translates into a Sn:Cu ratio of 6.9%. For the New Kingdom as a whole the corresponding ratio in faience si 9.9%, remarkably close to the 9.3% tin content of the British Museum bronzes alluded to above.

The data presented above lead to one inescapable conclusion: from the 16th c. B.C. onwards arsenical copper and tin bronzes were used on a regular basis as a source of copper in the faience industry. However, as in the case of arsenic we are again at a loss to explain why tin should make its dramatic appearance in faience several centuries after bronzes apparently ceased to be a rarity in Egypt. It has been widely accepted that tin bronzes were introduced into Egypt during the Middle Kingdom and bronze data plotted in Fig. 11 show that over one quarter of analysed copper objects of the period could be classified as bronzes.

We have so far discussed the average composition of Egyptian faience, and for the majority of glazes bronze is a satisfactory and plausible source of tin. There do remain, however, a number of objects in which the deliberate use of some other source of tin, such as cassiterite, is indicated. We have in mind, particularly, glazes in which the Sn:Cu ratio exceeds 15%, through many if not most of those with a ratio greater than 10% might also have received a dose of pure tin ore.

Bronzes with more than 10% tin were never very common in Egypt, if the surviving examples that have been analyses are a representative sample of the original output. Only one out of ten objects listed by Lucas[49] exceeded the value, as did a similar proportion of all the analysed copper objects from the Ashmolean Museum (29 out of 264).[89-91] The proportion among bronzes of the

Late and Ptolemaic Periods at the Berlin State Museum was not much larger.[115]
That the Ashmolean and Berlin collections should yield about the same figure
as the random and heterogeneous listing of Lucas is reassuring, for it
suggests that the proportions in other concentration ranges may also be
representative of the Egyptian production as a whole. Of course the
proportion of high-tin bronzes varies with time, rising to one in four during
the Ptolemaic-Roman period.[49] For the period during which the use of bronze in
the manufacture of faience is indicated (16th c. B.C. to 1st c. A.D.) we find
that 18% of the objects listed by Lucas and 14% of those from the Ashmolean
collection contain more than 10% Sn. Either figure is a small fraction of the
total. If we exclude the "non-bronze" with 75.7% Sn, there remain only two
objects containing more than 15% Sn, and only one falls within the time period
of interest ot us.

 The statistics presented above may have a wide margin of error,
nevertheless they do give an idea of the relative scarcity of bronzes with
more than 10% and 15% Sn. Unless it can be demonstrated that bronze was not
used in the manufacture of faience glazes (a difficult task), it is reasonable
to conclude that glazes with a Sn:Cu ratio of 1-10% obtained most, if not all,
of their tin from bronze, while those with a ratio greater than 15% received a
supplementary dose from cassiterite, or some other tin-rich source. Glazes
with a 10-15% ratio fall in a grey area where the precise source of tin
remains uncertain.

 The Sn:Cu ratios were divided into five ranges (0-1%, 1-5%, 5-10%, 10-
15%, and over 15%) and the population of each range in green and blue glazes
was examined. The histograms in Fig. 13 show that while the majority of
glazes of all time periods have ratios expected from bronzes and natural
impurities in copper, a disproportionate number have ratios in excess of 15%.
Even the 10-15% range is populated out of proportion to what one might expect
from bronzes, except for the 18th Dynasty faience. Among the latter, only 17%
of the analysed glazes had Sn:Cu ratios greater than 10:100. This is
remarkably close to the fractions of bronzes containing tin in excess of 10%
cited above (14-18% of samples). It would seem that beginning with the
Ramesside Period, if not earlier, a considerable number of faience objects
received a healthy dose of tin in some form more concentrated than bronze.

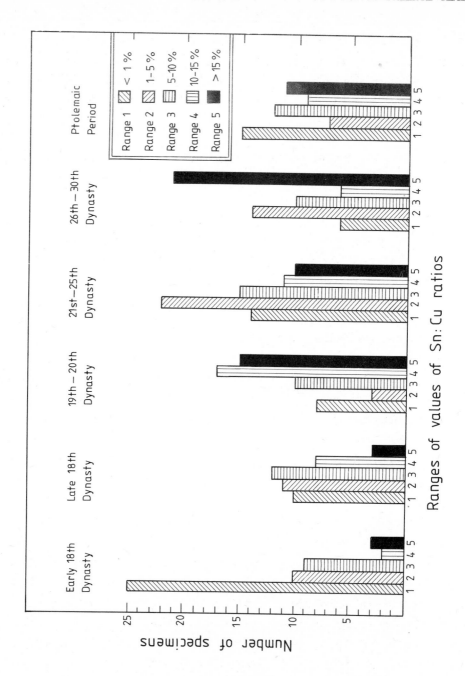

Figure 13. The distribution of the Sn:Cu ratios observed in blue and green faience.

This is consistent with the skewed or polymodal distribution of ratios, so evident in the glazes of Ramesside, Late and Ptolemaic Periods (see Fig. 13). It is regrettable that our data contain no information that would enable us to tell whether metallic tin or cassiterite (SnO_2) was used in the enrichment process.

The available analyses of copper-coloured Egyptian glass suggest sources of tin analogous to those indicated for faience. Sayre's 18th Dynasty copper blue glasses had SnO_2:CuO ratios of 0.02, 0.14, and 0.13, respectively. [22-24] Glasses analysed by Neumann either had no detectable amount of tin or enough to yield ratios in the 0.33-1.0 range. [20] While bronzes might have provided all the tin found in Sayre's specimens, they could not have produced the extraordinary ratios found by Neumann.

Since the deliberate introduction of tin, direct or more often via bronze, cannot be denied, one question remains, for what purpose? As we pointed out earlier, the levels and other factors argue against its use as opacifier. Several years ago while examining some of the faience we noticed that even among objects from the same tomb, and thus exposed to the same degree of weathering, those with high tin content were frequently the glossiest and looked freshest. In our opinion, sometime during the 18th Dynasty, the Egyptians must have noted that glazes containing tin are glossier and have greater depth of colour.

Whether the Egyptians were the first to note the connection between the brilliance of a glaze and the presence of tin is uncertain, but the knowledge certainly seems to have been available in areas as far apart as Mesopotamia and Britain. Thus Hedges and Moorey were puzzled by the presence of tin in a large number of Mesopotamian pre-Islamic pottery glazes, for the amounts were too high to be attributed to impurities and too low for a tin glaze. [117] The concentrations seen in these glazes were comparable to what we see in Ptolemaic Egyptian faience. We would like to suggest that tin-containing raw materials were employed to provide rather drab-looking pottery surfaces with a highly opaque and glossy skin, something even small amounts of tin are capable of doing.

Similarly, McKerrell was struck by the high proportion of British Bronze Age blue beads with excessive amounts of tin.[5] Admitting that he could see no technical reason for the tin, he concluded that the oxide had been added to enhance and darken the blue in imitation of lapis lazuli. We find ourselves in full agreement with McKerrell's conclusion and share his views that the use of tin in the faience and pottery glazes discussed above was dictated by aesthetic rather than purely technical reasons.

The brilliance of a glaze is a function of the refractive index of the surface layer. The oxides of tin, antimony, and lead have very high refractive indices and consequently their presence will make a glaze more reflecting as well as more opaque. As far as we know, the effects of tin, or other materials of high refractive index, on the reflectance of faience glazes have not been a subject of any intense quantitative study, but the optical properties of enamels have been investigated quite extensively. In a recent book on enamels by Vargin[118] one can find formulas and numerical parameters from which the quantitative effects of glaze components on the coefficient of reflectance (a measure of brilliance) may be estimated. Tin oxide is quite effective in enamels and must be equally effective in faience glazes, for the optical properties are quite similar. Thus the ancient glaze-makers knew what they were doing even if they did not know how the tin-containing additives produced the desired effect.

14. Antimony

The use of antimony and its compounds in Ancient Egypt has been a matter of considerable controversy for many years, as is well illustrated by the number of pages that Lucas devoted to refuting several misconceptions regarding the subject.[41] Lucas has clearly demonstrated that the often repeated equation of kohl with antimony sulphide is incorrect until Roman times, and he expressed serious doubts about the reported antimony plating on Old Kingdom copper vessels.[119] His skepticism was fully vindicated when almost 30 years after the original claim Pieter Meyers of the Metropolitan Museum in New York re-examined the surface coating and proved unequivocally by means of neutron activation analysis that the coating consisted of arsenic, a much less surprising fact.[120] Recent analyses of Ancient Mesopotamian cosmetics also failed to find any antimony sulphide in any of the eye-shadows (ref.28,

p. 117).

For many years there were serious doubts about the intentional use of antimony and its compounds, because many investigators failed to find much if any antimony in metals and glass. Lucas mentioned, in passing, that both he and Parodi detected large amounts of lead and antimony in yellow glass of the New Kingdom and later periods (ref.18,p.190), but he did not cite any percentage figures. The glass analyses tabulated by Lucas and Caley either do not include the element or show it at levels that cannot be considered too significant (0.03-0.05% Sb_2O_5)[18,20] Farnsworth and Ritchie reported finding "trace" amounts (below 1%) of antimony in 79% of their samples and moderate amounts (1-10%) in two yellow and two red glasses, or 5.5% of all the analysed objects; almost as many samples contained lead ("trace" amounts in 78% of objects).[19] The fact that they found both elements in practically all the objects, regardless of colour, led the authors to what we now know to be an incorrect conclusion: "...that an explanation of the yellow colour must be sought elsewhere, and, on similar grounds, to regard it as improbable that either lead, tin, or antimony is responsible for the opacity...". [19]

The X-ray diffraction work of Turner and Rooksby proved conclusively that antimony in the form of $Ca_2Sb_2O_7$ and $Pb_2Sb_2O_7$ was the principal opacifying agent in most Egyptian and other ancient glasses.[67,68,93,94] Results similar to those reported by Farnsworth and Ritchie were obtained by Sayre, who found Sb_2O_5 in each of his specimens of Egyptian glass.[22-24] The concentrations ranged from 0.01 to 2.5%, but only one white, one blue and all three yellow specimens contained the compound in excess of 0.1%; the yellows also contained an excess of PbO over Sb_2O_5. With the large number of analyses of ancient glasses at his disposal Sayre was able to establish the times when antimony was used as opacifier in various parts of the ancient world and when Sb_2O_5 also assumed the role of decolourizer in clear glasses.[23]

Thus the intentional use of antimony in ancient glass is now an established fact. What still remains unresolved is the form and manner in which antimony was introduced into the reaction mixture. Brill discusses the subject at some length, with references to surviving glassmaking Mesopotamian recipes, but leaves the matter unresolved.[28] It is obvious that some

additional textual evidence will have to be discovered before the subject is resolved to the full satisfaction of scientists, archaeologists, and ancient historians.

With regards to the use of antimony in Ancient Egyptian faience, where opacifiers may not be needed while clarifiers may be useful but not indispensable, very little accurate numerical data have been published to date. The analyses published by Lucas[1] and Kuhne[2] fail to mention the element. It is also puzzling that Stone and Thomas, who included antimony among the elements determined in Egyptian sands, left it out of their faience tables.[3] However, the published subsequent neutron activation analyses of many of the same beads listed one with 0.3% Sb_2O_5 and 37 others with less than 0.01%.[4] The same study included six glass beads of the 18th and 19th Dynasties. Four of those beads were yellow and contained from 0.8-1.2% Sb_2O_5. Antimony in Egyptian faience is also discussed by Dayton, but some of the concentration ranges and interpretations of results are open to question. [6]

The pattern of use of antimony in faience is relatively simple. Until the New Kingdom only trace amounts are detected and primarily in copper-rich glazes, as is shown in Table XVII. The scarcity of antimony in early faience is best illustrated by the fact that no faience object of pre-18th Dynasty date contained antimony oxide in excess of 0.1% and only seven specimens had Sb_2O_5 above 0.05%. It is safe to assume, therefore, that such antimony is an impurity, introduced with copper, most probably.

The Sb:Cu ratio in early faience is far below 0.7%, the highest ratio reported in Egyptian copper objects.[49] Analyses of copper objects from the Ashmolean Museum yielded only one object with Sb over 1%, and the object in question (statuette E.63) was an arsenical copper from an Archaic Period cache in the temple area of Abydos (chamber M69).[91] As in our discussion of arsenic, here too we find geographical parallels, for a vessel fragment (E.36) with decorations containing 0.08% Sb_2O_5 also came from the temple area at Abydos, and it too contained some arsenic. We do not believe this is mere coincidence, and the matter will be taken up in Chapter V.

Whether the early traces of antimony were introduced as an impurity with

T A B L E XVII

VARIATIONS IN THE CONCENTRATION OF Antimony Oxide
IN GLAZES OF VARIOUS COLOURS

THE MEDIAN AND
AVERAGE PERCENT VALUES

TIME PERIOD	White	Yellow	Green	Blue	Purple and Violet	Black and Grey	Brown and Red
Predynastic	---	---	0.00	0.00	---	---	0.03
	---	---	0.00	0.00	---	---	0.03
Dyn. 1-2	0.00	---	0.00	0.00	0.00	0.01	0.00
	0.01	---	0.01	0.00	0.00	0.01	0.01
Dyn. 3-6	0.00	---	0.01	0.00	---	0.00	0.00
	0.00	---	0.01	0.01	---	0.00	0.00
Dyn. 7-10	0.00	---	0.00	0.00	---	0.00	0.00
	0.00	---	0.01	0.01	---	0.00	0.00
Dyn. 11-12	0.00	---	0.01	0.01	---	0.00	0.01
	0.00	---	0.01	0.01	---	0.01	0.02
Dyn. 13-17	0.00	---	0.00	0.00	---	0.00	0.01
	0.00	---	0.00	0.01	---	0.01	0.01
Early 18th	0.00	0.78	0.00	0.00	---	0.00	0.00
	0.32	0.88	0.05	0.02	---	0.01	0.00
Late 18th	0.01	1.15	1.03	0.01	0.02	0.01	0.02
	0.02	1.18	1.07	0.11	0.04	0.51	0.07
Dyn. 19-20	0.03	0.75	0.03	0.03	0.03	0.02	0.04
	0.11	0.76	0.06	0.07	0.13	0.07	0.05
Dyn. 21-25	0.00	---	0.01	0.01	0.01	0.00	0.00
	0.00	---	0.02	0.02	0.01	0.01	0.01
Dyn. 26-30	0.16	0.62	0.07	0.04	0.03	0.06	0.01
	0.39	0.62	0.39	0.05	0.03	0.10	0.38
Ptolemaic	0.00	1.35	0.32	0.02	0.07	0.00	0.00
	0.00	1.42	0.53	0.25	0.22	0.02	0.01

elements other than copper is not certain, since too few objects have enough
to establish a clear correlation. We have not been able to find any analyses
of copper ores containing enough antimony to have yielded a finished product
with 0.7% Sb. A recent study of the copper ores from Timna, which is just to
the east of Sinai, showed that after the copper was smelted the antimony
content was only 200 ppm (0.02%).[122] In an earlier study of Timna copper the
smelting of a typical ore containing ca. 0.01% Sb yielded a metal with a 0.01%
content of antimony. [64]

We do not have as much information about the ores of the Western Sinai,
an area closer to Egypt and subject to Egyptian control for a longer period of
time. However, as we noted in the preceding section, the chalcocite deposits
reportedly contain traces of tin and bismuth.[113] Antimony was not reported,
but it frequently accompanies bismuth, so that it is likely that antimony
might still turn up as an impurity in some other ore specimens from the
general area. Copper ores from Cyprus and several other areas of the Eastern
Mediterranean are also relatively low in antimony.[88,90,123]

Since the highest impurity levels show up in objects of the Archaic
Period, at a time when the Egyptian exploitation of the Sinai had not yet
begun and the import of copper from abroad is most unlikely, the antimony as
an impurity is to be sought in some native Egyptian ores, only a small
fraction of which have been analysed by modern spectroscopic techniques.
Antimony from sources other than copper ore will be discussed at the end of
this section.

Antimony, accompanied by lead, first appears in amounts large enough to
indicate deliberate use in yellow and green faience beads at the time of
Tuthmosis III. From the 18th Dynasty on, no yellow object was ever found to
contain less than 0.27% Sb_2O_5 and a considerable excess of lead. As a matter
of fact, the association with lead extends to all other glazes which contain
antimony in excess of the impurity limit of 0.2%. The 0.2% was taken as the
dividing line, since one obtains a bimodal distribution with a gap between
0.15 and 0.2% when the concentrations of Sb_2O_5 in glazes of the 18th and later
dynasties are ranked. Sayre noted similar gaps in the antimony contents of
ancient glasses at ca. 0.1 and 0.4%.[23]

How close the correlation between antimony and lead is may be seen in Fig. 14, where the distribution of Sb_2O_5 concentrations in yellow, green and blue glazes is plotted. Both low and high-lead blue and green glazes show an almost-exponential decline in the 0.0-0.2% range, but here the similarity ends. While a very substantial number of yellow, green and blue glazes containing 0.2% or more PbO also have antimony oxide at levels above 0.2%, only **seven** low-lead specimens (four green and three blue) have Sb_2O_5 in excess of 0.2% and none above 0.7%.

To find out how much antimony, on the average, was being deliberately added when the element was a desired component of a pigment, we examined the compositions of glazes containing at least 0.2% PbO. The resulting figures were considerably higher than those in Table XVII, as one can see in Table XVIII below.

Glazes other than yellow or green seldom contain Sb_2O_5 in excess of 0.2%, and the few that do tend to be components of polychrome designs in close contact with green or yellow. For example, whereas all the yellow and three-fourths of the green glazes of the Amarna Period contained at least 0.2% Sb_2O_5 only one blue in eight did. The few blue glazes that did contain at least 0.2% antimony pentoxide overlay either a yellow or green ground. Out of almost 300 black, brown, violet and white glazes a mere dozen contained Sb_2O_5 in excess of 0.2%, and of these only **three** failed to have an excess of lead over antimony.

Since, as we already pointed out, monochrome faience of colours other than yellow or green rarely contains enough antimony to imply intentional use of the element, we were particularly intrigued by a group of white and creamy beads from the foundation deposit of the temple of Tuthomosis III at Coptos. These particular beads contained as much antimony and lead as yellow beads from the same site. Since these beads were mixed with some bright white ones containing very little antimony or tin, the possibility that antimony was intended as opacifier can be ruled out. We believe that these creamy white beads were intended to be yellow. As Sayre found out experimentally, after puzzling over the fact that some ancient colourless glass was rich in antimony and should have been opaque, a minor variation in the furnace conditions will

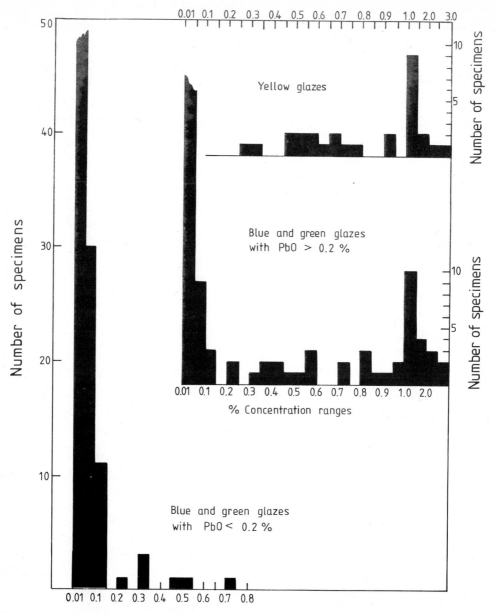

Figure 14. Distribution of antimony pentoxide concentrations in yellow glazes (upper right), blue and green glazes having PbO above 0.2% (middle), and blue and green glazes having PbO below 0.2% (lower left).

T A B L E XVIII

AVERAGE ANTIMONY PENTOXIDE CONTENT OF GLAZES CONTAINING OVER 0.2% PbO

Colour	Late 18th Dynasty	Dynasty 19-20	Dynasty 26-30	Ptolemaic Period
Green	1.44%	0.55%	0.60%	0.70%
Blue	0.60%	0.08%	0.06%	0.33%

result in the decomposition of Sb_2O_5 and the formation of Sb_2O_3,[23] which is soluble in glass. Needless to say, the reduction of antimony ruins the distinctive yellow colour of $Pb_2Sb_2O_7$. The conditions under which such an accident might occur will be discussed in Section 8 of the next chapter.

All evidence indicates that antimony was added primarily to create yellow glazes or, in combination with copper, green ones. All the yellow glazes seen by us were coloured by lead antimonate and when antimony disappeared from Egyptian faience during the Third Intermediate Period so did yellow glazes. The popularity of green glazes coloured by lead antimonate and copper varied from period to period. While fewer than 10% of non-Amarna New Kingdom green glazes owed their colour to this particular combination of pigments, 76% of the Amarna, 60% of the Ptolemaic and 35% of the Late Period green faience contained substantial amounts of $Pb_2Sb_2O_7$.

If one were to look for a time when antimony oxide might also have been added as a clarifier (or opacifier) and not solely as a pigment, it would be the 26th Dynasty. Three fourths of the few objects containing antimony and little or no lead come from this period. This lends support to Sayre's claim that the use of antimony pentoxide as a decolourizing agent is first seen in the ancient Near East in the 7th century B.C. [23] The similarity of faience glazes to contemporary glass has been noted before, and here again we find that the concentration ranges are not dissimilar. The concentrations of Sb_2O_5 in faience range from less than 0.01% to about 3%, a range of values

comparable to that reported in the literature for pre-Roman glass from Egypt.18,20,22-24

Since there is not much doubt that antimony and lead were both added intentionally, we decided to see if any particular ratio was favoured. Figure 15 shows the range of ratios encountered among objects containing at least 0.2% Sb_2O_5 and PbO. As expected, the spread is narrowest among yellow glazes, in which lead antimonate made its first appearance in Egypt. The upper and lower limits show only moderate variations with time, and the average tends to favour an Sb_2O_5:PbO ratio of approximately 1:5. Both the green and blue glazes show a wider spread for which variations in the lead content are responsible. Nevertheless, the average ratios in yellow and green glazes exhibit nearly parallel changes with time with the ratios in green always higher. The differential simply reflects the fact that more lead on the average is found in yellow than in green glazes.

Since the variability of lead concentrations is the primary cause of the temporal fluctuations in the lead-antimony ratios, the latter show trends that often run counter to those exhibited by the average concentrations of Sb_2O_5 itself. This is readily demonstrated by comparing previously tabulated concentrations with ratios plotted in Fig. 15. For example, the average concentrations of Sb_2O_5 in both yellow and green glazes exhibit a marked decline after the Amarna Period, but the decline in the use of lead is such that the ratio of Sb_2O_5:PbO actually rises. Similarly a big increase in the antimony levels between the Late and Ptolemaic Periods (more than two-fold in the case of yellow glazes, vid. Table XVII) is not reflected in the antimony-lead ratios which actually register a decline.

After the 18th Dynasty the blue glazes do not follow the trend of either yellow or green but show independent variations, as might be expected, since in colours other than yellow or green the presence of lead antimonate is intrusive and not intended. Another problem with the blue glazes is that we are dealing with a very small number of specimens so that the "average" is not based on a sound sample size but reflects the whims of one object or a handful.

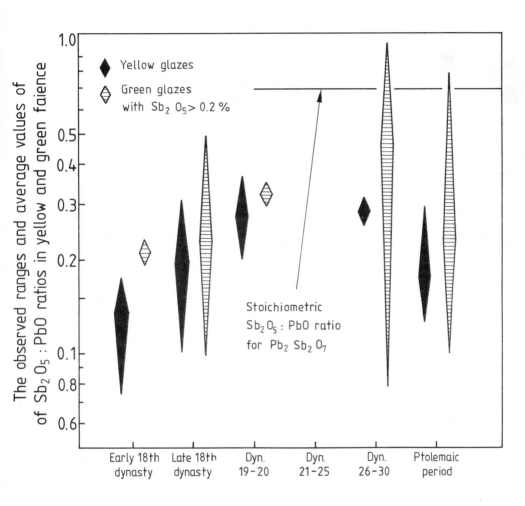

Figure 15. The ranges and average values of $Sb_2O_5:PbO$ ratios in specimens of yellow and green faience having over 0.2% Sb_2O_5.

While trying to see if the same formulation of lead antimonate was used in glass as in faience, we encountered an equally large spread in recorded values. If one confines the comparison to glass specimens with more than 0.2% Sb_2O_5 one is left with very little data. Sayre reports for three yellow New Kingdom glasses ratios of: 0.22, 0.25, and 0.138,[22-24] however, in one specimen of blue glass the ratio was 194, while an opaque white glass had a more modest ratio of only 31. Brill, who examined some Amarna and Ptolemaic-Roman Alexandrian glasses, reported a Sb_2O_5:PbO ratio of 0.102 in yellow glass, and ratios ranging from 0.03 to 91.0 in other colours. [25,121] On the whole, the best agreement between glass and faience was detected in yellow colours, where lead antimonate was the sole pigment. During the New Kingdom a higher proportion of lead was used in faience, than in glass. Greater uniformity is observed in the Ptolemaic and Roman times, when not only is the gap between the average values in yellow, green and blue glazes narrowed down to 20%, but the distinction between the glass and faience formulations is greatly reduced too.

In commenting on the roles of antimony in Mesopotamian glasses, Brill considered the possibility that antimony was an important ingredient of the high-lead opaque red glasses. [28] Our evidence indicates that in red faience at least, antimony had no role to play. In our discussion of tin we remarked that elevated amounts are often found when lead and antimony are also present. The common link must be lead, since no correlation between antimony and tin could be detected. For example, among yellow glazes, all of which contain in excess of 0.25% Sb_2O_5, the fraction of samples also containing at least 0.05% SnO_2 fluctuates from: 10% of the Amarna to 30% of the Ramesside, none of the Saite, and 40% of the Ptolemaic glazes. Thus, unless a major switch in the source of antimony occurred during the 18th Dynasty it would appear that in most instances the tin and antimony found their way into the faience separately (for possible exceptions see the preceding section). No correlation with elements other than lead was detected, not even with arsenic, which forms many compounds analogous to and often associated with those of antimony. Thus the published analyses of Egyptian copper objects show several cases in which both antimony and arsenic are elevated. [49] The same is true of copper objects from the Ashmolean Museum.

There remains the question of the provenance of antimony, since at the present time Anatolia and Iran are the nearest areas in which antimony has been mined for some time. A rich deposit of **stibnite** (Sb_2S_3) and **gudmundite** (FeSbS) is located at Turhal, Turkey,[44] but we do not know if it was exploited in the 2nd and 1st Millennia B.C. With regards to Egypt, Lucas stated that antimony has been detected in small quantities on the St. John's Island in the Red Sea, but that no evidence exists to show that the relevant minerals were mined in antiquity. [47]

Lucas, who is generally very thorough, somehow overlooked a very interesting ancient gold mine at the northern end of the Eastern Desert, at Wadi Ballit. The gold-bearing quartz is impregnated with pyrites which contain, among other things, 2.5% antimony, "the first record of this metal in the rocks of Egypt," to quote Hume (ref. 38, pp. 725-726). Hume also notes, in passing, that an antimony-rich gold deposit had been reported by some 19th century travellers to the north of Aqaba (Eastern Sinai or Western Negev) but could not be confirmed by subsequent surveys. Now, 2.5% is considered a reasonable tenor for antimony and could have been exploited, though there is no evidence that it was. Stibnite has also been found in the gold-quartz veins at Fawakhir.[107]

More recently a rich quartz-bearing stibnite vein was discovered to the east of Edfu in the vicinity of Gebel el Ineigi.[107,124] A sample of the ore contained 44.27% Sb_2S_3 and 0.38% PbS.[125] This particular find and the one reported by Hume suggest that others probably exist in Egypt and adjacent areas of Africa and Asia, and that some might show evidence of ancient workings. Antimony is often associated with rocks bearing gold, silver and lead,[126] and these metals have been mined by the ancient Egyptians since the 4th Millennium B.C.

While the presence of minerals such as **tetrahedrite** ($4Cu_2S.Sb_2S_3$) in copper ore might be responsible for the early traces of antimony in copper objects and in faience, it is tempting to see one or several of the very numerous mixed lead-antimony sulphides from some argentiferous galenas as a more significant source of antimony in later times.[44,126] It would explain why in all but a handful of cases so much lead accompanies the antimony. Such a

source is compatible with the composition of most faience glazes and yellow glass, but not with the low-lead high-antimony glasses of other colours. Unfortunately none of the Egyptian galenas analysed to date contain much antimony. For example, recent neutron activation analyses of Egyptian lead ores showed none containing more than 0.27% Sb, with the great majority having antimony at levels below 10 ppm.[79]

Future surveys may yet uncover ancient antimony mines at sites nearer Egypt than Anatolia, the Caucasus, or Iran. Hopefully more exploration will be done to the south and west of Egypt. For example, a limestone belt stretching from Tunisia to Morocco contains rich veins of antimony with primary stibnite (Sb_2S_3) and the oxidized minerals cervantite ($Sb_2O_3.Sb_2O_5$), senarmontite, and valentinite (Sb_2O_3).[126] The first of the three oxides is yellow and would have attracted early prospectors, but it remains to be seen if evidence can be found to show whether the very extensive deposits at sites such as those in the vicinity of Ain Beida in Algeria were being exploited in the 2nd and 1st Millennia B.C.

15. Barium

Some barium is to be expected in any product manufactured from sand and limestone. Farnsworth and Ritchie, reported finding "trace" amounts in 14% of their glass specimens.[19] The values reported for New Kingdom glass by Sayre explain why the element has been overlooked in most previous studies. Barium oxide was present in all specimens but at levels ranging from 0.0014 to 0.0062%, except for a single black specimen which contained 0.0151% BaO.[24] More recent studies have found up to 0.25% BaO in Egyptian glass and up to 0.02% in faience.[4]

It is difficult to tell how much barium one should expect from Egyptian sands. The ten analysed specimens listed by Lucas include one with 0.2% BaO and nine with no indication of the amount.[27] Four additional sand analyses have recently been published and these yield concentrations ranging from 0.001 to 0.036% BaO.[4] It is noteworthy that both sets of analyses show the highest barium concentrations in sand from Luxor.

For the glass and faience whose analyses have been published to date sand

is the most probable source of barium, with additional contamination from contact with clay moulds. Egyptian clays, shales and Nile alluvium are quite rich in barium.[35] Had the Egyptians seen a need to introduce barium purposefully they could have easily done so, for the country has rich deposits of baryte, in the granites of Eastern Desert and in the Great Western Oases. [39,46b,107] There is epigraphic evidence that baryte was mined in antiquity and a pendant made of this mineral has been recovered from an Archaic Period site at Maadi.[41]

Barium is not a common impurity in faience, as Table XIX clearly shows. The median figures indicate that seldom do the majority of glazes of any colour have BaO in excess of 0.1%, and that barium is most likely to be found in black and brown glazes. The tabulated data also show that the element is relatively more common in objects of the First Intermediate Period. The degree to which barium favours the black and brown glazes is best illustrated by comparing the fraction of specimens of each colour containing BaO in excess of 0.05% or 0.10%. Not a single yellow and only one white glaze have even as little as 0.1% BaO. Of the green, blue and violet fewer than one in twenty contain at least 0.05% BaO and only half as many have 0.1% BaO or more. In contrast, a third of the black and a fifth of the brown have at least 0.05% BaO, while concentrations in excess of 0.1% may be found in one out of four black and one out of six brown glazes.

The analytical data show that BaO in general, and when found in excess of 0.05% in particular, is most closely correlated with manganese. This is a natural correlation and is fully consistent with our conclusion that, regardless of concentration, barium is an impurity introduced into most faience with sand or manganese ores. Had it been introduced intentionally, as in the case of certain Chinese ceramics and glass,[127,128] the concentrations would have been higher and the element would not have been confined to high-manganese glazes. Although barium is a good opacifier and has a high refractive index, the amounts present in all but black or brown glazes would have no perceptible impact on any of the physical properties of the glaze.

Egypt contains numerous deposits of manganese in the Sinai and in the Eastern Desert. Pyrolusite (MnO_2), manganite (Mn_2O_3), psilomelane,

T A B L E XIX

VARIATIONS IN THE CONCENTRATION OF Barium Oxide

IN GLAZES OF VARIOUS COLOURS

THE MEDIAN AND
AVERAGE PERCENT VALUES

TIME PERIOD	White	Yellow	Green	Blue	Purple and Violet	Black and Grey	Brown and Red
Predynastic	---	---	0.00	0.00	---	---	0.35
	---	---	0.00	0.00	---	---	0.45
Dyn. 1-2	0.00	---	0.00	0.00	0.02	0.01	0.00
	0.00	---	0.01	0.01	0.02	0.01	0.07
Dyn. 3-6	0.00	---	0.00	0.00	---	0.02	0.05
	0.00	---	0.04	0.01	---	0.13	0.06
Dyn. 7-10	0.00	---	0.00	0.00	---	0.18	0.59
	0.00	---	0.10	0.10	---	0.17	0.60
Dyn. 11-12	0.00	---	0.00	0.00	---	0.02	0.00
	0.00	---	0.00	0.01	---	0.06	0.00
Dyn. 13-17	0.00	---	0.00	0.00	---	0.01	0.01
	0.00	---	0.00	0.00	---	0.06	0.01
Early 18th	0.00	0.00	0.00	0.00	---	0.00	0.00
	0.00	0.00	0.01	0.00	---	0.07	0.00
Late 18th	0.00	0.00	0.00	0.00	0.00	0.00	0.00
	0.01	0.00	0.00	0.01	0.02	0.00	0.01
Dyn. 19-20	0.00	0.00	0.00	0.00	0.00	0.00	0.00
	0.01	0.01	0.00	0.01	0.00	0.02	0.01
Dyn. 21-25	0.00	---	0.00	0.00	0.00	0.00	0.00
	0.00	---	0.00	0.00	0.00	0.06	0.09
Dyn. 26-30	0.00	0.00	0.00	0.00	0.00	0.04	0.00
	0.01	0.00	0.01	0.01	0.02	0.03	0.02
Ptolemaic	0.00	0.00	0.00	0.00	0.00	0.00	0.00
	0.00	0.00	0.00	0.00	0.01	0.04	0.00

ryptomelane, and other minerals are all well represented.[40] Psilomelane and related hydrated oxides (wads) tend to incorporate a variety of metallic species, among which barium is the most prominent. As a matter of fact, the latter is found in such an overwhelming majority of cases that psilomelane is sometimes written as: $(Ba,H_2O)_2Mn_5O_{10}$, or with some other similar formula which includes barium explicitly (ref.44, pp. 1007-1013). Egyptian psilomelane is no exception, a fact which El Shazly used to distinguish psilomelane from cryptomelane, in which the barium is replaced by potassium.[40]

In our discussion of manganese we pointed out that considerable amounts of the element are found in most faience, with the highest concentrations in brown and black glazes of the pre-Ptolemaic periods. Using barium as an indicator we must conclude that, except for the Old Kingdom and the First Intermediate Period, psilomelane accounted for no more than a quarter of the manganese used in the manufacture of brown and black faience. Pyrolusite or manganite must have definitely been the mineral of choice during the New Kingdom, for barium virtually disappears from Egyptian faience of the period. Equally free of barium is the manganese in cobalt blue and violet glazes of all periods. This is fully consistent with our earlier conclusion that the Egyptians did not make these pigments by mixing cobalt and manganese ores but used an ore in which both elements were already present.

If the purest and best quality psilomelane were to be used in the manufacture of faience, the BaO:MnO ratio would approach 0.86. As expected in a country where other types of manganese ore are also plentiful the observed ratios seldom approach this figure. Among the objects examined by us such high ratios are most often seen in faience of the Old Kingdom and the First Intermediate Period, and least often in glazes of the New Kingdom. The choice of one manganese ore over another is subject not only to temporal variations but must also have been dictated by by regional factors, such as proximity to the appropriate mines.

There remains only one question: was barium ever added intentionally, in its own right, for some specific reasons? We are inclined to say: not likely. Baryte or some other related mineral might indeed be responsible for all or

some of the barium found in glazes containing comparable amounts of manganese and barium. However, in view of the high BaO:MnO ratio that pure psilomelane can yield, only those glazes in which the percentage of BaO exceeds that of MnO might have received an extra dosage of barium.

Objects with a BaO:MnO ratio greater than 1:1 are few, and most tend to have very low concentrations of both elements, a clear indication of accidental intrusion. If we look for faience containing at least 0.1% BaO only a handful of objects fail to have an excess of MnO. The most interesting examples come from a First Intermediate Period pendant recovered at Sidmant (1941.1411). The pendant contains brown, green, and blue faience panels and red carnelian panels set in arsenical copper. All the faience panels show elevated levels of BaO (up to 1%), and all but the brown ones have considerably more barium than manganese. If this much barium was mixed with the pigment intentionally, we do not know for what purpose, for the practice certainly is not attested in any other of the many faience objects examined by us and others. When an undisputably intentional use of barium is encountered, as in the case of certain Chinese glasses, the levels tend to be above 10% BaO.[127,128] All that concentrations of about 1% would do is improve the reflectance of the surface, and the panels in the above-mentioned pendant do show a very fine gloss.

16. Lead

The mountains bordering the Red Sea are dotted with rich deposits of lead many of which have been worked since antiquity.[38,129] Galena is the dominant mineral form but its purity is highly variable. Though sphalerite (ZnS) is the most common impurity, mixed sulphides of iron, copper, zinc and lead are also encountered at several sites.[54,69,70] Even some of the purer galenas contain highly variable trace amounts of As, Ag, and Sb.[54,79] The mixed sulphides have already been discussed in sections devoted to copper and zinc, where we pointed out that large-scale contamination by lead was unavoidable with some of the copper deposits mined in antiquity.

Thus it is not surprising to find varying amounts of lead in glazes of all time periods. However, the median and average values listed in Table XX indicate that prior to the 18th Dynasty the occurrence of PbO was sporadic,

T A B L E XX

VARIATIONS IN THE CONCENTRATION OF Lead Oxide

IN GLAZES OF VARIOUS COLOURS

--

THE MEDIAN AND
AVERAGE PERCENT VALUES

TIME PERIOD	White	Yellow	Green	Blue	Purple and Violet	Black and Grey	Brown and Red
Predynastic	---	---	0.01	0.00	---	---	0.00
	---	---	0.05	0.03	---	---	0.00
Dyn. 1-2	0.00	---	0.00	0.00	0.00	0.00	0.00
	0.05	---	0.00	0.00	0.00	0.00	0.00
Dyn. 3-6	0.00	---	0.00	0.00	---	0.01	0.00
	0.00	---	0.03	0.03	---	0.11	0.00
Dyn. 7-10	0.00	---	0.00	0.00	---	0.00	0.00
	0.00	---	0.18	0.02	---	0.00	0.04
Dyn. 11-12	0.00	---	0.01	0.00	---	0.00	0.00
	0.05	---	0.22	0.02	---	0.06	0.01
Dyn. 13-17	0.00	---	0.00	0.00	---	0.00	0.02
	0.00	---	0.07	0.03	---	0.07	0.02
Early 18th	0.03	7.43	0.00	0.00	---	0.00	1.02
	2.12	6.70	0.21	0.04	---	0.01	0.81
Late 18th	0.10	6.25	5.12	0.00	0.03	0.32	0.23
	0.16	7.25	4.87	0.79	0.27	2.64	0.61
Dyn. 19-20	0.12	2.33	0.00	0.04	0.54	0.00	0.05
	0.18	2.26	0.07	0.20	1.11	0.06	0.49
Dyn. 21-25	0.00	---	0.08	0.08	0.00	0.04	0.00
	0.00	---	0.14	0.18	0.01	0.10	0.01
Dyn. 26-31	0.13	2.18	0.30	0.15	0.14	0.34	0.06
	0.50	2.18	0.83	0.22	0.12	0.41	0.18
Ptolemaic	0.02	7.57	2.74	0.58	0.94	0.64	0.16
	0.11	8.20	2.74	1.81	1.73	1.60	0.16

involving very few specimens, though the individual concentrations run as high as 4.3%. Moreover, the occurrence of lead-containing faience tends to favour certain geographical regions, as will be shown in Chapter V, suggesting that mines in close proximity were most likely to be exploited regardless of the purity of the ore. It is not uncommon to find concentration variations of over one order of magnitude among Predynastic beads from the same grave.

The published literature confirms the relative scarcity of lead in pre-18th Dynasty faience and objects of copper. Stone and Thomas failed to find any in faience of earlier periods,[3] while McKerrell shows only a few dots in his "Before 18th Dynasty" column of data.[5] It is impossible to tell what range of concentrations McKerrell was reporting since he only plotted the Pb:Cu ratios. Lucas performed qualitative tests on a number of faience glazes from the Cairo Museum while trying to identify "lead glazes", and failed to detect any on objects anterior to the 22nd Dynasty.[1] The published data and our own provide fairly conclusive evidence that only from the 18th Dynasty on is there evidence of deliberate use of lead compounds in the manufacture of faience.

The regular appearance of lead in faience glazes coincides with the introduction of glassmaking into Egypt. It is in yellow glass and yellow faience that consistently high concentrations of PbO are first observed. New Kingdom glass of colours other than yellow contains only modest amounts of lead; none of the non-yellow specimens analysed by Geilmann and Sayre contained more than 0.14%. [22,24,34] Farnsworth and Ritchie reported finding PbO in excess of 1% in one out of seven specimens, of which half were yellow or yellowish green. [19] Neumann reported 0.5% PbO in one specimen of New Kingdom green glass, and somewhat more in green and black glass of the Ptolemaic period: 0.95 and 1.3%, respectively.[18,20] Brill and Moll detected 0.1-0.4% PbO in white and blue fragments of Alexandrian mosaic glass of the late Ptolemaic-Roman periods. [25,121] Lead oxide in the same range was detected by Stone and Thomas in one blue specimen of 18th Dynasty glassy faience, one specimen of 19th Dynasty blue glass, and two specimens of blue faience of the 26th and 30th Dynasties, respectively.[3]

Though yellow glass and faience show consistently high levels of PbO, the highest values have been found in Ptolemaic-Roman specimens of red glass. For

yellow glass Farnsworth and Ritchie simply report that four out of six had PbO in the 1-10% range;[19] Sayre's specimens fell in the 2.5-3.6% range;[22,24] a specimen of yellow Alexandrian glass studied by Brill and Moll contained 21.5% PbO.[25,121] For other red Ptolemaic glasses the reported values range from 1.3 to 35% PbO.[18,20,25,121]

It would seem that if yellow glass and Ptolemaic-Roman red glass are excluded concentrations of PbO in excess of 0.5% are quite uncommon, with the majority of objects likely to have concentrations below the 0.2% mark. During the 18th Dynasty lead appears in amounts large enough to indicate beyond any reasonable doubt that it was deliberately introduced into the glazing mixture. Comparison of Tables XVII and XX shows that initially PbO was used primarily in yellow glazes with Sb_2O_5 and in red glazes without antimony. Few glazes of other colours show levels of lead oxide comparable to the Early 18th Dynasty yellows and reds until the Amarna Period, when lead antimonate seems to show up almost everywhere. In Figure 16, we have plotted the incidence of PbO at levels above 0.2% in glazes of several colours. The plot shows how startling is the jump during the Amarna period and how suddenly it is reversed during the 19th Dynasty. Much less extreme fluctuations are observed in glazes that contain little or no antimony. From the Ramesside Period on the fractions of green, blue and black glazes that have at least 0.2% PbO rise steadily. By the end of the Ptolemaic Period over two thirds of the black and three fourths of the blue and green glazes contain more than 0.2% PbO. If one compares only low-antimony glazes (Sb_2O_5 below 0.2%), the rise in the number of glazes having over 0.2% PbO is a little less pronounced but still significant.

A close examination of white, black, violet, blue and brown glazes revealed that most of those containing over 0.2% PbO were located in close proximity to yellow or green components of polychrome designs, or were painted over a yellow ground. Now, while studying some heavily leaded glasses we were quite surprised to discover how readily lead oxide creeps along the surface, and how easily it is transferred to a lead-free surface through close contact. Consequently, in the case of polychrome faience the presence of lead in glazes in which the compound does not serve as a pigment should not be interpreted as indicating deliberate addition, unless such glazes are physically separated from yellow or green components.

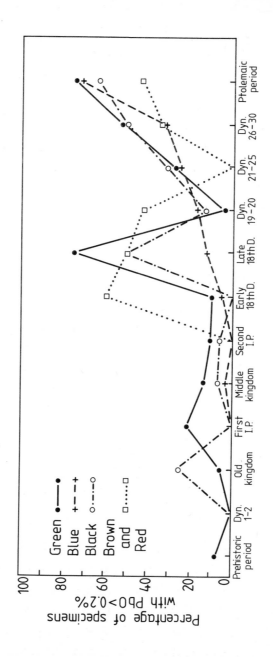

Figure 16. The fractions of blue, green, black, and brown and red glazes containing over 0.2% PbO.

Allowing for the relatively large amounts of lead that copper ores can introduce inadvertently into a glaze, it is difficult to find many instances where deliberate addition of lead without antimony is indicated. To determine more precisely the degree of interdependence between lead and antimony we divided the green and blue glazes into two groups: those with more and those with less than 0.2% Sb_2O_5. The two groups are compared in Table XXI and the differences are striking. For the low-antimony group the New Kingdom brings about only a small increase in the average lead concentrations over those observed during preceding periods. The amounts can still be accounted for by assuming that Egyptian copper ores, and after the New Kingdom leaded bronzes, were the chief sources of copper.

The second set of figures in Table XXI gives an indication of how much lead can be expected when its presence is the result of intent instead of accident. The concentrations of PbO in antimony-rich glazes are in most instances an order of magnitude higher than those encountered in contemporary antimony-poor glazes of the same colour. The intent is unmistakable -- lead was introduced for the purpose of making the lead antimonate yellow glaze, and rarely if ever for any other reason.

Among the numerous objects of all time periods we failed to find a single low antimony glaze with a concentration of PbO greater than 4.5%. Even during the late and Ptolemaic periods, when lead was being used extensively in the manufacture of copper objects, the highest value seen in a low-antimony glaze was 2.6% PbO, less than the amounts introduced unintentionally into some earlier specimens.

Concentrations of this order of magnitude (PbO below 5%) would have a marginal impact on the mechanical properties of the glaze. For example, if we look at the effects of introducing 8% PbO into ordinary soda-lime glass, we find that: the relative coefficient of thermal expansion increases by about 1%, the refractive index by 2%, while the softening point is lowered by about 50°C.[130] It is questionable whether the thermal effects would have been detectable without modern equipment. The improved gloss would have been noticeable, though. For example, one can estimate that the introduction of 10% PbO into SiO_2 increases the brilliance (as defined by the coefficient of

T A B L E XXI

LEAD OXIDE CONCENTRATIONS IN THE PRESENCE AND ABSENCE OF ANTIMONY

Time Period	Green Glazes with Sb_2O_5 below 0.2%			Green Glazes with Sb_2O_5 above 0.2%		
	Range	Median	Average	Range	Median	Average
Pre-18th Dynasty	0.00-4.35	(a)	(a)	-	-	-
Early 18th	0.00-0.22	0.00	0.03	2.13-2.92	2.53	2.53
Late 18th	0.00-0.13	0.00	0.03	2.53-12.2	5.61	6.48
Dyn. 19-20	0.00-0.15	0.00	0.01	0.00-1.54	0.77	0.77
Dyn. 21-25	0.00-0.74	0.08	0.14	-	-	-
Dyn. 26-30	0.00-0.97	0.15	0.22	0.00-3.68	1.98	1.78
Ptolemaic	0.05-2.62	0.18	0.49	1.68-7.61	4.51	4.35

Time Period	Blue Glazes with Sb_2O_5 below 0.2%			Blue Glazes with Sb_2O_5 above 0.2%		
	Range	Median	Average	Range	Median	Average
Pre-18th Dynasty	0.00-0.32	(a)	(a)	-	-	-
Early 18th	0.00-0.42	0.00	0.04	-	-	-
Late 18th	0.00-1.67	0.00	0.11	0.18-8.47	7.97	5.54
Dyn. 19-20	0.00-1.17	0.05	0.17	0.00-1.28	0.00	0.43
Dyn. 21-25	0.00-1.41	0.08	0.18	-	-	-
Dyn. 26-30	0.00-0.94	0.14	0.23	-	-	-
Ptolemaic	0.00-2.63	0.26	0.58	0.98-9.32	4.56	5.04

(a) See Table IX for the median and average values in earlier glazes.

reflectance) by almost 30%.[118]

As we noted in the preceding paragraphs, the levels of lead found in glazes where it is not serving as a pigment with antimony are too low to have had significant influence on the thermal properties of faience glazes. This should lay to rest speculation about the use of "lead glazing" techniques on Ancient Egyptian faience, a subject to which Lucas devotes a considerable amount of space (ref. 1, pp. 165-167). We also feel that there are no grounds for maintaining a separate category of faience under the rubric of "Variant F."

There remain two interesting questions: in what form was the lead introduced into the glazing mixture, and was all of it of native origin? If lead in the early glazes represents accidental intrusion, then the original ore would have been galena since the mixed ores are usually sulphides. In later times, when lead is added deliberately, the experimental data also favour unprocessed sulphide. The highest levels of sulphur are found in high-lead yellow and green glazes of the New Kingdom and later periods. If one were to select the colours and periods with the ten highest average concentrations of PbO one would simultaneously obtain the ten highest levels of SO_3. Had most of the lead been introduced as processed metal very little sulphur would have been seen, since the losses incurred in the process of glaze-making would have left almost nothing of what little normally remains in the reduced metal. What cannot be determined unequivocally at this time is whether the lead and antimony ores were mixed in the manufacturing process or were acquired together in a single mixed ore.

Several sources of lead are clearly indicated for various periods of time. From the earliest times one can distinguish zinc-free and zinc-containing lead, as we noted in Section 10. Most of the lead which found its way into faience of the Old and Middle Kingdoms must have been of the zinc-containing variety for the average levels of zinc in glazes containing 0.2% or more PbO are appreciably higher than in those of lower lead content. If the lead was not introduced intentionally but came in with the copper, deposits of the type located at Umm Samiuki are indicated. There is evidence that this particular area was mined in antiquity, and that copper was extracted on the

site.[69]

During the New Kingdom the situation is obscured somewhat by the fact that the Co/Mn pigments used in blue and violet glazes also introduced a considerable amount of zinc. However, if one examines only glazes containing less than 0.05% CoO, one finds that lead is still a major contributor of zinc. The situation changes abruptly after the 20th Dynasty, and the zinc content of high-lead glazes is not significantly different from that of the low-lead variety. This is shown below in Table XXII.

T A B L E XXII

CORRELATION BETWEEN THE LEAD AND ZINC CONTENTS OF GREEN GLAZES

Average Percent Concentration of ZnO

Lead content	Early 18th Dynasty	Late 18th Dynasty	Dynasty 19-20	Dynasty 21-25	Dynasty 26-30	Ptolemaic Period
Above 0.20%	0.08	0.18	0.21	0.00	0.01	0.02
Below 0.20%	0.01	0.06	0.00	0.03	0.02	0.02

For reasons that are not clear to us, as the zinc-rich lead deposits have still not been depleted, the Egyptian glaze-makers of the 1st Millennium B.C. were either exploiting low-zinc ores exclusively or utilized highly purified lead, a rather unlikely possibility. The use of corroded leaded bronzes, which are generally low in zinc,[41,115] would explain the disappearance of zinc from blue or green glazes but cannot account for the equally remarkable change in the zinc content of copper-free yellow (see Table XIII).

There remains the possibility that importation from some new foreign source is responsible for the changed nature of the post-New Kingdom lead. In their recent investigation of the lead-isotope ratios in Egyptian galenas and objects containing lead, Brill, Barnes and Adams noted that the lead found in glass appeared to be of a different origin than the Egyptian galenas. [131] Neither, however, matched the lead used in Mesopotamia or mined at Laurion, Greece.

In a series of recent papers Stos-Gale and Gale reviewed the geological information pertaining to Egyptian galena deposits with special emphasis on those which show evidence of ancient workings.[79,133] They subjected a number of modern and excavated galenas from burials of the Predynastic and Archaic Periods to neutron activation and mass-spectrometric analyses. To their surprise most of the burial galenas failed to match any of the analysed ores from the Eastern Desert. On the other hand, recently-excavated galena from a Late Gerzean site at Naqada matched almost perfectly the isotopic composition of lead from at least two near-by mining areas. [134] Considering the early date of these burials it is hard to believe that a simple commodity such as kohl (galena, at this time) would have been imported from abroad when ample supplies were available locally. The lead found in silver was distinctly different too, and some of it matched the variety mined at Laurion.[133,134]

Opinions differ as to when, how much, and from where was galena imported into Egypt.[135] Syria seems to be the most frequently mentioned source, but while Petrie believed that importation began as early as in Predynastic times,[136] Lucas was of the opinion that very little foreign galena entered Egypt prior to the 18th Dynasty.[43] If we agree with Lucas that for most of the pre-Roman period galena was the chief ingredient of eye-paint (kohl), then the earliest documentary evidence for the importation of the mineral comes from the famous Beni Hasan tomb of Khnumhotep II. The tomb contains a scene, dated to year 6 of Sesostris II (ca. 1891 B.C.), in which the nomarch receives a party of nomads and the figures are accompanied by the statement: "The arrival, bringing eye-paint, which 37 Asiatics bring to him".[137]

New Kingdom records mention the importation of lead metal more frequently (eight times in the tribute lists of Tuthmosis III)[114] than they do eye-paint, presumably galena, which is mentioned as a produce of Punt and as tribute from Naharin, in northern Mesopotamia (ref. 114, sections 265, 272, 501). The distinction may be significant, for Stos-Gale and Gale noticed that whereas the lead found in glass of the Amarna period resembled native galena, the isotopic composition of metallic objects containing lead was distinctly different from that of any of the Egyptian ores.[133] One is tempted to conclude that during the 18th Dynasty a lot of processed lead and only a little of galena was brought from abroad. If any of the imported ore found its way into

Egyptian faience, it either represented a small fraction of the total supply available in the country or was of the zinc-rich variety. Some lead-containing Syrian bronzes of the 2nd Millennium B.C. have have fairly high zinc concentrations. [116]

The situation for the 1st Millennium B.C. is quite obscure and records are particularly sparse during the Third Intermediate Period. We do know, however, that during the 26th Dynasty Egypt had extensive contacts with the entire East Mediterranean world. After the Persian conquest the country was linked by trade to many distant areas, from the borders of India to the Balkans and even farther west. Hence, there is no telling from how far away various minerals might have been imported during the second half of the 1st Millennium B.C.

At this point we must concur with the opinion expressed by Hassan and Hassan, [134] that final judgement regarding the origins of lead found in Egyptian objects should be reserved until Egyptian ores from deposits not included in previous studies have been analysed. Moreover, not enough has been done to identify minerals mined by the Egyptians in Nubia or imported from south of the 4th Cataract. A right step in this direction has been taken by Ogden, who examined the possible southern origins of platinum-containing Egyptian gold. [138] The Hejaz, where argentiferous galena is found, [79] and the Yemen also deserve closer scrutiny, particularly since some believe that the land of Punt was located in the incense-producing regions of Southern Arabia. The Hejazi galenas examined by Stos-Gale and Gale did not match the lead in Egyptian objects. [79]

If one accepts the evidence presented earlier for the use of arsenical copper and bronze scrap in the manufacture of blue and green faience, there is no reason to doubt that the practice would have been continued with leaded bronzes. These are quite uncommon till after the New Kingdom, as is indicated by the published[49] and unpublished analyses.[91] Among the numerous copper and bronze objects tabulated by Lucas, only five specimens antedating the 1st Millennium B.C. contain more than 1% Pb, and two of them are of questionable date. [49] Of the remaining three, none had more than 2.5% Pb and two came from Kerma in the Sudan. Both the number of leaded copper objects and the lead

content rise dramatically after the 20th Dynasty, with concentrations of over 20% not uncommon.[49,115]

In Figure 17 we have compared the incidence of copper objects containing over 1% Pb with the fraction of low-antimony high-lead red and brown, and blue and green glazes. The comparison was restricted to faience with less than 0.2% Sb_2O_5, to reduce interference from lead introduced for the purpose of making lead antimonate. The plotted data suggest that after the 20th Dynasty progressively more and more of such metal scrap was used as the fraction of leaded faience objects catches up with the fraction of leaded coppers. It is clear that prior to the 20th Dynasty scrap from such objects could not have contributed more than a negligible fraction of the copper that went into the faience production. After the Ramesside Period leaded copper and bronze were probably responsible for most of the lead seen in low-antimony glazes, but the lead-copper ratios indicate that a different source has to be sought for the lead that is accompanied by antimony. Of the low antimony glazes only a small minority, mostly Ptolemaic, had PbO:CuO ratios high enough to preclude leaded bronze or copper as the sole source of lead.

The Pb:Cu ratios in glazes of various colours fluctuate wildly until the Ptolemaic period, when both blue and low-antimony green converge at a ratio of 1:5, which corresponds to a copper alloy containing about 17% lead. This ratio is quite close to that seen in many of the contemporary metal objects. McKerrell looked at the lead:copper ratios in Egyptian blue beads and published the distribution of ratios within three groups: pre-18th Dynasty, 18th Dynasty, and post-18th Dynasty.[5] He found a progressive rise in the number of glazes of high-lead content, but a comparison with our data is not possible due to his broad temporal categories.

17. Silicon

It is difficult to tell from the few published values what levels of SiO_2 should be considered typical of Egyptian faience. Lucas reports 92.9% SiO_2 for a blue green 19th Dynasty specimen and 75.6% for a blue glaze of the Roman period.[1] Kuhne examined two blue-green glazes of the Amarna Period and found 90.5 and 91.6% SiO_2 respectively.[2] Comparison with the more abundant published glass data are of little value since glass by its very nature must have a

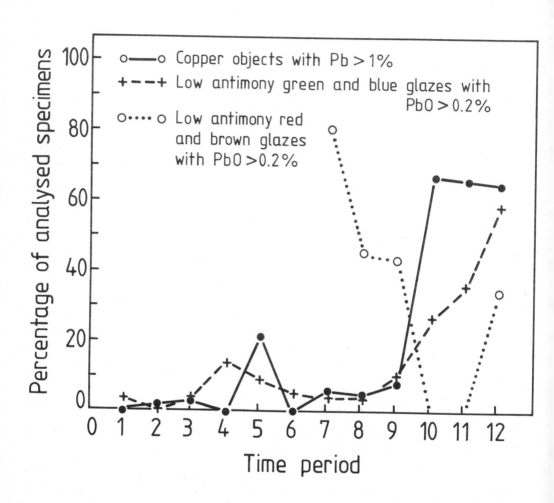

Figure 17. Percentage of copper objects containing over 1% Pb compared with the percentage of low-antimony glazes having PbO above 0.2%.

lower silica content to accommodate the much higher levels of alkali and lime.

The averages and medians listed in Table XXIII show no unusual trends and offer no surprises. As might have been expected, the highest values are generally encountered in white faience, and the lowest in the high-lead yellow and green glazes. Considering the uncertainties in the determination of SiO_2 we were quite gratified to find that the values published for New Kingdom and Roman period faience were within 10% of the averages found by us for contemporary glazes of like colours.

It is most unfortunate that after all the work done by Lucas one still encounters articles and books on Egyptian faience in which it is alleged that the glazes of Egyptian faience consisted of <u>crushed quartz</u> mixed with alkali (or natron) and mineral pigments. We have no idea how this misconception arose, but we are in essential agreement with Lucas, who was one of the first to note that ordinary sand, sometimes washed and sifted, sometimes not, was the norm and powdered quartz the exception.[1] Our analyses of the silica concentrations confirm the conclusions arrived at earlier, when sand impurities such as titanium and vanadium were being considered, that only in the case of white glazes is a preference for powdered quartz indicated.

Considering the sheer volume of faience that was manufactured in Egypt from the earliest times, it would have been a herculean and unnecessary task to crush that much quartz. The bulk of Egyptian faience was blue and green and here most sands would do very well. Turner, who examined the possible sources of sands used in Egyptian glassmaking, discussed the variety of sands available in the country at some length.[26] If one excludes a single rather peculiar specimen from the seashore near Alexandria (ca. 30% SiO_2) the silica content of Egyptian sands ranges from 60 to 99%, the latter figure representing sand from somewhere in the Sinai.[26] It does not take much sifting or washing to raise the silica content of most sands into the middle 90's as the data published by Turner show. The washed and some of the unwashed raw sands were rich enough in quartz to be used in the manufacture of white glazes and were more than adequate for dark colours.

T A B L E XXIII

VARIATIONS IN THE CONCENTRATION OF Silicon Dioxide
IN GLAZES OF VARIOUS COLOURS

--

THE MEDIAN AND
AVERAGE PERCENT VALUES

TIME PERIOD	White	Yellow	Green	Blue	Purple and Violet	Black and Grey	Brown and Red
Predynastic	---	---	87.3	86.4	---	---	85.8
	---	---	86.4	86.4	---	---	85.0
Dyn. 1-2	92.0	---	89.6	83.8	91.4	73.1	83.8
	92.4	---	88.3	82.8	91.4	70.4	81.8
Dyn. 3-6	96.1	---	90.7	85.2	---	85.4	88.7
	95.4	---	90.2	82.7	---	81.3	87.3
Dyn. 7-10	94.1	---	89.0	84.7	---	83.5	83.8
	94.1	---	88.1	84.1	---	83.4	84.1
Dyn. 11-12	93.8	---	88.0	87.4	---	82.2	88.9
	93.2	---	86.6	86.4	---	80.9	89.2
Dyn. 13-17	92.9	---	87.4	86.6	---	84.9	85.4
	92.9	---	87.1	86.0	---	82.8	85.4
Early 18th	93.6	81.4	85.4	87.5	---	83.0	83.7
	88.4	80.9	84.9	86.6	---	83.7	82.5
Late 18th	92.6	81.4	83.0	87.3	89.1	84.5	86.0
	92.3	79.1	82.5	87.4	88.6	84.9	85.9
Dyn. 19-20	93.3	88.3	89.3	88.3	88.9	88.2	85.3
	93.2	87.2	89.0	88.2	83.7	87.5	86.4
Dyn. 21-25	92.6	---	89.8	88.5	88.8	82.8	81.2
	92.6	---	90.0	87.8	88.6	77.4	81.3
Dyn. 26-30	93.5	90.7	88.4	86.1	85.2	87.1	87.4
	91.1	90.7	87.9	85.9	84.7	87.4	80.4
Ptolemaic	90.3	78.2	84.3	84.1	83.7	78.0	87.5
	90.5	78.8	83.9	83.6	82.8	79.2	87.0

18. Chloride

Acidic silica requires alkaline binding agents, which invariably are rich in chloride. If we exclude pure common salt, which Lucas found satisfactory for binding the faience body material,[1] there remain natron and plant ashes. Some Egyptian natron contains as much as 40% NaCl, while the ashes of Near Eastern plants have yielded as much as 14% NaCl.[26,28]

Unlike some of the other components of natron and plant ash, sodium or potassium chloride will not decompose at temperatures attainable by the Ancient Egyptians, but some losses due to volatilization are unavoidable. The melting points of NaCl and KCl are 801 and 776°C, respectively; the corresponding boiling points are 1413 and 1500°C.[26] Turner, who investigated the crucibles used in the glass-making factories at Tell el-Amarna arrived at the conclusion that 1100°C was the upper limit and 1050°C the probable practical limit of glass-melting temperatures.[26,139] Under those conditions only a fraction of the original chloride would have been lost by vaporization.

Sayre mentions detecting chlorine in the majority of his glasses but only Geilmann reports the results of a quantitative determination. He found chloride in all of his specimens and the range of values was 0.30-1.17%, with an average of 0.66%.[34] We have no doubt that had it been sought chloride would have been found in the majority of ancient glasses analysed to date. The reluctance to report chloride may in part be due to the fact that the burial conditions can drastically alter the chloride content of an object. Exposure to ground waters may increase or decrease the content depending on the salinity of the soil. Fortunately, in contrast with less arid parts of the world, conditions in most Egyptian tombs guarantee minimal contact with water of any type, particularly ground water, as anyone who has seen the condition of perishable Egyptian antiquities can attest.

Considering the small number of specimens examined by Geilmann it is not surprising that the range of values found by us in faience glazes is somewhat greater than that reported for glass. Our values ranged from 0.0 to 2.0% Cl⁻, but with an uncertainty as high as 60% in some instances, the two ranges are not that different. As may be seen in Table XXIV, the averages for late 18th Dynasty and Ramesside blue and violet faience are surprisingly close to the

T A B L E XXIV

VARIATIONS IN THE CONCENTRATION OF Chloride

IN GLAZES OF VARIOUS COLOURS

--

THE MEDIAN AND
AVERAGE PERCENT VALUES

TIME PERIOD	White	Yellow	Green	Blue	Purple and Violet	Black and Grey	Brown and Red
Predynastic	---	---	0.61	0.69	---	---	0.90
	---	---	0.69	0.70	---	---	0.95
Dyn. 1-2	0.00	---	0.24	0.17	0.00	0.00	0.42
	0.00	---	0.31	0.23	0.00	0.02	0.40
Dyn. 3-6	0.00	---	0.00	0.04	---	0.00	0.00
	0.00	---	0.14	0.23	---	0.19	0.00
Dyn. 7-10	0.00	---	0.12	0.00	---	0.15	0.47
	0.00	---	0.21	0.18	---	0.13	0.44
Dyn. 11-12	0.29	---	0.20	0.29	---	0.18	0.14
	0.28	---	0.28	0.30	---	0.22	0.19
Dyn. 13-17	0.00	---	0.31	0.20	---	0.29	0.24
	0.19	---	0.38	0.27	---	0.29	0.24
Early 18th	0.00	0.00	0.18	0.32	---	0.40	0.00
	0.00	0.01	0.25	0.44	---	0.50	0.16
Late 18th	0.27	0.00	0.00	0.56	0.39	0.19	0.13
	0.30	0.00	0.18	0.60	0.37	0.47	0.23
Dyn. 19-20	0.23	0.13	0.00	0.34	0.20	0.36	0.25
	0.21	0.15	0.13	0.29	0.31	0.32	0.24
Dyn. 21-25	0.13	---	0.24	0.52	0.57	0.32	0.00
	0.13	---	0.30	0.52	0.60	0.47	0.00
Dyn. 26-30	0.27	0.00	0.29	0.37	0.81	0.52	0.25
	0.34	0.00	0.28	0.43	0.85	0.46	0.26
Ptolemaic	0.07	0.00	0.02	0.12	0.25	0.57	1.23
	0.27	0.00	0.31	0.31	0.38	0.63	0.84

values reported for glass of corresponding colours and time periods.

The similarity suggests that the firing temperatures and general conditions employed in the manufacture of faience must not have been too different from those used in the making of glass. This adds weight to the arguments made by Lucas[1] and by Kuhne[2] that after a coloured frit was made in a separate step, it could be melted into glass or used as the glazing compound on the surface of faience. According to Turner,[26] such a frit would have been made at temperatures below 750°C and it would have retained essentially all of its chloride. It is during the subsequent final firing that the heaviest losses would occur.

Unfortunately, the presence of chloride in most glazes does not allow us to distinguish between objects that might have been made by the so-called "self-glazing" process and those that were dipped or painted with a coating of the glazing mixture. The volatility and the liquid state of NaCl at temperatures above 800°C would promote migration of the chloride from the body to the surface alongside the copper and alkali. While the surface would also sustain most of the losses at elevated temperatures, as soon as the object began to cool the poor thermal conductivity of quartz would sustain for a time the distillation of NaCl from hot interior to cold exterior and prevent a complete depletion of the surface.

No matter what process was used in the manufacture of faience the equilibration in solids is not rapid enough to prevent some depletion of the surface layer by vaporization. Since the analysis of glass involves predominantly bulk material, while that of faience the glazed surface, it is reasonable to assume that such differential depletion is responsible for the similar but systematically lower average concentrations of chloride in faience glazes.

A caveat is in order at this point. The position of the chlorine XRF peak is in a very crowded region of the spectrum. In certain spectra errors in excess of 60% of the reported value can be expected. The situation is particularly hopeless when large amounts of lead and/or sulphur are also present and the three sets of overlapping peaks can not be satisfactorily

resolved. Under those circumstances we simply disregarded the element.
Consequently the very low or zero values, particularly in the presence of the
two above-mentioned elements, should not be construed as indicating
overheating and greater loss of chloride from the object.

19. Sulphur

The published analyses of ancient glasses report sulphur much more
frequently than they do chlorine. The amounts are highly variable, with the
highest values reported for yellow and red glasses of the Amarna Period being
2.4 and 5.5% SO_3, respectively.[18,20] In Egyptian glasses of other colours and
in colourless glass the concentrations remain below 1.6% SO_3. There appears
to be a great discrepancy between the values reported by different workers,
and it is not clear how much of it reflects different experimental methods.
It could be just a matter of sampling, since a small number of objects were
involved in most of the published studies. Thus, whereas Neumann and Kotyga
found many specimens containing over 1% SO_3 and some as much as 5.5%,[18,20]
Geilmann and other workers report no glass with more than 0.5%.[34]

Sulphur is an important component of all living matter. When a plant is
burned some sulphur is volatilized as SO_2 and SO_3, but a sizeable fraction is
retained in the ash in the form of metal sulphates. Ashes of Near Eastern
plants contain as much as 29% SO_3, and an Egyptian Delta bush yielded ashes
with a 12% sulphur trioxide content.[28] Sulphate is also a major constituent of
Egyptian natron and specimens in which 70% of the natron consisted of Na_2SO_4
have been reported.[29] Though from a glassmaker's standpoint sulphur is as
undesirable as chlorine, excluding it was not an easy task, particularly since
some of the pigment minerals consisted of metal sulphides.

After the sulphur has been converted to the sulphate the loss by
volatilization is much less extensive than that of chlorine under similar
conditions. This of course is a major headache for metallurgists in the
smelting of sulphide ores.[140] All sulphates can undergo a decomposition of the
type shown below:

$$MSO_4 = MO + SO_3$$

Within the range of temperatures employed in the manufacture of faience and

glass, and for the kind of sulphates one is most likely to encounter, the equilibrium favours the left side of the equation. While $CuSO_4$, for example, will undergo "energetic decomposition" and will have lost most of its sulphur by 750°C, $PbSO_4$ retains its sulphur even at 1000°C, after undergoing several structural changes.[140] More importantly, the more common sulphates, Na_2SO_4, K_2SO_4, and $CaSO_4$ require temperatures above 1200°C before the loss of SO_3 can be considered significant.[26,140] If a furnace is designed so that the airflow is restricted and the oxides of sulphur cannot escape as readily, even more sulphur will be retained, particularly if the oxide is moderately soluble in the melt.

As long as some loss of sulphur is unavoidable and the amount lost indeterminable, it is not practical to make quantitative estimates of the amount of sulphur present in the original glazing mixture from the concentration found in the finished product. Nevertheless, the magnitude of the final concentration gives some indication of whether a lot or only a trace of sulphur was present before firing. Allowing for the regional variations in the relative use of natron or plant ash, as well as for choices dictated by the colour, it still seems reasonable to assume that a large systematic excess of sulphur in any grouping is indicative of the use of sulphide ore in the starting materials.

The data in Table XXV suggest that lead must often have been introduced as galena (PbS), since the sulphur levels among yellow and other lead-rich glazes are far in excess of the average values seen in low-lead glazes. In this respect the faience resembles contemporary Egyptian glass. For example, the average concentration of SO_3 reported for yellow glass of the Amarna Period is 1.7%;[20] contemporary yellow faience has an average concentration of 1.9%. The concentrations in Egyptian yellow glazes can be as high as 5%, but the highest single value (5.35%) was measured in an off-white bead of the 18th Dynasty (No. 183-115-772 in Appendix C).

Several observations add weight to the argument that excessive sulphur in the final glaze is indicative of sulphide ore in the original mix. Thus we know that the manganese ores exploited by the Egyptians were oxides, and not surprisingly the sulphur levels in manganese-rich glazes is rather low,

T A B L E XXV

VARIATIONS IN THE CONCENTRATION OF Sulphur Oxides

IN GLAZES OF VARIOUS COLOURS

--

THE MEDIAN AND
AVERAGE PERCENT VALUES

TIME PERIOD	White	Yellow	Green	Blue	Purple and Violet	Black and Grey	Brown and Red
Predynastic	---	---	0.32	0.30	---	---	0.22
	---	---	0.51	0.30	---	---	0.38
Dyn. 1-2	0.85	---	0.23	0.12	0.00	0.98	0.22
	0.74	---	0.31	0.21	0.00	1.05	0.37
Dyn. 3-6	0.12	---	0.00	0.07	---	0.02	0.07
	0.12	---	0.11	0.12	---	0.32	0.17
Dyn. 7-10	0.22	---	0.00	0.00	---	0.00	0.08
	0.22	---	0.06	0.02	---	0.15	0.09
Dyn. 11-12	0.03	---	0.24	0.10	---	0.17	0.17
	0.05	---	0.42	0.11	---	0.22	0.19
Dyn. 13-17	0.12	---	0.00	0.04	---	0.00	0.25
	0.12	---	0.08	0.26	---	0.08	0.25
Early 18th	0.31	1.27	0.05	0.00	---	0.00	0.00
	1.97	1.58	0.13	0.08	---	0.08	0.46
Late 18th	0.00	1.51	1.54	0.00	0.00	0.75	0.02
	0.08	1.89	1.37	0.37	0.19	1.20	0.22
Dyn. 19-20	0.17	0.18	0.11	0.02	0.08	0.16	0.25
	0.18	0.51	0.15	0.10	0.27	0.16	0.44
Dyn. 21-25	0.55	---	0.07	0.04	0.12	0.08	0.27
	0.55	---	0.12	0.10	0.14	0.20	0.36
Dyn. 26-30	0.23	1.17	0.17	0.14	0.22	0.32	0.08
	0.20	1.17	0.49	0.16	0.26	0.38	0.08
Ptolemaic	0.07	1.42	0.55	0.23	0.29	0.10	0.22
	0.62	1.79	0.73	0.53	0.39	0.30	0.23

slightly below average. On the other hand, if one compares iron-rich with manganese-rich glazes of same colour (black or brown) the former tend to exhibit higher sulphur concentrations.

Whether elements such as Ni, Co, Zn, or As were introduced as sulphides is difficult to tell. Their concentrations are far below those of Cu, Fe and Pb, consequently their contribution to the total sulphur background is hard to discern. We were unable to detect any clear-cut correlation between cobalt and sulphur, and if anything the correlation is inverse since cobalt blue glazes tend to contain less copper, which often seems to come in as sulphide too. It is noteworthy that low-antimony,high-copper lead-containing glazes of the Late and Ptolemaic Periods have considerably less sulphur, which is consistent with the assumption made earlier that such lead originated in metal scrap.

The effects of sulphur on the colour of a glaze are difficult to predict. The final colour will be a function of the oxidation state of the sulphur, the nature and concentrations of the transition metal ions, and the furnace conditions, i.e., whether oxidising or reducing conditions prevail. In his classic study of coloured glasses Weyl devotes considerable space to the effects of sulphur.[33] Even in the absence of transition metal ions sulphur is capable of imparting a wide range of colours to a glass, so it is obvious that in the faience glazes studied by us, where one usually finds substantial amounts of several metals, explaining the precise nature of the colouring species becomes that much more difficult.

The complexities of the problem are easily demonstrable. Sulphide and polysulphides are very good reducing agents. They will readily reduce trivalent iron and manganese. Consequently, they would promote the formation of black or blue colours if iron were the dominant ion, but if manganese were dominant the purple Mn_2O_3 (which in the presence of excess iron produces a black glaze) would be converted to colourless MnO. At elevated temperatures CuO will be reduced to the reddish brown Cu_2O, hence it is probably no coincidence that the ancient red glasses which are allegedly coloured by cuprous or even metallic copper contained the highest levels of sulphur. The latter would stabilize and protect the lower valence state of copper under

oxidizing conditions.

All figures used by us express sulphur as SO_3 since the content of our standards was expressed in the same manner. We have no means of telling what fraction of the sulphur is in the hexavalent state. If a sizeable portion of the element is trapped in lower oxidation states, particularly in the form of sulphides, the reported figures grossly overestimate the content. For example, the same amount of sulphur if expressed as 1% SO_3 would have to be revised to 0.4% of S if most of it were in the form of sulphide. None of the other elements investigated undergo such a large change in the expressed weight percent as a result of changes in the oxidation state.

20. Sodium, Magnesium and Aluminum

Although the XRF equipment at our disposal did not allow for a quantitative determination of sodium, magnesium or aluminum, the presence of the last one was noted by the appearance of a recognizable shoulder on the silicon peak. With the aid of an Atomic Absorption Spectrometer the oxides of Na, Mg, Al, K and Ca were determined in six specimens of carefully detached outer coloured layer (glaze and pigmented underglaze) and 52 faience bodies. Only four complete glaze analyses have been published to date; these and results obtained by us are shown in Table XXVI. The analyses of body material are tabulated in Chapter IV.

Whereas in preceding sections we recognized the many similarities in the composition of faience and contemporary glasses, particularly when it came to pigments and certain impurities, we can not fail to notice that 0ltda, magnesia and alumina contents are strikingly different in the two materials. Not only the concentrations, but the relative proportions of the three oxides are distinctly different from the corresponding ratios in contemporary glasses. Thus if we look at 18th Dynasty faience and glass we find that the latter tend to contain about 50 times more magnesia, 10 times more alumina and five times as much soda, on the average.[20]

In Section 2 of this chapter we pointed out that the calcium content of glass is also appreciably higher than that of contemporary faience of like colour. We must conclude that either the selection of sand that went into the

T A B L E XXVI

SODA, MAGNESIA AND ALUMINA IN EGYPTIAN FAIENCE GLAZES

Sample No.:	1	2	3	4	5	6	7	8	9	10
% Na_2O	1.99	1.45	1.04	2.54	4.95	4.20	1.6	1.24	2.66	5.5
% MgO	0.09	0.66	0.21	0.15	0.05	0.08	----	0.21	0.30	0.7
% Al_2O_3	0.25	1.64	0.75	0.47	0.12	0.14	0.3	0.88	0.58	0.8
% K_2O	(3.5)	1.33	0.14	2.59	----	----	0.5	0.68	1.17	10.7
% CaO	1.73	0.78	0.52	2.80	1.53	0.17	0.8	1.13	2.50	3.8
K_2O/Na_2O	1.75	0.91	0.13	1.02	----	----	0.31	1.55	0.44	1.97
MgO/CaO	0.05	0.84	0.40	0.05	0.09	0.47	----	0.18	0.12	0.18

1. Dark blue: 12th Dynasty, from Abydos (Ash. E. 3281).
2. Dark blue: 12th Dynasty, from Abydos (Ash. E. 3286).
3. Indigo-blue: 18th Dynasty, from Tell el-Amarna (Ash. 1893.1-41(481)).
4. Violet-blue: 18th Dynasty, from Tell el-Amarna (Ash. 1893.1-41(472)).
5. Greenish blue: 18th Dynasty, from Tell el-Amarna (Kuhne, ref. 2).
6. Greenish blue: 18th Dynasty, from Tell el-Amarna (Kuhne, ref. 2).
7. Pale greenish blue: 19th Dynasty, from Thebes (Lucas, ref. 1).
8. Greenish blue: Ptolemaic period, from Memphis (Ash. 1913.803c).
9. Dark blue: Ptolemaic period, from Memphis (Ash. 1910.551(2)).
10. Blue: Roman period, from Dima in the Faiyum (Lucas, ref. 1).

manufacture of faience glazes was more rigorous, or the sand was supplemented by powdered quartz. We have considered the possibility that these differences are the result of differential leaching. For reasons discussed in Section 3b of Chapter I and because the most soluble component, Na_2O, shows the least divergence, one must assume intentional avoidance of raw materials rich in magnesia and alumina, except for a limited group of faience glazes in which the alumina seems to have accompanied the pigment. These will be dealt with later.

If one looks at the published glass analyses one notices that the concentrations of Na_2O and Al_2O_3 fluctuate from period to period, but the average values in New Kingdom and Ptolemaic or Roman glasses are not significantly different.[18,20,22,25] Similar fluctuations without a sustained trend are apparent in the soda and alumina contents of Egyptian faience glazes (Table XXVI). However, the $K_2O:Na_2O$ ratios are consistently higher in faience than in glass. For example, the average ratios in Amarna and Ptolemaic glasses are 0.19 and 0.03, respectively.[20] The corresponding ratios in faience are 0.7 and 0.5.

It is in their magnesium content that glass and faience differ the most. New Kingdom glass is rich in magnesia, with an average concentration ca. 4% MgO and a MgO:CaO ratio of about 1:2. The corresponding ratio in faience is about 1:5. It has been recognized for a long time that during the second half of the 1st Millennium B.C. the entire Mediterranean world switched from "high-magnesia" to "low-magnesia" glass. Since the latter became widely disseminated within and beyond the Roman Empire it is sometimes called Roman Glass.[20,24]

Various suggestions have been made as to how the change was brought about. Matson was of the opinion that calcite replaced dolomite as the mineral of choice.[141] Sayre, after noting a strong correlation between Mg and K in the 2nd Millennium B.C. glasses, concluded that the production of high-magnesia high-potassia glass was most likely attributable to the use of mixed salts obtained as residues from the evaporation of riverine waters.[22] Such practice is alluded to in Pliny, who reported that the Egyptians produced "natron" by evaporating Nile waters.[142] A shift to true natron, a mineral

mined in several parts of Egypt, resulted in low-magnesia low-potassia glass of the type dominant from the 1st century B.C. on. That the Nile is indeed a good source of magnesia was confirmed by Popp, who found as much as 10% MgO in the residue left by evaporation.[143]

No comparable shift is seen in the magnesium content of Egyptian faience. Whereas the average concentration of MgO and the MgO:CaO ratio in Alexandrian glass are both about 1/5th as large as in glass of the 18th Dynasty, the consistently lower levels of magnesia in faience undergo no comparable decline. Consequently, faience of all periods tends to resemble the low-magnesia glass, and that is why only during the Ptolemaic and Roman Periods does one find the MgO levels in glass and faience to be similar.

One must conclude that the Egyptians seldom used dolomitic limestone in faience, if Matson's theory is correct, or Nile river evaporates, if Sayre is right. Since the K:Na ratios are consistently higher in faience than in glass, it would appear that natron, supplemented generously by plant ash, was the preferred form of alkali.

In their attempts to reproduce Ancient Egyptian faience Kiefer and Allibert found nitre (KNO_3) to be a satisfactory source of alkali ions too.[9] On the basis of certain Classical allusions and the presumed abundance of the mineral in Egypt the authors proposed nitre as one of the alkali used in the manufacture of Ancient Egyptian faience. This is quite unlikely, since Lucas pointed out a number of years ago that nitre is rather uncommon in Egypt and the apparent references to it in Greek and Roman texts stem from a confusion between "nitre" and "natron".[144]

Most of the magnesia and alumina found in Egyptian faience is probably traceable to the sand, with the ashes and the Nile water supplying the balance. The composition of Egyptian sands is so variable that it can easily accomodate both the faience and glass analyses. The analyses reported by Lucas fall into two groups, one with individual values for all three oxides and another with the combined $Al_2O_3 + Fe_2O_3$ in lieu of alumina. Within the former group MgO and Al_2O_3 show ranges of 0.1-2.4 and 0.5-8.2%, respectively.[27] The latter group has 0.1-2.2% for MgO and 0.7-3.6% for (Al_2O_3

+ Fe_2O_3), suggesting a much narrower range of values for alumina. Stone and Thomas analysed sands from four sites and found three specimens with 0.01-0.1% MgO and one with 0.1-1%; as far as alumina is concerned two specimens contained 0.01-0.1% Al_2O_3, and two 1-10% Al_2O_3.[3]

Though, as we indicated, the sand analyses can accommodate most of the published magnesia and alumina concentrations in glass and faience, there is one group of specimens which stand out on account of an abnormally high alumina content. These are the cobalt blue and violet glazes and glasses of the New Kingdom. Our spectra of cobalt-coloured faience of the New Kingdom show excessive amounts of alumina. Quantitative evidence of this will be presented in Chapter IV, when high-cobalt faience bodies are discussed.

Cobalt blue glass of the New Kingdom shows a similar correlation. Geilmann's analyses yield an average value of 2.8% Al_2O_3 for the three cobalt-coloured glasses, and 1.3% for the remaining specimens.[34] Similarly, Sayre's data yield an average alumina concentration of 2.4% for the cobalt blue glass and 0.8% for the others.[24] It is noteworthy that if the cobalt blue glasses are excluded only two of Sayre's other 15 specimens contain alumina in excess of 1%.[24] Very similar elemental correlations were detected by Noll and other investigators in the cobalt-containing blue pigment found on many examples of New Kingdom pottery; as a consequence such pigment was labelled cobalt aluminate. [36,51,52,53]

21. Other Elements

The oxides of Se, Rb, and Zr have been detected in about one percent of the samples analysed by us, but the levels in all instances were below 0.02%. Selenium was most frequently seen in yellow and in other glazes rich in lead and sulphur. The association of selenium with sulphur is natural, but why the other two elements should be seen most often in blue glazes is not clear. Bismuth is a rather uncommon impurity, but Bi_2O_3 at levels as high as 0.3% has been found in two specimens of Late Period frit and in a blue faience scarab from Naucratis (E.A. 908).

The elements discussed in the preceding paragraph are equally uncommon in Egyptian glass. Sayre reports the following concentration ranges for 18th

Dynasty glass: 0.0003-0.0089% Rb_2O, 0.0036-0.0098% ZrO_2 and 0.0003-0.0013% Bi_2O_3.[22,24] A more recent neutron activation study found ribidium concentrations ranging from 0.0001 to 0.03% in Egyptian glass and faience, and less than 0.008% in sand.[4]

Gold was detected on a handful of faience glazes. One 18th Dynasty scarab (1872.800) had as much as 0.3% Au on its back, but otherwise values greater than 0.01% are quite exceptional. A few other examples where concentrations in excess of 0.01% were detected, proved on close microscopic examination to have been covered at some time in the past with gold leaf, and all that we detected were the remains. For example, specks of gold are still visible on Old Kingdom inlay E.1764H and Ptolemaic Oinochoe 1892.1025.

The two specimens with most silver (over 0.1% Ag), scarab 1890.766 and cowroid 1890.769, had the element confined almost exclusively to the edges of the seals. There is good evidence that seals of this type were carried around mounted in silver, so the metal would have rubbed off exactly where we found it. It appears that as an impurity in faience silver is rarely, if ever, to be expected at concentrations greater than 0.1%. Egyptian faience in which higher values of silver are reported should be inspected very carefully to exclude the possibility that surface contamination is being measured. The analyses of Egyptian glass confirm our opinion. Silver was detected in all the specimens analysed by Sayre but at levels in the 0.0002-0.0046% range.[22,24] Aspinall et al. report finding less than 0.001% Ag and 0.0006% Au in Egyptian glass and faience.[4]

Phosphorus was detected in a majority of glazes, but we were not able to get reliable quantitative data due to the fact that the phosphorus peak overlaps the K-beta peak of silicon and the escape peak of calcium, both quite prominent in most faience specimens. All we can say is that the peaks seen by us were unlikely to represent more than 0.5% P_2O_5, and most were far below that figure. Phosphorus is such a prominent component of all plants (most plants contain more phosphorus than soda)[26,28] that whenever plant ashes are used in the manufacture of glass and faience, phosphorus will be found. Geilmann, one of the few persons to report the element, found it in all his specimens at concentrations ranging from 0.05 to 0.38%, with an average value

for Egyptian glass of 0.21% P_2O_5. [34] Sayre found it too and gives a concentration range of 0.04-0.18%. [22,24] Our own qualitative data are compatible with the New Kingdom glass analyses.

22. Concluding Remarks

The main information to be derived from elemental analyses concerns the production of the various glaze colours. Technical aspects of the glazing process itself are treated in Appendix A, where microscopic examination, simulation experiments, and other methods are brought to bear on the study. However, some features of the glaze formulation are directly apparent from our analyses, and these are considered first.

The chemical constitution of the glaze is at all times consistent with the generally accepted version of faience glazing, in which sand is combined with mineral pigments and alkali in the form of plant ashes or natron. The process is discussed at some length by Lucas,[1] Kuhne[2] and others. [6-12] There is no clearly discernible chemical difference between artifacts with an obviously applied glaze and those which may have been glazed by efflorescence (sometimes referred to as "self-glazing"). No glaze based on lead is found at any time.

The consistency in glaze composition is not surprising; the method is well adapted to its purpose, and was successfully employed for over four millennia. However, during this time many other relevant technologies were developed -- for example the production of glass, methods of moulding glass, the glazing of fired clay, et al., -- but such events appear to have had little impact on the basic method of formulating the faience glaze.

While in most instances domestic ores seem to have provided the bulk of the mineral pigments, our evidence suggests that during periods of prosperity even raw materials available locally, such as lead and copper, for example, were imported from abroad. The use of bronze scale and the corrosion products of leaded copper objects in the manufacture of faience pigments is also clearly indicated, though in some instances it might have been the by-products from the manufacture of bronzes (metal scrap) and other alloys of copper that were being utilized.

As a general comment, the broad similarity between faience glaze compositions and contemporary glass compositions should be noted. Attention has been drawn to this already, when individual elements were considered. Of course, no glass was being made in Egypt (except by accident) prior to the 18th Dynasty,[18,28,32,145,146] but it is more than likely that the formulations for faience glazes and for coloured glasses were the same and made up by the same workshop, after the art of glassmaking was introduced into Egypt.

III. THE PRODUCTION AND NATURE OF INDIVIDUAL COLOURS

1. General Introduction

We will preface the discussion of colours encountered in Egyptian faience by a brief explanation of the chemical nature of glass pigments in general. Except for the lead antimonate yellow, the pigments responsible for the colours observed in faience are transition metal ions embedded in a silicate matrix. The light absorbed by such chromophores depends primarily on the oxidation state and the chemical environment of the colourant. The metal is surrounded by a variable number of oxide ions. The latter form what is sometimes referred to as the first coordination sphere and tend to favour two types of geometrical arrangements: octahedral and tetrahedral. When the metal is surrounded by four oxygens in a tetrahedral configuration it acts as a network former, since it takes the place of a tetrahedrally coordinated silicon atom. A pigment surrounded by six oxygens in an octahedral environment is said to be a network modifier.

Since coloured glasses and glazes contain a number of different cations, such as alkali, alkaline earths, et al., in speaking of the chemical environment of the chromophore we have to consider the second coordination sphere, where the other cations will be located. One common fallacy occasionally expressed by those not familiar with the chemistry of coloured glasses is to assume that the colours exhibited by metal oxides in minerals are somehow a property of the ions and can be transferred to the glass. Rarely does a transition metal in glass have a chemical environment resembling that in a mineral. The most obvious difference is that in crystalline solids the oxides will form fairly regular tetrahedra or octahedra, whereas in a glass the symmetry will invariably be distorted. The extent of distortion will depend on the concentrations and nature of all the species present in the glass. Even small distortions can drastically lower or raise the energy levels of the chromophore and consequently shift the colour to longer or shorter wave lengths. [33,147]

How different can be the colour produced by an oxide in glass from what one observes in the original mineral is easily demonstrated by what happens when the oxides of lead and copper are used. Thus brown CuO yields blue and

green glasses whereas brown PbO yields colourless glass, even if its concentration approaches 90% by weight (ref. 147, p.328). However, despite the many variables it is possible to make a summary listing of the colours expected from the six most abundant pigments in Egyptian faience. This has been done below in Table XXVII. Most of the data were compiled from information contained in books by Weyl and coworkers.[33,147]

The ultimate colour of a glass or glaze will depend on the relative populations of the two coordination spheres and of the various possible oxidation states. The population ratios are primarily a function of the batch composition and the firing conditions, but the rate of cooling will affect the final colour too. At elevated temperatures not only will there be a preference for tetrahedral over octahedral sites, but with the symmetry of both configurations lowered the absorption bands shift to longer wave lengths. Unless the objects are annealed slowly the high-temperature equilibrium state will literally be "frozen" in the final glass or glaze.

In general, as the arrangement of the atoms surrounding the colourant ion becomes less symmetric the absorption bands responsible for the colour shift towards longer wave lengths. [33,147] Hence the factors listed in Note 1 of Table XXVII affect the colours of both colour centers, as well as shift their relative occupancy. Several examples are given below. Copper will generally yield blue colours if highly polarizable ions are absent, as in the case of the well-known Egyptian blue ($CaCuSi_4O_{10}$) and most soda-lime glasses. If however, the sodium is gradually replaced by potassium, or if elements such as Pb and Zn are introduced the colour can be shifted to green.

If manganese, nickel and cobalt are the chromophores, high potassium levels promote violet-blue (or indigo) while high soda enhances the reddish purple colour. With cobalt, under oxidising and strongly alkaline conditions one can even produce trivalent cobalt (Co^{3+}) in a tetrahedral environment which imparts an intensely blue colour to glass (ref. 147, p. 305). High alkalinity will promote the high oxidation states of all the species listed in Table XXVII. Introduction of sulphide has the same effect as increased alkalinity, and the retention of sulphide at elevated temperatures is enhanced by the presence of zinc (ref. 33, pp. 39, 44-46).

T A B L E XXVII

THE COLOURS PRODUCED BY SOME TRANSITION METALS IN ALKALI-LIME GLASSES

CHROMOPHORE	Octahedral Environment (favoured by Na_2O)	Tetrahedral Environment (favoured by K_2O)	Wave Length of Principal Absorption Bands in Angstroms
Ti^{3+}	purple	---	5700
Mn^{2+}	pale orange, red	green	4300
Mn^{3+}	reddish purple	bluish purple	4700
Fe^{2+}	blue--green	---	near infrared
Fe^{3+}	yellow, pink	deep brown	4100
Co^{2+}	pink	blue	5600,6000,6500
Ni^{2+}	yellow--red	purple	4250,5200,5900,6400
Cu^{+}	colourless--brown	---	
Cu^{2+}	blue	yellowish brown	7900

Note 1. Tetrahedral coordination is favoured by: a. high alkalinity; b. high temperatures; c. presence of highly polarizable anions, such as halides and sulphides; d. presence of cations with a d^{10} core, such as Pb^{2+} or Zn^{2+}, and of other transition metals; e. presence of oxygen-rich anions such as phosphate or sulphate.

Note 2. Simultaneous presence of both Fe^{2+} and Fe^{3+} species at moderate or low concentrations yields a clear blue colour.

Simultaneous presence of Cu^{+} and Cu^{2+} yields a bright red glass.

Note 3. Colour intensities increase in the presence of lead and darker colours are also obtained when Na_2O is used instead K_2O.

The combined effects of composition and firing conditions are best illustrated by what can happen to glass and glazes containing iron. Under oxidising conditions and with low concentrations of alkali it is possible to obtain a solid solution of Fe_2O_3 which imparts a pink colour to the matrix. The colour center in this case is similar to those found in carnelian and garnets. The pink bodies of many of the faience objects from Serabit el Khadim were, most probably unintentionally, produced in this way. The Sinai and adjacent regions have abundant supplies of ferruginous pink sand of the type shown in some of the colour plates of Rothenberg's Timna book.[64] If the object is maintained at elevated temperatures for any length of time the following equilibrium will be established

$$2Fe_2O_3 = 4FeO + O_2$$

The position of the equilibrium and consequently the final colour depend on the temperature (the process is endothermic), the degree of fluidity, the over-all composition of the glaze, and whether oxidising or reducing conditions prevail. Under oxidising or only mildly reducing conditions a blue or green colour is produced, but strongly reducing conditions yield grey or black glazes. The charge-transfer bands of the Fe^{2+}/Fe^{3+} system linked to the silicon via oxygens, are replaced by the broad absorption of the $--Fe^{2+}--O--Fe^{3+}--$chromophore, which is responsible for the black colour of magnetite.[148]

The presence of limestone and natron also promotes the decomposition of Fe_2O_3, since the CO_2 generated by the decomposition of the carbonates sweeps the oxygen trapped in the viscous fluid and reduces the equilibrium partial pressure of O_2. On the other hand glasses containing lead, barium, arsenic and antimony tend to retain the oxygen even at elevated temperatures (ref. 33, p.117). Similarly the bleaching action of substances such as MnO_2 and As_2O_5 rests on their ability to oxidise the ferrous species to ferric. At low concentrations of iron an almost colourless glass will be produced, but at higher concentrations amber or brown colours due to a mixture of MnO and Fe_2O_3 will result. If both iron and manganese are present in substantial amounts one gets the black glazes discussed in Section 5 of Chapter II.

Cupric oxide (CuO) undergoes a decomposition similar to that of Fe_2O_3, but the equilibrium can only be shifted to the right under very highly reducing conditions, when the reduction may go all the way to metallic copper.

Either Cu_2O or Cu can produce red glass.

2. The Colours of Egyptian Faience

Firstly, we should make a distinction between the different colours that were originally intended and those that we distinguish after the event, when perhaps the fabricator himself could not have anticipated the outcome. This was more likely to occur in earlier times. For example, it is probable that for a long time browns and reds were not deliberately distinguishable, at least not until the 18th Dynasty, nor probably indigo from blue. The case of greens and blues is difficult, since there tend to be many intermediate cases, with little chemical difference between them.

On deliberately manufactured polychromatic objects the intentions of the artist are much more obvious. By the Amarna period we find many greens containing lead antimonate and blues containing cobalt, as well as copper in both, but fewer than a handful of green objects which contain both lead antimonate and cobalt, suggesting that a proper distinction was now made between them. Purples, violets, indigos and blues are clearly distinguished by the Late Period. The reader should realise that while chemical evidence can throw light on the production of the different colours, it does not, by itself, enable one to infer the intentions of the fabricator.

Only green, blue and brown glazes have been seen by us on Predynastic faience. Black, white and purple colours appear during the 1st Dynasty. Yellow was added by the early 18th Dynasty, with a more intense variety of blue, indigo and violet making their appearance later in the same period. The development of new colours was, of course, a chemical innovation, but other changes also took place. The increase in polychromatic pieces was rapid. In the Hellenistic period a greater range of depth of colour was carefully employed as well as the technique of applying the glaze in layers, which could subsequently be partially cut away. Visually faience becomes far more complex, and some of this is reflected in the chemical composition of the glaze.

As we noted several times in the preceding chapter, there were also some major changes in the chemical composition, particularly towards the end of the

Late Period, which had only a minor effect on the appearance of the objects. For example, the black pigment becomes based on iron rather than the formerly used manganese, but the glaze remains the same colour. However, this change, which implies a different firing technology, is symptomatic of major cultural changes, which themselves are immediately evident in the visual design of the glaze. For example, elaborate polychrome figures done in bold relief on the sides of vessels become quite common during the Ptolemaic Period. Thus chemical and artistic changes have a close relationship, but are not necessarily causally related.

3. White

As was pointed out in the preceding chapter, no opacifier has been identified in any of the white glazes, although calcium antimonate was used extensively in 2nd and 1st Millennium B.C. white opaque glass.[23,67,94] Off-white and creamy beads containing more than 6% PbO and 1% Sb_2O_3 were found in the Coptos temple, in the foundation deposit of Tuthmosis III. They were part of a collection of yellow beads coloured by lead antimonate and bright white beads free of either lead or antimony (string E. 238). There is every likelihood that these off-white beads were intended to be yellow, but were over-fired. If the temperature is allowed to rise above 1050°C, the insoluble intensely yellow $Pb_2Sb_2O_7$ decomposes to PbO and Sb_2O_3.[118] Since the latter two are soluble in glass, the opaque yellow becomes transparent.[23] A similar transformation involving the loss of yellow colour has been noted when yellow $Pb_2Sn_2O_6$ was heated at 1100°C in air.[98]

Whether another white antimony-rich object, an uninscribed scarab from Naucratis (E.A. 905), with almost 2% PbO and over 1% Sb_2O_5 was also a misfired yellow is less obvious. Considering the site and the time period (26th-30th Dynasty) it is also possible that it was of foreign origin or inspiration.

The majority of objects listed as white are not what one might call "bright" white or "snow-white" but tend to be dull to creamy in complexion, and the analyses show traces of iron and other impurities. When the few brilliant white specimens (e.g. E.3303 and E.3304Q) were examined under a microscope, they were found to consist of a very thick glassy transparent skin over a white core of finely ground quartz. Under these circumstances the body

material too has to be free of coloured impurities, particularly iron and
manganese.

Glaze and body analyses make it plain that a more careful selection of
raw materials was practiced in the manufacture of white faience. It appears
that here natron was definitely the preferred source of alkali and ashes were
avoided. Of the 53 white specimens examined only three contained K_2O in
excess of 1%, and the highest recorded value was 2.2%. The low levels of
other metallic impurities suggest the use of powdered quartz instead of sand.
Of course, contact with clay moulds makes it impossible to prevent
contamination by some of the more abundant impurities from the container. The
matter of glass contamination by impurities leached at elevated temperatures
from clay moulds has been discussed by Turner. [139]

4. Yellow

Except in the form of spots or streaks surrounded by green or brown,
yellow glazes were not seen by us on any object antedating the 18th Dynasty.
Since the colours on these early spotted specimens are intermingled it is
difficult to tell what precisely is responsible for the yellow discolouration.
Even the most finely focused X-ray beam failed to detect elements other than
iron or copper that would explain unequivocally the nature of the yellow spots
and streaks. Yellow sections of objects such as pendant 1923.654B and bead
E.E. 163A are virtually indistinguishable in composition from the surrounding
green.

Pure yellow glazes unmingled with any other colour first appear during
the 18th Dynasty and may be found on objects of most later periods, except the
3rd Intermediate. Every single specimen examined by us was rich in lead and
antimony (see Figure 14), the same pigment that was used in contemporary
yellow glass. The lead antimonate ($Pb_2Sb_2O_7$) is invariably accompanied by a
large excess of lead, with the average $PbO:Sb_2O_5$ ratio (by weight) close to
three times higher than the stoichiometric ratio of 1.4:1. In this respect
the glazes resemble contemporary glass compositions which also favour lead by
a sizeable margin.

The effects of variations in the lead:antimony ratios on the properties

of yellow pottery glazes have been investigated by Chambers and Rigg, who also examined the influence of tin and iron.[149] Although the best colours were obtained when the $PbO:Sb_2O_5$ ratios fell in the 3:1 to 1:1 range, there is a range of other acceptable ratios, and Merrimee's yellow contains even greater excess of lead than we found in any of the Egyptian yellow glazes. The authors reproduced Merrimee's yellow and found the colour satisfactory but the glaze would not adhere to earthenware. Whether it would adhere better to faience, whose high silica body has a higher expansion coefficient, was not stated. The good condition of most of the yellow faience seen by us attests to the fact that the adhesion is good enough to have survived for over 3000 years, even if the formula had been copied from glass recipes.

Other pigments which were technically possible, for example, lead stannate or iron in a high-lead glaze, have not been detected by us in any yellow Egyptian faience. We noted in Section 13 of the preceding Chapter that some tin may be found in yellow and green glazes of the New Kingdom, but it is invariably accompanied by a large excess of antimony, so its contribution to the pigmentation is minor at best. Another substance which is found in somewhat elevated quantities is iron oxide. The levels are higher than in contemporary green or blue glazes and it is tempting to see intentional addition here. Unfortunately both Egyptian and foreign galenas that are known to have been exploited in antiquity are often contaminated by pyrites, as was shown in Section 10 of Chapter II and Table XIV in particular.

The presence of moderate concentrations of iron (see Fig. 3) in yellow glazes suggests that such faience must have been manufactured under good oxidising conditions. Otherwise, the reduction of 0.5-1% Fe_2O_3 would have undoubtedly marred the colour and converted it to blue, green, brown or black. On the other hand, manganese, copper and other oxides which retain a deep colour under oxidising conditions were scrupulously kept out, as may be seen in Tables VII and XII, for example. The potassium levels in yellow glazes tend to be among the lowest, which clearly indicates that plant ashes with their coloured impurities were also shunned in favour of natron. Careful selection of sand or use of powdered quartz is indicated by the low levels of substances such as strontium, titanium and vanadium oxides.

5. Green

Copper in amounts sufficient to give the observed colours was found in all of the over 350 green glazes examined by us. About 5% of the examined specimens contained more Fe_2O_3 than CuO, with the majority of such glazes coming from the Late and Ptolemaic Periods. It is possible that by that time the glaze makers realized that the presence of iron enhances the green colour. In general, exceptionally high concentrations of iron are more frequently encountered in green than in blue glazes. Some of the olive green glazes seen during most periods of Egyptian history owe their particular shade of green to iron and manganese. Similarly, iron and lead are most prominent in all of the distinctly yellowish green glazes of the Late and Ptolemaic Periods. Whether we have here intentional use of chalcopyritic ores, addition of pyrites to copper ores, or addition of iron in some other form is not clear. We might also be seeing the result of unintended presence of these elements. An unexpected bonus from the use of pyrites and galenas would have been the introduction of sulphide, a substance fairly effective in enhancing the green colour at the expense of blue.

With the introduction of lead antimonate during the 18th Dynasty the range of shades of green glazes that could be made by varying the proportions of the yellow pigment and copper was expanded considerably. This is reflected in faience from the reign of Amenhotep III and his successors at Amarna. It gives the Amarna objects their distinctive character, something art historians have frequently noted, and what Cyril Aldred characterised as "chromaticity".[150] Pastoral scenes, such as that of a cow grazing in tall grass on tile 1929.407a, which has the visual impact of an oil painting, would not have been technically possible if copper were the only source of green.

During the Early 18th Dynasty and the Ramesside Period objects coloured by the "unconventional" combination of copper and lead antimonate represent less than one-tenth of the analysed green glazes. The fraction rises to one in three during the Late Period. It would appear that during the Amarna and Ptolemaic Periods such combinations were the rule and green pigments based exclusively on copper the exception, since 75% of the Amarna and 60% of the Ptolemaic contained over 0.2% PbO and Sb_2O_5. Since some objects of these periods contain substantial amounts of other elements, such as iron, the

compositions become quite complex and offer opportunities for polychromy that did not exist in earlier times. The nature of pigments found combined on polychrome objects will be discussed in Section 10.

From the earliest times varying amounts of sulphur, lead and zinc are more likely to be found in green than in blue glazes, and have undoubtedly contributed to the stability of the green. In their attempts to simulate Egyptian faience, Kiefer and Allibert noted that in the presence of chloride and sulphate a green surface was obtained with copper.[9] The infrequent and sporadic appearance of lead in Predynastic times and in the 3rd Millennium B.C. makes it very doubtful that lead ores would have been added for the purpose of ensuring the formation of green glazes, but the intent is more difficult to dismiss after the 2nd Intermediate Period, when lead appears with greater regularity, albeit at low levels in the absence of antimony (Table XXI). Evidence presented in Chapter II suggests that during the First Millennium B.C. the use of leaded copper scrap instead of ordinary copper ore was probably intentional and designed to produce the desired green colour. However, in view of the ready availability of mixed copper-zinc-lead ores, we cannot be absolutely certain of such intent during the preceding centuries.

One possible combination that does not seem to have been realized by Egyptians was to mix copper-free cobalt blue with yellow lead antimonate. There are a number of specimens containing some lead, antimony, and cobalt, but they invariably also contain copious amounts of copper. Under those circumstances the role of cobalt would be secondary and simply result in a deeper shade of blue-green. Moreover, most such combinations are found on polychrome glazes, where it is difficult to tell which pigments were intentionally introduced together and which became mingled in the final stages of glazing.

6. Blue

Until the introduction of cobalt during the 18th Dynasty, blue faience was produced exclusively with the aid of copper. The factors which affect the stability of copper-based blue have been discussed at some length by Weyl,[33,147] and some of them were summarised in Section 1 of this Chapter. As expected, the purest and darkest blue glazes contain the most copper and the

least lead, zinc, antimony or sulphur, and more sodium than potassium.

We already pointed out that prolonged exposure to elevated temperatures will favour green over blue. Consequently, some of the beads with green on one side and blue or blue-green on the other might reflect rapid cooling of unevenly heated objects. After all, it must not have been easy to maintain a uniform temperature in some of the ancient furnaces, particularly if draughty oxidising conditions were desired. The effect would have been most pronounced if one of the so-called "self-glazing" techniques had been used, for the hot and cold sections would end up with different concentrations of alkali.[8,9] Among the more unusual objects showing adjacent blue and green glazes, separated by an uneven diagonal line, is an aegis of Bastet (1931.304) from a 3rd Intermediate Period grave at Matmar.

Consequently, we have no clear idea how many of the pre-18th Dynasty green and blue objects were intended to have the colours we now see. A random count of glazed objects at the Ashmolean Museum and at the Petrie Museum of the University College, London, showed that until the Middle Kingdom green glazes greatly outnumbered the blue. Whether this reflects aesthetic factors or difficulties in the manufacture of blue is not certain.

Attempts to discover when the Egyptians invented the very deep blue pigment often referred to as "Egyptian Blue",[1,30] have not been entirely successful. The colour is produced by a double salt of the composition: $CaCuSi_4O_{10}$, with a well defined crystal lattice. The nature of the salt has been investigated by Chase[30] and more recently by Tite, Bimson and Meeks. [31] Since all the components of this salt are commonly found in green, blue and other glazes, it is not possible to identify the pigment from the chemical analysis alone. The work has to be supplemented by X-ray diffraction, something which requires destructive sampling of the glaze. This we could not do.

Tite has synthesized glazes with all the appearances of the strong deep blue characteristic of later Egyptian work by incorporating synthetic Egyptian Blue as a frit into a typical glaze formulation. Scanning Electron Microscopy revealed the presence of small residual crystals of Egyptian Blue dispersed in

the vitreous phase of the glaze.[31] Furthermore, such crystals were also detected in a few examples of ancient Egyptian blue faience. Whether all such deep blue glazes necessarily required the addition of Egyptian Blue frit in their formulation is not certain. Where Egyptian blue frit was added it was not the sole source of copper (and therefore of colour) in the glaze, since measurements of the CaO:CuO ratios in the glazes do not correspond to the stoichiometry in $CaO.CuO.4SiO_2$, but generally show an excess of copper.

There is evidence suggesting that even if the formulation of Egyptian Blue had been invented earlier, it was not until the Middle Kingdom that it became common in Egyptian faience. Firstly, none of the blue objects antedating the 11th Dynasty have the characteristic depth and hue of glazes known to be based on Egyptian Blue, such as those that cover the Middle and New Kingdom hippopotami found in many museums. Secondly, if one plots the average CaO:CuO ratios in blue and green glazes of various time periods (see Fig. 18), a distinct change is observed at the time of the Middle Kingdom. While prior to the 11th Dynasty the ratios are extremely variable and on the average blue glazes show higher ratios than do the green, from the Middle Kingdom on the ratios are more constant and the averages are consistently lower in blue faience. For obvious reasons, cobalt blues (Co above 0.05%) were excluded from the data plotted in Figure 18.

Cobalt does not appear on a regular basis until the 18th Dynasty, and even after it does it is rarely found unaccompanied by a substantially greater amount of copper. However, the intensity of the blue colour produced by cobalt is so much greater, that in glazes containing more than 0.05% CoO the latter will be a major, if not the principal, source of colour. Concentrations in excess of 0.2% may produce an indigo or violet faience instead of blue, depending on the thickness of the glaze. In the preceding chapter we have used the 0.05% concentration as the dividing line between cobalt blue and copper blue glazes, and will do so in the future. Even during the Amarna and Ptolemaic Periods, when the use of cobalt was most extensive, fewer than one blue object in three are coloured by CoO, and during the 3rd Intermediate Period cobalt disappears altogether from Egyptian faience.

Another interesting aspect of the use of cobalt blue is the fact that

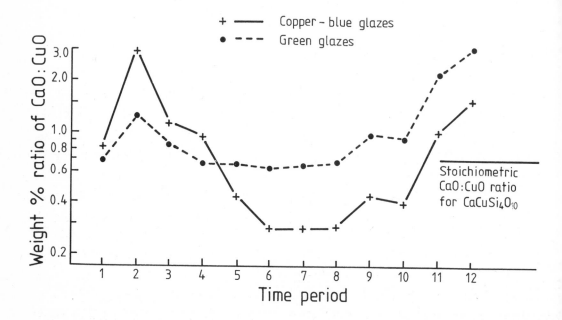

Figure 18. The average CaO:CuO ratios in green and copper blue faience.

during the New Kingdom and even more so during the Ptolemaic Period cobalt was most frequently utilized for decorative purposes, instead of being used to colour an entire object. More on this subject will be found in Section 10, where polychrome objects are discussed explicitly.

The role played by other elements, such as Ca, Mn, Fe, Sn and Pb, encountered in reasonable quantities in blue glazes of various times has been touched upon several times before. Though the effects of some of them on the enhancement or suppression of blue colour have been investigated by several authors,[33,147] and were briefly touched upon in Section 1 of this chapter, the combined effect of more than one can be quite different from what one might expect from a single species. Thus, as we noted earlier, lead and zinc will promote green colour in copper-rich glazes, but the addition of barium, aluminum, or boron can shift the colour to blue. The possible effects of elements found occasionally in amounts high enough to influence the blue colour are discussed explicitly below.

Deliberate use of manganese is indicated in the production of certain distinctly greyish blue glazes such as: inlay 1921.1134 (1.3% MnO) or bowl 1910.559(3) (1.2% MnO), but the majority of blue glazes have manganese levels compatible with expected impurity levels in other ingredients. The role of manganese in the production of purple glazes will be dealt with in the next section.

Iron shows such a continuum of values (see Fig. 2) that it is not always possible to tell where the impurity levels leave off and the intentional addition begins. Nevertheless, when present in over 1% (intended or not), oxides of iron will have an impact on the final colour, and under certain circumstances the blue will be enhanced; under others it may be converted to blue-green or green.

If there is one period of Egyptian history when the role of copper in the production of blue glazes was apparently down-played and that of iron elevated to where it made a major contribution to the final colour, it was the Ptolemaic. While the copper concentrations are lower than in blue glazes of any other period (Table XII), the median figure indicates the majority had

iron in excess of 1% (Table VII). The production of black glazes based on iron and the large amount of red glass based on reduced copper (the so-called **sealing-wax** or **ruby** red)[20,21,25,67] provide clear evidence that higher temperatures and reducing conditions were more common during the Ptolemaic and Roman periods than at previous times. These are just the conditions needed if iron is to yield a blue pigment by the process described at the end of the first section of this Chapter. As we pointed out on several occasions, under oxidising conditions instead of complementing the blue of copper iron will actually promote a green colour.

The over-all composition of Ptolemaic glazes suggests that the Egyptian craftsmen had become familiar with the conditions and ingredients needed for a satisfactory controlled and partial reduction of iron. Tables VII and XVII show that substances such as MnO_2 and Sb_2O_5, which interfere with the reduction, were kept down to a minimum while limestone, which assists in the dissociation of Fe_2O_3, must have been added in copious amounts, as is attested by the high concentrations of CaO (Table IV). Among the hazards of using highly reducing conditions is the danger that the copper will be reduced to the cuprous, or even metallic, state and the blue will turn brown or red. We have not found any faience showing evidence of such an occurrence.

The role of tin in enhancing the lustre of the blue (and for that matter green) faience has already been discussed in Section 13 of the preceding Chapter. Visually the high-tin objects are quite striking, and often look as bright and fresh as if they were recently made. Were it not that most came from well-documented excavations the state of preservation might easily have given rise to doubts regarding their authenticity.

7. Purple, Violet and Indigo

As anyone who has ever looked at a rainbow is well aware the boundary dividing violet from indigo and indigo from blue is not sharp. As a consequence we have no doubt that some of the objects we classified as indigo might be perceived by others as blue. In general the indigo is distinguished from blue by a higher concentration of the pigment responsible for the colour, but some overlap is inevitable (Figures 4-6). Similarly the distinction between violet and purple is somewhat arbitrary as it involves degrees of

"redness", a subjective criterion. In some instances to assist those who may not have an opportunity of viewing the objects in question we have resorted to hyphenated names, such as violet-blue, purple-red, etc.

The objects treated in this section have one thing in common, they contain colourants with one or several absorption bands near the center of the visible spectrum, so that some red and some blue are transmitted. What differentiates purple from violet or indigo is the fact that in the latter two the bands are closer to the long wave length (red) end of the spectrum. The colourants and their absorption bands are listed in Table XXVII. On the basis of their chemical composition the analysed objects can be classified into four distinct types. These are treated individually below.

Type I glazes are those which are relatively free of manganese (MnO below 0.1%), cobalt (CoO below 0.05%) and nickel (NiO below 0.05%) and have copper as the principal pigment (CuO above 1%). They are usually reddish purple in colour with a tendency towards brown, in places. Just about all of the faience objects on which Type I glaze was seen exhibited green or blue colours on adjacent or underlying areas without a clear-cut division between the purple and the other colours.

It is possible that some of these objects were initially purple over the entire surface with the blue and green indicating subsequent oxidation of copper. However, the appearance and the colour patterns suggest that the objects were intended as blue or green and acquired a purple colour accidentally, either during or after the final firing. This is most apparent on objects such as: 18th Dynasty scarab 1892.226, dish 1890.898 from Medinet Ghurab, and Late Period ushabti 1887.2443. On the last one, for example, the pattern of purple streaks gives a clear impression that a smouldering fabric wrapped around the object was responsible for the reduction of copper when the contents of the tomb had been set afire.

Evidence of such fires has been found in tombs of various periods. In some instances the firing of certain mortuary goods was a part of some burial ritual, as in the case of Petrie's "Burnt Deposit of Tutankhamon" at Medinet Ghurab.[151] On the other hand, the extensive fire-damage seen in many royal

tombs of the 1st Dynasty suggests deliberate posthumous desecration. [152] One of our Type I specimens came from the tomb of King Udimu (E. 3229B).

Glazes of this type are of little interest to us, since they are a product of accident and have no relation to the original intent. We have encountered a number of objects with Type I glaze but saw no need to analyse more than a few representative specimens.

Type II glazes are coloured by what is frequently called "manganese purple". They are characterized by virtual absence of cobalt (CoO below 0.02%) and nickel (NiO below 0.02%), and owe their colour to Mn_2O_3, which ranges in concentration from 0.3 to 2.0%. The contribution of copper is highly variable since its concentrations range from 0.03 to 2.9%. When present in excess of 2% it has a noticeable impact on the colour, shifting it towards violet. Iron is unlikely to be of great consequence since in no case does it exceed 1% Fe_2O_3.

On the objects examined by us Type II glazes were used exclusively to outline specific features on a coloured or white ground. For example, the greyish violet hair of some blue ushabtis of the 3rd Intermediate Period is coloured by a copper-rich Type II glaze (Queens College Loan Nos. 283-285). A reddish purple variety of low copper content was used to colour the hair of a Ptolemaic female head (1892.1028) and to outline an elaborate plant design on a late Ptolemaic-early Roman vase from Memphis (1910.554).

Type III includes a range of indigo-violet glazes containing significant quantities of manganese (MnO above 0.05%), cobalt (CoO above 0.05%), and occasionally nickel (NiO above 0.05%). This is the dominant type during the Amarna and Ramesside periods. The relative proportions of the three main components have been discussed in the preceding Chapter and are illustrated in Figures 4 and 5, with additional data provided in Tables X and XI. Though in the great majority of cases the concentration of manganese exceeds that of cobalt or nickel, the extinction coefficient of cobalt oxide is so much higher than that of manganese, that the latter plays a subordinate role and can only modify the basic blue or indigo produced by cobalt. The modification results in varying shades of violet-purple and can also affect the sharpness and

clarity of the design executed with a cobalt blue pigment.

The role of nickel and zinc, which is also elevated in Type III glazes (ZnO above 0.1%), is to promote the violet over indigo. As a colourant nickel resembles cobalt, except that the red component is more intense than in the case of CoO (see Table XXVII). Small amounts of zinc have little effect on cobalt, but at high concentrations a green glaze will result.[33] However, small to moderate levels of ZnO promote violet colours with NiO. At higher concentrations zinc shifts the colour of NiO to blue.[33] As in the case of Type II glazes, the levels of CuO are highly variable, 0.01-3.3%, but in the presence of so much cobalt the effect of copper is going to be marginal. Here again it is safe to say that glazes with CuO above 2% are more likely to be indigo-violet than purple-violet.

Type IV glazes are those that contain significant amounts of cobalt (CoO above 0.1%), but little or no manganese (MnO below 0.05%), nickel or zinc (NiO below 0.02%, ZnO below 0.02%). All of them have relatively high levels of copper, with the average value of CuO in the specimens examined by us being 2.6% (the lowest concentration was 1% CuO), a figure much higher than the average in Types II or III. One sees very little reddish purple in such glazes, the violet and indigo colours being similar to those produced in glass by high concentrations of pure cobalt oxide.

As we pointed out in Section 7 of Chapter II, glazes of Type IV composition are first seen on faience dated to the 26th Dynasty. The one possible exception, a fluted bowl fragment from Tell el-Amarna (1942.77) which was originally assigned an 18th Dynasty date, may in fact be of the Roman period. It was recovered in an area "dotted with Roman burials",[153] and stylistically it shows greater affinity to certain Roman bowl types than to anything known to be of the Amarna period.[154]

Variable though low levels of iron may be found in all four types of glaze. Its contribution is difficult to assess, but in the presence of zinc the blue colour of glasses containing ferrous and ferric iron is greatly enhanced.[33] Here again, if enough iron is present the violet will be favoured over purple. The effect must have been fortuitous. It is unlikely that iron

and zinc were introduced intentionally to promote one hue over another, or higher concentrations of the two elements would have been found.

The average and median figures listed in Table III show unusually high levels of potassium in violet glazes. The interquintile ranges plotted in Figure 19 give a graphic illustration of how much more potassium one can normally expect in violet versus blue or green faience of any time period. All this is unlikely to be the result of a biased sample selection. Apparently plant ashes were deliberately selected in the preparation of violet faience. No clear preference for ashes as opposed to natron is indicated for blue glazes, though potassium is somewhat more favoured during certain historic periods.

If the colours we see were intended, the choice of potassium-containing plants was a wise one. As we pointed out in Section 1 of this Chapter, sodium darkens and potassium lightens the colours produced by transition metal ions. This would prevent glazes containing several chromophores from turning black. Moreover, potassium promotes the blue over the red component of colours produced by Mn_2O_3, CoO and NiO (see Table XXVII). Elevated potassium concentrations may be one of the reasons why indigo-violet shades are that much more common than reddish purple ones.

Considering the craftsmanship of the 18th Dynasty faience-makers it is difficult to believe that by the Amarna period, at least, the link between the nature of the alkali and the colour had not been noted. Therefore, the relative scarcity of the more reddish shades of purple strongly suggests that initially, at least, the indigo violets were not a deliberate choice but represent early experimentation in which attempts were being made to produce very dark blue colours, colours that could be used beside copper blue and still give good contrast. As will be shown in Section 10, the indigo-violet glaze was more often used for decorative purposes than to colour entire objects.

If the early violets were the result of experimentation with deep blues, the design of some 19th Dynasty polychrome faience suggests that by the Ramesside Period at least some Egyptian craftsmen made attempts to distinguish

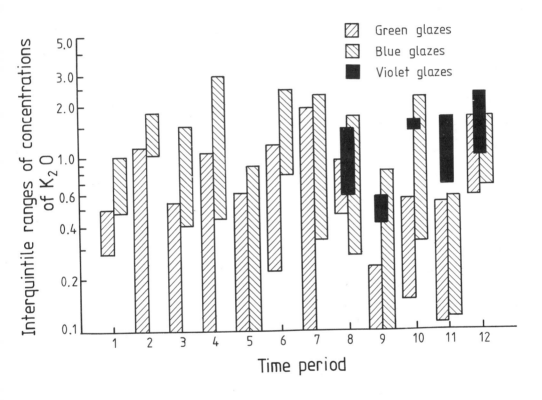

Figure 19. The interquintile ranges of potassia concentrations in green, blue and violet faience of various time periods.

between violet-blues and purples. However, the more reddish shades of purple did not become common until glazes containing very little copper and cobalt made their appearance in Ptolemaic times.

It is difficult to tell when the different types represent different raw materials (a problem discussed in Section 7 of Chapter II), and when an intentional colour variation. That certain types were more prevalent during specific time periods is obvious from the statistics presented in Table XXVIII, where we have indicated what fractions of objects of each period belong to each Type. It is quite apparent that Type III was in vogue during the New Kingdom, while during the Ptolemaic Period Types II and IV were favoured.

T A B L E XXVIII

RELATIVE PROPORTIONS OF TYPES II-IV VIOLET AND PURPLE FAIENCE

TIME PERIOD	Type II	Type III	Type IV
Late 18th	--	100%	--
Dyn. 19-20	--	100%	--
Dyn. 21-25	100%	--	--
Dyn. 26-30	--	50%	50%
Ptolemaic	50%	12%	38%

Type II:	MnO above 0.5%	CoO below 0.02%	NiO below 0.02%
Type III:	MnO above 0.05%	CoO above 0.05%	NiO above 0.05%
Type IV:	MnO below 0.05%	CoO above 0.1%	NiO below 0.02%

8. Black and Grey

These colours have an interesting history, which in some ways reflects a competition between black based on manganese and black produced by the reduction of iron. A similar competition has been noted in the production of black painted pottery of the Ancient Near East and the Aegean.[37] Until the second half of the 1st Millennium B.C. it is difficult to find black faience that does not contain at least 1% MnO, while most glazes contain considerably more (see Table VII). The early faience-makers must have been uncertain about the best means of producing black glazes, for among the glazes of the Archaic Period a majority have the manganese accompanied by an excess of iron. Starting with the Old Kingdom iron rapidly disappears from black faience, except for a few regional holdouts, such as El Kab, which will be discussed in Chapter V. Large amounts of iron reappear dramatically during the 26th Dynasty and by the Ptolemaic Period it is the dominant element in black faience (see Table VIII).

As we noted in Sections 5 and 6 of Chapter II, it is difficult to find any of the darker colours without some manganese and iron. However, in contrast with the black, the great majority of blue and green glazes of any period contain more iron than manganese, as is shown in Figure 20. Thus for two and a half millennia copious amounts of pyrolusite or psilomelane must have been mixed with the other ingredients in order to create a black glaze. We failed to uncover a single manganese-free specimen among objects dated to before the 26th Dynasty, whereas we found a considerable number in which no iron could be detected, particularly among Middle Kingdom blacks. It is obvious that, had most of the Egyptian pyrolusite deposits not been of the ferruginous variety, there would have been even more iron-free black faience.

The change-over from manganese to reduced iron, first clearly noticeable in objects of the Saite Period, coincides with the arrival and settlement of Greek colonists in the Delta. It is tempting to see in this a conscious attempt to imitate in faience the techniques perfected by the Greeks in the production of red and black figured ware. As we noted in the preceding section of this Chapter, the Ptolemaic Period was also the time when cobalt-free manganese is first seen in reddish-purple glazes. The new chemistry of both black and purple glazes is consistent with a fundamental change in the

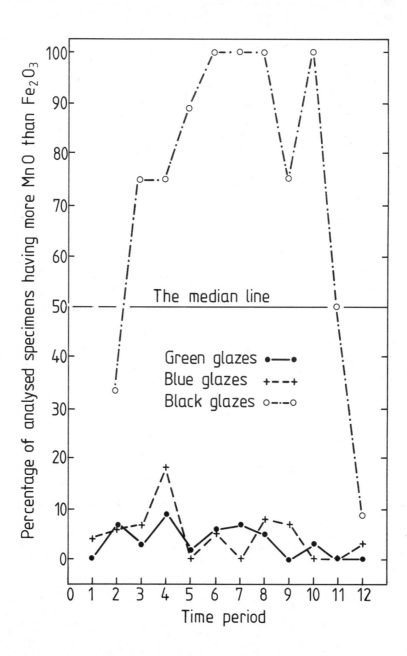

Figure 20. The fraction of blue, green and black glazes having the ratio of MnO:Fe$_2$O$_3$ greater than 1.

basic technology of glaze-making, a change from oxidising to reducing conditions, and the employment of higher firing temperatures.

It is quite certain that most if not all manganese deliberately introduced into Egyptian faience came from one of the mineral modifications of MnO_2. The behavior of MnO_2 within the range of temperatures employed in the manufacture of faience is well known. By the time $1100^\circ C$ is attained two successive decompositions with a loss of oxygen are observed:

$$MnO_2 \xrightarrow{535^\circ C} Mn_2O_3 \xrightarrow{877^\circ C} Mn_3O_4 \text{ (hausmannite)}$$

Therefore in any fritting or glazing operations only the latter two species are of interest. In the presence of iron mixed crystals such as the cubic bixbyite, $(Mn,Fe)_2O_3$, and the spinel jacobite, $(Mn,Fe)_3O_4$, are also formed.[44] The equilibria between the various oxides of iron and manganese and the amount by which the presence of iron raises the decomposition temperature have been investigated by Muan and Somiya.[155]

All three of the high-temperature crystalline species named above are black and have been found in the black pottery pigments used in Ancient Egypt and other parts of the Eastern Mediterranean world.[36,37] The situation is somewhat more complex in faience, for both Fe_2O_3 and Mn_2O_3 are soluble in an alkali-silicate medium, and the best that one can expect from these species, even at moderately high concentrations, is an amber or brown colour, or purple in the absence of iron (see Table XXVII). However, if the temperature is raised above $900^\circ C$ and the glaze is subsequently subjected to slow cooling in an oxygen-rich atmosphere microscopic crystals of hausmannite will create an opaque black glaze. Crystals of Mn_3O_4 have been detected in slowly cooled manganese glasses (ref. 33, p.130).

If the amounts of manganese encountered in some of the black faience appear excessive, one should keep in mind that the MnO_2 would often be accompanied by reducing agents, such as FeO, PbS, FeS, Cu_2S, chlorides, organic matter, and others. Under those circumstances there was always the possibility that the manganese would be completely reduced to the almost colourless MnO. As a matter of fact this is just the way in which MnO_2 is utilized to decolourize glasses containing iron impurities. Turner reports

that a soda-lime glass containing 2% Fe_2O_3 and 3% MnO is pale yellow and transparent.[21] With sulphide the reaction is:

$$7MnO_2 + 2FeS = 7MnO + Fe_2O_3 + 2SO_2$$

The stoichiometry shows that it does not take much sulphide to prevent the formation of Mn_3O_4, and sulphides were quite prominent among the raw materials utilized by the Ancient Egyptians (see Sec. 19 of Chap. II).

On the other hand, the craftsmen of the Late and Ptolemaic Periods had just the opposite problem. They had to worry about the re-oxidation of their black glaze, and the analysis indicates that potential oxidising agents were kept down to a minimum. For example, Table XVII shows that the amounts of Sb_2O_5 are noticeably lower in black than in green, blue or purple glazes.

The question of when the Ancient Egyptians began controlled reduction of iron oxides for the manufacture of black pigment has been and is likely to remain controversial. With so few published analyses of black glass and none of black faience the discussion has centered around the nature of the black pigment on Egyptian pottery. Lucas devotes a considerable amount of space to a discussion of the black and the black and red Egyptian ware.[156] After examining objects ranging in age from Predynastic to New Kingdom, he came to the conclusion that the black colour resulted from the entrapment of carbon-black particles and not from the reduction of iron and the formation of species such as magnetite (Fe_3O_4).

A recent study by Eissa et al. suggests that the picture is not as simple.[157] Their Mossbauer spectra of Badarian and later pottery revealed that at least 14% of the iron was in a reduced state and made them conclude that the ferrous species is a major, if not sole cause of the black colour. Moreover, they detected much less carbon than was expected on the basis of Lucas' theories.

It is a pity that the authors of the above-mentioned study did not report on the relative amounts of manganese and iron oxides, for Noll states categorically that the iron-reduction technique was never practiced in Egypt.[36] Noll's conclusions are based on a combined X-ray fluorescence and diffraction study of Egyptian black pottery pigments. All of his specimens,

ranging in age from late Predynastic (Naqada II) to the Graeco-Roman period, contained iron with variable but significant amounts of manganese. The Mn:Fe ratios ranged from 2:100 to 33:100 (Table 4 in ref. 36), but the ratios are misleading because of the large amounts of iron that are invariably bound to show up in any pigment applied to clay.

The glass data are not very helpful. We found only two complete analyses of pre-Ptolemaic black glass. One 18th Dynasty specimen, analysed by Neumann and Kotyga,[18,20] contained 0.5% Fe_2O_3 and 0.3% MnO; the other, analysed by Sayre,[24] had 1.29% Fe_2O_3 and only 0.018% MnO. It is difficult to see why either one should be black, for the levels of the pigments are lower than in many non-black glasses. The clue to this puzzle may be in the sulphur, which in the first glass is reported as 0.8% SO_3 but may still be in the form of sulphide, and glasses containing this anion can be exceptionally dark.[33] The second glass contains too little manganese for it to be of any consequence, so iron and maybe the sulphide (which is not reported) are responsible for the colour. Of the two specimens of Ptolemaic black glass analysed by Neumann and Kotyga,[18,20] one may owe its colour to manganese or a manganese-iron mixture (0.8% Fe_2O_3 and 0.5% MnO) and the other definitely to iron (10.0% Fe_2O_3 and 0.3% MnO).

Consequently, we find ourselves in partial agreement with Noll. Faience data indicate that until the arrival of the Greek colonists the controlled production of black glazes based exclusively on reduced iron was not being practiced. Whether it was beyond the means of Egyptian pyrotechnology, a doubtful proposition, or simply reflected the ready availability of manganese ores, as Noll believes, is not certain. What is certain is that only after the Saite Period does one find black faience containing a lot of iron with truly negligible amounts of manganese. For example, the black hair of the Royal Oinochai (1892.1025 and 1909.347) contain less than 0.1% MnO and have MnO:Fe_2O_3 ratios of less than 1:100.

Even if, as the Mossbauer spectra suggest, some Egyptian pottery was blackened by reduced iron, producing a black faience glaze is a different proposition. In the presence of all the other colourant ions, alkali, lime, etc., if only 14% of the total iron were to be reduced, as was the case with

the pottery studied by Eissa et al.,[157] one is unlikely to get a black glaze. A brown, green or blue is more probable. A much higher proportion of iron has to be reduced, and it has to remain reduced until the glaze has hardened. As we will point out in the next section, it is quite possible that some of the high-iron low-manganese reds and browns might have been intended as blacks, but the iron was re-oxidised.

What of the few pre-Ptolemaic black glazes that contained less than 1% MnO and an excess of iron? We find that they contain some other pigment in concentrations high enough to have produced objects that appear black to the eye. Some of them contained TiO_2 at levels close to 1%, others had combinations of cobalt, manganese, nickel, iron and copper, with absorption bands spanning the entire visible spectrum, at levels high enough to produce a black glaze. The presence of titanium and cobalt was undoubtedly unintentional. The former must have originated in the sand while the latter was found only in decorations on blue New Kingdom objects, and might represent contamination by underlying cobalt blue background. Only in Ptolemaic black glazes do we have evidence of intentional use of cobalt to darken the greyish black colour of reduced iron. It is found on objects where no cobalt-rich ground could have contaminated the black design (for example, vessels 1892.1025, 1909.247, and 1910.549(1)).

We were curious whether carbon-black particles might have been trapped in some glazes and coloured them black, but examination under a low power microscope showed no discernible particles. It is unfortunate that the analytical techniques employed by us will not detect elemental carbon. Hence the problem remains unresolved. The only instances where elemental carbon is probably responsible, in part at least, for the black colour involve several blue objects that had apparently been subjected to a smoky fire at some time after being deposited in the place of burial. The blackened areas were remarkably similar in composition to the adjacent unblackened ones (for example, the jar lid 1890.1001 from a 19th Dynasty grave at Medinet Ghurab) and were confined mostly to the edges and other protrusions, portions of objects most exposed and least protected from a tomb-fire.

9. Brown and Red

In many instances it was not easy to make a meaningful distinction between these two colours. The browns came in a variety of shades, from almost black to distinctly reddish. The majority were chocolate-brown and only about 15% might appropriately be called red-brown or red. The latter type were also restricted in time with almost all the specimens coming from New Kingdom sites.

Compositionally the distinction between red-brown and other shades of brown is not too clear, for many elements show overlapping concentration ranges. However, as a group the "red" ones are characterised by: lower levels of MnO and higher levels of Fe_2O_3, PbO and K_2O. The average concentrations of these four substances in specimens of the New Kingdom are compared in Table XXIX below.

T A B L E XXIX

COMPOSITIONAL DIFFERENCES BETWEEN THE RED AND BROWN NEW KINGDOM FAIENCE

COLOUR	Average for the 18th Dynasty				Average for the Ramesside Period			
	K_2O	MnO	Fe_2O_3	PbO	K_2O	MnO	Fe_2O_3	PbO
Red	1.3	0.00	4.0	0.8	2.3	0.02	5.2	1.0
Brown	0.9	0.75	0.9	0.4	0.8	2.70	0.8	0.1

Now, while all of the red glazes examined by us were characterised by barely detectable amounts of manganese and high iron and potassium concentrations, having the two elements at similar levels does not guarantee a red glaze. Among the many distinctly brown glazes without a hint of redness there were quite a few free of manganese and having levels of K_2O and Fe_2O_3 comparable to those seen in the red specimens. It is obvious that many more subtle compositional factors and manufacturing conditions play an important role in determining how red a faience glaze will turn out.

Iron is undeniably the principal pigment in all but a handful of red and brown specimens, even when the latter contain substantial amounts of manganese

(up to 7.6%). Only a minority of brown glazes have less Fe_2O_3 than MnO, a factor that sets them apart from most contemporary black ones. The contrast with black faience is underscored by the fact that the earliest browns and those of the Ptolemaic Period tend to have less Fe_2O_3 than MnO, whereas the reverse is true of black glazes of these time periods.

With that much iron and manganese, especially in the pre-18th Dynasty specimens, one must wonder how many of the brown beads or design patterns were originally intended to be black. As a matter of fact, we have seen objects decorated with stripes or spots, some of which were brown and some black (e.g. a 2nd Dynasty model vase, E. 658A), a distinction for which different $MnO:Fe_2O_3$ ratios were responsible. It appears that under suitable conditions a small increase in the proportion of manganese can convert brown into black. Noll reports that a ceramic pigment based on Fe_2O_3 and containing 5% Mn_2O_3 is distinctly brown but turns black when the concentration of the latter is raised to 8% (ref. 36, p.281).

Greater control and better execution is evident in the manufacture of brown and red glazes of the Amarna and Ramesside periods. In many instances the colour had to be brown or red and nothing else, for it represented brown wood, red plants or other non-black objects in an intricate design (for example, the red-brown head of a duck, inlay 1924.128, or the red lotus flower, tile 1871.34C). The reduced levels of manganese and copper are undoubtedly intentional, designed to ensure a redder colour (see Tables VII and XII).

A very interesting example of the manner in which the $MnO:Fe_2O_3$ ratio was manipulated to achieve the desired result is provided by a white ushabti of the 19th Dynasty. The object (1923.605) has reddish brown hands containing 4% Fe_2O_3 and 0.06% MnO, but the wig is dark brown and contains 2% Fe_2O_3 and 8% MnO. The artist obviously intended to have the hair considerably darker than the hands, in order to imitate human anatomical features.

Some of the browns on objects of the 21st-30th Dynasties might have been intended as black, for poorer execution is occasionally evident. Discernibly better quality control returns in the Ptolemaic Period. Moreover, the heavy

use of manganese at a time when it is replaced by iron in black indicates a clever attempt to achieve a brown colour under distinctly different conditions of manufacture. Under the mow more popular reducing conditions higher concentrations of manganese would help in several ways, two of which are discussed below.

First, if enough MnO_2 were put in the batch, reduced all the way to MnO, and shifted into an octahedral environment, a brown colour would result (see Table XXVII). For reasons discussed in Section 1, the lower concentrations of K_2O and of PbO (at a time when PbO is relatively more common in other glazes), are just right for the formation of brown glazes based on MnO. At the same time lower concentrations of Fe_2O_3 would prevent the reduced iron from turning the glaze black.

Second, as long as the reducing conditions are not too extreme and the time spent under those conditions not too long, and as long as the MnO_2 is in excess (as it is in all but one of the Ptolemaic browns), the reduced iron may be in part or wholly re-oxidised by the reaction shown below:

$$2FeO + MnO_2 = Fe_2O_3 + MnO$$

As a matter of fact, this reaction is used at the present time in the production of brown bottle glass.[33]

Interestingly enough, we failed to find a single specimen of red faience coloured by reduced copper, although sealing-wax red glass coloured by Cu_2O (or metallic copper) in a high-lead matrix was being fabricated in many workshops of the Ancient Near East. [21,25,67,158] According to Weyl and Marboe, a good red colour requires the presence of two oxidation states and it is not easy to maintain the cuprous and cupric species at the required equilibrium position (ref. 147, p.312). The authors note that oxides such as Mn_2O_3 or NiO destroy the colour, presumably by interfering with the charge transfer process.

The presence of manganese in most Egyptian brown faience cannot be held responsible for the apparent absence of copper red glazes, for although the red Egyptian glass from Amarna and Assyrian from Nimrud are free of manganese, red glasses of the Ptolemaic Period contain variable though low amounts of MnO

without loss of colour. Moreover, if the Egyptians were able to exclude
manganese quite effectively from their iron-coloured red New Kingdom glazes,
they could have done it as easily with other types. One plausible explanation
is that such faience was very rare and we have simply failed to encounter an
example to date. The copper-based red glass is not too common either,
especially before Roman times, as anyone familiar with the relevant technical
literature must be well aware.

We have analysed a few brownish objects of high copper and low iron and
manganese concentrations, but they differ in several respects from the
sealing-wax red glasses. Not only are they far removed from the red end of
the spectrum, but they have very little lead or sulphur, in contrast with most
glasses coloured by Cu_2O.[21,26] One group of such glazes is represented by the
brown triangular inlays, still _in situ_, in a 1st Dynasty wooden casket from
the tomb of Semerkhet (E.138+1255). These inlays look olive-green under
strong illumination and may simply represent very dark green against a brown
ground.

The few copper-rich low-iron low-manganese faience objects may have a
history similar to some of the Type I copper-rich purple ones discussed in
Section 7 of this Chapter. They may represent unintentional reduction of
faience intended as blue or green. Certainly none of them resemble in colour
the "sealing-wax" red glass produced by reduced copper. For example, a brown
bead (1890.770) from the tomb of Maket contains 8.5% CuO, 0.86% Fe_2O_3 and no
manganese or lead, and its colour could best be described as "dirty brown".
Somewhat more reddish beads containing over 1% CuO and less than 0.5% Fe_2O_3
have been recovered from the "burnt deposit of Tutankhamon" (string U.C.
27901ii), and have certainly been exposed to a conflagration. [151]

Among vessels of the Ptolemaic Period there were several on which brown
and green were parts of a planned design. For example, bowl 1913.799 has
clearly separated brown and green friezes, where the brown is coloured by
Fe_2O_3 and MnO, while the green by CuO. A more interesting example of
polychromy is exhibited by bowl 1913.808, which has a green bottom (0.7% CuO,
0.5% Fe_2O_3 and 0.1% MnO) and sides covered with a mottled brown and green
pattern (0.3% CuO, 2% MnO and 0.6% Fe_2O_3). These examples indicate that in

Ptolemaic times the reducing conditions were controlled so as to prevent
unintentional reduction of copper oxide, or used selectively when reduced iron
was desired.

10. Polychrome Faience

The analysis of polychromatic faience yields data which are not always
easy to interpret. The problem arises from the fact that the manner in which
the different components were applied and the type of glazing process used
influences the degree of contamination of one colour by ingredients originally
introduced with another. If one is primarily concerned with the composition
of the finished product the problem is of little consequence. However, if one
desires to understand the original technology and the composition of the
initial pigments it is essential to know which elements will migrate and under
what circumstances. In general we have found that the migration affects most
strongly the alkali and copper, both of which tend to move outward from
underlying to overlying layers. Lead also presents some problems for it is
capable of spreading laterally over a glazed surface.

A detailed discussion of the manner in which polychrome and monochrome
faience was manufactured at various periods of Egyptian history is reserved
for Appendix A. The brief discussion presented below will deal with the types
of colours, their relative proximity and observed degrees of mixing on faience
of various types.

We have found it convenient to classify the analysed polychrome faience
into five general types by using the expected degree of cross-contamination of
one segment by another as the dividing criterion.

Type 1 has the coloured components on a white or faintly pigmented ground
and separated from each other by several millimeters. Analysis of such glazes
yields a relatively true picture of the principal components of the original
pigment.

Type 2 has little separation between the coloured panels inlaid in a
white ground (or directly into the body material), and if several components
are present side by side a clear demarcation line is visible. The demarcation

line sometimes consists of an indentation separating two non-adhering glazes. In such faience several elements, of which lead is the most important, may diffuse slightly from one component to another, but the problem is not too serious.

Type 3 resembles the preceding one except that the components are inlaid in a heavily pigmented matrix so that both lateral and vertical migration of several elements may occur. The extent of contamination depends on the thickness of the inlaid piece, its permeability, its alkali and water contents, and the length of time spent at elevated temperature. Of the coloured ions copper is the one most likely to penetrate the outside layer.

Type 4 has a pigmented surface with a design painted upon it in some contrasting colour. The design may consist of very thin lines so thoroughly imbedded in the surrounding matrix that the only meaningful result of analysis is the identification of the pigment responsible for the design. We analysed a number of thin black lines, used to sketch lotus flowers upon a blue or green surface, and found that except for the elevated concentration of manganese the composition was virtually indistinguishable from that of the surrounding glaze. On some objects, however, the painted area can be extensive in size and consist of a fairly thick layer of glaze.

Type 5 involves a veined or marbled surface glaze where several pigments are spread in such a manner as to create a continuous spiral or mottled design. Except for some unusual cases, the analysis of such glazes yields the average composition of the combined pigments. Fortunately such faience is rather uncommon, and we have only analysed four specimens.

In reporting the analysis of polychrome faience in Appendix C we made every attempt to describe as fully as possible the segment being analysed, the colour of the underlying ground and of the surrounding areas. Cases where coloured segments are inlaid instead of being painted are clearly indicated, as are instances where colours are intimately mixed. In the next few paragraphs the types of polychromy most common during various periods of Egyptian history are listed.

Except for the accidentally-produced blue-green combinations mentioned several times before no polychrome faience of the Predynastic Period has been seen by us. However, all five types listed above make their appearance during the Archaic Period, but until the 18th Dynasty only combinations of black or brown with blue or green or white seem to have been deliberately applied on Egyptian faience. Designs in other colours may be seen on some Old Kingdom vessels from El Kab, but they show no traces of glaze and have all the appearances of having been painted on a finished but unglazed surface. Among the pigments we identified at least two metal sulphides and these would certainly not have survived a firing.

In Section 4 of this Chapter we noted that combinations of yellow and green have been detected on some pre-18th Dynasty faience. As these glazes exhibit yellow spots or streaks without any discernible pattern their formation must be considered accidental. Equally unintentional are some of the purple colours seen on green or blue. These have already been discussed in Section 7.

The faience of the Archaic period may only be dichromatic, but right from the beginning it shows considerable diversity in the ways that the colours are combined. Royal tombs of the 1st Dynasty have yielded green tiles with black inlaid panels (E.1172) and model vases with raised brown and black spots scattered over a pale green surface (E.658A). From Abydos also comes a rather unusual vessel (E.35) on which strips of alternating brown--green--white colours form a striped spiral design covering the entire surface. The only other object of this type seen by us came from a Middle Kingdom tomb at Abydos and had black and blue colours combined (E.2176). The tradition of applying thick layers of manganese-rich black to bring into prominence some specific features of a model figure also originates from this time period. It is best exemplified by the collar on a model baboon (E.5) and the wings of a model pelican (E.7). Both animals were recovered from the Main Deposit at Hierakonpolis.[160]

The chromatic traditions established during the Archaic Period were carried over, with few changes, into the Old Kingdom. What one sees is greater diversity in the use of black (or brown) to highlight features

reproduced in bas relief and more elaborate hieroglyphic tiles with black
panels inlaid in blue or green. The largest assortment of two-colour faience
came from the Sixth Dynasty Temple at Abydos.

During the First Intermediate Period and the Middle Kingdom faience with
the black painted instead of inlaid becomes more popular. Among the more
common practices we can mention the painting of thick continuous black ribbons
on blue or green tubular beads in a helical pattern (E.E.486A, E.E.486B, et
al.), the covering of the blue or green edges of pedestals and plinths with a
similarly thick black band (E.3285, E.3287), and the endowing of ushabtis and
other human figures with a thick black wig (E.3788, E.2199). In all these
cases the black is applied over blue and never the reverse, and the principal
difference between the background and the black section is the presence of
more manganese in the latter. Other elements present in the background show
up in highly variable concentrations in the black, and as we mentioned
earlier, the thinner the latter glaze the greater the similarity in
composition. As expected, copper and alkali seem most capable of penetrating
even reasonably thick black glazes.

While some of the above-mentioned design features common during the
Middle Kingdom became less popular at later times and died out, the practice
of sketching lotus and other plants in thin black lines over the entire
surfaces of vessels (E.3279, E.3278, E.2288) or other objects (staff-head
E.2172) remained popular for over 2000 years, as did the practice of
scattering faint black spots over the bodies of model leopards, cats and other
animals (E.3281, E.3286, E.3302F). One sees such lotus designs on the
charming hippopotami found in so many of the world's museums.

The lines and the spots are part of what we earlier called Type 4
polychrome faience. In many instances these features were so small and
completely submerged in the enveloping blue or green glaze that no attempt was
made to analyse them except to see whether manganese or iron were the
principal pigments. For example, if one looks at a relatively large spot on
object No. 120-107-178 in Appendix C, one can see that the black spot and the
surrounding blue glaze are virtually indistinguishable except for the presence
of manganese in the former and its absence in the latter. The results are in

agreement with the experiments reported in Appendix A which showed that manganese does not migrate very far. It is obvious, that this is at least one feature which must have made this element the principal pigment in just about all thinly outlined designs for almost 3000 years. It was less likely to diffuse into the surrounding glaze and blur the original sharp design lines.

The traditions perfected during the Middle Kingdom were continued during the Second Intermediate Period and into the Early 18th Dynasty with no noticeable improvements in quality. The most interesting object of the period is a blue Bes pendant (1926.176A) from grave 1806 at Abydos, a site dated to the start of the 18th Dynasty. The pendant consists of a blue Bes figure with a clear green socket attached to its head. Examination of the object suggests that this apparently deliberate combination of blue and green (both based on copper but of distinctly different overall composition) was achieved by fusing two separately made components, the way glass is worked, but at a time when it is believed glassmaking was still unknown in Egypt.[28,145,146] Of course, there is always the possibility that the dating of grave 1806 at Abydos is in error.

With the introduction of cobalt and lead antimonate into the artistic repertoire of the Egyptians the dichromy prevalent until now could be supplemented with true polychromy. While black on blue or green always remained the most popular combination, as one can see on the many menats from various sites of the 18th-20th Dynasties, just about all conceivable colour combinations begin to appear on objects dated to the time of Amenhotep III. Tell el-Amarna has yielded faience with up to six different colours in close proximity, with all five types mentioned at the beginning of this Section represented and often on the same tile simultaneously.

Among the more interesting innovations of the Late 18th Dynasty are tubes (U.C.587), dishes (1893.1-41(472)) and menats (1893.1-41(947)) with copper coloured green or turquoise-blue inscriptions set into a cobalt coloured indigo or violet-blue ground. Many such objects have a heavily pigmented body too. Faience with the reverse combination, indigo letters set in green or paler blue ground, was also manufactured during this period (Kohl tube 1889.148). Cobalt apparently shows as little tendency to migrate as manganese so that inscriptions or designs painted in indigo or violet on green or paler

blue (1893.1-41(482)) or in green on violet or indigo ground (bracelet 1924.123), remain as sharp after the firing as the original artist could have desired.

As we pointed out earlier, the Amarna faience is not confined to white, blue, green, black and brown but includes a whole spectrum of colours. It is a period when true polychromy has come of age. Among the more popular inlaid colour combinations (all Types 2 or 3) are: green and yellow-orange (1924.115a), green and reddish brown (1924.128), yellow and brown (1893.1-41(449D)), yellow and violet-purple set in white (1893.1-41(476)), and red and violet set in blue (1924.77). Some of the Amarna faience displays extremely elaborate checkered and other designs involving up to five interlocking colours. For example, one tile (1943.80) has violet, yellow, brown, green and white colours, all in close proximity; a fluted indigo-blue vessel (1924.114) has a smooth inner surface decorated in four colours with a mosaic of concentric diamonds separated by a dotted blue ground.

A novel and interesting use of polychromy may be seen in the manufacture of faience finger rings topped by fused imitation gem-stones also made of faience. The ring itself is usually made of yellow faience coloured by lead antimonate, undoubtedly in imitation of gold, with red (ruby?), blue (lapis lazuli?) or "stones" of other colours integrated into the bezel (e.g. 1934.264). From Tell el-Amarna also comes a very interesting ring (1932.1132), in which a white and two iron-rich red imitation stones are mounted on an elaborate open-work cobalt blue bezel and the latter is fused to a green copper-coloured band.

Just about all the colours enumerated above and others may also be found on painted tiles of the period. The designs were executed in careful brush strokes as an attempt was made to represent plants (lotus on tiles 1924.75 and 1924.115b), animals (a bird on 1924.113C), and entire pastoral scenes (grazing cattle and the surrounding landscape on tiles 1929.407a/b) in their natural colours and with the utmost realism.

The extent of elemental mixing between adjacent areas of different colours may in part be deduced from the data tabulated in Appendix C. As we

noted earlier, among the colourant ions cobalt and manganese migrate the least, copper the most. Some diffusion is also to be expected from the alkali ions and lead. After the Amarna Period came to a close, even the most extravagant polychrome faience produced during the next thousand years looks subdued compared to the exuberance of the material recovered from Tell el-Amarna. Here again one is reminded how atypical was the Egyptian faience of the late 18th Dynasty and therefore how erroneous were generalizations based on the earlier analyses of faience of the period. Between the 19th and 30th Dynasties the fraction of faience decorated in colours other than black, blue or green declined dramatically, and the decline was not fully reversed until the Ptolemaic Period.

Among the more interesting examples of Ramesside polychrome faience are the rectangular and circular tiles recovered from the palace of Ramesses III at Tell el-Yahudiya.[161,162] The former have bevelled edges and are decorated with either a continuous horizontal frieze of lotus flowers and leaves (1871.34C/D) or small rosettes enclosed in concentric circles (1871.34B). The tiles combine colours such as white, ochre, bright yellow, lemon yellow, blue, indigo, violet, lavender, red and brown.[162] Each tile contains both painted and inlaid colour sections.

The second and apparently novel tile type consists of large circular inlay discs glazed over the entire surface and decorated with a large rosette that covers the entire face.[161] None of the coloured components are inlaid in the disc. All of the examples examined by us had white petals and a protruding yellow boss at the center (1871.34E,F,G). The petals are outlined and surrounded by brown, greyish-violet or purple glaze which is applied over the basic white glaze and shows evidence of dripping on the edges of the discs. The central knob is coloured by lead antimonate, and the presence of lead (but not antimony) in adjoining areas may be the result of diffusion. No such problem affects the white petals, whose outlines remain sharp, for the surrounding zones are coloured with manganese-rich cobalt.

Between the 20th and 25th Dynasties both the quantity and the quality of polychrome faience declined dramatically. The unavailability of cobalt and antimony undoubtedly contributed to the decline, but cannot be blamed for it

entirely. The faience produced during the Third Intermediate Period is
inferior in quality to material manufactured prior to the 18th Dynasty, times
during which the oxides of manganese, iron and copper were also the sole
pigments.

Polychrome faience becomes more common and varied as both antimony and
cobalt reappear in Egypt during the 26th Dynasty. In comparison with faience
of the Amarna period the objects of the Late Period look subdued, for bright
strongly contrasting colours were avoided. Among the best examples of the new
polychrome faience are the polymorphic vessels of the Saite Period (aryballos
1911.358 and locust 1910.784 from Memphis; hedgehog 1872.298 from Thebes). By
applying one or several layers of properly selected glazing mixtures in
appropriate places several shades of green, blue, yellow and grey were blended
harmoniously on most such vessels. One interesting feature of the vessels
analysed by us are the large brown spots sprinkled on all three of them.
Examination of data tabulated in Appendix C reveals that the basic colour
distinctions were achieved by manipulating the relative concentrations of
manganese, iron, cobalt, copper, lead and antimony. Not unexpectedly, lead
permeates the entire surface and shows up at varying concentrations in all
colours. We must point out at this time that a foreign origin has been
postulated by some for these Saite vessels. The stylistic affinities of these
vessels with similar faience recovered from other areas of the Eastern
Mediterranean are treated in a recent study of Archaic Greek faience by
Virginia Webb.[163]

Cobalt, which played such an important role in the polychrome faience of
the New Kingdom, was used quite sparingly until the end of the Late Period.
As a matter of fact, it was never used with the same abandon as copper or
manganese, a possible indication of its relative scarcity. Even during
periods of greatest availability most went into decorative purposes,
especially when a design had to be imposed on a blue ground. The number of
objects with an entire surface coloured by cobalt must never have been great
for they account for less than half the cobalt-containing specimens examined
by us. This may be seen in Figure 21, where the relative proportions of
copper-coloured and cobalt-coloured glazes at various time periods are
compared.

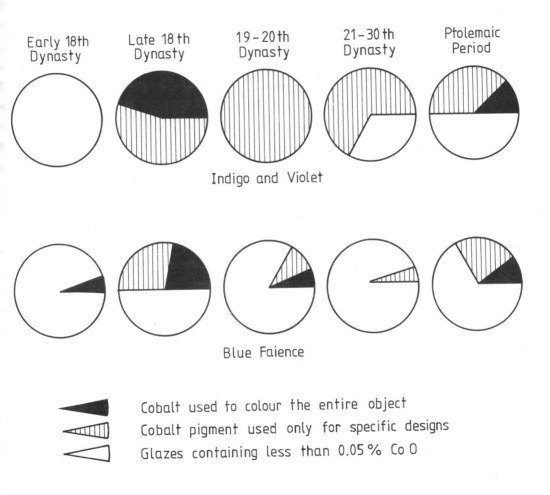

FRACTION OF GLAZES
COLOURED BY C_oO

Early 18th Dynasty Late 18th Dynasty 19-20th Dynasty 21-30th Dynasty Ptolemaic Period

Indigo and Violet

Blue Faience

Cobalt used to colour the entire object
Cobalt pigment used only for specific designs
Glazes containing less than 0.05% Co O

Figure 21. The relative proportions of blue and violet faience covered entirely or only in parts by cobalt-containing glazes.

During the Ptolemaic Period an indigo-violet paste of unusually high cobalt concentration is used to fill incised designs on dark blue ground. Sometimes the incisions are shallow and require little material, as in the case of the grooves outlining the feathers of the scarab wings from Abydos (1912.533) and the lines across the model Djed pillar, also from Abydos (1912.529). At other times wider and deeper cavities had to be filled, as in the case of the model cartouche of Philip Arrhidaeus from Tukh el Qaramus (1888.239), where incised hieroglyphs were filled with a glazing mixture containing over 1.5% CoO. The Djed pillar noted above provides an interesting example of early Ptolemaic polychromy. In addition to the cobalt-filled horizontal lines, the Atef crown on top of the pillar rests on black ram's horns coloured black with an Fe/Mn-rich glaze and is framed by cobalt-coloured feathers. The central part of the crown and the pillar itself are coloured by Egyptian Blue of the finest quality.

The early Ptolemaic models and plaques discussed above resemble some of the products of the Amarna factories. The same cannot be said of the huge volume of later polychrome faience recovered from Memphis. The range of colours, the boldness of design, and the clever ways in which colour distinctions are maintained will be treated more fully in Appendix A, but a few remarks are in order here.

One of the most obvious differences between the Amarna and Ptolemaic faience is the fact that the inlay technique is used much less frequently in the latter. It is obvious that to avoid possible spilling of colours the New Kingdom craftsmen pursued a safer course of action by combining prefabricated panels to create the final design in the manner of a mosaic. The Ptolemaic artists were confident enough of their pigments, and obviously aware which ones would and which ones would not run, to create intricate designs by applying pigments in several layers and by manipulating their thickness. One way in which this was facilitated was to have some parts recessed and others raised.

The recessed and raised parts were usually coated with pigments of different colours. Among the combinations seen on the Memphite faience analysed by us were: black and blue on 1910.557(1); dusty grey and two shades

of blue on 1909.1050; grey and brown on 1913.800A and 1910.549(1); brown and white on 1909.1044; yellow, and several shades of green and blue on 1909.1042, 1910.551(1,2), 1910.559(1), and 1910.553; brown, grey and green on 1913.799; indigo blue and emerald green on 1910.546(2) and 1909.1050. On some of the vessels polychromy involved carefully controlled shadings of the same basic colour: blue-green and yellow-green on 1888.1455; dark and pale blue on E.4620, E.4621 and 1949.748.

The recessed and raised parts are so bold on some vessels that the design is actually in relief and the glazing layers show even greater differences in depth. For example, a greyish-green human figure in relief over creamy-yellow surface of 1909.1056; a protruding green Bes head surrounded by recessed and raised blue and green designs sprinkled with yellow knobs on 1924.45. Of course, as an extreme case of bold relief en creux we can cite the Royal Oinochai,[164] in which the female figures attached to the outside of the vessel are raised to almost half the thickness of a fully three-dimensional statue. The examples examined (E.3720 from Naucratis, 1909.347 from Alexandria, and 1892.1025 of unknown provenance) were coloured green by copper (small amounts of lead antimonate have been detected too), had black hair coloured by cobalt-containing iron at very high concentrations, and had creamy-yellow faces.

Among the more unusual examples of polychrome faience recovered from Memphis are two specimens in which an attempt was made to imitate the chromatic texture of natural veined rocks. One of them (1913.808) was a bowl with a green bottom and sides covered with a serpentine design of interlocking brown and green wavy lines. The other bowl (1913.804) was uniformly marbled in white and grey, with grey veins of variable thickness connecting the larger patches of grey, all in perfect imitation of some natural coloured marbles. The grey portions are coloured by Mn-free Fe_3O_4 containing a substantial amount of CoO. In both vessels it is difficult to find a chemical distinction between the body material and the outside layer, except that the latter is more compact and glassier.

No discussion of polychrome faience would be complete without a few words about the artistic treatment of wigs and anatomical features of ushabtis and other anthropoid figures. For most of Egyptian history black was the

preferred colour for wigs, eyes and other facial features. In the case of ushabtis, for colouring the protruding hands, the hand-held implements, the seed bag on the back and the inscriptions, black was also the colour of first choice with brown coming second. Of course, there are many monochrome ushabtis and the features that would have been coloured are simply incised or outlined in positive relief.

As we noted in Section 9 of this Chapter, the browns seen on Egyptian faience come in many shades and some of them look as if they were ruined blacks. However, the distinctive light brown used in lieu of black on some of the green (1889.852) and white (1879.272) Ramesside ushabtis was undoubtedly meant to reproduce more faithfully the true colour of dark skin and hair. Unmistakably deliberate was the choice of colours for certain white ushabtis on which the Mn:Fe ratio was manipulated to distinguish clearly between a dark brown wig and a light brown skin of the hands and face (e.g., 1923.605). Equally intentional was the use of brown to colour the hair bands seen on wigs of many colours. This apparent imitation of leather may be seen on blue, green and black wigs of the Ramesside and Third Intermediate Periods (E.3589, E.3586).

Now, black or brown hair looks perfectly natural, while figures with hair of the same colour as the rest of the body and clothing are understandable too, for they imply an attempt to save time and labour. However, the treatment of skin and hair on several of the anthropoid figures of the 1st Millennium B.C. presents some interesting chemical problems. For example, a green statuette from the 25th Dynasty temple at Kafr Ammar (1912.607) has a distinctly blue wig the composition of which differs very little from that of the green body except in its considerably higher calcium content. The wig does contain slightly more manganese but not nearly enough to make it black, and if the latter had been the intended colour why was more manganese not added to the batch? If the elevated calcium concentration was responsible for accidentally producing Egyptian blue, why was that much more CaO (over 6%) used in the wig?

Black was probably the intended colour of the violet-grey wigs of certain blue ushabtis of the Third Intermediate Period (Queens College Loan Nos. 283-

285). The wigs, the eyes, and other like-coloured decorations are clearly distinguishable from the rest of the body by their higher concentrations of manganese and iron. It would appear that the levels of manganese were not high enough (ca. 1%), or the glaze too thin to prevent the concentrated CuO (ca. 3%) from penetrating the glaze and giving it its peculiar tint. Of course, the furnace conditions or some of the lighter elements not detected by XRF might have contributed to preventing the formation of the black Mn_3O_4/Fe_3O_4 pigment.

It is much more difficult to attribute to a manufacturing error the bright violet-purple wigs and inscriptions of certain dark blue ushabtis of the 30th Dynasty, since cobalt is responsible for the colour. Similarities in the composition of the copper-coloured blue bodies and the cobalt-coloured wigs suggest that the four specimens analysed by us (E.3565, E.3566, 1956.18, 1956.19) came from the same workshop, but that more than one batch of pigment was used since two specimens contain virtually no manganese and two levels of 0.1-0.2% MnO.

The few Ptolemaic heads examined by us show no clear colour preference, although in most an attempt was made to make the face and hair conform to the demands of human anatomy. All of the Royal Oinochai had black hair, coloured by Mn-free Fe_3O_4 supplemented by cobalt, but on some the face is creamy (1892.1025) while on others it is of the same green colour as the rest of the figure (1909.347). Different workshops are indicated.

One rather interesting example of polychrome faience of the Ptolemaic Period is a female head with a yellowish face and purple-red hair covered with a white scarf. Calcium/lead antimonate are responsible for the skin colour and cobalt-free manganese for the hair. It is tempting to see in this fragment (1892.1028) a fairly successful attempt to reproduce the head of an olive-skinned woman with henna-dyed hair. Henna has been used as a hair dye all over the Near East for thousands of years.

It would appear that a less serious attempt, if any, was made to imitate nature in manufacturing another female head, 1968.104, which has been attributed to the Late Ptolemaic or Early Roman Period. The copper-coloured

blue hair clashes with a deep yellow skin showing patches of green and purple. Yellow must have been the underlying ground colour, since high concentrations of lead antimonate may be found over the entire surface, regardless of colour. The hair does contain almost as much iron as copper and some manganese, so maybe we have here another failed black glaze.

That some of the unusual hair colours may have been dictated by aesthetic considerations is suggested by the fact that seldom was any attempt made to colour or even outline the hair or other features of the ushabtis of the Saite Period, at a time when all the pigments utilized during the 18th Dynasty were again available in Egypt. As a matter of fact, monochrome ushabtis remained in vogue during most of the Late Period.

The design features of a number of the polychrome objects discussed in this chapter are illustrated in black and white in Appendix A.

IV. THE COMPOSITION OF FAIENCE BODIES

1. Types of Body Material

In his detailed discussion of Egyptian faience, Lucas[165] recognized the existence of several types of body material which could be grouped into two broad classes. One, in which crushed quartz or sand of varying degrees of purity and coarseness, forms the core of what the author labelled "ordinary faience", and another in which the core shows evidence of having been deliberately coloured and which constitutes the interior of Variants B, C and D. Faience in which a white layer of finely ground quartz was interposed between the glaze and the bulk body material was given the name of Variant A.

Many of the objects studied by us were not damaged severely enough to reveal the nature of the core, but we were able to observe the colour of the body material in over half the analysed objects. The relative proportions of various body types among faience specimens of different time periods are listed in Table XXX.

Visual recognition of Variant A is relatively easy but the same is not always true of the other three variants. Since cobalt is not found in any significant quantities in either the sand or any other ingredients introduced to bind the body, we consider the presence of CoO in excess of 0.05% as evidence of deliberate pigmentation. Similarly, the presence of MnO in excess of 0.5%, well above what might be expected from sand[26,27] is also treated as intentional.

However, if either iron or copper are responsible for the colour of the body, distinguishing variants B, C or D from ordinary faience proves somewhat more difficult. Although the ingredients normally used for the production of a solid core tend to be free of copper had the object been made by one of the so-called "self-glazing" processes,[7-9] incomplete efflorescence to the surface would have left highly variable residual amounts of CuO.

The question arises how much copper should be considered more than accidental. Lucas offers little guidance in this matter and the data tabulated in his Appendix[1] show bodies containing as little as 0.4% CuO

T A B L E XXX

DISTRIBUTION OF FAIENCE BODIES ACCORDING TO
COLOR, TYPE AND PERIOD OF MANUFACTURE

TIME PERIOD	ORDINARY FAIENCE				VARIANT A	VARIANTS B, C, D
	White or Creamy	Shades of Grey	Brown	Yellow or Pink		
Predynastic	9 (90%)	-	1	-	-	-
Dyn. 1-2	19 (48%)	8	4	1	3	5
Dyn. 3-6	17 (45%)	5	4	3	4	5
Dyn. 7-10	12 (27%)	5	23	1	-	4
Dyn. 11-12	27 (44%)	10	10	2	7	6
Dyn. 13-17	11 (27%)	5	17	-	1	7
Early 18th	13 (35%)	13	3	-	2	6
Late 18th	19 (35%)	13	1	-	3	18
Dyn. 19-20	23 (47%)	2	-	2	10	12
Dyn. 21-25	16 (70%)	3	1	-	2	1
Dyn. 26-30	10 (53%)	5	-	-	2	2
Ptolemaic	22 (73%)	-	1	2	4	1
TOTAL	198 (44%)	69	65	11	38	67

Note 1. The term "ordinary" and the variants conform to the definitions given by Lucas (see ref. 165).

Note 2. The numbers in parentheses represent percentage of the total sample for the period.

Note 3. All the pink-bodied Ramesside faience from Serabit el Khadim seen by us consisted of Variant A material.

classified as Variant D. In our opinion the two specimens containing 0.4 and 0.5% CuO, respectively (ref. 1, p. 475, Nos. 3 and 4), should have been listed with others designated as "ordinary" faience, if the criteria enunciated by the author are to be adhered to.[165]

The four objects listed as "Faience Variant D" were analysed in the 19th century by Le Chatelier and it is very unlikely that Lucas ever had an opportunity of personally examining the faience from which the body specimens came. However, the original description of the two low-copper specimens virtually rules out their being Variant D. Thus, one (Saite faience from Saqqara), is described as: "white, sandy, coarse-grained and soft", the other (Ptolemaic faience from Saqqara) as: "Very fine grained and soft".[165,167] Only the other two, containing considerably more copper and manganese, have been described as being "hard" and distinctly coloured, as expected from a Variant D.

After examining the published and our own data we have decided to add an analytical criterion for distinguishing copper-coloured Variant D from ordinary faience. The body material of such faience should have at least 1% CuO and/or a glaze with a comparable copper concentration (i.e. not much greater than two-fold). The subject of Variant D faience will be taken up more fully in Section 5 of this Chapter.

Brown and grey faience bodies in which the oxides of iron were solely responsible for the colour were left in the ordinary faience group if the oxide concentrations fell comfortably within the range published for Egyptian sands and the glaze had a colour other than black or red. We found no evidence to contradict Lucas' arguments that distinct variants of faience were being produced by the deliberate addition of oxides of iron to the other ingredients of the body. Yet one is still faced with the question: how many of the grey-bodied black, and red-bodied red faience are the result of such mixing? Might not some of the red bodies simply been made by selecting and grinding pink sandstone or some of the iron-rich sands found abundantly in Egypt? Possible instances of such a selection will be discussed in subsequent sections.

Over a third of the faience body materials analysed by X-ray fluorescence were also subjected to Atomic Absorption Analysis for the purpose of determining their soda, magnesia and alumina contents. In addition to the three substances listed above, K_2O and CaO were also re-measured to obtain an independent check on the values determined by XRF. Both sets of analyses are presented in Table XXXI. The description of each object is followed by two rows of numbers. The first row lists the results of the X-ray fluorescence analysis, the second the values determined by the atomic absorption method.

[handwritten marginalia, reading approximately: "Some offwhite faience - white color-irregularities of the impurities of the sand - effects of the sand - pore or impure - on the texture. only the addition of white stain affected the color severely."]

2. Ordinary Faience

It is regrettable that too often when articles are written on the subject of Egyptian faience one still finds statements to the effect that powdered quartz was the _normal_ raw material for the manufacture of faience. Our analytical data and microscopic observations confirm the conclusions of Lucas[1] and others[2,9] that the use of raw sand, and often fairly dirty sand, was the rule. Few faience bodies show evidence of having been made from pure powdered quartz. The advantage of using impure sand is that it often contains enough calcium to require no further addition of limestone. The disadvantage is that a brown or grey ground may ruin the desired colour of the finished product. The production of Variant A offers one solution to the latter problem. After Kiefer and Allibert examined a number of faience bodies under the microscope, they also concluded on the basis of the shape and size of the quartz grains that sand and not crushed quartz was the preferred raw material.[9] Very little statistical data is available regarding the frequency with which some effort was made to either use quartz or select and purify high-silica sands. Only the rough survey of some Archaic faience from the Cairo Museum reported by Lucas (ref. 1, p. 157) gives us a clue of what was done at this very early period of Egyptian history. No more than 20% of the faience bodies could be termed as white, while the majority were distinctly brown or grey, a clear indication of the presence of oxides or iron.

T A B L E XXXI

PERCENT COMPOSITION OF FAIENCE BODIES SUBJECTED TO
X-RAY FLUORESCENCE AND ATOMIC ABSORPTION ANALYSES

Oxides of: Si K Ca Mn Fe Co Ni Cu Zn Pb Sn Sb
 Na Mg Al --

White core of prolate bead U.C.4407,Gerzean Period,Naqada,grave 1567
 XRF Data: 96.2 0.22 0.79 0.00 0.16 0.00 0.00 0.02 0.00 0.00 0.00 0.00
0.46 0.16 0.40 0.00 0.56

Pale blue core of blue vase E.1578,Dyn.I(Djer),Abydos,tomb O
 XRF Data: 85.1 0.53 9.44 0.02 0.77 0.01 0.01 1.39 0.01 0.00 0.22 0.00
2.43 1.76 1.09 0.33 9.79

Pale blue core of blue vase E.1577,Dyn.I(Djer),Abydos,tomb O
 XRF Data: 83.6 0.23 10.71 0.03 0.66 0.01 0.01 1.25 0.03 0.00 0.18 0.00
2.91 2.02 0.86 0.42 9.56

Blue-green core of blue-green vase E.3182,Dyn.I(Udimu),Abydos,tomb T
 XRF Data: 84.7 0.17 9.58 0.00 0.68 0.01 0.01 1.24 0.01 0.00 0.22 0.00
3.36 1.46 0.89 0.39 9.29

White core of green model vase E.42,Dyn.I-II,Abydos,temple area
 XRF Data: 94.9 0.00 0.76 0.09 0.34 0.00 0.00 0.01 0.02 0.00 0.00 0.00
0.26 0.15 0.35 0.00 0.59

Red core of green jar lid E.4006,Dyn.I-II,Hierakonpolis,Main Deposit
 XRF Data: 92.6 0.34 0.29 0.01 0.91 0.00 0.00 0.00 0.00 0.00 0.00 0.00
0.08 0.04 2.12 0.12 0.28

White core of model vase E.658A,Dyn.II(Kha-Sekhemwy),Abydos,tomb V
 XRF Data: 95.3 0.12 0.35 0.14 0.36 0.01 0.00 0.01 0.00 0.00 0.00 0.00
0.27 0.07 0.42 0.08 0.31

White core of green tile 1954.670b,Dyn.III,Saqqara,Pyramid of Djoser
 XRF Data: 95.0 0.19 0.49 0.04 0.18 0.00 0.00 0.01 0.00 0.00 0.00 0.00
1.05 0.09 0.36 0.05 0.43

White core of green tile 1937.115,Dyn.III,Saqqara,tomb of Djoser
 XRF Data: 94.4 0.08 1.15 0.16 0.29 0.00 0.00 0.07 0.00 0.00 0.00 0.00
0.27 0.08 0.30 0.14 0.73

White core of inlay E.1765F,Dyn.VI,Abydos,Sixth Dynasty Temple
 XRF Data: 95.0 0.00 0.24 0.07 0.14 0.00 0.07 0.00 0.00 0.00 0.00 0.00
0.48 0.00 0.26 0.00 0.00

Yellow core of blue hippopotamus E.1784,First I.P.,Mahasna,grave M560
 XRF Data: 93.6 0.36 1.43 0.00 1.04 0.00 0.00 0.14 0.00 0.00 0.00 0.00
0.31 0.33 0.74 0.38 1.22

T A B L E XXXI (Continued)

PERCENT COMPOSITION OF FAIENCE BODIES SUBJECTED TO
X-RAY FLUORESCENCE AND ATOMIC ABSORPTION ANALYSES

Oxides of:	Si	K	Ca	Mn	Fe	Co	Ni	Cu	Zn	Pb	Sn	Sb
Na	Mg	Al										

White core of blue model calf 1914.759,Dyn.XI,Haraga,grave 530
 XRF Data: 94.8 0.49 1.20 0.09 0.26 0.00 0.01 0.32 0.02 0.00 0.00 0.00
5.39 0.08 0.26 0.42 1.34

White core of blue staff-head 1914.755,Dyn.XI,Haraga,grave 530
 XRF Data: 96.1 0.31 0.50 0.23 0.28 0.00 0.00 0.37 0.01 0.00 0.00 0.00
0.75 0.13 0.36 0.36 0.81

White core of blue bowl E.2288,Middle Kingdom,Beni Hasan,tomb 294
 XRF Data: 94.1 0.24 1.14 0.05 0.17 0.00 0.00 0.12 0.03 0.00 0.00 0.00
0.13 0.13 1.29 0.17 1.34

White core of model grapes E.3289,Middle Kingdom,Abydos,tomb 416
 XRF Data: 94.0 0.47 0.91 0.11 0.24 0.00 0.05 0.14 0.01 0.00 0.00 0.00
0.40 0.07 0.26 0.39 1.12

Grey core of blue model leopard E.3281,Middle Kingdom,Abydos,tomb 416
 XRF Data: 94.9 1.17 1.23 0.28 0.57 0.00 0.00 0.65 0.01 0.00 0.01 0.01
0.91 0.13 0.45 0.86 1.26

Bluish core of model leopard E.3286,Middle Kingdom,Abydos,tomb 416
 XRF Data: 93.1 0.68 1.43 0.09 0.63 0.00 0.00 0.42 0.01 0.00 0.00 0.00
1.16 0.17 0.45 0.65 1.51

Brownish core of blue vase E.3279,Middle Kingdom,Abydos,tomb 416
 XRF Data: 92.2 0.24 2.80 0.12 0.58 0.00 0.00 0.26 0.02 0.00 0.00 0.00
0.59 0.15 0.36 0.31 2.85

White core of green jar-lid E.2150B,Dyn.XII,el Kab,grave 60
 XRF Data: 95.8 0.00 0.41 0.03 0.12 0.00 0.00 0.30 0.00 0.00 0.00 0.00
0.16 0.60 0.26 0.02 0.38

Grey core of green bead 1925.493A,Second I.P.,Badari,pan grave 5478
 XRF Data: 94.8 0.30 1.75 0.08 0.24 0.00 0.00 0.18 0.00 0.00 0.00 0.00
0.48 0.11 0.30 0.00 1.30

White core of menat E.2729,Dyn.XVIII (Hatshepsut),Deir el Bahari
 XRF Data: 95.9 0.33 0.38 0.05 0.23 0.01 0.00 0.04 0.00 0.00 0.00 0.00
0.27 0.00 0.52 0.25 0.30

Grey core of sistrum U.C.29145,Dyn.XVIII,temple of Tuthmosis IV,Thebes
 XRF Data: 95.8 0.23 1.06 0.02 0.25 0.00 0.00 0.72 0.00 0.01 0.04 0.01
0.28 0.17 0.00 0.14 0.78

T A B L E XXXI (Continued)

PERCENT COMPOSITION OF FAIENCE BODIES SUBJECTED TO X-RAY FLUORESCENCE AND ATOMIC ABSORPTION ANALYSES

Oxides of:	Si	K	Ca	Mn	Fe	Co	Ni	Cu	Zn	Pb	Sn	Sb
Na	Mg	Al										

Grey core of kohl tube U.C.587,Dyn.XVIII,temple of Amenhotep II,Thebes
XRF Data: 92.1 0.96 1.83 0.28 0.68 0.25 0.16 0.00 0.32 0.01 0.00 0.01
3.85 1.00 2.83 0.70 1.17

Blue core of blue vase 1893.1-41(471),Dyn.XVIII,Tell el-Amarna
XRF Data: 89.7 0.77 1.49 0.51 0.89 0.09 0.07 0.92 0.16 0.00 0.04 0.02
2.70 0.90 2.08 0.55 1.37

Blue core of blue-green bowl 1893.1-41(472),Dyn.XVIII,Tell el-Amarna
XRF Data: 94.5 0.34 1.02 0.16 0.38 0.16 0.08 0.01 0.06 0.00 0.00 0.00
1.13 0.64 1.25 0.27 0.81

Blue core of green sistrum 1893.4-41(945),Dyn.XVIII,Tell el-Amarna
XRF Data: 90.1 0.67 2.43 0.31 0.58 0.45 0.27 0.00 0.24 0.00 0.00 0.00
3.04 0.86 2.62 0.65 1.73

White core of tile 1893.1-41(448F),Dyn.XVIII,Tell el-Amarna,Great palace
XRF Data: 95.4 0.22 0.92 0.11 0.30 0.00 0.00 0.00 0.04 0.00 0.00 0.00
0.29 0.15 0.37 0.15 0.84

White core of tile 1936.637,Dyn.XVIII,Tell el-Amarna,Great palace
XRF Data: 95.8 0.17 0.46 0.09 0.27 0.00 0.00 0.00 0.03 0.00 0.00 0.00
0.15 0.03 0.17 0.03 0.30

Bluish core of vase 1924.114,Dyn.XVIII,Tell el-Amarna,house M50.33
XRF Data: 86.7 0.72 0.96 0.53 1.66 0.23 0.10 0.00 0.31 0.00 0.01 0.03
3.90 1.24 3.58 0.52 0.91

Blue core of blue crown 1931.511,Dyn.XVIII,Tell el-Amarna,house T.34.1
XRF Data: 92.9 0.26 0.50 0.24 0.37 0.15 0.11 0.00 0.14 0.00 0.00 0.00
2.32 0.66 2.04 0.28 0.64

White core of polychrome tile 1942.80,Dyn.XVIII,Tell el-Amarna
XRF Data: 92.8 0.11 1.54 0.10 0.15 0.01 0.02 0.00 0.02 0.00 0.00 0.00
0.30 1.00 0.36 0.16 1.62

Grey core of violet jar-lid 1893.1-41(481),Dyn.XVIII,Tell el-Amarna
XRF Data: 93.6 1.20 1.21 0.40 0.65 0.17 0.09 0.03 0.20 0.00 0.00 0.00
3.77 0.96 2.57 0.86 1.26

Blue core of violet statue 1893.1-41(439),Dyn.XVIII,Tell el-Amarna
XRF Data: 91.3 0.41 0.88 0.27 1.28 0.18 0.12 0.00 0.26 0.00 0.02 0.04
3.45 1.33 4.08 0.36 1.01

T A B L E XXXI (Continued)

PERCENT COMPOSITION OF FAIENCE BODIES SUBJECTED TO
X-RAY FLUORESCENCE AND ATOMIC ABSORPTION ANALYSES

Oxides of: Si K Ca Mn Fe Co Ni Cu Zn Pb Sn Sb
 Na Mg Al ---

Greyish core of blue model grapes 1921.1156,Dyn.XVIII,Tell el-Amarna
 XRF Data: 87.5 0.54 2.31 0.07 0.62 0.03 0.01 0.15 0.02 0.01 0.00 0.00
1.08 0.73 1.29 0.33 2.60

White core of polychrome vase 1942.77,Dyn.XVIII,Tell el-Amarna
 XRF Data: 95.1 0.55 0.47 0.01 0.13 0.00 0.01 0.36 0.02 0.00 0.00 0.00
1.24 0.08 0.23 0.30 0.50

Blue spot embedded in white core of vase 1942.77,Dyn.XVIII,Tell el-Amarna
 XRF Data: 92.1 0.23 0.90 0.00 0.17 0.04 0.01 0.35 0.00 0.00 0.00 0.00
1.16 0.02 5.30 0.33 0.90

Red core of red inlay 1936.635d,Dyn.XVIII,Tell el-Amarna
 XRF Data: 84.5 1.44 1.68 0.00 6.00 0.00 0.00 0.00 0.00 0.00 0.00 0.00
0.94 0.27 2.31 0.45 0.71

White core of vase 1911.614B,Dyn.XIX,Serabit el Khadim,temple of Hathor
 XRF Data: 94.6 0.05 0.31 0.07 0.28 0.00 0.00 0.09 0.05 0.00 0.00 0.00
0.24 0.07 0.26 0.11 0.34

Blue core,uraeus 1871.34A,Dyn.XX,Tell el-Yahudiya,palace of Ramesses III
 XRF Data: 91.7 0.39 1.96 0.73 1.32 0.00 0.07 1.13 0.01 0.00 0.14 0.01
0.89 0.58 1.29 0.36 1.90

Creamy core,tile 1871.34D,Dyn.XX,Tell el-Yahudiya,palace of Ramesses III
 XRF Data: 94.8 0.00 1.16 0.06 0.15 0.00 0.00 0.03 0.06 0.00 0.00 0.00
0.11 0.06 0.20 0.07 0.87

Pink core of vessel E.3410,Dyn.XX,Serabit el Khadim,temple of Hathor
 XRF Data: 90.2 0.20 1.42 0.12 2.04 0.02 0.00 0.11 0.00 0.00 0.01 0.01
0.78 0.86 0.76 0.22 1.40

White core of green ushabti E.3610,Dyn.XXI-XXIV,Abydos
 XRF Data: 96.9 0.14 0.41 0.07 0.28 0.00 0.00 0.03 0.05 0.00 0.00 0.00
0.27 0.03 0.49 0.19 0.34

White core of green ushabti 1971.1355,Dyn.XXII,provenance unknown
 XRF Data: 92.8 0.06 0.22 0.13 0.59 0.01 0.03 0.05 0.07 0.00 0.00 0.00
0.19 0.03 0.18 0.00 0.25

Creamy core of green ushabti 1971.1357,Dyn.XXVI,provenance unknown
 XRF Data: 93.5 0.20 1.99 0.07 0.40 0.02 0.03 0.07 0.00 0.00 0.00 0.00
0.49 0.22 0.49 0.18 1.83

T A B L E XXXI (Continued)

PERCENT COMPOSITION OF FAIENCE BODIES SUBJECTED TO
X-RAY FLUORESCENCE AND ATOMIC ABSORPTION ANALYSES

Oxides of: Si K Ca Mn Fe Co Ni Cu Zn Pb Sn Sb
 Na Mg Al --

Greenish-grey core of green ushabti 1916.2,Dyn.XXVI,Giza
 XRF Data: 91.4 0.00 2.91 0.08 0.54 0.00 0.00 1.38 0.01 0.00 0.01 0.04
0.40 0.35 0.49 0.07 2.57

Green core,sistrum 1909.1062,Dyn.XXVI-XXX,Memphis,palace of Apries
 XRF Data: 83.9 0.35 4.35 0.02 0.52 0.00 0.01 2.08 0.00 1.61 0.04 0.51
1.54 1.32 0.72 0.46 4.74

White core,head of a woman 1892.1028,Ptolemaic Period,Cairo
 XRF Data: 90.4 0.38 5.44 0.01 0.40 0.00 0.00 0.01 0.01 0.03 0.00 0.00
0.81 0.25 0.76 0.25 5.44

Creamy core of polychrome bowl 1913.803C,Ptolemaic Period,Memphis
 XRF Data: 92.6 0.59 1.02 0.11 0.56 0.00 0.01 0.04 0.00 1.26 0.02 0.21
0.43 0.13 0.62 0.21 0.84

White streak,core of marbled vase 1913.804,Ptolemaic Period,Memphis
 XRF Data: 92.9 0.23 0.76 0.02 0.34 0.00 0.00 0.29 0.02 1.49 0.00 0.35
0.40 0.18 0.38 0.16 1.01

Grey streak,core of marbled vase 1913.804,Ptolemaic Period,Memphis
 XRF Data: 64.4 0.62 3.92 0.00 9.76 0.68 0.00 2.96 0.11 8.32 0.09 0.13
1.89 1.06 2.57 0.51 4.34

Yellow core of polychrome vase 1910.551(2),Ptolemaic Period,Memphis
 XRF Data: 90.5 0.20 1.70 0.00 0.55 0.00 0.01 0.04 0.00 1.83 0.00 0.66
2.53 0.14 0.29 0.31 1.21

White core of lamp 1910.555(2),Ptolemaic Period,Memphis,Kom Hellul kilns
 XRF Data: 94.0 0.24 4.88 0.07 0.42 0.02 0.00 0.12 0.02 0.05 0.01 0.00
0.40 0.36 0.60 0.19 4.48

White core of indigo bowl 1924.119,Roman Period,Tell el-Amarna
 XRF Data: 93.7 0.69 1.70 0.00 0.17 0.00 0.00 0.00 0.02 0.00 0.00 0.00
2.16 1.09 0.87 0.68 1.87

We found a gradation of creamy colours and consequently decided to group all white and off-white bodies together in the first column of Table XXX. It is interesting to note that Lucas' "white" and "slightly yellow" cores represent 47% of the Archaic sample, fairly close to the 48% figure we found for the white and creamy specimens of the same period. The agreement suggests that the proportions are truly representative of the Archaic Period faience.

Table XXX makes it abundantly clear that while "ordinary" faience does account for the bulk of material produced during all periods of Egyptian history, the thoroughness and care with which the sand was selected and purified varied considerably. Not unexpectedly, the least careful selection is seen during the First and Second Intermediate Periods, when more than two-thirds of the objects had brown or grey bodies of iron-rich sand. A significant, though smaller proportion of Middle Kingdom faience have non-white bodies, but now a sizeable fraction are provided with a white coating of quartz powder characteristic of Variant A faience.

The data in Table XXX suggest that the rather low proportion of white bodies during the Eighteenth Dynasty is the result of deliberate preference for Variant D faience, particularly during the Amarna Period. The highest proportion of white cores was observed among objects of the Predynastic and Ptolemaic Periods.

While the iron-rich sands of Egypt usually yield grey or brown cores, occasionally the concentrations and firing conditions are such as to produce other colours. Some rather unusual iron-coloured yellow and orange-red bodies were seen by us in Fourth Dynasty vessels from El Kab (E.381 and E.382 from tomb C). Since we have seen nothing comparable from other contemporary sites in Egypt we suspect that a distinct local source of ferruginous sand (1.5-2.5% Fe_2O_3) served as the raw material for the body. Since the finished vessels were provided with a white surface coat, it is unlikely that better grade sand would have been deliberately mixed with haematite to give a darker ground that was harder to mask.

Another interesting example of red-bodied ordinary faience came from an Archaic Period site at Hierakonpolis (Main Deposit).[160] The nicely moulded

green jar lid (E.4006, shown in Figure 33, Appendix A) has a coarse-grained brick-red body coloured by about 1% Fe_2O_3.

On the whole, the compositions of "ordinary faience" bodies of most time periods fell well within the range of compositions expected for a material made of sand, limestone and natron or plant ash. The median and average compositions are shown in Tables XXXII and XXXIII. The sodium and potassium contents suggest that for most of Egyptian history natron or sodium-rich plant ashes were the dominant source of alkali. Only a very small minority of less than 10% had an excess of K_2O over Na_2O, and even then the excess was not overwhelming.

A number of the ordinary faience bodies contain impurities which could have been introduced with copper into objects made by a self-glazing process. This factor might be responsible for some of the lead found in bodies of the Late and Ptolemaic Periods, when leaded copper scrap appears to have been used extensively (see Sec. 16, Chapter II). However, when the lead approaches copper in concentration and is accompanied by substantial amounts of antimony, deliberate attempt to create a yellow core must be assumed. Examples will be cited in Section 6 of this Chapter.

Lucas, Kuhne and other investigators of Egyptian faience have favoured natron as the most probable source of alkali. Our data are consistent with this assumption and the presence of highly variable amounts of sulphur accords well with the fact that most Egyptian natron is heavily contaminated with Na_2SO_4. The only problem arises with the many low-sulphur bodies of the New Kingdom and the Late Period, which do not show a corresponding rise in the concentration of potassium (see Table XXXIII). It would appear that either a preference was shown for the ashes of plants that happen to be rich in sodium, or that low-sulphate natron deposits were being selectively exploited during these periods. That a wide range of natron compositions was available to the Ancient Egyptians is obvious from the reported analyses of El Kab and Wadi Natrun deposits.[29] The latter assumption, however, has to deal with the question of how they could tell the low-sulphate from high-sulphate natron, since both are white and soluble in water. Why nitre was not likely to have been used as a source of alkali was explained in Section 20 of Chapter II.

T A B L E XXXII

THE COMPOSITION OF "ORDINARY" FAIENCE BODY MATERIAL

--

THE MEDIAN AND
AVERAGE % CONCENTRATIONS OF OXIDES

	Predynastic	Dyn. 1-2	Dyn. 3-6	Dyn. 7-10	Dyn.11-12	Dyn.13-17
Sodium	0.46	0.20	0.60	0.31	1.19	0.48
Magnesium	0.16	0.06	0.09	0.33	0.18	0.11
Aluminum	0.40	0.96	0.31	0.74	0.46	0.30
Silicon	94.1 93.3	91.4 92.0	93.4 91.4	91.3 88.8	94.1 93.5	93.5 92.9
Sulphur	0.00 0.07	0.13 0.23	0.08 0.13	0.20 0.21	0.21 0.31	0.30 0.35
Potassium	0.36 0.46	0.55 0.68	0.05 0.15	0.82 0.95	0.24 0.32	0.28 0.42
Calcium	1.10 1.82	1.35 1.49	0.45 1.26	3.02 3.38	1.22 1.92	2.09 2.19
Titanium	0.03 0.17	0.15 0.22	0.08 0.10	0.14 0.14	0.07 0.08	0.06 0.07
Vanadium	0.00 0.00	0.04 0.04	0.08 0.07	0.04 0.03	0.07 0.07	0.08 0.11
Manganese	0.00 0.00	0.08 0.08	0.08 0.14	0.06 0.06	0.11 0.16	0.26 0.24
Iron	0.19 0.25	0.71 0.81	0.28 1.04	0.77 1.53	0.40 0.40	0.44 0.41
Copper	0.04 0.16	0.03 0.09	0.04 0.08	0.25 0.37	0.30 0.29	0.20 0.28
Zinc	0.00 0.01	0.01 0.02	0.01 0.04	0.00 0.01	0.02 0.03	0.04 0.04
Lead	0.00 0.00	0.00 0.00	0.00 0.02	0.00 0.00	0.00 0.03	0.01 0.13
Antimony	0.00 0.00	0.00 0.00	0.00 0.00	0.00 0.00	0.00 0.00	0.00 0.00

--

Note: since the concentrations of the oxides of Cr,Co,Ni,As,Sr,Sn,and Ba
were negligibly low,they were left out of this table.

T A B L E XXXIII

THE COMPOSITION OF "ORDINARY" FAIENCE BODY MATERIAL

THE MEDIAN AND
AVERAGE % CONCENTRATIONS OF OXIDES

	Early 18th	Late 18th	Dyn. 19-20	Dyn. 21-25	Dyn. 26-30	Ptolemaic
Sodium	0.28	0.50	0.38	0.23	0.49	1.12
Magnesium	0.08	0.32	0.33	0.03	0.22	0.37
Aluminum	0.26	0.28	0.41	0.34	0.49	0.59
Silicon	95.1	93.6	92.5	92.7	91.0	92.1
	94.7	93.9	92.1	91.7	90.9	91.7
Sulphur	0.00	0.00	0.03	0.04	0.05	0.00
	0.03	0.05	0.06	0.34	0.15	0.48
Potassium	0.18	0.22	0.20	0.16	0.64	0.38
	0.17	0.36	0.25	0.19	0.98	0.41
Calcium	0.56	0.92	1.16	0.39	2.00	1.82
	0.70	1.21	1.23	2.09	2.49	3.01
Titanium	0.06	0.06	0.07	0.08	0.09	0.07
	0.06	0.09	0.09	0.08	0.10	0.08
Vanadium	0.08	0.06	0.05	0.08	0.04	0.01
	0.08	0.06	0.05	0.07	0.05	0.04
Manganese	0.06	0.11	0.07	0.07	0.10	0.01
	0.07	0.09	0.11	0.07	0.09	0.04
Iron	0.30	0.27	0.56	0.27	0.93	0.50
	0.37	0.33	0.72	0.39	0.93	0.47
Copper	0.15	0.00	0.15	0.08	0.45	0.04
	0.25	0.18	0.28	0.15	0.47	0.09
Zinc	0.00	0.02	0.03	0.04	0.00	0.02
	0.01	0.02	0.02	0.03	0.00	0.01
Lead	0.00	0.00	0.00	0.00	0.84	0.04
	0.00	0.00	0.02	0.00	0.68	0.66
Antimony	0.00	0.00	0.00	0.00	0.09	0.00
	0.00	0.00	0.01	0.00	0.07	0.20

Note: since the concentrations of the oxides of Cr,Co,Ni,As,Sr,Sn,and Ba
were negligibly low, they were left out of this table.

Some authors have included bentonite and other clays among ingredients essential for the production of a suitable plastic body.[7,9,165] On the other hand Lucas[1] and Kuhne[2] have shown that perfectly good faience could be produced by glazing a core made of sand, limestone and natron. The averaged data in Tables XXXII and XXXIII suggest that if any clay was added the amounts in the majority of cases did not add significantly to the levels of magnesia and alumina found naturally in Egyptian sands.[26,27]

While we failed to detect any trends in the temporal variations of magnesia, the average levels of lime show a sustained rise from the New Kingdom on. The rise is particularly noticeable during the second half of the 1st Millennium B.C., a time when one must wonder if the apparently more generous use of lime is not somehow related to many of the other technological changes attributed in the preceding chapters to the influence of an ever increasing number of Greek colonists.

Comparison of our results with data published by earlier workers was only possible for faience of the 18th and later dynasties. For the 18th Dynasty we found only two analyses of body material, one of an ordinary faience tile and one of a Variant D ring, both reported by Kuhne.[2]. Both objects were recovered at Tell el-Amarna. The tile had a composition remarkably close (0.6% Na_2O, 0.12% MgO, 0.47% Al_2O_3, 97% SiO_2, 0.72% CaO, 0.06% TiO_2, 0.4% Fe_2O_3 nd 0.09% CuO) to the average found by us for ordinary faience of the period (see Table XXXIII).

Among older published data are four analyses of ordinary faience bodies of the Ramesside Period (ref. 1, p.474, Nos. 1-3, 9), one of the Third Intermediate Period (ibid, No. 4), one of the Saite Period (ref. 1, p. 475, No. 3) and one of the Ptolemaic Period (ibid, No. 4). The dates and provenance of several other objects whose analyses are reported by Lucas (ref. 1, p. 474) could not be ascertained, but they are probably of the Late or Ptolemaic Period. The high alumina content and the relatively large value of elements "not determined" in some of the analyses reprinted by Lucas (ibid, Nos. 5,10-12), must raise doubts as to whether all of them can indeed be termed "ordinary faience".

Comparisons with our data are somewhat hampered by the fact that Na_2O and K_2O are not distinguished in any of the reported analyses. Both substances are included under a general rubric of "alkali". Moreover, in the analyses performed by Lucas (ibid, Nos. 1 and 3) Al_2O_3 and Fe_2O_3 are combined.

One of the more surprising aspects of the published analyses is the great discrepancy in the reported values of magnesia. For example, while some analysts, among them Le Chatelier [166], reported no MgO, others detected amounts as high as 1.8% (ref. 1, p. 474, Nos. 3, 4 and 8) and MgO:CaO ratios greater than unity. We found some magnesia in each of our ordinary faience bodies, but not at the levels indicated above. Only one of the 35 ordinary faience cores listed in Table XXXI had an excess of MgO over CaO. A slightly higher proportion of Variant D specimens had more MgO than CaO. For the great majority of ordinary faience bodies the MgO:CaO ratio is close ot 15:100.

Now, while none of the reported concentrations of magnesia are outside the range of values encountered in Egyptian sands (as much as 2.4% MgO was found in sand from Luxor[26]), the extremely high published MgO:CaO ratios indicate a source of magnesia other than sand or ordinary limestone. The two possible sources, dolomite and Nile river evaporates have been discussed in Section 20 of Chapter II. Whatever their source of magnesia, the four high-magnesia cores listed by Lucas (ref. 1, p. 474) are completely atypical of ordinary faience, at least on the basis of our experience. Just about all of our specimens with a high magnesia-lime ratio owed the high value to a low concentration of CaO instead of high MgO. For example, a Middle Kingdom specimen from El Kab (jar-lid E. 2150B) had a body containing 0.6% MgO and 0.4% CaO.

3. Variant A

In his discussion of this variant Lucas remarked that he failed to find any Egyptian examples older than the Nubian specimens recovered by Reisner at Kerma from sites contemporary with the Late Middle Kingdom and the Second Intermediate Period. We have detected the presence of a white intermediate layer of finely ground quartz between the glaze and a coarser body on numerous objects of the Archaic Period, Old Kingdom and subsequent time periods.

One of the oldest examples was an Archaic Period model baboon (E.5) from the Main Deposit at Hierakonpolis.[159] The white layer is interposed between a grey core containing about 0.8% Fe_2O_3 and a green glaze coloured by 2% CuO. The white layer itself contains about 0.17% Fe_2O_3 and 0.15% CuO, both elements probably representing contamination by the adjacent layers. The alkali and lime contents of the intermediate layer were quite similar to those found in the core and the glaze. A similar white layer was found on other objects from the same site.

That the early manufacture of Variant A faience was not confined to Hierakonpolis is evidenced by the discovery of examples in the Dyn. I-II temple area at Abydos. Thus on one specific inlay (E.72) an almost 2mm-thick white layer had 0.3% Fe_2O_3 (same as the surface glaze), 0.6% CuO, and very little K_2O or CaO. The compositions of the intermediate white layers on Sixth Dynasty inlays from Abydos were very similar to the Archaic specimen just mentioned.

Whether the manufacture of Variant A faience at Abydos had its beginnings in Prehistoric times cannot be ascertained at the moment. However, the local technical tradition evident in faience of the first two dynasties was preserved for over two millennia, as Abydos continued to turn out vases, tiles, statuettes and other objects with a distinct intermediate white layer well into the Third Intermediate Period. Particularly numerous are examples of the Middle Kingdom.

The production of Variant A faience must have spread early to other parts of Egypt, for a white intermediate layer is clearly visible on a green vase (1923.557) from a Dyn. IX-X grave at Hammamiya. The white layer, which contains 0.3% Fe_2O_3 and 0.1% CuO, is interposed between a grey core containing 0.8% Fe_2O_3 and a green glaze coloured by 0.8% CuO. The alkali content is lower and the lime comparable to levels found in the adjoining layers.

Among the more interesting examples of Variant A are the Ramesside vessels from Serabit el Khadim. The bodies consist of very fine pink sand and are coated with a thick intermediate layer of white quartz powder. In one particular vessel from the time of Ramesses III (E. 3410) the copper-coloured

green glaze is separated from the iron-coloured (2% Fe_2O_3) pink body by a white layer almost 1 mm thick.

The pink colour represents a solid solution of Fe_2O_3 in SiO_2 which can be produced under suitable conditions at about $1000^{\circ}C$ (ref. 33, p. 94). Similar solutions are responsible for the colours of carnelian and garnet. The fact that an attempt was made to cover the pink core by a white skin is good evidence that the body was not made artificially by mixing haematite with whiter sand. Why this particular pink sand (see Plate VII of ref. 64 for a colour picture of such sand at Timna) was apparently only used in Late Ramesside faience from the site is not quite clear to us. None of the 18th Dynasty faience from Serabit el Khadim examined by us had a pink body. Many fragments from the site have what at first sight appears to be a pink core. However, in most instances a close examination reveals that the exposed core has acquired a layer of pink soil during burial which can be scraped away to reveal the true colour of the body material.

It is now safe to assume that the numerous examples recovered at Kerma from sites contemporaneous with the Middle Kingdom do not antedate analogous Egyptian faience, as appeared to be the case when Lucas first wrote his book. There is still nothing to suggest that the very fine faience manufactured at Kerma reflects a glazing technology more advanced than the Egyptian of the same or even earlier time periods.[165]

There is no doubt that Variant A is more common than the figures shown in Table XXX would indicate, for the intermediate layer can only be discerned on objects broken so as to reveal the cross-section. Moreover, some of the multi-layered polychrome faience popular during the New Kingdom and the Ptolemaic Period could be classified as an extension of Variant A. Good examples of such material are some of the tiles from Amarna (e.g. 1924.128) and Ptolemaic vessels from Memphis (e.g. 1909.1044), where an intermediate yellow layer provides an excellent ground for other colours.

Other examples of multi-layered faience were cited in Section 10 of Chapter III and Amarna specimens of this type are discussed by Kuhne.[2] The morphology of and the manner in which the intermediate layer was applied will

be treated in Appendix A.

4. Variant B

Lucas defines Variant B as faience consisting of a black glaze over a dark grey or dark brown body coloured by iron. In deciding to call such faience a distinct variant the author states that in most of the examples examined by him: " It is most probable that the oxide of iron was added intentionally...". [165] Considering that Egyptian sands from certain regions contain as much as 5.6% Fe_2O_3, how can one tell whether the iron oxide was added to a quartz powder (or purer sands) or whether ferruginous sands were intentionally or unintentionally used in the preparation of black faience? Only a very careful X-ray diffraction study combined with a microscopic examination of the body material might distinguish Variant B from ordinary faience.

Consequently, we are quite uncertain of how common Variant B faience ever was. Lucas lists a number of specimens from as early as the 3rd and as late as the 20th Dynasty.[165] We have examined a number of black beads and pendants of different periods and found that the majority of them have a white or creamy core. The oldest example of black glaze on a dark-grey core was found on a barrel bead (E.E.456A) from an Old Kingdom tomb at Mahasna.

During the Old Kingdom and the First Intermediate Period Variant B must have enjoyed particular vogue in central Egypt. Over half the black beads from Badari, Hammamiya, Matmar and Qau had grey or brown body materials. Such cores were also found in a similar proportion of black Middle Kingdom beads and pendants from Abydos and El Kab. Black faience of this type drops to less than 10% of the examined samples of later periods.

Of course, we are not sure that all of the examples noted above were indeed Variant B, especially instances where manganese was the dominant pigment in the glaze while the body material contained mostly iron. Deliberate pigmentation of the core is less open to question in specimens having the same dominant pigment in both the glaze and the core. Such is the case in some black Middle Kingdom faience from tomb 416 at Abydos. For example, the analysis of a truncated large black tubular bead (E.E.633D)

revealed that the black glaze contained: 3.3% MnO, 0.6% Fe_2O_3, and 4.1% CuO, while the grey-black body had: 3.3% MnO, 0.8% Fe_2O_3, and 0.4% CuO.

The same tomb has yielded a vase fragment (E.3306) consisting of a brown glaze containing 1.8% MnO, 0.3% Fe_2O_3, and 0.2% CuO over a grey core in which the concentrations of the three oxides were 1.2%, 0.3% and below 0.01%, respectively. In both specimens the body was deliberately coloured by ferruginous manganese at concentrations near those found in the glaze. Under ordinary circumstances and oxidising conditions the composition of the brown glaze should have yielded a black colour, and one must wonder if black had not been the intended surface colour of an apparent Variant B faience. On the other hand, the high copper concentration of the black tubular bead suggests that a dark blue colour was intended, but the copper was overwhelmed by the iron and manganese.

No preferred Fe:Mn ratio could be discerned among the presumed Variant B specimens. For example, while the glaze of a large grey-bodied biconical black bead (E.E.125B) from a Middle Kingdom tomb at El Kab contained 2% MnO, 0.1% Fe_2O_3, and 6% CuO, a First Intermediate black bead from Qau (1924.395A) was coloured by 2% MnO, 1.6% Fe_2O_3, and 1.4% CuO.

A rather intriguing example of what could be called a hybrid B/D variant was a kohl tube (1890.906) from an early 19th Dynasty tomb at Medinet Ghurab. The inside of the black-bodied hollow cylinder was coated blue, but the outside was black with an inlaid blue design. The body material and the black outside were both coloured by a combination of manganese, iron, cobalt and nickel oxides. Interestingly enough, while the glaze and the body had comparable concentrations of cobalt and nickel, the body material contained more than twice as much MnO and Fe_2O_3 as the black surface and hardly any copper (see Appendix C).

We found very few instances in which both the body and the surface of presumably Variant B faience were coloured by iron in preference to manganese. One was a Late Period ushabti of unknown provenance (E. 3577) which was coated with a glaze containing 0.4% Fe_2O_3, 3.5% CuO and virtually no manganese.

In concluding our discussion of Variant B we must point out that if the basic criterion distinguishing it from ordinary faience is the presence of a black glaze over a <u>deliberately</u> <u>coloured</u> dark grey or brown core then it is not iron but manganese which is most frequently found as pigment. The same purpose is achieved during the New Kingdom and the Ptolemaic Period with high concentrations of cobalt and iron. If one considers the likelihood that some of the brown faience of various periods represents unintentionally oxidised iron-rich black (see Sec. 9, Chapter III), then the production of iron-based Variant B faience might conceivably have been more extensive than our data indicate.

5. Variant C

The variant is defined by Lucas as faience consisting of a red body deliberately coloured by Fe_2O_3 and covered by a red or almost colourless glaze. Lucas cites numerous examples from as early as the 3rd and as late as the 20th Dynasty.[165]

The earliest examples of undisputably Variant C faience seen by us date from the early 18th Dynasty. All the red beads from the foundation deposit of the temple of Tuthmosis III at Coptos had a body material which was as red as the glaze (string E.E. 238). The glazes and bodies were singularly free of manganese and copper and were coloured by Fe_2O_3 ranging in concentration from 2.5 to 4.5%.

The same variant was used for the red design panels inlaid in tiles and vessels of the Amarna Period (e.g. 1936.636 and 1942.77) and in Ramesside tiles from the palace of Ramesses III at Tell el-Yahudiya (1871.35C and D). The combined thickness of the dull red body and the shiny red glaze amounted to 2mm on some tiles. The Amarna and Ramesside Variant C faience tends to have higher concentrations of Fe_2O_3 (up to 5% in the glaze and 6% in the body) but is as free of manganese as the earlier material. The alumina content of this variant is quite high, with the Amarna examples showing levels 10 times higher than the average for contemporary ordinary faience bodies (see Tables XXXI and XXXIII).

We have failed to find any Variant C faience securely dated to a time

period later than the 20th Dynasty. For example, a number of bright red beads have been recovered from a 25th-27th Dynasty deposit at the temple of Merneptah at Memphis. Outwardly they resemble beads of the New Kingdom, since the red glazes had similar concentrations of iron and manganese (ca. 4% Fe_2O_3 and 0.03% MnO in beads from string E.E.608), but their clear white body material relegates them into the category of ordinary faience.

When the body and the glaze have comparable concentrations of Fe_2O_3 and depth of colour, recognizing Variant C is no problem. It is in cases where the red body has a white or colourless skin, as in the case of the 4th Dynasty El Kab vessels discussed in Section 2 of this Chapter, that an uncertainty arises. It is possible that the vessels, E.381 and E.382, had their bodies artificially pigmented by the addition of Fe_2O_3, but we have decided to classify them as ordinary faience with a body made of highly ferruginous sand.

6. Variant D

The name "Variant D" has been assigned by Lucas to a hard and compact blue-bodied or green-bodied faience coated with a distinct glaze of similar colour. In his discussion of this Variant Lucas states that although such material is generally attributed to the Saite Period the Cairo Museum contains at least one example dated to the Third Dynasty.[165] The author was correct in suspecting that the variant was known in Egypt in the 3rd Millennium B.C. We have analysed the body material and glazes of three vessel fragments from the First Dynasty royal tombs at Abydos which are definitely made of Variant D faience. Two vessels are from the tomb of King Djer (E.1577 and E.1578) and one from the tomb of Udimu (E.3182). Similar vessel fragments of the Archaic Period have been seen by us in the Petrie Museum collection of the University College, London.

The vessels range in colour from pale blue to blue-green and the glaze, which is about 0.3mm thick, differs from the body by being darker, glossier and harder. The bodies of all three fragments are characterised by abnormally high concentrations of Na_2O, MgO, Al_2O_3 and CaO (ca. 3%, 2%, 1% and 10%, respectively, on the average), and the presence of small but significant amounts of cobalt. All of them have comparable concentrations of Fe_2O_3, CuO and SnO_2 (ca. 0.7%, 1.3%, and 0.2%, respectively) and remarkably similar

MgO:CaO, CaO:CuO, SnO_2:CuO, and Fe_2O_3:CuO ratios (Table XXXI).

The conclusion that all three vessels were made in the same workshop, or were imported from the same place, is inescapable. One of the most remarkable features of these vessels is the presence of SnO_2 both in the glaze (commented upon in Sec. 13 of Chapter II) and in the body at levels not seen again until late in the 18th Dynasty. The average SnO_2:CuO ratio of 15:100 is high even by New Kingdom standards. These royal vessels were most definitely made of a mixture unlike any used for the manufacture of faience anywhere else in Egypt for the next fifteen hundred years.

The glazes differ from the bodies by having significantly more CuO and SnO_2 and almost three times the concentration of K_2O. The concentrations of other elements have comparable values in the glaze and in the core.

Several specimens of Variant D faience from Old Kingdom sites have been analysed. Their K_2O and CaO concentrations are similar to those in the First Dynasty specimens discussed above but have significantly higher concentrations of CuO and barely any tin. For example, the glaze of a blue-bodied blue bead (1935.171a) from a Fourth Dynasty grave at Armant contained: 0.8% K_2O, 13% CaO, 6% CuO, 0.13% As_2O_3 and below 0.01% SnO_2. Copper oxide concentrations as high as 8% were seen in other specimens. The concentrations of K_2O, CaO, Fe_2O_3 and CuO in Variant D faience of the Middle Kingdom and the first two Intermediate Periods resemble the values observed in the First Dynasty specimens.

During the 18th Dynasty the production of the traditional Variant D in which copper is the chief pigment (e.g. vase 1890.815 from the tomb of Maket at Lahun), is supplemented by the creation of two sub-variants. One, which might be termed D1, has a green body covered by a green glaze both coloured by a mixture of CuO and $Pb_2Sb_2O_7$ (e.g., kohl tube 1889.148 from Tell el-Amarna). The other, tentatively labelled D2, has cobalt oxide as the principal pigment at comparable concentrations in the body and the glaze.

The colours of the cobalt-coloured bodies range from distinctly blue to virtually black. The compositions of a fair number (10 specimens) of such

bodies may be seen in Table XXXI. Comparison of the cobalt-containing
specimens with contemporary ordinary faience bodies (Table XXXIII) shows the
former as having much higher levels of alkali, magnesia and alumina but
similar concentrations of lime. In Table XXXIV the average compositions of
ordinary faience bodies recovered from Tell el-Amarna are compared with the
average compositions of Variant D2 cores (cobalt-coloured bodies) from the
same site.

T A B L E XXXIV

**COMPARISON OF ORDINARY AND VARIANT D2 BODY
MATERIALS OF AMARNA PERIOD FAIENCE**

Average % Composition of

	Na_2O	MgO	Al_2O_3	SiO_2	SO_3	K_2O	CaO	TiO_2
Ordinary:	0.50	0.32	0.28	93.3	0.05	0.36	1.21	0.09
Variant D:	2.64	0.83	2.76	90.3	0.11	0.61	1.36	0.11

	V_2O_5	MnO	Fe_2O_3	CoO	NiO	CuO	ZnO	PbO
Ordinary:	0.06	0.11	0.33	0.00	0.01	0.18	0.02	0.00
Variant D:	0.05	0.28	0.73	0.18	0.10	0.15	0.18	0.00

Note. In both types of body material average concentrations of less than 0.01%
were found for Cr_2O_3, As_2O_3, SrO, SnO_2, Sb_2O_5 and BaO.

The concentrations of elements whose association with New Kingdom cobalt
was noted earlier (Sec. 8, Chapter II) are found in similar proportions in the
body as in the glaze (see Fig. 22). It is obvious that the body material was
mixed with the same cobalt-containing mineral as was utilized in the
manufacture of the glaze. The mineral was one rich in aluminium, manganese,
iron, nickel and zinc as well as cobalt. Particularly remarkable are the
levels of alumina. For example, while the highest concentration encountered
in cobalt-free cores of Amarna faience was only 0.37% Al_2O_3, the lowest value
among cobalt-containing bodies was 1.25%. The sulphur content of Variant D2
cores is highly variable but significantly higher than in contemporary
ordinary faience. The alum deposits of the Great Oases are again indicated as

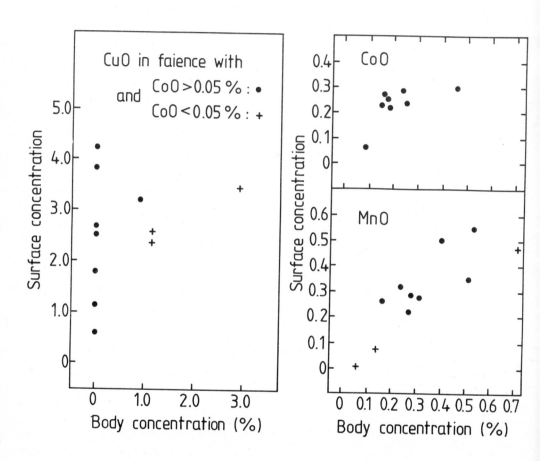

Figure 22. The correlation between the surface and body concentrations of CuO, MnO, and CoO.

a likely source of the cobalt. [46,53,56]

The data in Table XXXI show that strongly coloured cores of <u>all time periods</u> tend to have far above-average concentrations of alumina, suggesting that alum might have been a standard ingredient in this type of faience from the earliest times. It is possible that the alum was originally introduced to render the body harder and some of the high-fired high-alumina cores of the Amarna faience are exceptionally hard (see Appendix A, Table XLIII). If alum from a specific source was indeed responsible for introducing cobalt into the body fabric of both the First Dynasty and Amarna Period faience, it is unclear why such a cobalt-rich variety should have been employed in the latter, when the glaze contained enough cobalt and copper to mask a core of any colour.

Here again we are faced with the problem of distinguishing intent from accident, for the alum might have been used indiscriminately for cores of all types. For example, we found an interesting example in which alum must have been added to what was intended to be an ordinary faience body material, but incomplete mixing produced clearly visible blue-green spots in an almost white (faintly greenish) core. The object in question is a polychrome vessel (1942.77) from Tell el-Amarna decorated in red, pale blue and indigo. While the bulk of the white body has no detectable amount of CoO and only 0.23% Al_2O_3, a blue-green spot embedded in the white matrix contained 0.04% CoO and 5.3% Al_2O_3. Had the original body mixture been thoroughly homogenized, the colour would have been faintly blue and in no way comparable to that of the D2 variants discussed above.

One is tempted to see in the peculiar composition of cobalt-coloured Variant D2 faience the end result of a self glazing process in which a mixed copper-cobalt pigment was used initially. If Egyptian alum was the source of cobalt, it would have required some enrichment to yield the $CoO:Al_2O_3$ ratios observed in some specimens. Noll has assumed such enrichment in the production of Amarna pottery pigment.[36] However, the ratio in the blue spot noted above and in a few other cases is within the range reported for cobalt-containing alums of the Western Oases.[46,48,56] The high alkalinity noted earlier, and the firing temperatures indicated by the texture and hardness of such faience, would result in virtually complete migration of copper from the

interior to the surface to produce the type of concentration gradients observed by us (see Fig. 22). Comparable surface enrichment would not be expected with the other transition metals and none is observed, as may be seen in Fig. 22, where the body and surface concentrations of CuO, CoO and MnO are compared. No consistent body-glaze differential was detected in the concentrations of Fe_2O_3 or ZnO.

An alternative explanation which is applicable to any faience, regardless of how it was glazed, may be derived from the work done by Kuhne.[2] In trying to determine what type of binders might have been used in the manufacture of siliceous objects, Kuhne showed that pulverized glass or sintered material of similar composition would do very well. He also estimated the most likely compositions of such glasses and showed that they are comparable to the published compositions of New Kingdom glass. If high-cobalt glasses were to be used as binders for the body and the glaze in the manner described by Kuhne, faience of the type discussed above would result. Of course, copper would have been added to the glazing mixture in the traditional manner.

Cobalt-coloured body materials ceased to be made for almost a millennium after the 20th Dynasty. When they reappear during the Ptolemaic Period they are invariably black and very rich in iron (ca. 10% Fe_2O_3) and are used as background for black faience. Such faience is more appropriately classified as Variant B. As an example one can cite the marbled vase 1913.804 from Memphis in which the surface and the interior have contiguous black zones coloured by a combination of iron, cobalt and copper oxides, with a generous admixture of lead oxide. The concentration of alumina is still rather high (2.6% Al_2O_3), but the cobalt is free of manganese and nickel.

During the New Kingdom and subsequent time periods the traditional copper-coloured Variant D tends to have substantially lower concentrations of CaO and slightly less CuO than does most comparable pre-18th Dynasty faience. This is clearly evident, for example, in a blue model uraeus (1871.34A) from the palace of Ramesses III at Tell el-Yahudiya and a green vase (E.4548) of Late Period date from Naucratis.

Analyses of presumably Variant D faience have been published by Lucas[1]

and Kuhne.[2] In Section 2 of this Chapter we pointed out that of the four listed by Lucas (ref. 1, p. 475) the two low-copper specimens could not have been Variants D. The description of the other two is more compatible with Lucas' characterization of this variant.[165] Thus the 20th Dynasty violet-blue specimen from Qurna had a hard, coarse-grained body coloured brown by manganese oxide (2.4% MnO) while the Saite example from Saqqara was blue with a hard, fine-grained body tinted by 0.8% CuO. [166,167]

Without information about the compositions of the glazes it is not possible to tell whether either or both of the two specimens analysed by Le Chatelier [166,167] tymight not represent ordinary faience with incompletely effloresced copper. Of course, the same question can be raised regarding our tentative classification of Kuhne's Amarna ring as being Variant D. However, when the body contains 1.4% and the glaze 3.24% CuO, it is more difficult to presume unintentional core pigmentation.

Considering that Lucas described Variant D as faience with the body and glaze of the same colour, either blue or green,[165] we are curious about what criteria he used in classifying the violet-blue brown-bodied 20th Dynasty faience from Qurna (No. 1 in the 2nd Table on p. 475 of ref. 1) as Variant D. The copper concentration is rather low (0.8% CuO) and the dominant pigment is manganese. The concentration of the latter is too high (2.4% MnO) for it to have been introduced accidently with something else. Le Chatelier's description of the glaze[166,167] suggests that it too might have been rich in manganese.

If we allow the definition of Variant D to be extended to any shade of blue or green faience with a deliberately pigmented core, then the specimen discussed above would have been correctly classified. Such an extension would also obviate the need to create a new variant (G, for example) to accomodate several interesting specimens which do not fit any of the categories established by Lucas. One such example was the kohl tube (1890.906) mentioned in Section 3 of this Chapter, which was classified as hybrid B/D variant.

Another rather early example of faience to which the proposed wider definition of Variant D could be extended was a green segmented tubular bead

(E.1183) from the First Dynasty tomb of King Anedjib at Abydos. The body material is purple, but its composition (1.3% MnO, 1.0% Fe_2O_3 and 0.5% CuO) would have yielded a black colour if oxidizing conditions had prevailed. The glaze contained: 0.8% MnO, 1.0% Fe_2O_3, 7.0% CuO, 10% CaO and rather high levels of alkali and sulphur.

The observed colours and compositions could have been produced by the unexpected reduction of iron and manganese while a pigment containing manganese, iron and copper was being used in the manufacture of Variant D faience by the self-glazing process. It is uncertain whether the reducing conditions resulted from external factors, such poor draft in the oven or the nature of the fuel (too much green wood), or whether they were caused by internal factors, such as the presence of excess reducing agents, such as sulphides, in the faience itself. If the latter were the case it would partly account for the excess sulphate found in the glaze of this bead.

One cannot rule out another possibility, that black-bodied faience was being manufactured even at this early date and that the bead in question (E.1183) represents a misfired specimen. The majority of latter examples of black faience classified as Variant B had similar body compositions and comparable levels of copper in the glaze.

7. Variants E and F

The so-called "glassy faience" is a misnomer, for though it may be glassy, it is not faience, and an alternative name -- "imperfect glass" has been suggested.[165] As long as there is no distinct outer layer different in texture and/or colour from the interior the term "faience" is inappropriate.

In his compilation of faience analyses Lucas includes only one specimen of presumed Variant E faience (ref. 1, p. 475, No. 5). The object in question was a blue-green fragment of undetermined provenance and date. It was analysed in the 19th century by Le Chatelier,[168,169] whose description of it was not precise enough to rule out the possibility that Lucas' classification of the object as Variant E was in error. However, the object had a composition intermediate between that of faience and glass, a result compatible with the physical appearance of material generally classified as

glassy faience. [32,165]

The only object seen by us with the outward appearance of glassy faience, as described by Lucas[165] and Cooney[32], was a green ushabti (1965.176) of unknown provenance and dated to the 25th Dynasty. Its lime concentration was more than twice as large as the average in contemporary green or blue faience glazes (3.2% vs. 1.4% CaO), but only half as large as the levels reported for Egyptian glass.[18,20] Whether the total alkali were also intermediate in value between faience and glass is uncertain, because all we have is the concentration of potassium, which is comparable to that of contemporary faience glazes (ca. 0.4% K_2O).

Another object which might conceivably be Variant E, or just a frit with a polished surface, was a sistrum (1909.1062) from the Late Period palace of Apries at Memphis. The exterior of this object has a composition remarkably close to that of the glassy faience ushabti noted above (1965.176). For example, the K_2O levels of the two are 0.45 and 0.46%, respectively, while CaO has values of 3.22 and 3.26%, respectively. Only in their copper and lead contents do the two objects differ somewhat. The core of the sistrum (1909.1062) is also characterized by unusually high concentrations of Na_2O, MgO, Al_2O_3 and other elements (see Table XXXI).

On the basis of the information available to him Lucas concluded that Variant E was invented during the 22nd Dynasty.[165] Cooney has also failed to find evidence that the variant was known before the Third Intermediate Period. [32] Although we too were unable to push the date of invention back in time, more analytical and microscopic information is required before one can safely conclude that the variant was unknown during the New Kingdom. It is difficult to believe that a period not known for innovation in either glass or faience should have produced this rather unusual and highly durable type of material.

With regard to Variant F, we have failed to find a single specimen having other than an alkaline glaze. There is no need to repeat all the arguments presented in Section 16 of Chapter II to the effect that there is at present no evidence that lead glazing of faience was practiced in Ancient Egypt. The presence and the amounts of lead detected in Egyptian glazes of various time

periods can be attributed to accident or to purposes other than facilitation of the glazing process.

Lucas based his conclusions on qualitative, or at best semi-quantitative, evidence without exploring alternative explanations for the presence of lead.[165] As a matter of fact the author writes with reference to one object that: "The proportion of lead was small" (ref. 1, p. 167). Thus if the mere presence of lead regardless of amount were the only criterion, then more than half the faience produced from the New Kingdom on would have to be classified as Variant F.

8. Frits

In the course of the faience study we have had the opportunity of analysing 30 unglazed objects made of what is commonly referred to as "frit". The term frit refers to a material produced from silica, lime and alkali with or without a pigment and heated high enough to fuse but not high enough to flow as glass. Most of the Egyptian frits are intensely coloured and our sample included blue, green and black specimens.

Since all evidence seems to suggest that such frits were used primarily as painting pigments,[170] or as a substitute for faience and glass, they will be the subject of a separate study to be published soon. However, as it has been proposed that they may have also served as intermediates in the manufacture of glass[26,171] and faience[1,2,9], a summary discussion of the relevant analytical data is in order at this time. One reason the discussion was delayed until Chapter IV is that frits are unglazed, and if the objects are small it is sometimes difficult to distinguish frit from badly weathered Variant D faience.

Lucas mentions that a number of imperfectly fired faience objects showed clearly identifiable frit particles on the surface (ref. 1, p. 173) and lists six analyses of blue frits of various time periods.[172] Though he does not discuss the relationship between the elemental compositions of the frits and those of faience glazes, he does point out that the composition of Egyptian 18th Dynasty glass is not compatible with that of the frits, and suggests that at least the frits recovered from Amarna could not have served as

intermediates in the manufacture of glass.[171]

Kuhne has suggested that powdered glass or some sintered material such as frit might have been used as the binding agent for faience.[2] He goes on to compute the hypothetical composition of such a binder and its proportion in relation to silica. He suggests that an 80:20 silica:binder mixture, where the binder contained ca. 16% CuO, 2.9% alkaline earths (MgO, CaO), 24% alkali (Na_2O, K_2O), 55% SiO_2 and 0.7% SnO_2 would yield a glaze of the composition he found in two specimens of Amarna faience. Our figures for the same elements in Amarna blue and green faience (see relevant Tables in Chapter II) suggest a binding frit resembling the binder proposed by Kuhne, and a 70:30 mixing ratio.

While it may be comforting to know that our large analysed sample yields a hypothetical binder similar to the one deduced by Kuhne from two glaze analyses, it is disconcerting to discover that very few of the frits analysed to date have elements in the proportions indicated above. The overwhelming majority of blue and green frits have inadequate amounts of alkali and far too much lime to have been usable in the manner suggested by Kuhne. This is clearly evident in Table XXXV.

The fact that most faience glazes contain concentrations of alkali far in excess of what could have been derived solely from the frits can be explained by allowing for alkali migration from the body material to the surface (efflorescence) or by postulating that additional alkali were added to the silica-frit mixture. However, there is no way to explain how the very high CaO levels in most frits could have produced glazes with so little lime. Once the frit is made one would find it extremely difficult to remove the lime selectively. If a higher proportion of silica is postulated to accomodate the experimentally determined levels of lime (a 90:10 mixing ratio is needed to yield the average concentration of CaO in Amarna glazes), the computed levels of CuO and most other ingredients come out too far below the corresponding experimental levels.

There is one other puzzling factor. While the occurrence of arsenic, lead, and tin in the frits coincides well in time with the occurrence of these

T A B L E XXXV

THE CONCENTRATION RANGES AND MEDIAN VALUES OF SELECTED
COMPONENTS OF EGYPTIAN BLUE AND GREEN FRITS

	Na_2O	SiO_2	K_2O	CaO	CuO	SnO_2	PbO
	%	%	%	%	%	%	%

OUR RESULTS FOR VARIOUS TIME PERIODS

	Na_2O	SiO_2	K_2O	CaO	CuO	SnO_2	PbO
Old Kingdom:	---	57-64 (64)	0.0-0.8 (below 0.1)	15-20 (18)	11-17 (13)	0.0-0.1	0.0-0.1
Middle Kingdom:	---	69-77 (73)	0.7-1.2 (below 0.1)	7-15 (12)	6-11 (10)	0.0-0.1	0.0-0.1
New Kingdom:	---	64-84 (75)	0.0-0.8 (0.2)	4-12 (9)	4-16 (9)	0.2-1.5 (1.0)	0.0-0.2 (below 0.1)
Late Period:	---	71-88 (77)	0.0-0.4 (below 0.1)	2-13 (9)	2-10 (7)	0.1-1.0 (0.3)	0.0-1.0 (0.1)
Ptolemaic Period:	---	70-85 (80)	0.0-0.6 (0.4)	6-8 (7)	2-13 (7)	0.1-1.0 (0.3)	0.0-1.7 (1.3)

EARLIER WORK

	Na_2O	SiO_2	K_2O	CaO	CuO	SnO_2	PbO
Ref. 172 (Lucas' tabulation)	0.8-7.6	57-89 (70)	0.0-2.0	8-14 (9)	2-21 (16)	---	---
Ref. 97 (S.A. Saleh, et al.)	1.62	60.6	trace	16.1	12.3	1.79	---
Ref. 173 (Lahanier's data)	3.5-6.0	67-76 (70)	0.0-0.8 (0.5)	9-16 (14)	3-13 (11)	---	0.0-0.1 (below 0.1)

Note 1. The specimens listed by Lucas were primarily New Kingdom frits;
the frit analysed by Saleh et al. came from an 18th Dynasty tomb;
all of the frits analysed by Lahanier came from New Kingdom sites.

Note 2. The numbers written in parentheses represent the median values.

same elements in faience and glass, one finds very little manganese and/or cobalt in the blue frits analysed to date, by us or by others;[97,173] none contained more than 0.02% CoO. If our earlier conclusion (Chapter II) that most arsenic, tin and lead entered the glazes as alloyed copper scrap is correct, the presence of these elements in Cu-coloured frits during the same periods is perfectly understandable. Moreover, the fraction of pre-New Kingdom frits containing As_2O_3 and the absolute levels of arsenic are both much higher than in contemporary glazes.

Both Lucas[171] and Turner[26] have suggested that fritting might have been done at or below 750°C, well below the temperatures needed to form a glaze, and consequently the loss of arsenic through volatilization would not be as serious as in faience. This adds weight to our earlier contention (Section 11, Chapter II) that the paucity of glazes containing arsenic at detectable levels, during time periods when arsenical coppers were common, may be the unfortunate consequence of greater losses at the more elevated temperatures.

Less easy to deal with is the absence of cobalt from the over 44 specimens analysed to date by us and others. Of course, it may simply be a matter of chance that no analyses of cobalt-coloured blue frits have been reported. However, even if we allow for the fact that the specimens selected by us and others are unlikely to represent random samples, the elusiveness of such frits bespeaks of their relative scarcity. How non-random can such sampling occasionally be is well illustrated by the fact that whereas we found substantial amounts of SnO_2 (0.1-1.5%) in all blue frits of the New Kingdom and later periods, and Saleh reported 1.8% SnO_2 in his 18th Dynasty frit,[97] neither Lahanier[173] nor Lucas[172] report finding tin in a combined random sample of 13 specimens of mostly New Kingdom frits.

The problem of elemental proportions alluded to above and the scarcity (or absence) of cobalt blue frits suggest that the manufacture of frits must have been a more specialized industry than one might have guessed. If we postulate that the frits destined for the painters' palettes and for the manufacture of entire objects were formulated differently from those that were to be used in glass and glazes, the contradictions noted by us and the Amarna glass problem alluded to by Lucas,[171] can all be resolved. Our analyses

reveal that the composition of objects made of unglazed frit, in general, resembles that of lumped or powdered frits that were definitely designed to serve as painting pigments.[172,173]

Among our specimens, only three frits of the Ptolemaic Period might have conceivably been destined to serve as precursors in the manufacture of glass or glaze, since they came from the Kom Qalana kilns at Memphis. The remaining 27 frits consisted of beads, vessels, figurines and other finished objects. Interestingly enough, the three Kom Qalana frits (two of which were still attached to the fritting pans) had compositions which were perfectly compatible with those of contemporary faience glazes. By compatible we mean they could have served as the frit-binder in the manner suggested by Kuhne since they were not overburned with the excessive lime levels seen in other frits (see Table XXXV).

9. Concluding Remarks

In the course of this study it became apparent to us that the present classification of faience into variants A-F is not wholly satisfactory. We would like to suggest some small modifications of Lucas' original scheme, and the rationale for the proposed changes is presented below.

The term **ordinary faience** might as well be retained for faience whose body material shows no evidence of having been deliberately pigmented to provide a suitable background for the glaze. Thus, the core of ordinary faience can be white, creamy, grey, brown, pink or any of the other colours encountered in Egyptian sands. If the body material is greenish or bluish and the copper concentration in the interior is far below that found in the glaze (less than one third, for example) the faience is probably of the ordinary variety, unless it can be demonstrated that the self-glazing efflorescence process could not have been used on the object in question.

Variant A describes a technologically different product and consequently it serves a useful purpose in distinguishing such faience from material in which no separately-applied layer intervenes between the glaze and the body material. In most instances the variant would refer to faience in which the intermediate layer is white and more finely-grained than the body matrix.

However, objects such as some of the Ptolemaic vessels discussed earlier in which a yellow layer was interposed between the core and the glaze should also be classified as being made of Variant A faience, for the intent was the same -- to provide a better contrast for the components of the glaze.

When Lucas classified Egyptian faience into variants B, C, and D the principal feature distinguishing the three types was the physical appearance of the objects -- black-bodied black faience, red-bodied red faience and blue or green-bodied blue or green faience. Iron was supposed to be responsible for the colours of the first two variants and copper for the third. As we have shown in the preceding sections of this chapter the picture is much more complex, both with respect to the composition of the body and the glaze and with regard to the method of manufacture (see Appendix A).

Now, if the colours of the body and the glaze are to be the chief criteria for classification, then many more letters of the alphabet will be needed to distinguish objects with cores of colours other than black, red, green or blue and cases in which the body and the glaze are of different colours. By the time polychrome faience is considered half the alphabet might be needed to differentiate all the variants.

One possible solution to the problem is to group variants B, C and D into one variant designated as Variant DCB, for "deliberately coloured body". Intent may be inferred when the body contains lead antimonate or oxides of manganese, iron, cobalt or copper at concentrations comparable to (at least one third) or higher than those detected in the glaze. Of course, some ambiguous cases are bound to arise when the use of iron-rich or manganese-rich sand is suspected, but it is unlikely that the concentrations and the impurity patterns will be comparable to those in the glaze. Moreover, such "dirty" sand is often concealed by a white coating which relegates the faience to the Variant A category. Equally troublesome might be faience in which incomplete efflorescence has left too much copper in the body, but such cases are bound to show a high surface-body concentration gradient.

Another solution is to do away with the alphabetic designation of variants altogether and simply describe the faience as being black-bodied,

red-bodied, blue-bodied, etc. This has the virtue of by-passing entirely the question of whether a given core was coloured intentionally or not.

We are no more happy with the term glassy-faience than Lucas was,[162] but it is preferable to the term Variant E. The latter name implies that such material is just another form of faience, which is distinctly is not. In its properties it resembles glass much more than it does faience, as the alternate name "imperfect glass" clearly states. However, since the term glassy-faience is well enshrined in several important publications (for example, those of Cooney[32]) it might as well be retained, though not as a variant of faience.

With regard to Variant F, it is a meaningful distinction if one can be certain that the lead was introduced deliberately to modify the properties of the glaze and not accidentally (in leaded copper scrap) or to modify the colour (with antimony). We have not found a single case of lead glazing among the numerous faience specimens subjected to analysis. It would appear that the earliest documented examples of faience in which alkaline glazes were replaced by leaded glazes are to be found on Near-Eastern objects of the Islamic period.[117]

An alternative classification based on the nature of the manufacturing process could be devised, but it has some obvious disadvantages. It would require a more detailed examination of the objects and greater knowledge of ceramic technology than can be expected from most natural scientists, archaeologists, or museum professionals.

V. GEOGRAPHICAL AND HISTORICAL CONSIDERATIONS

1. The Problems of Regional Diversity

If one considers the huge volume of Egyptological literature published in the last 150 years, it is surprising how comparatively little work has been devoted to the matter of regional diversity. The dominant theme in books dealing with the history, language, or the arts of Egypt has been the uniformity, apparent or real, of Egyptian culture, even during periods of political fragmentation. A happy exception to the rule is the geographical history of the Nile by Hermann Kees. [110]

It must be obvious, however, that the elongated character of the country (750 miles from the sea to the First Cataract) and the stretches of sparsely populated land that one encounters along the Nile, particularly in Middle Egypt (see ref. 162, p. 16), would have helped preserve many old regional practices long after the country had been unified. One of the clearest manifestations of regional diversity in Egypt, as in any other country, is the existence of dialects. Though our knowledge of dialects in pre-Christian Egypt is severely hampered by the nature of the hieroglyphic and derived writing systems,[174] the existence and importance of these dialects has been recognized for a long time. For example, Edgerton has suggested that some of the synthetical peculiarities distinguishing Old Egyptian from Middle Egyptian, and the latter from Late Egyptian, may in fact reflect the differences between the dialects of the dominant ruling classes of each period, instead of a simple linguistic evolution. [175]

In addition to the diversity resulting from geographical separation there is ample evidence that independent, possibly competing workshops existed in larger population centers. For example, W. Stevenson Smith has pointed out that among the surviving Fourth Dynasty heads from Giza, at least two schools of sculpture are clearly recognizable in the reigns of Cheops, Chephren and Mycerinus. [176]

The examples cited above could be enlarged upon and supplemented by others, but they were simply designed to show that similar diversity is to be expected in the manufacture of faience, glass or bronze objects. Moreover,

the differences are not likely to be confined to matters of style but must show up in the composition of these man-made materials. The compositional differences can reflect different raw materials or different recipes. The problems of raw materials and their possible provenance were treated in various sections of Chapter II, but on a national scale, by examining the dominant composition of most objects of a given time period. In this chapter we will look at the recognizable differences between the nature of contemporary faience objects recovered from geographically diverse regions.

Of course, we are not the first to look at the problem of regional provenance from the standpoint of composition. Tobia and Sayre have measured trace metal concentrations in a variety of Egyptian soils, clays and shales in an attempt to see if they can thereby trace the provenance of Egyptian pottery. [35] Though the authors express "reserved optimism" towards future work, the results were not overly encouraging, since the compositional diversity was not as great in the Nile valley as one might have hoped for.

More recently, Riederer has looked at the variations in the compositions of Late Egyptian bronzes (ca. 700-300 B.C.). [177] On the basis of stylistic criteria bronze ushabtis were divided into three groups: Lower Egyptian, Middle Egyptian, and Upper Egyptian. Despite extensive overlap between the extreme compositions of each region, the bronzes of the three parts of Egypt yielded distinctly different average concentrations of elements such as tin, arsenic and lead. For example, the average concentration of tin varied from 6.94% in bronzes of Lower Egypt, to 3.78% in those of Middle Egypt, with an intermediate value of 5.12% in Upper Egyptian bronzes. On the other hand, Middle Egyptian bronzes had the highest average arsenic and lead levels, 0.94 and 16.11%, respectively. [177]

No such investigation has been published for Egyptian glass or faience. The paucity of analytical data makes the absence of a faience study understandable. In the case of Egyptian glass, where by now an appreciable number of analyses have been done, the lack of satisfactory geographical distribution makes such a study impossible even now. It is generally acknowledged that glass objects were considered luxury items during most of Egyptian history and their manufacture must have been restricted to a few

workshops. The bulk of New Kingdom glass was recovered from Thebes and
Amarna, while most Ptolemaic glass tends to come from Alexandria or Memphis.
Nowhere is this geographically narrow representation more clearly illustrated
than in the study of Farnsworth and Ritchie. [19] Of the 73 specimens analysed
by the two investigators 56 came from the palace of Amenhotep III at Thebes,
12 from Amarna and only 5 from other sites. Similarly, two thirds of the New
Kingdom glass analysed by Sayre was recovered at Thebes. [22-24]

New Kingdom glass objects recovered from some of the more remote areas
tend to bear evidence of having been manufactured in one of the royal
workshops. J. D. Cooney, author of of the recently published catalogue of
Egyptian glass in the British Museum and a scholar who has probably examined
more ancient Egyptian glass over the years than any other individual, was of
the opinion that the production of glass objects must have been a royal
monopoly during the 18th Dynasty, if not for the entire duration of the New
Kingdom. [178]

The tremendous output and the great variety of Egyptian faience of all
time periods are clearly indicative of a large number of workshops. Some of
these workshops were probably in operation long before the political
unification of Egypt, since faience and glazed steatite have been recovered
from numerous widely separated Predynastic sites. Considering how reluctant
the Egyptians were to change anything which bore the stamp of antiquity, it is
difficult to conceive that the workshops, other than the royal ones, would
easily abandon their cherished recipes. Since the royal workshops had to
satisfy the more refined taste of the king and his court they would be more
likely to experiment in an attempt to produce a better and more attractive
product.

On several occasions we pointed out that some of the material recovered
from royal tombs or those of high-ranking officials is distinctly different
from contemporary material found in more humble graves. However, it is the
non-royal workshops that account for most of the faience recovered in Egypt,
and the absence of uniform standards is amply demonstrated by the wide
variations in the quality of their voluminous output. Such workshops would
undoubtedly find it more difficult to obtain raw materials imported from

abroad or obtained as tribute from conquered nations. Of the materials used in the manufacture of faience copper and lead (as ores and metals) and possibly tin bronzes are explicitly listed as tribute from foreign lands during the 18th Dynasty. This small list will undoubtedly grow as the Egyptian philologists elucidate the meanings of many disputed names of minerals, metals and alloys. [65]

One would expect the workshops in areas remote from the royal residence and from the larger population centers to rely most heavily on materials mined in close proximity. Instances where the composition of the faience appears to have been dictated by such economic necessity will be pointed out in subsequent sections.

In order to identify local idiosyncracies and identify whenever possible what we have several times before referred to as "regional bias", we made a deliberate attempt to select within each historical period objects from as many sites as the Ashmolean and Petrie Museum collections permitted. Unfortunately, even with the large number of analyses it was not always possible to get a statistically satisfactory sample from some of the regions. Hence, our conclusions must for the time being be considered preliminary, and we intend to pursue the subject of regional variability further in the future.

The sites which have yielded objects included in this study are shown on the attached map of Egypt (p. vii) and are listed in Table XXXVI below. As one can see, there is a good representation of sites from the First Cataract to the Nile Delta. However, since no single site has yielded a continuous sequence of faience objects representing each of the 12 historical periods (see Table I), it seemed advisable to group the sites into nine regions. The groupings were partially based on the natural clustering of the selected sites. Despite the grouping of adjacent sites, it proved impossible to find faience from all of the historic periods in some of the regions. This is perfectly understandable, because many of the sites and regions fluctuated in importance and some, such as Serabit el Khadim in the Sinai, were only occupied for limited periods of time.[110,112]

The one region from which we have a continuous set of faience objects,

from the First Dynasty to the Ptolemaic Period, is the Eighth Nome, the area around Abydos. Since Abydos was a famous pilgrimage site, there is always the possibility that some of the faience recovered there was brought in from other parts of Egypt. However, just about all of the analysed Abydos faience came from graves and tombs belonging to the priests and other functionaries living and working in Abydos. As a matter of fact, faience from the Eighth Nome is most noteworthy for its conservatism.

The geographical limits and the estimated populations of the nine regions as well as a list of sites within each region are shown in Table XXXVI. The population estimates represent average values for the indicated Nomes during the New Kingdom. [179] A more detailed alphabetical tabulation of all the sit s, with the tombs, graves, and temples at each site listed in chronological order, may be found in Appendix D. The same appendix lists the code numbers of objects recovered from designated sites. The code numbers are those used in Appendix C, which gives the full description and elemental composition of each of the objects included in this study. Table XXXVI also lists the time periods which are represented by faience recovered from the indicated regions.

In the next two sections we will compare some of the salient characteristics, such as are clearly discernible, of the faience of various regions. In preceding chapters we made frequent allusions to impurities which most probably had entered the faience with sand, the major ingredient. The allusions had to be made with regards to the composition of Egyptian sands in general, as deduced from the 13 analyses published to date. [3,18,26] It is regrettable that the number of specimens from each site is too small and the sampling far too inadequate to allow for the data to be used for a study of regional differences on the basis of sand compositions. The differences between samples from the same region or from neighbouring villages are greater than those between sand specimens from very distant regions. For example, the sand from Karnak is reported as containing 12.0% lime and 1.3% combined iron oxides and alumina. [18] The corresponding ingredients in the sand from Luxor, practically next door, are given as 4.9 and 13.8%, respectively. [26] The discrepancy between the two reported specimens from the Faiyum is a little less glaring. [18]

T A B L E XXXVI

THE REGIONAL GROUPINGS OF SITES REPRESENTED IN THIS STUDY

Region	Geographical location, periods of history represented, and estimated population	Sites included in the region
1.	Lower Egypt, nomes 2-20. 1st I.P., Dyn. 19-20, 26-30, and the Ptolemaic Period.	Alexandria, Defenneh, Gumaiyima, Nabesha, Naucratis, Tell el-Yahudiya, Tukh el Qaramus
2.	Lower Egypt, 1st nome. Dyn. 3-6, 19-30, Ptolemaic. pop. 76,000	Cairo, Giza, Memphis, Saqqara
3.	The Sinai. 2nd I.P., Dyn. 18-20	Northern Sinai and Serabit el Khadim
4.	Upper Egypt, nomes 20-21, and the Fayyum. Dyn. 1-30 pop. 190,000	Dishasha, Faiyum, Haraga, Hawara, Ihnasiya, Kafr Ammar, Lahun, Medinet Ghurab, Medum, Qasr el Sagha, Riqqa, Sidmant, Tarkhan
5.	Upper Egypt, nomes 9, 10, 15, 16. Dyn. 1-25. pop. 208,000	Akhmim, Tell el-Amarna, Badari, Beni Hasan, Hammamiya, Matmar, Mustagidda, Qau
6.	Upper Egypt, 8th nome. Dyn. 1-30, Ptolemaic Period pop. 50,000	Abydos, Beit Khallaf, Mahasna
7.	Upper Egypt, nomes 4-7. Predynastic-Ptolemaic Periods. pop. 185,000	Abadiya, Armant, Deir el Bahari, Dra Abu el Naga, Hu, Naqada, Qift (Coptos), Qurna, Thebes
8.	Upper Egypt, nomes 1-3. Dyn. 1-6, 11-12, 18 and Ptolemaic Period pop. 173,000	Edfu, Gebel el Silsila, Hierakonpolis, el Kab
9.	Nubia, south of Aswan. 2nd and 3rd I.P.	Faras and Sanam Abu Dom

Note: For the proposed boundaries between Egyptian nomes one may consult
Baines and Malek, ref.162, pp.14-16. The population estimates are
those of Butzer (ref.179) for the average between 3000 and 1000 B.C.

Until much more raw sand analyses become available, it will be impossible to trace the faience sand and its accompanying impurities to their exact place of origin. Examination of the concentrations of elements such as titanium, vanadium or strontium, in the body materials and in glazes, failed to detect any consistent regional patterns. No one region emerged as having the highest or lowest concentrations over any extended period of time.

At first glance it would appear that tracing some of the faience pigments to specific mineral deposits should prove easier, since there is somewhat more analytical data in the form of geological assays. Such analytical information is most plentiful for copper, lead and iron deposits. As we will show in the next section, certain impurities associated with copper and lead tend to persist in Egyptian faience of certain specific regions over extended periods of time. Unfortunately, some of the impurities are of the type that can be found in many geographically separated deposits. So that all one can say is that the faience-makers of a given region persisted in using some favourite source of copper or lead. What we cannot tell, until more detailed and more numerous assays have been published, is which particular ore deposit (or deposits) was being favoured.

It is bad enough not to have satisfactory analyses, but even when such data are available one encounters another stumbling block. The nature of Egyptian manganese, copper and lead deposits is such that a single mine can contain several ores with an extremely wide range of impurity levels. In some instances what is an impurity at one spot can become the dominant component at another. An acute example of this problem exists at the Umm Samiuki copper mines (see Table XIV), which are among the few showing evidence of ancient workings. Since the nature of impurities associated with Egyptian manganese, copper and lead was discussed at some length in Sections 5, 9-11 and 16 of Chapter II, there is no need to go over the information again.

Two other factors compound our difficulties. First, we cannot be sure that all the mines which were exploited in pharaonic Egypt have been discovered, so that we might be trying to trace the ore to a mining area about which nothing is known at the present. Second, if we confine ourselves only to those deposits that show clear evidence of ancient exploitation in the form

of slag heaps, smelting furnaces, graffiti, building remains, etc., we still have to deal with a territory that stretches over a thousand miles. For example, the remains of ancient copper works extend from Abu Seyal in Lower Nubia, [63] located at a latitude of 22°47'N. (see ref. 38, p. 842), to Timna in the Negev,[64] at a latitude of 30°N., a distance of over 500 miles. Elimination of Sinai deposits, which appear to have been exploited only between the 3rd and 20th Dynasties, still leaves a copper belt stretching to the mouth of Wadi Araba, at a latitude of about 29°N. Moreover, only a small percentage of the copper ores contained in this long stretch of the Eastern Desert have been subjected to an accurate analytical assay.

The geographical spread of known lead and manganese deposits is somewhat narrower, but still almost 300 miles long. An up to date list of galena (lead sulphide) deposits, accompanied by a map and comments about evidence of ancient mining, has been compiled by Stos-Gale and Gale. [79] The publication also contains analytical information regarding certain selected impurities found in these galenas.

Manganese deposits are also numerous but quantitative data relating to the elemental composition of the various ores is hard to come by. Mineralogical information is available, and in some instances it can be related to certain characteristic elemental associations. Thus the presence of barium is a clear indication that the original ore was psilomelane. [44] In Sections 5 and 15 of Chapter II we noted that psilomelane was favoured at certain periods of time, and one can show that the preference for this ore as opposed to pyrolusite or manganite was not nationwide. Unfortunately, without extensive trace metal analyses we cannot pinpoint precisely the source of manganese found in faience or in any other material, since a recent mineralogical study done by el Shazly and Saleeb has shown that several of the Sinai and Eastern Desert deposits contain all three principal ore types. [40] The best example of such a mixed deposit occurs at Wadi Diib, near the northern end (Lat. 27°50'N., Long. 33°E.) of the Eastern Desert. [40]

One very unsatisfactory feature, from our standpoint, of the published studies of Egyptian manganese deposits is the absence of information regarding any evidence of ancient mining activities. At this point it is worth

mentioning one other possible source of ancient manganese -- some of the Nubian Sandstone deposits containing gold-bearing quartz (ref. 38, p. 810). Since the Ancient Egyptians seem to have exploited most of the known gold deposits of the Eastern Desert, one cannot rule out the possibility that the oxides of manganese remaining after the gold had been extracted might have been collected and utilised too.

The problems of tracing cobalt, tin and antimony to their sources, all of which might have been foreign, have been treated extensively in several sections of Chapter II. Later in this chapter we will return briefly to the whole subject of "foreign imports". The recent discoveries of rich tin and antimony deposits in the Eastern Desert,[103,125] the prospect that others will be discovered in the future, and the growing evidence that New Kingdom cobalt might have originated in the alums of the Great Western Oases (see Section 7 of Chapter II and Section 6 of Chapter IV), point out the hazards of making definitive and unequivocal statements as to what was and what was not being imported.

However, until the tin and antimony deposits show evidence of ancient mining one has to assume that minerals containing the two elements were brought in from abroad. Graffiti dated to the reign of Neferkare Pepy (end of the Sixth Dynasty) have been found in the vicinity of the el-Mueilha tin mine, but since the tin-bearing rocks are an extension of gold-bearing quartz veins it is probable that the inscriptions were left by Old Kingdom gold prospectors. [103,180]

Tracing elements such as tin, lead and arsenic to their original source is seriously complicated by one other factor -- in many instances they entered the faience glaze as alloying substances with copper. Hence, the impurity pattern represents contributions from copper ores as well as those of the three elements listed above. At the same time, some of the original ore impurities will have been lost in the metallurgical operations long before the element ended up in faience. This may also be true of antimony in yellow and green faience, if as Brill believes, the element might have been traded on occasion in the form of yellow lead antimonate pigment. [28,181]

Brief but reasonably good descriptions of Egyptian copper and other mineral deposits, with comments about evidence of ancient mining, may be found in Chapter XI of **Ancient Egyptian Materials and Industries**, [41] and in Hume's definitive geological study. [38] A more recent map showing the location of some of these deposits may be found in a review article by Azer. [107]

After the regional variability has been explored we will examine the affinities and differences between Egyptian faience and faience of neighbouring countries. Since we are primarily interested in the nature of the glazes, and these have been shown to exhibit many similarities to contemporary glass in Egypt, we will also compare Egyptian glass and faience pigments to those of Mesopotamia and the Aegean.

2. Egyptian Faience Prior to the 18th Dynasty

As far as Predynastic faience is concerned, it is difficult to talk of regional variations since we have only been able to get material from Naqada. All of the examined glazed objects from Gerza and el Amra proved to be steatite. On several occasions in Chapter II (Sec. 10 and 16, in particular) we commented upon the compositional heterogeneity of some assemblages recovered from a single grave. The most noticeable variability was in the zinc and lead contents of the principal pigment, copper. Thus while some beads were relatively free of either zinc or lead, others from almost the same spot contained appreciable amounts of zinc (up to 2.3% ZnO, in excess of CuO) and little lead, still others had moderate amounts of PbO (up to 0.6%) and no zinc, while a certain fraction contained modest levels of both ZnO and PbO.

The heterogeneity among apparently contemporary faience can be explained in one of two ways. Either ores from different sources were shipped to Naqada at this early date and mixed on the site, or copper deposits such as those of Umm Samiuki[69,70] were the dominant variety being exploited during the second half of the 4th Millennium B.C. We are inclined to favour the latter explanation, since the area containing the richest deposits of mixed polysulphide ores is located at the level of Aswan in the Eastern Desert. The mines lie close to a major caravan route connecting the Nile valley with the Red Sea coast around Ras Benas and are dotted with Ancient Egyptian shafts (ref. 38, pp.837-839), some extending to considerable depths, in excess of 40

metres in places. [69] Consequently, it is not unreasonable to assume, as our evidence suggests, that the exploitation of the Umm Samiuki and adjacent deposits dates back to prehistoric times.

Smaller deposits containing similar mixed ores also occur at several spots along the stretch of mountains extending from Wadi Hammamat (Lat. 26°N.) to the level of Aswan (Lat. 24°N.). These are discussed by Hume[38] and Lucas. [41] With Naqada located just south of Lat. 26°N., these mines would have been a logical source of copper too. Whether they actually were is uncertain at this time, since none of them show the same extent of ancient mining activities as Umm Samiuki. Of course, future archaeological surveys of the sites in question might force us to revise the picture.

Among copper mines close to Egypt that show evidence of having been exploited by the local inhabitants as early as the 4th Millennium B.C. are those in the Wadi Arabah area of the Negev. [64,182] This suggests that the western Sinai copper mines in the Wadi Maghara and at Serabit el Khadim might also have been exploited by local inhabitants prior to the imposition of Egyptian control during the Old Kingdom. [112] Early inscriptions from the Sinai suggest that turquoise and not copper was the primary commodity being sought by the Egyptian expeditions. [110] The region, however, also shows evidence of extensive exploitation of copper in the form of slag heaps, waste scraps, crucibles and other paraphernalia of presumably Old Kingdom date. [111]

Since precise dating of such remains is a difficult task we must take issue with Lucas' conclusion that: "...the Sinai ore was being smelted for copper as early as the middle Predynastic period,"[183] because traces of manganese have been detected in a predynastic copper axe-head and in Archaic period metal bands. [49,184] To Lucas the presence of manganese was: "...a very strong indication that the original copper ore had been obtained from the neighbourhood of the manganese ore deposits in Sinai, that is probably from Maghara,..."[183] The amounts of manganese found, ca. 0.1% Mn (see item No. 1 on p. 483 of ref. 49) are too small to warrant the second quote on which the first conclusion of Lucas hinges. Petrie remarked that some of the copper recovered from the royal tombs at Abydos contained <u>ca</u>. 1% manganese. [184] A concentration of this magnitude would be significant, but we do not know how

firm the quoted figure is, since no analyses have been published. The quoted manganese concentration could be a rough estimate from semi-quantitative analysis done almost a century ago.

Small amounts of manganese could have been easily introduced through the use of manganese ore as a flux, a practice well attested in the ancient metallurgy of copper. [122] For example, Tylecote has shown that the use of manganese fluxes and smelting equipment at the ancient Timna site can raise the manganese content of the resulting copper from 10ppm to 0.087%, [122] to about the level seen in the predynastic axe-head noted above. Similarly, the discovery of a flux containing 10.5% lead explained why some of the old pieces of copper found near the old smelting sites at Timna had Pb:Cu ratios greater than are found in the local ore (ref. 64, p.237). At the same time, there is nothing to show that the flux and the ores have to come from the same locality. The lead-rich copper slag (38% PbO, 22% CuO) from Serabit el Khadim that intrigued Lucas so much (see ref. 49, p. 482, n.2) can best be explained by assuming that a lead oxide flux had been used, in a region where not much lead is found. As a matter of fact, in dealing with finished metal objects or materials derived from processed metals, one must keep in mind the hazards of trying to trace the metal back to the ore on the basis of trace and/or major element patterns without considering the additions or losses in the metallurgical process. This point has been forcefully argued by Rothenberg in his **Timna** book (ref.64, p.237), since Timna is one of the few places where archaeologists and metallurgists have been able to study and use old smelters at a site that was used in antiquity and see how the metal composition compares with that of the original ore.

Another reason why the presence of manganese at levels noted above cannot be used to postulate Sinai as the source of copper is that trace to moderate amounts of manganese frequently accompany mesothermal and hypothermal sulphide deposits of copper of the type mined at Umm Samiuki and several other Eastern Desert sites. [54]

Therefore until there is strong evidence to the contrary, one must presume that at least until the Old Kingdom most if not all of the copper used in Egypt came from mines in the Eastern Desert. Moreover, as Butzer has

pointed out,[179] the Nile Valley between the First Cataract and the Wadi Hammamat was much more densely populated in the 4th and 3rd Millennia B.C. than in later times, so that extensive exploration and mining of the mineral deposits in the adjacent desert areas were to be expected.

Between the 3rd and 20th Dynasties varying amounts of Sinai copper must have reached almost all parts of Egypt, but tracing it either via metal or faience analyses may prove very difficult. Manganese and iron may be plentiful in the Sinai, but the manganese, at least, is not intimately mixed with the copper the way the various sulphides are mixed in some of the Eastern Desert deposits. The published analyses of Egyptian copper artifacts reveal that even during periods of known heavy exploitation of the Sinai copper mines, manganese rarely shows up as a significant impurity.[49] Zinc is much more common. Of course, using small levels of either manganese or iron as an indicator of the source of a faience glaze is even more hopeless due to the fact that sand and other ingredients that go into the making of faience can also contribute substantial amounts of the two elements, as was shown in Sections 5 and 6 of Chapter II.

However, more extensive use of Sinai versus Eastern Desert copper may be deduced from some negative evidence, such as the diminished incidence of zinc oxide and lead oxide in green and blue glazes of the Old and Middle Kingdoms as compared to the incidence of the same two elements in faience of the predynastic and early dynastic periods. Only in the southernmost regions, particularly the el Kab area, does one fail to notice an increased proportion of low-zinc and low-lead copper. Since these are the regions most remote from the Sinai, simple economic considerations would have encouraged continued exploitation of the neighbouring deposits. During the intermediate periods the incidence and the average concentrations of both zinc and lead show a slight rise, and the rise is greater during the First than during the Second Intermediate Period. All of this is consistent with a reduced access to the Sinai during the two troubled periods.

It is when the levels of impurities found in the copper objects rise from parts per thousand into the range of percentages, that a distinct source for the ore is indicated. Examples of such high impurity levels in predynastic

copper have been noted in Section 10 of Chapter II. We are referring to a pin from grave 218 at Naqada which contained 2% Zn and 1-2% Ni, among other impurities. [71] From another grave at the same cemetery Petrie recovered another copper object in which the zinc concentration was 1.55%. [185] While the Umm Samiuki and some of the adjacent deposits contain zinc-rich ores that could have yielded copper with the indicated levels of zinc, explaining the high nickel content is somewhat more difficult. We know of only one mine, Abu Seyal in Lower Nubia (Lat. 23°N.), that contains mixed nickel-copper sulphides. [63] In Section 8 of Chapter II we gave the results of modern ore assays and noted that metallic nodules containing up to 15% Ni have been recovered from ancient slag heaps.

The Abu Seyal ore is a mixed sulphide ore, but only the copper, iron, and nickel contents have been published. It is regrettable that no zinc analyses are reported, so that we do not know whether zinc is absent or simply has not been determined. If zinc were to be found in appreciable quantities, the mine would be the only one within a reasonable distance of Egypt that could have yielded copper with the types of impurities noted above. At the present time no evidence has been found to indicate that it was exploited prior to the 12th Dynasty, when the region came under direct Egyptian control. It would be interesting to know whether the Abu Seyal deposits were the place from which the so-called "copper of the Land of Nubia" was being collected during the Middle Kingdom,[186] and whether the mineral exploitation of the site dates to prehistoric times.

With the unification of Egypt one would anticipate improved and more secure transportation and greater movement of commodities. We do have Archaic faience from several sites and except for some peculiarities to be discussed below, its composition is rather homogeneous over the entire country. Whether it is more homogeneous than before, we do not know, since all of our prehistoric faience came from Naqada.

Some of the most unusual faience of the period came from grave 678 at Tarkhan. Within a single assemblage we found glazes containing from barely any to as much as 1.5% ZnO. One is tempted to see in this a southern ore, similar to the ones discussed earlier, being shipped as far north as Tarkhan.

No lead was found in any of the analysed Tarkhan beads, so that the better known ancient copper mines of Umm Samiuki and Atshan seem an unlikely source of the high-zinc ore (Table XIV). However, the copper-zinc mineralisation extends over several hundred miles of the Eastern Desert, and in places the ore contains very little lead. One such deposit is at the ancient copper mine of el Atawi, at the latitude of Thebes. [41,107] Additional support for the idea that the copper originated in the South-Eastern Desert comes from the observation that the high-zinc glazes contain three times as much iron as do the ones with little or no zinc. Iron is a major component of just about all the mixed copper-zinc ores. [107]

The geographical location of Tarkhan suggests another possible source for the copper, the adjacent Bir Thimeil mine in the Wadi Araba. [187] An 80-mile long trail marked by Ancient Egyptian guardhouses (one from the reign of Ramesses II) connects the mine to the Nile at a point only 15 miles upstream from Tarkhan. The ore consists of chrysocolla, which would be free of lead, but we have no information regarding possible copper-zinc mineralisation. Pottery recovered from the site consisted principally of New Kingdom fragments with a few specimens that could have been of Middle Kingdom date. [187] Should future surveys show evidence of copper-zinc mineralisation in the general area of Bir Thimeil, we will seriously have to consider the possibility that the mines abutting the Wadi Araba had been exploited at least since the 1st Dynasty.

However extensive copper shipments might have become after the unification of Egypt, the preference for ores from adjacent sites continued well into the 3rd Millennium B.C., particularly in the outlying areas. For example, during the Old and Middle Kingdoms it is in faience from el Kab (see the Map and Table XXXVI) that one finds the highest incidence of glazes containing more than trivial amounts of lead. Thus, while only 10% of blue and green Middle Kingdom faience from Abydos had PbO above 0.1%, an impressive 36% of like faience from el Kab had lead oxide in excess of the indicated level. Moreover, el Kab was the only site among those examined by us that yielded pre-New Kingdom glazes containing over 1% PbO (an impressive 4.3% PbO in one 12th Dynasty specimen).

Another important component of the mixed ores of the Umm Samiuki type is iron sulphide (see Table XIV). If one looks at pre-New Kingdom faience, the highest levels of iron oxide tend to show up in material from Hierakonpolis and el Kab, and areas further south, such as Faras in Nubia. The iron seen in blue and green faience need not have all come with the copper. Red ochre (Fe_2O_3) is a very plentiful mineral along the stretch of the Nile river from Gebel el Silsila to Aswan, so it might have been used on its own merits. In the glazes of Hierakonpolis and el Kab we might be seeing the first instances of a deliberate mixing of two mineral pigments of distinctly different colours to produce a particular shade of green or blue. Levels of iron as high as 4.8% Fe_2O_3 have been detected in green faience from el Kab. In contrast, no pre-18th Dynasty green or blue faience from any other site contained more than 3.6% Fe_2O_3. The effects of iron on the production of green colour have been dealt with in Chapter III.

The glazemakers of Hierakonpolis and el Kab also showed their attachment to iron in a different manner. In Sections 5 and 6 of Chapter II and Section 8 of Chapter III we pointed out that most of Egypt from the 2nd to the 26th Dynasty favoured a black pigment based on manganese containing variable but inferior amounts of iron. For over a thousand years the principal holdouts in maintaining a black pigment in which the iron was dominant and manganese at substantially lower concentrations or altogether absent were the craftsmen of the 3rd nome. The virtually national scope of the abandonment of a pigment based on reduced iron oxides was illustrated in Fig. 20. And yet if one examines the faience from Hierakonpolis and el Kab the statistics are quite different, as the figures in Table XXXVII clearly show.

T A B L E XXXVII

PERSISTENCE OF REDUCED IRON BLACK IN THE THIRD NOME

Percentage of Black Glazes with an Excess of Iron over Manganese

Region	Archaic Period	Old Kingdom	First I.P.	Middle Kingdom
The Third Nome	100	100	---	50
The Rest of Egypt	33	0	25	0

The 25% figure in the First Intermediate Period column represents beads from three graves at Mahasna, and not specimens from all over Egypt. Moreover, three of the four Mahasna beads had $MnO:Fe_2O_3$ ratios very close to unity (0.83, 0.95 and 0.97, respectively). On the other hand, the remaining 75% of the black First Intermediate Period glazes had ratios ranging from 1.4 to 15, with 5 being the average value for the period. In contrast with the Mahasna and other Egyptian material, black glazes from el Kab in which iron is dominant yield average $MnO:Fe_2O_3$ ratios of 0.38 and 0.26 for the Old and Middle Kingdoms, respectively.

During most of the 3rd Millennium B.C. the iron-based black pigment seems to have maintained an almost absolute dominance in the 3rd Upper Egyptian nome. By the Middle Kingdom, the old technical tradition and the new, based on manganese, seem to coexist in the same region. This is particularly evident in faience recovered from several graves at el Kab. Thus among the black beads from grave 36 three contained a large excess of iron and yielded an average $MnO:Fe_2O_3$ ratio of 1:10, while in the fourth the ratio was 16:1. The latter one was a large black-bodied bead of what Lucas would have called Variant B faience (see Sec. 4 of Chap. IV). Similarly, while a small flat amulet from grave 202 was coated with a black glaze in which the manganese:iron oxide ratio was 1:2, a black bead from the same grave had the reverse ratio of 2:1. However, the highest ratio, and one more closely conforming to what for a long time had been the norm in the rest of Egypt, was detected in the black hair of a green mummiform statue (E.3788) from grave 1 at el Kab. The $MnO:Fe_2O_3$ ratio of 27 is remarkably close to 30, the figure obtained as the average ratio for black Middle Kingdom faience from all the sites other than el Kab.

One may be tempted to see el Kab as a tradition-bound backwater unwilling to go along with the technological innovations introduced in other parts of Egypt, but there is another way to look at the evidence. Iron is very plentiful in the vicinity, manganese is not. Manganese ores are most heavily concentrated in the Sinai and near the northern end of the Eastern Desert. Hence, maybe the local craftsmen were just being thrifty and made do for a long time with a cheaper and more readily available commodity.

No comparable evidence of prolonged regional technological bias could be discerned in the analyses of glazes of other regions. Instead, what one does find is considerable uniformity punctuated by isolated instances of unusual compositions. By unusual we mean atypical of Egypt as a whole during a specified time period. In most instances such apparent aberrations show up in only one or two graves out of several representing a certain site and period. This might be interpreted as evidence of a particular workshop that used raw materials and recipes different from those being favoured in the rest of the country. Unfortunately, one cannot tell whether a distinctive workshop, whose unusual products caught our attention, was located close to or far from the site of recovery.

There also remains the possibility that such anomalous faience specimens were not of Egyptian manufacture but represent imports from abroad. Textual evidence for the importation of copper, lead and other minerals exists and has been cited in several sections of Chapter II. However, just about all such evidence dates from the New Kingdom. We do not know what the situation was in earlier times, but Kees states that "Asiatic copper" is mentioned as early as the Old Kingdom.[110] That some finished faience products, such as vessels, must have also been traded from the earliest times seems only logical, but to what extent and where from is a matter that is likely to remain unsettled in the foreseeable future.

We will now discuss a handful of the "exceptional" examples of pre-New Kingdom faience encountered by us in the course of our study. One of the advantages of working with the Ashmolean Museum collection was the fact that it has a good representation of Archaic material from the royal tombs of the first two dynasties. Faience from the tombs of five First Dynasty and two Second Dynasty rulers was analysed. Since we also had material from the temple area at Abydos, from several contemporary sites at Hierakonpolis, and other locations around Egypt (see Appendix D) we had an opportunity of comparing faience suitable for a royal tomb with products from other workshops.

While there were some minor differences between the faience of various royal tombs, it was the contents of the tombs of Djer and Udimu (Tombs O and

T, respectively, at Abydos) that stood out. Not only was the faience different from any other royal or non-royal Archaic material, but it was unlike anything seen again in Egypt for the next 1500 years. We are referring to three fragments of Type D faience in which the glaze and body were coloured by tin-rich copper. The concentrations of SnO_2 varied from 0.2 to 0.3% in the glaze, while the bodies all had ca. 0.2% SnO_2. Even more remarkable than the absolute concentrations were the Sn:Cu ratios. These ranged from 0.1 to 0.12 in the glaze and from 0.14 to 0.17 in the body.

We are at a loss to explain the presence of so much tin in a copper-containing object of this early date, 2900-2800 B.C. In our discussion of tin in Chapter II we showed that from the 18th Dynasty on bronze scrap was the primary source of tin in faience, and only a small proportion of glazes required that a secondary source be postulated. Tin bronzes were virtually unknown within a 500-mile radius of Egypt at this time, and even in northern Syria and Anatolia they were not too common at the beginning of the 3rd Millennium B.C. [88-90, 103-104] If the faience does not represent an accidental or early experimental mixing of cassiterite and copper ore, one must assume that a 15% tin bronze could only have come from some foreign source.

The only other pre-18th Dynasty glazes with comparable tin concentrations, but with lower tin-copper ratios (0.3-0.4% SnO_2, 4-5% CuO), were detected on 12th Dynasty faience from Abydos. However, by the Middle Kingdom tin bronzes and consequently bronze scale had ceased to be a rarity in Egypt, so faience with as much tin as was measured in beads from grave D2 are not anachronistic in the way that the Archaic vessels are.

Although the vessel fragments seen by us came from the tombs of Djer and Udimu (Den), and at least one ruler intervened between them (Djet), it is very likely that all three fragments represent rare specimens made at about the same time and in the same workshop. We had no specimens from the tomb of Aha, so we have no idea whether such faience was made before the time of Djer. We also failed to find similar vessel fragments among the objects of Djer's successor Djet, or among the remains from the tomb of Udimu's successors Anedjib and Semerkhet.

Thus until such objects are recovered from the tombs of rulers other than the two mentioned above one must presume that the vessels E.1577, E.1578 and E.3182 were made during the reign of Djer or before, and the fragment found in the tomb of Udimu came as a heirloom from an earlier reign. As a matter of fact, all the examined elemental ratios in E.3182, which came from tomb T, resemble so much the corresponding ratios in the fragments recovered from the earlier tomb O, that it is inconceivable that they were not coated with the same batch of glazing material. The resemblance extends to the body material and the mode of manufacture (see Appendix A). For example the MgO:CaO ratios in E.3182 and E.1577 are 0.15 and 0.18, respectively. The respective $Na_2O:K_2O$ ratios are 12 and 9. Equally remarkable are the similarities in the concentrations of Al_2O_3 all of which fall within a narrow range of values, 0.9-1.1%.

It is not just faience that makes the contents of royal tombs O and T unusual. Among the 79 copper objects of the Archaic Period analysed by McKerrell,[91] the only one to contain over 1% Sn was a nail (E.1239) from tomb T. It is fortunate that we had access to the unpublished analyses of copper objects from the Ashmolean collection, because the case cited above is only one of several in which the same grave has yielded both atypical faience and copper objects.

For example, among the 63 analysed copper objects of the Old Kingdom the only ones to contain over 0.1% Sb were those from tomb Kl at Beit Khallaf.[91] The same tomb accounts for three out of the four copper objects that contained over 0.1% Sn. Tin oxide (up to 0.06%) and Sb_2O_5 (up to 0.03%) were detected by us in all the faience beads recovered from this tomb. As a matter of fact, of the seven Old Kingdom faience objects in which SnO_2 in excess of 0.01% was detected four came from tomb Kl at Beit Khallaf.

These are not the only cases of apparent compositional coincidence between the faience and metal objects recovered from the same grave, but no useful purpose would be served by citing other examples. It is difficult not to see in each case of this type evidence that both the metal and the faience came from the same workshop. It would indeed be an amazing coincidence that so much tin, for example, should turn up independently in metallurgical and

glaze-making workshops, particularly at a time when the element was still an extremely scarce commodity.

At the present time in history, when specialisation has become the normal state of affairs in all fields of endeavour, one does not expect metallurgical and glazing operations to be carried out under the same roof. The ancients, however, did not regard the two professions as that different. Both crafts are branches of what is commonly termed pyrotechnology, and we can cite a story from Petronius' Satyricon to demonstrate that around the beginning of our era it was quite normal for the same individual to be engaged in the manufacture of glass and copper smithing. The particular story tells of an inventor of a secret formula for the manufacture of unbreakable glass, and begins with the words: "There was a coppersmith that made glass vessels...". [188] The tale has an unhappy ending, for when the inventor proudly presented an unbreakable glass vessel to Tiberius the latter, after ascertaining that no one else was privy to the secret, had the poor chap beheaded. The reason for the beheading was the fear that if the invention found wide acceptance, "gold and silver will be of no more esteem than dirt."[188]

It is difficult to see why in Ancient Egypt too the metallurgical operations and the manufacture of faience (and later glass) should not have been carried out in the same workshops. Such combined operations would facilitate the acquisition of metal scrap for the manufacture of faience pigments. Ample evidence for the use of scrap was presented in Chapter II when arsenic, tin and lead were discussed. Consequently, it is difficult not to concur with the views expressed by many investigators of early pyrotechnology and most recently by Peltenburg, to the effect that: "...some close association between the earliest glazers and metalworkers seems likely."[189]

We must now mention one other instance of a most peculiar composition for which we have absolutely no explanation. We have in mind the faience panels of a large heavily restored polychrome pendant (1921.1411) recovered from grave 2108 at Sidmant. The grave has been assigned a Dyn. IX-X date. The panels come in several shades of green, blue and brown. However, regardless of colour, all of them contain exceptionally high levels of barium, 0.5-1.1%

BaO. The faience is also characterised by high concentrations of copper (4-8% CuO) and sulphur (0.4-1.1% SO_3). In accordance with contemporary practice, manganese was the element used to produce the brown panels. Unlike the blue and green panels, which contained less than 0.2% MnO, the brown ones had the colouring compound at levels of 3-4%.

The detected concentrations of barium oxide may not seem so high when compared with the levels observed in some early Chinese glass,[127,128] but they are quite extraordinary within the Egyptian context. Several things make these Sidmant panels unlike anything else seen before or after. Firstly, in contrast with the few specimens of Egyptian faience that contained significant amounts of barium, the BaO showed no correlation with manganese (see Section 15 of Chapter II), or with any other element for that matter. Secondly, the concentrations were substantially higher than the highest values seen in any other faience, regardless of colour. For example, no other blue or green faience has been found to contain more than 0.25% BaO, and no more than 0.7% BaO has been detected by us in any brown or black faience.

The question then arises, how did this particular object (1921.1411) end up with so much barium? Was the barium introduced accidentally or was it added deliberately? If the barium had found its way into the faience accidentally it must have come with copper. The only mine within a reasonable distance of Egypt that contains a copper ore rich enough in barium to yield the type of glazes detected in the pendant is located in northern Mesopotamia, at Norsun-Tepe (Keban) on the Upper Euphrates. [190] The site has yielded evidence of ancient smelting activities dating to the 4th Millennium B.C. Un-enriched specimens of copper ore with a Ba:Cu ratio as high as 6:10 have been recovered from the site. The ore is also extremely rich in antimony, with the Sb:Cu ratios in the assayed specimens ranging from 0.2 to 0.5. Since our analyses have failed to detect any significant amounts of antimony in any of the coloured panels, it is difficult to see how Norsun-Tepe could have been the source of the barium-rich copper found in the Sidmant pendant.

We are thus forced to conclude that whoever made the Sidmant pendant introduced some type of barium mineral into the glazing mixture. The elevated levels of sulphur suggest that baryte ($BaSO_4$) might have been the mineral

used. The compound is readily available in several localities in Egypt, 38,39,46b,107 and it seems to have been mined during the Middle Kingdom; a pendant made of baryte has been recovered from an Archaic Period grave (see notes 12 and 13 on p. 259 of ref. 41). Consequently, one must actually wonder how is it that the mineral does not appear to have been used in Ancient Egyptian glazing recipes more often. It would have certainly added lustre to the faience. One can only hope that future analyses of faience from other collections will turn up products that can be traced to the same faience-making establishment. Of course, if the pendant is of foreign origin, similar specimens of faience may never again be discovered in Egypt.

Before proceeding to the discussion of New Kingdom and later faience we should mention a broad geographical pattern which seems to persist from predynastic to Roman times. We are referring to a pattern of potassium oxide concentrations which reflect the preference for alkali derived from plant ashes as opposed to natron. [28] With the exception of Late Ptolemaic-Roman faience from Memphis, the lowest levels of K_2O are encountered in glazes from Lower Egypt and from el Kab. On the other hand, the highest concentrations of K_2O were most often seen in objects recovered from central Egypt. It is tempting to see in this bimodal pattern a reflection of the fact that the two large natron deposits are located at Wadi Natrun in the north (west of the Delta) and near el Kab in the south. The two sites must have been the principal, if not the sole, source of Ancient Egyptian natron throughout the pharaonic period. The Pyramid Texts indicate that as early as the Old Kingdom the Egyptians made a clear distinction between the products of the two areas by compounding the mineral name (ntry) with a suitable geographical term (ref. 65, p.193). If the low potassium concentrations do reflect greater use of natron, then the extreme north and south are just the areas in which the mineral would be most plentiful. Egyptians in the center of the country would be more inclined to rely on plant ashes as their primary source of alkali.

The regional variability in the levels of potassium may not be overwhelming, but it is significant. For example, green and blue Old Kingdom faience from Saqqara, Abydos, and el Kab yield median concentrations of 0.15, 0.50, and 0.22% K_2O, respectively. Similar Middle Kingdom glazes from central Egypt (regions 5-7 in Table XXXVI) yielded median K_2O concentrations ranging

from 0.5 to 0.6%, in contrast with those from el Kab which gave a median concentration of only 0.12% K_2O. If a similar comparison is made between the black faience from Hyksos graves at Tell el-Yahudiya with material of the same colour and period from central Egypt, the contrast is equally striking. For example, the median (and average) concentrations of potassium oxide in black faience from Tell el-Yahudiya, Mustagidda, and Abydos were 0.45, 4.27 and 2.68%, respectively.

In looking at the alkali in faience or glass, one must keep in mind at all times that while natron is rich in sodium and virtually free of potassium, plant ashes contain variable amounts of both elements. Therefore, the use of plant ash, as opposed to natron, can accommodate a wide range of $K_2O:Na_2O$ ratios, so no special significance can be attached to the actual concentration figures cited above. Only the relative magnitudes are indicative of general preference for one sort of alkali over another. The relative amounts of potassium and sodium in a variety of plants have been tabulated by Turner[26] and Brill. [28]

3. Egyptian Faience of the New Kingdom

The Egyptian faience industry underwent some of the most revolutionary changes within a century after the expulsion of the Hyksos. Some of the changes can undoubtedly be attributed to the intimate contacts that were established between Egypt and the various urban centers of Syria and Mesopotamia. The question of foreign influences will be touched upon in later sections; here we will simply discuss some of the innovations, how long they endured and how widespread they became wi.hin the country.

The three most important innovations that became established during the reign of Tuthmosis III are: 1. the use of cobalt for the manufacture of indigo and violet faience; 2. the use of antimony and lead for the manufacture of yellow and softer shades of green; 3. the establishment of a glass industry which had a considerable impact on the nature of polychrome faience, in particular. The relationships between the compositions of faience and contemporary glass have been brought to the attention of the reader on many occasions in Chapters II and III.

Our data suggest that the use of cobalt preceded that of lead antimonate by almost a century. However, new analyses in the future may prove the conclusion incorrect. In trying to establish the precise chronology for the introduction of new techniques one is at the mercy of the archaeological dating of sites from which the earliest object of a kind was recovered. A century is too short a span of time to allow us to differentiate the ages of grave goods by techniques such as radiocarbon dating or thermoluminescence. Dendrochronology will enable us to distinguish and arrange graves in a chronological order, but no reference data exist at the moment for Egypt or the neighbouring countries of the Near East.

The oldest faience in which we have been able to detect cobalt at concentrations high enough to indicate deliberate use of a CoO pigment was an indigo blue lenticular bead (1926.176C) from tomb 1806 at Abydos. The tomb has been dated to the late 17th or early 18th Dynasty. The cobalt is of the usual New Kingdom variety -- rich in manganese, iron, nickel and zinc. It is not only the cobalt that sets this particular tomb apart from any other site of pre-Amarna age. It was the only site to yield blue and green faience of which every specimen that was not coloured by cobalt contained high levels of tin. The Sn:Cu ratio was in the 0.06 to 0.1 range. Now, variable amounts of tin are to be seen in green and blue faience from other early 18th Dynasty tombs, but only in a fraction of the objects (see Figs. 11 and 12). Were the tomb to prove to be of the 17th Dynasty, its contents would represent the earliest instance of undisputably deliberate and wholesale use of bronze scrap for the manufacture of faience glazes.

Cobalt seems to have remained a scarce commodity for a long time, since the next oldest object in which we discovered significant amounts of the element (CoO above 0.05%) was a kohl tube (U.C. 587) from the temple of Amenhotep II at Thebes bearing the cartouche of Amenhotep III. This makes the appearance of cobalt in faience from tomb 1806 at Abydos look even more precocious, unless its dating is grossly in error. It would be interesting to know whether the owner of tomb 1806 was a foreigner or a high-ranking Egyptian who had extensive contacts with Asia.

From the time of Amenhotep III until the end of the New Kingdom cobalt

does not seem to be confined to any one region or site, and the same chemical variety is used everywhere. The manner in which the element is used in monochrome and polychrome faience does differ a little from place to place, and particularly noticeable are the differences between material from Tell el-Amarna and Tell el-Yahudiya. However, since the objects recovered from the two sites are separated in time by almost two centuries, we cannot tell how much the differences reflect changed tastes and how much Upper versus Lower Egyptian preferences. Some of the differences were discussed in Section 10 of Chapter III. Anyone wishing to see the analysed objects themselves can consult Appendix C from which the accession numbers of specific items may be obtained.

We have no evidence that lead antimonate was used as pigment before the reign of Tuthmosis III. The substance was found in all the yellow glass and faience beads (string E.238) recovered from foundation deposit No. 3 of Tuthmosis III at the temple of Min in Coptos.[191,192] Since we do not know to what regnal year this particular deposit belongs, all we can say safely at the moment is that the substance was in regular use by the middle of the 15th century B.C. Its use was not confined to yellow, since a few of the green beads recovered from the same deposit also contained substantial amounts of lead and antimony in addition to the traditional copper. However, unlike the yellow, all of which were coloured by lead antimonate, only a very small fraction (less than 2%) of the green beads contained the new pigment.

We had hoped to discover whether the use of lead antimonate was introduced into Egypt before or during the reign of Tuthmosis III. Unfortunately, the only Early 18th Dynasty site to have yielded yellow faience which can be dated at least to a specific reign, is the Coptos foundation deposit mentioned above. The only other examples of pre-Amarna (or more specifically pre-Amenhotep III) faience to contain lead antimonate were the yellow beads from tomb E266 at Abydos. All we know of the tomb is that it is of the early 18th Dynasty but we cannot tell how early.

Interestingly enough, the formulation of the yellow glaze on the beads from tomb E266 at Abydos is radically different from the recipes employed in yellow 18th Dynasty faience from Coptos and Tell el-Amarna, and even more

different from Ramesside material from Medinet Ghurab and Tell el-Yahudiya.
The most obvious difference is in the lead-antimony ratio. The Abydos yellows
are characterised by high ratios, with an average value of 13:1 for the
examined specimens. This must be contrasted with values such as 5.6:1 and
5.8:1 recorded for the average $PbO:Sb_2O_5$ ratios in yellow faience from Coptos
and Amarna, respectively. The average $PbO:Sb_2O_5$ ratio in the three specimens
of New Kingdom yellow glass (one from Lisht, two from Thebes) recently
analysed by Sayre was 5:1. [22,24] Ratios of approximately 5:1 and 6:1 were also
obtained for the antimony-containing green faience from Coptos and Amarna.

One must wonder if the higher ratios reflect an attempt to economise on
the antimony, because the differences are entirely the result of lower
antimony concentrations and not higher lead concentrations. Thus the median
lead oxide concentration for the Abydos beads is 7.72%, not that different
from 6.25 and 6.12%, the corresponding values in faience from Tell el-Amarna
and Coptos, respectively. In contrast the median (and average) concentration
of Sb_2O_5 in Abydos beads is <u>half</u> as large as in faience from the other two
sites.

Assuming that antimony was not obtainable in Egypt but had to be imported
from Asia (the subject will be taken up again in subsequent sections), any
attempt at economy can be interpreted in one of two ways. If tomb E266
antedates the reign of Tuthmosis III, the supplies of a scarce foreign
commodity might still have been rather limited and obtainable only
sporadically. On the other hand, as long as antimony was obtained as tribute
or in exchange for Egyptian commodities, only the royal workshops could have
been assured of an adequate supply. While we do not know where the Abydos
beads were manufactured, the Coptos and Amarna faience were undoubtedly made
in royal ateliers.

Other differences could be cited between the yellow faience from Abydos
and material from Coptos or Amarna, such as much lower concentrations of lime
and tin in the former, but it is the difference in zinc concentrations that is
most significant. As we pointed out in Section 16 of Chapter II, the New
Kingdom lead is characterised by high levels of zinc impurity. In yellow
faience from Coptos and Amarna, respectively, the average concentrations of

ZnO are 0.35 and 0.34%, while the respective ZnO:PbO ratios are 0.054 and 0.073. In contrast, the yellow beads from tomb E266 exhibit an average ZnO concentration of only 0.06% and a zinc-lead oxide ratio of 0.007. What this suggests is that the royal workshops responsible for the Coptos and Amarna material used lead which was different in origin from that used in the Abydos beads. Lead of high zinc content was also employed in faience of the Ramesside period. Curiously enough, two of the three yellow New Kingdom glasses analysed by Sayre were of the low-zinc variety with an average ZnO concentration of 0.02% and a ZnO:PbO ratio of 0.006. [24] Zinc concentration in the third was 0.17% and the ratio 0.047.

Stray glass objects, presumably made by accident, have been recovered from pre-New Kingdom sites, but their number is not impressive. [145] In recent years there has emerged a general consensus that the art of glassmaking was introduced into Egypt from Asia during the Eighteenth Dynasty. [28,146] There still remains the question of whether the local manufacture of glass vessels began in the reign of Tuthmosis I or Tuthmosis III. Both rulers campaigned extensively in Asia and deported to Egypt many Syrian artisans among whom there must have been some glassmakers.

Since glass vessel fragments have been recovered from the tomb of Tuthmosis I, the name of this monarch is occasionally linked with the introduction of glassmaking into Egypt. The association is very tenuous at the present time. The find consists of just two fragments of a blue vessel decorated with white, yellow and blue threads, of the type common during the entire 18th Dynasty. [193] Moreover, the glass has a high probability of being intrusive, since Tuthmosis I was reburied during the reign of Hatshepsut, [194] and it is not known to what use the original tomb was put after the body of the king was removed. Strong Mesopotamian influence has been detected by some in the earliest forms and decorations, but it is uncertain whether they represent the products of Asian workshops or of Asian glass-workers residing in Egypt. [195] At present, the earliest securely dated glass vessels of local manufacture are those that bear the cartouche of Tuthmosis III, and even they are not too numerous. [28,178,195,196,197]

If glassmaking had been introduced into Egypt during the reign of

Tuthmosis I it would be difficult to understand why several generations had to pass before a form distinctly different from Mesopotamian evolved, and why so little glass was produced during the next half century. On the other hand if the techniques had been introduced during the reign of Tuthmosis III, there would be added validity to Barag's suggestion (ref.195, p.25) that: "The scarcity of Egyptian glass before Amenhotep II and the fact that it reached its full intensity, together with a change of character during the monarch's reign may indicate the moment of this industry's becoming truly 'native' to Egypt.", since Amenhotep II was the successor of Tuthmosis III.

All evidence seems to indicate that the introduction of glass coincided with that of the lead antimonate pigment. It is difficult to find early Egyptian glass vessels that do not employ yellow colour for decorative purposes or for the entire surface. All the yellow 18th Dynasty glass analysed to date is coloured by lead antimonate.[20-25,26,93,94] We had thus hoped that by establishing the earliest use of lead antimonate in faience we would also be able to determine which ruler introduced glass into Egypt. As we noted above, the earliest "firm" date that we have for the use of lead antimonate is the reign of Tuthmosis III.

Before leaving temporarily the discussion of glass, we must mention that there are some who believe that the Egyptians of the New Kingdom did not know the secret of glassmaking. According to Newton, the Egyptians of the period knew only how to melt and manipulate ready-made glass slabs or rods (cullet) imported from Asia.[198] His opinion has not gained wide acceptance, despite the fact that some translators of the Amarna letters have identified raw coloured glass among the commodities sought by the Egyptians in Asia.[199] Even if some glass was being imported, that does not prove that the Egyptians were not also making some of their own. For example, the fact that both copper and lead were being mined in Egypt did not prevent the Egyptians from acquiring the same materials from abroad, as we pointed out in Sections 9 and 16 of Chapter II. Moreover, if all New Kingdom Egyptian glass had been made abroad how does one explain the many similarities in the composition of New Kingdom glass and faience glazes. One would have to postulate that the glazing mixtures also came from outside Egypt.

If one accepts the overwhelming evidence that the same pigments were used
in New Kingdom faience and glass, one finds in recent isotopic distribution
studies additional clues regarding the possible origin of 18th Dynasty lead
antimonate. Whereas the lead in pre-New Kingdom faience was most often
encountered in high-copper glazes and was presumably introduced as an impurity
with copper, the yellow glazes require a different source of lead, one of low
copper content. Egypt has a number of galena (PbS) deposits which contain
variable amounts of zinc but almost no copper.

In recent years the isotopic compositions of the leads in several Ancient
Egyptian kohls (mostly galenas), 18th Dynasty glasses, and in objects made of
silver and lead have been determined.[79,131-134,200,201] When these are
compared with the isotopic ratios in modern galenas from the Eastern Desert,
it is immediately obvious that of the various ancient materials containing
lead, it is glass that most closely matches the tested ores.[79,132] The
glasses, all from Tell el-Amarna, form a cluster which is within a reasonable
distance of four of the tested ores (see Fig.8 in ref.132). The best match is
with ores from Umm Gheigh, Gebel Rosas, Zog el-Bohar and Umm Anz. The four
mines are located close to the Red Sea littoral, along a straight line between
the 25th and 26th parallel.

Admittedly, the match is not perfect, but one must note that the spread
of the ratios within the glass cluster is as large as the distance from one
end of the cluster to the galenas from Umm Gheigh and Gebel Rosas. In any
event, unlike silver and lead objects, or some of the galenas recovered from
ancient burial sites, the glasses do not have an isotopic composition that
would require postulating a foreign origin for the lead contained in them.
The closeness suggests that even if the lead did not originate in any one of
the four mines listed above, it must have come from a very similar mine which
is probably located somewhere in the vicinity of the others. It could be a
known mine the ore of which has not yet been tested, or an as yet undiscovered
ancient mining site. Brill's isotopic analyses showed that the Mesopotamian
and various "Levantine" leads must have had a very different origin from the
lead found in Egyptian galenas and glasses.[79,200,201] The differences were so
great that we feel fully justified in ruling out Mesopotamia and Western Asia
as important sources of the lead in most 18th Dynasty Egyptian glass.

The next question is whether the lead contained in New Kingdom faience, particularly yellow faience and green coloured by lead antimonate and copper, could have originated in the galenas from the four sites enumerated above. Of the four, the three whose leads best match those of glass--Umm Gheigh, Gebel Rosas, and Zog el-Bohar, show evidence of having been worked in antiquity. 129,202,203 The three sites contain Miocene sediments with extensive lead-zinc mineralisations. 54 In places the zinc content of the Gebel Rosas galenas, for example, approaches 37% as ZnS. 72 Of the three, it is Umm Gheigh that contains galena that not only best matches the isotopic composition of the glass but also contains the major impurities found in yellow glass and faience of the 18th Dynasty. In addition to zinc, iron is also a very prominent component of the Umm Gheigh lead. 70,202 This is significant, because iron is the only impurity other than zinc that is elevated in yellow faience and glass, though it could not have been added deliberately for any sensible reason. If one looks at the New Kingdom faience as a whole, only the brown and red glazes, in which the principal pigment is Fe_2O_3, yielded consistently higher average concentrations of iron than the yellow; all other colours exhibited much lower concentrations, as may be seen in Table VIII.

Equally elevated is the iron in yellow glasses of the period. Thus, the average concentration of Fe_2O_3 in the three yellow specimens analysed by Sayre was 0.92%, and the values ranged from 0.48 to 1.17%. 24In contrast, none of the colourless, white, amber, blue or violet glasses contained more than 0.68% Fe_2O_3. 24 The yellow glasses analysed by Neumann and Kotyga also had levels of Fe_2O_3 close to 1%, but some of their other glasses did have higher concentrations of iron. 18,20 Consequently, until some other not yet analysed lead deposit gives a better isotopic and impurity match, we are inclined to consider Umm Gheigh and Gebel Rosas as the two most probable sources of much of the lead used in New Kingdom faience and glass.

One interesting feature of the yellow faience of the Ramesside Period is that although it contains the same general variety of high-zinc lead, the proportions of both antimony and zinc are much higher than in 18th Dynasty yellows. The difference is almost entirely the result of reduced lead concentrations (by more than 50% on the average, see Table XX). It would seem that different mines but from a similar geological deposit provided the lead

for these objects.

The average $PbO:Sb_2O_5$ ratios in the yellow 19th Dynasty faience from Medinet Ghurab and 20th Dynasty faience from Tell el-Yahudiya were 3.7 and 3.3, respectively, in contrast with 5.6 and 5.8, the respective average ratios for the 18th Dynasty yellow faience from Coptos and Tell el-Amarna. The absolute values of the zinc and antimony oxides in Ramesside yellows differ only slightly from the corresponding concentrations in 18th Dynasty faience from Coptos, Thebes, or Tell el-Amarna. It is not clear to us whether the apparent preference for lower lead-antimony ratios, ratios closer to the stoichiometric weight ratio of 1.4 for lead antimonate ($Pb_2Sb_2O_7$), is a regional factor indicating a greater supply of antimony in Lower Egypt, or whether it implies a higher demand for lead and reduced supplies during the 19th and 20th Dynasties. Maybe the deficit resulted from the loss of Asian tribute, which often included Syrian lead. [65,114]

As one examines the compositions of New Kingdom faience of colours other than yellow, some regional variations are discernible. However, the differences seem to reflect much more the proximity to royal workshops than they do the specific geographical location of the recovery site. This is best illustrated by examining the occurrence of antimony in green glazes and of cobalt in blue and violet. Unlike yellow faience, the production of which would have been virtually impossible without lead antimonate, the green could always be made by returning to the traditional antimony-free copper. In the case of blue faience, if one were not too fussy about the precise shade, plain copper or the artificial pigment Egyptian Blue could be resorted to. It is reasonable to assume that when new pigments, such as lead antimonate or cobalt, were first introduced their availability outside the royal workshops must have been highly restricted, particularly if any of the basic ingredients had to come from abroad. Foreign trade was a royal monopoly, after all. Undoubtedly, large temple establishments, such as those of Amon at Thebes, which enjoyed generous royal patronage during most of the period, could also obtain some of the scarce commodities. The same applies to the workshops of the short-lived faience industry of Akhetaten (Tell el-Amarna).

Green faience is so common that we had no difficulty finding 18th Dynasty

specimens from most of the regions into which Upper Egypt was divided in this study (see Table XXXVI). With the exception of the two beads from the foundation deposit of Tuthmosis III at the Coptos temple, all the green objects containing lead antimonate came from Thebes or Tell el-Amarna. Thus among the many analysed green specimens from the tomb of Maket at Lahun, or from Serabit el Khadim in the Sinai, not one contained both lead and antimony above the 0.2% mark.

Thebes remained an important religious center during the 19th and 20th Dynasties, but the principal royal residence and the political power moved north to Lower Egypt. The only examples of green Ramesside faience coloured by copper and lead antimonate that we have encountered came from the palace of Ramesses III at Tell el-Yahudiya. Objects containing more than trace amounts of antimony without lead are less common, but the only example of the period to contain over 0.2% Sb_2O_5 (ushabti 1872.940) was recovered from the cemetery at Giza, which is located near the old metropolitan center of Memphis in Lower Egypt.

We looked next at the regional distribution of cobalt. Even though in individual objects cobalt and antimony show absolutely no correlation, the geographical distribution of objects containing either of the two elements shows certain similarities. An important difference is that the distribution of glazes containing cobalt is somewhat less restricted geographically than the distribution of faience containing antimony. The great majority of cobalt-coloured 18th Dynasty blue, indigo and violet faience came from Tell el-Amarna, but similar material was also recovered from Thebes and Abydos (from tomb 1806, discussed earlier in this section). As regards Ramesside glazes of the same colours, CoO in excess of 0.05% was detected in 9 specimens, of which six came from Tell el-Yahudiya, two from Medinet Ghurab and one from Serabit el Khadim. It would appear that during the New Kingdom cobalt too was a commodity in high demand and not readily available outside the royal workshops and large temple establishments.

Interestingly enough, the published data for blue pottery pigments and glass yield a similar picture. All of the cobalt-coloured blue and violet glass analysed by Farnsworth and Ritchie came from either Thebes or Tell el-

Amarna.[19] The three cobalt blue glasses analysed by Sayre also came from Thebes.[23,24] In both instances the Theban material came from the Malkata palace of Amenhotep III. Provenance was only specified for two of the three New Kingdom glasses in which Geilmann detected cobalt,[34] and it turned out to be Thebes. For one of them the findspot was stated more explicitly as Medinet Habu, the site of the Theban mortuary temple of Ramesses III.

The great majority of New Kingdom painted pottery on which cobalt aluminate has been detected came from Tell el-Amarna or Thebes, particularly the Malkata palace of Amenhotep III.[36,50,53] However, among the pottery fragments examined by Noll there was one specimen from Hermopolis (central Egypt) and one from Elephantine (First Upper Egyptian nome).[36] We do not know whether it is significant, but Hermopolis is almost next door to Tell el-Amarna. We expect that more cobalt-coloured glass and pottery will be found at other sites, but we seriously doubt whether the numbers will be as large and the proportion of all blues as high as among fragments recovered from Thebes or Tell el-Amarna, or any other "royal residence". Moreover, if the number of fragments found at a site is very small and there is no other evidence that the objects were locally manufactured, there is always the possibility that a particular item was shipped to the site from somewhere else.

We also decided to examine the distribution of tin among blue and green faience of different regions. If, as we concluded in Chapter II, most of the tin originated in bronze scale, the geographical distribution of tin-containing faience should be much less restricted during the New Kingdom. After all, the Egyptian bronze industry dates back at least to the Middle Kingdom, if not earlier (see Fig.11).[89] While the incidence of tin-containing faience differed from region to region, not one of the seven regions into which Egypt was divided (see Table XXXVI) failed to yield a reasonable proportion of specimens containing over 0.1% SnO_2. However, the faience from Thebes and the Memphis area had the highest average concentrations. Thus there was apparently no shortage of tin or tin bronzes in New Kingdom Egypt, but some workshops had more tin to work with than others.

Regarding the black, brown and red faience of the New Kingdom, only minor

variations between the products of different regions were detected. This came as no surprise, since the principal ingredients, the oxides of iron and manganese, were readily available in many parts of Egypt. As far as we can tell, all of Egypt, including the extreme south, had switched by this time to the manganese-based black. The preference for pyrolusite over psilomelane, as indicated by the reduced incidence of barium (see Sec. 15 in Chap. II), seems to have prevailed in most of Egypt. This suggests that some particularly rich area, such as western Sinai, for example, which contained readily accessible deposits of ferruginous pyrolusite, was being exploited more actively than the many smaller and less economical mines, and the mineral was shipped to all other parts of Egypt.

As a general historical note, we must point out again that we have failed to discover a single example of high-lead red faience coloured by reduced copper. Moreover, contrary to statements occasionally encountered in articles dealing with the history of glass, there is absolutely no evidence that high-lead copper-based red glass, of the type made in Assyria in the 1st Millennium B.C. [158,159] and in Alexandria during the Ptolemaic and Roman times, [25,121] was being made in Egypt or anywhere else in the 2nd Millennium B.C. To quote Brill: "It appears that those red glasses attributed to the Eighteenth Dynasty in Egypt were made without the benefit of lead,...". [204] The statement cited above follows the opinion that: "The beneficial effect of lead in making the red glasses must have been discovered quite early in the history of glassmaking." [204] The unanswered question is "how early ?", particularly, since the famous Nimrud sealing-wax red glass, long considered to be the oldest fully-analysed example of such glass, [158,159] has recently been re-dated from the 6th to the 2nd century B.C. [205] Assyria may still retain the distinction of being the place of origin of the high-lead copper-coloured red glass. Two red glass fragments from the Fort Shalmanaser area of Nimrud dated to the 8th-7th c. B.C., are coloured by copper and contain an undetermined amount of lead. [201,206]

At this time we are inclined to agree with Brill's first quote and we would extend it to include all of New Kingdom instead of just the 18th Dynasty. The number of published analyses of red New Kingdom glass is not great, but there is nothing to suggest that the analysed specimens are not

representative of the red glass of the period. Farnsworth and Ritchie
analysed two, one an 18th Dynasty fragment from Tell el-Amarna and the other a
19th Dynasty piece from Matmar, and reported moderate amounts of copper (1-10%
Cu_2O) and traces of lead (0.1-1% PbO) in both. [19] Neumann and Kotyga found 12%
Cu_2O and no PbO in their specimen of 18th Dynasty red glass from Tell el-
Amarna (ref.20, p.48). We too have analysed a cane of red glass from Tell el-
Amarna (1936.635g) and found it to contain ca. 5% Cu_2O, PbO below 0.1%, and
0.4% Fe_2O_3.

The absence of any significant amount of lead in the red glasses tested
so far is very puzzling, particularly after one looks at the red faience data.
The faience differs from contemporary glass in that it is coloured by Fe_2O_3
instead of Cu_2O and it contains generous amounts of lead. The compositional
characteristics of red New Kingdom faience, particularly the red-bodied
faience of Type C, were discussed in Section 9 of Chap. III and Section 5 of
Chap. IV. The concentrations of Fe_2O_3 ranged from 2.5 to 6%. Lead was absent
from some of the red faience, but the majority contained PbO far in excess of
impurity levels. Values as high as 2.3% PbO have been recorded, and the
average for all New Kingdom reds was 1%. The red faience is the only faience
of this period to contain significant amounts of lead in the absence of
antimony or copper (Fig.17), and it appears early in the 18th Dynasty, at a
time when glazes of colours other than yellow rarely contain much lead
(Fig.16).

The earliest dateable specimens of such red faience seen by us were
recovered from the oft-mentioned foundation deposit of Tuthmosis III at
Coptos. Consequently, there can be no doubt that by the 15th century B.C. at
least the royal workshops knew of the beneficial effects of lead but in
conjunction with iron instead of copper. The high-lead variety of red faience
seems to be confined to the same sites that have yielded faience coloured by
lead antimonate, even though the principal pigments were common minerals. The
recipe must not have been widely known in Egypt, for the brown and red faience
manufactured in other workshops was virtually free of lead.

We have examined carefully the compositions of the body materials of New
Kingdom faience hoping to find some clear regional variations in the nature of

the alkali, lime and sand. No well-defined geographical pattern could be discerned in the sodium:potassium or magnesium:calcium ratios, nor in the impurities associated with sands. [26,27]The one exception to the last statement were the distinctive pink bodies seen in some of the faience recovered from the Sinai (see Sec. 3, Chapter IV). Of course, as more information on Egyptian sands becomes available in the future other impurity patterns might become recognizable in our data.

A caveat is appropriate at this time. Some elements exhibit regional variations which are illusory, especially if there is a correlation between a particular element and a particular type of faience which has only been recovered to date from a limited number of sites. Such is the case with aluminum, for example. The largest number of high-alumina bodies were recorded in faience recovered from Tell el-Amarna. From this one might erroneously conclude that local faience-makers discovered the value of alumina in strengthening and hardening high-silica bodies. Maybe they had, but a closer look at the data shows that the substance was only elevated in the high-cobalt bodies of what we called in Section 6 of Chapter IV type D2 faience, and most such faience was recovered on the site of Tell el-Amarna. In contrast, the body material of ordinary faience from Tell el-Amarna contains very little alumina, and shows nothing to distinguish it from faience excavated in other parts of Egypt. Similarly, high-cobalt type D2 bodies in faience from other sites are as rich in alumina as those recovered from Tell el-Amarna.

Before proceeding to the next section we must point out an interesting observation regarding the faience recovered from Tell el-Amarna. The material manufactured at Tell el-Amarna is different in many respects from faience made in the early 18th Dynasty and the 19th-20th Dynasties, but it shows striking similarities to Theban objects of the time of Amenhotep III. As a matter of fact, the resemblance is so great than one is tempted to conclude that the workshops set up at Akhetaten were staffed almost exclusively by craftsmen transferred from Thebes, in preference to professionals from other parts of Egypt.

Yet as we looked more closely at the analytical data, we were struck by the fact that hardly any specimens of 18th Dynasty faience from Tell el-Amarna

contained arsenic at detectable levels (i.e. above 0.01% As_2O_3). The number of analysed objects was too great to blame statistics for the absence of arsenic-containing objects within the group selected for analysis. This absence is responsible for the dip in the arsenic-incidence plot shown in Fig.8. Three explanations can be put forth to account for this anomaly.

The first, and least satisfactory, is that the temperatures in Amarna kilns were substantially higher than in those of other places, and consequently the loss of volatile oxides was much greater. The site has yielded some very hard high-fired high-alumina faience, such as the black-bodied kohl tubes discussed in Chapter IV, but these represented only a small fraction of the analysed specimens.

The second explanation is that the workmen who accompanied Akhenaten to Akhetaten took along only bronzes of recent vintage or copper and tin for the manufacture of new bronzes on the site. Once the local industries were fully set up and operational fresh supplies of any needed minerals would be procured in the same manner as at any royal residence. By the time of Akhenaten the manufacture of arsenical coppers had long been superseded by that of tin bronzes. [89] Arsenic-containing scrap would consist almost exclusively of ancient objects. Such objects must have been available in larger and older population centers, but it seems unlikely that such venerable "junk" would have been transported to the new royal residence at Akhetaten.

The third explanation might be that most of the arsenic encountered in Egyptian faience of the New Kingdom and later periods did not originate in old arsenical copper scrap, but in one of the many copper ores that were being exploited outside of Egypt by the Egyptians or by foreigners for the benefit of the Egyptians. The number of arsenic-containing copper objects and faience glazes is so small that one does not have to postulate a very large volume of such foreign ore. The Amarna correspondence offers clear evidence that the Egyptians began loosing control of parts of their Asian empire, particularly northern Syria, during the waning years of Amenhotep III, and that the losses became progressively more serious during the reign of Akhenaten. [207] The revolts in Syria could not have failed to affect the trade with Anatolia, Mesopotamia, and other regions of Western Asia. Consequently, if the

arsenical copper ore had come from somewhere in Western Asia or some other part of the Eastern Mediterranean world, one would not expect to see much of it, or of copper objects made out of such ore, in Tell el-Amarna.

Only after the conditions in Syria were stabilized during the reign of Ramesses II, after the famous peace treaty with the Hittites, would such copper again be reaching Egypt. Our data show that the incidence of arsenic in Ramesside faience returns to the levels recorded for pre-Amenhotep III 18th Dynasty faience (Fig.8). It is significant that among the copper objects from the Ashmolean museum analysed by McKerrell none of those containing over 1% As came from Tell el-Amarna, and even the objects that did contain traces of arsenic came mostly from sites dated to the early 18th Dynasty or the Ramesside Period. [91] The reduced volume of arsenical copper among metal objects of the Late 18th Dynasty shows up as a dip on the incidence plot in Figure 8.

4. Egyptian Faience of the Third Intermediate Period

Until not long ago the term "Late Period" designated all the dynasties between the New Kingdom and the Ptolemaic Period. In recent years it has become customary to restrict the term to the second half of this long period of time and call the first half the "Third Intermediate Period". However, there is still no consensus as to whether the new Late Period should begin with the 25th or the 26th Dynasty. We decided to follow the division proposed by Kitchen,[208] who unlike Baines and Malek (ref.162, pp.37-49), assigned all of 25th Dynasty to the 3rd Intermediate Period.[162]

The Third Intermediate Period presents us with some interesting paradoxes. Of the three elements which first became prominent during the New Kingdom, antimony and cobalt virtually disappear from Egyptian faience, while tin remains relatively common. Lead, is still found very frequently, but in moderate concentrations, at levels below those of the Late 18th Dynasty but comparable to those of the 20th. The concentrations of other elements were only marginally affected by the passing of the New Kingdom.

The period is also one during which the output of glass decreases markedly, but the art of glassmaking is not lost entirely. [196,197] Cooney

interpreted the reduced glass production as partly connected with the invention of glassy faience, which is now often used to make objects previously made of glass or faience. [32] Interesting glass vessels of a type distinctly different from those made in Asian factories have been recovered from several tombs of the 21st-25th Dynasties. Some of the best known and most complete pieces came from the tomb of Nesikhons, the younger wife of the High Priest of Amon Pinudjem. [195,196,197] The vessels are good examples of Egyptian glassmaking at the beginning of the First Millennium B.C., since Nesikhons died in the 5th year of the 21st Dynasty Pharaoh Siamun (ca.974 B.C.; ref. 208, p.277).

Short-term or intermittent absence of antimony is understandable if the substance was not obtainable locally and had to be imported from Asia. In the aftermath of the devastating raids of the Sea People, portions of Western Asia were in turmoil for a time. However, by the first decade of the 11th century B.C., during the usurpation of Hrihor, the conditions on the Levant coast were secure enough to enable Wenamun to travel from Thebes to Byblos in search of timber for the bark of Amon. [209]

While information is lacking for most of the 21st Dynasty we do know that the rulers of the 22nd were quite successful in maintaining good commercial relations with the princes of Byblos and other cities of the Phoenician coast (ref.208, pp.292,308 and 324). During the last century of the 2nd Millennium B.C., and the first two of the 1st Millennium, overland trade in Western Asia must have been affected by the intermittent warfare involving the Assyrians, the old states of Syria and the Aramaean newcomers. [210] However, after the establishment of Assyrian hegemony in the Levant, minerals available to the Assyrians should have been obtainable by the Egyptians, unless the Egyptian economy was so depressed that they could not afford to import what must have been considered a luxury commodity. While chaotic political and economic conditions were not uncommon during the Third Intermediate Period, a more plausible explanation might be that the Assyrians maintained strict restrictions on trade in certain minerals, controls comparable to the embargo imposed by Tiglath Pileser III on the export of Lebanese timber to Egypt. [211]

The disappearance of cobalt presents us with another puzzle. In Sec. 7 of

Chapter II we pointed out that the cobalt used in New Kingdom faience, glass, and pottery pigments might have come from the alum deposits of the Great Western Oases or from Iran. We also noted that the elements regularly associated with the cobalt pigment, such as: Al,Mn,Fe,Ni and Zn, made the Egyptian origin more reasonable, because such impurities are not to be found in the dominant varieties of the Iranian ores. Moreover, Noll's microscopic examination of pigment particles on the surface of 18th Dynasty pots indicated that the cobalt aluminate was probably precipitated from a colloidal suspension in a solution of alums (ref.52, p.150).

Archaeological evidence from the Dakhla and Kharga Oases shows that they were under Egyptian administrative control during most of the 21st and 22nd Dynasties. For example, during the 21st Dynasty Kharga Oasis served as a place of involuntary exile for prominent Egyptians banished by their political enemies. [212] From the 22nd Dynasty we have a stela that deals with disputed land and water rights in the Dakhla Oasis. The stela makes frequent references to land registers of the preceding dynasty and the final adjudication is handled by an Egyptian official. [213] We also know that during the 25th Dynasty the Pharaoh Piye was formally recognized as sovereign at Dakhla, [214] even if the de-facto control had lapsed into the hands of local Libyan chieftains at the end of the 22nd Dynasty, as Yoyotte has suggested. [215] Regardless of what the political situation at the Kharga Oasis might have been by the end of the 22nd Dynasty and during the 25th, the Egyptians of the Saite Period were actively exploiting the local vineyards, which had an old reputation as a source of fine wines. [216]

Among the 40 violet, indigo and blue glazes of the Third Intermediate Period only three had CoO in excess of 0.01%. The highest value, 0.03%, was recorded in a blue ushabti (1964.706) from the Theban tomb of Amenemope, an important Theban official whose father served Ramesses IX and whose life spanned the 20th and 21st Dynasties. If the Oases had been the source of New Kingdom cobalt, why is it that the mineral was not used in Egyptian faience and glass between the 12th and 6th centuries B.C. ? The absence of the element is puzzling, unless transporting the alum and extracting the pigment became uneconomical. As Hassan and Hassan pointed out, with reference to the importation of foreign lead while deposits were available locally: " Trade is

motivated by economic considerations and is not necessarily linked to unavailability." [134] Of course, there remains the possibility that with the noticeable return to traditional recipes based on copper, iron and manganese the use of cobalt was abandoned deliberately. However, no return to pre-18th Dynasty tradition was possible in the case of glass, and here too the cobalt is conspicuous by its absence, if the violet glass analysed by Geilmann is representative of the Third Intermediate Period. [20,34]

In some respects the absence of cobalt is more pronounced than that of antimony, since the latter shows up more frequently, albeit at concentrations that border on impurity levels. The average concentrations of antimony in many glazes return to pre-18th Dynasty values, while those of cobalt drop below (Tables IX and XVII). No faience of the Third Intermediate Period has been found to contain more than 0.11% Sb_2O_5, and when found the substance is not correlated with lead, as it was in New Kingdom faience (Table XXI). As one can see in Table II, we have been unable to locate any yellow faience securely dated to the period separating the 20th and 26th Dynasties. Concentrations near the upper end of the observed range (i.e.,ca. 0.1% Sb_2O_5) may seem a little too high for an impurity, but the substance shows up indiscriminately in glazes of all regions and colours (Table XVII). Consequently, if antimony were still available but as a relatively scarce commodity, one feels that it would have been used in a more prudent fashion, in glazes where it might be of some benefit. One would expect to find antimony less frequently but at higher concentrations in yellow (and maybe green) faience and accompanied by lead.

Considering what happened to cobalt and antimony, one might have expected to see, if not an equally dramatic, at least a gradual decline in the levels of SnO_2. Though there are graffiti showing that some of the areas where high-grade cassiterite has been discovered were visited by Ancient Egyptian prospectors, no one has found any evidence to indicate that they were in search of tin. [103,108] Therefore, it has been tacitly assumed until now that tin was another commodity that had to be imported from abroad. [104]

Let us look more closely at the tin situation during the Third Intermediate Period. The number of bronzes containing over 1% Sn declines slightly after the Ramesside Period and the decline is matched by a comparable

drop in the number of faience glazes having a Sn:Cu ratio greater than 1:100 (Figs. 11 and 13). The number of glazes containing less than 0.01% SnO_2 rises a little, and there is a decline in the number of specimens containing excessive amounts of tin (Figs. 9 and 10). The over-all effect is to reduce the averages in green and blue faience, for example, from the very high Ramesside to the still impressive levels of the 18th Dynasty (Fig. 12 and Table XVI). Consequently, the tin data suggest slight shortages, at least in comparison with the 19th Dynasty, possibly connected with economic and distribution problems, but nothing comparable to the scarcity of antimony and cobalt.

One could try to explain the continuing presence of tin in metal objects by assuming that old bronzes were being regularly re-melted. Similarly, old corroded bronzes could have been the source of SnO_2 in faience. Undoubtedly, old objects were re-melted from time to time and corroded bronzes were an important source of copper pigment, but it is difficult to see how all the bronzes found in Egypt at the end of the 20th Dynasty would not have been exhausted within a century or two. It is downright inconceivable that the supplies would have lasted for five centuries, no matter how thrifty the Egyptians might have been.

We are thus forced to conclude that fresh tin, unlike cobalt and antimony, was available to the Egyptians during the first half of the 1st Millennium B.C. The unanswered question is, where was the tin coming from ? If the tin was coming from somewhere in Asia, why cobalt or antimony were not? This raises some interesting questions regarding the original sources of the minerals mentioned above. It would seem that if the tin was not of local origin, the trade with tin-producing countries was not interrupted to the same extent as was contact with areas exporting antimony and cobalt. The Phoenicians were busy exploiting some of the West Mediterranean mines later in the millennium, but who would have provided the Egyptians with tin ca. 1000 B.C.?

What we must seriously consider, in view of our results, is the possibility that the Egyptians were getting their tin from the Eastern Desert. Maybe the native origin of Egyptian tin has been too readily dismissed in the

past. Future archaeological surveys of known tin-bearing areas may still uncover evidence of mining activities in Pharaonic times. Perhaps the source of Ancient Egyptian tin should also be sought in Nubia, since the highest concentrations of the element were seen in 25th Dynasty faience from Sanam Abu Dom in the Sudan. As a matter of fact, during the Third Intermediate Period, in general, more tin is seen in faience from southern Egypt than in objects from other areas.

Lead is another substance which is seen less frequently than it was during the 18th Dynasty, but at levels comparable to those in Ramesside faience. Examination of Tables XX and XXI, and of Fig.16, shows that lead remains plentiful in high-copper glazes, but disappears from those into which it could not have been introduced as leaded copper or bronze scrap. For example, more PbO is seen in green, blue and black glazes of the Third Intermediate Period than in faience of corresponding colours from the New Kingdom (Fig.16). At the same time the substance disappears from white, brown and red glazes. This suggests that after the 20th Dynasty the supplies of lead could not keep up with the growing demand from producers of leaded copper and bronze objects. Copper objects of very high lead content become common during the Third Intermediate Period. Two thirds of the analysed copper objects of the period contained more than 1% Pb (Fig. 17). The apparent shortage might have been aggravated by the loss of Asiatic supplies, which during the New Kingdom supplemented the lead available from local sources.

Since little lead is seen in low-copper glazes, it is difficult to tell whether the material is of the low-zinc variety or not. Establishing a lead--zinc correlation in high copper glazes is virtually impossible, because of the uncertainty regarding the zinc content of the original copper ore. What we do know is that in objects of the 26th and later dynasties the lead is unaccompanied by zinc.

In view of the fragmentation of the country during the 21-25th Dynasties we had hoped to find clear regional distinctions in the general composition of Egyptian faience. We were particularly curious to see if a difference could be detected between faience from southern and central Egypt, areas dominated by Thebes, [208] and material from the north of the country. As we indicated

above, tin is the only substance whose occurrence and concentrations seem to favour southern over northern Egypt. The observed north-south gradient makes sense if the tin had come from the Eastern Desert, because the tin deposits are concentrated at the southern end of the region. [107,109] The area containing tin minerals might extend far south of the presently known belt, well into the Sudan. [102,107] Thus all the green and blue faience from Sanam Abu Dom (upper Nubia, Sudan) contained tin, and since the Sn:Cu ratios ranged from 0.11 to 0.37, bronze scale could not have been the sole source of tin.

Regional distinctions in the concentrations of other elements are too fine to be seriously considered as indicative of different technical traditions or raw materials in the South and the North. The clearly discernible conservative trend and return to traditional recipes seems to have affected most workshops between Memphis and Thebes. The picture could alter dramatically in the future should a large volume of Delta faience become available for analysis.

5. Egyptian Faience of the Late Period, Dynasties 26-31

Compositionally the Egyptian faience of the Late Period is more heterogeneous than at any time other than the 18th Dynasty. There are signs of transition from what might be called "traditional Pharaonic' to Hellenistic faience in the chemical nature of various pigments and in the manner that the colours are used. We see the gradual abandonment of long-established techniques and the first appearance of those which subsequently gave the Ptolemaic faience its distinctive character. The concentrations of many elements have values intermediate between those of earlier faience and faience of subsequent centuries, as can be seen in many of the Tables and Figures in Chapter II.

The changes in faience technology are most noticeable when one compares the faience of the 26th with that of the 30th Dynasty. Three centuries separate the beginning of the former from the latter, but we cannot tell how rapid or how slow the technological changes were, since only a small number of objects can be pinpointed to a specific dynasty. Of course, one is confronted by the same dating problems in dealing with material of the Third Intermediate Period, but since there was much less difference between the faience of the

earliest and last centuries, the lack of precise chronological information was
not as distressing.

The reunification of the country under the 26th Dynasty inaugurated a
period of intense artistic activity, much of it directed at the restoration
and imitation of ancient monuments. As a result, the term "Saite Renaissance"
has been applied to the century and a half during which the Dynasty ruled
(664-525 B.C.). Technically Saite faience is superior to much of the output
of the preceding five dynasties, both with regards to glaze adhesion and
colour control. The ushabtis of the 26th Dynasty not only have a very
distinctive novel body shape, but they also favour a characteristic soft shade
of green, which sets them apart from earlier and later figures. Matte colours
are preferred to glossy, and monochrome ushabtis are the rule, unlike earlier
and later examples, in which the wig, body features, and tools are rendered in
darker or strongly contrasting colours.

The chemical compositions of green Saite glazes were cleverly manipulated
so as to promote the particular shades that must have been dictated by
esthetic considerations. The concentrations of iron are up over the preceding
periods by almost a factor of two (Table VIII), while the concentrations of
copper are slightly lower, and manganese disappears almost entirely (Table
VII). However, it is the fresh infusion of antimony and the increased
concentrations of lead, both of which rise to levels not seen since the Amarna
Period (Tables XVII and XX), that are responsible for the more delicate shades
of green. Of course, one would not expect to see antimony in all Egyptian
workshops, either by reason of choice or economy. The data in Appendix C show
that a lot of very conventional green and blue faience, coloured by copper
free of lead and antimony was still being made in Egypt. There are also
specimens containing lead without antimony and vice versa. It is obvious that
traditional recipes were less strictly adhered to in some workshops than in
others.

The 26th Dynasty saw the reappearance of antimony in quantities
sufficient to satisfy the needs of the faience industry. For example, the
average concentration in green faience jumped from 0.02% Sb_2O_5 in Third
Intermediate Period glazes to 0.35% in glazes of the Late Period (Table XVII).

With the return of antimony, true yellow glazes become possible again, and these are characterised by $PbO:Sb_2O_5$ ratios very similar to those of Ramesside yellows (Fig. 15). In sharp contrast with the New Kingdom the Late Period sees extensive use of antimony pentoxide, with or without lead, in glazes of all colours (Table XVII). At the same time, the manganese content of most glazes declines significantly (Table VII), so the Sb_2O_5 must have been added as a decolorizer in lieu of MnO_2. [23] The antimony pentoxide undoubtedly helped suppress the undesirable effects of increased iron concentrations, which are noticeable in glazes of all colours (Table VIII). We must be seeing a very different type of sand in Late Period glazes, a possible reflection of the higher proportion of objects made in Lower Egypt.

The concentrations of lead in most glazes of this period tend to be intermediate between those of preceding and subsequent times (Fig. 16), and the lead is of the zinc-free variety. This is particularly evident in white and yellow faience, where the results are not obscured by the presence of zinc introduced with copper or other ingredients (Table XIII). It is not only in faience that the low-zinc lead is dominant at this time. Riederer's extensive analyses of Late Egyptian bronzes showed that even those with the highest lead concentrations contained only trivial amounts of zinc. For example, in bronzes containing 10-20% Pb only 0.00-0.10% Zn was detected. [177]

In preceding sections we noted an **apparent** link between the appearance and disappearance of antimony and cobalt and the rise and fall in the production of glass. Whether the link was ever real or not, it was definitely broken during the Late Period. Glassmaking languished long after the antimony and cobalt reappeared in Egypt. The output and quality of the glass manufactured in Egypt did not improve significantly before the end of the 4th century B.C. The revived industry produced a new, Hellenistic, glass totally different from New Kingdom glass, both in chemical composition and in appearance; it has been characterised by Cooney as being "thicker, more opaque and less vitreous". [32]

Cobalt, unlike antimony, returns to Egyptian faience much more gradually. In blue faience securely dated to the 26th Dynasty we see little change other than an increase in the number of glazes having CoO concentrations in the

0.03-0.05% range. Cobalt oxide at levels comparable to those of New Kingdom faience was detected in an aryballos (1911.358), which might be of foreign origin (see below), and in an Achaemenid seal (1892.1384), which might have been made at any time during the 5th or 4th century B.C. We do not know whether the seal was made in Egypt or Asia, but the design is foreign. The cobalt is of the dominant Iranian variety--free of manganese, nickel and zinc and containing traces of arsenic.

The only other "precisely" dated objects with comparable amounts of cobalt were the peculiar ushabtis (E.3565 and E.3566) from the 30th Dynasty tomb G50 at Abydos, and two similar ones of uncertain provenance (1956.18 and 1956.19). It is the intensely violet wigs, coloured by 0.1-0.2% CoO, over dark blue bodies, that make these ushabtis look so strange. In the past the wigs were either left alone or coated with a layer of brown or black glaze. They look so unlike all the rest of faience recovered from contemporary tombs and graves at Abydos, that we feel they were probably manufactured elsewhere, possibly in Lower Egypt.

It is unlikely that the two sets of ushabtis were made in the same workshop, since different glazing mixtures were used for their wigs. The ones from Abydos have higher CoO concentrations and no manganese. The other two (1956.18 and 1956.19) have lower levels of CoO and low but comparable concentrations of MnO, with the accompanying BaO. None of the four ushabtis contain enough ZnO or NiO to suggest that the cobalt was of the same mineral origin as that used during the New Kingdom. Since the manganese naturally associated with cobalt is free of barium, the presence of BaO in the wigs of the two unprovenanced ushabtis indicates that psilomelane (barium-containing MnO_2) was deliberately added to the cobalt pigment.

While we cannot date the two unprovenanced violet-haired ushabtis on the basis of their findspot, and they could prove not to be contemporaneous with the two from tomb G at Abydos, we can still restrict them on stylistic grounds to after the Saite Period, i.e.,to the 5th or 4th centuries B.C. Consequently, our evidence suggests that the regular use of cobalt lagged behind that of antimony by at least a century and a half. The scarcity of entire objects coloured by cobalt blue and the restricted manner in which the

pigment was used only when copper would not do (blue on green or indigo on blue), strongly suggest that as late as the middle of the 4th century B.C. the substance remained much scarcer than antimony.

Unless cobalt was consciously shunned by Egyptian glazemakers, the inescapable conclusion is that the cobalt and antimony could not have originated within the same general geographical area, or within the boundaries of the same state at that time in history. Otherwise it is difficult to understand why one should be plentiful in the country during the 26th Dynasty and the other one not. Both do become available, though not equally plentiful, during the period of Persian domination, but by that time the Persian Empire stretched from the Bosphorus to India, and an innumerable variety of minerals must have been mined within its boundaries. A canal linking the Nile to the Red Sea was begun by Necho ca. 600 B.C., and completed by the Persians. [217] The canal facilitated trade with East Africa, Arabia and the more remote areas of the Achaemenid Empire.

One of the most interesting changes, first noticeable in black faience of the Late Period, and one which became firmly entrenched during subsequent centuries, was an increased use of kilns operating under reducing instead of oxidising conditions. The change was not a trivial one, but had to be made to accommodate the growing popularity of black glazes coloured by iron without the assistance of manganese. On several occasions in Chapters II and III we pointed out that from the Second Dynasty onwards manganese became the pigment of choice in all but few remote areas of Egypt. Even the latter changed from iron to manganese by the Middle Kingdom.

Thus, a technical tradition that endured for over 2000 years was gradually abandoned during the Late Period. The earliest dateable example of reduced iron black that we have been able to locate was a black unglazed frit cylinder (U.C. 16538) inscribed with the name of Wahibre Necho (ca. 600 B.C.). The cylinder owes its colour entirely to reduced iron (ca. 1.3% as Fe_3O_4), since it contains only 0.04% MnO.

For the period as a whole, half the black glazes still had an excess of manganese over iron (Fig.20). These statistics, however, hide some

interesting geographical and historical factors. One such factor is that the south of Egypt retained the traditional black pigment longer than other parts of Egypt. Among the black 26th Dynasty faience examined by us, the only one to be coloured by manganese instead of iron was a vessel from Thebes, whose black glaze contained 3.7% MnO and 0.2% Fe_2O_3. The southern conservatism is even more conspicuous in black faience of the subsequent Ptolemaic Period. Of the ten examples analysed by us, the only one not coloured by reduced iron was a black glaze on a blue plaque from Abydos. That the Theban workshops of the First Millennium B.C. should be strongly attached to tradition is quite understandable. As an important religious center the town lived on tradition, its glories were in the past. It ceased to be the capital of a large Empire, and its remoteness from the centers of political and mercantile activities insulated it from most of the foreign influences to which places such Memphis and the Delta towns were exposed.

Both the manganese and reduced iron blacks have an ancient pedigree going back in time as far as the 6th Millennium B.C. [37] Both pigments have been used on pottery as well as in glass and faience, and their relative popularity varied from country to country and from age to age. The iron-reduction technique was raised to an unprecedented level of perfection by the Greeks, as is attested by the many superb pieces of red and black ware in existence.

Therefore, it is tempting to see a Greek hand behind the change in the established glazing technology. The pharaohs of the 26th Dynasty began a program of wholesale recruitment of Carian, Ionian and other Greek mercenaries as a matter of policy. [218] It was unavoidable that the soldiers would be followed by kinsmen and other compatriots. For a time, the principal base for the foreign troops was at Defenneh in the Eastern Delta, and some soldiers were stationed in Memphis. However, for a variety of internal political reasons a special permanent settlement was established for the Greeks at Naucratis in the Western Delta. [218,219] The town became the principal port of entry for ships from the Aegean and the Western Mediterranean world. Naucratis retained that role until eclipsed by Alexandria during the 3rd century B.C. The town had its own thriving faience industry, as is attested by the unearthing of a scarab factory, next to the temple of Aphrodite. [220]

Since we have known for a long time how difficult it is to find black faience that can be securely dated to the 26/30th Dynasties, we were disappointed but not surprised by our failure to locate examples from Naucratis. It would be nice to know whether the local faience-makers used the old or the new pigment formulations for their black glazes. The only example from a Delta site, a distinctly Asiatic-looking votive figure (1888.264) from Tukh el Qaramus, had a black wig coloured by the traditional ferruginous manganese (1.6% MnO, 0.2% Fe_2O_3). Of course, it could be a simple coincidence that the change to the reduced iron technique should begin after the Greeks perfected the process on pottery and after a large number of them emigrated to Egypt, but we find it hard to believe that it is.

The green and blue faience from Naucratis shows little to distinguish it from similar material from other Delta sites (Nabesha, Defenneh, Tukh el Qaramus and Gumaiyima). On the whole, the Delta greens are characterised by concentrations of lead and antimony far below the average for the period, and above-average tin contents. The one exception was a green plaque (1887.2459) bearing the name of Amasis, from the foundation deposit of the temple of Wadjet at Nabesha. It had no detectable amount of lead, hardly any tin (SnO_2 below 0.02%) and about 0.2% Sb_2O_5. The plaque was probably not manufactured in a local workshop, but must have been made for the king elsewhere, possibly at a royal workshop in Memphis or some other large town. Assuming that the Naucratis factory was run by Greeks, the very low levels of lead and antimony in green faience could be mistakenly attributed to unfamiliarity with the uses of lead antimonate, were it not that the two elements were used liberally in yellowish-white faience from the site (1.7% PbO, 1.2% Sb_2O_5, in one example).

In our opinion, the traits common to the homogeneous green (and blue) faience from Naucratis and the other Delta towns, and which distinguish them from like-coloured faience from Memphis, for example, reflect the same distinction, as before, between the products of small local workshops and those of large royal and temple ateliers. If the green faience of known Delta provenance is representative of the smaller workshops of the region, one could interpret the absence of Sb_2O_5 in excess of 0.2% as indicating an attempt to use an expensive commodity sparingly, except where it is indispensable. For example, the yellow glaze on a 26th Dynasty bead from Nabesha (1969.710A)

contained 2.2% PbO and 0.7% Sb_2O_5, concentrations not that different from those found in the yellow area of a contemporary vase from Memphis. Having said all this, one cannot but wonder as to where a Carian scarab (1895.105) coated with a pale green glaze containing 3.0% PbO and 2.7% Sb_2O_5 was made.

The Memphis material by itself is quite diverse in composition, something to be expected from a large metropolitan center. The city undoubtedly boasted a large number of faience-making establishments, and was also a most likely recipient of finished products from other parts of Egypt and from foreign countries. For example, among the Late Period faience from Memphis one can find the most conventional specimens of blue and green, as well as some very innovative examples of blended colours. Antimony, in particular, must have been plentiful for some of the highest concentrations were recorded in faience recovered from Memphis.

While the Delta workshops show strong adherence to cheap recipes for traditional green and blue glazes, the raw materials, particularly during the Persian Period, were obtained from a geographical area much wider than at any previous time in history. We were vividly reminded of this by the discovery of significant amounts of bismuth (ca. 0.2% Bi_2O_3) in two blue objects from the Naucratis scarab factory. The two, an unglazed blue frit amulet and a blue faience scarab (E.A. 908), look like thousands of other copper-coloured blues, but they are the only ones of any colour in which we have detected bismuth oxide in excess of 0.02%. The bismuth must have originated as an impurity in copper, since no other element was present in sufficiently high concentrations to have been the carrier for this much bismuth.

What we have here is evidence that copper from some very unusual source ended up in the hands of the Naucratis faience makers. The ore could not have originated in any of the local or foreign copper mines from which the Egyptians obtained copper in the past, otherwise, comparable quantities of bismuth would have been detected by us or others in faience and glass. In glass the element has only been reported at concentrations below 0.01% (see Sec. 21, Chapter II). As a matter of fact, copper deposits containing as much bismuth as the composition of the two objects would require (a Bi_2O_5:CuO ratio of 4:100) are very rare. For example, according to a recent study of

impurities in a worldwide collection of copper ores, the probability that a sulphide ore would contain enough bismuth to yield the oxide ratios indicated above is only 0.01; in an oxidised ore, such as malachite, the probability is reduced to one in a thousand. [221] The numerous graffiti, official inscriptions and physical remains in the Eastern Desert indicate that the Saite rulers pursued a most vigorous prospecting and mining program. [129] Consequently, it is not inconceivable that the ore could have come from some new mine opened up during the 26th Dynasty.

Naucratis has been proposed as the place of manufacture for three rather unusual vessels of the 26th Dynasty that we had an opportunity of analysing. The vessels in question, an aryballos (1911.358) and a locust vase (1910.784), both picked up by Petrie on the site of Memphis, and a hedgehog vase (1872.298) purchased in Thebes, are so unlike traditional Egyptian faience in appearance that attributing them to a Greek factory in Egypt or somewhere in the Eastern Mediterranean does not seem to us that unreasonable. [163] For a discussion of the stylistic affinities of these vessels with similar faience from a variety of Archaic Greek sites we refer the reader to a recent study by Virginia Webb, in whose book the three are numbered 704, 950 and 907, respectively. [163]

Since we have no polychrome faience from Naucratis for comparison, we decided to compare the one colour common to all three vases, green, with Naucratis and other Delta faience of same colour. Both in composition and in elemental ratios the match between the three vessels and the Naucratis reference data was not very good; particularly noticeable were the much more elevated lead and antimony concentrations in the former. Moreover, the lead-antimony ratios suggest that the hedgehog was not made in the same workshop as the locust and aryballos. While the latter two had green glazes containing almost equal concentrations of the oxides of lead and antimony, the hedgehog had several shades of green, none of which contained less than a two-fold excess of lead over antimony.

Until we do get adequate analytical data for polychrome faience from Naucratis, all we can safely say is that we cannot attribute any of the three vases to Naucratis on the basis of elemental analyses. Memphis seems like a

more likely site of manufacture. However, of the three the hedgehog resembled the Naucratis faience the most in its over-all composition.

Red glazes resembling those of the 18th Dynasty have been found on beads from the temple of Merneptah in Memphis. Appearances can be deceiving, for the resemblance is superficial. While Fe_2O_3 was still the pigment, the Late Period faience, unlike the majority of New Kingdom reds, was of the ordinary variety (i.e.,it had a white body material) and the glaze contained no lead.

Judging by what we saw at the Ashmolean Museum, the Petrie Museum, and several larger museums in England, France and the U.S.A., polychrome faience must have accounted for a very small fraction of the Egyptian faience turned out during the Late Period. However, the few objects that we have been able to examine were of excellent quality both in design and in composition. The various colours were rarely inlaid, as was the custom during the New Kingdom. Instead they were usually superimposed yielding a wide range of hues. Among the finest examples of polychrome faience of the Late Period were the three small vessels discussed above.

Riederer's bronze analyses afforded us an opportunity of comparing regional variations in the tin and lead contents of Late Period faience and bronze. [177] We picked tin, since of the three elements that entered the faience glaze primarily via bronze scale, it was the one which exhibited the best match between the occurrence in faience and in contemporary bronzes (Fig. 11). In conformity with Riederer's geographical divisions, we assigned each analysed object to one of three regions: Lower, Central and Upper Egypt. To get a larger sample size for each region we combined the blue and green analyses. Tin in bronzes was compared with SnO_2 in faience and the results are tabulated below.

Each row shows the highest values in Lower Egypt, the lowest in Central, and intermediate in Upper. The tabulated data not only confirm our previous contention that most, though not all, of the tin came from contemporary bronzes, but they provide additional evidence of close cooperation between the metallurgical and glazing industries. It is obvious that the tin content of copper-coloured faience mirrors the composition of contemporary bronzes made

T A B L E XXXVIII

REGIONAL VARIATIONS IN THE TIN CONTENT OF LATE PERIOD BRONZES AND FAIENCE

Average tin concentration	Lower Egypt	Central Egypt	Upper Egypt
in Late Period Bronzes	6.94%	3.78%	5.12%
in Late Period Faience	0.32%	0.21%	0.30%
Percentage of Blue and Green Glazes Having SnO$_2$ above 0.2%	48	37	40

in the same broad geographical area. No such correlation is expected between the regional variations of lead concentrations, for obvious reasons. More lead was often added, to green faience in particular, in combination with antimony than would be expected from some of the most heavily leaded bronzes. The data in Table XXI show this quite convincingly.

6. Hellenistic Faience, 4th c. B.C.-1st c. A.D.

We could not think of a more suitable adjective than Hellenistic to describe the faience made during the centuries of Greek political control and early decades of Roman rule, i.e. from 332 B.C. to the First Century A.D. While some faience can be assigned unequivocally to the reign of Philip Arrhidaeus (323-316 B.C.), the bulk of analysed material belongs to the Ptolemaic Period proper (304-30 B.C.), where the dates of manufacture cannot be narrowed down even to a century. There are also fragments which can only be designated as belonging to the Late Ptolemaic or Early Roman Period. The word Hellenistic is also very appropriate for the extravagant display of colours and subtle nuances that make polychrome faience of the period unlike anything seen since Amarna days. The diversity of Ptolemaic polychromy and the colour combinations in vogue at the time were fully treated in Section 10 of Chapter III.

The repertoire of mineral pigments was no greater than during the Amarna Period, but the basic ingredients were rarely used in the same way as before. For example, the yellow pigment is the same old lead antimonate, and the lead:antimony ratios are back to the values typical of 18th Dynasty faience

(Fig. 15). However, seemingly for the first time, $Pb_2Sb_2O_7$ is also used to colour the entire body material yellow and provide a new type of contrasting background for the blue and green glazes. Only a minority of Ptolemaic glazemakers were content with a green coloured solely by copper. The fraction of analysed green glazes containing enough lead and antimony to influence the colour is only slightly smaller than the corresponding Amarna figure of three quarters. With or without antimony, lead is more pervasive than ever (Fig. 16 and 17). Only in white, brown and red glazes are the levels of lead no higher than at previous times (Table XX).

The popularity of lead is also apparent in the analyses of Hellenistic glasses. [18,20,25,121] For example, a high-lead (20-30% PbO) opaque red glass coloured by reduced copper, similar to the Assyrian glass from Nimrud, [159,206] first appears in Egypt in Ptolemaic times. [20,21] Surprisingly, no faience of similar composition has been seen by us, while the red glazes coloured by Fe_2O_3 have much less lead than they did in New Kingdom faience (Fig. 16 and 17).

Both the faience and the glass contain the zinc-free lead, different from the New Kingdom lead, but similar to the lead in Late Period faience and bronze. After comparing the isotopic ratios in lead extracted from New Kingdom and Hellenistic glasses, Brill also concluded that very different sources have to be sought for the leads of the two periods. [131] The ratios spread out over the range of values between Brill's empirical S and L groups. [131,200] The L group includes the famous argentiferous Greek Laurion galena as well as a variety of Anatolian and Iranian ores. For obvious reasons, this form of lead is sometimes called "Levantine lead". Between groups L and S, which includes ores from the Western Mediterranean, lie groups E and X. Leads belonging to the latter two groups are frequently encountered in Roman coins minted in Syria, Antioch in particular. [131,201] One wonders if the lead of the Antiochene coins came from the argentiferous galenas of the adjacent Amanus mountain range that have still not been completely exhausted. [222]

With our analytical and Brill's lead-isotopic studies in full accord, the question is not whether a new and probably foreign lead was used, but why ?, as long as there were still large galena deposits in Egypt. We have no answer

to the question at the present time, but it is not hard to guess that the reasons had to be economic. Perhaps with the great increase in maritime commerce foreign lead became cheaper than the cost of maintaining a labour force in the inhospitable mines of the Eastern Desert. The hardships and the miserable conditions under which the Ptolemaic gold miners toiled in the Eastern Desert, as observed by Agatharchides of Cnidos ca. 130 B.C., are described by Diodorus Siculus. [223] It is obvious that what was marginally profitable for gold would not have been worth doing for lead.

As in the case with the iron-black technique, the introduction of the new type of lead coincided with the expansion of Greek maritime activities and colonisation. With Egypt and the rest of the Levant within the Greek cultural orbit, lead from Laurion and Anatolian mines must have been shipped to many parts of the Mediterranean world, as a cheap by-product of the extraction of silver.

Whether cobalt was plentiful during the first half of the 4th century B.C. may be uncertain, but the lavish manner in which it was used at the time of Philip Arrhidaeus (over 1% CoO, in many instances) leaves little doubt that it had become common by the end of the century. As before, cobalt is used most often in the production of violet and indigo glazes, particularly as a means of imprinting a design on deep blue or green surfaces, but it also is used for the first time in high concentrations in conjunction with iron to make black manganese-free faience.

The Memphis glaze-makers, in particular, showed great ingenuity in the way they manipulated iron, cobalt and manganese minerals to make some very elegant vessels decorated in soft brown and dark grey colours (1913.800A, 1910.549(1)). The two colours are juxtaposed in a manner that would have been extremely difficult if only iron and manganese were used to differentiate the brown from the greyish-black (see Sec. in Chap. III). The Ptolemaic artists solved the problem of having pigments of similar composition, distinguished by elemental ratio alone, by using two chemically different pigments -- iron with cobalt for the black and iron with manganese for the brown, and firing the faience under reducing conditions.

The cobalt ore was of the same type as the one used in the Late Period, i.e., free of manganese, nickel and zinc. With the manganese divorced from cobalt, the Egyptians used the two elements separately or in combination to create a wide range of indigo, violet and purple colours. The most common form of violet and indigo, seen on faience recovered from all parts of Egypt, contained pure cobalt oxide. Contemporaneous with the violet-blue was a reddish purple glaze coloured by reduced manganese alone (Mn_2O_3). So far we have only seen such glazes on faience from Memphis. Among the finest specimens of faience thus coloured were some vessel fragments (1910.544, for example) from the Kom Hellul kilns. Violet glazes resembling those of the New Kingdom were also being made by adding highly variable amounts of manganese to the cobalt. Such a mixture was seen on a plaque from tomb E460 in Abydos, and the MnO:CoO ratios varied from 2:1 on one design segment to 1:6 on another.

Cobalt with little or no manganese (MnO below 0.11%) was detected in black faience from Memphis and Alexandria, but not in Abydos material. The latter utilised the traditional ferruginous manganese instead of the reduced iron, which had become the new fashion in Egypt.

No regional pattern could be discerned in the use of lead antimonate in green faience, since all but one specimen came from Lower Egypt. The one green Upper Egyptian specimen from Coptos was coloured by copper alone. Of the Memphis greens three quarters contained enough $Pb_2Sb_2O_7$ to influence the basic green. Analyses of green faience from three Delta sites leave the impression that there was an absence of any generally accepted glaze formulations, even within the same geographical area. The local workshops must each have had their own favourite recipes. For example, a green Royal Oinochoe vessel from Naucratis contained plenty of lead and antimony, while only bare traces of the two elements were present in a fragment of a similar vessel recovered in Alexandria. Some lead and antimony were detected in a green plaque from the foundation deposit of the temple of Philip Arrhidaeus at Tukh el Qaramus, but at levels that could not have had much impact on the copper pigment.

One interesting observation is that the levels of tin which have been rising steadily for almost a millennium show a drop during the Ptolemaic Period. The decline is graphically illustrated in Fig. 9, where one can see

how uncommon have become glazes containing even 0.5% SnO_2. Since no corresponding decline has been detected in the tin content of contemporary bronzes, [49] it means that the tin derived from bronze scale is not being supplemented, as in the past, with additional copper-free tin. This is reflected in the reduced size of the last histogram column in Fig. 13. The column represents glazes having Sn:Cu ratios highly improbable, or even impossible, for an Egyptian bronze. If, as the data suggest, a much higher proportion of Hellenistic faience obtained all its tin from bronze, one can understand why the average SnO_2:CuO ratios of high-copper glazes of all colours should converge toward a common value (Fig. 12). The value would now reflect the average tin content of contemporary bronzes. The gap between high-lead and low-lead glazes disappears too (Fig. 10), since there is no specific correlation between the lead and tin contents of Hellenistic bronzes. [49]

In connection with the use of bronze scrap, a very interesting distinction arises between green and blue glazes. Such scrap was apparently used freely with blue but sparingly with green glazes. For example, 22% of blue glazes had SnO_2 above 0.2% and 41% contained both SnO_2 and PbO in excess of the same concentration. The high proportion of glazes containing both lead and tin tallies well with the popularity of leaded bronzes in Ptolemaic and Roman Egypt. [49] On the other hand, while 52% of the green glazes contained both PbO and Sb_2O_5 in excess of 0.2%, fewer than 5% had either tin and/or lead above the indicated concentration in the absence of antimony.

It is worth noting that fewer than 10% of either blue or green glazes had PbO above 0.2% unless it was accompanied by significant amounts of tin or antimony. Apparently hardly any lead entered the glazes except as a component of bronze scrap or as the yellow lead antimonate pigment. This should once and for all dispel any notions that lead glazing of faience was practiced in Egypt at any time before our era.

In its appearance, particularly choice of colours, faience of the Late Ptolemaic and Early Roman periods is noticeably different from earlier, less extravagant, products of the Ptolemaic factories. During the last century of Ptolemaic rule the tastes might have changed, but our analyses reveal no

accompanying change in the basic formulation of pigments. To those who know Egyptian history it must come as no surprise that the arrival of Roman legions and administration had little impact on the nature of local faience and glass industry. By the time of Augustus most of the production and trade in luxury items were in the hands of Greeks and Hellenized Egyptians who retained their privileged status in Egypt.

We must mention however, at least two cases which might represent a distinction between early and late Hellenistic faience or another example of regional diversity. As we noted earlier, the characteristic reddish violet glaze coloured by cobalt-free manganese was only seen by us on Memphis faience. However, all of our specimens exhibiting this type of glaze were considered to be of Late Ptolemaic or Early Roman date. Consequently, what appears to be a Memphite formulation of purple glazes might in fact prove to be an invention made late in the Ptolemaic period.

Similarly puzzling are some of the features of the distribution of potassium among faience glazes of different regions. Faience from the Delta (Naucratis, Tukh el Qaramus and Alexandria) is characterised by low potassium concentrations, as befits material made in a area close to the natron deposits of Wadi Natrun. What is difficult to understand, is why the Memphis workshops, particularly the Kom Hellul kilns, show much higher preference for potassium-containing alkali, such as plant ashes. For example, the average concentration of K_2O in blue and green faience from Memphis is 1.3%, in contrast with 0.36% in similar faience from the three Delta sites listed above.

This could be considered just another case of local idiosyncracy, were it not that most of the high-potassia Memphis faience is of much later date than the Delta objects. Similarly, the low-potassia Abydos faience is also of fairly early date. Therefore, until a chronological series of reasonably well dated objects from a site or two have been analysed it will not be possible to state unequivocally that the high potassium levels in Memphis faience represent a technological change instead of a local preference for alkali other than natron.

At this time we are inclined to favour the latter explanation, since no change from low to high-potassia glasses has been detected during the same time interval, and the glass and faience industries often worked in tandem. Curiously enough, at about this time in history the Graeco-Roman world was changing everywhere from high-magnesia, high-potassia glass to a variety low in both elements, the so-called "Roman glass". [22,23] The old variety did persist, though, in Mesopotamia and areas further east. One puzzling aspect of this whole affair is why Memphis, in view of its geographical location, should not have continued to rely more heavily on natron than on plant ashes, as it had done for centuries. There is solid archaeological evidence, in the form of Roman glass kiln remains, that the natron of Wadi Natrun remained an important ingredient in the manufacture of glass. [224]

Potassium is not the only element to show different trends in glass and faience. Ptolemaic faience, for example, fails to show any of the shift from antimony to manganese as decoloriser, something that has been detected in glasses of the 1st c. B.C.-2nd c. A.D. [23,242] Ptolemaic and Early Roman faience from Egypt is remarkable for its low manganese concentrations. These divergencies suggest that the faience and glass industries came to a parting of the ways during the last centuries of the 1st Millennium B.C., assuming, of course, that they ever returned after the post-New Kingdom slump to the close relatioship that existed between them in the 2nd Millennium B.C.

7. Comparisons with Mesopotamian Faience and Glass

With the exception of the paper by Stone and Thomas, [3] which deserves special consideration, we will restrict our comparative survey to those publications that report numerical percent figures. For this reason, publications that mention faience and record only that such and such element was present in "high" or "low" concentrations, as well as others which tabulate only broad ranges, will be referred to in passing, if at all. In the latter category belongs Dayton's book. [6] The book contains few detailed quantitative (as opposed to semi-quantitative) analyses and of those most are from older literature or obtained by others, who must be given credit for the work. Moreover, some of the figures are patently impossible; we cannot conceive of a blue glaze containing 10-15% CoO, as is reported for a specimen of Amarna faience, for example. [6]

For a discussion of the sites at which the earliest examples of faience have been discovered one still is hard pressed to find anything as brief and comprehensive as the 1956 article by Stone and Thomas. [3] Many more faience finds have been made since that date, but the information is scattered among hundreds of journals. What we do not know is whether the conclusions reached by the authors regarding the origin and early diffusion of faience technology have gained additional support or have been undermined by more recent discoveries.

In view of what we now know about the earliest Egyptian faience (Amratian, Naqada I), the claim that Mesopotamia for a long time held a commanding lead does not look so solid. As Stone himself pointed out, the one faience seal of presumably Halafian date from Tell Arpachiya might in fact had come from the Al Ubaid stratum. [225] If that were to be so, the object could be contemporaneous with Amratian faience, since the Northern Ubaid Period stretches well into the 4th Millennium B.C. [226] Having raised doubts about the existence of a pre-Ubaid faience industry in northern Mesopotamia, the author goes on to state that: "Unequivocal confirmation of these apparently very early finds is unfortunately not forthcoming from the nearby contemporary site at Tepe Gawra."[225] After voicing his disappointment at the large number of "inadequately recorded finds", Stone can only state with certainty that a variety of faience objects: "...were recovered from very early and possibly pre-Uruk (our emphasis) levels."[225] Of course, the most spectacular early find in terms of quantity was made by Mallowan in the Grey Eye Temple at Tell Brak, [227] which the excavator has dated to ca. 3200 B.C., a time contemporaneous with the Late Gerzean (Naqada II) Period in Egypt.

Lest there be a misunderstanding, we have no intention of claiming priority for Egypt. To do this would be foolish, until after more analytical work had been done on early faience from Syria and Mesopotamia, and the Egyptian and Mesopotamian chronologies of the 3rd and earlier millennia are better synchronised. [228,229] What, in our opinion, must be recognised is that there is no concrete evidence to suggest that the Egyptian faience industry was that much younger than the Mesopotamian. This has been recognised by Peltenburg, who in referring to the invention of glazing, states: "We will need more evidence, especially radiocarbon dates, to establish the country in

which it was first invented,...". [189]

As long as there is a distinct possibility that none of the Mesopotamian faience predates the Al Ubaid period, and there is no evidence that the Amratian faience recovered at Naqada, for example, was not made in Egypt, we find untenable Stone's conclusion that the art of faience making: "...appears to have been introduced into Egypt probably by the Naqada II (Gerzean) invaders."[225] Equally erroneous is the next sentence in which it is stated that: "...the foundations of the subsequently supreme Egyptian faience industry were laid without question (our emphasis) in the Predynastic Gerzean Period." We have analysed faience from four Amratian graves at Naqada (see Appendix D) and found the glazes in no way inferior to those on beads from later Predynastic and Archaic Periods. It is the uncritical acceptance of Stone's conclusions that have misled Biek and Bailey, in an otherwise fine review article, to state with reference to faience that: "...it would appear to have been common in Mesopotamia c. 3000 B.C. and in Egypt 1000 years later."[230] This will undoubtedly come as a surprise to anyone who has seen the very fine and diverse faience that was turned out by the Archaic workshops of Abydos and Hierakonpolis and the faience from Djoser's pyramid complex at Saqqara.

For all the thousands of faience objects recovered from 4th and 3rd Millennium Mesopotamian sites, our knowledge of their composition is just about nil. Only two complete analyses of Mesopotamian faience antedating the second half of the Second Millennium B.C. have been published. The 4th Millennium is represented by a segmented bead from Tell Brak, which was subjected to a qualitative and semi-quantitative analysis, but only the core was examined. [3] The bead seems to have been made of rather ordinary faience. The presence of 1-10% copper and iron suggest that the glaze was originally green or blue. The very high Na:K ratio indicates that natron, ordinary salt, or low-potassium plant ashes were the source of alkali. [28] From the 3rd Millennium we have a tubular bead from Kish dated to ca. 2500-2400 B.C.,which will be discussed later.

Until more analyses of 4th and 3rd Millennium B.C. West Asian faience become available for comparison, we will still be unable to tell whether any

of the unusual early Egyptian faience discussed explicitly in Section 2 of this chapter were aberrations or imports from Asia. Of particular interest are the blue-bodied vessels from the royal tombs T and O at Abydos which were discussed at some length in Section 2. We pointed out that the most intriguing thing about them was their high tin content and Sn:Cu ratios. Considering the relationship between the availability of bronzes and the occurrence of tin in copper-coloured glazes, so evident in the glazes of the 2nd and 1st Millennia B.C., vessels of this type would be more at home in Anatolia, Syria or northern Mesopotamia than in Archaic Egypt. Bronzes containing 5-20% Sn were not uncommon in western Asia almost a millennium before they ceased to be a rarity in Egypt. [83,85,88,89] For example, within a group of analysed Syrian bronzes dated to the end of the 3rd Millennium B.C. those from Byblos all contained over 12% Sn, while the Ras Shamra specimens had 4-18% Sn. [116] Interestingly enough, all of them contained 0.5-1.5% Pb and in some the lead was accompanied by substantial amounts of zinc (1.5% Pb and 0.58% Zn, in one Ras Shamra specimen). If this is typical of some of the lead being mined in Syria at this time, the metal would be hard to distinguish from the Egyptian high-zinc lead.

Although there are some indications that a native bronze industry was established in Egypt by the 12th Dynasty, tin bronzes remained a scarce commodity until the Hyksos Period (Fig. 11). The large number of analyses of Egyptian and West Asian metal artifacts that have been published to date leave no doubt that Egypt lagged behind western Asia in bronze-making and the lag was particularly pronounced during the 3rd Millennium B.C. [89,90]

If the vessels in question and the accompanying bronzes were imported from Syria or some more distant land via Syria, it is difficult to understand why faience containing that much tin is not seen again until the Middle Kingdom. Commercial ties with Byblos, for example, were not broken until the end of the Sixth Dynasty, and then not for long. [231-233] Until there is evidence that the Syrians placed restrictions on the export of tin and bronzes, one must conclude that either the vessels in question (and possibly the bronzes) were made locally or were imported from somewhere else, from Mesopotamia via the Red Sea or Canaan, for example.

Recent archaeological work has shed more light on the early commercial relations between Egypt and Canaan. They appear to have been intimate during the Archaic period and ceased abruptly at the beginning of the Old Kingdom. [234] Only future analyses of Palestinian and Syrian faience will tell whether the unusual vessel fragments from tombs T and O at Abydos have any historical significance with regards to trade relations in the early 3rd Millennium Levant. While the scarcity of bronzes in Egypt until the Hyksos Period might reflect an unwillingness on the part of Syrians to trade the commodity, they would be less reluctant to export vessels coloured by a pigment derived from bronze scale. As it is, we do not even know if such vessels were being made in Syria and Mesopotamia at the time.

The composition of Mesopotamian glass has attracted much more attention from past investigators than has faience. One of the most interesting pieces of early glass, a large working piece (cullet) from Abu Shahrein, ancient Eridu, has been fully analysed. [235] Since it was found below a pavement constructed by Amar Sin, the third king of the Third Dynasty of Ur, it probably belongs to the 21st century B.C. [236] It constitutes the oldest fully analysed example of deliberately manufactured glass. Together with some earlier and as yet unanalysed specimens, [145] it established Mesopotamian precedence in the art of glassmaking. [146,195] To us it is of special interest, since it represents the earliest documented case of the use of cobalt blue in a glass or glaze. As in many later Egyptian glazes and glasses, copper is still present, but at concentrations which make its contribution to the blue negligible (0.49% CuO, 0.15% CoO). The concentration is in the range found by Farnsworth and Ritchie and by Sayre in 18th Dynasty cobalt blue glass, [19,22-24] and similar to concentrations in cobalt blue New Kingdom faience (Table X). However, not unexpectedly in view of the geographical location of Eridu, the cobalt is of the dominant Iranian variety, i.e., free of manganese, nickel and zinc (MnO ca. 0.04%, NiO and ZnO below 0.01%). It certainly is different in origin from cobalt used in the Second Millennium B.C. Egypt, but similar to that used in the First.

Considerably more analytical data are available for 2nd Millennium B.C. Mesopotamian faience and glass. Analyses of faience and glass from Nuzi and Tell al-Rimah, and of glass from Choga Zanbil and Nippur have been published.

The Nuzi collection consisted of faience, glass, frit, and glazed pottery from Temple A, stratum II. [237,238] Recovery of a letter written by the Mitannian king Saushasatar dates the stratum to the first half of the 15th century B.C. [239] Copper, in the form of Egyptian Blue (calcium copper silicate), was the only pigment detected in blue. The red pigment consisted primarily of iron in the case of the frit and of reduced copper in glass; yellow lead antimonate was identified too. The nature of the black is not certain, since iron was the only possible pigment explicitly listed. Whether by coincidence or because of wide dissemination of old established glaze formulations, many elements in the blue Nuzi faience glaze had concentrations close to the median values for Late 18th Dynasty blue faience. For example, 0.17 and 2.35%, the respective values for iron and copper in the Nuzi blue, [238] should be compared with the Egyptian medians of 0.24 and 2.85%.

The Tell al-Rimah material consisted of glass, faience and glazed pottery. [240] The objects came from a temple complex dated to the 15th-13th centuries B.C. [241] Of the seven faience objects four had traces of green glaze and the fifth was yellow. As expected, the yellow contained lead and antimony, with the lead greatly in excess and free of zinc. The Tell al-Rimah yellow faience was distinguished from like Egyptian material of the New Kingdom by a much higher $PbO:Sb_2O_5$ ratio (compare 20:1 with data in Fig. 15) and the absence of zinc. However, it is the same two factors that make this Assyrian yellow very similar to the yellow glazes on beads from the 18th Dynasty tomb E266 at Abydos. The K_2O and CaO concentrations were very similar too, but Fe_2O_3 was not. In Section 2 of this chapter we pointed out how much these particular Abydos beads differ from all the other 18th Dynasty yellow faience analysed by us. In our opinion tomb E266 deserves closer scrutiny, for if these beads are of Mesopotamian or Syrian origin, other items in the tomb might be too.

As in Egypt, lead antimonate combined with copper was used as a green pigment. In their lower lead concentrations and lead:antimony ratios the Tell al-Rimah greens resembled Ramesside glazes more than they did 18th Dynasty faience. Interestingly enough, one of the Ancient Mesopotamian glassmaking texts speaks of adding substances which have not been identified so far but which convert a blue glass into green; [28] Brill has surmised correctly that at

least one of the two has to be lead antimonate (ref.28, p.116). The black pigment in glass and faience consisted of ferruginous manganese of highly variable iron content. The $MnO:Fe_2O_3$ ratios in the glass and faience were 3:2 and over 6:1, respectively. [240]

Included in the collection analysed by Pollard was a black faience tube from a 25th century B.C. stratum at Kish. [240] This piece is of particular interest since it represents the only fully analysed example of Mesopotamian faience of the 3rd Millennium B.C. There was nothing unusual about the glaze, which was coloured by ferruginous manganese (5% MnO, and Fe_2O_3 below 1%), as were the black faience and glass from Tell al-Rimah.

We have been fortunate enough to have at our disposal E.V. Sayre's complete analyses of five glasses and a glazed brick from the Elamite city of Choga Zanbil. [24] Strictly speaking Elam was not a part of Mesopotamia, but is included in this discussion because for most of its history it was within the cultural orbit of southern Mesopotamia. The collection consisted of two white, two black and one blue glass, all dated to the 13th century B.C., and a blue glazed brick of the 19th-15th century B.C. The white glass was composed of a very pure soda-lime silicate material without any identifiable opacifier (Sb_2O_5 below 0.02%, SnO_2 below 0.002%). The blue glass contained less than 0.02% CoO and less than 0.04% MnO, so the colour was produced by copper and iron. Both of the black glasses owed their colour to reduced iron and not to manganese, since their iron oxide contents (0.87 and 0.68% , respectively) were far in excess of the trace amounts of manganese (0.04 and 0.02% MnO). None of the Elamite glasses contained much lead, the highest amount being 0.07% PbO in the blue glaze. Only one of the four had a detectable opacifier, 2.2% Sb_2O_5 in the blue glass, a figure close to the concentrations seen by Sayre in several other contemporary Mesopotamian glasses. [23]

In general the Choga Zanbil glasses are distinguished from Egyptian New Kingdom glasses and glazes by having lower concentrations of: lead, tin, manganese and copper, in the case of blues, and higher levels of iron in all colours, but particularly black. All glasses were of the high-magnesia high-potassia variety. [22,23] Although the complete analyses of these and some other South Mesopotamian glasses have not yet been published, a diagram comparing

the standard deviation ranges of a number of elements in these glasses with the corresponding ranges in Egyptian New Kingdom glasses has appeared. [22]

Included in Neumann's 1920's study of ancient glasses were two 14th century B.C. specimens of blue glass from Nippur. [20,21] One of them was turquoise-coloured and contained no cobalt or lead, but its copper was accompanied by some tin (2.6% CuO, 0.32% SnO_2). The tin:copper ratio was comparable to ratios in contemporary Egyptian copper blue faience (Fig. 12). The other, darker one, apparently made in imitation of lapis lazuli, was coloured by cobalt, which was accompanied by some manganese (0.93% CoO, 0.65% MnO). Since no nickel or zinc were reported, and the cobalt exceeded manganese, we doubt that the Nippur cobalt was derived from the same ore as the Egyptian. It is more likely that the cobalt and manganese found their way independently into the glass, and that Iran was the source of the cobalt as in the case of the Eridu piece discussed earlier. For example, another piece of contemporary cobalt blue glass from Nippur, analysed by Bertrand but mentioned in Neumann's report, contained 0.42% CoO and no manganese. [20,21]

Thus the pigments favoured by the faience factories of Kish, Nuzi and Tell al-Rimah were similar to the Egyptian ones. Until a larger number of Mesopotamian faience have been analysed, we will not know how similar or different the average concentrations are. In general, however, the concentrations of the principal components of the specimens analysed so far fall within the ranges observed in contemporary Egyptian faience of like colour. Two things, however, seem to set the Assyrian Tell al-Rimah faience apart from typical Egyptian faience of like colours—the absence of zinc in lead-containing glazes and the very much higher iron concentrations. For example, in three of the four green Tell al-Rimah glazes the Fe_2O_3 was in the 1.8-9% range, while the average for all New Kingdom greens was 0.5%, the same value as on the fourth Tell al-Rimah green glaze.

Unlike Egyptian glass and faience, about which we have much more information, we do not know whether in Mesopotamia the same pigment combinations were used for glass as for faience glazes, but the odds are that in most instances they were. Therefore, it is hard to believe that anything other than inadequate sampling is responsible for the fact that significant

amounts of cobalt have been reported in glasses, but hardly any in the fully analysed glazes. We might add that Dayton does report 0.01-0.1% CoO, but in a white glaze from Choga Zanbil. [6]

On the whole, as far as the principal colourants and their concentrations are concerned, the 2nd Millennium B.C. Mesopotamian glasses of all colours but black are not that different from contemporary Egyptian faience and glass. However, although in both regions cobalt, in conjunction with copper, was used to create indigo and dark blue colours, in New Kingdom faience and glass zinc, nickel, and manganese were its constant companions, in Mesopotamian glass they were not. Only manganese is encountered occasionally, but at highly variable concentrations in relation to cobalt.

The black glasses present us with some interesting problems. Until more analyses become available, we will not know whether manganese or reduced iron were the preferred pigments in 2nd Millennium B.C. Mesopotamian glasses. Present indications are that iron was. It is the dominant component in Nuzi and Choga Zanbil glasses, while manganese predominates in Tell al-Rimah glass, but not by much. As we have pointed out on numerous occasions, between the 1st and 26th Dynasties manganese reigned supreme in Egyptian black faience. However, the few reported analyses of New Kingdom black and amber glasses show more iron than manganese. For example, a black 18th Dynasty specimen analysed by Sayre contained 1.29% Fe_2O_3, 0.02% MnO, and no other pigment. [24] The discrepancy is less glaring in a fragment analysed by Neumann and Kotyga, 0.5% Fe_2O_3 and 0.3% MnO. [18,20] Consequently, if one compares the glasses only, Mesopotamian and Egyptian recipes for black were not that different.

Having pointed out some of the similarities and differences between Mesopotamian and Egyptian glasses and glazes of the 2nd Millennium B.C., we would like to return briefly to Oppenheim's suggestion that raw glass (cullet) was avidly sought by the Egyptians in Syria. [199] We find Oppenheim's philological arguments and readings of the pertinent Amarna letters very persuasive, since this early in the history of glassmaking a highly coloured glass could have been regarded as a "kind of precious stone" (ehlipakku and makku). [199] We can see how this could happen in the case of dark red, blue or green glasses, but what about colourless, white or yellow ?

Oppenheim also suggested that initially the glassmakers of Upper Syria might have been supplying glass to Mitanni and other parts of Mesopotamia as well. In that case the raw materials would all have had a common origin in northern Syria or south-eastern Turkey. We cannot with the present limited Mesopotamian data base distinguish the copper blues, but the cobalt blues analysed to date clearly indicate that different sources of cobalt have to be sought for the Egyptian and Mesopotamian brands of cobalt.

To this we must add the weight of our analytical and Brill's isotopic evidence, which leave little doubt that during the 2nd Millennium B.C. the two regions did not use the same lead, and lead is a very important constituent of many green and all yellow glasses. Brill himself, after expressing the opinion that: "...the $Pb_2Sb_2O_7$ yellow pigment was a commodity traded over considerable distances." (ref.28, p.119), concluded from his lead isotope studies that: "The results establish beyond reasonable question that the yellow pigments were manufactured at different places, the Egyptian in Egypt and the Mesopotamian elsewhere. ...So the yellow pigment itself was not--in this instance--an article of trade."[131]

Therefore Oppenheim may have been correct, but the amount of imported glass, especially the cobalt blue and the lead antimonate yellow, which was particularly popular on 18th Dynasty vessels, must have represented a small fraction of the total glass utilised by the Egyptian glassmakers, otherwise it would not have been so elusive. Maybe the imported glass was considered superior and used only for a few specially commissioned pieces that have so far escaped analysis. This would answer Oppenheim's rhetorical question: "How does it come that the Pharaoh is clamoring for the delivery of raw glass from Asia when Egypt, at the time, boasts of a wide array of beautifully made glass objects in Egyptian style, hence, made in Egypt?" (ref. 199, p.261).

An interesting by-product of Brill's investigation of the isotopic composition of lead extracted from Tell al-Rimah glasses was the discovery that one greenish specimen (Pb-410) contained lead of the same general class as the lead used 1000 years later in Ptolemaic (Pb-415) and Roman (Pb-417/419) glass from Egypt.[131,201] Brill's numerical designations of relevant samples are cited in the preceding sentence in parentheses. These leads and some

other leads from Palestinian glass of the Roman Period belonged to Brill's group E (see Fig.3 in ref. 201), which includes leads from Roman coins minted in Syria. This is further proof that the zinc-free lead used in Egypt during the second half of the 1st Millennium B.C. was probably not of local origin, but came from somewhere in western Asia. In case someone wonders about the same mine yielding lead for over 1000 years, we refer the reader to Brill's recent study of some Nimrud glasses, [206] in which he showed that another tight isotopic cluster contains leads from Nuzi, Tell al-Rimah and Nimrud spanning a period of over one millennium. Some of these lead deposits must have been very rich indeed.

Let us now examine the relevant analytical data on 1st Millennium B.C. material. Few complete faience or glass analyses have been published, and the lack of information is particularly acute for the first half of the millennium. Turner has published the composition of a few 8th century fragments from Nimrud. [67,158,159] However, the most interesting of Turner's original set, a sealing-wax red glass of high copper and lead content, originally thought to be of the 8th-6th century B.C., has been re-dated to after 220 B.C. [205,206] More recently, Brill has published the compostions of some 8th century B.C. fragments from Fort Shalmanaser, Nimrud. [206] Chemically the two sets of 8th-6th century Nimrud glasses are not very interesting, except for Brill's discovery that some of them have been painted in the past. Future investigators should carefully examine black glass and glazes to make sure that the colour is not caused by a surface coating of bitumen.

From our point of view, one of the more interesting pieces of information contained in recent publications of Brill has to do with the presence or absence of lead antimonate. What we find is that yellow glass coloured by $Pb_2Sb_2O_7$ was being manufactured, or at least available, between 1000 and 800 B.C. at Hasanlu (Persian Kurdistan), and during the 8th and 7th centuries at Nimrud. [201,206] What makes one wonder how close Hasanlu might have been to a good source of antimony is the fact that it is one of the few places in the Ancient Orient to have yielded a piece of very pure metallic antimony. Brill, who analysed the piece, states that the metal came from a stratum dated to ca. 850 B.C. (ref.28, p.118, n.15). Of course, that by the end of the 8th century B.C. Assyria, unlike Egypt, experienced no antimony shortage was made plain

when Turner published his analysis of a cake of opaque blue glass from the North West Palace at Nimrud dated to ca. 715 B.C. The glass contained 2.8% Sb_2O_5 but no lead. [67,158] Analyses of colourless glasses from Persepolis show that lead-free (PbO below 0.01%) antimony at concentrations between 1 and 3% Sb_2O_5 continued to be used during the Achaemenid times. [23,242] A lump of blue green glass from the same Nimrud spot as the red glass mentioned above, and consequently of Hellenistic date, contained an impressive 4.18% Sb_2O_5. [159] More recently, the abundance of antimony in Neo-Assyrian times was confirmed by Hedges and Moorey when they identified lead antimonate by X-ray diffraction as the yellow pigment on 8th century B.C. glazed bricks from Nineveh. [117] Such bricks were made by the thousands.

Antimony and lead (9.53% Sb_2O_5 and 2.63% PbO) were both present in one of the Fort Shalmanaser glasses. [206] No zinc was detected, and the lead belonged to an isotopic group which included 2nd Millennium B.C. glasses from Nuzi and Tell al-Rimah, as well as early 1st Millennium B.C. glasses from Hasanlu, and the Hellenistic red glass from Nimrud. [206] Sayre too, found lead and antimony combined in a 7th century B.C. opaque white Mesopotamian alabastron but at fairly low concentrations, 0.10% Sb_2O_5 and 0.11% PbO. [23]

For reasons that are not immediately apparent the Asian antimony was not reaching Egypt during the first few centuries of the 1st Millennium B.C., even during times when relations between Assyria and Egypt were still cordial (ref.208, pp.255,267,325-327). The intermittent warfare that raged over large parts of western Asia around the turn of the millennium must have played havoc with overland trade to the Levant ports, which at this time were Egypt's main link to Asia. [208,210] Maybe the substance remained scarce in Assyria, at least until the Assyrians overran Hasanlu and and other parts of Iran. The antimony might have been coming from regions of Anatolia, Iran or the Caucasus outside the reach of Assyrian power until the 8th century B.C.

During the 8th and 7th centuries, when we know antimony was available in Assyria, Egypt could have been the victim of an Assyrian trade embargo, as we suggested in Section 4 of this chapter. Such embargos were used by the Assyrians as a political weapon and are known to have been rigorously enforced in Levantine ports under Assyrian control, often to the great dissatisfaction

of the local merchants. [211] For example, Assyrian displeasure with Cyprus, because of the aid its king rendered to rebellious Tyre, resulted in an embargo on Syrian goods destined for the island. This embargo has been blamed for the sudden disappearance of North Syrian goods from Cypriote sites at the end of the Eighth century B.C. and the general isolation of the island during the Seventh. [243]

Neumann analysed six Seleucid Period glasses from Babylon dated to ca. 250 B.C. [20,21] No cobalt was found in the blue nor lead antimonate in the green, but glasses of both colours had abnormally high concentrations of manganese. The blue ones contained 1-2.8% MnO, the green ones 4.4-6.0%. Rarely have we seen Egyptian blue or green faience or glass of any period with that much manganese (see Fig. 1 and Table VII; to compare with Egyptian glass consult ref. 18-21). The discrepancy is particularly glaring when comparisons are made with contemporary Ptolemaic faience of Egypt. For example, among our Ptolemaic greens we found none with MnO above 1% and no blues had MnO above 1.2%. Whereas the manganese levels in Egyptian faience and glass are consistent with the use of MnO_2 as a decolourizer, [23] the extraordinary concentrations in the blue and green Babylonian glasses are difficult to understand.

There is at the present time no evidence that the practice of stabilizing the copper red by the addition of lead oxide had its origin prior to the 1st Millennium B.C. The earliest examples of such high-lead red glass, as far as we know, have been recovered from a 9th century B.C. site at Hasanlu and a 7th century spot at Nimrud. [28,201,206] The tradition was continued in Mesopotamia into Hellenistic times and the early examples differ from the late ones in their lead content. For example, a red Hasanlu glass contained only 3% PbO while the often mentioned Hellenistic Nimrud sealing-wax red had ca. 20% PbO. The 2nd century B.C. Ptolemaic red glasses from Elephantine had lower lead concentrations (1-6% PbO) than the contemporary Nimrud specimen, but the lead in the red components of Alexandrian mosaic plaques, dating from the 1st century B.C. to the 2nd century A.D., contained almost 30% PbO. [25,121] A record figure of 35% PbO has been reported for an Egyptian red glass of the Roman Period from Canopus. [20]

Neither the Ptolemaic nor the Seleucid high-lead glasses contained an zinc. One must remember that lead was not an important ingredient in the 2 Millennium B.C. red glasses coloured by copper, but in red faience coloured iron it was. Iron did remain the key ingredient in Egyptian red faience f another millennium but lead did not (see Fig. 17, Table XX).

In discussing the isotopic ratios of leads extracted from some of th 8th-7th century B.C. Nimrud glasses, Brill remarked that some of them ar very similar to what one finds in Sardinian and Spanish lead ores. [201,20] Recent evidence of Phoenician mining activities in the Rio Tinto area southern Spain, [244] where lead-antimony mineralisation has been reported prompted Brill to express an opinion with which we heartily concur and whic we quote below: "The fact that Phoenician miners might have been taking lea ore from Spain this early raises the possibility that some of this lead migh have found its way back to Syria or Egypt or elsewhere in the Easter Mediterranean and have become incorporated into the lead antimon pigments..."[201] To this we might add that the Maghreb area of North Afric (modern Morocco, Algeria and Tunisia), which contains rich deposits of lea and antimony, [44] was being colonised by the Phoenicians at about the sam time. [245] Maybe some of these Maghrebi ores were also being shipped East. Th thought had occurred to Dayton too. [6] What we need is some concrete evidenc that the Phoenicians and their Carthaginian descendants did work these min or were buying ore from native Berber miners.

We realised how fragmentary and inadequate is the present state o knowledge of 1st Millennium B.C. Mesopotamian faience and glass when w searched for information about the use of cobalt blue. None of the analyse discussed above mention the element. The two things that interested us wer 1. whether the substance was unavailable or scarce during certain centuries and if so, did the times coincide with periods of scarcity in Egypt; 2. whe cobalt is present what concentrations of elements such as aluminum, copper manganese, iron, nickel, and zinc accompany it and in what proportion. Dayto reports finding cobalt in some Assyrian and Neo-Babylonian faience, but th information has to be taken with a grain of salt, because of the 10-15% Co reported again, this time for a blue glaze from Susa. [6] First of all, such concentration is unheard of in the ancient world, and second, the glaze woul

ot have been blue but jet black! However, regardless of problems with
individual analyses, no meaningful elemental ratios can be computed from the
type of ranges used by Dayton and by Stone and Thomas. [3] Equally frustrating
are the letter designations used by Ritchie. For example, for a blue
"Egyptian" bead found in Persia Ritchie reports "trace" amounts of: Fe, Al, Ni
and Co, and no manganese. [246] Since the word "trace" can denote any detected
amount below 1%, the information is only marginally more useful than
qualitative analysis.

Some additional information on the cobalt-manganese relationship in First
Millennium B.C. Mesopotamia can be gleaned from Sayre's analyses of Late First
Millennium B.C. glasses from Susa. [23,24] The relative constancy of CoO and the
extent to which manganese and several other elements vary in the Susa glasses,
and in an early Parthian one from Babylon, are shown below. Sayre's specimen
Nos. are written after the recovery site.

T A B L E XXXIX

THE COLOURANTS IN SOME SELEUCID AND PARTHIAN COBALT BLUE GLASSES

%MnO	%Fe$_2$O$_3$	%CoO	%NiO	%CuO	Provenance
0.70	2.4	0.15	0.004	0.16	Susa, No. 203
1.29	2.1	0.19	0.012	0.071	Susa, No. 205
0.033	1.6	0.17	0.006	0.15	Susa, No. 204
0.065	4.2	0.18	0.004	0.14	Babylon, No. 946
0.012	0.89	0.13	0.003	0.011	Uncertain, No. 565

Susa glass samples 203 and 205 belong to the late Seleucid or early
Parthian Period, while No. 204 and the Babylonian glass were Parthian, of no
later date than the 1st century A.D. Glass No. 565 was a Late Mesopotamian
cylinder seal purchased in Iraq. [24] The data reinforced our conviction that in
Mesopotamian glasses of all periods, and Egyptian glasses and glazes of the
1st Millennium B.C., the highly variable amounts of manganese did not
originate in the cobalt ore. Specimen No. 204 also contained 0.37% ZnO, a
figure quite remarkable in the presence of so little copper and only 0.11%
PbO. [24]

Having that much zinc in proportion to the elements tabulated for Susa specimen No.204 is most unusual for a glass or faience glaze, Mesopotamian or Egyptian. However, Hedges and Moorey report finding equally puzzling elevated zinc concentrations in the majority of Parthian pottery glazes from Nineveh that they examined. [117] Some of those glazes also contained more tin and lead than could be justified by assuming that bronze scale had been used by the glaziers, but comparable excesses of the same two elements have at least been occasionally detected by us in some Egyptian faience. It is obvious that the zinc could not have originated in brass, but that a high-zinc mineral was being mixed with the glazing slurry by the Parthian potters, for reasons that escape us at the present time. It is not clear whether the practice was confined to a fixed geographical area, since pottery from other Mesopotamian sites of about the same time period contained zinc much less frequently. [117]

In the majority of Mesopotamian glasses and faience glazes lead correlates well with copper and antimony, and tin with copper. This only confirms, what has been suspected by many for a long time, [28] that the practice of using oxidised bronze and copper scrap as a source of copper blue pigment was widespread throughout the Ancient Near East.

8. Comparisons with Minoan and Mycenean Faience and Glass

We have decided to restrict our comparisons to East Mediterranean faience and glass of the 2nd Millennium B.C. for the following two reasons: no complete analyses of any pre-2nd Millennium B.C. faience from the area are known to us, and because of the maritime activities of the Phoenicians and Greeks, the 1st Millennium East Mediterranean faience is scattered over a very wide geographical area and the benefits of including all such faience in a book whose primary focus is Ancient Egypt are not commensurate with the effort. Moreover, the nature of contacts between Egypt and the Minoan and Mycenean worlds has many more intriguing and unanswered questions than does the subject of commercial activities during the First Millennium B.C.

For a general description of the surviving Aegean faience of the Bronze Age and a thorough stylistic analysis one should consult a recent book by K.P. Foster. [247] In a paper by Foster and Kaczmarczyk are to be found the analyses of just about the entire collection of the Minoan faience at the Ashmolean

Museum, [248] which has the largest assemblage of such material outside of Greece. The analysed faience ranged in age from Middle Minoan III to Late Minoan I, i.e., from the 17th century B.C. to ca. 1450 B.C. [249,250]

In contrast with almost any assemblage of Egyptian faience, the Knossos collection was remarkable for the virtual absence of blue glazes, which have only been observed on a few Cretan beads of uncertain provenance. Best represented were black, including many shades of grey, green, brown and white. No significant amount of cobalt was detected in any of the glazes; copper was the colourant in all the green and blue faience.

The black and grey faience have an interesting history. All of the Middle Minoan IIIA blacks were coloured by reduced iron virtually free of manganese (MnO below 0.1%), in sharp contrast with contemporary Egyptian faience. During the Middle Minoan IIIB iron is abruptly replaced by ferruginous manganese, which remains the black pigment of choice into the Late Minoan Period. [248] Was the change influenced by greater familiarity with Egyptian practices ? It is noteworthy that Minoan potters went on using the reduced iron technique on their clay ware. [37,251]

Between the MM IIIB and LM IA another interesting change takes place. Pyrolusite or manganite replaces the barium-rich psilomelane used in the MM IIIB pigments, as evidenced by the disappearance of barium from high-manganese faience. [248] At about the same time in Egypt barium also becomes much less common in glazes coloured by manganese. Are both the Cretans and the Egyptians employing pyrolusite from the same source, perhaps from the rich mines of the Sinai ?

The Cretan faience exhibits a greater range of grey and brown shadings than any collection of Egyptian faience seen by us. By manipulating the relative concentrations of copper, iron and manganese, the Minoan faience-makers created some wonderful shades of olive green and olive brown, greys and blacks. Red, seen only on MM IIIA fragments from the Town Mosaic, [247] was produced with fairly pure Fe_2O_3, without all the lead that accompanied similar Egyptian red faience of the 18th Dynasty.

Tin is seen infrequently and much of the lead turned out to be surface contamination. Equally uncommon is antimony in excess of 0.05% Sb_2O_5. It appears that during the MM III Period bronze scale was rarely used and lead antimonate was unknown or its merits unappreciated. However, if one accepts the current chronology for the Aegean which places the end of the Middle Minoan period at the beginning of the 18th Dynasty, [249,250] the low incidence and concentrations of lead antimonate do not look so strange, and the little that is found is ahead of comparable levels in Egyptian faience. In Egypt lead antimonate first shows up in green glazes at the time of Tuthmosis III, whereas the Temple Repository at Knossos has yielded a MM IIIB draughtboard (1938.542) covered with a green glaze containing 0.23% PbO and 0.06% Sb_2O_5. The few MM IIIB and LM I glazes that did contain tin had the element in the 0.1-0.2% concentration range and the ratios to copper were within the range expected from bronzes. The highest recorded lead levels (ca. 0.8% PbO) were recorded on a Late Minoan tile fragment, and no object had Sb_2O_5 in excess of 0.06%. [248]

A little less restrained but still on a modest scale was the use of antimony in Late Minoan glass analysed by Turner, who found 0.5% Sb_2O_5 in an opaque pale blue glass from Knossos dated to ca. 1400 B.C. [21] It contained no cobalt or lead and was not easily distinguishable from contemporary Egyptian copper blue glass. A comparable concentration of antimony was reported for a waz lily from a late 15th century B.C. Warrior Grave at Sellopoulo, near Knossos (LM IIIA). [252]

However, the same site has yielded some very strange "faience" and some interesting decayed glass. By "strange" we mean a specimen with 5% Sb_2O_5 and 31% CuO in the body and 1.5% and 26% of the two respective compounds in the glaze. [252] Alongside the objects mentioned above, there were glass beads containing more than 20% each of CaO and CuO, and even more surprisingly, in excess of 10% Sb_2O_5. X-ray diffraction showed that the antimony was in the form of $Ca_2Sb_2O_7$, a well-known opacifier in ancient glasses. [67,94] Knossos was not the only place to yield such high-antimony material. One of the investigators (R.E. Jones) had analysed about 20 pale yellow faience fragments from Cadogan's Royal Road excavation at Pyrgos and found among them one containing over 5% Sb_2O_5. The use of this much antimony suggests some wild

experimentation with a recently introduced new ingredient, for we know of no useful purpose that would be served by having that much of it. Wherever the Cretans obtained their antimony, their extravagance is unmatched in any 2nd Millennium B.C. glass or faience, Egyptian or Mesopotamian, analysed to date.

One must conclude that whatever the nature of Cretan-Egyptian contacts in the 2nd Millennium B.C., and the subject is prone to generate vigorous debate among scholars, the Middle Minoan faience-makers had their own cherished techniques which served them well. Except for the problematic matter of changed black colourant, compositions do not seem to mimic those of contemporary Egyptian or Mesopotamian faience. The basic ingredients were the same, but they were used in different combinations to produce the characteristic Minoan faience. Even after manganese replaced reduced iron, it was used to produce black and white inlays unlike any contemporary Egyptian or Mesopotamian seen by us. We must add that the Sellopoulo material although excavated on Crete bears little resemblance to any of the Minoan faience or glass analysed to date. As we will show below, it shows much greater affinity with Mycenean glass.

If the Tell al-Rimah faience investigated by Pollard and Moorey[240] represents a technical tradition of long standing, the Cretan change in the formulation of black faience could as easily have been stimulated by Mesopotamian techniques transmitted via the Levant as by Egyptian. However, if by adopting the new manganese-based formulations the Minoans were emulating the Egyptians, it is legitimate to ask how come the reduced iron was not abandonned earlier, during the Middle Kingdom, for example ? Even if the interpretation of Egyptian finds on Crete is treated with due caution, as suggested by Ward, [232] there still remains a substantial amount of evidence of contacts between the two countries during the 500 years preceding the change in colourants. Of course, if the Egyptian faiencemakers, like traditional craftsmen of all times, kept their recipes secret, the Minoans might simply not have learned what ingredients to use and how until the Hyksos times or the 18th Dynasty. Once they acquired the knowledge, it would have been only natural for them to use Egyptian manganese ore, psilomelane or pyrolusite, if the information had been obtained in Egypt.

The absence of cobalt from the Minoan specimens discussed above may be illusory, related to the fact that so few blue glazes have been analysed. It is difficult to see how the Minoans could have failed to get all the cobalt they needed in view of its abundance in Egypt, Mesopotamia and other Aegean sites. As early as the 19th century, X. Landerer reported the presence of cobalt in glass from Tiryns and Mycenae. [253]

More recently, Sayre has shown that cobalt of the same general type as that used in New Kingdom Egypt was employed in 13th century B.C. Mycenean glass. [22-24] The concentrations of elements normally associated with cobalt in contemporary Egyptian blue glass have been determined in several Mycenean glasses from Kakovatos (in Elis, near Pylos), Ialysos (Rhodes) and other sites, and the data are tabulated below. [22-24] Mycenean copper blue glasses are included for comparison.

--

T A B L E XL

THE COLOURANTS IN SOME 13TH C. B.C. MYCENEAN GLASSES

%Al_2O_3	%MnO	%Fe_2O_3	%CoO	%NiO	%CuO	%ZnO	Provenance
Cobalt Blue							
2.1	0.24	0.93	0.079	0.041	0.052	0.12	uncertain
3.2	0.35	1.62	0.120	0.068	0.091	0.14	Ialysos
2.8	0.42	1.15	0.170	0.083	0.182	0.14	Ialysos
Copper Blue							
0.55	0.026	0.42	0.0018	0.0058	1.51	0.018	Kakovatos
1.38	0.048	0.85	0.0087	0.0058	0.79	0.016	uncertain

--

The difference between the copper blue and cobalt blue is quite pronounced and is reminiscent of what we saw in Egyptian New Kingdom faience (Tables X and XI). The analyses leave no doubt as to which elements accompanied the cobalt. Diagrams illustrating some of the similarities between the Mycenean and Egyptian 2nd Millennium B.C. glasses have been published by Sayre and Smith, [22] and the resemblance is remarkable.

Neither lead nor antimony play an important role in the blue Mycenean glasses examined by Sayre, since the highest observed values of their

respective oxides were 0.078 and 0.76%. However, antimony oxide in the 1-3%
range, with hardly any lead, was detected by Sayre in a number of opaque white
glasses. [23] Tin is under-represented too; the differences between the copper
blue and cobalt blue glasses are minimal, since the entire range of reported
concentrations was 0.0027-0.0052%. [24] Such low tin levels are typical of
Egyptian cobalt blue faience, but far below what one observes in contemporary
Ramesside copper blue faience (Fig. 9 and 12). Of course, with only a handful
of analyses at our disposal we cannot judge whether bronze scale was or was
not used extensively in Mycenean workshops.

In the course of his analytical investigation of the Ashmolean Museum
holdings of Minoan faience A. Kaczmarczyk took the opportunity also to examine
a small collection of Mycenean glass from Thisbe (Boeotia) and several other
sites. [254] Most of the glass consisted of pale honey-coloured pendants
containing up to 2% Sb_2O_5 without lead. The over-all analyses indicated a
high-potassia (2-4% K_2O) glass with the customary calcium antimonate
opacifier. [93,94] Some of the pendants had protruding dark blue decorative
bosses coloured by ca. 0.2% CoO. As expected, the cobalt was accompanied by
all the other elements associated with it in 2nd Millennium B.C. Egyptian and
Mycenean faience and glass analysed to date. Some of the Thisbe pendants
could have been easily mistaken for faience, because the weathered glass
consisted of a thick iridescent layer over a darker somewhat granular core.
We could not help noticing that the Warrior Graves glass from Sellopoulo,
discussed earlier, shows great affinity with the Mycenean glass from Thisbe.
Therefore, the designation "Mycenean", often given to these graves, is quite
appropriate, since the glass and faience were undoubtedly made in Mycenean
workshops.

We had hoped that we might find additional concrete information on the
subject of Mycenean cobalt in the work of Dayton, who has taken great interest
in the problem of its provenance. Cobalt is indicated as present in a number
of Mycenean glasses and glazes listed in Dayton's book, [6] but the data have to
be treated as qualitative at best, for the following reason. At the 1980
Archaeometry Symposium in Paris Dayton presented an analysis purporting to be
that of a fragment of Mycenean cobalt blue glass (p. 58 of ref. 55b). At first
we were delighted to have an additional complete quantitative analysis of a

Mycenean glass, but on close inspection we discovered that the composition matched number for number a previously reported composition of the blue pigment on a decorated Egyptian clay pot from Thebes (see ref. 55a and p. 457 of ref. 6). No reasonable person can be expected to believe that twelve elements could end up having identical concentrations (to the first decimal place) in two such disparate materials as glass and pottery pigment. One cannot help but worry about similar oversights among the very many numbers in the book.

Before we leave the subject of Dayton's researches on cobalt, we must admit that the arguments used by the author to trace the ore to the Bohemian Erzgebirge are unconvincing, since they do not fully take into account all the correlations observed in Egyptian and Mycenean glass and faience. Thus antimony and bismuth are important and manganese is not in supporting Dayton's arguments, as articulated at several Archaeometry Symposia and in written works. [6,55] Yet our and Sayre's data reveal that bismuth is hardly ever seen above bare trace levels while antimony shows absolutely no correlation with cobalt. Since, some glazes containing cobalt also contain lead, and the latter is often correlated with antimony, an apparent Co-Sb correlation could be adduced at first glance. However, if one examines only high-cobalt low-lead glazes, of which we have many examples in Appendix C, there is absolutely no correlation between antimony and cobalt. Moreover, the 18th Dynasty pigment alluded to above and which was used by Dayton in support of his thesis, [55] must represent an exceptional if not unique specimen, if one is to believe recent measurements of Noll and other investigators. [51-53] The spectra reproduced in their publications show very plainly that the MnO:CoO ratios are more than an order of magnitude greater than the percentages obtained by Dayton for pottery from the same site (Malkata palace) would indicate. [55]

From the little data available at the moment one must conclude that the Bronze Age Aegean faience-makers probably obtained their cobalt from the same source as the Egyptians, but the source cannot be pinpointed at the moment with any degree of certainty. All of the many correlations will have to be satisfied by a single ore deposit, if the latter is to be accepted as the true source. Of course, it is quite possible that the mine containing that particular cobalt was exhausted by the end of the 2nd Millennium B.C., and

therefore finding the source will be that much more difficult. Such depletion would help explain why during the 1st Millennium the Egyptians had to turn to the same or similar source of cobalt as the one that has been supplying Mesopotamia for millennia. The German mines to which Dayton traced his cobalt still have plenty of ore in them.

We will now turn our attention briefly to Bronze Age Cyprus. Because of its geographical location, Cyprus has been exposed throughout its history to Syrian and Anatolian influences of varying degrees of intensity. However, the degree of contact with the more remote Egypt has been a matter of considerable controversy for a long time. For this reason Cypriote faience in which Egyptian characteristics are detected is of great interest to archaeologists, since such material might have been made locally in imitation of Egyptian objects, and maybe even by resident Egyptian craftsmen. On the other hand the object could have come from Egypt or been the product of the Egyptianising industries in the Levant. This question arose in connection with some very fine faience vessels excavated at Kition. The glazed wares from the site were dealt with by Peltenburg in an appendix to the excavation report. [255] In addition to a thorough description of the objects, the appendix contains some analytical data obtained by McKerrell, who proceeded to draw parallels between the Cypriote ware and Egyptian New Kingdom faience. [255] It is this latter subject that we wish to treat in the next few paragraphs.

Since our manganese, cobalt, and nickel analyses compare so closely with the published data for Egyptian glass of the same colour and period, we feel we have a fairly clear picture of the pigments in regular use during the second half of the 2nd Millennium B.C., and so we are at a loss to explain the unusual composition of blue-grey glazes and black decorations on certain faience vessels excavated at Kition, but said to be of Egyptian origin. [255] The objects in question (nos. 14, 20, and 22 on pp. 110-116 of ref. 255) are blue-grey and decorated in black. The black decorations are said to consist of an iron-nickel oxide pigment, and the blue-grey is said to be the result of mixing the black pigment with copper oxide (ref. 255, p. 113). H. McKerrell, who performed the analyses and wrote the technical notes, alludes several times to the composition of most of the objects discussed in the article, but gives partial analytical data for two objects only: a presumed Egyptian

pilgrim flask (no. 14) and a Levanto-Egyptian conical rhyton (Special Series no. 1). The reported composition is unlike anything we have ever seen in Egyptian faience of any period. The unusual features of the blue glaze are: very low manganese content (MnO below 0.01%), very high nickel content (0.2% NiO) in the complete absence of cobalt, and an unusually low CuO concentration (0.5%) for the presumed period (14-13th c. B.C.). We do not know whether cobalt was actually absent, or whether it was simply not reported. If an adequate amount of CoO were to be found the analyses would not seem so unusual.

We have analysed about a dozen blue 19th Dynasty faience vessels from Medinet Ghurab and some other Egyptian objects of the type explicitly mentioned by Peltenburg (ref. 255, p. 130) and have found that none of them even remotely resemble in composition the Kition vessels. It is unfortunate that no quantitative analytical data for any contemporary Egyptian object of known provenance are included in the publication, since the attribution of the above-mentioned Kition vessels to an Egyptian source relies too heavily on some rather vague statements (ref. 155, pp. 117 and 132) that the same peculiar mixture of CuO-NiO-FeO was used in the blue-grey glaze of a British Museum bowl (B.M.4796) bearing the names of Ramesses II.

The author was well aware of how atypical of Egypt such a pigment is, as is attested by the frequent use of words such as: "somewhat unusual", "quite unusual", and "peculiar" with reference to the pigment. Yet, by the end of the article, it is taken for granted that the pigment was invented in Egypt, as the following quotes demonstrate: "At least by the time of Ramesses II, therefore, a thickly applied blue-grey glaze with particular colour qualities was developed in Egypt...", and "The development of the highly distinctive copper-iron/nickel grey glaze in Egypt may well have resulted from the more extensive application of brown-black line drawing which tended to supplant dark blues after ca. 1350 B.C." (ref. 255, pp. 133, 138). The conclusions may well be correct, and we have no quarrel with the stylistic arguments, but the limited technical evidence presented to date can not be used to support the argument. In our opinion, even if the analyses of the Kition vessels and the Ramesses bowl are confirmed, it is premature to argue that the characteristic nickel-rich glaze was developed in Egypt, until a reasonable number of

undisputably Egyptian faience glazes have been shown to contain the same peculiar pigment.

If future analyses should confirm the existence of a number of glazes coloured by a pigment composed principally of iron, nickel and copper oxides, we should be quite pleased. Such a discovery would eliminate one nagging question: how come the copper-nickel-iron ore from Abu Seyal, a site exploited during the Middle and New Kingdoms, has not been detected in any of the faience or glass analysed to date ? Allowing that most of the copper was extracted on the site or in the general vicinity, we still find it hard to believe that some crude ore was not at one time or another shipped north to Egypt. The thought that it might have ended up on a faience vessel in Cyprus is very intriguing.

A suitable way to conclude this section is with a brief commentary on the subject of polychrome faience. Having analysed a moderate number of polychrome fragments from Knossos and having seen many others in musea, we are as full of admiration for the artistry of Minoan faience-makers as anyone else. However, in our opinion, unless one dismisses tricolour faience as not true examples of polychromy, the claims often made that polychrome faience made its first appearance on Crete[6,256] are contradicted by the evidence available from Egypt. Three-colour combinations, most often white, green and black or brown, are not uncommon on Archaic and Old Kingdom faience. As an example of Archaic trichromy we can point to a model vase (E.35) from Abydos which has a twisted pattern of white, green and black bands. Moreover, the technique of inlaying a glaze of one colour into a background of another, which according to Peltenburg was: "directly inspired by glass working",[256] and therefore unknown in Egypt before the 15th century B.C., was used successfully on a hieroglyphic tile (E.1172) from the First Dynasty tomb of king Djet at Abydos, and on many decorative tiles from the Sixth Dynasty temple at Abydos. When one considers that the Knossos Town Mosaic dates from the 18th century B.C.,at the earliest, the greater antiquity of Egyptian polychrome objects must be apparent to all.

That the Minoan polychrome faience tiles are in many respects esthetically more pleasing most observers will concede, but such

considerations have no bearing on the matter of priority of invention. Besides, the fact that polychrome faience was made in Egypt long before it appeared on Crete in no way detracts from the achievements of the Minoan faience-makers, whose artistic inspiration owes little to Egypt. The colour combinations and shade gradations on the Town Mosaic, for example, are unlike anything we have seen on contemporary or earlier Egyptian faience.

We are aware, of course, that because of insufficient data we might be underestimating the contributions of Asian factories to the development of polychrome faience. According to Peltenburg, who refers to unpublished data, the earliest Asian polychrome faience comes from a 15th-14th century B.C. stratum at Alalakh. [256] Future excavations could drastically alter our views of the development of Asian polychrome faience.

APPENDICES

APPENDIX A:
THE MANUFACTURE OF FAIENCE

by

Pamela Vandiver

1. INTRODUCTION

The technology of Egyptian faience was studied in order to characterize the diversity of manufacturing techniques and to understand the chronological sequence of technological development. A survey of 700 Egyptian faience objects from Predynastic to early Roman times was undertaken using collections at the Ashmolean Museum and supplemented by objects from the Boston Museum of Fine Arts and University College (London). The results of this survey of the forming and glazing of faience are summarized in Table XLI.

The problem of glazing was of prime interest during the initial stages of this study. Three different methods of producing glazes have been described: application of a fine particled slurry which forms a glaze during firing (Petrie, Reisner, Lucas)[136,257,1], glazing by the firing and melting of efflorescent salts which accumulated during drying (Binns, Noble)[8,7], and the cementation or slow roasting of the faience body material in a glazing powder (Kieffer and Allibert, Wulff)[9,10]. These three methods of glazing are shown in Figure 23 and discussed in section 6 of this appendix. I wanted to find examples of each of these methods and determine how their distributions changed with time. Laboratory studies replicating each of these three methods of glazing were conducted, and the external morphology of these objects was studied with a binocular microscope (Figure 24). A set of criteria for each of the glazing methods was established, and museum objects were compared with these criteria. A few fragments from museum

TABLE XLI. SUMMARY OF FAIENCE STUDY AT THE ASHMOLEAN MUSEUM

PERIOD	BODY MANUFACTURE	GLAZE PROCESS	FACTORY EVIDENCE	NUMBER OF SAMPLES EXAMINED	SITES SURVEYED
PREDYNASTIC PERIOD (4000-2900 B.C.)	Modeling a Shape to be Ground Surface Scraping and Grinding Drilling of Holes Free Form Modeling (rare)	Experimental Period: Results Inconclusive as to Method: Application (set forth by Beck and Petrie) Cementation? Efflorescence Unlikely	None	55 Faience 125 Glazed Stone	Naqada, Badari, El Amrah, Mitmar, Harageh, Abadiya, Gerza
PROTODYNASTIC (2920-2649), OLD KINGDOM (2649-2150), AND FIRST INTERMEDIATE PERIOD (2150-2040)	Modeling Surface Scraping and Grinding Drilling Holes Painting with a Slurry Layering (rare) Forming on a Core (rare) Marbleizing (rare) Molding at Saqqara?	Efflorescence (Binns, Noble)	None	128 Faience	Hierakonpolis, Abydos, Saqqara, Hammamiya, Mahasna, Qau, Matmar, El Kab, Armant
MIDDLE KINGDOM (2134-1783) AND SECOND INTERMEDIATE (1783-1550)	Modeling Surface Finishing Molding on a Form Forming on a Core Marbleizing Painting with a Slurry or Pigment Wash Piercing and Drilling Holes Incising, Inlaying, Resisting (rare)	Efflorescence (Binns, Noble) Cementation (Kieffer and Allibert) Application as a Liquid (Reisner)	Kerma (late)	229 Faience	Abydos, Kerma, El Kab, Haraga, Beni Hasan, Mustagidda

PERIOD	BODY MANUFACTURE	GLAZE PROCESS	FACTORY EVIDENCE	NUMBER OF SAMPLES EXAMINED	SITES SURVEYED
NEW KINGDOM (1550–1070)	Molding on a Form Molding into Open Face Molds Forming over a Core Joining of Molded Parts with Slurry of Body Material Layering Incising Inlaying with Slurry of Body Material and Colorant Painting with Pigment Wash Holes Added as Loops, Other Methods Rare Throwing (?)	Efflorescence (Binns, Noble) Finely Powdered Glass Added to Body as Inlay (Kuhne) Cementation (Kieffer and Allibert) Application as a Liquid	Tell el-Amarna, Lisht	232 Faience	Amarna, Abydos, Serabit el-Khadim, Yahudiya, Lahun, Nabesha, Medinet Ghurob, Akhmim
LATER PERIODS: THIRD INTERMEDIATE (1070–657), LATE PERIOD (664–332) PTOLEMAIC (332–30)	All of New Kingdom Techniques and Throwing	Application as a Liquid Efflorescence	Memphis, Naucratis	105 Faience	Memphis, Abydos, Thebes, Giza, Matmar, Saqqara

Note: 50 glazed stone objects examined from periods other than Predynastic.

objects were then destructively, analyzed along with the
replications, by electron microprobe, scanning electron
microscope with simultaneous energy dispersive x-ray analysis and
x-ray diffracton in order to explain and precise the low power
microscopic observations (Table XLII). The results of this study
show that glazing technology changed with time, contrary to what
is often stated about the conservative nature of Egyptian
technology.

Following an initial period of experimentation with the
forming and glazing of beads and amulets in a variety of
materials during the Predynastic Periods of the fourth
millennium, one method of glazing, the heating of effloresced
salts, became the established means of producing faience during
the Protodynastic, Old Kingdom and First Intermediate Periods in
the third millennium B.C. During the Middle Kingdom, a variety
of glazing methods was used including efflorescence, application
and, to a lesser extent, cementation. During the New Kingdom,
all methods are used (occasionally one finds them all used
together on one object) and in addition powdered glasses in a
variety of colors are added to the glazes. Finally, during the
later periods, all techniques are represented, with application
probably becoming the major technique during Roman times.

The study of glazing techniques was my main interest in this
project, but the primary reason that I was invited by Roger
Moorey and Alex Kaczmarczyk to participate was to examine those
objects which gave unexpected or anomalous results when analyzed
by x-ray fluorescence. This gave me an opportunity to see the
great variation in objects catalogued as faience. This variation
is in some instances truly quite amazing. In other instances,
materials were mislabeled, or a variety of restoration treatments
had been applied ranging from plaster, varnish and paint to
various adhesives. A surprising number of the faience objects
had high concentrations of MgO, and examination showed them to be
glazed soft stone, steatite and others. During one period of
study, the Ashmolean Museum's collection of forty-five
predynastic faience beads was eliminated because it consisted of

mislabeled glazed steatite. Many other glazed stone objects had been identified as faience as well, and for this reason, part of this study of faience manufacture became the study of glazed stones and the means to differentiate them from faience. During the process of attempting to separate various glass coated materials, including some high in calcium phosphate, definitions of various materials became very important. For this reason, I have tried in the first part of this appendix to present definitions based on technological criteria of the various types of ceramic materials used by Egyptians during the time period under discussion. The definitions are based on morphology and evidence of manufacture. Following the definitions, the problem of differentiating glazed stones such as steatite is addressed at some length. Because the majority of predynastic glazed objects are steatite or similar soft stone, I believe that a consideration of glazing technology is incomplete without a study of steatite. Because glazed steatite has not been studied since the 1930's (H. C. Beck's study of predynastic beads, or F.A. Bannister and H.J. Plenderleith's study of New Kingdom glazed steatite)[258,259], I felt it relevant to include questions and problems which arose during what is only a preliminary examination.

Because of the nature of the information desired, fragmentary remains were considered of first quality, and whole objects unless chipped were relegated to minor status. The study of artifacts proceeded in chronological order. Both of these factors led to the third, and probably most fruitful, problem studied, that is the diversity and development of manufacturing techniques. That predynastic and protodynastic faience and glazed steatite were studied first, led to the conclusion that early faience technology was derivative of lithic technology and that faience was used to imitate shapes of objects in other materials, such as shells (a group of such shells is U.C. 5021, grave 661, Naqada II), as well as other materials, such as lapis and turquoise. These other materials were available only on a small scale in limited quantity. The advantage of faience was

that objects could be produced on a relatively large scale, such
as wall tiles and inlays, as well as in quantity at relative low
cost. Sufficient raw materials were locally available. Thus,
the elaboration of ways in which the faience bodies were formed
became a prime goal of this study. The interpretation of those
groups of external characteristics found by examining objects at
the Ashmolean Museum during parts of three summers was
interspersed with studies aimed at replication carried out during
the school year.

The conclusions highlight some of the concerns of craftsmen
working within a framework of a traditional craft specialty, as
well as those parameters important to the initial development and
those factors which persevered through the long development of
the tradition of Egyptian faience. For example, the array of
different processes carried out on a variety of materials during
predynastic times indicates beadmaker's concerns involved the
physico-chemical experimentation necessary to repeatedly produce
artificial blue-green beads. First, beads and amulets, flaked
and ground from stone, were made to look blue, like turquoise and
lapis, by glazing. Then semiprecious stones were imitated in
such easily modeled materials as wetted, crushed stone, possibly
the deboutage from a grinding operation, and then fired with a
glaze. The recognition of the potential use of the residue of a
grinding process and the coupling of such residue with glaze
firing is the basis of faience making. The iron-bearing clays or
marl clays common in Egypt may have been tried but failed to
produce a suitable color when glazed. Replications fire a dull
blue-green to brown when translucent and, when opaque, the color
is a bright blue but lacks the depth and brilliance of much
Egyptian faience. By the Old Kingdom, the method of modeled and
ground faience predominates over glazed soft stones. The process
is well understood, and the main thrust of experimentation
appears to be toward making larger objects fulfilling new
functions and toward developing a repertoire of techniques for
the manipulation of the body material. The method of glazing is
established as efflorescence. The faience grave goods of each

regnal period seem to embody a special character, either because of new uses or new visual effects or new techniques for faience production. Developments in glaze technology characterize the Middle Kingdom as brighter colored, more durable glazes are produced. The development of cementation glazing probably occurred at this time. Cementation and the occasional use of application glazing necessitated changes in the way the chemical composition characteristic of faience is compounded as well as a refined knowledge of processes carried out during heat treatment. During the New Kingdom, there is evidence of close ties between faience and glass technology, mainly related to the development of color, as colored glasses and pigments are added to faience. Many techniques were employed on single objects to meet practical and aesthetic criteria. The same variety of techniques is found in the later periods as was used during the New Kingdom, though in the service of different aesthetic ideals. Generally, techniques are not combined in a single object during the later periods. The organization of production is extensive during the New Kingdom and later periods. During the later periods faience manufacture probably caters to a wider range of social strata as can be argued by the great numbers of shawabtis produced and the great variation in craftsmanship.

In summary, once the best method of producing artificial stone was found, the early development persisted through years of technological modification and elaboration, but the principal process remained modeled and molded powdered quartz or sand mixed with small amounts of the oxides of sodium, calcium and copper. One must also emphasize the conservative nature of glazing methods in that the efflorescent method of glazing persisted throughout this time span as a means of producing a brilliant, durable glaze with good color quality.

Following is a brief outline of the text which follows:

I. Introduction, scope of work, outline
II. Egyptian Ceramic Production in General: Definitions
 A. Ceramic Types found in Egypt, 4500B.C.-A.D.40
 1. Clay-based ceramics, pottery
 2. Egyptian faience
 3. Glass

 4. Glazed stone
 5. Egyptian blue, frit
 6. Glassy faience
 B. Chronological Development
 1. Predynastic Period: basic materials developments of pottery, glazed stone, Egyptian blue, faience; faience used for beads and amulets; relation of faience to lithic technology;
 2. Protodynastic and Old Kingdom: development of faience for sculpture, wall reliefs and tiles; faience technology established as modeling and grinding of body and glazing by efflorescence
 3. Middle Kingdom: changes in faience processing and glaze technology to incorporate all three glazing methods; molding technology introduced
 4. New Kingdom: glass, faience color palette increases; glass introduced into faience bodies
 5. Late Periods: incorporation of pottery technology into faience industry

III. Morphology of Egyptian Siliceous Ceramics
 A. Homogeneous Structures: glass, Egyptian blue,
 B. Layered Structures: faience, glazed stone

IV. Processing Technology of Egyptian Siliceous Ceramics
 A. Glassmaking process
 B. Ceramic processes
 C. Powder processes
 D. Multiple processes

V. The Manufacture of Faience Bodies
 A. Composition and previous studies
 B. Differences in body color
 C. Working properties of body
 D. Techniques of body manufacture; their change with time

VI. The Glazing and Firing of Faience
 A. Application of glaze
 B. Self glazing
 1. Development during drying of coating which fires to become glaze: efflorescent method
 2. Deposition during firing from surrounding powder; cementation method of glazing
 C. The composition of the glaze

VII. Methods of Examination
 A. Plan of work
 B. Optical microscopy
 C. Scanning electron microscopy
 D. Microprobe analysis

VIII. Examination of Pre- Old Kingdom Glazed Steatite
 A. Bead manufacture
 B. Morphology

2. EGYPTIAN CERAMICS IN GENERAL: DEFINITIONS

Description of Ceramic Types: Many types of ceramics were produced in Egypt between 4000 B.C. and 30 B.C.; Egyptian faience is one of these. The other types are Egyptian blue, glassy faience, glass, glazed stone and clay-based ceramics. The study of Egyptian ceramics involves a large and diverse corpus of objects with technological traditions approximately 6000 years old. Both the student of Egyptian ceramics and the museum visitor encounter considerable difficulty in understanding the nature and variety of materials and methods of their manufacture. Considerable effort has been expended by researchers in attempts to explain the variety and complexity of Egyptian ceramics, as surveyed in this appendix. Common to each of the ceramic types listed above is a technology which involves the selection and manipulation of natural, inorganic, polycrystalline materials and

their irreversible heat treatment in order to form durable, rocklike materials.

If clay-based ceramics and glazed stones are excluded from the group, then Egyptian ceramic production can be characterized as the heat treatment of specific natural materials which, when fired to temperatures ranging from 800 to 1000°C., form the oxides of sodium, calcium, and silicon (Kieffer, Noble, Binns, Chase, Saleh, Wulff)[9,7,8,30,97,10]. Generally, these ceramic materials are referred to as soda-lime-silicates. In contrast, glazed stones usually are composed of either magnesium silicates, such as steatite or serpentine, or silicates, such as flint, chert, quartz, or quartzite, which frequently contain iron as an impurity. (Clay is an alumino-silicate composition.)

The raw materials from which the soda-lime-silicates are formed consist of finely ground quartz, calcite lime and a mixture of alkalies. Sources of the more refractory silica materials include quartz pebbles, sand, and sandstone (Lucas, Reisner)[1,257]. Feldspar is present only in trace quantities (Kieffer)[9]. Alumina is unintentional and introduced with the silica materials. The prime source of alkali is natron, which is gathered from low lying desert areas where evaporation of flood or rain water has left a residue of sodium salts in the form of carbonates, sulfates and chlorides (Lucas)[1]. Another possible source of fluxing oxides is plant ash which depending on the soil composition in which the plants grew may be rich in sodium or potassium (Brill)[28]. The calcite lime may be an intentional addition or may be introduced with the sand (Lucas, Turner)[1,21]. Magnesium oxide may be introduced as an impurity in the lime or as dolomitic limestone. Dolomite does not seem to have been added to Egyptian faience, although it is present in some Near Eastern faience (Vandiver)[238]. These three groups of raw materials, the alkalies (Na_2O, K_2O), alkaline earths (CaO, MgO) and refractory constituents (SiO_2, Al_2O_3), when combined in different proportions and fired to a limited range of temperatures, form ceramic materials with a wide range of properties.

Chronological Development: Glazed stone, clay-based ceramics, Egyptian blue and faience were developed during predynastic or early dynastic times and represent an uninterrupted tradition established long before the Middle Kingdom (Petrie, Stone)[136,3]. In the early palette of ceramic colors, blue and green objects are most common. White objects are rare. During the Old Kingdom, small areas of the blue and green objects were decorated with small areas of brown, black or violet. These consist predominantly of mixtures containing manganese dioxide and iron oxide. The technology of faience is applied to new types of objects and to their production on a grand scale. During the Middle Kingdom, the range of objects broadens, and the technology of body manufacture becomes more diversified and refined. The cementation method of glazing can first be documented at this time. All of the techniques of body and glaze manufacture used in the manufacture of faience during the New Kingdom are prefigured in objects from the Middle Kingdom with one exception. During the New Kingdom, glass is added to the traditional composition in order to produce a wider range of colors. Glass vessels first appear; glass is introduced as a raw material in faience bodies, and the color range of the ceramic palette is enlarged to include the common occurrence of colors found in the early glasses, including red, yellow, light green and opaque white (Petrie)[136]. There are also indications that during the New Kingdom, higher flux contents or occasionally higher firing temperatures were achieved. The maximum firing temperature was still near 1000°C. In the later periods, the technology remains the same but is used in the service of changing aesthetic ideals, until the Ptolemaic times when pottery techniques are introduced.

In summary, the early chemical technology required to glaze solid stones, the predynastic development of sintering and glazing synthetic conglomerates, the change in glazing processes during the Middle Kingdom as well as the extended color range of New Kingdom ceramics and the application of glass technology to faience production are all tangible aspects of change in Egyptian

understanding of the physical and chemical properties of ceramic materials, whether or not these changes represent indigenous developments. In addition, other more subtle changes in technology occurred. In order to recognize the various ceramic types, two different criteria can be employed: (1) the identification of physical structure or (2) the identification of those traits indicative of manipulation of that structure, that is the processing technology (Kingery)[260].

3. MORPHOLOGY OF EGYPTIAN SILICEOUS CERAMICS

Homogeneous Structures: The first approach is to describe the visual appearance and the fine scale structure of the end products. For instance, the cross section of a broken object may appear by low power microscope homogeneous in texture or may reveal a multiple layer structure in which a surface layer coats an interior body of a different composition and structure. Glass is an example of an homogeneous, noncrystalline material at low power. On the finer scale of a high power microscope, such heterogeneities as bubbles, striations caused by incompletely mixed raw materials, unmelted stones or lumps of raw material, crystalline precipitates or second phase glasses, as well as random unintentional additions from crucible or furnace become apparent in a glass. Egyptian blue is another example of homogeneity at low magnification, but this material, in contrast to glass, is polycrystalline and composed of numerous fine, platey particles sintered or fused at the edges by heating. On a finer scale, unreacted raw materials, impurities, inclusions and porosity of both intergranular and spherical nature become apparent. The fine intergranular porosity is caused by voids between packed particles; whereas, the larger spherical pores are the result of air bubbles or burned out carbonaceous material. In order to understand the morphology of these silicate products, a study of the degree of homogeneity on many scales of magnification must be undertaken. For the purpose of this

appendix, the low magnification definition of glass and Egyptian blue as homogeneous will be used.

Layered Structures: The cross sections of Egyptian faience, glazed stone and many clay-based ceramics exhibit a layered structure when viewed with a low power microscope. Glassy faience is the least well characterized of the Egyptian soda-lime-silicates. It either may or may not have a surface glaze layer (Noble)[7], and in general is considered to have very little void space and less homogeneity than a glass. The layered structures of faience, glazed stone and some pottery can be composed of (1) simply a body with glaze coating, (called ordinary faience by Lucas), or (2) there may be an additional, intermediate layer between body and glaze of a different material or structure (called variant A by Lucas)[1]. For example, off-white colored faience bodies often have a layer of fine white quartz particles below the glaze. A glaze is defined as any glassy coating melted onto a ceramic body. Glazes are often confused with other types of coatings which are not melted as a glass coating, yet may contain small amounts of glass (Shepard)[261a]. Slips or engobes are suspensions of fine clay particles applied to clay-based ceramics prior to firing, often being rubbed or burnished to consolidate the surface (Parmelee)[261b]. Slips when fired contain a minor glassy fraction, but they are not glazes in the sense of being glassy coatings. Those coatings generally referred to as paints, stains or pigments are either organic or inorganic, but do not contain clay binders[261b]. Pigments, paints, and stains, in practice, may be applied either before or after firing, although paint is usually reserved for coatings applied after firing. Slips and paints (or pigments) are difficult to differentiate by external morphology, but require careful interpretation of composition and microstructure, as they may contain a wide range of crystalline and glassy phases.

A glaze can be applied to solid materials such as stone or to conglomerates of fine particles such as faience, clay or ground stone. Glaze-body interaction zones large enough to see

with a low power microscope can be caused by many factors, among which are the intergrowth of a crystalline phase at the boundary, a fluid glaze composition wetting and penetrating the body, hastened by high temperature or long soaking time near or at peak temperature, or slow drying of a salt-rich porous body in which incomplete efflorescence of the soluble salts on the surface leads to a gradient of salt deposition in the body. The appearances of the last two types of interaction zones are similar in that the fraction of glaze will decrease with distance into the body interior. Other indications, such as body hardness and appearance of the glaze, can be used to differentiate these two cases. There are examples of each of these three interaction zones in Egyptian soda-lime-silicate ceramics. These glaze-body interaction zones should not be confused with the presence of intentionally added layers of fine body material applied between the body and the glaze.

From the Middle Kingdom onwards, the presence of an intermediate body layer in faience which resembles the body in color and texture more than the glaze is quite common, examples from the Protodynastic and Old Kingdom are rare. Figures 32a and 33f show examples of two layered bodies. A thin layer measuring 1-8 mm. of fine white quartz particles located between the glaze and body often is observed to be whiter or lighter in color than the interior and usually is composed of finer particles. The function of this layer has been attributed variously: to enhancing the reflectivity and color intensity of the glaze by providing a white opaque background for the glaze (Noble)[7], to the need to extend limited supplies of pure white quartz which had been collected and ground in a labor intensive practice (Reisner)[257], to the use of finely ground particles to promote better fusion of the surface and thus to increase the strength and longevity of the object, and to provide an even surface for decoration or use as a tile (Kuhne)[2].

This intermediate layer can be the result of three different phenomena, so far as we know. This layer can be formed firstly by the intentional application of a white coating more finely

ground than the interior body. The largest particles observed in the coating are often an order of magnitude smaller than the largest observed in the body, (for example, body particle 1 mm. and layer particle 0.1 mm.). Both color and particle size differentiate a layer so applied. Secondly, this layer can be formed experimentally by modelling a simple shape and by applying sufficient compression so that water and finer particles are drawn to the surface and larger particles are moved into the interior. Here, there is no color difference between the interior and exterior, only a particle size difference, and no extra layer has been added intentionally. Thirdly, an intermediate layer lighter in color can be the result of oxidation in the surface layer of added organic matter and incomplete oxidation of the interior. The transition of color is not related to a change in particle size, but is a function of time, temperature and atmosphere during heat treatment. In other words, this layer was not applied to the body by the faience makers, and there should be no size distinction among particles in the two areas. The type of layer found in Egyptian faience is almost entirely of the first type, a fine, usually white, intentionally added layer beneath the glaze.

4. PROCESSING TECHNOLOGY OF EGYPTIAN SILICEOUS CERAMICS

A second criterion used to differentiate ceramic types is to describe the processing technology employed to form the objects. With archaeological ceramics, the subtle richness and variety of manipulation directly available to the ethnographic observer is lost, and only the meager outline of a craft or workshop can be inferred by repeated recognition of marks, imprints or traits in the objects which draw an accurate picture of techniques but without the richness of context. Examples of such traits are fingerprints or indentations, mold marks, scraped or ground grooves, coils or bits of faience used to join preformed parts, kiln setter marks or areas if adherent powder.

Examples of process reconstruction are, for instance, derived
from the dryness of the body which can be judged by observation
of the texture of the surface; when very wet, the body material
is pastey in appearance even after firing (Figure 39c), and when
too dry, it cracks easily when manipulated (Figure 37f). This
method of reconstruction is appropriate to an understanding of
how particular artifacts are made, but falls short of explaining
the workings of a craft technology. Knowledge of workshop
remains, often referred to as manufacturing elements, such as
fragments, wasters, kilns and other material of technological
importance is necessary, but, in addition, the parameters of
material processes and those used by the particular craftsmen in
question must be established and understood by physical and
chemical analysis in order to build from the manufacture of
individual objects, and their replication, to an understanding of
the craft.

Three types of processes are used in the manufacture of
Egyptian siliceous ceramics. In a glassmaking process, an object
is formed from a molten mass and cooled slowly in order to
prevent cracking, or a glass is melted, quenched and ground to be
used as a raw material in another process. In a ceramic process,
like the manufacture of clay-based ceramics, a fine powder is
mixed with water and formed by extending the plastic mass as one
would shape or mold dough. When dry, the newly formed shape is
hardened by firing. In powder processing, the emphasis is placed
on grinding one or more coarse raw materials to a limited range
of finer particle sizes. These particles are then sintered
together to form a new, coherent polycrystalline substance.

In attempting to investigate the process technology of
Egyptian ceramics, a combination of these processes is often
found. For instance, faience body materials are prepared as
powders by grinding, as evidenced in the angular quartz grains
found in Figure 40f. There is a possibility of using range of
grain size as one of the identifying traits to characterize the
production of certain periods or workshops. The powdered raw
materials are then wetted and plastically formed, dried and

fired, according to ceramic practice. The glaze in certain instances during the New Kingdom and later periods is premelted as a glass, powdered and applied to the surface of the body or mixed together with the body to promote color formation or adhesion of the crushed quartz (Kuhne)[2], adhering to glassmaking practice. Another example of the use of several types of processing to produce an object is Egyptian blue. Egyptian blue can be defined restrictively as a particular mineral, cuprorivaite ($CuO-CaO-4SiO_2$), made by calcining or heating the raw materials quartz, malachite and calcite and a minor amount of alkali to a lower temperature than required for complete fusion so that platey, hexagonal crystals are precipitated by solid state reaction or crystallization from a melt around quartz grains (Chase, Saleh, Tite, Bayer)[30,97,31,262]. In this case, the primary technology is powder processing and the resultant product can be scraped or carved to shape or can be used as a pigment when ground. Russell reported evidence of such grinding of Egyptian blue as a pigment at Amarna[263]. In addition, this powdered pigment often in combination with other materials such as crushed quartz, calcite and water can be formed plastically into objects which are then fired. To form such objects, a ceramic process analogous to that of faience manufacture is employed with the exception that there is no glaze layer on Egyptian blue objects.

Another forming process frequently is observed in Egyptian siliceous ceramics. Following the initial wet forming of faience, a process of surface reduction was carried out in which the surface was shaped by scraping when the object was almost leather hard, or rarely when dry. The result of scraping the surface was to create sculptural detail, to incise an inscription, to form a channel into which a different color faience could be inlaid, or to reveal the white body as the background in a relief. Such alteration of the surface of an object is indicated by scratches visible under a low power microscope or by undercuts present in a molded object. Scraping of the surface involves the elimination or plucking of grains

which are very loosely adhered. A distinction should be made between scraping the surface of faience body material and abraiding a glassy surface by rubbing it with a harder material. The details in faience, glassy faience and Egyptian blue objects were formed by such scraping prior to firing. The body surface of Egyptian blue and glass faience is generally harder than the interior, better sintered, and occasionally has a thin, glassy surface. Reduced reflectance from the surface of a glass or glaze or the occurrence of open- sharp-edged bubbles at the surface serve as evidence of abrasion.

5. THE MANUFACTURE OF FAIENCE BODIES

An extensive literature has accumulated in attempts to explain the processing of Egyptian faience. The principal methods of study have been visual examination of many objects, chemical analysis, and finally the attempted replication of processes capable of duplicating the Egyptian results. Such studies began with Russell[263] in the 1890's and Burton[264] at the turn of the century, and were continued by Binns, Beck, and Lucas in the 1930's, and more recently by Kieffer, Noble, Wulff, Kuhne, Aspinall, and Stone[9,7,10,2,4,3]. As analytical tools and the understanding of ceramic processes have developed, the knowledge of ancient materials has become more extensive and precise. However, understanding of the basic composition of faience has remained fairly constant. Analysis of the bodies of Egyptian faience have shown about 92-99% silica, 1-5% lime, and 0-5% soda, with lesser amounts of Al_2O_3, Fe_2O_3, MgO, and CuO. Lucas[1] experimented with various means of binding the finely ground quartz during forming and firing, and found that using only clay or organic gums or lime was insufficient. Using alkalies in the form of natron (impure soda ash, Na_2CO_3) or plant ash (where the principal flux is usually potash, K_2CO_3) as binders produced suitable results. Organic gums in minor amounts succeeded in improving the wet working characteristics, but not the fired

strength.

Researchers have observed the body often times is tinted rather than being completely white. These departures in body color from white occur in the range of blue, green, purple, brown, grey or tan. The first three of these tints usually are caused by glassy particles in the body on the order of 0.05 to 0.1 mm. Occasionally, one observes a highly fired or fluxed body in which the glass coats the quartz with the appearance of an overall tint. The blue, green and purple tints can be attributed to incomplete efflorescence of the glaze, to overfiring or to the recycling of fired faience failures. During the New Kingdom, these and colors, such as yellow, yellow-green and red, can be attributed to the intentional addition of powdered glass (Kuhne)[2]. The blue and green bodies are both colored by copper oxides. The differences are caused by two possibilities, neither of which is related to differences in technique of manufacture or chemical composition. The blue color of copper can be changed to green by slight reduction during firing or by time at high temperature. Weathering also may be a factor as blue glass weathers or corrodes to light green. The brown, grey and tan tints can be caused by additions of iron-containing sands to the body or by incomplete combustion of organic additives. The incomplete combustion of organic matter can be related to the presence of fine black carbon particles or large pores (Stone, Beck)[3,258]. These large pores are probably the result of air pockets entrained during mixing, similar to those found in clay bodies. Occasionally, residual impressions of seeds can be found in some body cross sections, although their presence is rare.

Body color provided the basis of the typology proposed by Lucas[1] in which seven variants are proposed: A, faience with an extra layer; B, black faience; C, red faience; D, faience with a hard blue or green body; E, glassy faience; G, variants with clay in the body and/or lead glazes. This typology permits easy visual distinctions by differences in color, density or luster, appropriate to field sorting during excavation, but this criteria does not follow either divisions which are based on stylistic or

technological criteria. For instance, the hard blue and green bodies, colored by CuO, Lucas suggests are formed by an intentional addition of powdered glass or alkaline flux. However, these dense bodies may be formed if faience is overfired to 975-1050°C. The color change is caused by high copper vapor pressure at peak temperature within the glass encapsulated body. Among the tiles excavated by Reisner at Kerma are examples of tiles with the same shape but having varying degrees of hardness and tint. Some of these tiles would certainly classify as variant D. The visual differences are believed to be caused by variation in firing temperature as no difference can be found in body composition (Vandiver)[266]. The category of hard bodied faience is distinguishable from Lucas' category of ordinary faience, but hard bodied faience is not distinct from ordinary faience. Lucas' categories allow visual discrimination but do not relate to differences in technology or style. Likewise, the distinction between black and red faience variants as containing greater or lesser amounts of iron oxide, respectively, does not separate them into distinct categories, and ignores the role of manganese.

An example of these categories obscuring potential technological relationships is Lucas' definition of glassy faience (variant E) as a body having the approximate composition of ordinary faience but being higher in alkalies, alkaline earth and copper oxide constituents. This is chemically similar to Lucas' definition of variant D, hard blue and green bodies, as having added flux or powdered glass. The distinction which Lucas makes is one of microstructure; the glassy faience being continuous and homogeneous, whereas the hard blue and green faience is porous and layered with glaze over body. Even though these two materials, hard bodied faience and glassy faience, are visually distinguishable, their separation into variants D and E probably conceals a technological continuum, although far from proven. Fine grinding a faience body with extra crushed glass or the raw materials of the glaze, followed by firing to the high end of the firing range yields a material similar in visual

appearance to glassy faience. Only the destructive analysis of minute quantities of glassy faience will demonstrate the validity of such a connection. What is necessary to replace the categories of Lucas is a grouping based on stylistic analysis using manufacturing techniques, chemical composition, microstructure and phase analysis as well as the more familiar criteria of art historical method so that similar types of artifacts can be grouped, so that long and short term artistic and technological changes can be characterized and understood within a cultural framework.

In addition to understanding the fairly limited range of chemical composition and the variation in body color, an appreciation of the working properties of faience is necessary to an understanding of manufacture. Unlike fine, platey particles of clay which slide over one another to plastically extend a form, the angular particles of quartz seen represented in Figure 40f are difficult to form when wetted, even when gums or alkalies are added. Noble has observed that the gritty paste slumps and will not hold a shape if it is too wet, and that if too dry, the material cracks and crumbles. Kieffer has noted that the material is thixotropic, that is if flow has begun it will continue. Many objects modeled by hand, such as spherical beads, have an oval cross section and a flattened side where they were set to dry (Figure 37e,f). If pressed vigorously this material will resist flow until it yields and cracks. Faience bodies generally crack if pushed too vigorously into a mold, their low yield strength being exceeded with very limited plastic deformation.

Techniques used in the manufacture of faience change with period, as listed in Table XLI. Modeling, scraping, and grinding are the techniques of manufacture most widely used in earlier times, as represented in Predynastic and Protodynastic faience. Predynastic bead manufacture employs lithic technology, a general form is modeled, then holes are drilled from 2 sides more often than 1 side, and beads are rounded by grinding to shape (Figure 28a,b; Figure 29a). Only a limited amount of extension of the

faience body is possible. Thus the blocky form of early faience may be an indication of the way the material behaves when modeled within its limits (that is, without cracking) and when ground during drying. If the scraping and grinding is carried out during the drying process in a stage just before or at the state which is usually referred to as the leather hard condition in pottery, then the during the subsequent period of drying an alkaline layer is effloresced on the surface which during firing forms part of the glaze. From the Middle Kingdom, molding (Figure 36a,c) and forming on a core (Figure 36a,b) were employed; intermediate layers are also common (Figure 38c). The occasional marbleized appearance of faience resulted from the working of two different colored faience bodies together so that a uniform wetness made them adhere and model as if one body (Figure 36d, left). Other Middle Kingdom examples show that a similar effect was achieved by painting a pattern with a dark colored slurry of body material and colorant onto the lighter colored body material (Figure 36d, right). Late in the period, incising, inlaying and resisting appear. During the New Kingdom, the techniques of incising and inlaying were used to a far greater extent, and frequently modeling and molding are used together in the same object, such as finger rings, beads and amulets. During this study of the Ashmolean collection, very few objects from the later periods and one from the New Kingdom were documented which were turned on a wheel in the manner of pottery. Both Reisner[25] and Kieffer[9] state that wheel turning is a method used in the manufacture of faience vessels. Due to the limited plasticity of the body, throwing is extremely difficult. One might expect to find a rise in the quantity of wheel thrown faience as clay is added to increase plasticity of the body, which culminates in the quartz, clay, and glass frit bodies of Islamic times.

Alternatives to throwing and modeling are a wide variety of molding techniques. In indentifying molding as the method of manufacture, the type of mold can usually be determined. Three broad categories of molds are used in ceramics. There are two

kinds of single piece molds: an open face or female mold, a
cavity into which a lump or layer of faience is placed, and a
convex or male mold around which faience is formed. These two
types of molds are really extensions of how the hand can be held
to support the body while it is being shaped: a cupped hand is
similar to an open face mold, and one or more fingers held
together or a fist is similar to a convex mold. Each of these
molds must be shaped so that the faience can be released from the
mold; that is, the walls of the mold cannot have undercuts or
parallel sides, but must be inclined and open to view. In other
words, the mold must have an angle of draft. If not, the form is
called a core and is burned out during firing or removed after
firing. A third type of mold is a piece mold; that is, the
complexity of the object or the need to form an interior and
exterior surface simultaneously require that the mold be composed
or two or more pieces. This type of mold is difficult to use
when forming a small object in a pastelike material because the
material must be pressed into the mold. Piece molds are not
commonly used in the forming of ceramic bodies until the advent
of slip casting when the body material is altered by the addition
of water to flow like a liquid.

Petrie collected several thousand small one-piece, open
face, earthenware clay molds for amulets and beads at Tell
el-Amarna, some with faience material still attached (Figure
39a)[266,136]. Faience paste would have been pressed into these
porous molds, released immediately and set aside to dry prior to
firing. Firing faience in a mold, as has been suggested many
times, would result, when cooling had occurred, in the fusion of
the object to the mold by means of the glaze. During drying no
alkaline salts would effloresce on the surface of the faience in
contact with the mold. All evaporation would occur on the back
side. Thus no glaze could be formed by firing an effloresced
coating in a mold. If one hypothesizes that the glaze was
applied to the molded object, then the object must have been
removed from the mold. No glazed objects adhered to molds have
been reported. Molding was completed by a finishing operation,

or several molded parts were joined with a slurry (Figure 36c), and then the surface was finished. The back side of some amulets were carefully scraped to insure the fully three-dimensional character of the small sculpture (Figure 39d,f).

Often beads for collars were molded in such open face, female molds as found by Petrie (Figure 39a). Prefabricated loops were attached to the molded faience shape in order to form holes (Figure 39b,c). The loops, still slightly moist, were attached with a slurry of paste onto the back of the bead. In using such molds there is no need for parting agents. Experimental work has shown the molds can be used directly wet or dry. If the molds were used dry, then the least possible amount of water was contained in the paste-like body material, or the porous earthenware mold would have drawn water out of the paste and adhered the faience paste to the mold. Not a lot of extension is possible without cracking of the paste. Some of the amulets do have small cracks in the body where the greatest amount of extension would have occurred. If the mold was used in a wetted condition, the water would have to have fully penetrated the earthenware clay, or water from the faience would have been drawn into the mold. No residue or layer of water could have remained on the surface, or the surface of the body would have become so pastey or sticky that the body would not have separated from the mold. In general, when both mold and paste are "equally" wet, so no flow of water occurs, then the two materials will separate easily. A greater extension without cracking seems to be possible with the mold wet than when dry. The mold can be used rapidly many times before rewetting is required.

In about fifteen minutes to an hour, depending on the temperature, humidity, air flow, and water content of the body, a white efflorescent salt forms on the outer convex edges of the body where the fastest rate of drying has occurred, in other words in greatest surface to volume ratio. With time, a layer is formed over the entire surface where evaporation has occurred, but not where the body has rested during drying as no evaporation occurs on this surface. Just as the white, efflorescent layer

appears on the faience body, a layer can also deposit on the mold. Wetting the mold will remove the efflorescent coating of salt which has not separated from a mold. Soaking and scrubbing removes residual body material. With use, the detail in the molds deteriorates, which may be the reason some molds were discarded. The reference made by Petrie to the existence in the Amarna midden of molds "choked" with paste may be a reference either to the efflorescent coating or to such errors as the lack of mold separation from paste as described above. In investigating some of the Amarna molds, foreign materials such as plaster and oil-based clays were encountered. These materials are probably the result of impressions made since excavation.

In addition to the use of the open-face, female molds cited above, evidence of the use of single piece, male molds is common, although no such molds have been found. The molding of vessels over fingers or a core, which is removed prior to firing or which burns out during firing, has been concluded by inspection of the interior vessel surfaces (Figures 31b,c,d,e,f,q,s,t,v and 36b,c) Residual imprints indicate that ball of straw or textile occasionally may have served as a core. A sand-filled cloth bag has also been proposed as a core by Reisner[257,p. 115]. Occasionally two molded halves of a sphere or other shape were joined together with a glue-like slurry of faience which squeezed out of the joint, as shown in Figure 36c from Kerma or in a cucumber-shaped bottle from Sedment, Dynasty 19-20[265]. The exterior was smoothed or ground, leaving no trace of the joint. The occasional uneven wall thickness and faceting of the bottom of open bowls during the New Kingdom supports the contention that they were molded over a simple convex mold, as shown in Figures 36a and 40n. Molding and joining forms such as tubes and bowls to make long necked, bulbous base vessels is found in the New Kingdom (B.M.F.A. No. 09.376, shown as no. 149, p. 148 of Ref. 265).

A slurry of body material with more than the usual quantity of water was used to model beads and form inlays. The thinness of certain vessel walls and tubular beads with no joint seams has

led to the proposition that forming over armatures or cores was performed by dipping the core into a thick, thixotropic slurry of faience (Kieffer)[9]. The slurry consisted of the same faience body material but with a greater addition of water. The coarser quartz particles encountered in body fabrics, in general, are excluded from such slurry mixtures. This same slurry when mixed with a colorant was used for surface decoration. Surface decoration consisted of painting a wash or slurry, or incising and inlaying lines or areas with faience of a different color, as shown in Figure 40a,c,e. The initial wetness of the inlaid slurry varied from piece to piece. During drying, body shrinkage of about 5-12% (linear drying shrinkage) occurs. If an inlay is added once drying of the body has begun, then the inlay will shrink away from the initial body leaving a parting line around the inlay. This greater shrinkage of the inlay may also be a function of finer particle size of the slurry as well as the greater dryness of the preformed base faience. During the Amarna and Ramesside periods, this linear division was intentionally used as a decorative element to outline and separate the inlay with an indented, dark-appearing line. There are also examples of decoration with a thick slurry of faience mixed with pigment used in combination with thin pigment washes as in Figure 40g,h.

6. THE GLAZING AND FIRING OF FAIENCE

Three different techniques have been proposed to account for the glaze on faience, as shown in Figures 23 and 24. The glaze can be applied to the body as mixture of various powdered raw materials with water. The glaze can also be deposited on the surface of the body during drying in the form of efflorescent salts which, when fired, melt and flux quartz particles at the surface of the body to form a glaze. In addition, the residual alkaline salts remaining in the interior of the body serve to promote the formation of glass between the quartz particles and thus to cohere, or sinter, the body into a fairly hard but still

porous mass. Alternatively, the glaze may be deposited on the body surfaces during firing from an enveloping powder which is later removed. The glaze tends to soak into the body sintering the quartz particles. Several combinations of these three glazing techniques are possible. For instance, a body with effloresced salts on the surface may be placed in a glazing powder.

Application: The first technique to be considered is the application of a glaze slurry, consisting of a mixture of water with a fine grain powder. The glaze can be applied by dipping the dried object, or by pouring or painting the slurry onto the body (Figure 23). The powder may consist of raw materials, such as quartz, calcite and natron, which have been mixed and/or ground together or raw materials which have been prepared either wholly or in part by fritting, that is, by a process of firing involving sintering or melting, followed by quenching and pounding or grinding in order to achieve a fine particle size. When the glaze is applied to the dried body, the porous body absorbs water from the glaze leaving a fine, powdery coating which melts during firing. The thickness of the glaze before firing depends on the porosity of the body and the water content of the slurry. The unfired glaze layer is thicker if the body is more porous or drier or if the glaze slurry contains less water.

The external characteristics of an applied glaze consist of uneven application such as drips or flow lines (Figure 37d). These drips or flow lines occasionally run in directions other than the base upon which the object was placed during firing. The glaze may end at a distinct line (Figure 25d and 38b) which would facilitate handling during glaze application, and which would mean that the object could not adhere to the kiln support after firing, as there would be no solidified glaze serving to glue the body to the kiln support. H. C. Beck describes the earliest application of glazes as occurring on stone beads[258]. He also states that the application of only an alkali will achieve a glaze on quartz, but not steatite. No comment is made about the durability of such a glaze. However, the importance of

Beck's comments is that a bead with a moistened surface could be dipped into one or more powders, or a dry bead into one or more slurries. The process of applying a glaze probably involved very different processes during the Predynastic Period, as compared with the later periods, when remains from the Memphis clearly demonstrate that fritted or premelted glazes, common to pottery technology, were used in faience manufacture.

With this application technique of glazing, the extent of the glaze-body interaction zone and the hardness of the body are not characteristic of the process. With the other two glazing processes, these two criteria can be characteristic of the process. In an applied glaze, a sharp boundary and soft friable body are likely to be produced after firing if the object is heated to the lower end of the range of glaze melting, below about 900°C., and/or when the content of flux in the glaze is in the 1-5% range. As the firing temperature and/or flux content of the body is increased the extent of glassy phase formed in the body increases, the body appears harder and grains do not spall, or detach from the body, when it is touched or rubbed. A thick glaze-body interaction zone and hard, nonfriable body are formed if the flux content and/or temperature are high or the time at peak temperature is long. Replications show that approximate bounds for the development of a thick glaze-body interaction layer are flux content (combined sodium and potassium oxide concentration) greater than about 10% and/or firing above 950°C. Higher firing temperatures and flux concentrations cause the glaze to soak into the body, obscuring the boundary, and lead to formation of an interaction zone between glaze and body, and to a thin layer of glaze.

In determining whether a glaze has been applied as a slurry, it is important to access firing temperature and flux concentration. The flux content can be exactly and destructively determined by atomic absorption or microprobe, or roughly estimated from the XRF data (potassium is given and sodium can be roughly estimated by difference). The firing temperature can be approximated directly by removing a small sample of glaze and

reheating it or by analyzing a small sample of the body by x-ray diffraction in order to determine the presence of crystobalite, a high temperature form of quartz. The firing temperature can also be roughly accessed by examination of external morphology. Kieffer has stated that lower temperature firing conditions are met by the faience, mainly from the Middle and New Kingdoms, he has studied in the following way[9]. He did not find crystobalite in ancient objects of faience, nor did he find crystobalite in replications of faience fired to below 920°C. Replications fired above 920°C. contained crystobalite. However, the flux content of his replications is not precisely given. Increased flux content will, of course, decrease the melting temperature of the glaze, providing more glassy phase. Crystobalite crystallizes at the quartz-glass boundary in a reconstructive transformation which requires overcoming a barrier to nucleation and growth (Kingery)[268]. Thus the presence of crystobalite in faience provides an indication of firing temperature but should not be used quantitatively without understanding.

External morphology of the glaze can be used to differentiate high from low firing temperatures, given a known flux content. The existence in the glaze of pinholes, crawling and fire-polished or rounded edges, rough glaze surface (Figures 25a,b and 32a), and in the body of friable, easily spalled grains and low MOHS or scratch hardness are morphological evidence of low firing temperature and/or low flux content (Figure 32c). A thin layer of glaze or flow of the glaze leading to a thickening of the glaze in the lower parts of the body compared to the top are common in overfired, well fluxed glazes (Figure 25d), as are the flow lines on the tile shown in Figure 38a. In addition, drips of glaze may flow from the lower edge of the glaze. Such glaze flow is in one direction only as it is caused by gravity and can be used to indicate the orientation of an object during firing. Egyptian faience objects, in general, are particularly free of indications of molten glaze flow.

Factory or Workshop Evidence: The application of a glaze is insufficient to explain the appearance of many faience objects

which have an overall layer of glaze with no trace of marks lef
by kiln supports. Direct information about the glazing proces
does not exist. There is a lack of carefully documente
archaeological evidence as to the nature of faience factor
sites. Petrie reports finding two workshops or factories, a
Tell-el-Amarna[136,267] and Naucratis[220]. Lucas reports larg
numbers of molds found in the palace area of Amenhotep III and a
Qantir from Dynasties 19-20. Naucratis is described in differen
sources as a scarab maker's workshop and as a faience factory[163
p.3].

In the Tell el-Amarna factory remains, circular, presumabl
domed, furnaces measuring two to three feet across were found[136]
Crucibles were placed on inverted pots and quartz pebbles. Th
fired quartz pebbles were coated on one side with materia
resembling Egyptian blue, and some with overfired clay remains
Petrie's description, W.E.S. Turner's study of the crucibles[2]
and the presence of blue frit on quartz pebbles and in crucible
demonstrates that these furnaces may have been used for th
preparation of frit and glass, and possibly not for the firing o
faience. On the other hand, the furnaces may have been used fo
many different firing operations. Until analyses show otherwise
possibilities which cannot discounted are that this frit might b
an addition to either the glazing powder or faience body. Th
quartz pebbles may have been used to line the furnace or may hav
been heated to insure ease of fracture. Glass-containin
crucibles, studied by Turner, indicate glass making was practice
at the site[21]. Petrie, however, definitely maintains th
existence of faience kilns at Amarna. Knowing the placement o
these various activities in the craft complex at Amarna woul
yield valuable information on the inter-relationships of th
various soda-lime-silica pyrotechnical arts.

Also from the New Kingdom and found near the South Pyrami
at Lisht are similar remains including a similar kiln about thre
feet across, quartz pebbles, furnace refractory and glassy sla
(Bourriau)[269]. Kerma, active during the Second Intermediat
Period, has also been described as a factory site, although m

actory remains have been located, with the exception of one
aster (Lacovara)[270].

Remains of the first century B.C. Kom Qalana kilns at
emphis indicate that glaze raw materials were formed as small,
oughly spherical lumps measuring about 1 cm. in diameter and set
n a crucible for calcining, a low temperature firing.
resumably these lumps were ground, mixed with water and applied
s a glaze slurry. A small sample was ground and fired to 950°C.
o yield a glaze. Their overall composition is the same as the
laze, according to XRF. In addition, kiln wasters in the form
f overfired faience vessels adhering to clay setters or supports
nd furnace remains have been preserved. Petrie described Roman
aience kilns as 8 feet square with an arch for the introduction
f fuel on the windward side. This represents a different scale
f production than the earlier furnaces from Amarna and Lisht.
n addition, Kieffer has brought to attention a very revealing
xample of glazing methods indicating cementation may have been
racticed at Fustat[9]. In summary, there is a considerable amount
f factory material but better context is needed to evaluate the
lace of these remains within the manufacturing process and even
o state for sure to which soda-lime-silica technology they
elong and thus how the soda-lime-silicate technologies relate to
ne another.

Self Glazing by Efflorescence: With such a lack of
etailed evidence about manufacturing processes, two other
ngenious methods of glazing have been proposed. These have been
termed self-glazing in order to distinguish them from the
pplication process (Binns, Kieffer)[8,9]. In one of these, the
method being called efflorescent in this paper and proposed by
inns and later studied by Noble[7], water soluble alkaline salts
such as sodium (and to a lesser extent, potassium) carbonates,
sulfates, and chlorides in the form of natron or ash, migrate
during drying from the body to the surface by capillary action as
water evaporates from the surface. During drying, the alkalies
effloresce, or precipitate, as salts on the surface. A white
crusty layer forms on the surface within half an hour of forming.

During firing, this alkaline layer melts to fuse with the fine quartz, copper oxide and lime, and gradually to dissolve the surfaces of quartz particles. A replication of this process is shown in Figure 24c,d). A parallel for this deposition process, which would have been observed by Egyptians, is the collection of efflorescent sodium salts by evaporation in low lying areas following periodic flooding.

During drying, efflorescent salts cannot form where there is no evaporation, and therefore objects glazed by this process should have no glaze where they rested during drying (Figures 24d or 32b). At the edge of the glaze, there is a gradual decrease in thickness (Figure 25c). In other words, objects should exhibit drying marks unless they were carefully turned over during drying. If turned, these objects often display an unevenness in the glaze at the air-support junction. Once the object is completely dry, the salt layer is extremely brittle and will crack or delaminate and peel if handled (Figure 25a). Evidence of open cracks in the which have the same appearance as fissures formed by cracking of the salt layer during prefiring handling are common on ancient faience objects (Figure 32a).

In areas where there is a small surface to volume ratio, as in concave or inner surfaces of an object, the rate of deposition is slow compared to regions of high surface to volume ratio, such as convex curvatures or outer surfaces (Figure 37b). Surfaces exposed to greater flow of air exhibit greater salt deposition, as sketched in Figure 23. Therefore, the thickness of the glaze is a function of local drying rate, as drying conditions and particle size range of the body remain constant. In addition, the layer of glaze often gradually changes thickness from inner to outer surfaces and where the base of the object has touched a drying support (Figures 24c and 37b). This gradual change in thickness tends not to occur if a glaze has been applied or achieved by the cementation method. If the drying rate is rapid as would be expected in a warm climate, then there is a sharp transition between the effloresced alkaline glaze constituents and the interior of the body (Figure 24f). When fired in the

lower temperature range, this same transition from sintered body to glaze should be apparent in the finished object. However, overfiring produces a gradual transition as discussed above because the glaze wets and soaks into the body. In general, one finds a viscous, low fired glaze coupled with the small interaction zone and friable body (Figures 24f,h; 29b, or 41d,e,f). An increase in flux content makes the glaze more fluid, thus giving a larger interaction layer and harder body (unless corrosion has progressed). An increase in temperature gives a larger interaction layer and harder body.

During firing, the faience is placed on setters or a supporting material. These supports can be expected to leave marks where glaze has formed and joined the body to the supports (Figures 24d, 25a, 29a lower bead, 37e, 43b upper shawabti). Often times, the supports have been broken away leaving a rough, raised surface. If an effloresced glazed object is placed on a nonwetting support then there will be no firing marks and confusion with the cementation process may occur, unless other criteria such as drying marks can be found. Kieffer reports another criterion which may distinguish the efflorescent and cementation methods of glazing[9]. He states that the efflorescent method does not produce sufficient chemical resistance of the glaze to acid attack as does the cementation method. Our experience with replication studies has not confirmed this observation. Acid resistance seems to relate more to state of preservation than to method of glazing. In summary, although the efflorescence method is reasonable to account for objects with evidence of drying and firing marks and a low temperature glaze with small interaction zone and fairly hard body, it is insufficient to explain an object totally covered by a glaze and having no residual kiln support marks.

Self Glazing by Cementation: A third method has been proposed by Kieffer[9] and by Wulff[10] in which the unglazed, dried faience object is placed in a powder which, upon heating, partially melts to form a glaze on the surface of the object. The low melting alkalies presumably draw away from the mixture of

calcium oxide and charcoal and wet the quartz. After firing, the friable, unreacted powder is removed from the object to reveal an even coating of glaze all over the object, as shown in Figure 24a. The powder may be applied wet or dry around the faience object, according to Kieffer's and our studies. The glazing powder is composed of CaO, ash, silica, charcoal and colorant according to Wulff, and $CaCO_3$ (50-75%), bauxite 0-20%, niter 15-25% (chiefly potassium nitrate), CuO frit 0-12% or $CaCO_3$ (5-28%), SiO_2 (20-36%), Na_2CO_3 (12-23%) according to Kieffer. Our studies show that a wide range of compositions will work as long as the powder is porous, contains lime, soda and copper (in chloride, oxide or carbonate form). Wulff's study documents the contemporary use of this process of employing a self glazing powder for the production of blue donkey beads in Qom, Iran; whereas, Kieffer's study deals with the examination of many ancient faience objects, primarily of New Kingdom date, now at the Louvre and their replication and comparison at the Sevres National Ceramic Factory.

Cementation Replication Studies: Kieffer postulates that the mechanism of glaze deposition is a complex process in which alkaline salts in the vapor phase react at the interface of body and enveloping powder, that is, at the interface of alkaline earth and silica at a temperature between 800 and $1000^{\circ}C$. The alkalies can come from the body as effloresced salts or from the enveloping powder. The alkali reacts at the surface of the silica particles to form a glass. Presumably, when this glaze which acts essentially like a high silica soda-lime-silica glass is formed, the molten or liquid glass wets the body in the process of formation and draws away by surface tension from the lime and charcoal-rich enveloping powder. Kieffer states that a quantity of silica in the glazing powder enhances this reaction and gives better results. In other words, glass may form in the powder. There are many unexplained aspects of this glazing process, not the least of which is the role of the lime which is present both in the final glaze as well as in the glazing powder.

The beads from Qom are bright blue, have no drying or firing

marks, an all over glaze, a large interaction zone between the glaze and body and a fairly friable, soft body, similar to the replication shown in Figure 24a,e,g). In some examples, the glaze is thicker on what would have been the underside during firing. This thicker glaze is evidence of flow. The underside may also have marks from the glazing powder upon which the bead rested, and occasionally there are bits of embedded powder or quartz in the glaze (Figure 25f). The quartz particles tend to be larger than those encountered in most Egyptian faience, thus giving the appearance of a more coarse fabric, and the glaze-body interaction layer is larger than that encountered in most Egyptian faience. Wulff and Koch describe the body of beads made in Qom, Iran, as having a small amount of cristobalite, and no tridymite present, an indication that the beads are fired to $1000^{\circ}C$, the upper limit of temperatures for Egyptian faience. Another indication of high firing temperature is the line of gas bubbles found in thin section at the transition zone, although the glaze is remarkably free of bubbles. Presumably gas was trying to escape from the body once the glaze had formed. The glaze is described as having few surface cracks (similar to most Egyptian faience we have examined). The blue glaze color is described as being more intense toward the surface, which may be an indication of higher quartz content in the interior of the glaze, or perhaps high copper vapor pressure in the glazing powder. According to Wulff, the glaze has a few unidentified crystallites present at the surface and interface, another indication of high firing temperature.

In Qom, Wulff witnessed about 40,000 beads being placed in each of many open crucibles and fired at one time in a downdraft kiln using oil for fuel. Firing time was 12 hours; cooling time was also 12 hours. Wulff's reheating of an unfired bead in glazing powder from Qom in a closed crucible to $1000^{\circ}C$. in 12 hours resulted in a perfectly fired bead. In another similar experiment, but fired to $1090^{\circ}C$., a glassy mass was produced from the glazing powder. This rigid glassy mass embedded the beads permanently. These results are the same as ours. When Wulff

fired to 900°C. for 8 hours, a patchy, slightly glazed surface was produced. In our replication studies, underfiring to 925°C. in 8 hours resulted in the presence of small glassy stanchions of glaze protruding from the surface, as shown in Figures 24b and 25e, while firing to 850°C produced a patchy, slightly glazed surface. No lighter oxidized layer was reported by Wulff in the glazing powder next to the beads, as we found in our replications at and above 900°C., and which are shown in Figure 24a and b. However, Wulff states that the firing to 900°C., produced a dark brown color of glazing powder, probably from the incomplete burning of the charcoal in the glazing powder. In all cases, Wulff reports the inside of the crucible and lid were glazed a green color, whereas, ours were not. Wulff explains that the inside of the crucible could only have been attacked by copper and alkalies in a volatile or gaseous form. Samples of quartzite and fused silica were glazed along side each Qom bead with identical results. Cyril Smith suggested to Wulff at the time that molten alkali might wet, but not dissolve, the calcium oxide in the glazing powder and be transferred to the outside of the bead[10]. The resulting glaze would wet the silica grains of the bead and would withdraw from the embedding powder. The presence of stanchions (Figure 25e) supports this view, as does the lack of glaze on the crucible interior.

Another researcher has suggested that a vapor phase reaction similar to salt glazing is the mechanism of glaze deposition. W.O. Williamson has proposed that vaporization or dissociation of Na_2CO_3, NaCl, and $CuCl_2$ leads to vapor transport through the enveloping powder to the quartz body where a glaze is formed[271]. The glazing powder used by Williamson in replication experiments is composed of 62% by weight $CaCO_3$, 10% Na_2CO_3, 28% SiO_2. Two percent NaCl where added enhanced the formation of glaze, according to Williamson. Samples were fired to 950°C. in a closed crucible in 6-12 hours. Tridymite was found to occur in the glazes, and SiO_2 grains in the glaze were rounded. The major difficulty in accepting this explanation is that tridymite has not been found in Egyptian faience, and in fact very little of

the higher temperature form of quartz, cristobalite, has been found by Wulff or Kieffer. While this process explains overfired samples with blue and green colored, hard bodies, and the diffusion of copper to form a halo around an inlaid or painted line, its general applicability to the glazing of Egyptian faience is in doubt. To support the contention of vapor glazing, Williamson fired faience samples partially embedded in the glazing powder and found that sample surfaces were unglazed when above the level of the powder or when isolated from the powder. The crucible surfaces above the level of the powder apparently were not glazed during firings to 950°C., but were glazed in firings above 950°C. This finding is not in agreement with the results of Wulff or with our replication studies, which suggests that some variable is not being controlled and that more quantitative tests with a simplified system are necessary. Vapor transport, Williamson states, is possible only through the powder bed and not through the air space above the powder, because of the probability of higher vapor pressure in the powder bed. Experimental verification of the difference in vapor pressure in this porous powder from that of the enclosed air space above it is also needed.

In our experiments in replicating the Qom technique of cementation glazing, the convection free wetting of the surface of the crushed quartz or sand beads placed in a closed crucible on the surface of the glazing powder did occur, as shown by the presence of glaze above the glazing powder level to a distance of 3 mm. (firing to 975°C. over 8 hours). Using an open crucible and firing with a gas burner so that convection was present but otherwise having the same firing conditions, the glaze travelled 8 mm. up the surface from the point of contact of a bead hung on a platinum wire so that the bead just touched the powder surface. Furthermore, underfiring the beads to 950°C. in the glazing powder resulted in stanchions protruding from the glaze surface, as shown in Figure 25e. Such protrusions should not be present in a process which occurs entirely by vapor transport. A light, almost white colored, oxidized glazing powder was found close to

the surface of the beads in firings above 900°C. The thickness of this layer varies between 2-8 mm. The rest of the powder was grey indicating incomplete oxidation. In some of these experiments we used the glazing powder composition as specified to Wulff by the beadmaker, Ustad Reza Kashipaz, and members of his workshop: 3 parts ash, 3 parts hydrated lime, 2 parts quartz powder, 1/2 part charcoal, and 1% copper oxide as a colorant. An attempt to reproduce the composition of the plant ash was made by dry milling together the materials specified in Wulff's analysis. Two percent CuO was needed to obtain a sufficiently strong blue, instead of the 1% specified by Wulff. Further experiments using a simplified system are required to clarify the role of the different constituents and to elucidate the physico-chemical nature of the cementation process, and the roll of the oxidation layers at the bead surface needs to be explained.

In another experiment, the glazing powder composition as specified by Wulff's analysis of the glazing powder was employed. The results were a nonfriable, well sintered glassy mass from which no bead could be extracted. The firings were to 950°C. and 1000°C. for 8 hours. This is an interesting note on the technological worth of an analysis of chemical composition which could lead to misleading conclusions if replicated when the accompanying technical knowhow is lost.

Criteria: Replications of the cementation and efflorescence glazing processes lead to the establishment of fairly straight forward criteria to be used in identifying the glazing process of ancient glazes. In a cementation process the glaze soaks into the body (Figure 24e). Unless drying occurs slowly over a period of days, unlikely in Egypt, the effloresced glaze tends to remain as a distinct surface layer (Figure 24f). In general, a body glazed by the cementation process tends to be somewhat soft and friable because there is but little glassy phase to adhere the body (Figure 24g), whereas in the effloresced process, a fairly extensive glassy phase tends to adhere the quartz grains solidly together (Figure 24h). These criteria are subject to variation caused by increases in flux concentration,

firing temperature and/or time at peak temperature. In using these criteria, flux concentration was estimated from the XRF data, and firing temperature was estimated based on external morphology. In addition, four ancient samples were refired. The extent of interaction layer and hardness of the body must be combined with other aspects of external visual appearance and the determination of the amount of flux and firing temperature. To apply these criteria, information on particle size, degree of sintering, glaze thickness, presence and extent of interaction zone, weathering, material identification and techniques of manufacture were assembled and recorded, as shown on a sample examination form reproduced in Figure 26. In this study, identification of glazing process was made if an object met all of the criteria for that process as given below and explained above. The last criterion which is given in parentheses is considered optional for that process, and if met only serves to strengthen the identification.

 I. Efflorescence
 A. Edge of glaze decreases in thickness
 gradually (Figures 25c and 32b)
 B. Drying marks (Figures 24d and 32b)
 C. Firing marks (Figures 24d, 25a,
 29a lower, 37e, 42b upper)
 D. Less glaze on inner surfaces;
 more glaze on outer surfaces (Figure 37b)
 E. (No or less glaze on underside) (Figure 35b)
 II. Application
 A. Uneven application consisting
 of drips and flow lines (Figure 37d)
 B. Preferably low firing temperature
 so flow is not caused by molten
 glaze (Figure 37d)
 C. (Glaze may end at distinct line)
 (Figures 25d and 38b)
 III. Cementation
 A. All over glaze (Figure 24a and 37c)
 B. No drying marks (Figure 24a and 37c)
 C. No firing marks (Figure 25b and 37c);
 if object greater than 1.5 cm., then rough
 surface where rested in firing (Figure 25f)
 D. (Glaze may be thicker on underside) (Figure 25b)

Mutiple Processing: Variants of these processes are

possible; in which case, characteristics for more than one process may be apparent or only those characteristics of the chief glazing process may be apparent. Kieffer's and our replications show that a combination of cementation and efflorescent glazing works. In this case, the characteristics would identify the process of cementation as the chief glazing process. The body is fairly hard and has a large interaction zone. There is a potential relationship between these two processes which is worth pursuing. From predynastic times there was probably a need to stack more objects in a kiln to increase kiln or bonfire output for a given amount of fuel collected, or to form an overall glaze which would be a better imitation of semiprecious stones. There was also a need to be able to remove a glazed object with glaze adhering to the bottom of the object and to the kiln once the glaze had solidified during cooling. Materials which would withstand high temperature and which could be used as parting layers (materials which the glaze would not wet) were probably sought after and studied. Examples of such readily available materials are green wet wood, mica sheet, charcoal, and calcium oxide. From the occurrence of so many Predynastic beads with no firing marks, the conclusion can be drawn that some parting material was known and used. Because of the homogeneity of Protodynastic and Old Kingdom faience in which the efflorescent method of glazing is used and kiln marks are common, it seems likely that some of this understanding of the nonwetting behavior of some materials was lost. During the Middle Kingdom and Second Intermediate Periods, there is evidence of its rediscovery. From both Abydos and Kerma, there are small, friable bits of calcium-containing material adhering to the center of firing marks, a small sample of which can be readily reacted under a microscope with hydrochloric acid. Some of this material needs to be sampled and destructively analyzed for residual carbonaceous or micaceous material, and for crystalline form and microstructure of calcium. Very likely is the possibility that some of the materials in what we are calling glazing powder are being used to separate faience from its kiln

support and to stack several objects, such as the Kerma tiles, which were probably stacked and fired in a diagonal position. In replications of the cementation process, objects can only be glazed without any traces of contact with the glazing powder in sizes up to 1.5-2.5 cm., depending on body density and object shape. If objects are larger that this size, then their weight pushes them down into the glazing powder. For large objects, the powder could be used in small bits to provide some separation, as is probable on the Kerma tiles and many other objects.

Adding glass or flux to the body and then glazing by cementation has a similar effect on microstructure to combining efflorescent and cementation glazing processes, and unless individual particles of glass can be found, their addition cannot be identified. Fortunately, during the New Kingdom when glass is first introduced into Egypt in general and faience bodies in particular, it is for reasons of color, and in some cases the particles can be identified. For instance, the bowl in Figure 40n has a white outer layer on a tan body. There are discrete blue glass particles in both layers. Also during the later periods, crushed colored glasses are added to the bodies, and uncertainty prevails as to whether or when clear glass was added. Presumably before the first century B.C. nearly clear glass was not available in any quantity. Yet by the 1300 A.D. in Persia, it is considered a constituent of white bodies. Abu'l-Qasim's treatise[58] gives a formulation of 10 parts quartz to 1 part each glass frit and clay. Studies of microstructure, composition and phase analysis should reveal when such a change in body composition takes place.

Another hybrid manufacturing process is possible which would invalidate using such criteria as friable, angular body particles to indicate a cementation process. That process is the forming of a high quartz or sand body and the coating of the body with an intermediate layer of high flux composition which would effloresce during drying. The resultant morphology would be a friable angular body, an intermediate layer less friable and containing considerable glass phase, and a surface glaze layer

which has a sharp interaction zone if low fired or a large interaction zone if overfired. Replications of this process have been successfully carried out.

In summary, a hard body and sharp boundary in general characterize the efflorescent and low temperature applied glaze processes, and a friable body and large interaction zone in general characterize the cementation and high temperature applied glaze processes. A hard body with large interaction zone can be formed if a glaze is formed by efflorescence combined with cementation or the addition of glass to the body, or if the efflorescence process is carried out with a slow drying rate or if only an intermediate body layer provides the source of efflorescent salts for the glaze. The existence of a friable body and sharp glaze-body boundary can be obtained if the glaze is applied or if the flux content in the efflorescent process is very low, or if the cementation process is carried out rapidly or with a low quantity of flux in the glazing powder. Thus the need for combination with such morphological criteria as given above is readily apparent, as well as the discipline to decide when undetermined is the best label for the glazing process.

7. THE COMPOSITION OF THE GLAZE

One aspect of the XRF analysis which I found most puzzling was the determination of such high silica concentrations in the overall glaze composition. Any student of glass science knows that a glass or glaze containing 80-90% SiO_2 cannot melt in the 800-1000°C. range. Reference to the phase diagram in Figure 27a for the soda-lime-silica system shows that given a melting temperature of 900°C., the composition of the liquid glassy phase should be about 75% SiO_2, 18% or more Na_2O and 7% or less CaO[278]. At 1000°C. the composition of the glassy phase should be about 74% SiO_2, 13% or more Na_2O and 13% or less CaO. A first attempt to explain this discrepancy is to suggest that the XRF sampling volume is deep enough to include quartz body material.

Kaczmarczyk states that the glazes are thicker than the sampling volume; the sampling volume having an average depth of 200 microns, and the average glaze thickness being about 350 microns. Another suggestion is that faience glazes contain undissolved quartz particles. The purpose of the destructive microprobe analysis of a very limited number of minute samples was to determine the composition of the glassy fraction of the glaze and body so that the behavior of these glazes could be better understood.

If one presumes that Egyptian craftsmen mixed a large amount of quartz grains with a small amount of soluble sodium and calcium salts, then the reaction path which would be expected on heating to about 900°C., shown in Figure 27a, is the same as that for a soda-lime-silica glass, that is, a liquid of sodium and calcium oxides forms, and at 725°C. the surfaces of the quartz grains begin to dissolve forming a eutectic glass composition of 73.5% SiO_2, 31.3% Na_2O and 5.2% CaO at point O. Increasing the temperature causes more silica to dissolve into the liquid and, if sufficient sodium and calcium oxide are present, then the equilibrium glass composition will shift along the thermal divide from point O to P toward Q. The final phases present after heating to 900°C. will be unreacted quartz grains and a glass. If the glass were held at peak temperature for a long time, then the equilibrium crystalline phases which would be expected to precipitate are devitrite, a sodium-calcium-silicate ($Na_2O-3CaO-6SiO_2$), sodium-disilicate ($Na_2O-2SiO_2$) and quartz, as shown in the corners of the primary phase field of our glass composition. Quartz may occur in either of the polymorphs, cristobalite or tridymite, depending on heat treatment.

The objects and sites represented in this part of the study are a predynastic green glazed steatite bead fragment from the famous girdle (Ash. No. 1925.551a-e, grave 5735, Badari, Naqada I, Figure 28a); a predynastic bead fragment with green glaze (Ash. No. 1895.880a, grave 1783, Naqada, Naqada I or II, Figure 29a,b); an Old Kingdom Dynasty VI grey faience substrate from an IB Hieroglyph having a two layered body, white on a grey base and

weathered glaze with light green and white areas (Ash. No. E.A.526, temple, Abydos, Figure 31L); a glossy copper blue bead fragment with white body from the Middle Kingdom Dynasty XII at El Kab (Ash. No. E.E.125, grave 36); another Middle Kingdom fragment from a vessel having a bright blue glaze on two body layers (white on bluish-grey) and formed on a rod with a bulbous core on the end (Ash. No. E.3278, tomb 416, Abydos, Figure 31q); a New Kingdom lip fragment from a bowl having a friable, bluish body with thin glossy dark blue glaze inlaid with a turquoise blue cartouche of Akhenaten and dated to late Dynasty XVIII (Ash. No. 1893.1-41(472), a first century B.C. fritted raw material from the Kom Qalana (Memphis) kiln site (Ash. No. 1910.564, E.2, Figure 46). Three other samples from the Boston Museum of Fine Arts are included in these analyses, copper blue glazed tiles from Kerma, 1312.1029, Cabinet 13B, M.I.T. nos. 1981.IIIB(soft), 1981.VIC(hard) and 1981.IE(hard). The results of the microprobe analysis are given in Table XLII. These results can be compared with microstructure and firing temperature determined by refiring under a hot stage microscope (where the sample was large enough and sufficiently unweathered to allow such a test) in Figure 27.

The compositions given in Table XLII represent small areas of the glassy fraction of glaze about 15 microns in diameter and should not be compared with the bulk analyses of the glazes reported in the rest of this text. The low soda concentrations and low totals are indicative of weathering, and are apparent in the older samples and those with a soft, friable body, indicating lower firing temperature and less durability. Information on the procedures used in these analyses are presented in the next section.

The results show that the predynastic steatite glaze is surprisingly stable, contains very little calcium and potassium, and about equal proportions of sodium and copper oxides. If steatite had dissolved into the glaze from the body, one would expect the same ratio of $MgO:SiO_2$ in the glaze as occurs in the body. The chemical formula of steatite, $Mg_3(OH)_2Si_4O_{10}$, gives a ratio of $MgO:SiO_2$ of 3:4. The glaze has an average ratio of

2.3:3.5. More MgO has dissolved into the glaze than SiO_2, and no ground quartz seems to have been added to the glaze. Fine particles about 1 micron in diameter were observed in the glaze with the scanning electron microscope (Figure 27b), but these were too small to be probed for composition. (The volume from which this microprobe samples was calculated to be about 3 microns for iron in an alumino-silicate matrix.) Further study by electron diffraction should be used to identify these inclusions.

Considerable alkali losses in the softer bodied faience are indicated by the low totals and low soda contents. A micrograph of the Old Kingdom hieroglyph fragment (Figure 27c) shows that weathering has progressed from the back or body side of the glaze, indicating that moisture expansion of the body may have been significant in causing cracks to develop in the glaze, thus accelerating the weathering process. The micrograph of the Middle Kingdom bead from El Kab (Figure 27d) shows from the surface cracks that weathering has probably proceeded from the exposed surface of the glaze. In addition, quartz particles darker than the glassy matrix can be seen in the body. Black angular-edged voids are prorosity. The weathered and unweathered regions can be clearly distinguished in the micrograph of the Kerma tile (M.I.T. 1980.II, hard, Figure 27e), and the compositions from these two regions clearly show the sodium loss (Table XLII). The grey region is more heavily weathered and a cracking of the surface due to weathering can also be detected. The interaction zone of this hard bodied tile (Figure 27f) contains glass (light in color) and quartz (large dark grains). The dark needlelike growths are probably cristobalite.

The Predynastic faience bead, Old Kingdom IB hieroglyph and Middle Kingdom vessel fragment from Abydos have very little calcium and magnesium, less than 1%. The other faience samples show an increase in alkaline earth content, from 2.4-5.6% for the Middle Kingdom and Second Intermediate samples to 11.4% for the Amarna sample. The glassy fraction of the Amarna fragment glaze contains considerably more alkaline earth than the glassy

fraction of the body (3.6%), which may indicate that the glaze was applied to the body and that the calcium and magnesium were intentionally added to the glaze.

Surprising is the high copper content of all the analyses except the one from Amarna; they range from 3.6-18.1% CuO. The soda-lime-silica phase diagram discussed above is insufficient to deal with this system in which copper plays an important role, and lime an insignificant one. It is not until the analysis of the New Kingdom Amarna bowl fragment that this diagram is useful. Copper content drops off to below 2% and the calcia plus magnesia total rises to above 10% in the Amarna sample. The changes in the amount of copper and alkaline earths separate this Amarna composition from any of the others, as do inclusions rich in calcium and antimony, having a diffraction pattern of calcium antimoniate ($CaSb_2O_4$), the largest of which (13 microns) is shown in Figure 27g. The other inclusion in this figure, consisting of acicular growths rich in calcium and silica is probably wollastonite was not positively identified. The body of the Amarna fragment, shown in Figure 27h, has large regions of porosity and quartz particles encased in a thin layer of intergranular glass. A $CaSb_2O_4$ inclusion is in the center.

TABLE XLII. RESULTS OF MICROPROBE ANALYSES OF GLASSY
FRACTION OF GLAZE AND INTERGRANULAR GLASS FRACTION IN THE BODY

Analysis of M.I.T. Glass Standard #II by Electron Microprobe
and Atomic Absorption

	Probe Detection Limit Estimates	Analyses at Beginning of Probe Run Range	Average of 3	At End of Probe Run Range of 2	Atomic Absorption Analysis
SiO2	0.029	68.98-69.90	69.56	69.03-69.94	71.13
Al2O3	0.020	10.52-10.85	10.72	10.51-10.68	11.50
FeO	0.044	0.00	0.00	0.00-0.02*	0.02
MgO	0.017	4.35-4.52	4.42	4.34-4.47	4.51
CaO	0.020	5.16-5.27	5.24	5.13-5.21	5.08
Na2O	0.017	4.71-4.85	4.78	4.66-4.86	4 37
K2O	0.016	5.10-5.26	5.17	5.17-5.22	4.45
CuO	0.063	0.00-0.04*	0.02	0.00-0.01*	0.00
Cl	0.013	0.00	0.00	0.01*-0.02	0.00
Total		99.45-100.36	99.93	99.13-100.17	101.06

*Indicates value which is less than detection limit.

Steatite glaze, bead fragment 1925.551a-e, grave 5735, Badari,
Naqada I, analysis of glassy fraction of glaze

Oxide	Range	Average of 5	Point Analysis of Inclusion
SiO2	56.95-64.82	60.08	53.02
Al2O3	0.23-0.87	0.56	1.16
FeO	0.15-0.23	0.20	0.13
MgO	22.81-29.36	25.94	23.02
CaO	0.60-0.80	0.72	0.68
Na2O	4.33-6.16 (0.27)	5.40(4.12)	4.33
	1 low value given in parentheses		
K2O	0.07-0.10	0.09	0.13
CuO	4.38-8.78	5.21	6.01
Cl	0.57-1.61	1.09	0.70
Total	98.10-101.59	99.29(98.01)	89.18

inhomogeneous glaze with 1 micron inclusions of undeter-
mined composition

Predynastic faience glaze, green bead 1895.880a,
grave 1783, Naqada, Naqada I or II

Oxide	Range	Average of 4
SiO2	77.45-80.50	78.97
Al2O3	0.21-0.41	0.51
FeO	0.18-0.21	0.19
MgO	0.00	0.00
CaO	0.60-0.73	0.70
Na2O	0.16-0.29	0.25
K2O	0.18-0.30	0.24
CuO	8.06-10.57	9.46
Cl	0.52-0.67	0.59
Total	87.87-94.12	90.92

homogeneous glaze with trace of sulfur about 1/3 height
of Cl peak

Glaze from IB Hieroglyph grey substrate, E.A.526,
temple, Abydos, VI Dyn.

Oxide	Range	Average of 5
SiO_2	80.68-82.12	81.55
Al_2O_3	0.25-0.69	0.42
FeO	0.10-0.14	0.12
MgO	0.00	0.00
CaO	0.84-1.08	0.95
Na_2O	0.46-0.53	0.49
K_2O	0.28-0.60	0.44
CuO	3.31-4.37	3.56
Cl	1.49-1.63	1.59
Total	88.01-89.59	89.00

heavily weathered, homogeneous glaze

Glassy fraction of glaze and intergranular glass from body,
vessel fragment, E.3278, tomb 416, Abydos, Middle Kingdom
Glaze

Oxide	Range of 5	Average	Point Analysis	
SiO_2	69.87-71.48	70.79	68.44	69.88
Al_2O_3	0.03-0.07	0.05	0.04	0.04
FeO	0.00	0.00	0.00	0.00
MgO	0.00	0.00	0.02	0.00
CaO	0.52-0.54	0.53	0.60	0.54
Na_2O	1.75-3.02	2.24	0.40	0.69
K_2O	0.35-0.37	0.37	0.19	0.16
CuO	14.20-15.20	14.66	18.16	15.99
Cl	1.12-1.18	1.16	0.59	1.17
Total	88.47-90.81	89.80	88.43	88.48

Body, point analyses on glassy fraction

Oxide	Low Alkali	Medium Alkali	High Alkali in a Large Glassy Area
SiO_2	73.30	69.51	70.70
Al_2O_3	0.12	0.11	0.16
FeO	0.00	0.00	0.01
MgO	0.00	0.00	0.00
CaO	1.11	1.00	1.10
Na_2O	1.67	5.89	10.20
K_2O	1.03	4.96	5.31
CuO	12.94	11.78	12.37
Cl	1.13	1.00	1.15
Total	91.28	94.25	100.00

weathering accounts for low totals

Glaze from bead fragment, E.E.125, El Kab, Middle Kingdom

Oxide	Range	Average of 4
SiO_2	75.72-77.32	76.33
Al_2O_3	0.19-0.31	0.22
FeO	0.06-0.15	0.11
MgO	0.00-0.05	0.03
CaO	4.14-5.87	5.14
Na_2O	0.00-0.03	0.01
K_2O	0.00	0.00
CuO	5.45-6.08	5.88
Cl	0.69-0.79	0.75
Total	87.45-89.75	88.48

weathering apparent in low alkali concentrations,
surface weathered and cracked, quartz and minor potassium
feldspar inclusions

Glassy fraction of glaze and interstitial glass from body, bowl
fragment, 1893.1-46(472) Amarna, New Kingdom
Glaze

Oxide	Range	Average of 5
SiO_2	64.51-64.88	64.67
Al_2O_3	0.71-0.94	0.83
FeO	0.30-0.40	0.37
MgO	3.24-3.45	3.36
CaO	7.94-8.21	8.06
Na_2O	17.86-18.59	18.35
K_2O	1.58-1.62	1.60
CuO	1.41-1.54	1.48
Cl	0.98-1.10	1.06
Total	99.14-100.02	99.78

trace of Mn in glaze, inclusions of $CaSb_2O_4$ (confirmed by XRD)
and possibly $CaSiO_3$

Interstitial glass in body

Oxide	Range	Average of 4
SiO_2	71.92-74.74	73.75
Al_2O_3	6.38-10.96	7.63
FeO	0.59-0.98	0.72
MgO	0.79-2.38	1.77
CaO	1.60-1.96	1.80
Na_2O	9.71-9.83 (3.65)	9.52(8.05)
K_2O	1.60-2.19	1.91
CuO	1.34-2.19	1.75
Cl	0.19-0.39	0.30
Total	98.72-100.86(92.76)	99.15(97.93)

inclusions of $CaSb_2O_4$ also present in body glass fraction;
increase in alumina concentration in body intergranular
glass may indicate clay is present in body

Plano convex, soft bodied tile, M.I.T. No.1981.IIIB, Kerma,
Second Intermediate Period

Oxide	Range	Average of 4
SiO2	62.89-69.89	66.83
Al2O3	0.35-1.00	0.57
FeO	0.07-0.14	0.11
MgO	0.04-1.66	0.56
CaO	0.82-1.74	0.91
Na2O	1.13-2.83	1.99
K2O	0.70-1.60	1.23
CuO	15.37-17.80	16.28
Cl	0.11-1.63	0.84
Total	87.47-90.71	89.53

glaze is heterogeneous, patches of weathering apparent and some
striations in glaze high in sulfur, about 2 times Cl peak height

Plano convex, hard bodied tile, M.I.T. No. 1981.IVD, Kerma,
Middle Kingdom

Oxide	Range	Average of 4
SiO2	64.32-65.16	65.08
Al2O3	0.12-0.25	0.15
FeO	0.04-0.08	0.06
MgO	0.03	0.03
CaO	2.27-2.49	2.37
Na2O	8.59-8.69	8.64
K2O	5.60-5.81	5.71
CuO	17.68-18.63	18.11
Cl	0.48-0.56	0.51
Total	99.70-100.68	100.66

high fired, unweathered body, presence of cristobalite confirmed
by XRD

Concave convex, hard bodied tile, M.I.T. No. 1981.IE, Kerma,
Second Intermediate Period

Oxide	Range	Average of 5	Weathered Layer
SiO2	63.80-65.05	64.44	69.61
Al2O3	0.26-0.40	0.03	0.28
FeO	0.16-0.28	0.24	0.33
MgO	0.00	0.00	0.00
CaO	0.74-0.80	0.78	0.79
Na2O	13.69-14.18	13.94	0.87
K2O	5.94-6.16	6.03	2.12
CuO	13.69-14.55	13.96	14.73
Cl	1.17-1.35	1.23	1.36
Total	100.62-102.07	100.93	90.07

surface weathering layer, presence of cristobalite
confirmed by XRD

8. METHODS OF EXAMINATION

The prime aim of this study was to identify and characterize those examples of faience with anomalous compositions. The second aim of the study was to investigate the technology of Egyptian faience by surveying a representative sample of 700 objects from various periods and geographical locations as represented in the collections of the Ashmolean Museum. To identify and describe methods of body manufacture and glaze application, fragmentary examples of faience were examined with a binocular microscope. In order to try to understand the diversity and complexity of the technology of faience manufacture, as well as to question the existence of workshops employing a characteristic style of making faience, three sites were chosen for emphasis: Abydos, a site of continuous occupation with great diversity of objects and well represented in the collection which could be used to study changes with time; El Kab, a site with chemically anomalous faience; and Amarna, a short-lived site with outstanding faience objects but which are not technologically distinctive from the rest of the period.

The principal method of analysis was nondestructive microscopic examination of faience which had been chipped or was fragmentary so that body structure and glaze cross section could be observed. Background information consisted of a compilation of literature about faience coupled with laboratory replication of the processes described in the literature. The XRF data on chemical composition assembled by Kaczmarczyk was available during microscopic examination to provide invaluable supplementary information. Examples of the use of this data for technological purposed include the identification of colorants, the CaO content, and the presence of PbO fluxes. An example of the limits of this information is provided by the problem of whether to attribute a hard, dense faience body to high firing temperature or highly fluxed composition, or both. The XRF data could help to limit the variables by providing an indication of how much flux might be present on a relative scale among objects.

Na_2O, the prime flux, cannot be detected. By assuming any error in the determination of SiO_2, the major constituent, and Al_2O_3, Al having a peak which overlaps with the large silicon peak, were systematic and by assigning the amount of undetermined material as indicative of possible Na_2O content, a general idea of the amount of Na_2O was obtained.

The XRF analyses were indirectly valuable in another respect. A small area of the exposed bodies had been cleaned to permit XRF analyses of uncontaminated samples, free of the dirt and soil which commonly collect in and discolor the porous faience body. This cleaning process had the advantage of allowing a reasonably pristine surface to be available for microscopic examination. Thus the confusion which usually arises in identifying original body and glaze surfaces was dispensed with. The presence of intermediate layers, the degree of sintering, type of porosity and method of inlay could be easily described.

In addition to the microscopic analysis, samples measuring about one cubic millimeter were taken from six technologically distinct types of objects for destructive analysis. The samples were not selected but rather were found. During the course of microscopic analysis, some objects with broken, but still adherent, bits of glaze and body were discovered and with permission passively sampled. The samples were used to characterize the microstructure and elemental composition with a scanning electron microscope (SEM) with simultaneous energy dispersive x-ray analysis and to determine quantitative composition of the glazes and interstitial glass in the bodies by wavelength dispersive microprobe analysis (the technique used to analyze inclusions in glass by R. Brill and others)[121]. The characterization of fine structure by SEM was revealing of the layered structures in the faience and the variable degree of sintering of the body fabrics, as shown in Figures 25, 27, 33, 37 and 40.

Finally, in order to maximize the technological information obtained from the atomic absorption analyses of low atomic number

elements, measurements of MOHS hardness and particle size were made on a group of 24 samples. The results are presented in Table XLIII.

The plan of study was, firstly, to account for the anomalous XRF analyses by (a) identifying those materials catalogued and analyzed as faience but which are not in fact faience, such as frits and glazed stones, (b) those objects in which weathering products had skewed the analyses, and (c) those instances where restoration had added material, such as plaster, paint and adhesives, to the surface. For example, more than seventy objects were eliminated from the XRF study because they were found to be glazed stone. The following definition of faience was closely adhered to: a polycrystalline body composed chiefly of crushed quartz or sand, sintered at earthenware temperatures and coated with a soda-lime-silica glaze.

The second task was to try to reconstruct the method of manufacture by recognizing those traits which a particular technique of manipulation would impart to the object. The pioneering work of C.S. Smith and J.R. Gettens in the analysis of metals in order to determine the sequence of manufacturing events and the delicate interplay between artisan and material in the forming of an object must be cited as seminal to any such attempt as reported in this appendix[272,273]. By their investigations of structure on many levels of scale, they were able to characterize and explain the style of working materials. Cyril Smith's long standing challenge that the structures of inhomogeneities studied at various scales should reveal the character of ancient glass and ceramic technology are a stimulus for all such attempts.

A great deal of valuable literature has been written about faience processing. This literature and preliminary studies of museum objects was used as the basis for many replication trials. The results of these tests were used to establish criteria for visual and microscopic examination; these criteria were organized into the sample examination form included as Figure 26 which was employed in each such examination at the Ashmolean Museum. The upper part of the form reports weathering and restoration. The

Table XLIII. Description of Samp

Number	Site Object	Condition	Body+ Grain Size & Color	MOHS Hardness, & Friability	Relative Porosity
Protodynastic and Old Kingdom					
E. 4006	Hierakonpolis Dyn. I-II Lid	Broken, Surface dirt	Range, Red	2-3 Friable	Lots
1937.115	Saqqara Dyn. III Tile	Broken	Range, White	3-4 Barely friable when rubbed	Medium
1954.670B	Saqqara Dyn. III Tile	Broken	Range, White	3-4 Barely friable when rubbed	Medium
Middle Kingdom					
1914.759	Haraga 530 Statuette	Chipped, Broken	Range, Bluish white	4-5 Nonfriable	Some
E.3281	Abydos 416 Statuette Leopard	Broken, Surface dirt	Range, Grey white, some blue and brown grains	2-3 Friable to touch	Lots
E.3289	Abydos Violet Grapes	Broken	Range, Pinkish white core, Large inter-action layer	3-4 Friable when rubbed	Medium
E.2150	El Kab, Jar & lid	Weathered glaze	Range, White	2-3 Friable when rubbed	Very littl
E.2288	Beni Hassan, Bowl	Broken	Fine & medium white core	2-3 Friable when rubbed	Little
E.3279	Abydos 416 Vessel	Broken	Range, Grey-ish white	3-4 Friable when rubbed	Some
1914.755	Haraga 530 Staff head	Glaze chipped & part weathered brown	Range, Grey-ish white	4-5, Barely friable when rubbed	Some

lyzed by Atomic Absorption

Second y Layer	Manu-facturing Technique	Glaze, Overall or Partial	Firing/Drying Marks	Probable Glazing Method[++]	Wt % Na$_2$O/CaO in Body Determined by Atomic Absorption
ιe, White	Modeled & Ground	Partial	Firing Marks, top	Effloresced coating	-
ιe	Molded (?) & Ground	Partial	Drying, bottom	Effloresced coating	-
ιe	Molded (?) & Ground	Partial	Drying, bottom	Effloresced coating	-
ιe white h blue-een grains	Modeled	Overall	Undeterminable, No	Undeterminable	5.3/1.34
ιe white	Modeled	Overall	Bottom, No	Effloresced coating	0.8/1.0
ιe	Spheres modeled & joined wet	Matt over-all with few glossy areas, pinholes	Undeterminable, No	Effloresced coating	0.4/1.1
ιe	Undeter-minable	Overall	Firing marks beneath lid in a ring, No	Undeterminable	0.2/0.4
ιe	Undeter-minable	Overall, pinholes	Possible on bottom & interior, No	Undeterminable	0.1/1.3
ιe white	Modeled over rod and core	Overall exterior only	Bottom, No	Undeterminable	0.6/2.7
obably in layer	Interior scraped, perhaps modeled on stick	Overall probable	2 of 3 triangulated marks on end, another possible	Effloresced coating	0.7/0.8 Less flux than appearance would indicate

Number	Site Object	Condition	Body+ Grain Size & Color	MOHS Hardness, & Friability	Relative Porosity
New Kingdom					
1893.1-41 (448F)	Amarna, Palace, Tile	Broken	Range, but mostly coarse white	6 Friable when rubbed	Lots
1942.80	Amarna, Plaque	Broken	Medium & fine white	2-3 Friable when rubbed	Lots
1893.1-41 (439)	Amarna, Lyre & hands	Broken fragment	Fine & few medium, bluish grey, no separable blue grains	4-5 Nonfriable	Little
E.3410	Serabit el Khadim, Temple Vessel	Broken	Medium & fine pinkish tan & white	2-3 Friable to touch	Lots
1892.816	Akhmim, Vessel	Broken	Medium & fine, bluish grey body, bluish & white grains	3-4 Nonfriable	Little fine scale
1871.34A	Yahudiya, Palace of Ramesis III, Inlay	Broken	Fine & medium greyish white & no blue grains	3-4 Barely friable when rubbed	Little fine scale
1871.34D	Yahudiya, Palace of Ramesis III, Inlay	Edge broken	Medium & fine white grains	2-3 Friable when rubbed	Some, large size range
1911.614B	Serabit el Khadim, Temple, Vase	Broken fragment	Range, mostly coarse, white & tan grains	2-3 Friable to touch	Lots, large size range
Late Period - Roman					
E.3610	Abydos, Shawabti	Broken, weathered glaze	Range, White	2-3 Friable to touch	Lots

Second ...ly Layer	Manufacturing Technique	Glaze, Overall or Partial	Firing/Drying Marks	Probable Glazing Method[++]	Wt % Na_2O/CaO in Body Determined by Atomic Absorption
...e, White	Undet., No scratch or mold marks visible	Top only	No, fairly high fired, No	Applied glaze	0.3/1.01 Higher MOHS hardness due to large coarse fraction
...ne	Undet., decoration incised & inlaid	Overall, pinholes crawling	No No	Undet.	0.3/1.6
...ne	Undet.	Undet.	No, fairly high fired, No	Effloresced coating	3.49/1.01
...ne white, ...ry thin	Interior rough & wet when ground smooth, exterior decoration painted	Undet.	Botom firing marks, No	Effloresced coating probably	0.8/1.4
...ne	Ground & hole drilled	Undet. very thin glaze	No No	Undet.	0.4/5.32
...ne	Undet., Scratch marks on back, & square hole	Undet.	No No	Effloresced coating	0.9/1.9
...ne	Undet., Part of surface inlaid part painted	Overall, thinner layer on back	Back side firing marks, Yes	Undet.	0.1/0.9
...ne	Undet., Decoration incised & inlaid	Undet.	No No	Undet.	0.2/0.3
...one	§Molded & back, sides & arms scraped	No glaze	No No	Undet.	0.3/0.3

Number	Site Object	Condition	Body[+] Grain Size & Color	MOHS Hardness, & Friability	Relative Porosity
1913.803C	Cairo, Bowl	Broken	Medium & fine tan	2-3 Friable when rubbed	Lots
1892.1028	Cairo, Head	Broken, weathered	Medium & fine white	3 Nonfriable	Lots
1910.555[2]	Memphis, Lamp (Kom Hellul kilns)	Broken	Range, White	3-4 Nonfriable	Lots
1916.2	Giza, Shawabti, Glassy faience	Broken	Fine vitreous texture, white	6 1/2 Nonfriable	Very little

+ Grain size was measured as follows: Fine, 0.01-0.09, Medium, 0.1-0.3, Coarse, 0.4-0.7 r Fine grains cannot be visually resolved. The distinction between medium and coarse grai is merely one of convenience.

§ E.3610, 1913.803C and 1910.555[2] were each molded in open face molds.

++ Due to the fragmentary nature of these examples, glazing by a cementation process can no be identified.

Second y Layer	Manu-facturing Technique	Glaze, Overall or Partial	Firing/Drying Marks	Probable Glazing Method[++]	Wt % Na_2O/CaO in Body Determined by Atomic Absorption
e	§Molded & incised; Slip plane at midline of cross section	Overall	Interior & exterior have 4 marks at 90° apart, stacked	Undet.	0.4/0.8
ond layer y on face	Undet.	Undet.	No No	Undet.	0.8/5.44
e	§Molded	Overall	No No	Applied glaze	0.4/4/48
e	Undet., detail incised	Glossy exterior is not separate layer from body	No No	None	0.4/2.57 Hardness probably due to higher firing

middle separates materials other than faience. The lower part of the form characterizes the faience. Methods of forming the body include modeling, molding, forming over a core, scraping, building up the body in layers, inlaying or mixing two or more different colored bodies to achieve a marbleized surface. Grain size, color, porosity, hardness and inclusions were all used to characterize the body. The glaze was described as coating all of the object (overall) or only part of the body (partial). Marks on the glaze from drying or firing which aid in determining the method of glazing were carefully noted. The decoration of polychrome faience was judged to be inlaying or painting by viewing a cross section to decide if a second color paste was set into the body or if a wash or slurry was painted onto the surface in which case the second color does not protrude beneath the glaze layer. An inlay in cross section has a body and glaze layer. If no cross section was available the surface of the decorative element was studied to determine whether the surface was raised above the base glaze, as with a painted or daubed slurry, or had a line of separation partly or completely surrounding it, as with an inlay, whether the second color had the diffuse appearance of dissolving into the base glaze, as with a pigment wash. The caveat of low firing temperature must of course be made. A second body layer coating the entire interior body was defined on the basis of having either a different color, porosity or particle size from the interior body.

A Bausch and Lomb stereozoom 7 with a range of magnification from 10x-270X was used to study the faience. A MOHS hardness scale was used under the microscope being sure to avoid dislodged material and by first scratching one surface upon another and then the second on the first. The MOHS hardness rating does not test the hardness of the grains in the faience, but rather is an indication of the extent of sintering or fusing of one particle to its neighbor and thus serves as a rough and relative indication of firing temperature, only if other factors such as extent of weathering, particle size and composition are considered. Another qualitative measure of the strength of

sintered joints is to rub the surface gently with a finger. The material is considered friable when grains are loosened or removed, and the material is said to spall. Differences in friability may be used to indicate differences in composition and heat treatment. In general, the greater the MOHS hardness, the less friable the body and the greater the glassy fraction. According to Petrie, the strength of faience resides in the rigid surface glaze and not in the generally friable body[136].

Particle and large spherical pore sizes were measured using a reticle calibrated with a microscale with the microscope set at 20x and 70x or by measuring SEM micrographs of known magnification. Sizes are classified as coarse, 0.4-1.0 mm.; medium 0.1-0.3 mm., fine, less than 0.09 mm. The largest observable silica granule was measured in addition to approximating an average range. An attempt was made to characterize the size and shape of both fine intergranular porosity and large voids. Large intergranular pores could be measured, but intergranular porosity was determined on a relative scale using replication standards of measured porosity. Porosity varied from about 10-40%, and was denoted as lots, medium, some, little, very little. This attempt needs improvement.

Generally, during the Protodynastic and Old Kingdom Periods, lots of porosity was evident, and later there was less. During the New Kingdom a great variety of bodies for different purposes were used and thus porosity varies. From a determination of partcle size range, relative porosity and color, the rare occurrence of burned out organic material may be located. When one encounters grains of nearly the same size, lots of intergranular porosity is expected, but when a mixture of fine to coarse sizes is encountered, one expects to find much less intergranular void volume. When there is a range of particle sizes with lots of porosity, one must then suspect the possibility reacted or burned out material. Approximately spherical pores, cited by Beck and Kuhne as the result of burned out organic material, can be the result of entrained air bubbles or such burned material[258, 2]. In fired clay one frequently

encounters air bubbles flattened during the forming of plastic clay. Wet faience bodies do not have the extensive property of clays and thus rounded pores are common.

The SEM micrographs were taken using a Cambridge Instrument Company Stereoscan II operated at 20 KV. Simultaneous semiquantitative information on elemental composition was available with KEVEX energy dispersive x-ray attachment capable of resolving elements with atomic number of Na and above in concentrations of 2% and above.

The quantitative chemical information was acquired with a Cameca MBX electron beam microprobe run at a beam current of 15 KV with Tracor-Northern 1310 automation to correct for differential matrix effects by the technique of Bence-Albee. Geological standards were used in addition to working glass standards. Areas of glaze were selected starting at the exterior surface and progressing to the interior at 50-100 micron intervals, where weathering did not prohibit such a procedure. The probe analyses were coupled with the constant monitoring of microstructure with a scanning electron microscope operated in backscattered emission mode, in order to obtain an analysis of the glassy fraction of the glaze without unmelted quartz particles or heavily weathered products. Quartz could be easily detected (Figures 27d and 27h). Use of a solid state detector, instead of the standard Everhard-Thornley detector, with backscattered emission can detect average differences of 2 in atomic number. A thin surface layer of weathered glass, which could not be detected using a low power microscope, could be differentiated by grey level contrast from unweathered glass (Figure 27e).

Volitilization of alkalies, especially soda, is a serious problem with old glasses and nondurable newly melted glasses[282]. In order to obtain representative values for soda, the stage was traversed beneath the electron beam at a rate established empirically, between 1-3 microns/second. A comparison of point analysis with traversed analysis is shown for the glaze in the sample from E.3278, Abydos, Middle Kingdom in Table XLII.

Corning glass standards A-D and a M.I.T. glass standard were traversed to obtain a constant count rate which did not fall off with time and to obtain a total soda content which was comparable to that analyzed for the standard glasses, as shown in Table XLII. Similar results were obtained by rastering the beam over a 15 micron area of sample, while traversing the sample stage.

Low totals indicate that the peak height of each element has been compared with that of the standard and that the total concentrations of the elements do not add to 100%. Low totals indicate one of the following: poor sample preparation (rough surfaces), fine scale porosity in the sample or missing elements. Weathering is believed to be responsible for the low totals. Surfaces were smooth and no porosity was present in the areas sampled. EDAX spectra were acquired for each sample to be sure no high atomic number elements were being missed. For instance, in the Amarna sample trace amounts of manganese was detected; in two other samples amounts of sulfur were detected just at the detection limit. The limit of detection of this EDAX system is about 0.5%. Low atomic number elements which are not detectable with either EDAX or probe are probably responsible for the low totals. Most likely water has entered the glass structure, and hydrogen ions have substituted for the leached sodium ions.

The microprobe can detect low concentration elements, but in order to obtain meaningful numbers, one must employ standards which bracket the concentration of interest. Such standards were not used. Counting errors also tend to be greater for low count rates. Thus the confidence bounds on concentrations of elements near or less than 1% are large, up to 20%. For the major elements such as silica, confidence bounds are within a percent as standards have proven homogeneity. Bounds increase from +-1% to +-5% of the reported number for the alkalies, alkaline earths, alumina, copper and iron oxides. Within these limits, the range of values represents real chemical differences in the material.

Errors in this work may have been introduced by the descriptive nature of much of the work. This study of artifacts in the Ashmolean collections was carried out over three years

during parts of summer vacations, thus introducing the possibility of error. The advantage of such layoffs was that more experimental work was attempted. Where possible standards were used and each time I returned to the work I reviewed examples of the previous year's work. The central theme of this work was to find out how much could be learned from careful looking, an approach which has generated more questions than were originally posed, and, where possible, to further the looking with analysis.

9. EXAMINATION OF PRE- OLD KINGDOM GLAZED STEATITE

In the Ashmolean Museum's collection there are very few examples of faience from the Predynastic Periods (ca. 4000-2900 B.C. In fact, forty-five predynastic examples of beads catalogued as faience on closer inspection were found to resemble steatite, according to the criteria established by Beck for the external appearance of steatite[258]. Steatite, or soapstone, is a platey hydrated magnesium silicate $(Mg_3(OH_2)Si_4O_{10})$, shown in Figure 28c, which is soft enough to be easily scraped and carved, and which can be hardened by heating. Small, short tubular beads excavated from graves located at Naqada, El Amra, and Gerza, all dated Naqada II, had a similar appearance to the girdle of several hundred steatite beads from Badari (grave 5710, Ashmolean No. 1925.551 a-e, Naqada I)[274], a few beads of which are shown in Figure 28a. This large girdle as well as the fine example in the British Museum (B.M. No. 62150) were examined.

Bead Manufacture: The overall shape of these beads, and some of the early faience ones as well, is a short cross section of a cylinder, usually with edges rounded as shown in Figure 28b. Some of the beads have no rounding of the edges, and occasionally the end faces of these beads are not parallel to one another (Figure 28a). The two girdle examples contain a high incidence of the harder-edged beads. In cases where only a few beads were found in a grave, the beads tend to be more rounded and tend to

be shaped more carefully, or at least shaped in a more labor intensive way. In comparing Figures 28b and 29a. the similarities in shape and processes of manufacture of faience and steatite beads may explain why confusion has arisen in the identification of the two body materials.

Most of the holes in steatite beads are drilled from both ends, the shape of the hole being concave from each end. Only a very few holes in steatite are conical in shape, indicating drilling from one end. Most holes in faience are conical. The probable process of manufacture of the steatite beads is by grinding a rod, chipping or cleaving discs from the rod, drilling holes in the discs and then in some cases abraiding to the final shape. There are examples of chips from the edges which have been made prior to firing (E.E494b and E.E.36, or third bead from left, Figure 28a). There are a few examples with residual scratch marks beneath the glaze (most occur in the girdle, 1925.551). These occur most frequently at the rounded outer surface and in the hole. Beck found "coarse marks resembling file marks showing through the glaze" and "parallel to the axis" (Beck, p. 73)[258]. Protodynastic beads he found had scratch marks about 30 degrees off-axis. No similar difference could be discerned in the present study.

The crystal structure of steatite is platey, and the manufacture of steatite might be expected to take advantage of natural cleavage. However, in the one bead fragment (girdle, 1925.551) destructively analyzed there was no correspondence between the alignment of the crystal planes and the surfaces of the bead. The platey alignment formed a diagonal through the bead. This bead may be an anomaly or the lack of regard for the natural cleavage planes of the material is an indication of the soft, easily worked nature of steatite, which has a MOHS hardness of 1 before firing and which changes to 4-6 after firing at the exterior of the body surface and 4-5 on the interior. The unweathered glaze hardness ranges between 5 and 6. Beck found a hardness of nearly 7 in some bodies[258]. Bannister and Plenderleith report 6 measured on New Kingdom glazed steatite

scarabs[259]. Firing of steatite results in the loss of water between plates. Compare Figure 28c, a broken fragment of unfired steatite with 28d, the same piece fired to 900°C. and broken. The platelets are thicker and cleavage more dificult. In Figure 28e, soda ash ($NaCO_3$) has been fired to 800°C. on the surface of the steatite, resulting in the rounded shape of the edges of large and small particles and in the breakdown of the anisotropic platelets into smaller particles. In Figure 28g, a micrograph of a bead fragment from the Badari girdle (1925.551a-e, grave 5735, Naqada I) this same breakdown and rounding of fine particles occurs. This study of microstructure shows that the ancient sample was fired, but is also shows that changes in microstructure accompany firing which are characteristic of this material.

Morphology: In Figure 28b, the surface of the body where the glaze has flaked away has a semi-glossy, opaque white appearance. The color of the glaze is usually a glossy translucent blue from copper with a rare examples being translucent white (for example, 1911.368b Gerza, grave 133). The thickness of the glaze is about 0.05-0.1 mm. with thicker areas where flow has occurred measuring about 0.5 mm. In contrast to faience glazes, where there tends to be a measurable interaction zone between glaze and body, the glaze on steatite is a distinct glassy coating which easily chips and flakes from the body, as shown in Figure 28a.

Almost without exception in Pre- and Protodynastic glazed steatite, a system of fine cracks, both radial and circumferential can be observed in the glaze about 0.2-0.5 mm. apart. The probable cause of these cracks is crazing of the glaze in response to residual stresses set up by differential thermal expansion between the glaze and body, although another possibility is moisture expansion of the body due to rehydration. The anisotropic thermal expansion of steatite would contribute to a glaze fit problem. Beneath the glaze, one can frequently observe a separate group or mesh of cracks in the body (for example, E.E.494a and b, Naqada II, Naqada grave 1257 or E.E.34a

and b). A depression in the glaze surface may follow an unusually large crack line in the body. One cannot determine how far the glaze has flowed into the crack without examination of a cross section. However, of five steatite beads (E.E.36, Predynastic or Protodynastic, El Amra, grave B62) several have glaze which adheres in the cracks of the steatite even though most of the glaze has peeled. A probable source of these body cracks is thermal shock, a rapid change of temperature during firing. The existence of this type of crack in about 25% of the beads examined, and not in later steatite, reinforces the contention of careful but not perfect control of the means of heating the beads, and that an open fire is as, if not more, probable than a furnace.

Beck suspected from the variety of body color and texture that other stones besides steatite were glazed. In one case, he suggested chlorite. These findings compare well with the recent work of P. Kohl who found chlorite and other altered, soft stones were used in the manufacture of what had been called steatite bowls at Tepe Yahya, Iran, during the third millennium B.C.[275]. John Boardman has also suggested the possibility that other soft stones such as serpentines were used in predynastic Egypt[276].

Heat Treatment: An indication of firing temperature can be gained by refiring experiments and from observation of the surface and cross section of the body. Bannister and Plenderleith fired fine grained Bavarian steatite for 2 hours at 600°C. and found the MOHS hardness to be 1. On refiring the same piece for 1 hour at 900°C., the MOHS hardness increased to 7. The XRD powder pattern for 3 New Kingdom samples and the Bavarian sample were the same. In the ancient examples from the Ashmolean, the steatite surface where the glaze has chipped away is only semi-glossy because of small depressions with granular interiors when examined at low magnification. A vitreous surface skin has not formed over the entire surface. Fully aware of the great variation in beads, one might attempt to describe an average cross section of the body as having a greyish-white, opaque, polycrystalline interior with a more finely textured and

more opaque, white surface layer, measuring 0.1-0.3 mm. beneath the glaze. This layer appears more highly sintered than the interior. With a petrographic microscope, Beck consistently observed this layer in thin sections of beads from the British Museum girdle and found a multiple layered (dark and light) structure with a reduced polarizing effect when compared to the interior of the bead. The inner dark and light layers of this surface layer he found to be the most intensely dark and light, thus probably the most highly stressed. The layers which Beck noted as well as the phenomenon of delamination of the glaze may be stress related, that is the result of the differential expansion coefficients.

In firing steatite from Vermont, U.S.A., in 100 degree increments between 700-900°C. (4 hours to 700°C., 15 minutes soaking at each temperature), no such layer would form without contact with a highly fluxed glaze, and then the surface layer was very thin in comparison with the predynastic beads. That formation of such a surface layer occurs through a firing of long duration and relatively modest peak temperature is a best guess. This surface layer may be the result of one of two mechanisms: (1) the formation of a glass-containing layer through the migration of flux into the body in which case incomplete dissolution of the body material, and possibly crystallization from the melted fraction may have occurred, or (2) less likely, solid state reaction of flux and body may have produced a solid solution or fine scale crystalline phase. Further study is required to resolve the nature of this surface layer.

Glaze: On one side of many beads (about 50% of the total examined) are 2 or 3, but occasionally just 1, small brown protrusions from the glaze measuring about 0.2-0.7 mm. in diameter and about 0.1-0.5 mm. in height (an example is 1924.340, Naqada II, Badari grave 4622). These are probably the result of contact with a support during firing. The brown color seems to be the result of clayey soil becoming embedded in a white or tan polycrystalline material probably during burial. That these marks are from supports which would prevent the molten glaze upon

cooling and becoming rigid from adhering the bead to its support is all the more plausible because any flow of glaze is in the direction of these firing marks. Beck reports that he was successful in obtaining a glazed surface by the application of a mixture of crushed glass, soda and salt, but was able only to whiten and harden the surface of steatite and chlorite by treating it with soda or salt. Beck also reported finding a layer of blue crystals in the glaze near the interface in the Badari steatite beads, but not in other beads, for instance from Naqada. This observation requires further investigation. Because of the high CuO concentration, about 5% and equal in amount to Na_2O, found in the probed composition (Table XLII), the role of copper in this system should be investigated.

Of the methods proposed as possible ways of glazing faience and steatite, we have tried the application of synthetic natron (mixed according to Lucas' analyses of ancient natron #1 and #2, and modern natron from the Wadi Natrun #1, p. 493), or a 30 weight % soda, 10% lime, 60% silica glaze or straight soda ash or salt, applied as a powder and in an aqueous slurry to the Vermont steatite. This process of glazing by application of materials resulted in a satisfactory glaze in all cases. The reaction layer at the surface of the steatite was too thin. Underfiring the soda ash coating on the steatite to $800^{\circ}C$. in order to understand the interaction of flux and substrate produced the results seen in the SEM micrograph in Figure 28e, which shows molten flux wetting and dissolving steatite to form a stable glass. Soaking steatite in solutions of synthetic natron, soda ash, salt, sodium oxide and synthetic plant ash failed to produce an efflorescent layer upon drying which could be fired as a glaze. As a last resort, saturated solutions of these alkalies were autoclaved with the steatite, again with no resultant effloresced coating. We presume either our steatite is too dense or this process does not occur. A successful replication of the Qom cementation glazing technique for faience fired to $1000^{\circ}C$., as described by Wulff, failed to produce any glaze on steatite. These experiments should be redone using a 50-50 mix of Na_2O and CuO.

10. EXAMINATION OF OLD KINGDOM AND LATER GLAZED STEATITE

Another large group of steatite which is sometimes labeled faience is encountered in seals and scarabs of the dynastic periods. The fine detail of inscriptions and cartouches is achieved through reduction of the surface by carving and scraping. This degree of detail is much finer than can be found in a faience body, and the platey crystalline habit is diagnostic. Grooves are usually "V"-shaped but some examples are undercut. Occasionally multiple scratch marks reside at the bottom of grooves, indicating the probable use of a chisel or point. The same reaction layer occurs in the body as in the Predynastic glazed steatite. In some examples, there are brown streaks in the body which are observable through the glaze. These striations Kaczmarczyk has shown by XRF contain small amounts of Cr and Ni. The occurrence of Cr and Ni containing striations in dynastic glazed steatite is higher than in Predynastic steatite, but our small sample of only 50 dynastic examples allows no conclusions about manufacture. A variety of glazes are used which vary in appearance from even thickness, smooth surfaced, and satin matt luster, almost jadelike in appearance to very glossy and uneven with multiple drips and rivulets, an indication of variation in firing temperature and composition.

Of the fifty samples identified, 29 were examined for method of manufacture. Of the 29 samples, one was eliminated as a possible forgery due to high PbO content in the glaze, poor craftsmanship in carving and lack of provenance (1892.542 scarab, Dynasty XV, no provenance). Two other scarabs were very weathered steatite (E.2645a scarab, Ihnasiya, Temple of Tuthmosis III; and E.E.3490a white scarab, Hyksos Period, Yahudiya, grave 19). Yet another scarab is a glazed brown stone with no firing cracks or bedding and is not steatite (1872.148 scarab, early Dynasty XVIII, no provenance). Of the remaining 14, 8 had an overall glaze and no firing marks could be found. Firing marks consist of a small roughly circular patch where the body is

exposed with no glaze or a roughly circular granular accretion, brown in overall color, which penetrates below the surface of the glaze (similar to that shown in Figure 29a, lower bead). Occasionally where the glaze is thick, a bare spot may be surrounded by a jagged broken edge. Presumably, a firing support has been forcibly removed or the object came into contact with another object. The absence of firing marks and presence of an overall glaze is an argument for a cementation method of glazing, but as stated above we have been unable to replicate this method on steatite. Further replication studies need to be undertaken using native steatite and the various other stones, and concentrating on the role of copper in this process. The presence of firing marks and an overall glaze is evidence for an impure enveloping powder or that some objects were glazed directly by application of glaze materials and then fired on supports such as lumps of clay or a calcium-containing material. We have been unsuccessful at efflorescing a coating from steatite. Our sample of steatite is too dense to allow this method of glazing. In short, the evidence is inconclusive as to the method of glazing. The placement of firing marks will be important. Microanalysis of body stone type and glaze accretions should identify stone type and clarify the composition of the the accretions and relate it to either glazing powder or kiln supports. In addition to identification of the range of stones glazed, and the glazing method, the problem of glaze fit could also be profitably studied. About half of these steatite objects were crazed, and half were not.

11. PREDYNASTIC FAIENCE

A well known example of faience, shown in Figure 29c, is the falcon (1895.142, Naqada I, Naqada, grave 1774) dated to the first part of the Predynastic Period (ca. 4000-2900 B.C.). The falcon is an excellent example of an imitation blue stone made in faience. The body was probably modeled to its general form, then

it was scraped and ground to shape before firing. The hole was drilled from two sides. Based on the angular shape of the head and eyes and the grooves or scratch marks which can be seen through the glaze, the details of the falcon were shaped by scraping the surface, the removal of material by rubbing, not by modeling, the building up of material. This is a clear example of the adaptation of lithic techniques to the manufacture of faience.

There is disagreement between myself and a geologist as to whether the body is white sandstone instead of faience. Through a small hole in the glaze at the bottom of the piece, the body appears to consist of a friable, polycrystalline body of white, angular grains in the fine to medium size range, measuring 0.2-0.07 mm. However, some soil and dirt adhere to the body, producing some confusion about what is original and what has been added with burial and age. Sandstone deposited close to the parent rock source could have angular particles, as opposed to the rounded particles common to water and wind worn sand. Kieffer has produced a blue glaze on sandstone by a cementation process. Characterization of porosity is not possible with such a small sample of body exposed. Without a reasonable nondestructive, microscale test to separate fired sandstone from sintered sand or quartz, only qualitative supposition is possible regarding the nature of the body material. The glaze is very hard, exhibits little crazing and very few pinholes. There does not seem to be a large glaze body interaction zone. There are no firing marks, although one side has a thicker glaze coating. One cannot state whether the hole in the bottom was used to set the falcon during firing. Efflorescence, application and cementation are equally probably as the method of glazing.

The two beads shown in Figure 29a all agree are faience. However, the only substantive difference is that the bodies have a higher glassy fraction than the body of the falcon. In the collections Ashmolean Museum, the one undoubtable example of Predynastic faience (1895.880a, Naqada I or II, Naqada, grave 1783) consists of three bead fragments, the top two of which fit

together, as shown in Figure 29a. The body is composed of medium to fine, opaque particles which are quite vitreous, exhibit very little porosity and are not friable. The holes are ground from one side. The pale green overall glazes exhibit pinholes and crazing. There is a firing mark on the edge of the partially complete fragment; the whole bead has no firing marks. The method of glazing remains undetermined. Both body and glaze of these beads are very different in character from those of the falcon. The body of these beads is more vitreous. The body is more highly fluxed and/or fired than the falcon, and the glazes are more weathered, less durable and less homogeneous than that of the falcon. One would expect poorer durability in a more highly fluxed glaze, given a similar firing temperature. A cross section (Figure 29b) of a small fragment shows the glaze coating as a distinct layer on a body composed of angular quartz particles held together with glass. From this microstructure, the lack of plasticity during modeling of the body can been understood as well as the friable nature of the body once it is fired. The dark area is a pore, probably caused by air entrained during the initial forming of the bead.

There are other Predynastic beads which have technological affinities with faience. Glazed stones, such as steatite, are more common than faience, and their points of overlap in technology have been discussed above. Comparing Figures 28a and 29a makes this comparison tangible in that one must look closely to identify the differences. An unusual example shown in Figure 30a of a glazed material is the chipped and ground bead of rock crystal (U.C. 4507, Naqada, grave 1248, Naqada II) which has three areas on indented surfaces with somewhat weathered glaze. A great deal of experimentation with faience bodies and glazes seems to be taking place at this time.

Another example of beads having technological affinities with faience is the gold foil covered bead with a faience body from El Amrah, one of which is shown in Figure 30b. The body material was originally identified as clay, but it is grey, sandy and friable. By X-ray diffraction it contains no clay, only

quartz and minor glass. Further study by SEM showed that the friable core has been fired because of the glassy fraction present. This unusual use of the white, polycrystalline body material of faience is one of seven gold foil beads from El Amrah[277], each of which is formed over a friable core composed of medium size, tan sand grains and medium (0.3-0.6 mm.) to fine, angular whiter grains which are quartz. Minor quantities of clay or soil not detectable by x-ray diffraction are present only on the exposed surface of the body where the gold foil has broken away, and were probably not added intentionally but rather deposited during burial. The sample for XRD and SEM was taken from a fresh fracture to avoid contamination by soil and dirt. The foil may have been formed over the core, but the appearance of the surface of the gold is much smoother than one would expect from the present broken lumps inside. The manufacture of these beads bears further study. The significance of these beads is that the same spherical shape and body materials of early faience beads are transferred to another technological function; that is, for use as a substrate for metal. Faience or frit beads in later times are enclosed between metal end caps but the El Amrah beads are a clear example of encapsulation of body material for manufacturing purposes other than the end product, faience. Beck reports the occurrence of such beads from the Dynasties V-VIII as being "mounted on a core made of a mixture of a kind of resin and powdered crystal, quartz being used in one case and calcite in another"[258, p.22]. Another example of the use of gold foil over a tubular bead of unknown material is in the University College collection (U.C. 5432, Naqada grave 667, Naqada II), one of a group of beads containing lapis and tubular faience beads.

In order to augment the Ashmolean collection, Predynastic beads were studied from the Petrie Collection, University College, London. The data from the study of these beads is given in Table XLIV. There is a great diversity of styles present from (1) beads whose appearance is due mainly to abrasion techniques similar to those used on soft stone beads (sharp and rounded edges are found and holes were drilled;, some beads appear to be

Table XLIV. Description of University College Predynastic Beads

Number and Grave Site at Naqada	Material & Shape	Is it possible to see into body? Surface Fractures? Color & Grain Size	Glaze Overall or Partial	Firing Marks	Glaze Color	Body Manufacture	Possible Glaze Method
Naqada I							
5031 (1752)	1 faience spherical	No, rough estimate of largest grain size is 0.1-0.2 mm.	Overall	Yes, wider end near hole	Blue-green	Modeled & slumped, large hole off center	Fired on substrate
	2 faience disc	No, through hole, white friable, some dirt		Yes, near hole at 1 end	Blue-green	Ground sharp edges	Fired on substrate
Naqada I-II							
5007 (B51)	2 steatite disc	No, body surface cracks	Partial	Yes, on 1 end	Green both ends	Abraded, hole drilled from both ends	Fired on substrate
4407 (1567)	1 faience barrel	Yes, friable, coarse & medium grains (0.4 mm. largest), some porosity	Overall	On side	Green, one area blue green, pinholes	Undeterminable	Fired on substrate
Naqada II							
4266 (499)	10 frit barrel	Blue, friable, fine (0.9 mm. is largest), lots porosity, some grains light blue	None	No	No glaze	Ground, faceted surface	Undet.
5015 (13)	4 disc faience or steatite	No, one has crawling of glaze on side	Overall	2 with, 2 without	Green with white patches	Ground, hard edged shape	2 on substrate, 2 by cementation
5020 (630)	1 faience spherical	No, through hole polycrystalline, friable, white; some dirt	Overall	Yes, near hole	Blue-green	Modeled and slumped on side, hole is oval	Fired on substrate

Number and Grave Site at Naqada	Material & Shape	Is it possible to see into body? Surface Fractures? Color & Grain Size	Glaze Overall or Partial	Firing Marks	Glaze Color	Body Manufacture	Possible Glaze Method
5021 (661)	+4 faience 2 barrel & 2 shell shape	3 No, 1 with exposed fine gray body (0.06 mm. largest particle), some doubt about material being faience	Overall	Yes, on one side	Blue	Undet., shell shape is elongated with 1 bulbous end	2 on substrate, 2 by cementation
	8 faience shell shape	No, through glaze and holes estimate largest grain to be 0.07 mm.	Overall glaze with variations in thickness	Yes, on side	Brown glaze, ridges lighter where body shows through thinner glaze	Ground to overall shape & grooves cut circumferentially	Fired on substrate
5022 (704)	28 faience or soft stone	No, disc. spherical and 1 with conical end	Overall	Yes, only 3 have no firing marks near hole, & 1 of these is worn & 2 are weathered	6 blue green, rest green	Modeled & ground	25 on substrate, 3 undet.
4507 (1248)	2 steatite disc	No, body surface cracks	Partial, due to flaking	No	Green	Ground	Undet.
	1 faience tubular	Yes, range particles 0.1-0.3 common, 0.4 largest, lots of porosity, oval hole	Overall	Yes, near U.C. no.	Green, pinholes	Undet.	Fired on substrate
	1 (?) faience disc	No	Overall, weathered	No	Off white	Undet.	Undet.
	1 rock crystal	No cracks, oval shape	Remnants of glaze	No	Blue-green	Conchoidal fractures	Undet.
4569 (869)	1 faience tubular	Yes, medium & fine but one larger one 0.8 mm.	Overall, thinner on 2 sides 180° apart, thicker on 2 other	Yes, on 1 of thinner sides	Blue-green	Undet., hole off center	Fired on substrate

Sample	Body	Glaze extent	Firing/hole marks	Color	Shaping	Method
2 steatite & 17 other soft stone(?) beads						
5001 (1330) 1 faience spherical with 1 end larger	Yes, medium & fine (0.2 mm largest) white, little porosity, barely friable, quite vitreous	Glaze remains at 1 end only, weathered	No	Green	Modeled & slumped, large hole ground, no cracks at hole	Undet.
5084A (804) 24 faience or soft stone	No	Overall	Yes, near hole at 1 end	Blue-green with white inclusions	Large holes, of which 2 off center & 3 oval, ground as tube and separated from 1 another by abrading circumferentially grooves	Fired on substrate
5116 (343) 1 faience disc	No	Overall	Yes, near hole at 1 end	Blue-green, uneven thickness, patchy color	Ground	Fired on substrate
5432 (667 1 steatite	No, body surface cracks	Overall, flaking	No	Bluish green	Ground	Cementation
3 faience, 2 tubular & 1 disc	Yes, medium grains with some coarse, largest 0.9 mm.	Overall	1 tubular has none, 2 firing marks on 1 side of other, disc marks near hole	Blue-green	Undet.	Fired on substrate
1 Au foil covered bead tubular	Yes, fine polycrystalline, grey core	None	No	None	Undet.	Was the core fired?

individually worked and others could have been segmented from a preformed rod because of constant diameter and lack of facets, and rare occurrence of a ridge near but not concentric with the hole) to (2) beads with very little or no grinding where hand modeling is the dominant method of manufacture. Shapes vary from tubular, spherical, oval to a few shell-shaped beads. A difference in size is found between steatite and faience; faience beads tend to be larger probably because the material breaks more easily than steatite when drilled. Faience beads are difficult to form by the process of modeling and scraping followed by drilling on a scale finer that about 4 mm. because of the ease with which cracking occurs when wet or dry and because of their friable nature when dry. A 2 to 3 mm. size is common in steatite. The holes in faience beads also tend to be larger in diameter than those in steatite. Because faience beads break easily when drilled, the larger holes spread the load over a larger area, allowing grains to be plucked as opposed to abraided.

One would like to be able to report a gradual development from carved soft stone to glazed soft stone or sandstone to glazed crushed stone, but this is not the case. The concurrent appearance of a variety of processes for the manufacture of beads adds support to the ideas of Brunton[274] and Petrie[279] that the technology of glazing may have been imported, but the question of invention and diffusion is open. There has been no adequate study of Near Eastern faience and other early glazed materials.

12. PROTODYNASTIC AND OLD KINGDOM FAIENCE

Faience, chiefly from three Protodynastic (ca. 2920-2649 B.C.) or Old Kingdom (ca. 2649-2150 B.C.) sites, was examined. These sites are Abydos, Saqqara and Hierakonpolis. The two most common means of body manufacture are free modeling or modeling over a core, each of which are usually followed by a finishing operation which involved scraping or incising of the surface to

final form. In several examples from Abydos, two different colored body layers are used to emulate the color and texture effects possible in bas relief (for example, E.1764H, Figure 31i). The glazing method which predominates is that of firing an effloresced coating. There are only a few objects, about 30 in the Boston and Oxford collections, well enough preserved to unequivocally determine the method of glazing. These early objects display a greater degree of weathering than later period objects, and most of them are fragmentary. The means of decoration include inlaying or painting a brown colored slurry or pigment, containing as colorants manganese and iron oxides, onto the surface prior to firing. The presence of workshops with different styles or ways of working faience can be shown by comparing the remains found at Abydos with those of Hierakonpolis and Saqqara. Finally, the Protodynastic and Old Kingdom group exhibits strong technological affinities. The processes are more limited than during later periods but there is a greater diversity in how the basic technological corpus of information is used to produce a wide range of artifacts types, so that stylistically the faience from one royal site is very different from another.

Hierakonpolis: Of the 17 examples selected for examination from the first or second dynasty main deposit, 7 are solid glazed objects or statuettes, 2 are vessel fragments, and 7 are beads, and 1 is a plaque, (solid glazed objects: E.4, E.5, E.6*, E.7, E.16*, E.17*, E.191; vessel and probably jar lid, E.45 and E.4006, beads E.E.9 and E.E.26, and plaque, E.15*; no XRF was performed on those numbers with an asterisk). The standing baboon (E.5) and calf (E.4) are shown in Figure 32. The standing baboon rests equally well in a standing or walking posture. All of these objects have the appearance of having been modeled in a wet, fairly plastic state. There are no mold marks or imprints, and many of the objects have undercuts which would prohibit the use of molds. Although the general forms could be attained by modeling, the fine details could not be modeled in such nonplastic, pastelike material as faience. Furthermore, the

objects are unique; for instance, no two faience baboons have the same dimensions so far as can be determined. Fine details were formed by the subtractive process of scraping or grinding during drying or when almost dry. Inner surfaces exhibit scrape marks, for instance around the heads of the pelican (E.7) and calf (E.4) and at the tied feet of the calf. The calf exhibits only residual traces of glaze. The calf, seen in Figure 32d and e, reveals the great care and skill which was taken in defining the contours of each area. Areas are defined as convex volumes which meet along at lines defined by intersecting planes of those volumes. This is a reductionist approach to form definition, more common to stone than terracotta sculpture. This same approach is also used in E.6, E.7, E.11, E.13, E.14, and E.191.

The glaze on these Hierakonpolis objects is is quite uniform in appearance, light green, has a somewhat rough surface, and meets the criteria of an effloresced glaze. Firing and drying marks are present; there is very little or no glaze on inner surfaces and the glaze coating decreases in thickness gradually at the edges. Because of the scraping operation proceeded once drying had started and because of greater evaporation of water from those areas most exposed to the flow of air, less efflorescence took place on the inner, concave areas than on the convex surfaces, and there is now less or no glaze on these indented areas. The glaze on the seated baboon (E.191), and pelican (E.7) most clearly display this appearance. The seated baboon and the statue of a prisoner, a man in loin cloth with bound arms and looking upward (E.6), both have considerably less glaze on one side than on the other, probably due to orientation during drying. The thickness of the glaze bears special mention because it is thicker in the center of a glazed volume and gradually thins as the sculpted form turns into a concavity at the edge of the glaze. The presence of all these indications of drying in the fired objects is evidence of a glazed coatings formed by efflorescence, and that the glaze was fired to a relatively low temperature. If the glaze had been worn away, or weathered or had flaked off due to water accumulation in the body

beneath, then the opposite would probably have occurred, the outermost surfaces would have less glaze than the recessed surfaces. There is an interrelationship between composition and processing of the body which must be controlled for the efflorescent process to produce a reasonable thickness of glaze. Enough water soluble flux must be present so that even with handling and carving causing some of the efflorescent salt to be removed during drying, there is still enough flux to coat the object during the rest of the drying process. It is therefore interesting to find that those objects which do not have detail as fine or contours so sharply delineated are those with the greatest amount of glaze; for example, the standing baboons (E.5 and E.15) do have glaze in recessed areas, and the glaze is thicker on these examples, than on the calf. Also these examples have pronounced firing marks on the bottoms, for example the hind end of E.5 shown in Figure 32b.

The character of the glaze combined with the friable, porous nature of the bodies, indicate a lower range of firing temperatures than encountered in later faience objects. The glazes are pale green in color, although there are some white patches on the pelican and standing baboon (E.5), caused by deterioration of the glaze. The glazed surfaces tend to be semi-matt, rough to the touch, and barely translucent. These glazes contain many pinholes, some fissures where crawling has occurred and no evidence of flow (Figure 32a). Some areas of glaze contain hard, white, rounded inclusions, presumably quartz. Some of the Hierakonpolis statuettes have areas or lines painted in brown prior to firing. The appearance of these areas also supports a low firing temperature. Although one would expect these manganese and iron-containing areas to be more vitreous, there is no evidence of flow. These brown areas are raised from the general level of the glaze, but are in a poor state of preservation, as shown in Figure 32c, in a similar example from Abydos, the vase. The pelican's dark brown wing is the best preserved; it has a matt texture and is flaking. The brown was probably daubed onto the body as a pigment which contained very

little if any body material (later a mixture of crushed quartz, fluxes and colorant is used as a slurry so that the colorant will melt sufficiently to adhere to the body).

The body fabrics are friable, very porous, white and soft (MOHS hardness 2-3, except the Saqqara tiles which are MOHS 3-4 and the inner part of the lid, E.4006, which has a hardness of 1-2). An example of a typical body is shown in Figure 32c, in the model pillar (E.42) from the Temple, Abydos, Dynasty I-II. There are lots of spherical pores, and measuring, for example, 0.1-0.3 mm. in the pelican and 1.0 mm. maximum in the lid (E.4006, Figure 33b). There is also lots of intergranular porosity. The amount of porosity, given the range of grain sizes, is sufficient evidence to support the addition of an organic additive, such as finely chopped grass or a sizeable amount of gum or resin, to the body. This amount of porosity may also be related to weathering of the intergranular glass. (Black inclusions in the glaze in E.191 should also be investigated to find out their composition and possible relationship.) The range of particle sizes which occurs in these bodies includes a few coarse particles up to 0.5 mm. which occupy about 10-20 volume percent.

In order to show the variety of faience production from the main deposit at Hierakonpolis, a short description of some vessels and beads is included. The fragmentary jar lid (E.4006) with a spiral incised decoration, shown in Figure 33, is the earliest example found, and the only example from the main deposit, of a double-layered body; the inner sandy, reddish body either quartz with a minor amount of iron-containing clay or sand having a higher iron content than quartz. At the surface is a thin layer of fine quartz which is then coated with a glaze. The outer body layer is white, finer grained and seems to be less friable; whereas, the inner layer is reddish, coarser, very soft and friable. A few grains of body material detached after cleaning of the surface was complete were viewed at high magnification with the SEM, with the result that the place of calcium was identified in the microstructure, as shown in Figure

33a. The calcium-containing grain before fracture was embedded in the interstitial glass which holds the quartz particles together. Petrographic thin sections of faience bodies are seen to consist of alpha-quartz with occasional hematite, biotite or plagioclase grains, yet the location of calcium had been a problem. Other characteristics are in accord with the rest of the Hierakonpolis faience. The flat, two-handled, wide-mouthed vessel (E.45), similar to stone prototypes, has irregular depressions on the inner bottom surface, probable evidence of forming over fingers or a core. The outside of the vessel has been ground to shape and the glaze is thin. The holes were drilled, not pierced. Three firing marks are found on the bottom in a roughly triangular pattern. Six green glazed helical beads (E.E.26) are barrel shape but consist of a double spiral. One side of each of these beads has less glaze, is flattened and has firing marks, all good corroborating evidence of the firing of an effloresced coating.

Saqqara: From the Djoser or Step Pyramid and South Tomb (Dynasty III) are convex rectangular tiles which provide the first instance of large scale production and molding, an example of which is shown in Figure 35. These tiles provide the only possible exception to the conclusion of Protodynastic faience technology based on modeling and grinding. The tiles have been described as molded. The long dimension of the tiles is standardized to 6 cm.; while the shorter dimension varies from 3.5-4 cm. A photograph of one of these tiles is shown in Figure 34. By counting the number of tile holes per panel and panels per room from the photographs of Lauer[280], we arrive at a figure of 36,000 tiles. The variation in only one dimension may indicate that a crude mold was used; the tiles may have been made by pressing between two stationary sticks of established thickness into a depression, thus insuring the one constant dimension measured and a similar thickness. Even though these tiles may have molded, there is extensive hand work involved in grinding the protrusion on the back and in drilling a hole through each protrusion from two directions. The backs were

ground to leave a central rectangle protruding in relief, and a hole was drilled from two directions so the tiles could be strung on copper-containing wire prior to setting in the wall.

Two rectangular tiles with a convex exterior from the third dynasty Djoser pyramid at Saqqara (1954.669, and 1954.670) and two similar tiles from the Heb Sed Temple of Djoser (1937.115 and 1942.280) also at Saqqara were studied. The bodies of these tiles are composed of nonfriable or barely friable, white, fine and medium sized grains (0.2 mm. maximum grain size measured). There are no body layers. These bodies have little porosity (largest spherical pore measured 0.2 mm.). MOHS hardness measurements of 3-4 indicate well-sintered bodies. The glazes are in excellent condition; they are glossy, smooth and vary in color from copper blue to green often on the same tile. The color change is caused by differences in atmosphere of the kiln. There are few glazing defects: few pinholes, no crazing, and crawling only in one small area of 1942.280. The glazes coat the upper surfaces of the tiles. On 1942.280 and 1937.115 the glaze coats the sides and just wraps around the edges on the back surfaces. The sides of 1954.669 and 1954.670 have been ground, which tends to favor modeling, not molding, as the means of manufacture. There is no sharp boundary where the glaze coating stops, but a gradual decrease in thickness. Efflorescence is the method of glazing.

The reverse side of each of these tiles has been ground so that a central rectangular boss protrudes from the surface (the boss on the 1954.670 fragment has broken off). On the back sides of these tiles there is a colored glaze layer on the central raised boss, and the ground surfaces do exhibit a thin, clear, glassy layer with an occasional blue tint where thicker. The grinding operation took place prior to firing, because there is a glassy coating over the ground ridges. The succession of grinding operations can be clearly reconstructed in tile 1954.669 as proceeding from a long side of the rectangle sequentially counterclockwise. Tile 1937.115, however, seems to proceed clockwise, but only one corner has deep enough ridges to

certainly identify the order of grinding. The central bosses on these tiles are undercut; the indentation is rounded. The grooves in the back of the tiles measure 0.020 +-0.005 inch. The rounded shape of the undercut on the edge of the boss and the symmetrical shape of the grooves, lead one to conclude that a saw was not used to cut the tile to shape, but rather a grinding operation took place. Only two of the tiles (1937.115 and 1954.669) were complete enough to see that holes were double-drilled into the narrow width of the boss.

One may argue that cementation was used in addition to efflorescence to achieve a glaze on these tiles, because of the scant evidence of firing marks. Tile 1942.280 has a small accretion on the boss, and 1937.115 has a similar accretion on the front surface diagonally opposite the broken corner, both of which may be firing marks. The way a modern might replicate these tiles is to set the ground part of the back on 2 parallel supports during firing. The scant evidence of such a setting should make firing marks the object of search in further studies. Firing on a bed of powder cannot be discounted. Glaze durability also could be measured according to the procedure specified by Kieffer to determine into which glazing category these fit. The composition of the accretions should be investigated.

In summary, efflorescence was used and perhaps there was knowledge of a nonwetting substrate, though there is no direct evidence for cementation glazing. The problem of firing large numbers of tiles was present, and only examination of more tiles will reveal the solution. Finally, large numbers of these tiles should be measured to determine whether molds were used. Only 2 of these tiles at the Ashmolean Museum were complete enough to allow measurement. Other tiles at the Boston Museum of Fine Arts were also measured, and estimates of size were made from Lauer's photographs. (Hopefully, before this goes to press a large group of these tiles at the Fitzwilliam Museum in Cambridge will also have been examined and measured).

Abydos: Protodynastic and Old Kingdom faience production at Abydos displays great interest in polychrome and bas relief

techniques and also common is the forming of faience over a core. From the first dynasty tombs of Anedjib, Udimu, Djer and Semerkhet, small monochrome copper blue green vessels (E.1183 and E.3239, as sketched in Figure 31a and b) were formed over a core decorated with circumferential grooves ground into the exterior vertical walls, and roughly spherical vessels (E.3182 and E.1578 as sketched in Figure 31c and d) formed over a core with no ground decoration. From the first to second dynasty temple, there are polychrome vessels modeled over a core with the lips ground to shape and decorated with spots painted in a brown slurry (E.42 as sketched in Figure 31e). There is also an early example (E.35 in Figure 31f) of a polychrome vase made by a neriage or marbleizing technique. It was made by pressing or pinching and working together two different colored faience bodies by joining strips of alternating colors and forming them plastically into a striped spiral design, very similar to the Middle Kingdom vessel shown in Figure 36d. The flow of the body material in a counterclockwise direction can be observed by looking down on the ground lip. An inlay technique common in the Dynasty VI Temple of Pepy is present in many fragments (Figure 31g-l). Layers of brown and white body material as well as glazed surfaces are juxtaposed on three levels by in a bas relief technique.

E.E.1183 (Figure 31b) is a core-formed neck and lip fragment of a fluted vessel from the first dynasty tomb X of Anedjib. Vertical scratches were located on the interior wall. Many circumferential grooves and a flat lip were formed by grinding. The possibility cannot be discounted that a rotary method might have been used. The glaze is matt with greater glaze thickness on the exterior ridges. The glaze extends over the lip and into the interior of the neck. Therefore, the most probable method of glazing is by efflorescence, although the fragmentary nature of the piece does not allow examination of the base and thus better determination of glazing method. The color of the glaze on the ridges is blue green; the interiors of the grooves are yellow as is the inside of the vessel below the glaze line. The core is

purplish brown. The explanation of these unusual colors is the combination of Fe, Mn and Cu oxides in the body and glaze. The concentration of Cu is greater at the outer blue green surface (7% as compared to 1.9% at the yellow inner surface and 0.5 in the body). Mn and Fe occur in larger concentration in the body than on the outer surface. In replication attempts, MnO_2, Fe_2O_3 and also $CoCO_3$ were mixed with the body in 3, 5, and 10% additions, and analyzed before and after firing by energy dispersive x-ray analysis to determine the relative concentration of the colorant in the body as opposed to that on the surface. In each instance, the Cu concentration was greater on the surface both before and after firing, whereas the concentrations of Mn and Co were each greater in the body than on the surface both before and after firing. Fe varied, but in general had a similar concentration on the interior and exterior. Study of the transport of colorants through the body before and during firing should be undertaken.

The lip fragments from the first dynasty Abydos tombs of Udimu (E.3182, Tomb T) and of Djer (E.1578, Tomb O) provide an interesting comparison to the fluted vessel fragment cited above. These two fragments are from nearly spherical vessels and both were formed over a core (Figure 31c and d). The inside of the lip on E.1578 has a flaired opening, presumably so that the rod or armature could be withdrawn, and a ridge of body material protrudes on the interior of the vessel where the neck joins the body, a ridge which may be caused by the paste filling in the space between the armature which held the core and the internal core material. The core may have burned out during firing. E.3182 is a thin walled (2-4 mm.) vessel fragment, also core formed and having drips of paste on the interior of the neck probably from rounding and smoothing the neck with watery paste once the upper part or all of the core was removed. The bodies of both fragments consist of fine and medium grains with lots of porosity, an indication of the possibility of an organic additive. The exterior glazes can be described as having satin matt textures and were fired just barely to maturity. They are

smooth but not truly vitreous throughout, as the milky appearance belies. There is only slight efflorescence on the interior increasing near the lip to full glaze thickness, thus supporting glazing by firing a salt deposit.

The two fragments E.3239(a and b) form a part of a vase from the first dynasty tomb of Udimu (Tomb T). The walls of this vase are vertical and thick (7-10 mm.). Not enough remains of the vase to determine if the vessel was core formed. This example is of interest because of brown linear inlay set circumferentially in the wall, as shown in Figure 31a. The broken cross section reveals a mixture of white and brown grains in this inlay which is flush with the vessel surface. A coil or slurry was probably pressed into the surface when the vessel was quite wet as there is no separation between the inlay and body which would be caused by incising a partly dry body, inlaying the wet paste and then during the course of dry shrinkage differences causing the two to part.

The next group includes four vessel fragments, including the one shown in Figures 31e and 32c left, which span the first and second dynasties (E.36, E.40, E.42 from the Temple at Abydos and E.658 from Tomb V of Kha Sekhemwy). The exterior surface of each of these has been dotted with a pattern of brown daubs which are roughly oval in shape. These spots are raised from the surfaces of the light green glazes. No glaze layer is beneath the brown areas which in cross section continue all the way to the body but do not penetrate it. The brown layer is inhomogeneous, containing white and brown particles. The glaze has a rough surface with pinholes and fissures where crawling has occurred. E.42 formed over a rod; however, only the bottom section remains. E.658a (Figure 32c, right) has no interior hole and is now a half round shape; E.40 is too fragmentary to specify manufacture, and E.36 has a ground lip and fairly thick walled body. These fragments share a common body appearance, that is, white, friable, soft (MOHS hardness 2-3), coarse grained (0.5 is the maximum grain size measured in E.42) with lots of porosity (spherical pores measure 2.0 mm. in E.658a).

Finally, the bas relief technique eloquently used in inlays from the sixth dynasty Temple consists of a two or three layer structure, with each of the underneath layers exposed. In several examples (E.1765H, E.1764H, E.1766, the anubis tail; E.A. 526, the "IB" hieroglyph, and E.1767A, the tip of the lotus petal), there are three layers: a coarse brown clay and sand containing layer is coated with a finer white layer, chiefly consisting of quartz. Part or all of the white layer is coated with pale green glaze. Brown lines are inlaid into some examples with the glaze layer. Sketches of some of these can be seen in Figure 31g-1. This complex technique allows the juxtaposition of areas of different depths which contrast in color and texture. The white body is exposed and shaped by scraping in E.1765F; whereas, in E.1764H the white layer is inlaid as blocks into a brown background material. There are indentations in the brown layer which may have once contained some of the white inlay. On the back of this brown layer is a cloth impression, indicating that the body material was formed on cloth. This technique is quite common during the Middle Kingdom at Kerma and Abydos. E.1769C and E.1765F are examples where only a white body is used beneath the glaze and in those areas which have been ground free of glaze. E.1765F has two straight, parallel lines scratched into the body. The highly porous nature of the body has attracted dirt onto the surface of these stripes which cannot be properly called inlay in this one case. The brown material is inlaid in E.1767A, E.1765H, and E.A.526.

Where the white body layer is thin, the glaze layer is either very thin (as on E.A.526) or has almost disappeared (as in E.1764H). If efflorescence is the method of glazing, then one would expect a thin coating of flux to effloresce from a thin layer of white paste, only if the brown layer did not contribute to any significant extent. This requires further study of the overall compositions of the three types of materials. There is never any glaze on the brown surfaces. The glaze which is present ends fairly abruptly at the edges of the white body areas, or in the case of E.1769C just wraps around the bottom

surface upon which the object was placed to dry. To attempt to reconstruct the processing of these reliefs, one must hypothesize that the white layer was laid upon the brown layer, that the white was shaped during the early stages of drying, and a brown material darker than the substrate was inlaid into channels in the surface. Salts effloresced on the surface of the reliefs. Where no glaze was wanted the salts were wiped or washed from the surface, or the brown material was prefritted and no soluble salts were present. E.767A exhibits evidence of grinding or scraping on the sides of the white layer where there is no glaze. A line has been scribed through the effloresced deposit on E.72 and in the tail of the anubis, E.1766, and there is no glaze where the lines were scribed. The edge of the glaze would not be rounded but would appear chipped if such a sgraffito technique were employed after firing, such as one finds at a later date on an object from Lisht[269]. These reliefs would have been quite remarkable in their complete and assembled state, but to understand their manufacture further study is necessary.

The structure of the brown substrate of the IB hieroglyph is very similar to the reddish body in the lid from Hierakonpolis, as shown in Figure 33. Fused areas high in Ca have been identified in addition to high Si-containing grains, presumably quartz, and areas rich in a layered structure with an Al:Si ratio of about 0.6, presumably clay. No sample of the brown material which has been inlaid into the surface of the glaze was tested to determine if the inlay contains the same material as the substrate.

Objects from the First Intermetiate Period: During the First Intermediate Period (ca. 2150-2040 B.C.) the same manufacturing methods and techniques continue. The neriage or marbleizing technique is represented in a biconical bead (E.E.98A, black on copper blue-green, Mahasna, M319), shown in Figure 31m. The copper-containing body material was wrapped around a rod, then a coil was attached at the center or widest part of the bead. The bead and coil were rolled together, forming a spiral which changes direction at the widest dimension

of the bead. There is an overall glaze with firing marks on the side which flattened during the initial stages of drying. The glaze was formed from an effloresced coating. Modeling by pinching over a finger, a precursor or forming on a rod, is shown in a weathered, green vase from Hammamiya (1923.489, grave 1648), which has wet forming marks on the interior. One side is more heavily glazed than the other, and there is little glaze on the interior. There are firing marks on the bottom. Efflorescence is the probable glazing method. Another vase, heavily weathered with only a few patches of green glaze left, from Hammamiya (1923.557, grave 1509) was formed in a similar way, and the lip was ground so that the top is flat and the shape hard edged.

The hippopotamus from Mahasna (E.1784, grave M560) continues the tradition first observed in the falcon, in which a solid form is modeled and then scraped and ground to shape. Between the base, legs and stomach are multiple grooves, evidence of scraping. The glaze is heavily weathered to near matt appearance, and displays evidence of flaking and pitting, so that the method of glazing is indeterminate. A type of bead, often called a crumb bead, is represented from this period (Mahasna, E.E.92(ii)B, grave M587), and shown in Figure 31n. A bluish-black biconical bead with a central band of green glass and rounded, white quartz fragments, this bead was probably made by rolling a pad of the dark body material onto a rod and then rolling it in a powder of raw materials which were probably partially fritted and ground to a powder. The seam where the pad of body material joined is still visible at the ends of the bead. It is unlikely that quartz particles would be so rounded during a single firing.

Summary: During the Protodynastic and Old Kingdom Periods, the manufacture of blue-green stonelike materials is greatly expanded, as shown both in the size and variety of objects, but the prime technology remains one of modeling, surface grinding and daubing with slurry. The prime glazing method is the firing of efflorescent salts. The adding of an intermediate body layer is rare as are such techniques as forming on a rod, inlaying, or

creating a marbleized appearance by working together two different colored bodies; only one or two examples of each technique was found. The use of a simple mold for the Saqqara tiles is probable, but needs further investigation. Once the wet faience body was modeled roughly to shape, extensive scraping and grinding of the surface was carried out. The final forms of the objects rely heavily on lithic techniques of surface reduction, to an extent not seen in later faience as techniques for molding and decorating surfaces replaced scraping and grinding. The glazing method found in this study was the firing of efflorescent salts. There is no Protodynastic or Old Kingdom object surveyed in either the collections in Oxford or Boston whose manufacture cannot be explained by efflorescence glazing. The question, however, is still open and more information about other collections must be researched. All that can be stated at this time is that of 128 objects, efflorescence was determined to have been the glazing method.

12. MIDDLE KINGDOM AND SECOND INTERMEDIATE FAIENCE

During the Middle Kingdom (2134-1783 B.C.) faience manufacture can be characterized as a technology in which technical knowhow is applied to the production of many types of objects as was also evident during the Old Kingdom, and in which developments take place in the various ways faience can be made and glazed. At this time faience manufacture is a 2000 year old craft tradition which is well established, but certainly not stagnant. Glazes are more durable and have brighter hue; bodies are less friable, indicating better control over composition and firing. In this period are displayed a large repertoire of body-forming and decorating techniques, as summarized in Table XLI, and the first clear evidence for all three glazing processes. The body forming techniques remain quite conservative and include: modeling, molding on a form, forming on a core or rod, marbleizing, and layering to cover off-white body material

(Figures 36,37 and 38). In addition, there is evidence of experimentation with manganese as a purple colorant in bodies as well as painted onto the body. A survey of marks from setting faience on various supports in a kiln also shows great variety, indicating possible experimentation with powder as well as the more traditional kiln furniture.

In this period, more interest in surface decoration develops than evident in previous periods, and many decorative techniques are used. During the Old Kingdom, surface decoration is limited to the occasional daubing of small areas with slurry or the few instances of inlaying of areas with what is probably a dark body material. Faience of the Middle Kingdom was often decorated by painting linear designs with a colored quartz-containing slurry which vitrified to have the same luster as the rest of the glaze unlike the Old Kingdom faience (Figure 36a). Other techniques include painting with a pigment wash (Figures 38 and 36d, right) rich in iron and manganese oxides and without the addition of body material, yielding lines of a more painterly quality than lines painted with a slurry of colorant and body material. During the Second Intermediate Period (1783-1550 B.C.) from Kerma are examples of incising channels in the body material and either leaving the channels as decoration or inlaying the channels with faience body material in the form of a paste, a technique common during the New Kingdom. Another technique found at Kerma is the resisting of an area, followed by application of a dark iron-manganese oxide wash over the blue glaze (Figure 38d).

All of these decorating techniques are consistent with an effloresced glaze except one (resist), and each would have been carried out before the object dried so that the effloresced salts would not have been removed from the surface by a liquid or so that the added slurry or paste inlay could shrink at the same time as the body. Resisting a surface so that water will not penetrate the resist can be carried out only if an object is dry, and from the fresh quality of the pigment and subtle variations in pigment intensity related to brush stroke and to build up near the edge of the resist coating (Figure 38d), the argument can be

made that a glaze had already been applied prior to the resist
and pigment. Cementation destroys this quality of line due t
the flow of the glaze. Thus application is the only metho
possible for a glaze with resist decoration. There is also mor
direct evidence for the application of a glaze in the form o
drips of glaze and random patterning of glaze on the backs o
tiles from Kerma (Figure 37d).

Examples of Middle Kingdom forming methods show an increas
complexity beyond those used during the Old Kingdom, but no grea
differences in kind. The execution tends to show a greate
familiarity with the limits of the material, and the product i
more uniform and durable during the Middle Kingdom. Fo
instance, forming a vessel on a core is rare in the Old Kingdom
but is common during the Middle Kingdom (Figures 36a,b,
31p,q,s,v). Onto a rod, the faience body was pressed, and then
the rod was removed once drying had started, or if the core coul
compress or shrink as the body shrank, then the removal of th
rod could be carried out later, during or after firing.
(Shrinkage in replications can vary from about 4-10% depending o
particle size distribution of the body.) Some spherical shape
were formed over spherical cores placed on the end of a rod. On
possibility for such a core is a wound ball of grass which ma
have been placed over the end of a rod, or a bag of sand which i
emptied during drying, as Reisner suggested[257]. There are n
cloth or matt imprints found on the interiors of vessels, as have
been found on tiles both from Abydos and from Kerma. Often time
the vessel interior, and thus the core, is small, the body i
thick and outer form does not conform to the inner form, as in
Figure 31q. Perhaps, either small holes were desirable fo
precious substances or stone vessel shapes which have small hole
influenced the faience aesthetic.

Another forming method common during the Middle Kingdom wa
molding parts, such as a bowl, onto a form and joining these
parts with a slurry of body material. The bowl shown in Figure
36a left was formed over a male mold which probably resembled a
hemisphere. The fragmentary vessel in Figure 36c was formed by

oining two hemispheres with slurry and by attaching a preformed
ip with slurry. In Figure 36d are examples of the mixing and
orming of two different colors of body material so that a
arbleized effect is attained (Figure 36d, left). There is only
ne example of this marbleizing process from the Old Kingdom, but
any from the Middle Kingdom. Another process involves the
nlaying of faience paste of one color into channels hollowed out
f the faience of another color. The quality of line is such
hat the edges tend to be much sharper or more distinct than
ainted lines. This process is carried out when the faience is
uite wet. If an inlay were made into a fairly dry body, the
nlay would tend to shrink away from the rest of the body. This
eparation of inlay from the rest of the body occasionally occurs
n the Middle Kingdom, but is used regularly in the New Kingdom
s a controlled decorative effect to produce a dark shadow which
utlines the inlay (Figure 40c,e).

Application of a white surface layer over a grey body is
lso commonly observed in Middle Kingdom bodies. Reproductions
how that it is possible to effloresce sufficient salts from only
he surface layer, in which case the composition and
icrostructure of the interstitial glass in the white layer may
e different from the interior of the body. However, in examples
rom Abydos and Haraga the intermediate layer tends to be quite
ranular and as friable as the body. In an example from Kerma in
igure 38f, the greater glassy fraction in the intermediate layer
istinguishes intermediate layer from the inner body material.
ifferences in composition and microstructure of the intermediate
ayer from the body may serve to distinguish different groups of
aience.

One can study the three glazing processes by looking at
epresentatives of fairly large groups of beads from Abydos and
f tiles from Kerma (Figure 37). In Figure 37b, a melon bead is
hown to illustrate the efflorescent method of glazing in which
ess salt effloresced on concave surfaces. Cementation is
xemplified in the overall green glazed beads in which no firing
arks occur on any of the beads of this type (Figure 37c).

Application of a glaze slurry is exemplified on the tile from Kerma (Figure 37d) which has two drips down one edge. The appearance and composition of the glaze show that this glaze was quite viscous at temperature and could not have flowed in drips during firing. In addition the random flow of glaze over the backs of some of the tiles from Kerma demonstrate application as the means of glazing (Figure 38b).

The Manufacture of Beads: The study of the forming and glazing of beads was based on many examples from tombs and graves at El Kab, Abydos and Haraga. From Abydos are three groups of beads which have a semi-spherical shape which is more bulbous at one end than the other (E.E.480, E.E.481, and E.E.478, all tomb E.3). At the more bulbous end of each of these beads is a round hole, and at the other end of these beads is a hole surrounded by a crack, as shown in Figure 37f. H. Beck's excellent study of bead classification[282] falls short of a description of this semi-spherical shape. Replication studies helped explain the form characteristic of this collection of about 75 beads. These beads were formed by modeling, and then, when still wet, piercing the bead to form a hole from the more bulbous end. The shape is characteristic of the behavior of faience when formed. The lack of plasticity of faience is demonstrated in this shape. Perfectly spherical beads of faience are difficult to form when the hole is pierced, and much simpler when the hole is drilled and the body material does not deform. As the hole was begun in these semi-spherical beads, the body material compressed enlarging the diameter of the bulbous end and decreasing the length of the bead. The bead elongated at the end where the point exited. As the point exited, the faience surface developed a tensile crack consisting of a two, three or four pointed rip (a three point crack is shown in Figure 37f). The forces exerted in making the hole are localized because the material cannot deform to relieve the stress, whereas in a clay the more plastic body deforms allowing the localized stress to spread over a greater volume and thus the passage of a tool without cracking the body. It is difficult, though not impossible, to rapidly form clay

beads of this characteristic faience shape; whereas, it is equally difficult to form spherical faience beads without drilling the hole when the bead is dry. With some degree of certainty based on replication studies with bow and pump drills, the statement may be made that drilling a hole is a more time consuming process than piercing a hole. From the Middle Kingdom there are very few examples of spherical beads with drilled holes (one such example is a bluish black bead with a rough, white speckled surface probably caused by quartz particles protruding through the glaze, 1913.405A, Abydos, tomb D166)

One group of green semi-spherical beads made by the technique described above and glazed by a cementation process (E.E.478, Abydos, tomb E.3(32.W)) measure 9-11 mm. in length and 10-12 mm. in diameter (Figure 37c), adhering to fairly close tolerances. There are no facets on the surfaces of the beads, indicating care in manufacture. The glaze is translucent and thicker on one side of these beads, and in small submillimeter size patches the glaze appears darker because the glaze extends into a pore or hole in the body. The translucency, flow and body-glaze interaction characteristics indicate a considerable reaction of the glaze with the body, and it is likely that a fairly high temperature was reached. Some of the beads have glaze inside the holes. There is a lack of drying and firing marks, making the cementation method of glazing most probable. There is crazing, a fine mesh of hair line cracks, of these glazes, which in addition to the texture, presence of surface salt deposits visible with a microscope and light green color, indicate that weathering has occurred. The melon beads glazed by the efflorescent method (E.E.481, Abydos, tomb E.3) are less weathered, and a single bead will vary in color from green to light blue, indicating a mixed oxidation state during firing. The glaze contains many quartz inclusions and pinholes, probably indicating a lower firing temperature or less flux. Each of this group of about 41 beads has 5 or 6 indentations which were formed probably before the hole was pierced. Piercing a hole in a bead of with such large variations in wall thickness causes the bead

to deform or crack. There is more variation in the relative size of these beads than with other groups. of beads. The efflorescent method of glazing is indicated by the drying marks, less glaze effloresced in the interior of the indentations, and by the presence of firing marks. Another group of beads (E.E.480, Abydos, tomb E.3) consists of a majority having an opaque, bright blue glaze with less luster than the other two groups, no crazing, more pinholes and cracks where the glaze has crawled than the other two groups, and a few beads which have weathered to light green. These group of beads measure from 9-12 mm. in diameter and 8-10 mm. in length. The beads were glazed most probably by firing an effloresced coating to the low end of the firing range. Many of these beads have from 2 to 4 firing marks. The cracks, or fissures, in the glaze are similar to those produced when the effloresced layer cracks or chips prior to firing and the surface tension of the glaze pulls the glaze back from the crack or chip (an example of such a chipped area is shown in Figure 25b and an example of a crack formed before firing occurs in Figure 25a and in the vessel fragment, E.E.3305, Abydos, tomb 416, sketched in Figure 31o; examples of both faults occurring on the same object are the bottom of the base and side of the head of the child figurine, E.2199, Abydos, tomb E303). One other bead is worth mention because it has rounded quartz particles held on one end of the bead with a copper blue-green glass similar to the crumb bead described from the First Intermediate Period and firing marks about 120° apart on one side (E.E.633C, Abydos, tomb 416). The quartz particles and fluxing material were applied to the end before firing.

Tomb 416, Abydos and the Use of Intermediate Layers: A large group of vessels and fragments of fairly homogeneous manufacture from tomb 416 at Abydos were studied in order to characterize the problem of the application of a fine, white intermediate layer between the glaze and inner grey or tan colored body, first discussed on page 13 of this appendix. One would like to know the purpose of the layer as well as the means of application of this layer to the body, whether the layer was

wiped on as a paste or whether the body was dipped into a slurry. With very few exceptions, where there is a white body, there is no intermediate layer, and where there is a colored body and blue/green glaze, there is a white intermediate layer of finer particle size than the body. In one example of model fruit, a cluster of grapes, a dark purple glaze coats a purplish white body with no intermediate layer. From this one can conclude that the white intermediate layer was applied only beneath the copper blue-green glazes and that it served primarily to cover an off-white body which was colored with iron, manganese and copper oxides. This layer prevents iron and manganese from migrating into the glaze during drying or firing and causing the copper-colored glaze to darken. The white layer will only brighten the color of the glaze by increasing the reflection of light from such a white background if the glaze is translucent, and only two of fourteen glazes are translucent. There are no microstructural differences in the degree of sintering of the body and intermediate layer in these examples which would indicate that the white layer was added to increase the strength of the body. The intermediate layer is not necessary to provide a smooth surface for glazing, as smooth surfaces were obtained without this layer. Whether supplies of white quartz were limited cannot be determined, but there are more examples at this site with a white body and no intermediate layer than examples of colored bodies with an intermediate layer. According to the criteria for glazing method, efflorescence can be shown to be the method of glazing in most of these fragments. It is suggested that craftsmen were aware that iron and manganese do not migrate as completely as do copper colorants during the drying and firing processes, and that the white intermediate layer was added as a means of color control.

Particular examples from tomb 416 are considered below. There are four examples with a brownish white or bluish to purplish grey body coated with a white intermediate layer, measuring from 0.1 to 2 mm. thick (E.3286, E.3279, E.3285 and E.3305, all Abydos, tomb 416). In some examples, such as the

fragmentary lion (E.3286) which is a solid object formed by freely modeling the shape, the intermediate layer is very uneven, indicating that some areas were reworked after the intermediate layer was applied. The inner body material contains areas which are a bluish grey and some which are a purplish grey, perhaps indicating that the body material is a mixture. The intermediate layer contains white particles finer than the inner body and having little glassy fraction. In the vessel fragment with a lotus design (E.3278), the intermediate layer has a much more even thickness, 1 mm. on two sides and about 0.1 on a third side. The inner body is brownish white and more homogeneous than the lion fragment. Two other examples with a white intermediate layer about 1 mm. thick are a pedestal (E.3285) having a purplish grey core and a vessel fragment (E.3305) having a bluish grey core. Manganese is the oxide primarily responsible for the purplish grey inner body in the amount of about 0.3, and is coupled with about 0.5-1.0% iron oxide. About 0.25-0.5% copper oxide coupled with iron oxide is responsible for the bluish grey core. About 0.5% iron oxide is responsible for the brown colored body. How the intermediate layer was applied cannot be determined, nor can the production of the grey bodies. Iron contamination in sand is possible, but manganese and copper are probably deliberate additions. It is suggested that these bodies represent the reuse of materials made in the workshop.

The other group of fragments from tomb 416 consists of nine fragments with no intermediate layers. In two instances the faience glaze is white, crazed and translucent and the bodies are very friable (E.3303, possible a model, and E.3304Q, a vessel fragment). In two instances the glaze is blue, uncrazed and opaque, and the body is white (E.3282, plaque with animal, and E.3288, vessel fragment). And in the last three instances the body is lightly colored bluish or greenish white from copper and the glaze is blue, opaque and uncrazed (E.3287, statuette, E.3288, vessel fragment, and E.3302F, leopard). In two other instances the glaze was dark purple almost black or a speckled brown from two different concentrations and oxidation states of

manganese and minor amounts of iron and the bodies were purplish or brownish grey.

The methods of manufacture represented in tomb 416 consist of the modeling of solid objects and molding of open forms over a hump mold or core, frequently followed by a scraping or grinding operation. The firing temperature of these fragments is generally in the low range, as evidenced by fissures and pinholes in the glaze, edges of which have high curvature, indicating very little flow of the glaze. Drying marks, the decrease in the amount of effloresced product and thus glaze on the inner surfaces, are pronounced on those objects with the greatest relief (E.3287, statuette; E.3289, model fruit, and E.3285, pedestal). The gadrooned (that is, having parallel convex ridges like the melon beads considered above) vessel fragment (E.3288) has a thin wall when estimating the size the vessel would have been from the radius of curvature. There is lots of porosity in the body particularly on the inner facing side of the body, supporting molding as a means of forming. The gadroons were probably formed by scraping, once the vessel was molded, although there is no direct evidence of grooves. There are firing marks on the side of this vessel. The animal plaque (E.3282) has evidence of scraping as the legs are narrow and one is undercut and grooved. This plaque has a part of an arc-shaped firing mark on the backside, and a black band painted along the edge. The model lion (E.3286) also has a firing mark on the base, and dark blue painted lines. There are firing marks on the sides of two pieces (E.3305 and E.3303), and on a side near the base (E.3285). These firing marks on the sides of objects indicate either that the object was fired on its side, that two pieces touched one another or that powder was placed partially or wholly around the objects. Some firing marks are elongated and have formed circumferentially around a region of curvature, so it is unlikely that two pieces touched one another during the firing. Firing an object on its side is in itself an unlikely ceramic practice, unless a powder was used and expected to work.

Use of Manganese as a Colorant at Abydos: Although it

is not possible to detail all of the processes being carried out by craftsmen, it is possible to discern certain areas where craftsmen were focusing their attention. One of the areas where I believe there was such a focus in the Middle Kingdom is the use of finely powdered manganese as a colorant. In addition to being used decoratively as a colorant painted onto an object either as a slurry with body material or solely as a wash (E.E.3279, vessel, Abydos, tomb 416, Figure 31p; E.1750 and E.1751, tubular beads with spiral decoration, Abydos, tomb E30, Figure 36d, left), it is also formed with the blue colored body material into a marbleized pattern (E.2176, vessel, Abydos, tomb E3, Figure 36d, right), and it is used solely as the colorant for a body. And it is at least possible that we are seeing some experiments which dead-ended with the objects produced. Manganese is being used in the body to affect the overall color of the glaze in two examples; iron is also present in a ratio of 1:5 to 1:20 in these glazes and does not much affect the color of the glaze. In the model grape cluster (E.3289), a piriform-shaped white core with no hole is surrounded by individually formed spheres, similar to beads. These are attached to the core and to one another without the aid of a slurry. The color is a saturated dark purple and appears black at first glance. There is 5% MnO_2 in the body, when half that amount would have achieved the dark purple of grapes. The grapes are mostly matt in texture, while a few at the outermost surfaces have glassy surfaces. The glaze was effloresced. The lack of migration of manganese colorants from the interior to the surface experienced in replication studies and seen in this example explains the dark body color. If manganese dioxide, MnO_2, is reduced to MnO, instead of purple a brown color is produced; likewise if the manganese is held at temperature for a length of time the manganese will tend to turn brown. In the vessel fragment (E.3306) the glaze is brown, speckled and has an orange peel texture. The manganese concentration is about 2% in the glaze. What I think we are observing is the manganese colorant concentrated in coarse particles which were not ground finely enough to go into solution

to produce an overall purple color, and which were either fired for a long time or held in a reducing atmosphere toward the end of the firing. The body is colored a purplish grey. This object may represent an experimental effort to produce a purple colored body which failed. Only destructive analysis of a small fragment could determine if this opinion is correct.

Another object which might be taken for such an experiment is the beautifully shaped and ground lion (E.2183, Abydos, tomb E3) with a glaze which is in terrible condition. It is splotchy consisting of blue-green and reddish brown areas, and there are bubbles and craters at the surface. This object has probably been in a post deposition fire in which a reduction atmosphere reduced the blue CuO to red cuprite, Cu_2O. Between 1 and 4% copper oxide is present in the glaze, far more than would be present in socalled copper red glaze. In each such example the reddish brown color formed with copper oxide upon visual examination can be established as not intentional.

One other example of the use of a purple colored body should be discussed. The neriage or marbleizing process, in which bodies of two or more different colors are pressed together in bits or layers and shaped by pinching and other forming method, is exemplified in a vessel (E.2176, Abydos, tomb E3), shown in Figure 36d, left and Figure 31v. The characteristic which identifies this process is that the colors (with the exception of copper colorants) continue into the body and if the different colors are of sufficient size then the pattern continues through to the other side, allowing for a certain amount of flow. The characteristic which differentiates this process from the inlaying of one color paste into another color body is that the boundaries between the two colors are not as distinct and there is evidence of flow in the marbleizing process. In this example the pattern runs through the body from the outside to the inside. The method of manufacture can be specified as follows. The wall thickness is uneven, although the interior and exterior shapes are similar and there is a sharp angle where the inner wall meets the base, indicating that the vessel may have been pinched over a

finger or rod. The base is slightly rounded and there is very little glaze on the base and interior, indicating that efflorescence was the probable method of glazing. A little glaze has formed at the edge of the bottom due to the rounded base. The surface of the glaze is quite rough and many pinholes are present. It is very difficult to determine how the vessel was fired because there are many firing marks, one on each of two sides, on one edge of the lip as well as rough areas and an embedded quartz particle on the interior. It is possible that the vessel was fired inverted, and it is also possible that the vessel may have been placed in powder. The drying marks and viscous, orange peel texture of the glaze with numerous pinholes argues that the glaze was not deposited from a glazing powder, but the case of firing is far from resolved. In summary, from the objects which display the presence of manganese in the body material and are covered with a white intermediate layer, from the not quite successful attempts to color the glaze surface with manganese, as well as from the presence of the marbleizing technique, it seems probable that craftsmen at Abydos were experimenting with manganese as a colorant.

Firing Marks on Vessels, Staff Heads and Other Objects: The use of kiln furniture is well documented in objects from the Middle Kingdom. The staff head (E.2172, Abydos, tomb E3) gives clear indication of setter marks, as shown in Figure 31s. There are three distinct marks, a worn patch and a central area where contact with a surface during firing is indicated. The object was formed over a core and has internal scrape marks which might possibly have been incurred after firing. There is a fine, white intermediate layer over a bluish white core. A similar object is the staff head (1913.755, Haraga, house ruin 530, Dynasty XI), shown in Figure 31t, which has two firing marks from a stilt and the possibility of a third where the glaze has worn away. This body also has a friable white intermediate layer over a bluish grey core. Each of the above examples has point contact between the support and faience, indicating that the faience was set on small pointed lumps of material during firing and possibly during

drying.

Another design of setter is indicated by arc shaped setter marks. For instance, the ring stand (1981.950, provenance unknown) has a three-contact setter mark on the bottom, as shown in Figure 31u. The contact areas are elongated and are shaped like arcs of a circle, indicating that a ring-shaped setter may have been used. The fragmentary animal plaque (E.3282, Abydos, tomb 416) also has a partial ring shape on the bottom with signs of glaze breakage along the length, indicating a ring-shaped setter was used as a support during firing. The body has a fine white intermediate layer on top of a bluish grey core. Another example is the vessel (Newbury Loan 94, Haraga, grave 7) which has firing marks on the side a short distance from the flat bottom, shown in Figure 31w, indicating that a setter too large to fit the base may have been used. These examples clearly demonstrate that objects were set on three and perhaps four point kiln supports of two different designs during firing.

These firing marks described above are the only ones present on the objects, and they contrast with those on other objects, where there are large areas with firing marks or multiple firing marks on different surfaces of the object. For example, the pedestal (E.3285, Abydos, tomb 416) has no firing marks on the bottom and firing marks along one side close to the bottom, indicating that the object was fired on its side. An example of multiple firing marks is the marbleized vessel (E.2176) described above which has firing marks on the lip, two concave areas on the sides and perhaps on the interior. Several examples of vessel fragments (E.3305, E.3288, E.3303, Abydos, tomb 416) also have firing marks on the sides, indicating either that they were placed on their sides during the firing, an unusual practice leading to marks on the sides of the vessel, or that the stacking of objects may have been practiced. The model cucumber (E.3790, El Kab, grave 1) has one firing mark at each end but they are not at the lowest point where the object would naturally sit. Also these marks cover a considerable area, indicating that the support was not a single pointed object which held its shape

during firing, but may have been a powder support.

From these examples, one can conclude that considerable experimentation with support for the faience objects was being carried out. Clay and faience body material if used as supports would be wetted by the glaze when molten and would adhere when cool. When broken away from the faience object, it is as likely that the object would break as the support. This is certainly the case in replicated objects. The hypothesis that nonwetting materials were investigated and used as supporting material rests on such evidence as the appearance and location of support marks which cannot be explained by the use of setters. For instance, the appearance of the cucumber or marbleized vessel could easily be explained if they were fired on their sides and settled into the surrounding powder due to the weight of the object. As the powder would shrink during firing the weight of the objects would settle where the present marks occur.

El Kab, Anomalies: The material from El Kab is in general quite heavily weathered, and presents difficulties in trying to make observations of technological value. In addition, many of the objects are heavily restored, glued and rebuilt. However, this faience is chemically anomalous. Most analyses show the presence of Zn, Pb and Co. Some of the objects are glazed black, and many of the cores are yellow, brick red or brown. Some of the beads appear to be imitations of poor quality lapis and contain many white large quartz inclusions (E.E.121). There is a chemical continuity from the Old Kingdom, but little to separate the objects from the rest of Egyptian production on technological grounds. The vase (E.381, tomb C, Dynasty IV, Old Kingdom) has an iron-rich brick red inner body coated with a friable white intermediate layer and was probably formed by pinching. A similar body material is used in such beads as the spherical bead with drilled hole (E.E.169, grave 85, Dynasty XII, Middle Kingdom). Efflorescence glazing is demonstrated in the statuette (E.3788, grave 1, Dynasty XII) or the bracelet (E.3789, grave 1) in which there is less glaze effloresced on indented surfaces. There are firing marks on the bottom of the statuette and on one

flat end of the bracelet. There are pinholes and fissures in both glazes, evidence of a low firing temperature, and both have white bodies as seen through holes in the glaze.

Summary: This study of 229 faience objects from the Middle Kingdom and Second Intermediate Periods revealed a conservative technology based on a 2000 year tradition which encountered relatively little upheaval due to socio-economic or political and military instabilities. However, there is a gradual development of forming techniques, shapes and glazing methods, and a probable increase in the amount of experimentation with materials and processes. Molding, use of intermediate layers, use of manganese in different ways as a colorant, setting and stacking ware in a kiln and the probable development of cementation glazing are examples of experimentation. In support of the development of powder supports and cementation glazing, both of which involve a knowledge of the nonwetting properties of calcium oxide and control of calcium compounds in various compositions, Kacymarczyk finds the range of CaO:CuO values narrows and stabilizes from the Middle Kingdom (this text, p. 181-182). Such experimentation and innovation produce a more brilliant and durable product, an increase in the repertoire of technological skills, and by implication, an increase in understanding of the technology. This increase in understanding essentially means an increase in technical sophistication.

The question of intent must be addressed. The developments outlined above in no way mean that a craftsmen intended to invent a new or better way of doing something. Instead, these are developments which seem to occur naturally in working with the material and in making the best possible piece of faience. What is needed is investigation of what constitutes an excellent object (well crafted, beautiful, etc.). What is the sense of aesthetic value which makes one object good or useful or beautiful and another not so? Within this framework must be fitted ideas of intent and technological change. From investigation of the objects and the probable remains of factories is found support for the contention that variety, high

quality and fairly large quantity characterize faience from these periods. With the beginnings of the preparation of glazes by premelting or calcining and the better control of composition are laid the foundation for the later development of glass technology.

13. NEW KINGDOM FAIENCE

Study of 232 faience objects from the New Kingdom (1550-1070 B.C.) revealed that molding replaced modeling as the primary means of body manufacture, and that glazing technology was modified, although efflorescence seems to be the prime means of glaze production. The (1) greater MOHS hardness, (2) more vitreous structures viewed by SEM, (3) colored glass fraction observed in thin section, and (4) small particles of colored glass found in some friable bodies are all evidence that with the introduction (either from within or without) of glass into Egypt, glass was added to some of the faience bodies and to inlays in faience (an idea first proposed and investigated by Kuhne[2]). The increase in the fraction of glass served to promote formation of the glassy phase and thus yield harder, stronger bodies. Formation of a glaze by combining the efflorescence method with an addition of premelted and ground glass was carried out in replication studies. In addition, in some instances colorants, such as lead or calcium antimonates, were incorporated into the faience in the form of premelted glasses. The use of a mixture of colorant and glass allowed the dispersal of the the colorant and an overall reduction in the amount of colorant used to produce a certain color. Thus the use of glass in faience promoted experimentation which extended the color range of faience.

There is a great variety in the body fabric of New Kingdom faience, and there seems to be design in the use of various bodies for various purposes. For instance, the number of objects of personal adornment made of faience increased during the New

Kingdom, as for example the molded beads, amulets and rings from Tell el-Amarna. Forming a greater proportion of glass in these bodies gave added strength to such small objects, so they no longer have the friable body held together by a surface glaze coating, described by Petrie[136]. Instead, there is very little porosity and an almost continuous glassy phase. In the rings, there is evidence that not only was more alkaline flux added to alter the chemical composition, but that the type of flux was altered so that XRF compositions show up to 20% lead oxide. The bodies of most tiles are coarse and friable; often there is no glaze on the back. Here strength is not needed because the tiles would have been set in a wall. Thus, an addition of glass to the body is not necessary. There is great variation however in the body fabric of tiles. The bodies of many thin walled vessels have fine particle size and a large glassy fraction, and in fact, one drinking vessel was found to be so thin as to be translucent on one side (Ref. 265, no. 148, p. 147).

In addition, there are objects of tour de force craftsmanship which push the limits of what is possible to make with faience as a material. The production of many quite amazing objects, the quantity of molds, tiles and beads found from this period, and the number of steps required in the decoration of many of these objects seems to imply a level of organization or knowhow not encountered in previous periods.

Another change in Egyptian faience of the New Kingdom which bears further study to be believed is the decrease in copper oxide and increase in calcia, a chemical change seen in microprobe analyses of the glassy fraction of the glazes and intergranular glasses (Table XLII). On the basis of only one New Kingdom sample, it appears that the glass composition changes from one consisting of copper oxide, silica and soda common in faience of previous periods to one in which soda, lime and silica are the chief components and copper oxide is added as one of many possible colorants. We know in our twentieth century understanding that copper is added to glass and glazes as a colorant, not a flux or stabilizer. From the probe analyses of

pre-New Kingdom glassy fractions which show unusually large amounts of copper for a colorant, far in excess of the amounts of CaO, it seems likely that Egyptians making faience did not share our bias until well into the New Kingdom. Although it is very dangerous to generalize from one sample, and especially so because we have no data from later periods, one might expect that those New Kingdom samples which have harder bodies and added glass or applied glazes are those most likely to contain higher concentrations of calcia and lower amounts of copper oxide. If this is so, then we can hypothesize a chemical change occurring in the formulation of faience which correlates with the development of glass, whether from within or without, and its affecting the chemistry and properties, and thus appearance and style, of faience.

Close inspection of Eighteenth Dynasty glazes shows that many of the glazes subtly change to a less shiny and more opaque appearance. The presence of numerous fine calcium antimonate inclusions, as determined by x-ray diffraction and shown in Figure 27g, may explain this change of appearance. The presence of such inclusions found in the body, although rare, indicates either that the glaze materials were intentionally added to the body or that glaze materials were recycled in the body (as either unfired scrap faience or ground up fired wasters). The differences between the glass compositions of the glaze and the body indicate that this glaze was probably applied (for instance, note the variations in amount of Al_2O_3 and FeO, ratio of CaO:MgO, and the lack of expected increase in CuO at the surface compared with increases in Na_2O and Cl).

In the XRF analyses of previous period glazes, we wondered whi the copper did not significantly drop when manganese was encountered, ans we presumed that the copper had effloresced from the body or that the manganese was added only to the surface and a layer of copper-containing glaze was beneath, which is essentially correct but it is probably not the whole story. If CuO was considered an essential faience-forming oxide then those unusual examples of white glazes deserve re-examination in order

to determine what was added if CuO was deleted and whether the microstructure changed.

Bead Manufacture: Processing by molding can be investigated by observing the open face molds from the factory at Tell el-Amarna into which beads and amulets were pressed (Figure 39a). In Figure 39b are examples of beads formed by pressing a small pad of faience into a mold, giving a shape in which the back is flat and the front has a molded design. The hole is made by the joining of a loop, the small segment of a tubular bead, to the molded shape. A slurry of body material often of a different color joins the bead and molded shape. The example in Figure 39c shows a brick red molded shape joined to a loop of the same color with a blue faience slurry. This example shows a model date fruit; the blue slurry functions as the sepal of the fruit. The lumpy, pastelike quality and irregular surface of the slurry is very different from the flat surfaces and smooth curvature of the two preformed parts. The beads shown in Figure 39b have such loops added to both ends, for stringing in a collar. No disruption of the molded form occurs when the hole is added as a loop in this manner. Piercing a hole has a disruptive effect similar to that observed in the Middle Kingdom spherical beads seen in Figure 37. Both piercing a hole and adding a loop with slurry are faster than the drilling of a hole, as was observed in beads of the Predynastic, Protodynastic and Old Kingdom Periods.

Based on observation of many beads and molds and on attempts at replication, this method of bead manufacture is quite rapid. Based on this study and the large numbers of such molds and beads reported by Petrie at Amarna, this process seems to represent a substantial and well organized effort in the palace workshop. This process is easiest to visualize as a set of production steps, each of which are specialized and yet which must occur in order and in fairly rapid succession to prevent the uneven drying and thus cracking of the parts and to produce an even layer of effloresced salts. These beads are formed by a fairly complex process which requires the division of bead manufacture into

several functions: molding, loop making and assembly. In replication studies, it was difficult, although not impossible, for one person to handle the three tasks by batch processing one and then another task. The most difficult part was sufficient organization so that the faience parts would come together at the correct consistencies. The body material was formed into bits of the correct size and consistency to be molded, so that it was not so dry to that it would crack when pressed into the mold nor so wet that it would stick to the mold. The mold had to be held at the correct wetness to form reasonable impressions and so that the paste would release easily from the mold. The wet slurry used in joining loop and molded form had to be kept the correct consistency, as the surface of the slurry supply tended to dry out and effloresce, causing alkali rich pockets to form in the faience which would burn out during firing leaving voids. To form the small tubular beads, either of two methods could be used: rolling a small pad of paste around a small diameter rod, or dipping the rod in a much wetter slurry than used in joining the loop and molded form and then letting this tube dry sufficiently so that it could be segmented by slicing loops and slipping them off the rod. The second process actually produces more beads in a given time and is the one found in these New Kingdom beads. There is no evidence of join marks which would occur if a pad had been folded over and wrapped around the rod. There is occasionally evidence of a raised flange at the end a loop such as would occur if the loop had been incompletely cut from the tube. It is certainly easier to carry out this process with more than one person, but whether the division of tasks is reflected in a real division of labor, in the factory sense of simultaneous, specialized tasks which are assembled to produce an object, cannot be concluded. From the large quantity of molds and beads, numbering in the thousands, from the sort of forming processes required to produce them, and from the other kinds of objects, such as tiles, which can be made by similar batch processing methods, it seems probable that a level of organization can be hypothesized which is not apparent in the

products of earlier workshops.

Tour de Force Craftsmanship in the Production of Beads, Amulets and Rings: In addition to quantities of beads which require a sophisticated knowledge of how faience can be worked, one also finds objects which are extremely difficult to produce because they push the limits of what is possible with faience as a material, given a mastery of the techniques. Examples of tour de force limited production objects are shown in Figure 39d, e, f, and g. The tour de force craftsmanship is exemplified in the hollow cagelike bead (1933.1201, Amarna, Dynasty XVIII) measuring 8 mm. in diameter and made of preformed beads built up and balanced, like a card house, using a small amount of slurry at the joints. H. Beck refers to this type as a lattice-work bead[282]. Fine detail and manipulation of surface texture can be seen in the workmanship of the light yellow seated figure with missing head (1921.1144b, Akhenaten (?) figure, Amarna, Dynasty XVIII) which is smaller than the lattice-work bead. The general shape of the figure has been molded, and then details of drapery and anatomy have been incised and modeled. The skin has a smooth texture, and the drapery and base have a rough texture.

Two other excellent examples of the limits of what is possible with faience are the blue wadjet eye (1932.1135, Amarna, Dynasty XVIII) and Bes figure (1925.415, Amarna, Dynasty XVIII). The wadjet eye is quite vitreous, and the glaze is translucent. It was formed by molding, then the three perforations were made. Prior to firing the faience paste cracked in the three thinnest places (which measure 1-3 mm.). During firing, surface tension drew the glaze away from the cracks, and flow caused some of the detail to blur. From the appearance of the cracks and glaze, it is obvious that a large fraction of this piece is made of glass, and very little undissolved quartz and porosity remains. In an example such as this amulet, the distinction between faience and glass becomes somewhat blurred. The amulet was formed as faience and yet the body composition is chiefly glass. Unfortunately, there is no XRF data on these pieces to determine if, in addition to increasing the glassy phase, lead oxide was added. The

concept and execution of such an object in faience, instead of molded glass, is quite amazing and indeed the cracks show that it is at the limit of what can be made with faience. The polychrome Bes amulet measures 7 by 10 mm. and was molded of an orangish yellow body and decorated in several areas with a red and a bluish grey paste. The eight red and four grey additions were made by taking pieces of the faience and rolling between the fingers to form millimeter size spheres or 3 mm. long coils which were pressed onto the molded body. The Bes amulet is also quite vitreous and much detail has been lost because of surface tension forces during firing. These beads and amulets are well worth study because they epitomize New Kingdom faience objects as displaying tour de force craftsmanship, and experimentation with forming, coloring and compounding body compositions in order to produce objects of excellence.

Beads and amulets usually have an overall glaze and occasionally firing marks are found on the back. However, the lattice-work bead has no firing marks. Molded wadjet amulets were made into a rings by adding coils to the back (1934.109A, wadjet ring, Amarna, house, late Dynasty XVIII, no XRF). Most rings have an overall glaze and two or three firing marks where the ring rested with the circular shape horizontal (1924.154 no XRF , 1932.1132, 1934.264, 1934.265, Amarna City, houses, late Dynasty XVIII). However, there are a few instances where a special firing support was built so that the ring could hang vertically from a point inside the circumference, such as the wadjet ring. The compositions of these rings contain lead oxide from about 1.5-21%. The yellow parts of these rings contain the greatest amounts of lead oxide, more than found in any other objects during this study, and lead is in excess of the stoichiometry required by the colorant lead antimonate. The result of such additions of PbO is to increase the volume fraction of glassy phase, which as mentioned above, has the advantage in the production of small objects of personal adornment of increasing their strength.

Variety of Body Manufacture in Vessels and Model

Grapes: The same organization of multiple step forming and decorating of faience can be seen in the manufacture of tiles and vessels. The vessels and tiles are fragmentary, often having no original edge, making the study of mold type, forming and glazing methods difficult. For tiles, there is insufficient information. However, from such whole objects as the bowl (1977.619, provenance unknown, Dynasty XVIII, shown in Figure 40n)[265, p. 143], methods of manufacture can be reconstructed. The bowl was formed by traditional methods, molded over a hemispherical form and coated with a white, fine particled slurry. During examination the bowl was inverted and rotated so that the faceted outer contour was revealed. The outer surface was pressed or scraped vertically. The cross section of the body, exposed during conservation treatment, showed a friable, coarse, greyish white body, which contains discrete particles of light blue glass. The fine, white intermediate layer present on all surfaces measured about 1.5 mm. thick. Decorative lines were painted in slurry on the body and are raised from the surface of the glaze. The bottom surface displays marks of having been fired on three points. From the rough surface of the glaze, friable body, and presence of unmelted glassy particles in the body interior, a low firing temperature is probable. These combined characteristics are indications of a well-established technological tradition, one which has synthesized diverse elements to produce an excellence in craftsmanship. However, there is nothing new in the techniques of body manipulation used to form this bowl when compared with the Middle Kingdom. The only new element is the addition of glass to the body.

Another traditional example of body forming techniques is the kohl tube (1890.906, Medinet Ghurab, Petrie's group of Amenhotep III, early Dynasty XIX, shown in Figure 40o). The kohl tube was formed over a rod. The core was off center, and the wall thickness is quite thin, varying from 2-6 mm. There are some vertical scrape marks on the interior. The decoration is inlaid, blue on a near black background. It is suggested that the inlay was rolled into the body in order to achieve a surface

level with the background, a process similar to marvering in the working of glass. The body and glaze are colored with oxides of Mn, Fe, Co, Ni and Zn. The greyish black body is unusually hard (MOHS 7), fine grained and has very little porosity. At a magnification of 70x, no quartz particles could be isolated. There does not seem to be excess flux present; about 3-8% is unaccounted for in the XRF analyses. There is obviously considerable glassy phase present, yet the texture of the body is matt. A finely ground body, probably prefritted or calcined, combined with a high firing temperature are the best choices to explain the appearance of this object. However, there is no evidence of warping, and there are no firing marks on this fragmentary vessel. There is considerably more glaze on the outer surface than on the inner surface. Method of glazing could not be determined. This kohl tube combines traditional molding technology with careful control of body composition and probably firing temperature in order to achieve a product unlike traditional faience, and yet neither appearance nor composition would allow calling this glassy or vitreous faience.

One more example of body manufacture will be discussed, a purplish blue bundle of grapes (1921.1156, Tell el-Amarna, late Dynasty XVIII) which is very unlike the dark purple bunch of grapes from the Middle Kingdom, colored with MnO_2 and individually modeled around a core (Figure 31r). The New Kingdom grape bunch is molded in two halves and then assembled with a slurry of body material. The joint between the two molded halves is not aligned. There are drying marks on the top, and firing marks in a small area on one side. There are several fissures where crawling has taken place. The purplish blue color is caused by a combination of the oxides of Mn, Fe, Co, and Cu. There are copper blue colored splotches in the glaze in the purplish blue glaze. The glaze was probably effloresced and fired on a powdered substrate. Another grape cluster (1924.153, late Dynasty XVIII, Tell el-Amarna) has a copper-containing metal rod attached where a stem would be placed, and only one of the two sides is molded. Yet another grape cluster (1931.509, Tell

el-Amarna, late Dynasty XVIII) is present only as a half model of the fruit. This solution to the problem of making grape bundles is different from the Middle Kingdom solution in that a more rapid means of production is used (molding and assembly, as opposed to modeling), as well as a different, more complex colorant. In fact, this method is very similar to the manufacture of beads. In these objects, it is suggested that the mental set of the palace faience craftsmen is quite different, one of a kind, labor intensive practice is substituted with an increase in quantity, which implies, though does not require, a higher order of organization.

Decoration of Tiles by Incising and Inlaying: From the number of broken fragments, it is very easy to study methods of decoration by examining the numerous available cross-sections (Figure 40). A common means of decoration is incising a channel (Figure 40d, 1893.1-41(945), sistrum handle, Amarna, Dynasty XVIII, Nefertiti, high fired, cracked and perhaps warped) and inlaying with a body material of contrasting color (Figure 40a, 1893.1-41(471), vessel fragment, Amarna, late Dynasty XVIII, Akhenaten). The problem of putting together two colors with a sharp boundary between them is solved so that cartouches or other details are easily differentiated from the background. The inlay usually is applied into an incised groove after the body has begun to dry. The inlay shrinks away from the body as it dries, thus a division between the inlay and background occurs which forms an outline around the inlay (Figure 40c, 1942.80, tile, Amarna, late Dynasty XVIII, and 40e, 1924.114, vessel, Amarna City, house M50.33, late Dynasty XVIII). The glaze can either be formed from an effloresced coating as the white background, or added to the body material as a glass as in the inlays of Figure 40c. Occasionally the joint between inlay and body is insufficient and the inlay detaches as in Figure 40L, left (1871.34d, Palace of Ramesses III, Tell el-Yahudiyeh, Dynasty XX); for instance, if the paste is inlaid into a body which is too dry. If the inlay is placed in the channel when it is too wet or when the body is too dry, then the inlay tends to crack in

the middle as it shrinks, as in Figure 40a. If the glaze is effloresced, then salts are not deposited in the groove between the body and inlay thus reinforcing the division between inlay and background. When the faience is fired, whether the glaze is a glass added to the body or an effloresced coating, either the glaze which forms if in sufficient quantity or if heated sufficiently high will fill in and partially close the gap (as shown in Figure 40k, an enlargement of 40j, inlay, Amarna, Dynasty XVIII, object discussed below), or surface tension of the two different colored glazes will maintain a division by drawing the glaze back from the edge of the inlay, as has happened in Figure 40c, e and f. In pottery terms, these tile and vessel fragments display the controlled occurrence of crawling, usually described as a glaze defect, which has been intentionally used in order to produce a decorative effect.

Several other techniques are combined with incising and inlaying in order to decorate tiles. Usually the inlay is flush with the surface of the tile, but occasionally the faience is placed on the surface in relief (as the central boss in Figure 40L, right, 1871.34F, wall tile, Palace of Ramesses III, Tell el-Yahudiyeh, Dynasty XX). This same building up of a surface is seen in the tile (1936.637, Great Palace, Amarna, late Dynasty XVIII, shown in Figure 40i), an unusual polychrome tile exemplifying tour de force craftsmanship. The white background which has been scraped and ground to form a relief. The lowest level is a hard, matt white of body material without a glaze layer which is surrounded by a raised white and blue glazed border. To the right in Figure 40i, a channel has been inlaid in the border with purplish blue paste and to the left the scraped body surface has been built up first with reddish brown paste to form a model date or seed and then one end of this brick red paste has been covered with a small amount of yellow paste to form the sepal. A sketch of this tile is shown in Figure 31x. The brick red paste does not rest directly on the white background but is raised on a platform of white body material. There is no glaze on the back of the tile and very little glaze

on the sides. There are no firing marks on either side of this fragment. A complex method of glazing the tile was used. Efflorescence is indicated by there being no glaze on the back of the tile and very little glaze on the sides. The glaze probably effloresced evenly on the surface of the tile and was scraped or washed off the depressed white areas leaving the brick red paste raised. In addition, the inlaid and built up areas either had an addition of fine particled colored glasses or pigments, containing for the yellow, lead-antimonate and iron oxide; for the brick red, iron oxide and for the purplish blue, a combination of iron and manganese with a trace of zinc and cobalt oxides, and no copper, according to the XRF analyses.

Three other tiles represent equally complex processing, the tile with thistle blossoms (1924.75, Amarna City, house M50.52, late Dynasty XVIII), tile with mandrake (Brooklyn Museum No. 52.148.2, Hermopolis Magna, Dynasty XVIII, reign of Akhenaten, Figure 40g and h) and lotus flower inlay (Brooklyn Museum No.49.8, Charles Edwin Wilbour Fund, said to be from Amarna, Dynasty XVIII, reign of Akhenaten, Figure 40j and k)[265]. All three tiles have white backgrounds, and each is inlaid with green leaves, a color composed of a combination of copper and lead antimonate. In the lotus flower inlay the mixture lead antimonate and copper oxide is not homogeneous and areas of yellow can be seen in addition to areas of bluish green. In addition, in the lotus inlay and thistle tile, there is a halo effect around the leaves, as if the blue-green color had bled into the white area of the glaze, and around to the back of the lotus inlay. This effect is produced when copper diffuses, probably in vapor form, from the area of the leaves to the surrounding white background. In the lotus inlay, yellow paste is inlaid at the base of the petals and added to the white body at the top to form a mandrake. At the base of the yellow mandrake blue paste is inlaid. Incised lines which form the lotus petals are painted in a blue wash. The glaze was effloresced due to the drying marks on the reverse side, but there are multiple firing marks on the front surface which argue

that the piece was embeded in a powder. The mandrake and thistle tiles have yellow and green inlays which undulate in slight relief from the white body and which are outlined by a separation of inlay from body. The naturalistic motif is emphasized by the painting of outlines and details in a brown wash colored with iron oxide. There are thin white glazes on each of the reverse sides. The thistle blossoms are a bluish purple colored by about one-third percent of each of the oxides of Fe, Mn, Co and Ni, with about two-thirds percent zinc oxide (which presumably is unintentional, but which would have a minor effect in brightening the glaze by increasing the index of refraction very slightly). These tiles were fired to a relatively low temperature as indicated by the orange peel texture of the glazes and presence of pinholes, crazing and crawling, yet the body is hard, nonfriable and contains a large glassy fraction. The method of glazing could not be determined. Even though each of these tiles would be assigned to the low end of the firing range, it is obvious that considerable control was exercised in the firing of these tiles, as overfiring would result in loss of detail.

Another decorative technique is represented in the blue crown (1931.511, Amarna City, Room T.34.1, Late Dynasty XVIII), shown in Figure 40b and sketched in Figure 31y. Two rings have been drilled with different sized hollow drills into the surface concentric around a more deeply drilled hole. There is no glaze in the deeper center hole and green glaze which partially fills the two concentric rings. The overall glaze is grey blue or violet blue and composed of a mixture of manganese, iron, cobalt, copper and a trace of nickel and other elements. That this mixture is not homogeneous can be seen in the speckled appearance of the glaze. The way the green color in the concentric rings was achieved could not be satisfactorily explained, except to suggest that a colorant such as copper oxide was painted in the holes. The body is nonfriable, blue grey in color and becomes darker near the surface. The glaze is uneven with a gradual decrease in thickness on one side and a sudden decrease in thickness on the other. There is a gradual color gradation in

the body from grey in the interior to blue at the exterior. Based on this color gradation and the fact that colorants in the body are similar in amount to those in the glaze, efflorescence is the probable method of glazing, but application cannot be totally discounted. These gradations in glaze thickness are not possible with a cementation method of glazing. There are no firing marks on this fragment.

Brief mention should be made of the vessel fragment shown in Figure 40c (1924.114, Amarna City, house M50.33) because the exterior blue monochrome decoration is fluted in three-dimensional relief in a lotus petal design and because the interior polychrome decoration is inlaid in a two-dimensional repetitive pattern made by impressing each round hole with a stylus of the appropriate shape prior to inlaying, thus combining a strong sculptural form with interior decoration. The diamond shaped indentations appear to be made with the same tool, and the opened to full size as the bottoms of the channels contain scratch marks. The glaze is satin matt to semi matt in texture and very thin, exhibits pinholes, and crawling around the inlay edges. There is less glaze on the heavily inlaid interior than the exterior. The body is bluish, single layer, composed of medium and fine particles, has a fairly large glassy phase and average hardness (MOHS 3-4).

Experimentation with Body Composition: It has already been shown that high lead oxide contents in finger rings may have been for the purpose of increasing strength by increasing the amount of glasy fraction. The high glassy fraction in beads and amulets and some tiles and vessels also has the function of increasing strength. Some tiles and vessels, however, have friable bodies, as discussed above. These objects cannot be divided neatly into categories. However, some bodies such as the kohl tube are unlike anything seen in other periods. Even though one cannot generalize from large numbers, I believe one can discuss specific instances of such anomalous compositions and microstructures as examples of experimentation with body compositions. Figure 41 contrasts two typical microstructures of

a tile and vessel. The upper three micrographs show a cross section of a tile at increasing magnification. They exemplify finely ground quartz immersed in a large volume fraction of glassy phase. Fine spherical pores from mixing and forming are present in the body. The edges of quartz particles have been rounded by dissolution. In the lower three micrographs, the jagged ground quartz particles have barely begun to react at the surfaces, and rare are glassy sintered joints between quartz particles. Changes in firing temperature are insufficient to explain such variation; intentional conpositional change (increase in amount and type of flux) and change in preparation of raw materials (grinding to finer particle size, pre-fritting glassy constituents) explain such variations in morphology.

The development of new colors is another example of the experimentation being carried out during Dynasty XVIII. The earliest color change seems to be the introduction of lead antimonate yellows. During the late Dynasty XVIII, copper blue-green and lead antimonate are combined to give a light yellowish-green and various combinations of the oxides of Mn, Fe, Co, Ni, and Zn are formulated to yield a range of blue colors from dark blue to purplish blues, which are not obtainable with the traditional colorants, CuO and MnO_2. These colorants are introduced into the faience either as fine colored glass powders or raw materials, usually added to the inlay or surface layer, rather than to the entire body, probably in order to minimize the amount of colorant used. A small fraction of the fine particled colorants in replication studies migrate to the surface to form a layer similar in function, but not mechanism or appearance, to the effloresced salts. Further investigation of the way this process operates should be carried out.

Summary: New Kingdom faience is highly innovative in the increased color range of faience and in the use of glass in the bodies, but all within the traditional framework of faience manufacturing methods. All of the methods of forming and decorating faience, with the exception of the technique of outlining an inlay involving the controlled shrinkage and

crawling of the glaze, are seen in earlier periods. However, the assembly oriented organization of faience production is not seen in earlier faience. A cataloging of the instances of glassy faience, combined with a study of composition and microstructure, might shed interesting perspective on the relationship of glass with faience. The overlap between faience and glass technology first seen in the New Kingdom is based not only on the commonality of colors and increasing presence of glass in faience bodies, but also in processing. For instance, core and rod forming is common to both technologies. Rolling of the kohl tube inlay probably represents a process similar to the marvering of glass. If during the Middle Kingdom, there is increased investigation of the role of calcium oxide in glazing processes and the proliferation of Egyptian blue, then the conditions appropriate for the development of glass may be hypothesized as occurring in Egypt within the faience industry. However, this case is far from established. In summary, the need for, or possibility of, large quantities of brightly colored faience during the New Kingdom increased production, streamlined many processes and changed glaze technology to incorporate advances in glass technology.

14. FAIENCE OF THE FIRST MILLENNIUM, B.C.

From the later periods (1070-30 B.C.), 105 samples were examined. This sample size was insufficient to characterize the diversity of manufacture over such a long time span with so many intrusive variations in culture. In this section are grouped objects from the Third Intermediate Period (1070-657 B.C.), Late Period (664-332 B.C.) and Ptolemaic Period (332-30 B.C.). The detailed and complex chemical knowledge of the New Kingdom is not found, but the more applied aspects do survive, for instance, the knowledge of how to make certain colors, such as the lead antimoniate coloring of the face of the female statuette

discussed below. From the appearance of glazes and from the faience factory evidence at Memphis, it is apparent that applied glazes were extensively used. A future study might show that the preparation and use of such glazes was a major point of cross-fertilization between faience and pottery manufacture during the first millennium B.C. From the variation in the level of craftsmanship employed in the manufacture of shawabtis and other wares, one may try to generalize the use of faience production to meet the needs of a larger social stratum than previously encountered.

Thrown Faience and the Need for Adjustment of Body Composition: The later periods incorporate all of the methods of body manufacture seen earlier. Several possible examples of thrown ware are encountered. The earliest example found in this study of what may be faience made by throwing on a wheel in the manner of pottery is shown in Figure 42, a heavy, thick-walled vessel with throwing ridges on the interior and inlaid decoration on the exterior (E.3410, Temple, Serabit el-Khadim, New Kingdom). The difficulty in assessing whether faience has been thrown arises because the exterior is smoothed and often ground, thus eliminating evidence of throwing. In addition, concentric throwing ridges on the bottom or parallel ridges on the walls are less distinct than in thrown clay wares because faience is much less plastic than clay. Because of the lack of plasticity of faience, one cannot press very hard when faience is thrown or it will tear, thus ridges are less likely to occur, and much of the production speed which accompanies thrown pottery is not present with faience. All those faience objects which one might establish as potentially thrown are thicker and heavier than if made in clay and the throwing ridges will have very low relief.

Presumably, in order to throw wares from faience, potters of faience makers would try to make several adjustments in the formulation of the body. Adjustments made by contemporary potters include additions of organic binders and minor amounts of certain plastic clays as well as adjustments of the particle size of the quartz for optimum throwing properties. A wide range of particle

sizes allows more plasticity, coarse particles for strength and finer one to fill the gaps, promoting extension instead of tearing. If changes in particle size or composition were being made for whatever purpose, these could be detected by analysis. Minor additions of organic binders which have burned out during firing cannot be determined. A judgement of the existence of quantities of thrown ware concomitant with changes in particle size and composition is essential to fully establish and understand the introduction of throwing technology.

Changes in particle size so that more fine particles are present occurs in many of the faience bodies of the late New Kingdom, probably for reasons of increasing strength. There is no evidence to suggest that the use of finer particle sizes was related to throwing properties. During the later periods, no variation in particle size could be related to those few objects which might have been thrown, and there is no evidence that clay was added to extend the plasticity of faience bodies, as indicated by the low Al_2O_3 concentrations found by XRF. One would expect the light colored Egyptian marl clays to be a reasonable choice. From the Protodynastic and Old Kingdom Periods on, there are a few isolated instances of the presence of a minor amount of clay in red and brown bodies. These bodies seem to be of two types. In one case, the color is desired and used as an inlay (for instance, see Figures 31g-j, reliefs from Abydos). In the other case, the color is hidden with a white intermediate layer (Figure 33, two layered body from Hierakonpolis).

Shawabti Manufacture: Shawabtis, funerary statuettes interred with a mummy in order to help the deceased or perform those tasks of daily afterlife which the deceased wished to avoid, constitute a major class of faience production during the first millennium B.C. According to H.D. Schneider[283], shawabtis of faience were first made during the Middle Kingdom; prior to this time shawabtis were made of wax, wood and stone. Pottery and faience shawabtis were first made during the Middle Kingdom and continued in use through Roman times[283]. In general, from

the New Kingdom to the end of the Third Intermediate Period, the faience shawabtis were molded; the blue glaze was formed by efflorescence, and decorated by painting linear details and inscriptions with a dark black, violet or blue slurry (Figure 43c and d). Rarely, are there instances of inlaying. There is a change is style which occurs at the end of the Third Intermediate Period, during Dynasty XV, as molding followed by painting is replaced by molding followed by the incising of detail and inscriptions during the Late Period (Figure 43a and b,lower). A back pillar is also added (Figure 43a,b,e,f). Molding involves pressing one or more pieces of wet faience body material into an open face or female mold. An example of more than one piece of faience being pressed into a mold is the shawabti not shown (E.3615, D3, Abydos, Dyn XXV-XXX). The shawabti E.3616 has a mold mark along the proper right side of the figure (also not shown).

The shawabtis vary in the amount of detail which has been scraped or incised into surfaces. This variation does not seem to systematically vary with period. Instead, there seems to be a range of detail, and thus amount of labor, invested in the manufacture of shawabtis in both the Third Intermediate and Late Period. The greater degree of detail and clarity of form are indications of a higher level of craftsmanship. From the range of goods available there is a likelihood that workshops were producing a variety of goods to suit the needs of a range of customers. This is a very different organization of production than that heretofore found in the palace or temple workshops where the level of craftsmanship is high, and one which seems to imply a larger group of Egyptians purchasing grave goods of differing quality.

The occurrence of modeling to build up a surface is rarely found. Open face molds were used to shape the initial form, as can be seen in Figure 43c and d, in which almost no detail or three dimensionality has been scraped into the surface. The back remains flat. This contrasts strongly with the light green glassy faience shawabti (1916.2, Giza, Dyn. 25-30, shown in

Figure 43a,lower) in which considerable detail has been formed by a scraping operation carried out during drying. Around the pillar on the back side are multiple scraping marks. This amount and clarity of detail is common in shawabtis of faience from the Late Period. In Figure 43e and f further detail has been added to the front of the shawabti by modeling, the addition of a lump of wet faience to form the skirt.

Many of the glazes on the Late Period shawabtis, particularly on larger shawabtis, have the characteristics of applied glazes, that is splotchy, uneven surfaces with more glaze accumulated in the inner surfaces where planes meet than on exterior convex surfaces (the opposite of what is expected with an effloresced glaze). An example of an overall glaze applied to the body is the copper blue shawabti with cobalt blue painted decoration (E.3565, tomb G50, Abydos, Dyn. XXX shown in Figure 43a and b upper). This translucent glaze contains small bubbles and fine white opaque particles, further indications of an applied glaze. This unusual example has a carefully incised and scraped details, and the dark blue slurry appears to be painted under the glaze. From the precise outline of the hieroglyphs, it is likely that the slurry was inlaid into incised grooves. Only examining a crossection could demonstrate whether this supposition is correct (such an opportunity might arise if the mended break the ankles were disassembled).

Firing mark types also seem to change with time period. No examples of shawabtis from the Middle Kingdom were examined. Those from the New Kingdom usually have an all over glaze with two or three horizontal firing marks from setters on the backs of the shawabtis (examples of such firing marks can be seen in ref. 283, catalog nos. 3.3.0.4, 3.3.1.1., 3.3.1.18, or 3.3.1.15); there are also instances where powdered supports were used. From later periods, the firing marks are also on the backs, but no horizontal firing marks were found. There are many instances of setters which have left marks of attachment in small rounded area as well as powdered beds used to support the statuettes during firing. Cementation glazing of shawabtis is highly likely as a

means of glazing these figures although no examples were found which did not have distinct firing marks on the backs in positions where the figure would rest or balance during firing. One example had firing marks around the ankles and it is probable that a powdered support was used.

Faience Manufacture at the Memphis Kiln Site: Techniques now commonly attributed to glazed pottery are seen in wares from the Kom Qalana and Kom Hellul kiln sites near Memphis (Figure 44a). From factory remains, a sense of factory operations can be obtained. For instance, applied glazes were used, as shown in Figure 44b, and discussed in more detail below. Three or four pointed clay cones were used as setters for the stacking of bowls. For the first time the actual setters are present instead of only the residual firing marks on faience (center and left of Figure 44a). Overfired and warped faience is present, indicating high firing temperatures (Figure 44a, lower center). Finally, glaze for application was prepared by fritting or premelting the glaze. Presumably, first the ground raw materials were formed into spheres about 1 cm. in diameter, as shown in Figure 44a, left, and Figure 45 (1910.564, Kom Qalana, Memphis). Each sphere is now a grey color and contains quartz, cristobalite, and calcite by x-ray diffraction and a glass with the oxides of Si, Ca, Fe, Cu, Mg, and Zn in order of descending EDAX peak height. The clay support on which these spheres rest is warped, due to high firing. Either the fritted glaze was ground and used at this point or a further melting was carried out.

A crucible which may have been used to further melt the glazes is shown to the right of Figure 45a with residual glass inside. The advantage of using spheres to frit the glaze is that they can be easily separated from the container in which they were fired and easily crushed to a suitable size for fine grinding. However, a glass such as is found in the crucible is difficult to separate from the clay in either a molten or hard state, and the small size of the glass pot would allow only a small amount of glaze to be produced. It is likely that this

crucible may be the result of a glassmaking process, unrelated to faience manufacture.

Another sample from this same site now at University College (M.I.T. no. 268, a fragment of which was given to C.S. Smith) is a clay crucible lined with thin layer of calcium oxide and containing a high calcium material similar in appearance at the surface to Egyptian blue and gradually changing to tan in color near the interface with the crucible. The crucible contents are not well fused; inclusions of quartz and calcite were found by x-ray diffraction in addition to glass with an elemental composition in descending order of EDAX peak height of the oxides of Si, Ca, Cu, Al, Fe, Mg, K, Zn (no Egyptian blue was found). The clay crucible was not highly fired.

This fragment along with the others shows that many different compositions were being heat treated prior to their use on finished objects. When efflorescence of the glaze coating is such a simple process, requiring no previous heat treatment of materials and only a single firing, one must ask how these various operations were related to faience manufacture. One highly probable speculation is that more than one craft was being practiced and that a milieu was present in which both clay and faience technologies were well known, yet only the faience was intentionally glazed. Another highly probable speculation is that these three manufacturing remains were not successful or they would have been used in production. Whether they were unsuccessful because they were tests or because of accidents during firing cannot be determined. All of the clays used as refractories were of the high iron Nile mud variety and not the high calcium marl clays.

A means of developing two-color polychrome faience by applying a single glaze is shown in molded ware from this kiln site in which varying the glaze thickness produced two different colors (Figure 44b). The glaze was applied and then wiped to produce such variation: the thinner, lighter color glaze occurring on the raised portions of the molded body (the opposite of that expected with an effloresced glaze). Rubbing a dried

effloresced glaze delaminates the effloresced salts in large flakes, so that an uncontrolled pattern develops. In one example, five small bits of green faience colored by lead antimoniate and copper oxide (a small amount of tin oxide is also present) were applied on the surface of the lamp fragment after it was molded (1910.555(2), lamp fragment, Kom Hellul kilns, Figure 44b, left).

Figure 44b, right, shows a kiln waster in which two tiles with plano-convex crossection and having overall glazes are laid one on top of the other (1910.560, kiln waster, Kom Hellul kilns). The lower tile is embedded in overfired, bloated, black, glassy mass. The overfired mass rests on a layer of clay which has not been overfired. The overfired mass may very well be a powder on or in which the tiles were placed. The upper tile is exposed and the top surface of the lower tile is exposed. Another possibility is that the faience fell into some well-fluxed refractory.

One final example of two color polychrome faience should be considered (1913.803c, bowl, Memphis, Ptolemaic, probably of earlier date than the two fragments considered above and not from the kiln site), as shown in Figure 44c. A tan body was molded so that the light green surface is in relief and painted so that indented bands and petals became dark blue-green. This is the only possible example of a two part mold found in this study. There are four drying and firing marks on the exterior at 90° intervals and two smaller ones on the interior, indicating that the glaze was effloresced. In summary, at Memphis molding is the chief means of forming the bodies and at least two types of glazing are represented.

Other Examples of Polychrome Faience Manufacture: Although the methods of manufacture remain the same as in earlier periods, these techniques are used in the service of a very different aesthetic. For example, Figure 46 shows two examples of polychrome faience, where different colors of faience body material were joined. In the marbleized vessel fragment (1913.804, Memphis, Ptolemaic) greenish-white grains are set into

a greyish black background in imitation of stone. From the different states of preservation of the two different colored materials, it is likely that the glaze was effloresced from two different body compositions. There are no drying marks on the base and one elongated firing mark. The interior is rounded and the exterior has near vertical walls, making the vessel quite heavy and thick walled near the base. The probable method of forming was wet joining of the body parts, forming it to approximate shape, followed by molding over a hump mold.

The female figure (1892.1025, no provenance, Ptolemaic) was joined to a now fragmentary oinochoe. The details of dress, face and hair were modeled and scraped to form, and the hair was painted with an iron-rich slurry. Another fragmentary vessel with attached female form (1892.1028, purchased in Cairo, Ptolemaic) has a white body with blue effloresced glaze, a face which has been inlaid with tan body material containing lead antimoniate, and a manganese dioxide wash which has been painted over the hair and then wiped off to give a variation in shade. The lead antimoniate particles in the body material of the face are bright yellow and about 0.1 mm. in size.

Two other examples of core formed vessels from the Late Period are the hedgehog vessel (1872.298, Thebes, Dyn XXV-XXX) and grasshopper vessel (1910.784, Memphis, Dyn XXV-XXX). The hedgehog has a greyish body, with fine texture, no intermediate layer, a white shell with incised decoration and green face, handle and foot, with painted eyes and daubs of slurry on the back. There are no drying or firing marks and an overall glaze. The grasshopper vessel has an overall glaze with small firing marks on the base. Colored slurry was painted over scraped and incised details. No body is visible. The range of colors includes a yellow body, blue lip, white head and tail, brown eyes, feelers and spots on the body.

15. CONCLUSIONS AND SUGGESTIONS FOR FURTHER WORK

Methodology: This study emphasized the need for an interdisciplinary approach combining Egyptian history and art, materials science and ceramic technology in order to study the manufacture of faience, but the prime focus of the study was the objects and interpretation of data based on examination of those objects. From a nondestructive microscopic survey, categories were identified to describe differences in material, manufacture and technological concerns of different periods. Those objects, usually fragmented, were sought which reveal a great deal about technology but which, as Anna Shepard stated, simply slip through the more general stylistic categories. The approach of "just looking" places an emphasis on recognizing simple structural differences between objects, and acquiring sufficient background to understand and relate the context, function and process of objects, so far as one is able. The interpretation of such differences can then proceed with the more intensive and destructive study of chemical composition and microstructure with just a few samples selected to maximize the information gained by destructively sampling. Once broad categories which can serve to identify technological differences have been drawn, then the interpretation of microstructure and composition can be used to reconstruct how the objects were made. Here a study of microstructure and composition was attempted with those few fragments found broken or ready to break if given permission.

There is an all important link between cognizance of the range of variation and yet the limiting of analysis to a select few samples. Ideally this link would extend from the field excavation to the laboratory. In this era of excellent specialists' technical studies, one cannot help but believe that conclusions and generalizations would be easier to make and be more meaningful if this link were maintained and the study of structure was emphasized as much as the study of chemical composition.

Further Work: Further work on Egyptian faience should

include characterizing in more detail the wares of different periods, wares and refuse from different kiln sites as well as such technical anomalies as the beads wrapped in gold foil in the hope of identifying workshop characteristics which could be used to identify exports and which could elucidate variations of manufacture.

In addition, further investigations of processing should be undertaken. Many of the accretions which may be kiln marks should be studied to find out if they are the link between efflorescence and cementation glazing methods. For instance, questions of what composition are kiln setters made and how similar is the setter and glazing powder composition should be investigated. Replication studies should be used to refute or support observations.

The steatite glazing process must become the object of study in order to determine if raw materials are applied to the steatite before they are roasted or if cementation glazing is employed. A study of other glazed stones would be useful in elucidating the range of materials glazed. Can the use of deboutage from the carving process, which seems a likely developmental path for faience, actually be demonstrated in any predynastic beads?

Details of the interrelationships between the manufacture of faience, glass, pottery and pigments should be isolated and studied in depth. Cross developments between these technologies represent state of the art improvements and are an indication of the technical, aesthetic and economic concerns of craftsmen, and less directly of a ruling elite.

The Reconstruction of Technology: The beginnings of glazing, and soda-lime-silicate technology in general, are found in steatite and other soft stone beads. Their manufacture is based on lithic processing, and the imitation of natural blue and green stones, such as lapis and turquoise, which were presumably in short supply. From the beads found in graves, it appears that the ability to produce such glazed beads was widespread and that the products were shared. An indepth study of glaze formation is

essential in trying to trace the development of such a technology, its relations to other technologies such as copper production as well as to understand the conditions in which it arose.

The Protodynastic and Old Kingdom workshops sponsored by central authority extended the scale and types of objects produced. These workshops developed one technological solution to the problem of producing faience, modeled and scraped bodies with effloresced glazes. Craftsmen seem to have had confidence in the solution to the problems of raw materials and their heat treatment. The objects which were formed show a great deal of innovative work was being conducted in the fabrication of faience, as the core formed vessels and multi-layer inlays reveal. Saqqara is the first site where relatively large scale tile production can be investigated. A worthwhile study would consist of investigating these tiles to see if and how the character of workshop production was modified to accommodate this scale of production, or whether the same methods continued to be used and only the duration of production was increased. That the efflorescence method of glazing seems is the only glazing method of Old Kingdom faience also requires further scrutiny.

The Middle Kingdom seems to be a period of extensive investigations which for lack of a better label might be characterized as chemical investigations. At some point, the scale of production may have necessitated efficient kiln stacking and at this time experimentation with materials for setters and kiln floor or shelf linings may well have been an important concern. Cementation glazing might develop out of this melieu. Cementation glazing develops as does the variation in firing supports, both of which involve the use of calcium oxide. Kaczmarczyk has noted that at this period on the CaO:CuO ratio stabilizes. Further evidence of experimentation with manganese dioxide, used as a colorant both added to the body and painted onto the glaze. The more durable, brighter glazes are caused by better firing control, probably higher firing temperatures, and possibly chemical changes. One would like to know if this method

had other visible benefits. Most of the objects made during the Old Kingdom are green. Most of those during the Middle Kingdom where there is good evidence of cementation glazing are a much stronger blue-green or blue. One would like to know if cementation glazing improved the quality of texture or color of faience, or if such factors as low firing temperature and low flux compositions have caused the Old Kingdom faience to weather from stronger colors to the present pale greens.

During the New Kingdom, a technical sophistication in the formulation of body compositions and colorants develops, perhaps based on the introduction of glass technology or perhaps the developments in faience are precursors to developments in glass technology. The character of faience changes in texture, composition and feel. There seems to be a way of organizing production not readily evident in earlier periods. Molding becomes the chief means of production and is combined with other techniques so that complex objects can be rapidly produced using the capability of assembling different parts together.

During the later periods, the same body forming and glazing techniques continue, although the same tour de force craftsmanship seen during the New Kingdom is not found. The objects reveal the many levels at which craftsmanship can be practiced. Whether this can be related to the use of the goods or to the social status of those who purchase the faience would be a worthwhile area of search. At the end of this period there is evidence of the introduction of pottery techniques into faience manufacture, such as throwing, fritting of glazes, stacking loading of kilns. In which way the transfer of technology proceeds is a question well worth investigating.

Another scenario of faience development, unlikely in the view of this study, would posit continuous development from predynastic times of cementation methods of glazing. In this case, efflorescence glazing would be viewed as brief development of the Old Kingdom which was replaced by cementation and application techniques, but which still continued to be used. Application glazing could be viewed as developing in the

Predynastic Period and continuing in a minor capacity until the first millennium B.C. or as an experimental development during the Middle Kingdom, one which foreshadows the development of glass, as the glazes are mixed, prefired and ground before application. However, the objects studied do not support these views. Clearly, further study of early Predynastic glazing is required, as is further evidence from other collections.

Another approach to the problem of the early development of faience is to investigate the relationships between the early glazes on faience and the earlier technologies of pigment processing, metal smelting and lithic processing and heat treatment. How these other technologies employ materials and processes related to forming, glazing and firing faience may reveal important structural similarities, as well as differences. Much technological development is based on the transfer of an idea from one applied discipline to another. The blue and green colors of early glazed objects are no accident. Can the use of this color be the result of connections with other technologies, or is it the result of an intentional search to formulate synthetic, available objects of prestige, protection or power which were required to have the appropriate color. The way to begin such a search for direct precursors of glazing would be to examine the various examples of predynastic slag beads. Another approach is to examine early examples of blue and green pigments and especially powdery, weathered white ones to determine if some are not naturally occurring ground minerals such as azurite and malachite. A third approach is to characterize early heat treated rocks for any evidence of a fluxed surface. The difficulty with each of these problems is that one cannot write to a museum or university and request to see, for instance, slag beads or glazed stones other than steatite. This general approach will require a lot of fruitless searching.

A final area of interest is the fusion of pottery and faience technology during the first millennium A.D. The development of lead glazes should be pinpointed, describing the conditions which lead to such a development. The glazes in this

study have persistently been based in the soda-lime-silica system. The historical conclusion which can be drawn from this study is that Egyptian faience is based on a conservative soda-lime-silica technology which maintained certain ways of working with the material throughout 4000 years. The protection from intervention provided by the Nile Valley was a very powerful force in the longevity and constancy of the technology in addition to the natural limits proscribed by the material, once chosen and understood by faience makers.

ACKNOWLEDGMENTS

I would like to thank A. Kaczmarczyk and P.R.S. Moorey for making this study possible, for their direction and corrections, and W.D. Kingery and R.H. Brill, for their time and stimulating discussions. The Council for the Arts at M.I.T. kindly provided funding for analysis. Appreciation is expressed to those museums which allowed me to study and photograph the objects in their care: The Ashmolean Museum, Boston Museum of Fine Arts, University College Museum, and Brooklyn Museum.

FIGURE 23. THREE METHODS OF GLAZING FAIENCE

FIGURE 24. REPLICATIONS OF GLAZING PROCESSES
 a. Replication of cementation glazing process, using Wulff's Qom bead glazing powder composition, but with 2% CuO, fired to 1000°C for 8 hours. All scales read in millimeters unless otherwise stated.
 b. Underfired example of cementation process, same composition but with 1% CuO, fired to 925°C for 8 hours. Surfaces of beads have protrusions or glassy stanchions, shown magnified in Fig. 25e.
 c. Replication of efflorescence glazing process, fired to 900°C in 8 hours. Blue molded body with 3% CuO above; lead antimoniate yellow below, and polychrome bead to right.
 d. Reverse of effloresced sample shown in Fig. 24c., showing drying and firing marks where glaze has adhered to kiln shelf. Bead was rotated during drying and no drying marks are present.
 e. Microstructure of replication of cementation glazing method; cross section showing that glaze has soaked into body.
 f. Microstructure of replication of efflorescence glazing; glaze is distinct layer on surface of body.
 g. Microstructure of cementation glazed body showing sintered quartz particles.
 h. Microstructure of body (replication of effloresced glaze), showing greater extent of sintering and rounding of quartz particles; arrow at right points to sintered joint, and left arrow points to clay platelet.

FIGURE 25. LOW POWER MICROGRAPHS OF REPLICATIONS
 a. Firing marks from placement of effloresced glaze on powder of lime (CaCO3); and fissures in glaze caused by cracking of dried glaze prior to firing.
 b. Thick side of glaze on bead with cementation glaze; dark areas occur where glaze is thickest; white specks are undissolved quartz; no firing marks are present.
 c. Effloresced glaze with thickness of glaze gradually decreasing at edge.
 d. Applied glaze which ends at a distinct line.
 e. Enlargement of stanchions produced by underfiring cementation process.
 f. Underside of cementation glaze replication in which rough surface is evidence of contact with glazing powder; quartz particles show through thin glaze.

FIGURE 26. EXAMINATION FORM.

FIGURE 27. MICROSTRUCTURES OF SAMPLES SUBMITTED TO MICROPROBE ANALYSIS.
 a. Soda-lime-silica phase diagram, after reference 278.
 b. SEM micrograph, backscattered emission, of glaze on Predynastic Badarian glazed steatite bead (Ash. 1925.551a-e), showing 1 micron inclusions, 1000x.
 c. Glaze from IB hieroglyph (Ash. E.A.526), Abydos,

Old Kingdom, showing weathered glaze, 200x.
 d. El Kab bead (Ash. E.E.138), Middle Kingdom,
showing weathered surface to left, porosity in center and
quartz particles in grey to lower right, 400x.
 e. Kerma tile, M.I.T. 1981.IE, showing weathered
surface, 100x
 f. Kerma tile, M.I.T. 1981.IVH, at glaze-body
interface. Dark inclusions are quartz and cristobalite,
400x.
 g. Amarna (Ash. 1893.1-41(472)), glaze with calcium
antimoniate (CaSb2O4) inclusion above and wollastonite
(CaSiO3) inclusion below, 800x.
 h. Amarna (Ash. 1893.1-41(472), body showing
porosity, glass coated quartz particles and CaSb2O4, 400x.

FIGURE 28. GLAZED STEATITE BEADS AND MICROGRAPHS OF
STEATITE
 a. Steatite beads (Ash. 1925.551a-e, grave 5710,
Badari, Naqada I-II) from girdle.
 b. Steatite beads with rounded edges (Ash.
1911.368b, Gerza, grave 133, Naqada II); pale green bead
above and rare white bead below.
 c. Unfired broken crossection of steatite, showing
platey structure, 1070x.
 d. Fired crossection of steatite, showing fracture
of platelets and rounded microstructure of fine particles,
1070x.
 e. Steatite with soda ash (Na2CO3) flux fired onto
surface, showing glassy areas; finer particles of steatite
have rounded structure, 2180x.
 f. Fragment of Badarian bead (Ash. 1925.551a-e)
showing fine, rounded particle morphology and platey nature
of material, 1070x.
 g. Fragment of Badarian bead at right angles to Fig.
28f, showing rounded particles and anisotropic structure,
2180x.

FIGURE 29. PREDYNASTIC FAIENCE BEADS AND FALCON AMULET.
 a. Faience beads (Ash. 1895.880a, grave 1783,
Naqada, Naqada I-II), lower bead has mark from firing.
 b. Microstructure of Fig. 29a, showing
polycrystalline body with pore in lower right and glaze
layer at top.
 c. Falcon (Ash. 1895.142, grave 1774, Naqada, Naqada
I), faience (or glazed quartzite or sandstone) amulet with
double drilled hole.

FIGURE 30. OTHER PREDYNASTIC BEADS HAVING TECHNOLOGICAL
AFFINITIES WITH FAIENCE.
 a. Glazed rock crystal (U.C. 4507, grave 1248,
Naqada, Naqada II); residual traces of glaze are located at
upper right and below the hole.
 b. Spherical bead made of faience body material and
covered with gold foil (Ash. E.E.36, grave b62, El Amrah,
Naqada II).

FIGURE 31. DRAWINGS OF PROTODYNASTIC, OLD KINGDOM, MIDDLE
KINGDOM AND NEW KINGDOM FAIENCE.

FIGURE 32. PROTODYNASTIC FAIENCE FROM HIERAKONPOLIS AND

ABYDOS.
 a. Standing baboon (Ash. E.5, Main Deposit,
Hierakonpolis, Dyn. I-II), glazed by efflorescent method.
 b. Bottom of baboon showing drying and firing marks.
 c. Left: green vase with brown daubed decoration
(Ash. E.658A, Tomb V, Khasekhemwi, Abydos, Dyn. II); right:
body of model pillar, with porous, friable texture (E.42,
Temple area, Abydos, Dyn. I-II).
 d. Bound calf, contours carefully formed by scraping
(Ash. E.4, Main Deposit, Hierakonpolis, Dyn. I-II).
 e. Bound calf showing shape of body; stand has been
added.

FIGURE 33. PROTODYNASTIC FAIENCE FROM HIERAKONPOLIS HAVING
TWO LAYERED BODY.
 a. Microstructure showing red coarse body with white
intermediate layer and green glaze.
 b. Top surface of lid (Ash. E.4006, Main Deposit,
Hierakonpolis, Dyn. I-II).
 c Bottom surface of lid showing texture of body and
locating cleaned area shown in Fig. 33a.

FIGURE 34. MICROGRAPH OF HIERAKONPOLIS FAIENCE BODY.
 Above is shown area high in silica and below is area
high in calcium, which can be tentatively identified as
quartz and calcite, respectively. Magnification of top
micrograph is 1060x.

FIGURE 35. SAQQARA TILE(1937.115, Tomb of Djoser near Step
Pyramid, Saqqara, Dyn. III)
 Arrow points to marks left by grinding; raised boss
has been drilled from two directions to form hole for wire.

FIGURE 36. MIDDLE KINGDOM MOLDED VESSELS, AND BEADS FORMED
OVER A ROD.
 a. Lower left, molded bowl fragment (E.3280, Abydos,
416); right, vessel formed over a rod (E.3277, Abydos, 416);
and fragment of vessel formed over a rod (E.3278, Abydos,
416).
 b. Rod formed vessel fragments (B.M.F.A. 14.2.314,
Kerma).
 c. Vessel fragment made of molded parts and joined
with slurry (B.M.F.A. 14.3.1443.B49, Kerma).
 d. Vessel (Ash. E.2176, Tomb E3, Abydos) and tubular
beads (E.175˙, Tomb E.30, and E.E.488, Tomb E2, Abydos).
The vessel and small bead are formed from two different
colors of paste, whereas the large bead is made of one color
paste with a painted spiral surface decoration.

FIGURE 37. MIDDLE KINGDOM BEADS FROM ABYDOS AND A TILE FROM
KERMA, SHOWING THREE GLAZING PROCESSES.
 a. Strings of Middle Kingdom beads from Abydos in
the Ashmolean Museum; individual numbers given below.
 b. Melon bead with blue-green effloresced glaze
(Ash. E.E. 481, Tomb E3, Abydos).
 c. Green bead with no firing or drying marks on
entire string, cementation process (Ash. E.E.478, E3,
Abydos).
 d. Edge of Kerma tile fragment showing two drips of
applied glaze (B.M.F.A. Cabinet 13B, Drawer 1, see Reisner,

Vol. VI, p. 149).

 e. Blue beads with firing marks (Ash. E.E.480, E3, Abydos).

 f. End of blue bead shown in Fig 37e, showing cracks from forming process

FIGURE 38. TILES AND VESSELS FROM KERMA.

 a. High fired, hard bodied plano-convex Kerma tile.

 b. Back of Kerma tile showing sharp edge of applied glaze.

 c. Two layered bodies, uppermost has not been cleaned, while lower soft body rilled tile has been cleaned.

 d. Vessel fragments with resisted glaze, Reisner, Vol VI, Plate 45.

 e. Back sides of tiles which have been formed on reed mat supports.

 f. Composite SEM micrograph of Kerma tile with two layered body, showing weathered surface of bright blue glaze, glaze layer, well sintered intermediate layer and inner body which is not as vitreous as the intermediate layer. Photograph to right taken at 200x.

FIGURE 39. NEW KINGDOM MOLDS, BEADS AND AMULETS.

 a. Group of clay molds for molding of faience from Amarna, Boston Museum of Fine Arts; top, left to right, mandrake mold 36.478; Bes mold, 36.503; mold of grapes, 36.481; bottom, left to right, Bes mold 36.501; Thoeris mold 36.509; wadjet eye mold, 36.498.

 b. Strings of beads from Amarna; lower two strings are molded beads with loops joined at each end, and upper string shows segmented, spherical and melon beads.

 c. Part of model date bead in Figure 39b, middle string, third from right. Brick red loop and molded body were joined with blue slurry.

 d. Blue molded uadjet eye amulet (Ash. 1932.1135, Amarna).

 e. Molded figure of Akhenaten (?) with incised drapery (Ash. 1921.1144b, Amarna).

 f. Bes amulet with red and grey inlay into yellow molded form (Ash. 1925.415, Amarna).

 g. Spherical lattice-work bead made of preformed beads joined with slurry (Ash. 1933.1201, Amarna).

FIGURE 40. NEW KINGDOM TILES AND VESSELS.

 a. Molded greyish blue vessel fragment with white inlaid decoration (Ash. 1893.1-41(471), Amarna, Akhenaten cartouche, Late Dyn. XVIII). There are indications from crossection of body that outer surface has slipped relative to inner surface. There is no glaze on the interior.

 b. Plaque, blue crown, with drilled decoration (Ash. 1931.511, Amarna City, house T.34.1, Late XVIII).

 c. Tile, below is blue inlay on white background and above is green, red and blue inlay on yellow background (Ash. 1942.80, Amarna, Late XVIII).

 d. Sistrum handle, probably warped in firing, showing incised grooves without inlay (Ash. 1893.1-41(945), Amarna, Nefertiti cartouche, Dyn XVIII).

 f. Fragment of kohl tube with blue inlay on green background (Ash. 1889.148, Amarna, Amenhotep III cartouche, Dyn XVIII).

g and h. Mandrake tile consisting of inlaid yellow and green plant parts outlined in brown (Brooklyn Museum 52.148.2, Hermopolis Magna, Dyn. XVIII, reign of Akhenaten).

h. Close up of Fig. 40g, showing brown brush strokes used to outline inlays.

i. Tile, with inlaid decoration and background scraped in relief (Ash. 1936.637, Great Palace, Amarna, Late XVIII).

j. Lotus flower inlay, with inlaid and painted decoration (Brooklyn Museum 49.8, Charles Wilbour Fund, said to be from Amarna, Dyn. XVIII).

k. Close up of Fig. 40j, showing center petal.

l. Right: tile with draft, with white, shiny glaze, worn on top surface, with brick red and blue inlay and having brown painted outlines (Ash. 1871.34D, Palace of Ramesses III, Tell el-Yahudiya). Center: inlay with lotus pattern consisting of light blue with blue and brick red inlay outlined in brown (Ash. 1871.34C, Palace of Ramessis III, Tell el-Yahudiya). Left: wall tile, with white petals on brown background and having raised yellow center (Ash. 1871.34F. Palace of Ramesses III, Tell el-Yahudiya).

m. Left: sistrum handle shown in Figure 40d, and right vessel fragment shown in Fig. 40a.
(Editorial note: This figure is redundant and should be deleted.)

n. Molded bowl with two layered body, painted decoration and fired on three supports, Amarna (B.M.F.A , 1977.619).

o. Kohl tube with extremely hard body and inlaid decoration (Ash. 1890.906, Medinet Ghurab, early Dyn XIX, Petrie's group of Amenhotep III)

FIGURE 41. MICROGRAPHS OF NEW KINGDOM FAIENCE.

a. Microstructure of glassy Amarna tile with spherical porosity, large glass fraction, 10x. Glaze is distinct layer on surface.

b. SEM micrograph of tile shown in Fig. 41a, 1100x, showing well sintered particles.

c. SEM micrograph of tile at 5000x, showing conchoidal fracture in center and below fine rounded grains high in silica coated with glass.

d. Microstructure of coarse bodied vessel fragment, with fragments of glass as well as quartz in the body, 10x.

e. SEM micrograph of fragment shown in Fig. 41d, 1100x, showing barely sintered particles.

f. SEM micrograph of fragment at 5000x, showing reaction at surface of quartz particles and near center, top, a sintered joint.

FIGURE 42. SHAWABTI MANUFACTURE.

a and b, upper figure: Shawabti figure molded in open face mold with sculpted back and facial features, and painted decoration (Ash. E.3565, Abydos, G50, Dyn. XXX). Cobalt painted decoration on copper blue-green background. Thick overall glaze. Firing marks are present on the back.

a and b, lower figure:' light green colored glassy faience with precisely incised decoration (Ash. 1916.2, Giza, Dyn. XXV-XXX). Back of figure is carefully formed. Grinding marks are found near column in back.

c and d, upper figure: dark blue shawabti, molded

in open face mold, with painted black details, fired to low
end of firing range (Ash. E.3586, Abydos, Dyn. XXI-XXV).
Firing marks on back. No detail has been sculpted into the
back.

c and d, lower figure, blue shawabti figure with
black painted decoration (Ash. 1884.35, no provenance, Queen
Maakare', Dyn. XXI). Molded in open face mold with very
little alteration of form from the mold.

e and f. Molded blue shawabti figure with skirt
added in faience of wet, pastey consistency (Ash. 1884.34,
no provinance, Painedjem, Dyn. XX1). The basic molded shape
has been altered. Decoration painted black.

FIGURE 43. SOME EXAMPLES OF FAIENCE MANUFACTURE IN THE
LATER PERIODS.
a. Female statuette (1892.1025, no provenance,
Ptolemaic) with light yellow inlaid face with lead
antimoniate colorant, drapery also inlaid in light blue, and
hair painted black. Form modeled and possibly sprigged onto
a vessel as join line is visible at bottom.
b. Marbleized vessel (1913.804. Memphis, Ptolemaic)
in greenish white imitation grains in black background.

FIGURE 44. VESSEL FRAGMENT WITH INLAID DECORATION, THROWN,
NEW KINGDOM.
a. Vessel fragment with inlaid decoration, probably
thrown (Ash. E.3410, Temple, Serabit el-Khadim). There are
ridges and grooves from throwing on the interior. The body
is coarse, friable and porous.
b. Base of Fig. 44a, showing dirt and glaze covering
base as well as raised firing marks; decoration is inlaid.

FIGURE 45. REMAINS FROM KOM QALANA AND QOM HELLUL KILN
SITES, MEMPHIS, FIRST CENTURY B.C.
a. Left to right: spheres of fritted glaze, kiln
wasters including warped bowl with triple support marks,
kiln setters and crucible (Ash., 1910.564, etc., and
1922.79, Memphis kilns)
b. Molded objects with applied glaze of two colors,
light blue raised surfaces on dark blue recessed surface,
formed by differing thicknesses of glaze. Lamp fragment to
left (1910.5552, Kom Hellul kilns, Memphis, Roman) has light
green inlays at ends of curvilinear designs. Object to
right is a waster (1910.560, Kom Hellul kilns, Memphis,
Roman), adhered to another similar shaped waster and to a
substrate of overfired clay which has a vitreous black
surface coating.
c. Bottom of vessel (1913.803C, Memphis, Ptolemaic)
probably thrown over hump mold with incised exterior and
fired on a four point support. There are slip planes at
center of cross section indicative of throwing.

FIGURE 46. FRITTED GLAZE PREPARATION FROM MEMPHIS KILN
SITE.
a. Conglomeration of individually modeled fritted
spheres and fragmented earthenware crucible, Ash. 1910.564
(scale in inches).
b. Mixture of quartz, calcite and glass is shown in
crossection of single fritted spherical form.
c and d. Micrographs showing considerable glassy
fraction in frit.

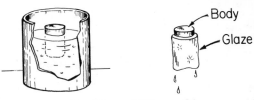

Application of Glaze Slurry

- ## Thickness Depends On Body Porosity and Water Content Of Slurry.

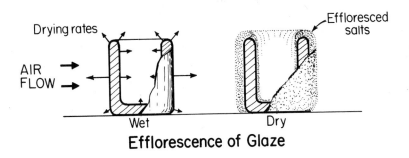

Efflorescence of Glaze

- ## Thickness Depends On Drying Rate.

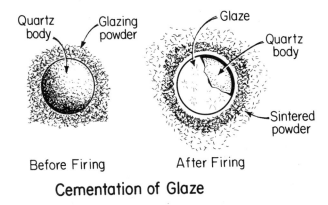

Cementation of Glaze

- ## Thickness Depends On Firing Time and Temperature.

Figure 24 Replications of glazing processes

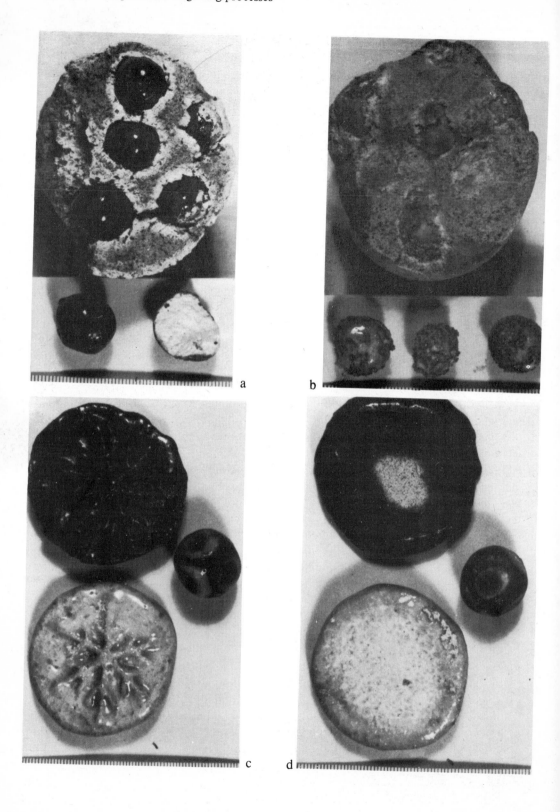

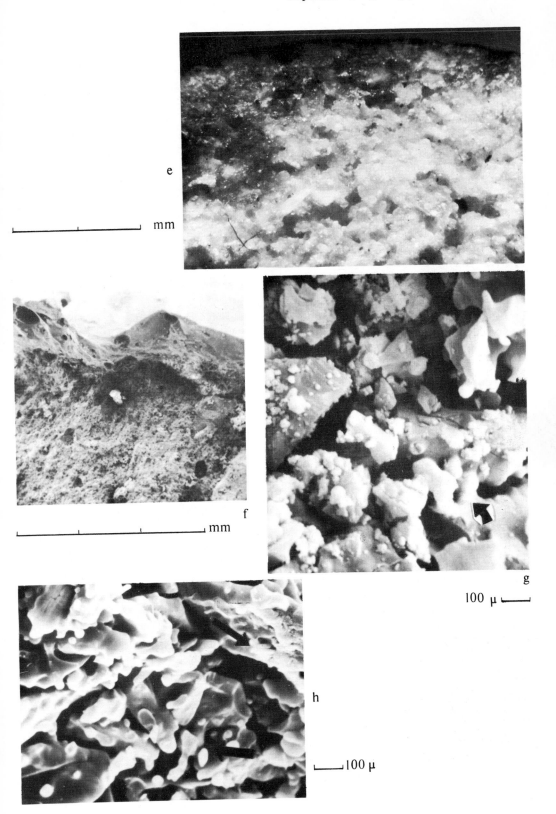

Figure 25 Micrographs of cross-sections of replications of bodies

a

⊢_____⊣ 1 mm

b

c

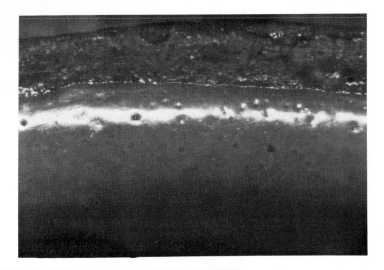

d

1 mm

e

f

Museum No._____ (dat▮

Description Bead___ Vessel___ Amulet___Manufacturing Elem▮

Preservation Weathering Layers___ Pits___ Flaking___ Powd▮
 Coated___ Efflorescence_____ Dirt _____
Body
 Homogeneous Sintered Frit Color _____
 Sketch Approx particle size___
 Identification of materi▮

 SiO$_2$ Fractures_____

 Degree of sintering & por▮

 Relative hardness___ (MOH▮

 Glass Color(s) Opaque___ Translucent___
 Striae/Cord_____ Bubbles/See▮
 Technique of manufacture Molded_
 Degree of annealing_____
 Other_____
 Inhomogeneous Sintered Frit ⌠Colors_____
 | Particle size range___
 or ⟨ Particle identificatio▮
 | SiO$_2$ Fractures_____ D▮
 Multi-layered | Sand _____ Quartz_____
 | Core_____ C▮
 | Other_____
 ⌡State of oxidation: i▮

 Surface Scraped or
 Ground Yes___ No___ _____
 Bubbles exposed_____ Ridges gr▮
 Fire polished surface Color_____Texture
 Summary Method of manufacture Soli▮
 Molded_____Ground _____
 Bubbles_____ Pinh▮
 Embedded particles, inclusi▮
 Color___
 Composition Glazed by Appli▮
 Efflo▮
 Cemen▮
 Undet▮
 Evidence Drying marks_____
 Firing marks_____
 Glazed top surfac▮
 Overall glaze_____
 Other comments_____

 XRF composition _____

 References _____

inance, museum case number also)

her _____

Fractured___ Surface Cracks___ Wear Scratches _____

;lue_____ Plaster._____

(range, fine, medium, or coarse)

ossibility of contact \angle measurement_____

vitreous or sintered, friable or nonfriable, and

ess)___ porosity by bubbles, intergranular
 or organic impressions)
rent___ Thickness _____
___ Stones/Devitrification/Brick_____
ed___ Wound on core___ Rods fused on core_____

sintering & porosity_____ Hardness_____
__ $CaCO_3$_____ $CaSO_4$_____ Metal Oxide Layer____Charcoal___
_____ Bone_____Carbon.___
_Number & color of layers_____
e_____Layers have size difference._____

_____ Evidence of cutting process_____
___Under or over painting_____
t glazed____ Inlay_____ Joined_____
ormed_____ Hole____Cored____Drilled_____Hollow__
_____Crawling_____ Crazing_____

___Shape_____Identification_____

e of soluble salts_____
in molten alkalies_____

Figure 27 Microstructures of samples submitted to microprobe analysis

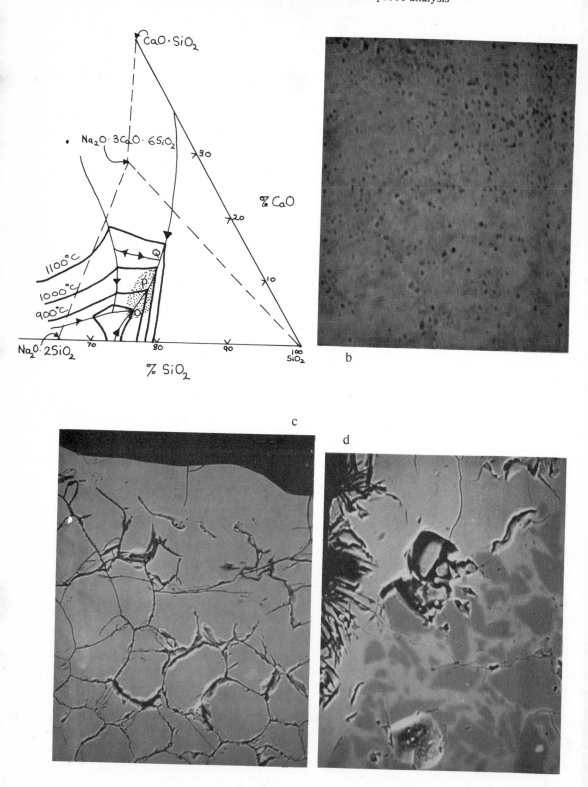

e

f

g

h

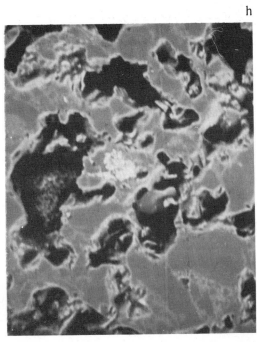

Figure 28 Glazed steatite beads and micrographs of steatite

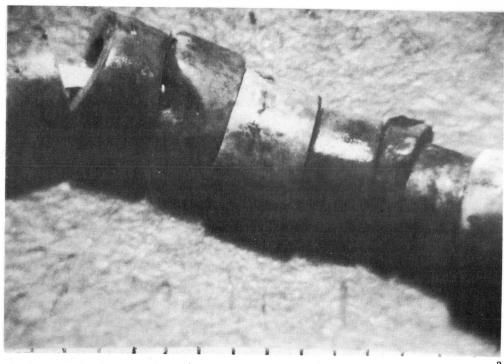

a

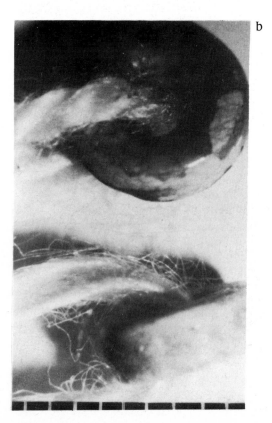

b

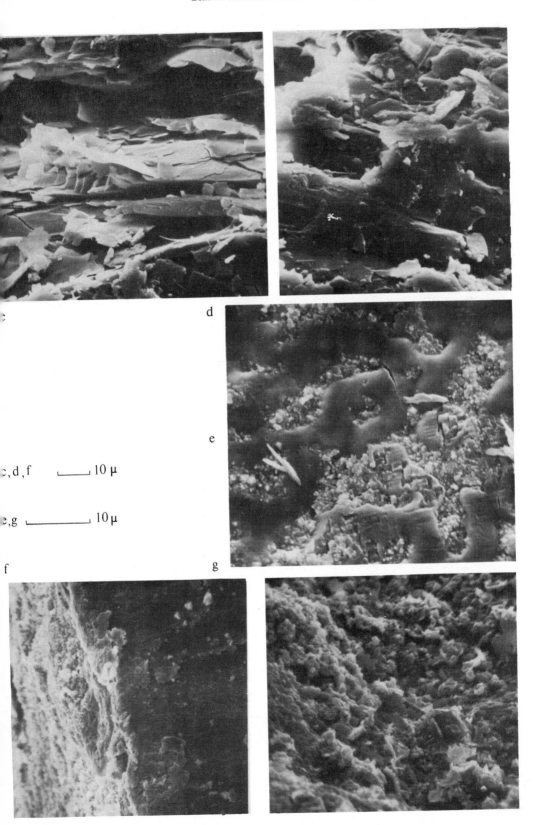

c

d

e

c,d,f ⌞————⌟ 10 μ

e,g ⌞————————⌟ 10 μ

f

g

Figure 29 Predynastic faience beads and falcon amulet

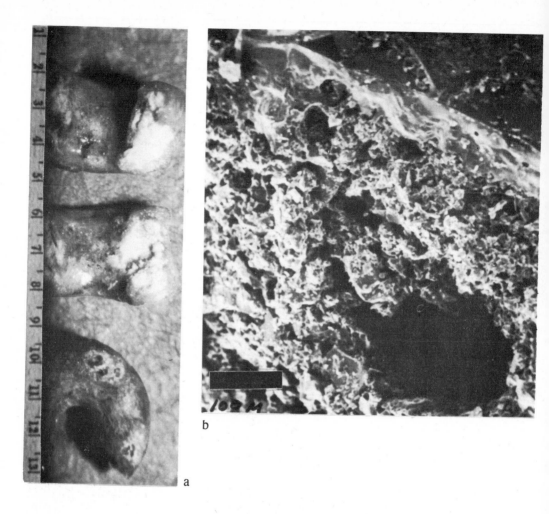

a

b

c

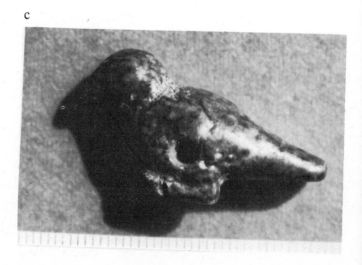

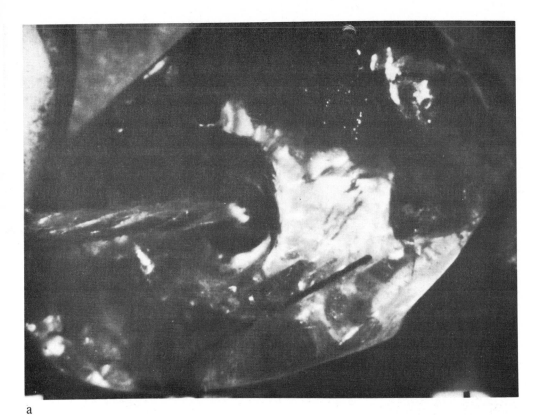

a

b

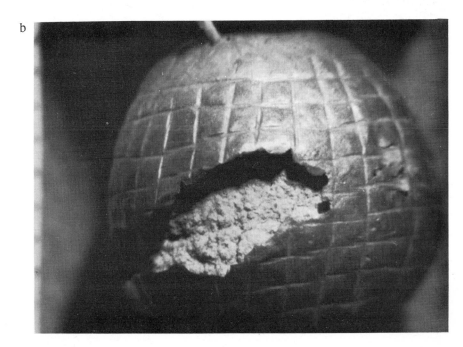

Figure 31 Drawings of Protodynastic, Old Kingdom and Middle Kingdom faience

Protodynastic Period

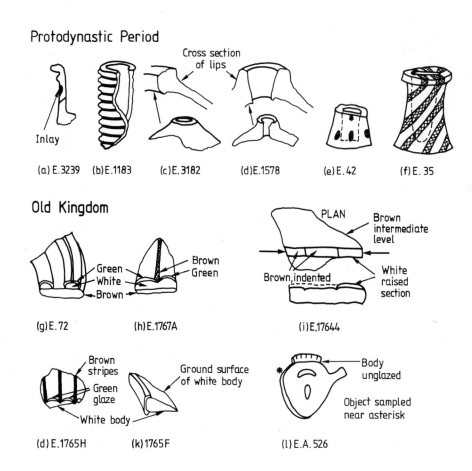

Cross section of lips

Inlay

(a) E.3239 (b) E.1183 (c) E.3182 (d) E.1578 (e) E.42 (f) E.35

Old Kingdom

Green
White
Brown

Brown
Green

(g) E.72 (h) E.1767A

PLAN

Brown intermediate level

Brown, indented

White raised section

(i) E.17644

Brown stripes

Green glaze

White body

Ground surface of white body

Body unglazed

Object sampled near asterisk

(d) E.1765H (k) 1765F (l) E.A.526

First Intermediate Period

(m) E.E.98 A (n) E.E.92(ii)B

Middle Kingdom

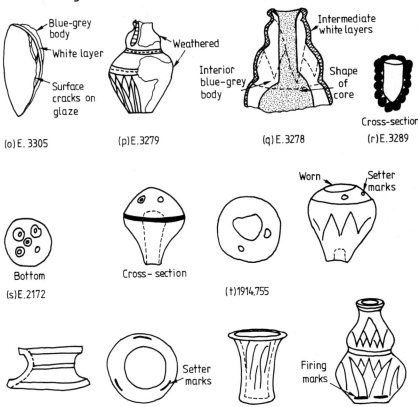

Blue-grey body
White layer
Surface cracks on glaze

(o) E. 3305

Weathered

(p) E.3279

Intermediate white layers
Interior blue-grey body
Shape of core

(q) E.3278

Cross-section

(r) E.3289

Bottom

(s) E.2172

Cross-section

Cross-section

(t) 1914.755

Worn Setter marks

(u) 1971.950

Setter marks

(v) E.2176

Firing marks

(w) Newbury loan 94

New Kingdom

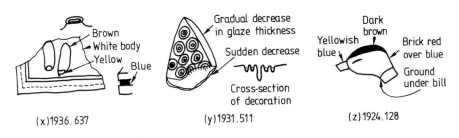

Brown
White body
Yellow
Blue

(x) 1936.637

Gradual decrease in glaze thickness
Sudden decrease
Cross-section of decoration

(y) 1931.511

Dark brown
Yellowish blue
Brick red over blue
Ground under bill

(z) 1924.128

Figure 32 Protodynastic faience from the Main Deposit at Hierakonpolis and from Abydos

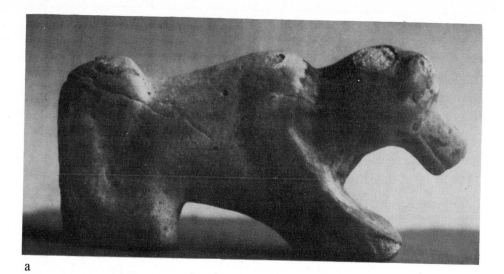

a

b

c

d

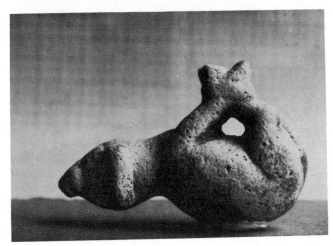

e

Figure 33 Protodynastic faience from Hierakonpolis having two-layered body

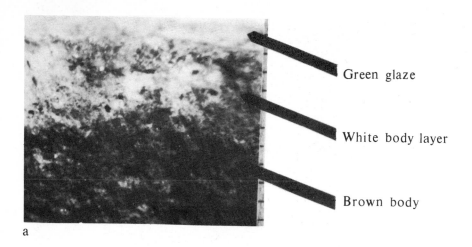

Green glaze

White body layer

Brown body

a

b

c

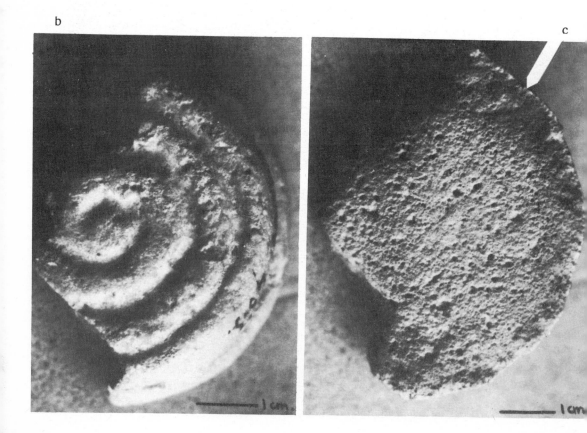

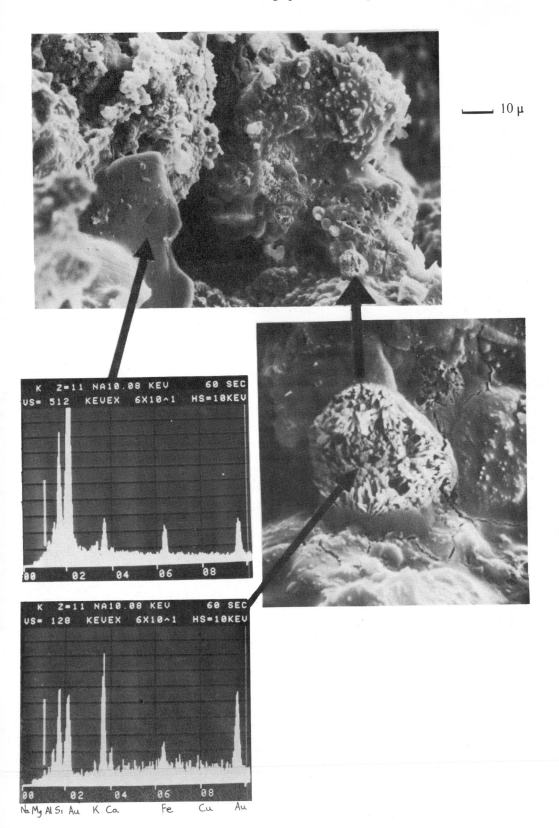

Figure 35 Saqqara tile

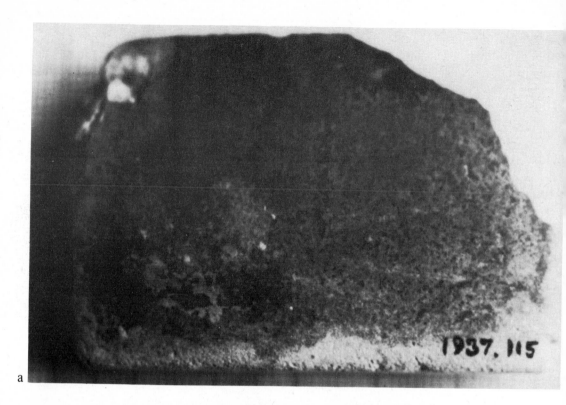

a

b

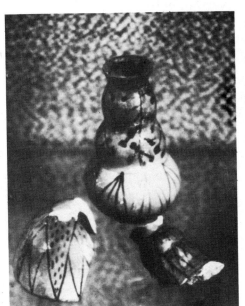

b

a

d

c

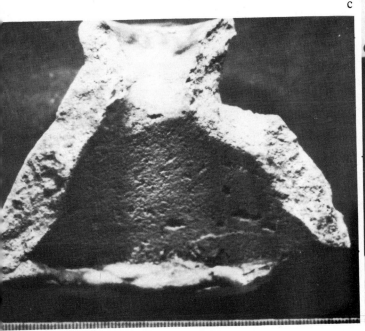

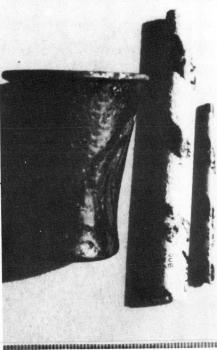

Figure 37 Middle Kingdom beads from Abydos and a tile from Kerma showing three glazing process

a

b

c

d

e

f

Figure 38 Micrograph of cross-section of Kerma tile

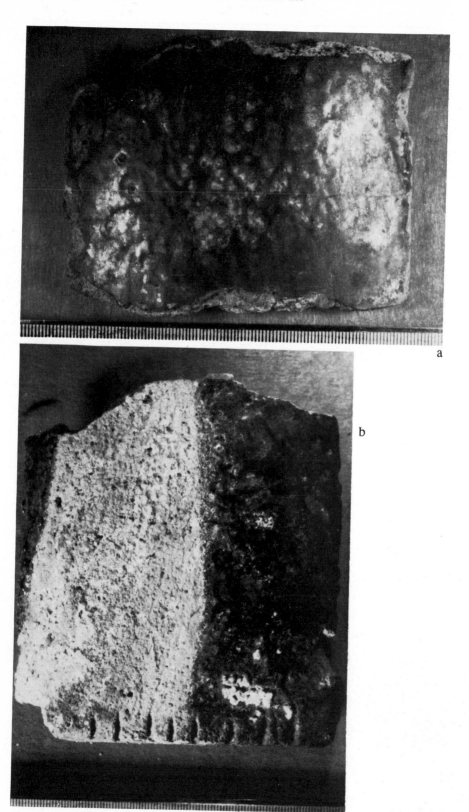

a

b

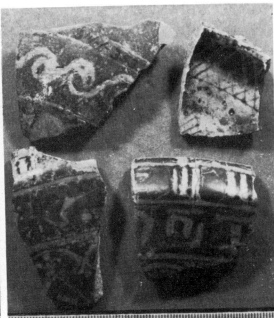

c

d

e

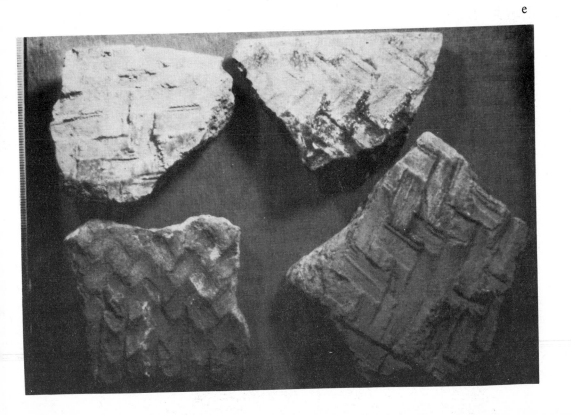

Figure 38 Micrograph of cross-section of Kerma tile

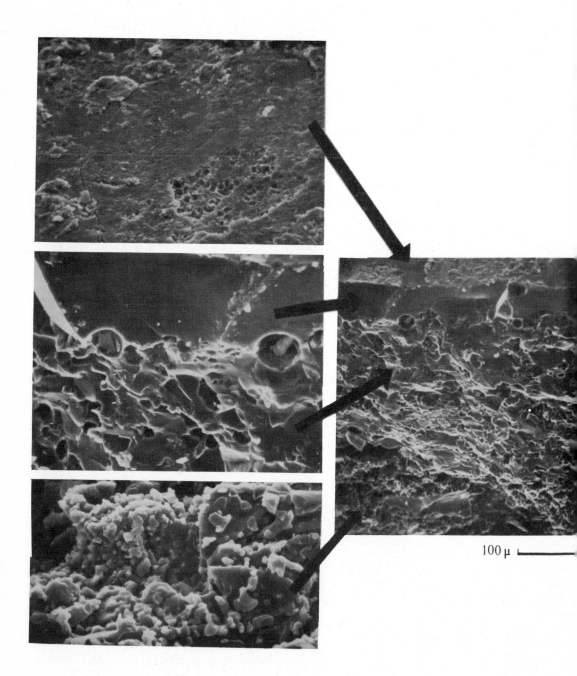

100 μ

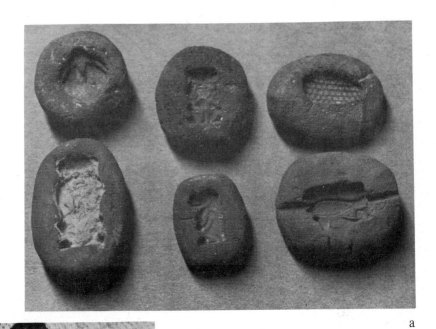

a

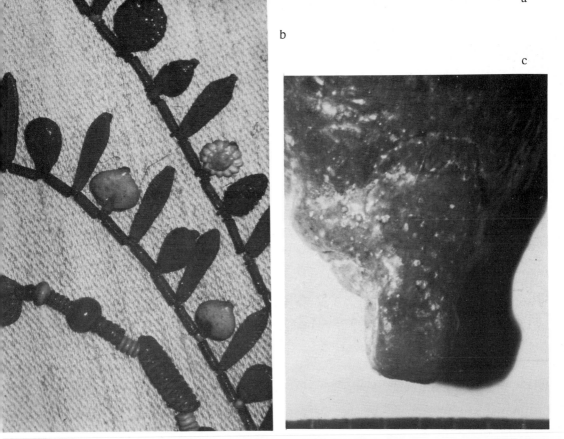

b

c

Figure 39 New Kingdom molds, beads and amulets

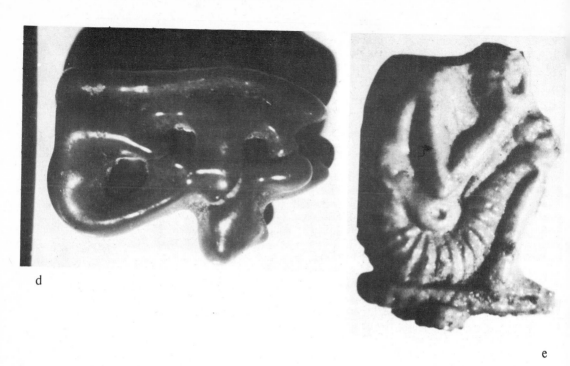

d

e

f

g

Figure 40 New Kingdom tiles and vessels

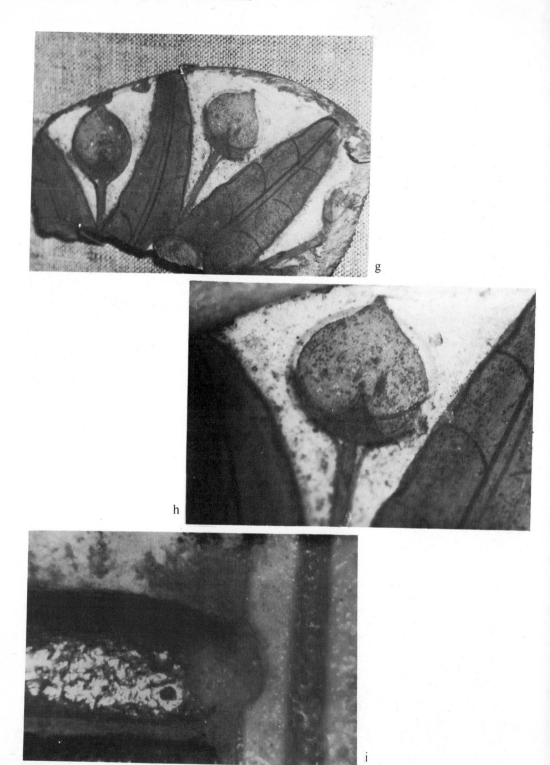

j

k

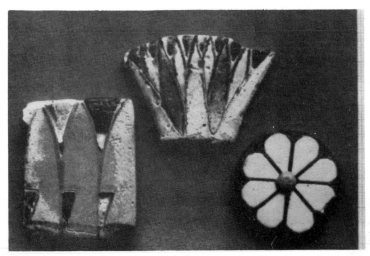

l

Figure 40 New Kingdom tiles and vessels

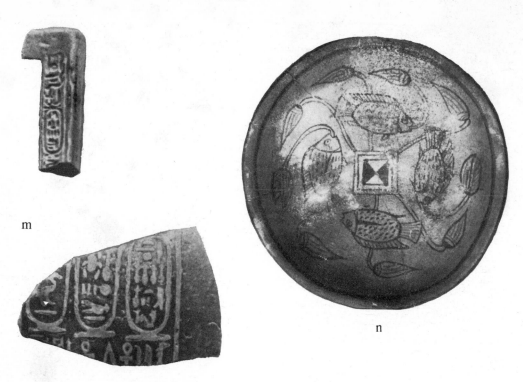

m

n

o

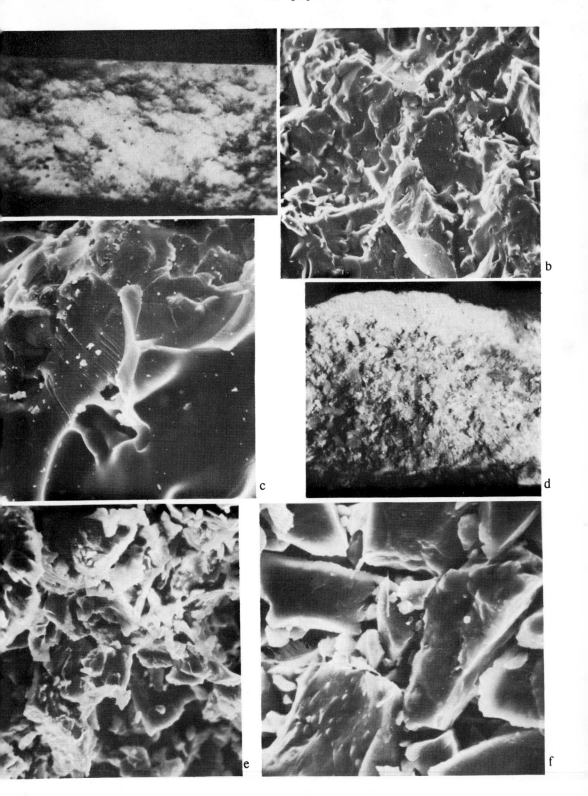

Figure 42 Shawabti manufacture

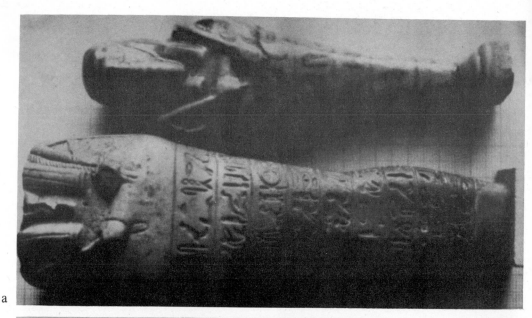

a

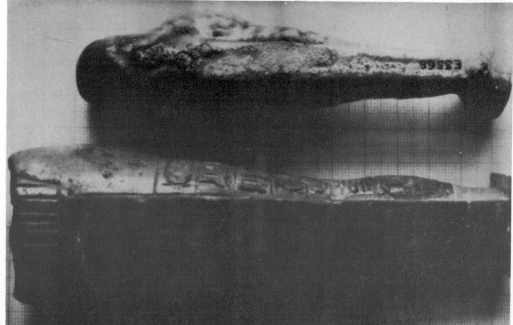

b

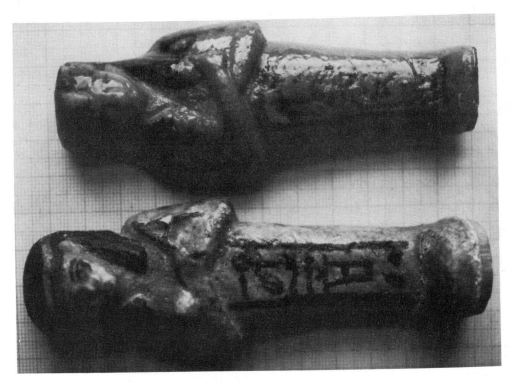

c

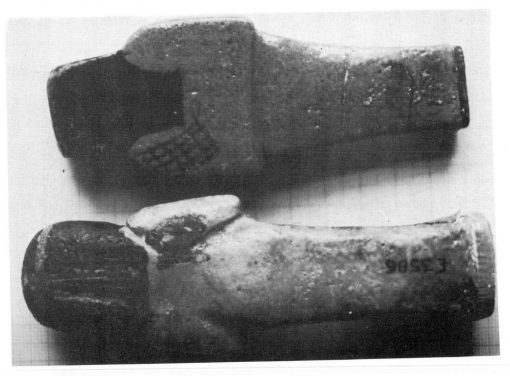

d

Figure 42 Shawabti manufacture

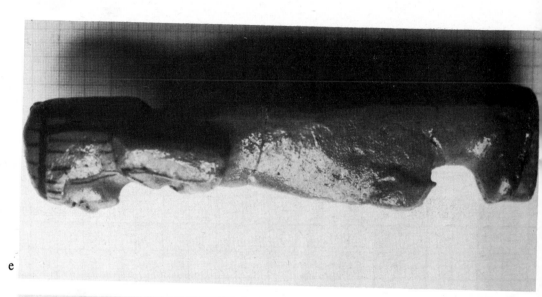

e

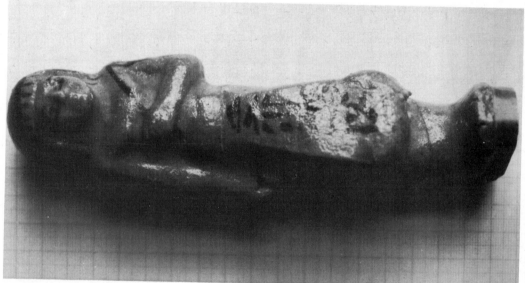

f

Figure 44 Vessel fragment with inlaid decoration, thrown, New Kingdom

a

b

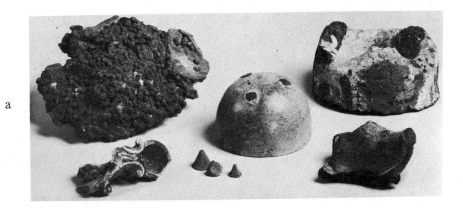

a

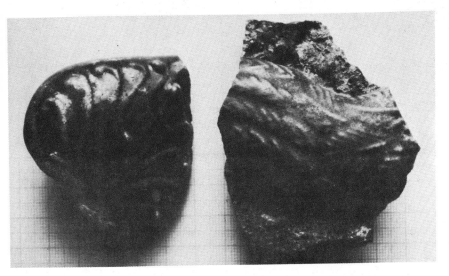

b

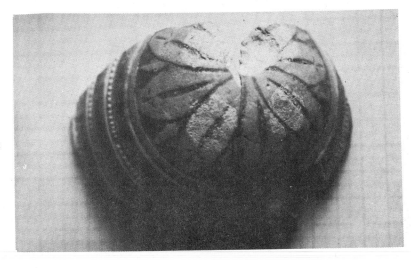

c

Figure 46 Fritted glaze preparation from Memphis kiln site

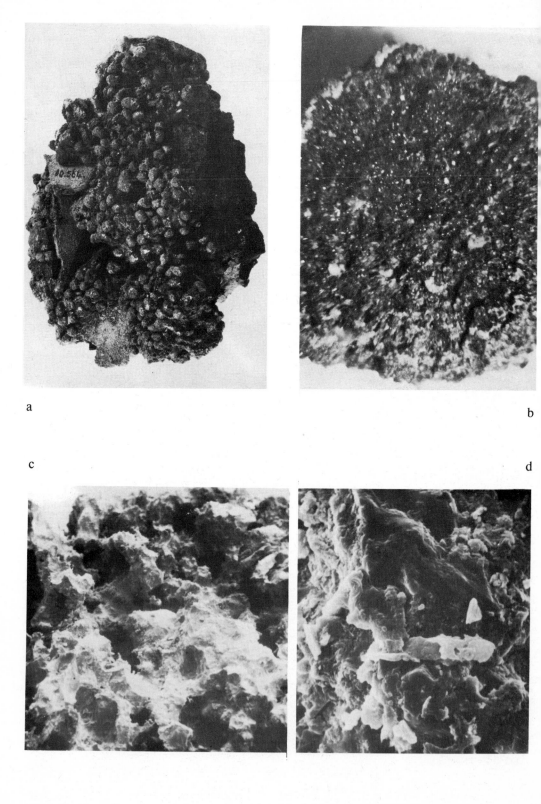

a

b

c

d

Museum Accession Nos.	Appendix C Code Nos.	Museum Accession Nos.	Appendix C Code Nos.
Unprefixed Accession Numbers		1888.264	285- 10-676
		1888.266	200- 10-659
1871.34A	203- 20-373	1888.710	185-200-268
1871.34B	203- 20-376	1889.101	181-200-291
1871.34C	203- 20-374	1889.110	185-200-279
1871.34D	203- 20-375	1889.125	185-200-275
1871.34E	203- 20-657	1889.148	185- 68-331
1871.34F	203- 20-658	1889.851	214-107-430
1871.34G	203- 20-765	1889.852	200-200-408
1871.34H	203- 20-639	1889.1073	260- 51-489
1872.80	257-200-509	1890.406	151-200-220
1872.162	182-200-266	1890.408	182-200-271
1872.169	193- 26-660	1890.410	178-200-222
1872.186	257-200-221	1890.412	185-200-284
1872.298	262-118-501	1890.766	181- 54-304
1872.330	225-118-432	1890.769	183- 54-307
1872.330	225-118-796	1890.770	183- 54-299
1872.800	183-200-287	1890.771	183- 54-305
1872.812	203-200-406	1890.772	183- 54-295
1872.813	185-200-274	1890.774	183- 54-300
1872.933	257- 33-481	1890.776	183- 54-306
1872.936	261- 33-482	1890.777	183- 54-298
1872.939	214- 33-664	1890.779	183- 54-296
1872.940	200- 26-661	1890.782	183- 54-297
1872.944	214- 26-662	1890.785A	183- 54-301
1872.946	214- 26-663	1890.815	183- 54-302
1874.230	257-200-508	1890.821	183- 54-303
1874.233	257-200-510	1890.897	190- 53-377
1878.41	214- 33-665	1890.898	190- 53-378
1878.193.o	257- 33-483	1890.901	190- 53-380
1879.272	200-200-407	1890.905	190- 53-379
1879.277	210-200-437	1890.906	190- 53-381
1879.293	185-200-285	1890.925	190- 53-382
1879.356	185-200-265	1890.953	192- 53-384
1884.34	210-200-438	1890.986	195- 53-385
1884.35	210-200-440	1890.1001	195- 53-386
1884.36	210-200-441	1890.1014	195- 53-387
1884.44	214-118-431	1890.1117	192- 53-383
1884.48	210-200-442	1891.84	214-200-449
1884.54	210-200-439	1891.297	257- 47-490
1885.330	310-135-516	1892.226	185-200-280
1886.139a	182-118-286	1892.262	135-200-218
1887.2438	275- 8-463	1892.273	179-200-262
1887.2441	275- 8-464	1892.638	214-200-457
1887.2443	275- 8-462	1892.641	285-200-511
1887.2446	201- 8-371	1892.643(E3571)	185- 82-292
1887.2447	201- 8-372	1892.789	188-200-401
1887.2459	263- 8-467	1892.816	200- 82-390
1887.2523	262- 9-465	1892.1025	309-200-542
1887.2527	275- 7-466	1892.1028	310- 25-519
1888.1455	310-200-539	1892.1384	270-200-469
1888.213	285- 5-684	1893.1-41(392A)	186- 68-340
1888.239	308- 10-512	1893.1-41(393)	185- 68-333
1888.248	308- 10-687	1893.1-41(394)	185-115-332
1888.256A	308- 10-688	1893.1-41(439)	187- 68-346

Museum Accession Nos.	Appendix C Code Nos.	Museum Accession Nos.	Appendix C Code Nos.
1893.1-41(448F)	187- 68-313	1911.614B	193- 38-656
1893.1-41(449D)	187- 68-312	1912.225A	145-150-257
1893.1-41(450C)	187- 68-314	1912.225B	145-150-258
1893.1-41(451)	187- 68-348	1912.233A	145-150-259
1893.1-41(471)	186- 68-334	1912.233B	145-150-260
1893.1-41(472)	186- 68-335	1912.522A	120-107-158
1893.1-41(476)	186- 68-336	1912.522B	120-107-159
1893.1-41(480)	186- 68-339	1912.524A	120-107-160
1893.1-41(481)	187- 68-345	1912.528	310-107-515
1893.1-41(482)	187- 68-355	1912.529	310-107-513
1893.1-41(485)	186- 68-341	1912.533	310-107-514
1893.1-41(501)	186- 68-337	1912.607	250- 39-436
1893.1-41(541)	187- 68-344	1912.726	145-150-261
1893.1-41(945)	186- 68-338	1913.405A	120-107-151
1893.1-41(947)	187- 68-330	1913.494A	20- 40-569
1895.105	285-200-473	1913.494B	20- 40-570
1895.142	3-117- 10	1913.494C	20- 40-745
1895.880A	3-117-741	1913.494D	20- 40-636
1895.880B	3-117-742	1913.513	204-119-400
1895.880C	3-117-743	1913.789	250- 43-458
1909.347	310- 1-541	1913.799	310- 32-534
1909.1042	310- 32-524	1913.800A	310- 32-533
1909.1044	310- 32-525	1913.803C	310- 32-535
1909.1045	310- 32-526	1913.804	310- 32-537
1909.1050	310- 32-527	1913.808	310- 32-536
1909.1056	310- 32-528	1914.471	252-151-461
1909.1062	285- 32-503	1914.476	252-151-459
1909.1069	192-120-397	1914.477	252-151-460
1910.518	131-107-244	1914.653	115- 55-192
1910.533A	277- 32-478	1914.680	182- 55-308
1910.533B	277- 32-477	1914.712A	220- 54-413
1910.533C	277- 32-479	1914.725	220- 54-412
1910.544	320- 32-553	1914.755	115- 55-194
1910.545	320- 32-556	1914.759	115- 55-193
1910.546(2)	310- 32-529	1914.762A	115- 55-592
1910.549(1)	310- 32-532	1914.762B	115- 55-593
1910.551(1)	310- 32-530	1916.2	261- 26-474
1910.551(2)	310- 32-531	1921.1134	187- 68-349
1910.553	320- 32-557	1921.1156	187- 68-350
1910.554	320- 32-558	1921.1201	270- 25-470
1910.555(2)	320- 32-543	1921.1203	285- 25-471
1910.557(1)	320- 32-550	1921.1345A	90- 56-146
1910.557(2)	320- 32-549	1921.1373	130- 56-217
1910.559(1)	320- 32-554	1921.1375A	130- 56-216
1910.559(3)	320- 32-552	1921.1411	90- 56-147
1910.560	320- 32-551	1921.1411	90- 56-148
1910.564A	315- 32-520	1921.1411	90- 56-156
1910.565(2)	315- 32-521	1921.1411	90- 56-793
1910.567(1)	315- 32-522	1921.1411	90- 56-794
1910.576	285- 42-488	1921.1411	90- 56-795
1910.671H	120-118-191	1922.152	270-200-472
1910.784	262- 32-476	1923.489	90- 79-142
1911.358	262- 32-480	1923.542A	45- 80- 64
1911.358	262- 32-799	1923.542B	45- 80-577
1911.614A	193- 38-655	1923.542C	45- 80-576

Museum Accession Nos.	Appendix C Code Nos.	Museum Accession Nos.	Appendix C Code Nos.
1923.543A	45- 80- 63	1925.491B	131- 78-617
1923.557	90- 79-143	1925.493A	131- 78-236
1923.571A	131- 80-240	1925.493B	131- 78-237
1923.571B	131- 80-241	1926.176A	182-107-247
1923.605	193- 80-391	1926.176B	182-107-242
1923.635A	61- 80- 67	1926.176C	182-107-610
1923.635B	61- 80- 68	1926.176D	182-107-611
1923.644A	61- 80- 69	1929.406	187- 68-361
1923.654A	61- 80- 70	1929.407a	187- 68-326
1923.654B	61- 80- 71	1929.407b	187- 68-325
1924.45	310-200-538	1930.468A	131- 76-225
1924.75	187- 68-317	1930.468B	131- 76-226
1924.109a	187- 68-359	1930.468C	131- 76-614
1924.109b	187- 68-358	1930.468D	131- 76-615
1924.112	187- 68-318	1930.483A	130- 76-227
1924.113c	187- 68-321	1930.483B	130- 76-228
1924.114	187- 68-323	1930.504A	130- 76-229
1924.115a	187- 68-319	1930.504B	130- 76-230
1924.115b	187- 68-320	1930.507A	130- 76-231
1924.119	325- 68-352	1930.507B	130- 76-232
1924.123	187- 68-351	1930.508A	130- 76-233
1924.128	187- 68-322	1930.508B	130- 76-234
1924.154	187- 68-360	1930.508C	130- 76-235
1924.339A	56- 78- 78	1930.513A	130- 76-612
1924.339B	56- 78-578	1930.513B	130- 76-613
1924.339C	56- 78-579	1930.513C	130- 76-638
1924.348A	78- 78-124	1930.521A	51- 76- 77
1924.348B	78- 78-125	1931.250A	11- 74- 46
1924.349A	78- 78-126	1931.256A	90- 74-136
1924.349B	78- 78-127	1931.258A	90- 74-137
1924.351A	78- 78-128	1931.273	225- 74-417
1924.351B	78- 78-129	1931.281A	225- 74-672
1924.368A	61- 80- 73	1931.281B	225- 74-671
1924.384A	78- 79-138	1931.304	225- 74-416
1924.384B	78- 79-139	1931.317	225- 74-418
1924.387A	78- 79-140	1931.322	225- 74-419
1924.387B	78- 79-141	1931.323	225- 74-670
1924.395A	90- 80-144	1931.326A	61- 74- 87
1924.395B	90- 80-145	1931.352C	225- 74-675
1925.431A	119- 45-594	1931.381	225- 74-414
1925.431B	119- 45-595	1931.385A	20- 74-571
1925.432A	119- 45-596	1931.385B	20- 74-572
1925.432B	119- 45-597	1931.385C	20- 74-573
1925.432C	119- 45-640	1931.509	187- 68-347
1925.447A	61- 78- 79	1931.510	187- 68-356
1925.447B	61- 78- 80	1931.511	187- 68-324
1925.449A	61- 78- 81	1932.921A	78- 74-133
1925.449B	61- 78- 82	1932.921B	78- 74-134
1925.450A	61- 78- 83	1932.933a	78- 74-131
1925.458A	61- 78- 84	1932.933b	78- 74-132
1925.459A	46- 78- 85	1932.1132	187- 68-357
1925.459B	46- 78- 86	1932.1134b	187- 68-329
1925.479A	131- 78-238	1933.54	188-200-402
1925.479B	131- 78-239	1933.56	189-200-404
1925.491A	131- 78-616	1933.59	185-200-276

Museum Accession Nos.	Appendix C Code Nos.	Museum Accession Nos.	Appendix C Code Nos.
1933.60	185-200-277	1971.1456	214-200-455
1933.62	189-137-403	1971.1457	214-200-456
1933.606	220-200-443		
1933.675	185-200-282	Numbers Prefixed by E.	
1933.798	285-118-500		
1933.1462	185-200-283	E.4	20-134- 14
1933.1503	214-200-448	E.5	20-134- 15
1934.264	187- 68-328	E.7	20-134- 11
1934.265	187- 68-327	E.19	20-134- 48
1935.169A	41-124- 98	E.21	20-107- 41
1935.169B	41-124- 99	E.27	20-107- 38
1935.171aA	41-124-584	E.33	20-107- 37
1935.171aB	41-124-585	E.35	20-107- 39
1935.590a	187- 68-354	E.36	20-107- 34
1935.635d	187- 68-797	E.42	20-107- 35
1936.636	187- 68-316	E.45	20-134- 12
1936.637	187- 68-315	E.50	20-107- 40
1937.115	31- 33- 65	E.72	20-107- 36
1938.303	257-200-506	E.138+1255	18-107- 1
1942.77	187- 68-353	E.138+1255	18-107- 2
1942.80	187- 68-342	E.138+1255	18-107- 3
1942.80	187- 68-343	E.138+1255	18-107- 4
1942.94	250-118-435	E.138+1255	18-107- 5
1942.280	31- 33- 52	E.138+1255	18-107- 6
1947.291	262-200-502	E.138+1255	18-107- 7
1949.353	120- 55-195	E.138+1255	18-107- 8
1949.748	320-200-548	E.138+1255	18-107- 9
1954.669	31- 33- 50	E.191	20-134- 13
1954.670b	31- 33- 51	E.381	41-133- 56
1956.18	300-200-770	E.382	41-133- 55
1956.19	300-200-768	E.648	29-107- 20
1956.954	131-200-223	E.649	29-107- 21
1957.215	183-200-309	E.658A	29-107- 19
1958.346	214-200-447	E.1172	15-107- 22
1960.798	263-200-499	E.1183	17-107- 24
1961.410	262-200-505	E.1577	14-107- 30
1962.864	131-200-224	E.1578	14-107- 29
1962.888	182-200-269	E.1750	120-107-161
1962.892	182-200-270	E.1751	120-107-162
1964.219	183-200-272	E.1764H	61-107- 91
1964.706	209-118-410	E.1765F	61-107- 92
1965.175	265- 33-484	E.1766	61-107- 93
1965.176	250-200-504	E.1767A	61-107- 94
1968.104	320-200-555	E.1769C	61-107- 95
1968.111	189-200-405	E.1770A	61-107- 96
1968.158	310-200-523	E.1784	80-106-113
1968.776	214-200-454	E.1785	120-110-189
1969.474	285- 33-486	E.1810	46-133- 57
1969.710A	262- 8-468	E.2150A	125-133-204
1971.69	310- 33-517	E.2150B	125-133-759
1971.104	285- 33-487	E.2160	120-107-188
1971.950	120-200-197	E.2172	120-107-187
1971.1355	220-200-444	E.2176	120-107-185
1971.1357	260-200-507	E.2183	120-107-186
1971.1413	214-200-452	E.2199	120-107-184

Museum Accession Nos.	Appendix C Code Nos.	Museum Accession Nos.	Appendix C Code Nos.
E.2205	180-107-263	E.3595	193-107-393
E.2217	131-110-252	E.3610	214-107-427
E.2288	120- 62-190	E.3613	214-107-428
E.2445	193- 38-650	E.3615	251-107-492
E.2643	183- 38-310	E.3616	214-107-429
E.2644	183- 38-273	E.3622	193-107-392
E.2645	183- 58-293	E.3720	310- 5-540
E.2656	193- 38-651	E.3749A	320- 32-544
E.2729	183-119-288	E.3784	151- 12-215
E.3182	16-107- 28	E.3788	121-133-200
E.3239B	16-107- 27	E.3789	121-133-198
E.3278	120-107-179	E.3790	121-133-199
E.3279	120-107-180	E.4006	20-134- 16
E.3281	120-107-176	E.4080C	31-104-582
E.3282	120-107-181	E.4080D	31-104-583
E.3285	120-107-175	E.4455a	194- 38-367
E.3286	120-107-178	E.4455b	194- 38-366
E.3287	120-107-170	E.4455e	194- 38-653
E.3288	120-107-177	E.4458A	192- 38-363
E.3289	120-107-172	E.4462a	183- 38-311
E.3302F	120-107-171	E.4467	193- 38-654
E.3303	120-107-168	E.4532	183-115-290
E.3304Q	120-107-169	E.4548	285- 5-680
E.3305	120-107-173	E.4611	320- 32-559
E.3306	120-107-174	E.4614A	320- 32-560
E.3320	191- 38-362	E.4620	320- 32-545
E.3322	194- 38-365	E.4621	320- 32-546
E.3324	195- 38-368	E.4624	320- 32-547
E.3325	193- 38-652		
E.3327	203- 38-369		

Numbers Prefixed by E.A.

E.3333	194- 38-364	E.A.521A	285-107-677
E.3370	192-118-396	E.A.521B	285-107-678
E.3384	196-118-399	E.A.526	61-107- 97
E.3391	196-118-398	E.A.555	285- 5-681
E.3405A	210-107-420	E.A.798A	302-107-498
E.3410	203- 38-370	E.A.889	285- 5-682
E.3451A	300-107-494	E.A.898	285- 5-683
E.3451B	300-107-495	E.A.905	285- 5-679
E.3462	302-107-497	E.A.908	285- 5-685
E.3519	178-107-248	E.A.1077	141-107-243
E.3519	178-107-249		

Numbers Prefixed by E.E.

E.3565	300-107-496	E.E.5A	20-134-631
E.3566	300-107-769	E.E.5B	20-134-632
E.3570	200- 53-388	E.E.6A	20-134-633
E.3574	250-107-491	E.E.6B	20-134-634
E.3577	285-200-771	E.E.8A	20-134-635
E.3580A	300-107-493	E.E.8B	20-134-636
E.3585	200- 53-389	E.E.9A	20-134- 17
E.3586	214-107-422	E.E.26A	20-134- 18
E.3588	210-107-421	E.E.30A	17-107- 25
E.3589	201-107-394	E.E.63	17-107- 44
E.3590	214-107-423	E.E.67A	19-107- 23
E.3591	214-107-424		
E.3592	214-107-425		
E.3593	214-107-426		

Museum Accession Nos.	Appendix C Code Nos.	Museum Accession Nos.	Appendix C Code Nos.
E.E.68A	20-107- 32	E.E.165B	131-110-256
E.E.71A	20-107- 42	E.E.169A	126-133-219
E.E.72A	28-107- 26	E.E.169B	126-133-760
E.E.76A	20-107- 33	E.E.169C	126-133-761
E.E.81A	11-110- 45	E.E.238A	183-115-772
E.E.84A	51- 60- 76	E.E.238B	183-115-773
E.E.85A	51- 60- 74	E.E.238C	183-115-774
E.E.85B	51- 60- 75	E.E.238D	183-115-775
E.E.89B	46-133- 59	E.E.238E	183-115-776
E.E.89C	46-133-574	E.E.238F	183-115-777
E.E.89D	46-133-575	E.E.238G	183-115-792
E.E.90A	80-106-114	E.E.238H	183-115-779
E.E.90B	80-106-115	E.E.238I	183-115-785
E.E.90C	80-106-586	E.E.238J	183-115-786
E.E.90D	80-106-587	E.E.238K	183-115-787
E.E.90E	80-106-588	E.E.238L	183-115-788
E.E.90F	80-106-589	E.E.238M	183-115-789
E.E.90G	80-106-590	E.E.238N	183-115-790
E.E.90H	80-106-591	E.E.455A	46-106- 62
E.E.92(ii)A	80-106-108	E.E.455B	46-106-580
E.E.92(ii)B	80-106-110	E.E.455C	46-106-581
E.E.92(ii)C	80-106-109	E.E.456A	46-106- 60
E.E.92(iii)A	80-106-106	E.E.456B	46-106- 61
E.E.92(iii)B	80-106-107	E.E.458A	80-106-102
E.E.98A	80-106-111	E.E.458B	80-106-103
E.E.98B	80-106-112	E.E.478A	120-107-746
E.E.102A	80-106-104	E.E.478B	120-107-747
E.E.102B	80-106-105	E.E.478C	120-107-748
E.E.106A	124-133-604	E.E.480A	120-107-750
E.E.124A	122-133-602	E.E.480B	120-107-751
E.E.124B	122-133-637	E.E.480C	120-107-752
E.E.124C	122-133-201	E.E.481A	120-107-754
E.E.125A	123-133-210	E.E.481B	120-107-755
E.E.125B	123-133-202	E.E.486A	120-107-182
E.E.125C	123-133-211	E.E.486B	120-107-183
E.E.125D	123-133-756	E.E.487B	120-107-157
E.E.125E	123-133-758	E.E.488A	120-107-152
E.E.125F	123-133-757	E.E.488B	120-107-153
E.E.131A	124-133-600	E.E.489A	182-107-625
E.E.131B	124-133-601	E.E.489B	182-107-626
E.E.131C	124-133-212	E.E.492A	131-107-245
E.E.131D	124-133-603	E.E.492B	131-107-246
E.E.133	125-133-203	E.E.492C	131-107-606
E.E.138A	127-133-206	E.E.492D	131-107-607
E.E.138B	127-133-207	E.E.492E	131-107-608
E.E.138C	127-133-208	E.E.492F	131-107-609
E.E.138D	127-133-205	E.E.495A	131-112-250
E.E.138E	127-133-209	E.E.495B	131-112-251
E.E.138G	127-133-763	E.E.500A	20-107- 31
E.E.138H	127-133-764	E.E.512A	182-107-627
E.E.163A	131-110-253	E.E.607A	225- 32-666
E.E.163B	131-110-254	E.E.607B	225- 32-667
E.E.164A	120-110-598	E.E.607C	225- 32-668
E.E.164B	120-110-599	E.E.608A	257- 32-475
E.E.165A	131-110-255	E.E.608B	257- 32-564

Museum Accession Nos.	Appendix C Code Nos.	Museum Accession Nos.	Appendix C Code Nos.
E.608C	257- 32-767	U.C.4507	9-117-707
E.608D	257- 32-565	U.C.4507	9-117-708
E.608E	257- 32-566	U.C.4507	9-117-709
E.608F	257- 32-567	U.C.4507	9-117-791
E.608G	257- 32-762	U.C.4569	6-117-714
E.611	225- 32-669	U.C.4569	6-117-715
E.633A	120-107-163	U.C.4569	6-117-716
E.633B	120-107-164	U.C.4569	6-117-717
E.633C	120-107-165	U.C.4569	6-117-718
E.633D	120-107-166	U.C.4569	6-117-719
E.643A	183-115-628	U.C.4569	6-117-720
E.643B	183-115-629	U.C.5001	5-117-705
E.657	151- 20-621	U.C.5015	6-117-724
E.659A	151- 20-213	U.C.5015	6-117-737
E.659B	151- 20-214	U.C.5020	5-117-706
E.659C	151- 20-619	U.C.5021	6-117-725
E.659D	151- 20-618	U.C.5021	6-117-726
E.659E	151- 20-620	U.C.5021	6-117-727
E.660A	151- 20-623	U.C.5021	6-117-728
E.660B	151- 20-622	U.C.5021	6-117-736
E.660C	151- 20-624	U.C.5022	6-117-738
E.670	258- 5-686	U.C.5022	6-117-739
		U.C.5022	6-117-740

Other Ashmolean Objects

		U.C.5022	6-117-744
		U.C.5022	6-117-753
ortnum C2	209-118-411	U.C.5022	6-117-783
ortnum R19	185-118-289	U.C.5022	6-117-784
ortnum R23	225-118-433	U.C.5022	6-117-796
ortnum R25	225-200-434	U.C.5031	3-117-700
		U.C.5031	3-117-701

Objects on Loan to the Ashmolean

		U.C.5031	3-117-702
		U.C.5084A	7-117-729
ewbury Loan No.94	120- 55-196	U.C.5084A	7-117-730
ueens College Loan No.44	191-118-395	U.C.5084A	7-117-731
ueens College Loan No.271	214-200-445	U.C.5084A	7-117-732
ueens College Loan No.272	214-200-446	U.C.5084A	7-117-733
ueens College Loan No.283	214-200-450	U.C.5084A	7-117-734
ueens College Loan No.284	214-200-766	U.C.5084A	7-117-735
ueens College Loan No.285	214-200-451	U.C.5084A	7-117-778
ueens College Loan No.287	214-200-453	U.C.5084A	7-117-780
ueens College Loan No.288	200-200-409	U.C.5084A	7-117-781
ueens College Loan No.1216A	11-124- 47	U.C.5084A	7-117-798
ueens College Loan No.1280A	80-107-149	U.C.5116	5-117-704
ueens College Loan No.1280B	80-107-150	U.C.5432	6-117-721
ueens College Loan No.1284A	120-107-154	U.C.5432	6-117-722
ueens College Loan No.1284B	120-107-155	U.C.5432	6-117-723
		U.C.12221	183-200-689

University College Objects

		U.C.12229	183-200-690
		U.C.12354	190- 53-694
.C.587	185-118-692	U.C.12361	190- 53-693
.C.4266	6-117-710	U.C.27901ii	188- 53-695
.C.4266	6-117-711	U.C.27901ii	188- 53-696
.C.4266	6-117-712	U.C.27901ii	188- 53-697
.C.4266	6-117-713	U.C.29145	184-118-691
.C.4407	4-117-703	U.C.34696	320-116-699

APPENDIX C

X-RAY FLUORESCENCE ANALYSES OF INDIVIDUAL OBJECTS ARRANGED CHRONOLOGICALLY

Chloride and oxides of:

Sample / Description	Si	S	K	Ca	Ti	V	Cr	Mn	Fe	Co	Ni	Cu	Zn	As	Pb	Sr	Sn	Sb	Ba	Other
3-117- 10 — Brown body material,hole in green model falcon 1895.142,Amratian Period(Naqada I,S.D.31),Naqada,grave 1774	0.00	89.5	0.22	0.81	3.58	0.45	0.00	0.00	0.40	0.00	0.00	0.41	0.02	0.00	0.00	0.00	0.00	0.00	0.00	4.6
3-117- 10 — Green area of model falcon 1895.142,Amratian Period(Naqada I,S.D.31),Naqada,grave 1774	0.00	84.0	0.00	2.20	3.03	0.38	0.00	0.00	0.43	0.01	0.00	7.55	0.07	0.00	0.00	0.00	0.00	0.00	0.00	2.4
3-117- 10 — Blue-green area of model falcon 1895.142,Amratian Period(Naqada I,S.D.31),Naqada,grave 1774	0.00	77.4	0.00	4.12	3.02	0.45	0.00	0.00	0.39	0.00	0.00	10.95	0.00	0.00	0.00	0.00	0.00	0.00	0.00	3.7
3-117-700 — Green bead,first from string U.C.5031,Amratian Period(Naqada I),Naqada,grave 1752	0.61	89.8	0.28	0.28	1.04	0.02	0.00	0.00	0.19	0.00	0.00	2.58	0.00	0.00	0.21	0.01	0.00	0.00	0.00	4.9
3-117-701 — Green bead,second from string U.C.5031,Amratian Period(Naqada I),Naqada,grave 1752	1.43	85.6	1.06	0.34	2.53	0.00	0.00	0.01	0.27	0.00	0.00	4.37	0.00	0.00	0.60	0.00	0.00	0.00	0.00	3.8
3-117-702 — Green ball bead,third from string U.C.5031,Amratian Period(Naqada I),Naqada,grave 1752	1.11	88.4	0.65	0.36	1.73	0.02	0.00	0.01	0.12	0.00	0.00	2.86	0.00	0.00	0.02	0.00	0.00	0.00	0.00	4.7
3-117-741 — White body material,fragment of green bead 1895.880A,Amratian Period(Naqada I),Naqada,grave 1783	0.00	94.1	0.00	0.36	1.10	0.03	0.00	0.00	0.19	0.00	0.00	0.04	0.00	0.00	0.00	0.00	0.00	0.00	0.00	4.2
3-117-741 — Green bead fragment 1895.880A,Amratian Period(Naqada I),Naqada,grave 1783	0.49	91.2	0.16	0.50	0.64	0.03	0.00	0.00	0.11	0.00	0.00	2.53	0.00	0.00	0.00	0.00	0.00	0.00	0.00	4.3
3-117-742 — Green bead fragment 1895.880B,Amratian Period(Naqada I),Naqada,grave 1783	0.42	88.9	0.24	0.48	0.85	0.07	0.00	0.00	0.02	0.18	0.00	2.42	0.00	0.00	0.00	0.00	0.00	0.00	0.00	6.4
3-117-743 — Green bead fragment 1895.880C,Amratian Period(Naqada I),Naqada,grave 1783	0.42	89.8	0.34	0.42	0.78	0.06	0.00	0.00	0.01	0.19	0.00	2.97	0.04	0.00	0.00	0.01	0.00	0.00	0.00	5.0
4-117-703 — White body material,half of large prolate bead U.C.4407,Early Gerzean Period(Naqada I-II),Naqada,grave 1567	0.00	96.2	0.00	0.22	0.79	0.02	0.01	0.00	0.16	0.00	0.00	0.02	0.00	0.00	0.00	0.00	0.00	0.00	0.00	2.6
4-117-703 — Large green prolate bead fragment U.C.4407,Early Gerzean Period(Naqada I-II),Naqada,grave 1567	1.32	88.7	0.31	0.39	1.52	0.02	0.00	0.00	0.13	0.00	0.00	4.11	0.01	0.00	0.04	0.01	0.00	0.00	0.00	3.4
5-117-704 — Green bead from string U.C.5116,Gerzean Period(Naqada II),Naqada,grave 343	1.45	84.9	0.35	0.40	1.37	0.01	0.01	0.00	0.19	0.00	0.00	2.99	0.00	0.00	0.08	0.00	0.00	0.00	0.00	8.3
5-117-705 — Olive green ball bead U.C.5001,Gerzean Period(Naqada II,S.D.35-43),Naqada,grave 1330	0.00	89.6	0.80	0.28	1.38	0.02	0.00	0.00	0.03	0.27	0.00	2.51	0.00	0.00	0.00	0.00	0.00	0.00	0.00	5.2
5-117-706 — Blue ball bead U.C.5020,Gerzean Period(Naqada II),Naqada,grave 630	0.35	87.9	0.28	0.95	1.53	0.08	0.00	0.00	0.47	0.00	0.00	2.47	0.00	0.00	0.00	0.01	0.00	0.00	0.00	5.9
6-117-714 — Long blue tubular bead fragment,first from string U.C.4569,Gerzean Period(Naqada II),Naqada,grave 869	0.44	91.4	0.18	1.02	0.85	0.03	0.00	0.02	0.01	0.22	0.00	2.52	0.35	0.00	0.10	0.01	0.00	0.00	0.00	2.9
6-117-715 — Small blue bead,second from string U.C.4569,Gerzean Period(Naqada II),Naqada,grave 869	0.64	86.4	0.24	0.39	3.41	0.05	0.00	0.00	0.14	0.00	0.00	3.67	0.00	0.00	0.00	0.00	0.00	0.00	0.00	5.1
6-117-716 — Dark green bead,third from string U.C.4569,Gerzean Period(Naqada II),Naqada,grave 869	0.83	84.1	0.12	0.46	4.33	0.01	0.00	0.00	0.01	0.12	0.00	3.61	0.00	0.00	0.00	0.01	0.01	0.02	0.00	6.4
6-117-717 — Blue-green bead,fourth from string U.C.4569,Gerzean Period(Naqada II),Naqada,grave 869	0.58	78.2	0.01	0.46	6.55	0.04	0.00	0.00	0.17	0.00	0.00	2.16	0.00	0.00	0.00	0.06	0.00	0.00	0.00	11.7

X-RAY FLUORESCENCE ANALYSES OF INDIVIDUAL OBJECTS ARRANGED CHRONOLOGICALLY

Chloride and oxides of:

Object	Si	S	K	Ca	Ti	V	Cr	Mn	Fe	Co	Ni	Cu	Zn	As	Pb	Sr	Sn	Sb	Ba	Other
6-117-718 Blue-green bead,fifth from string U.C.4569,Gerzean Period(Naqada II),Naqada,grave 869	0.74	87.3	0.02	0.37	2.15	0.00	0.00	0.00	0.07	0.00	0.00	2.98	0.00	0.00	0.00	0.01	0.01	0.00		6.3
6-117-719 Blue-green bead,sixth from string U.C.4569,Gerzean Period(Naqada II),Naqada,grave 869	0.64	82.3	0.32	0.51	2.51	0.02	0.00	0.01	0.10	0.00	0.00	4.46	0.00	0.00	0.04	0.00	0.01	0.02	0.00	9.0
6-117-720 Pale green bead,seventh from string U.C.4569,Gerzean Period(Naqada II),Naqada,grave 869	0.26	86.9	0.19	0.45	2.46	0.01	0.00	0.00	0.08	0.00	0.00	2.92	0.00	0.00	0.02	0.00	0.01	0.00		6.7
6-117-721 Blue tubular bead,second from string U.C.5432,Gerzean Period(Naqada II),Naqada,grave 667	0.27	91.8	0.38	0.79	1.58	0.07	0.00	0.01	0.21	0.00	0.01	1.62	0.01	0.00	0.00	0.00	0.01	0.01		3.2
6-117-722 Blue tubular bead,third from string U.C.5432,Gerzean Period(Naqada II),Naqada,grave 667	0.42	92.2	0.19	0.86	0.88	0.03	0.00	0.00	0.05	0.25	0.00	2.45	0.00	0.00	0.03	0.00	0.00	0.01	0.01	2.6
6-117-723 Blue tubular bead,first from string U.C.5432,Gerzean Period(Naqada II),Naqada,grave 667	1.53	85.8	0.16	0.64	4.61	0.06	0.00	0.01	0.21	0.00	0.00	3.91	0.00	0.00	0.00	0.01	0.00	0.00		3.1
6-117-724 Small pale green bead,second from string U.C.5015,Gerzean Period(Naqada II),Naqada,grave 13	0.21	75.9	3.32	0.20	5.62	0.03	0.00	0.01	0.52	0.00	0.00	3.20	0.03	0.00	0.00	0.01	0.00	0.00	0.00	11.0
6-117-725 Blue-green drop bead,first from string U.C.5021,Gerzean Period(Naqada II),Naqada,grave 661	0.69	87.8	0.30	1.01	2.93	0.07	0.00	0.02	0.45	0.00	0.00	3.09	0.00	0.00	0.00	0.01	0.00	0.01	0.01	3.7
6-117-726 Blue-green drop bead,second from string U.C.5021,Gerzean Period(Naqada II),Naqada,grave 661	0.77	85.4	0.44	0.88	2.14	0.05	0.00	0.04	0.52	0.00	0.00	3.62	0.03	0.00	0.00	0.00	0.00	0.01	0.01	6.1
6-117-727 Dark brown segmented barrel bead,third from string U.C.5021,Gerzean Period(Naqada II),Naqada,grave 661	1.07	88.3	0.22	0.32	1.64	0.06	0.01	0.00	4.26	0.14	0.00	0.24	0.07	0.00	0.00	0.03	0.00	0.03	0.32	3.3
6-117-728 Dark brown segmented barrel bead,fourth from string U.C.5021,Gerzean Period(Naqada II),Naqada,grave 661	0.90	80.8	0.73	0.23	3.93	0.06	0.02	0.00	0.25	0.00	0.00	0.29	0.07	0.00	0.00	0.06	0.00	0.02	0.67	4.7
6-117-736 Dark brown segmented barrel bead,fifth from string U.C.5021,Gerzean Period(Naqada II),Naqada,grave 661	0.89	85.8	0.19	0.26	2.80	0.13	0.02	0.00	0.11	0.01	0.00	0.25	0.07	0.00	0.00	0.04	0.00	0.03	0.35	3.3
6-117-737 Small blue-green bead,first from string U.C.5015,Gerzean Period(Naqada II),Naqada,grave 13	0.32	81.5	1.65	0.37	3.64	0.01	0.01	0.00	0.14	0.00	0.00	4.49	0.01	0.00	0.00	0.03	0.00	0.00	0.00	7.9
6-117-738 Dark blue bead,third from string U.C.5022,Gerzean Period(Naqada II),Naqada,grave 704	1.04	85.5	0.29	0.84	1.26	0.01	0.00	0.01	0.08	0.00	0.00	7.19	0.00	0.01	0.00	0.00	0.00	0.02	0.00	3.7
6-117-739 Green bead,fourth from string U.C.5022,Gerzean Period(Naqada II),Naqada,grave 704	1.23	86.4	0.39	0.33	3.70	0.02	0.00	0.00	0.13	0.00	0.01	3.91	0.00	0.00	0.01	0.00	0.00	0.00		3.9
6-117-740 Blue bead,fifth from string U.C.5022,Gerzean Period(Naqada II),Naqada,grave 704	0.98	87.2	0.36	0.27	1.20	0.01	0.00	0.00	0.07	0.00	0.00	5.53	0.00	0.00	0.08	0.00	0.00	0.00		4.3
6-117-744 Green bead,first from string U.C.5022,Gerzean Period(Naqada II),Naqada,grave 704	0.33	91.1	0.65	0.08	0.85	0.02	0.00	0.00	0.10	0.00	0.00	0.63	0.00	0.00	0.01	0.00	0.00	0.00		6.2
6-117-753 Blue bead,second from string U.C.5022,Gerzean Period(Naqada II),Naqada,grave 704	0.76	88.5	0.37	0.46	1.13	0.03	0.00	0.00	0.13	0.00	0.00	3.69	0.00	0.00	0.01	0.01	0.00	0.00		4.9
6-117-783 Blue bead,sixth from string U.C.5022,Gerzean Period(Naqada II),Naqada,grave 704	0.51	89.8	0.62	0.80	1.10	0.08	0.00	0.04	0.02	0.30	0.00	2.70	0.04	0.00	0.02	0.00	0.00	0.00		4.0

X-RAY FLUORESCENCE ANALYSES OF INDIVIDUAL OBJECTS ARRANGED CHRONOLOGICALLY

Chloride and oxides of:

Sample	Description	Si	S	K	Ca	Ti	V	Cr	Mn	Fe	Co	Ni	Cu	Zn	As	Pb	Sr	Sn	Sb	Ba	Other
6-117-784	Blue bead, seventh from string U.C.5022, Gerzean Period (Naqada II), Naqada, grave 704	1.31	84.6	0.56	3.46	0.02	0.00	0.00	0.00	0.12	0.00	0.00	4.05	0.00	0.00	0.00	0.01	0.00	0.00	0.00	5.3
6-117-796	Blue bead, eighth from string U.C.5022, Gerzean Period (Naqada II), Naqada, grave 704	0.38	88.0	0.19	2.09	0.04	0.00	0.00	0.01	0.39	0.00	0.00	2.76	0.00	0.00	0.00	0.01	0.00	0.00	0.00	5.4
7-117-729	Dark blue bead, first from string U.C.5084A, Gerzean Period (Naqada II, S.D. 40-63), Naqada, grave 804	0.66	83.6	0.21	0.48	1.88	0.02	0.00	0.00	0.10	0.00	0.00	4.81	0.00	0.00	0.00	0.01	0.00	0.00	0.00	8.2
7-117-730	Pale green bead, second from string U.C.5084A, Gerzean Period (Naqada II, S.D. 40-63), Naqada, grave 804	0.60	87.2	0.22	0.39	0.92	0.02	0.00	0.00	0.17	0.00	0.00	4.08	0.01	0.00	0.00	0.00	0.00	0.00	0.00	6.4
7-117-731	Pale blue bead, third from string U.C.5084A, Gerzean Period (Naqada II, S.D. 40-63), Naqada, grave 804	0.76	88.0	0.30	0.54	2.09	0.02	0.00	0.00	0.13	0.00	0.00	1.88	0.00	0.00	0.16	0.01	0.00	0.00	0.00	6.1
7-117-732	Green bead, fourth from string U.C.5084A, Gerzean Period (Naqada II, S.D. 40-63), Naqada, grave 804	1.36	77.0	0.43	1.44	4.75	0.03	0.00	0.00	0.19	0.00	0.00	3.05	2.32	0.00	0.02	0.01	0.00	0.00	0.00	9.4
7-117-733	Green bead, fifth from string U.C.5084A, Gerzean Period (Naqada II, S.D. 40-63), Naqada, grave 804	0.62	87.6	0.27	0.75	3.10	0.02	0.00	0.00	0.14	0.00	0.00	3.57	0.03	0.00	0.01	0.01	0.00	0.00	0.00	3.9
7-117-734	Blue bead, sixth from string U.C.5084A, Gerzean Period (Naqada II, S.D. 40-63), Naqada, grave 804	0.73	88.5	0.27	0.51	2.74	0.02	0.00	0.00	0.11	0.00	0.00	2.80	0.00	0.00	0.15	0.01	0.00	0.00	0.00	4.2
7-117-735	Dark blue bead, seventh from string U.C.5084A, Gerzean Period (Naqada II, S.D. 40-63), Naqada, grave 804	0.91	85.3	0.38	1.50	2.77	0.02	0.00	0.00	0.14	0.00	0.00	5.38	0.00	0.00	0.12	0.00	0.00	0.00	0.00	3.4
7-117-778	Blue bead, eighth from string U.C.5084A, Gerzean Period (Naqada II, S.D. 40-63), Naqada, grave 804	0.75	83.6	0.35	0.45	4.18	0.02	0.00	0.00	0.16	0.00	0.00	2.45	0.00	0.00	0.00	0.01	0.00	0.00	0.00	8.1
7-117-779	Blue bead, ninth from string U.C.5084A, Gerzean Period (Naqada II, S.D. 40-63), Naqada, grave 804	0.67	86.4	0.52	1.06	4.01	0.02	0.00	0.00	0.11	0.00	0.00	3.58	0.00	0.00	0.00	0.01	0.00	0.00	0.00	3.7
7-117-780	Blue bead, tenth from string U.C.5084A, Gerzean Period (Naqada II, S.D. 40-63), Naqada, grave 804	0.96	83.4	0.32	1.36	5.08	0.02	0.00	0.00	0.16	0.00	0.00	3.51	0.00	0.00	0.00	0.00	0.00	0.00	0.00	5.2
7-117-781	Green bead, eleventh from string U.C.5084A, Gerzean Period (Naqada II, S.D. 40-63), Naqada, grave 804	0.58	90.4	0.15	0.45	2.69	0.02	0.00	0.00	0.18	0.00	0.00	2.79	0.00	0.00	0.01	0.01	0.00	0.00	0.00	2.7
9-117-707	Long green tubular bead, first from string U.C.4507, Gerzean Period (Naqada II), Naqada, grave 1248	1.26	85.3	0.55	0.56	0.92	0.03	0.00	0.00	0.14	0.00	0.00	2.23	0.00	0.00	0.01	0.01	0.00	0.00	0.00	9.0
9-117-708	Small green bead, second from string U.C.4507, Gerzean Period (Naqada II), Naqada, grave 1248	0.16	87.9	0.33	0.20	0.91	0.06	0.00	0.09	0.33	0.00	0.00	1.47	0.02	0.00	0.02	0.00	0.00	0.00	0.00	8.5
9-117-709	Small green bead, third from string U.C.4507, Gerzean Period (Naqada II), Naqada, grave 1248	0.18	89.7	0.31	0.21	1.11	0.07	0.00	0.14	0.40	0.00	0.00	1.25	0.02	0.00	0.03	0.00	0.00	0.00	0.00	6.5
9-117-791	Small green bead, fourth from string U.C.4507, Gerzean Period (Naqada II), Naqada, grave 1248	1.36	85.7	0.28	0.17	1.13	0.02	0.00	0.00	0.20	0.00	0.00	4.46	0.00	0.00	0.08	0.00	0.00	0.00	0.00	6.6
11-74-46	Dark green bead 1931.250A, Dyn. I (S.D. 78), Matmar, grave 220	0.00	88.3	0.16	1.51	2.05	0.10	0.07	0.00	0.36	0.02	0.00	3.91	0.02	0.00	0.00	0.00	0.00	0.02	0.00	3.5
11-110-45	Dark green bead E.E.81A, Dyn. I (S.D. 77), Hu, grave R208	0.26	91.7	0.32	0.48	0.78	0.05	0.00	0.00	0.20	0.02	0.00	2.92	0.03	0.00	0.00	0.00	0.00	0.00	0.00	3.3

X-RAY FLUORESCENCE ANALYSES OF INDIVIDUAL OBJECTS ARRANGED CHRONOLOGICALLY

Chloride and oxides of:

Cat. No. / Description	Si	S	K	Ca	Ti	V	Cr	Mn	Fe	Co	Ni	Cu	Zn	As	Pb	Sr	Sn	Sb	Ba	Other
11-124-47 — Dark green bead, Queens College Loan No.1216A, Dyn. I(S.D.80), Armant, grave 1208	0.00	90.2	0.16	0.86	1.75	0.10	0.00	0.02	0.16	0.02	0.00	3.94	0.05	0.00	0.00	0.00	0.00	0.00	0.00	2.7
14-107-29 — Pale blue body material, fragment of blue vase E.1578, Dyn. I(Djer), Abydos, tomb O	0.27	84.8	0.30	0.53	9.47	0.10	0.01	0.00	0.02	0.77	0.01	1.40	0.01	0.00	0.00	0.04	0.22	0.00	0.00	2.0
14-107-29 — Blue exterior of vase fragment E.1578, Dyn. I(Djer), Abydos, tomb O	0.24	86.7	0.41	1.65	5.13	0.08	0.00	0.00	0.00	0.87	0.00	1.73	0.00	0.00	0.00	0.04	0.21	0.01	0.01	2.9
14-107-29 — Another spot on the exterior of blue vessel fragment E.1578, Dyn. I(Djer), Abydos, tomb O	0.44	83.8	0.35	1.14	6.55	0.06	0.00	0.00	0.03	0.84	0.00	2.06	0.00	0.01	0.00	0.03	0.26	0.00	0.00	4.4
14-107-30 — Pale blue body material, fragment of blue vase E.1577, Dyn. I(Djer), Abydos, tomb O	0.00	79.7	0.28	0.52	11.86	0.05	0.00	0.00	0.00	0.72	0.03	1.11	0.03	0.00	0.00	0.01	0.18	0.00	0.00	5.5
14-107-30 — Pale blue body material, another side of fragment of blue vase E.1577, Dyn. I(Djer), Abydos, tomb O	0.30	83.3	0.25	0.23	10.73	0.06	0.03	0.00	0.03	0.66	0.01	1.25	0.03	0.00	0.00	0.03	0.18	0.00	0.00	2.9
14-107-30 — Dark blue exterior of vase fragment E.1577, Dyn. I(Djer), Abydos, tomb O	0.00	81.0	0.00	1.81	10.85	0.05	0.00	0.00	0.00	0.68	0.01	2.33	0.00	0.00	0.00	0.01	0.27	0.00	0.00	3.0
14-107-30 — Another spot on the exterior of blue vessel fragment E.1577, Dyn. I(Djer), Abydos, tomb O	0.00	79.1	0.00	1.14	12.89	0.16	0.00	0.00	0.05	1.00	0.01	2.32	0.00	0.03	0.00	0.05	0.23	0.00	0.00	3.0
15-107-22 — Pale green fragment of inlay E.1172, Dyn. I(Djet), Abydos, tomb Z	0.77	90.0	0.00	0.33	0.93	0.04	0.26	0.00	0.10	0.02	0.00	1.42	0.00	0.00	0.00	0.00	0.00	0.01	0.00	6.1
15-107-22 — Black hieroglyph on green fragment of inlay E.1172, Dyn. I(Djet), Abydos, tomb Z	0.00	88.1	0.04	2.09	0.39	0.00	0.00	0.82	2.35	0.02	0.00	1.06	0.02	0.00	0.00	0.00	0.00	0.01	0.02	5.0
16-107-27 — Greyish body material, fragment of purple and green vase E.3239B, Dyn. I(Udimu), Abydos, tomb T	0.00	93.5	0.00	1.30	0.18	0.26	0.00	0.09	0.65	0.05	0.07	0.65	0.12	0.00	0.00	0.00	0.00	0.00	0.00	3.7
16-107-27 — Purple and green interior surface of vase fragment E.3239B, Dyn. I(Udimu), Abydos, tomb T	0.15	82.7	0.34	0.50	8.59	0.08	0.07	0.00	0.04	1.79	0.00	1.09	0.04	0.00	0.00	0.02	0.20	0.00	0.02	4.7
16-107-28 — Blue-green body material, fragment of blue-green vase E.3182, Dyn. I(Udimu), Abydos, tomb T	0.24	84.5	0.28	0.17	9.60	0.04	0.03	0.00	0.03	0.66	0.03	1.24	0.01	0.00	0.00	0.04	0.22	0.00	0.00	5.5
16-107-28 — Blue-green body material, another side of fragment of blue-green vase E.3182, Dyn. I(Udimu), Abydos, tomb T	0.00	79.2	0.00	1.84	11.55	0.05	0.00	0.00	0.00	0.68	0.01	2.45	0.00	0.00	0.00	0.02	0.31	0.00	0.00	3.0
16-107-28 — Blue-green exterior of vase fragment E.3182, Dyn. I(Udimu), Abydos, tomb T	0.00	80.1	0.00	1.28	12.45	0.16	0.00	0.00	0.04	0.96	0.00	1.84	0.00	0.02	0.00	0.04	0.21	0.00	0.00	3.8
16-107-28 — Another spot on the exterior of blue vessel fragment E.3182, Dyn. I(Udimu), Abydos, tomb T	0.00	88.9	0.06	0.58	2.20	0.20	0.05	0.00	1.29	1.01	0.00	0.46	0.00	0.00	0.00	0.00	0.00	0.00	0.00	2.9
17-107-24 — Purple body material, fragment of green segmented tubular bead E.1183, Dyn. I(Anedjib), Abydos, tomb X53	0.66	74.5	0.82	1.69	10.38	0.00	0.00	0.00	0.75	0.98	0.10	7.18	0.00	0.00	0.00	0.00	0.00	0.02	0.03	5.2
17-107-24 — Blue-green segmented tubular bead fragment E.1183, Dyn. I(Anedjib), Abydos, tomb X53	0.00	88.9	0.06	0.58	2.20	0.20	0.05	0.00	1.29	1.01	0.00	0.46	0.00	0.00	0.00	0.00	0.00	0.02	0.03	2.9
17-107-25 — Pale green edge of bead E.E.30A, Dyn. I(Anedjib), Abydos, tomb X84	0.23	94.3	0.00	0.69	0.00	0.00	0.00	0.00	0.07	0.00	0.00	2.27	0.00	0.00	0.00	0.00	0.01	0.00	0.00	2.4

X-RAY FLUORESCENCE ANALYSES OF INDIVIDUAL OBJECTS ARRANGED CHRONOLOGICALLY

Chloride and oxides of:	Si	S	K	Ca	Ti	V	Cr	Mn	Fe	Co	Ni	Cu	Zn	As	Pb	Sr	Sn	Sb	Ba	Other
17-107-25 Darker green face of bead E.E.30A,Dyn. I(Anedjib),Abydos,tomb X84	0.00	93.7	0.00	1.14	0.00	0.00	0.00	0.00	0.13	0.00	0.00	2.61	0.00	0.00	0.00	0.00	0.00	0.00	0.00	2.4
17-107-44 Dark green fluted conical pendant E.E.63,Dyn. I(Anedjib),Abydos,tomb X	1.07	74.4	0.49	0.00	13.74	0.00	0.00	0.80	0.44	0.00	0.00	6.11	0.06	0.00	0.00	0.00	0.01	0.00	0.00	2.9
18-107-1 Pale green inlay,wooden casket E.138+1255,Dyn. I(Semerkhet),Abydos,tomb U	0.11	87.5	0.21	1.66	2.83	0.00	0.00	0.00	0.25	0.00	0.00	3.68	0.17	0.00	0.00	0.00	0.00	0.00	0.00	3.6
18-107-2 Another green inlay in wooden casket E.138+1255,Dyn. I(Semerkhet),Abydos,tomb U	0.24	87.4	0.25	0.86	2.20	0.08	0.02	0.00	0.24	0.00	0.00	3.08	0.14	0.00	0.00	0.01	0.00	0.00	0.00	5.4
18-107-3 Dark olive green (almost brown) inlay in wooden casket E.138+1255,Dyn. I(Semerkhet),Abydos,tomb U	0.35	87.9	0.00	0.56	1.83	0.03	0.00	0.00	0.26	0.01	0.01	2.64	0.17	0.00	0.00	0.02	0.00	0.00	0.00	6.3
18-107-4 Pale blue inlay in wooden casket E.138+1255,Dyn. I(Semerkhet),Abydos,tomb U	0.21	88.4	0.19	0.97	4.14	0.06	0.02	0.00	0.06	0.00	0.00	2.23	0.07	0.00	0.00	0.06	0.00	0.00	0.00	3.6
18-107-5 Blue-green inlay,wooden casket E.138+1255,Dyn. I(Semerkhet),Abydos,tomb U	0.12	85.1	0.21	1.88	5.44	0.00	0.00	0.00	0.11	0.00	0.00	2.22	0.03	0.00	0.00	0.09	0.00	0.00	0.00	4.8
18-107-6 Bluest green inlay,wooden casket E.138+1255,Dyn. I(Semerkhet),Abydos,tomb U	0.08	87.0	0.21	1.68	5.18	0.00	0.00	0.00	0.10	0.00	0.00	3.17	0.08	0.00	0.00	0.04	0.00	0.00	0.00	2.4
18-107-7 Olive brown inlay in wooden casket E.138+1255,Dyn. I(Semerkhet),Abydos,tomb U	0.78	85.8	0.21	1.29	1.54	0.13	0.01	0.00	0.19	0.00	0.01	5.94	0.01	0.00	0.00	0.03	0.00	0.00	0.00	4.0
18-107-8 Another brown inlay in wooden casket E.138+1255,Dyn. I(Semerkhet),Abydos,tomb U	0.44	84.4	0.08	0.97	4.05	0.04	0.00	0.03	0.13	0.00	0.00	2.89	0.05	0.00	0.00	0.04	0.00	0.00	0.00	6.9
18-107-9 Dark brown inlay,wooden casket E.138+1255,Dyn. I(Semerkhet),Abydos,tomb U	0.76	80.5	0.24	2.87	3.40	0.00	0.00	0.00	0.23	0.00	0.00	8.69	0.00	0.00	0.00	0.00	0.00	0.00	0.00	3.3
19-107-23 Dark green part of long tubular bead E.E.67A,Dyn. I(Ka'a),Abydos,tomb Q	0.50	78.7	0.34	0.00	6.14	0.00	0.06	0.00	0.27	0.00	0.00	10.14	0.00	0.00	0.00	0.00	0.00	0.00	0.00	3.9
19-107-23 Pale green part of long tubular bead E.E.67A,Dyn. I(Ka'a),Abydos,tomb Q	1.02	85.5	0.19	0.00	2.65	0.00	0.06	0.02	0.26	0.01	0.00	7.91	0.03	0.00	0.00	0.00	0.00	0.00	0.00	2.4
20-40-569 Pale green tubular bead 1913.494A,Dyn. I-II,Tarkhan,grave 678	0.50	92.5	0.10	0.08	0.62	0.05	0.04	0.03	0.22	0.00	0.00	1.65	0.03	0.02	0.00	0.00	0.00	0.00	0.00	4.1
20-40-570 Small green bead 1913.494B,Dyn. I-II,Tarkhan,grave 678	0.33	84.8	0.35	0.17	5.85	0.12	0.00	0.03	0.68	0.00	0.00	1.81	1.50	0.00	0.00	0.00	0.00	0.00	0.00	4.4
20-40-636 Small green bead 1913.494D,Dyn. I-II,Tarkhan,grave 678	0.31	85.7	0.54	0.17	5.79	0.15	0.05	0.03	0.67	0.00	0.00	1.68	1.47	0.00	0.00	0.00	0.00	0.00	0.00	3.4
20-40-745 Blue-green bead 1913.494C,Dyn. I-II,Tarkhan,grave 678	1.79	89.6	0.26	0.31	0.94	0.03	0.00	0.00	0.26	0.00	0.00	1.95	0.00	0.00	0.02	0.00	0.01	0.00	0.00	4.8
20-74-571 Small pale green bead 1931.385A,Dyn. I-II,Matmar,grave 2001	0.59	88.6	0.36	0.26	2.62	0.00	0.03	0.00	0.10	0.00	0.00	2.88	0.00	0.00	0.00	0.00	0.08	0.04	0.01	4.4
20-74-572 Small blue bead 1931.385B,Dyn. I-II,Matmar,grave 2001	0.53	82.4	0.11	0.82	3.71	0.03	0.00	0.02	0.17	0.00	0.00	6.68	0.00	0.00	0.00	0.00	0.00	0.00	0.00	5.6

X-RAY FLUORESCENCE ANALYSES OF INDIVIDUAL OBJECTS ARRANGED CHRONOLOGICALLY

Chloride and oxides of:	Si	S	K	Ca	Ti	V	Cr	Mn	Fe	Co	Ni	Cu	Zn	As	Pb	Sr	Sn	Sb	Ba	Other
20-74-573 Small blue bead 1931,385C,Dyn. I-II,Matmar,grave 2001	0.60	84.5	0.08	1.40	3.09	0.00	0.00	0.00	0.02	0.22	0.00	7.07	0.00	0.00	0.00	0.00	0.00	0.00	0.00	3.1
20-107-31 Small blue-green bead E.E.500A,Dyn. I-II,Abydos,tomb W37	0.00	87.4	0.00	5.47	0.02	0.00	0.00	0.00	0.07	0.00	0.00	4.15	0.00	0.00	0.00	0.01	0.00	0.00	0.00	2.9
20-107-32 Pale green barrel bead E.E.68A,Dyn. I-II,Abydos,tomb W9	0.00	94.5	0.00	0.00	0.83	0.07	0.07	0.00	0.15	0.01	0.00	1.08	0.00	0.00	0.00	0.00	0.00	0.00	0.00	3.3
20-107-33 Pale green bead E.E.76A,Dyn. I-II,Abydos,tomb M16	0.00	90.0	0.00	1.12	1.23	0.05	0.06	0.00	0.33	0.00	0.00	0.65	0.00	0.00	0.00	0.00	0.00	0.00	0.00	6.1
20-107-34 White body material,fragment of model vase E.36,Dyn. I-II,Abydos,temple area	0.00	91.4	0.17	0.76	1.28	0.14	0.12	0.00	0.86	0.00	0.02	0.27	0.09	0.00	0.00	0.00	0.00	0.00	0.00	4.9
20-107-34 Brown spot on white lip of vase fragment E.36,Dyn. I-II,Abydos,temple area	0.00	71.5	0.22	1.52	4.04	0.05	0.00	5.21	7.05	0.00	0.00	0.76	0.00	0.02	0.00	0.00	0.00	0.08	0.47	9.0
20-107-35 White body material,fragment of green model cylinder vase E.42,Dyn. I-II,Abydos,temple area	0.00	94.9	0.04	0.00	0.76	0.06	0.04	0.09	0.34	0.00	0.00	0.01	0.02	0.00	0.00	0.00	0.00	0.00	0.00	3.7
20-107-35 Green model cylinder vase fragment E.42,Dyn. I-II,Abydos,temple area	0.66	92.5	0.00	0.77	0.94	0.00	0.00	0.00	0.19	0.02	0.00	1.18	0.00	0.00	0.00	0.00	0.02	0.01	0.00	3.7
20-107-35 Brown spot on green model cylinder vase fragment E.42,Dyn. I-II,Abydos,temple area	0.42	90.2	0.11	0.87	1.30	0.00	0.00	1.52	2.26	0.00	0.00	1.18	0.00	0.00	0.00	0.01	0.01	0.00	0.00	2.1
20-107-36 Grey body material,unglazed reverse side of plaque fragment E.72,Dyn. I-II,Abydos,temple area	0.00	90.5	0.06	1.18	1.65	0.35	0.00	0.11	1.41	0.00	0.00	0.04	0.01	0.00	0.00	0.00	0.00	0.00	0.00	4.7
20-107-36 Intermediate white layer,inlay fragment E.72,Dyn. I-II,Abydos,temple area	0.00	94.8	0.04	0.00	0.12	0.06	0.00	0.12	0.27	0.00	0.00	0.05	0.00	0.00	0.00	0.00	0.00	0.00	0.00	4.4
20-107-36 Green exterior of inlay fragment E.72,Dyn. I-II,Abydos,temple area	0.00	89.6	0.90	0.93	2.04	0.00	0.02	0.00	0.14	0.25	0.00	3.65	0.00	0.00	0.00	0.00	0.00	0.00	0.00	2.2
20-107-37 Dark green bent tubular bead E.33,Dyn. I-II,Abydos,temple area	0.33	91.5	0.34	0.50	1.32	0.00	0.07	0.00	0.31	0.00	0.00	2.39	0.00	0.00	0.00	0.00	0.00	0.05	0.25	3.2
20-107-38 Grey body material,hole in large green tubular bead E.27,Dyn. I-II,Abydos,chamber M69	0.00	90.9	0.00	0.68	2.44	0.07	0.01	0.01	0.56	0.00	0.00	0.03	0.01	0.00	0.00	0.00	0.00	0.00	0.00	5.3
20-107-38 Large olive-green tubular bead E.27,Dyn. I-II,Abydos,chamber M69	0.75	90.4	0.00	2.51	2.27	0.00	0.00	0.00	0.63	0.01	0.01	2.42	0.01	0.00	0.00	0.00	0.00	0.00	0.07	1.0
20-107-39 White stripe bordered by brown and green,model vase E.35,Dyn. I-II,Abydos,chamber M69	0.00	91.1	0.55	2.24	2.08	0.08	0.12	0.46	0.46	0.02	0.11	0.18	0.05	0.00	0.00	0.00	0.00	0.00	0.00	2.5
20-107-39 Green lip of striped model vase E.35,Dyn. I-II,Abydos,chamber M69	0.00	85.9	0.71	4.66	4.48	0.00	0.00	0.01	0.22	0.01	0.00	0.81	0.08	0.00	0.00	0.00	0.00	0.00	0.00	3.1
20-107-39 Brown stripe bordered by green,model vase E.35,Dyn. I-II,Abydos,chamber M69	0.00	83.8	0.68	3.53	3.33	0.14	0.17	2.17	2.76	0.00	0.00	0.12	0.08	0.00	0.00	0.00	0.02	0.00	0.00	3.2
20-107-40 White body material,fragment of green inlay E.50,Dyn. I-II,Abydos,chamber M69	0.00	92.0	0.00	0.52	1.91	0.21	0.00	0.03	0.55	0.01	0.00	0.03	0.05	0.00	0.00	0.00	0.00	0.00	0.00	4.6

X-RAY FLUORESCENCE ANALYSES OF INDIVIDUAL OBJECTS ARRANGED CHRONOLOGICALLY

Chloride and oxides of:

ID	Description	Si	S	K	Ca	Ti	V	Cr	Mn	Fe	Co	Ni	Cu	Zn	As	Pb	Sr	Sn	Sb	Ba	Other
20-107- 40	Pale green fragment of corrugated inlay E.50,Dyn. I-II,Abydos,chamber M69	0.65	85.5	0.40	2.31	3.51	0.00	0.00	0.03	0.35	0.03	0.00	3.73	0.10	0.00	0.00	0.00	0.00	0.00	0.00	3.4
20-107- 41	Remains of pale green glaze,model baboon E.21,Dyn. I-II,Abydos,chamber M69	0.53	88.9	0.00	1.51	3.23	0.00	0.00	0.07	0.73	0.03	0.00	1.75	0.06	0.00	0.00	0.00	0.00	0.00	0.00	3.2
20-107- 42	Remains of black glaze,tubular bead E.E.71A,Dyn. I-II,Abydos,chamber M69	0.00	68.6	1.18	4.74	9.05	0.09	0.05	0.10	11.20	2.72	0.00	0.18	0.42	0.00	0.00	0.15	0.00	0.01	0.01	1.6
20-134- 11	Exposed white body material,fragment of green model pelican E.7,Dyn. I-II,Hierakonpolis,Main Deposit	0.00	92.6	1.33	0.55	1.25	0.18	0.08	0.08	0.46	0.01	0.00	0.12	0.00	0.00	0.00	0.00	0.00	0.00	0.00	3.4
20-134- 11	Porous white right breast of model pelican E.7,Dyn. I-II,Hierakonpolis,Main Deposit	0.00	92.9	1.15	0.87	1.96	0.15	0.17	0.00	0.74	0.01	0.00	0.13	0.00	0.00	0.00	0.00	0.05	0.00	0.00	1.8
20-134- 11	Remains of green glaze on the pedestal of model pelican E.7,Dyn. I-II,Hierakonpolis,Main Deposit	0.32	86.3	0.31	0.53	0.76	0.08	0.37	0.00	0.26	0.01	0.00	1.17	0.00	0.00	0.00	0.01	0.00	0.00	0.00	9.8
20-134- 11	Black left wing of green model pelican E.7,Dyn. I-II,Hierakonpolis,Main Deposit	0.14	48.7	2.40	0.96	10.06	0.29	0.00	0.00	5.69	8.61	0.00	0.78	0.00	0.00	0.00	0.03	0.00	0.00	0.02	22.3
20-134- 12	Grey body material,chipped edge of green model vase E.45,Dyn. I-II,Hierakonpolis,Main Deposit	0.00	92.4	0.13	1.39	0.88	0.72	0.01	0.06	0.80	0.00	0.00	0.04	0.00	0.00	0.00	0.00	0.00	0.00	0.00	3.6
20-134- 12	Green lip of model vase E.45,Dyn. I-II,Hierakonpolis,Main Deposit	0.00	88.8	0.74	3.47	1.63	0.81	0.01	0.00	0.00	0.44	0.01	0.00	1.35	0.01	0.03	0.00	0.02	0.00	0.06	2.6
20-134- 13	Remains of green glaze,pedestal of model baboon E.191,Dyn. I-II,Hierakonpolis,Main Deposit	0.20	90.9	0.79	0.42	2.49	0.09	0.00	0.00	0.26	0.00	0.00	1.51	0.00	0.00	0.00	0.00	0.00	0.00	0.00	3.4
20-134- 14	Remains of olive green glaze,tail of model calf E.4,Dyn. I-II,Hierakonpolis,Main Deposit	0.19	87.0	0.87	1.16	1.77	0.11	0.04	0.00	0.32	0.00	0.00	4.29	0.00	0.00	0.00	0.02	0.00	0.00	0.00	4.2
20-134- 15	Grey body material,hole in right hind leg of green model baboon E.5,Dyn. I-II,Hierakonpolis,Main Deposit	0.00	90.1	0.38	0.48	4.50	0.21	0.02	0.00	0.73	0.01	0.00	0.05	0.00	0.00	0.00	0.00	0.00	0.00	0.00	3.5
20-134- 15	Grey body material,hole in left flank of green model baboon E.5,Dyn. I-II,Hierakonpolis,Main Deposit	0.00	91.5	0.24	0.90	2.74	0.23	0.00	0.00	0.84	0.00	0.00	0.08	0.00	0.00	0.00	0.00	0.00	0.00	0.00	3.5
20-134- 15	White left shoulder of model baboon E.5,Dyn. I-II,Hierakonpolis,Main Deposit	0.00	90.9	1.23	0.63	2.81	0.01	0.11	0.00	0.17	0.01	0.00	0.15	0.01	0.00	0.21	0.01	0.00	0.00	0.00	3.6
20-134- 15	Remains of dark green glaze,right hip of model baboon E.5,Dyn. I-II,Hierakonpolis,Main Deposit	0.16	92.1	0.39	0.43	1.82	0.00	0.00	0.00	0.04	0.13	0.00	1.87	0.00	0.00	0.00	0.00	0.00	0.00	0.00	3.0
20-134- 15	Black collar,right side of green model baboon E.5,Dyn. I-II,Hierakonpolis,Main Deposit	0.00	77.6	0.47	3.65	2.40	0.10	0.00	2.13	4.48	0.00	0.00	2.61	0.01	0.00	0.00	0.00	0.00	0.00	0.00	6.6
20-134- 15	Black collar,left side of green model baboon E.5,Dyn. I-II,Hierakonpolis,Main Deposit	0.00	79.2	0.77	3.97	2.60	0.10	0.00	2.23	5.05	0.02	0.00	2.56	0.01	0.00	0.00	0.00	0.00	0.00	0.00	3.5
20-134- 16	Brick-red body material,fragment of green jar lid E.4006,Dyn. I-II,Hierakonpolis,Main Deposit	0.00	92.6	0.00	0.34	0.29	0.04	0.00	0.00	0.01	0.91	0.00	0.00	0.00	0.00	0.00	0.00	0.00	0.00	0.00	5.5
20-134- 16	Grey-stained body material,next to the green surface of jar lid fragment E.4006,Dyn. I-II,Hierakonpolis,Main Deposit	0.00	85.5	0.44	3.09	2.42	0.60	0.01	0.00	0.25	2.24	0.03	0.00	0.05	0.00	0.00	0.00	0.00	0.00	0.00	5.4

X-RAY FLUORESCENCE ANALYSES OF INDIVIDUAL OBJECTS ARRANGED CHRONOLOGICALLY

Chloride and oxides of:

Object / Description	Si	S	K	Ca	Ti	V	Cr	Mn	Fe	Co	Ni	Cu	Zn	As	Pb	Sr	Sn	Sb	Ba	Other
20-134- 16 Remains of green glaze on fragment of jar lid E.4006,Dyn. I-II,Hierakonpolis,Main Deposit	0.00	86.7	1.07	5.34	1.93	0.22	0.00	0.02	0.82	0.01	0.00	1.25	0.02	0.02	0.00	0.00	0.04	0.06		2.5
20-134- 17 Green tubular bead E.E.9A,Dyn. I-II,Hierakonpolis,Main Deposit(?)	0.50	92.9	0.10	0.58	1.01	0.04	0.00	0.01	0.15	0.01	0.00	1.55	0.00	0.00	0.00	0.00	0.01	0.00		3.1
20-134- 18 Brown body material,chipped edge of large green fluted tubular bead E.E.26A,Dyn. I-II,Hierakonpolis,Main Deposit	0.00	90.5	0.50	0.40	1.53	0.12	0.01	0.20	0.69	0.00	0.00	0.59	0.01	0.00	0.00	0.00	0.00	0.00		5.4
20-134- 18 Yellow green section of fluted tubular bead E.E.26A,Dyn. I-II,Hierakonpolis,Main Deposit	0.00	83.6	1.83	3.69	3.03	0.05	0.00	0.53	0.27	0.01	0.00	6.31	0.00	0.00	0.00	0.00	0.01	0.10		3.6
20-134- 18 Dark blue-green section of fluted tubular bead E.E.26A,Dyn. I-II,Hierakonpolis,Main Deposit	0.00	85.6	0.84	1.02	3.07	0.13	0.00	0.43	0.83	0.01	0.00	4.29	0.00	0.00	0.00	0.00	0.01	0.09		3.7
20-134- 48 Grey body material,hole near the base of green model vase E.19,Dyn. I-II,Hierakonpolis,house 144	0.00	90.4	0.17	0.36	1.71	0.15	0.04	0.09	1.37	0.02	0.00	0.00	0.06	0.00	0.00	0.00	0.00	0.00		5.6
20-134- 48 Remains of green glaze,bottom half of model vase E.19,Dyn. I-II,Hierakonpolis,house 144	0.34	90.1	0.25	0.58	2.69	0.06	0.00	0.08	1.44	0.05	0.00	0.97	0.21	0.00	0.00	0.00	0.00	0.00		3.2
20-134-631 Green tubular bead fragment E.E.5A,Dyn. I-II,Hierakonpolis,group 61	0.46	91.4	0.04	0.39	1.44	0.10	0.01	0.04	0.17	0.00	0.00	2.02	0.04	0.00	0.00	0.00	0.00	0.00		3.9
20-134-632 Green tubular bead fragment E.E.5B,Dyn. I-II,Hierakonpolis,group 61	0.50	91.6	0.03	0.22	0.69	0.05	0.04	0.03	0.11	0.00	0.00	1.60	0.01	0.00	0.00	0.00	0.00	0.00		5.1
20-134-633 Green tubular bead E.E.6A,Dyn. I-II,Hierakonpolis,grave 30	0.00	78.9	0.36	0.00	13.74	0.04	0.03	0.01	0.18	0.00	0.00	2.92	0.02	0.04	0.00	0.00	0.02	0.00		3.8
20-134-634 Green tubular bead E.E.6B,Dyn. I-II,Hierakonpolis,grave 30	0.00	77.5	0.18	0.00	12.95	0.04	0.05	0.00	0.16	0.00	0.00	3.47	0.03	0.04	0.00	0.00	0.00	0.00		5.6
20-134-635 Bright blue bead E.E.8A,Dyn. I-II,Hierakonpolis,grave 206	0.52	83.7	0.13	1.02	1.85	0.02	0.00	0.04	0.23	0.00	0.00	9.63	0.00	0.00	0.00	0.01	0.00	0.00		2.9
20-134-636 Bright green bead E.E.8B,Dyn. I-II,Hierakonpolis,grave 206	0.14	91.5	0.07	0.13	0.63	0.05	0.05	0.02	0.19	0.00	0.00	1.93	0.00	0.03	0.01	0.00				5.3
28-107- 26 Pale green edge of bead E.E.72A,Dyn. II(Peribsen),Abydos,tomb P	0.00	91.0	0.00	0.53	3.33	0.00	0.00	0.12	0.09	0.00	0.00	1.76	0.02	0.00	0.00	0.00	0.00	0.00		3.2
28-107- 26 Blue-green face of bead E.E.72A,Dyn. II(Peribsen),Abydos,tomb P	0.33	77.0	0.00	3.57	13.74	0.00	0.00	0.35	0.27	0.00	0.00	1.56	0.02	0.00	0.00	0.00	0.00	0.00		3.2
29-107- 19 White body material,fragment of green model cylinder vase E.658A,Dyn. II(Kha-Sekhemwy),Abydos,tomb V	1.00	95.3	0.00	0.12	0.35	0.08	0.04	0.14	0.36	0.01	0.00	0.01	0.00	0.00	0.00	0.00	0.00	0.00		3.6
29-107- 19 Green model cylinder vase fragment E.658A,Dyn. II(Kha-Sekhemwy),Abydos,tomb V	0.00	89.9	0.00	0.00	1.82	0.00	0.07	0.14	0.14	0.00	0.00	5.42	0.00	0.00	0.00	0.00	0.00	0.00		2.5
29-107- 19 Black spot on green model cylinder vase fragment E.658A,Dyn. II(Kha-Sekhemwy),Abydos,tomb V	0.00	60.3	1.42	0.00	19.42	0.00	0.00	3.87	3.01	0.00	0.00	8.33	0.00	0.00	0.00	0.00	0.01	0.00		3.6
29-107- 19 Brown spot on green model cylinder vase fragment E.658A,Dyn. II(Kha-Sekhemwy),Abydos,tomb V	0.37	76.7	1.06	0.34	9.69	0.05	0.00	0.87	0.98	0.00	0.00	4.93	0.00	0.00	0.00	0.02	0.01	0.00		4.?

X-RAY FLUORESCENCE ANALYSES OF INDIVIDUAL OBJECTS ARRANGED CHRONOLOGICALLY

Chloride and oxides of: Si S K Ca Ti V Cr Mn Fe Co Ni Cu Zn As Pb Sr Sn Sb Ba Other

ID	Description	Si	S	K	Ca	Ti	V	Cr	Mn	Fe	Co	Ni	Cu	Zn	As	Pb	Sr	Sn	Sb	Ba	Other
29-107- 20	Pale green fragment of inlay E.648,Dyn. II(Kha-Sekhemwy),Abydos,tomb V	0.00	90.2	0.00	0.00	3.12	0.00	0.00	0.00	0.00	0.26	0.00	3.08	0.00	0.00	0.00	0.00	0.00	0.00	0.00	3.3
29-107- 21	White body material,fragment of green inlay E.649,Dyn. II(Kha-Sekhemwy),Abydos,tomb V	0.00	94.7	0.00	0.42	0.59	0.13	0.09	0.01	0.08	0.71	0.01	0.00	0.00	0.03	0.00					3.2
29-107- 21	Green fragment of inlay E.649,Dyn. II(Kha-Sekhemwy),Abydos,tomb V	0.00	83.8	0.53	0.00	6.04	0.00	0.00	0.00	0.72	0.01	0.00	5.71	0.02	0.00	0.00	0.00	0.00	0.00	0.00	3.2
31- 33- 50	Blue-green tile 1954.669,Dyn. III,Saqqara,Pyramid of Djoser	0.36	88.4	0.00	0.00	0.49	0.00	0.00	0.00	0.13	0.00	0.00	5.11	0.00	0.00	0.00	0.00	0.00	0.00	0.00	5.5
31- 33- 51	White body material,fragment of green tile 1954.670b,Dyn. III,Saqqara,Pyramid of Djoser	2.30	92.7	0.29	0.20	0.51	0.03	0.00	0.00	0.04	0.18	0.00	0.01	0.00	0.00	0.00	0.00	0.00	0.00	0.00	3.7
31- 33- 51	Green fragment of tile 1954.670b,Dyn. III,Saqqara,Pyramid of Djoser	0.85	91.7	0.00	0.00	1.24	0.02	0.00	0.00	0.09	0.11	0.00	3.28	0.00	0.00	0.00	0.00	0.01	0.00	0.00	2.7
31- 33- 52	White body material,fragment of blue tile 1942.280,Dyn. III,Saqqara,Heb Sed Temple of Djoser	0.00	94.0	0.00	0.02	0.38	0.05	0.10	0.00	0.15	0.26	0.00	0.07	0.01	0.00	0.00	0.00	0.00	0.00	0.00	5.0
31- 33- 52	Dark blue fragment of tile 1942.280,Dyn. III,Saqqara,Heb Sed Temple of Djoser	0.48	87.2	0.00	1.50	1.17	0.04	0.00	0.00	0.00	0.14	0.00	5.80	0.00	0.00	0.00	0.00	0.00	0.00	0.00	3.7
31- 33- 65	White body material,fragment of blue tile 1937.115,Dyn. III,Saqqara,tomb of Djoser	0.00	94.4	0.41	0.08	1.15	0.07	0.13	0.00	0.16	0.29	0.00	0.07	0.03	0.00	0.00	0.00	0.00	0.00	0.00	3.2
31- 33- 65	Greenish blue fragment of tile 1937.115,Dyn. III,Saqqara,tomb of Djoser	0.51	87.7	0.00	0.30	2.22	0.00	0.09	0.00	0.09	0.22	0.01	5.39	0.00	0.00	0.00	0.00	0.00	0.02	0.00	3.4
31-104- 53	Small pale green bead E.4080A(E.E.482A),Dyn. III,Beit Khallaf,tomb Kl	0.00	92.8	0.00	1.13	1.80	0.06	0.00	0.00	0.20	0.00	0.00	1.45	0.07	0.00	0.00	0.00	0.02	0.01	0.00	2.5
31-104- 54	Small pale green bead E.4080B(E.E.482B),Dyn. III,Beit Khallaf,tomb Kl	0.00	89.3	0.58	0.00	3.75	0.06	0.00	0.00	0.01	0.29	0.00	2.40	0.06	0.00	0.00	0.00	0.04	0.01	0.00	3.5
31-104-582	Small pale green bead E.4080C,Dyn. III,Beit Khallaf,tomb Kl	0.02	88.9	0.02	0.37	1.99	0.01	0.00	0.00	0.02	0.18	0.00	1.51	0.09	0.00	0.00	0.00	0.02	0.03	0.06	6.8
31-104-583	Small pale green bead E.4080D,Dyn. III,Beit Khallaf,tomb Kl	0.00	89.6	0.08	1.12	1.25	0.04	0.00	0.02	0.02	0.26	0.00	1.80	0.04	0.00	0.00	0.00	0.06	0.03	0.02	5.7
41-124- 98	Small black-bodied black bead 1935.169A,Dyn. IV,Armant,grave 1310N	0.00	86.6	0.11	2.02	0.67	0.03	0.00	1.16	0.26	0.00	0.00	4.63	0.00	0.02	0.03	0.00	0.01	0.01	0.06	4.4
41-124- 99	Small black-bodied black bead 1935.169B,Dyn. IV,Armant,grave 1310N	0.00	87.8	0.00	1.61	0.58	0.00	0.00	1.20	0.12	0.00	0.00	5.29	0.00	0.00	0.00	0.00	0.01	0.01	0.03	3.4
41-124-584	Dark blue-grey tubular bead 1935.171aA,Dyn. IV,Armant,grave 1310N	0.00	75.2	0.19	0.82	12.89	0.20	0.01	0.00	0.02	1.20	0.01	6.00	0.04	0.13	0.00	0.08	0.00	0.00	0.00	3.2
41-124-585	Blue tubular bead 1935.171aB,Dyn. IV,Armant,grave 1310N	0.04	82.4	0.07	0.79	10.57	0.11	0.01	0.00	0.04	0.58	0.00	2.14	0.03	0.00	0.00	0.11	0.01	0.03	0.00	3.0
41-133- 55	yellow body material,chipped mouth of white vase E.382,Dyn. IV,el Kab,tomb C	0.13	83.2	0.15	0.07	1.04	0.18	0.00	0.00	0.06	2.61	0.01	0.09	0.22	0.00	0.04	0.00	0.00	0.00	0.00	12.2

X-RAY FLUORESCENCE ANALYSES OF INDIVIDUAL OBJECTS ARRANGED CHRONOLOGICALLY

Chloride and oxides of:

Object	Si	S	K	Ca	Ti	V	Cr	Mn	Fe	Co	Ni	Cu	Zn	As	Pb	Sr	Sn	Sb	Ba	Other
41-133-55 Black decoration on white vase E.382,Dyn.IV,el Kab,tomb C	0.00	59.9	2.02	0.00	7.79	0.33	0.00	0.00	7.34	13.37	0.00	1.40	0.43	0.00	0.45	0.00	0.00	0.00	0.00	7.0
41-133-56 Red body material,fragment of white vase E.381,Dyn.IV,el Kab,tomb C	0.00	92.1	0.10	0.00	0.12	0.10	0.07	0.00	0.05	1.58	0.02	0.00	0.00	0.00	0.00	0.00	0.00	0.00	0.00	5.9
41-133-56 Black decoration on white fragment of vase E.381,Dyn.IV,el Kab,tomb C	0.16	80.1	0.37	0.29	2.50	0.39	0.00	0.00	1.73	8.45	0.00	0.33	0.60	0.00	0.40	0.00	0.00	0.00	0.00	4.7
45-80-63 Olive green bead 1923.543A,Dyn.IV-V,Qau,grave 677	0.00	89.6	0.00	0.36	0.78	0.11	0.02	0.00	3.34	0.03	0.00	2.05	0.02	0.00	0.00	0.00	0.01	0.01	0.00	3.6
45-80-576 Dark blue tubular bead 1923.542C,Dyn.IV-V,Qau,grave 677	0.00	74.1	0.39	0.40	12.15	0.08	0.04	0.02	0.85	0.00	0.00	7.36	0.01	0.06	0.00	0.07	0.00	0.00	0.00	4.5
45-80-577 Dark blue tubular bead 1923.542B,Dyn.IV-V,Qau,grave 677	0.02	72.0	0.26	0.32	15.09	0.08	0.04	0.00	0.60	0.00	0.01	7.72	0.00	0.00	0.00	0.08	0.00	0.00	0.00	3.8
46-78-85 Dark green bead 1925.459A,Old Kingdom,Badari,grave 5433	0.37	90.5	0.00	0.51	1.36	0.05	0.00	0.00	0.24	0.00	0.00	4.70	0.00	0.00	0.00	0.00	0.00	0.00	0.00	2.2
46-78-86 Black-bodied black bead 1925.459B,Old Kingdom,Badari,grave 5433	0.00	86.0	0.00	1.46	0.80	0.00	0.00	2.91	1.22	0.00	0.00	1.97	0.01	0.00	0.00	0.00	0.00	0.00	0.01	5.7
46-106-60 Black barrel bead E.E.456A,Old Kingdom,Mahasna,tomb M114	0.00	79.4	0.00	3.80	3.09	0.00	0.00	3.71	0.54	0.00	0.00	5.81	0.09	0.02	0.02	0.10	0.00	0.00	0.61	2.8
46-106-61 Small green flattened lozenge bead E.E.456B,Old Kingdom,Mahasna,tomb M114	0.00	86.0	0.00	0.55	4.92	0.00	0.00	0.00	2.16	0.01	0.00	3.04	0.04	0.00	0.00	0.00	0.02	0.00	0.00	3.2
46-106-62 Dark green bead fragment E.E.455A,Old Kingdom,Mahasna,tomb M114	0.00	90.6	0.10	0.27	3.51	0.02	0.00	0.00	0.61	0.00	0.00	1.90	0.07	0.00	0.00	0.00	0.00	0.00	0.00	2.9
46-106-580 Highly vitrified dark blue bead E.E.455B,Old Kingdom,Mahasna,tomb M114	0.30	85.2	0.14	0.97	3.30	0.14	0.02	0.00	0.33	0.00	0.00	6.35	0.00	0.00	0.00	0.00	0.00	0.00	0.00	3.2
46-106-581 Highly vitrified dark blue bead E.E.455C,Old Kingdom,Mahasna,tomb M114	0.31	86.8	0.07	0.80	1.71	0.05	0.01	0.01	0.19	0.00	0.00	6.09	0.00	0.00	0.00	0.00	0.00	0.00	0.00	4.0
46-133-57 Traces of green glaze on jackal-headed pendant E.1810,Old Kingdom,el Kab	0.00	88.4	0.15	0.17	2.33	0.21	0.00	0.00	4.75	0.00	0.00	0.81	0.11	0.00	0.00	0.00	0.02	0.03	0.00	3.0
46-133-59 Blue tubular bead E.E.89B,Old Kingdom,el Kab,tomb 166	0.00	86.0	0.00	0.29	1.49	0.00	0.00	0.00	0.79	0.00	0.00	7.63	0.00	0.00	0.19	0.00	0.00	0.00	0.00	2.7
46-133-574 Dark blue recumbent lion,pendant E.E.89C,Old Kingdom,el Kab,tomb 166	0.00	78.1	0.19	0.27	8.03	0.09	0.04	0.00	0.64	0.01	0.00	7.41	0.03	0.04	0.00	0.06	0.00	0.00	0.00	5.1
46-133-575 Green ball bead E.E.89D,Old Kingdom,el Kab,tomb 166	0.09	87.2	0.38	0.09	3.12	0.00	0.00	0.51	0.28	0.00	0.00	3.31	0.07	0.00	0.00	0.00	0.03	0.03	0.14	4.8
51-60-76 White tubular bead E.E.84A,Dyn.V,Dishasha,tomb 22	0.09	96.1	0.32	0.00	0.28	0.00	0.04	0.06	0.10	0.00	0.00	0.47	0.03	0.00	0.00	0.00	0.03	0.03	0.00	2.6
51-76-77 Green tubular bead 1930.521A,Dyn.V,Mustagidda,grave 3540	0.47	87.4	0.42	2.25	1.40	0.00	0.00	0.15	1.01	0.00	0.00	3.16	0.56	0.00	0.36	0.00	0.00	0.00	0.00	2.8

X-RAY FLUORESCENCE ANALYSES OF INDIVIDUAL OBJECTS ARRANGED CHRONOLOGICALLY

Chloride and oxides of:

Object	Si	S	K	Ca	Ti	V	Cr	Mn	Fe	Co	Ni	Cu	Zn	As	Pb	Sr	Sn	Sb	Ba	Other
56- 78- 78 Dark blue highly vitrified barrel bead 1924.339A,Dyn. V-VI,Badari,grave 3236	0.00	80.9	0.00	4.48	3.87	0.08	0.00	0.93	0.63	0.00	0.00	6.35	0.00	0.00	0.00	0.00	0.00	0.00	0.14	2.7
56- 78-578 Dark blue highly vitrified bead 1924.339B,Dyn. V-VI,Badari,grave 3236	0.75	85.7	0.15	1.85	2.79	0.08	0.02	0.01	0.55	0.02	0.00	5.19	0.02	0.00	0.09	0.00	0.03	0.02	0.00	2.7
56- 78-579 Dark blue highly vitrified bead 1924.339C,Dyn. V-VI,Badari,grave 3236	0.61	83.4	0.01	5.32	1.85	0.06	0.00	0.03	0.62	0.00	0.00	9.21	0.05	0.00	0.11	0.00	0.05	0.06	0.00	-1.4
61- 74- 87 Black pendant 1931.326A,Dyn. VI,Matmar,grave 838	0.67	85.7	0.00	0.00	3.34	0.01	0.00	1.09	0.53	0.00	0.00	3.21	0.06	0.00	0.00	0.00	0.01	0.01	0.30	5.1
61- 78- 79 Small black-bodied black barrel bead 1925.447A,Dyn. VI,Badari,grave 5535	0.65	85.0	0.03	0.00	1.85	0.00	0.00	2.02	1.74	0.00	0.00	3.61	0.00	0.00	0.00	0.00	0.01	0.00	0.01	5.1
61- 78- 80 Pale green barrel bead 1925.447B,Dyn. VI,Badari,grave 5535	0.27	91.5	0.00	0.17	0.87	0.07	0.01	0.05	1.49	0.00	0.00	1.70	0.01	0.00	0.00	0.00	0.00	0.02	0.02	3.8
61- 78- 81 Dark green highly vitrified tubular bead 1925.449A,Dyn. VI,Badari,grave 5535	0.00	92.5	0.00	0.00	1.38	0.00	0.00	0.00	1.16	0.02	0.00	2.45	0.00	0.00	0.00	0.00	0.00	0.00	0.00	2.4
61- 78- 82 Small dark green anthropoid pendant 1925.449B,Dyn. VI,Badari,grave 5535	0.43	91.5	0.00	0.00	0.45	0.00	0.00	0.00	0.06	0.00	0.00	3.96	0.00	0.00	0.00	0.01	0.01	0.02	0.00	3.5
61- 78- 83 Dark green Tauret-pendant 1925.450A,Dyn. VI,Badari,grave 5535	0.64	90.8	0.00	0.17	0.99	0.00	0.00	0.00	0.13	0.00	0.00	3.87	0.00	0.00	0.00	0.00	0.00	0.00	0.00	3.4
61- 78- 84 Pale brown bead 1925.458A,Dyn. VI,Badari,grave 5543	0.00	91.6	0.79	0.31	1.66	0.16	0.04	0.06	0.66	0.00	0.00	0.87	0.00	0.00	0.00	0.00	0.01	0.00	0.00	3.9
61- 80- 67 Small flat blue-green pendant 1923.635A,Dyn. VI,Qau,grave 676	0.00	88.1	0.00	0.54	1.51	0.02	0.00	0.02	1.69	0.01	0.00	5.25	0.01	0.00	0.00	0.00	0.00	0.01	0.00	2.8
61- 80- 68 Grey body material,crack in green barrel bead 1923.635B,Dyn. VI,Qau,grave 676	1.11	83.4	0.00	0.82	6.39	0.23	0.10	0.52	3.02	0.00	0.00	0.43	0.00	0.00	0.00	0.00	0.00	0.00	0.00	3.9
61- 80- 68 Small olive-green barrel bead 1923.635B,Dyn. VI,Qau,grave 676	0.00	89.2	0.00	0.34	1.24	0.00	0.01	0.47	0.58	0.01	0.00	3.61	0.01	0.00	0.11	0.50	0.00	0.00	0.00	4.0
61- 80- 69 Pale green edge of bead 1923.644A,Dyn. VI,Qau,grave 613	0.00	91.5	0.33	0.00	2.24	0.03	0.08	0.05	0.07	0.02	0.00	3.09	0.00	0.00	0.00	0.00	0.00	0.00	0.00	2.6
61- 80- 69 Darker green face of bead 1923.644A,Dyn. VI,Qau,grave 613	0.00	84.8	0.44	0.00	8.23	0.00	0.00	0.04	0.06	0.00	0.00	3.50	0.00	0.00	0.00	0.00	0.00	0.00	0.00	2.9
61- 80- 70 Pale green ball bead 1923.654A,Dyn. VI,Qau,grave 557	0.10	86.8	0.23	0.00	1.72	0.04	0.10	0.10	0.24	0.00	0.01	0.66	0.04	0.00	0.00	0.00	0.01	0.00	0.00	9.9
61- 80- 71 Green anthropoid pendant 1923.654B,Dyn. VI,Qau,grave 557	0.00	90.9	0.19	0.00	2.09	0.00	0.00	0.00	0.22	0.00	0.00	3.62	0.36	0.00	0.00	0.00	0.00	0.00	0.00	2.6
61- 80- 71 Yellow-green spot on green anthropoid pendant 1923.654B,Dyn. VI,Qau,grave 557	0.00	85.6	0.29	0.00	2.13	0.00	0.00	0.00	0.22	0.00	0.00	7.69	0.47	0.00	0.00	0.00	0.00	0.00	0.00	3.6
61- 80- 73 Green fluted tubular bead 1924.368A,Dyn. VI,Qau,grave 7317	0.00	86.6	0.00	1.08	2.55	0.00	0.00	0.00	3.39	0.03	0.00	3.50	0.00	0.00	0.00	0.00	0.00	0.01	0.00	2.7

X-RAY FLUORESCENCE ANALYSES OF INDIVIDUAL OBJECTS ARRANGED CHRONOLOGICALLY

Chloride and oxides of:

Sample	Description	Si	S	K	Ca	Ti	V	Cr	Mn	Fe	Co	Ni	Cu	Zn	As	Pb	Sr	Sn	Sb	Ba	Other
61-107-91	White area of inlay fragment E.1764H, Dyn. VI, Abydos, Sixth Dynasty Temple	0.00	90.2	0.12	0.27	4.88	0.00	0.00	0.00	0.41	0.00	0.00	0.05	0.07	0.00	0.00	0.00	0.00	0.00	0.00	4.0
61-107-91	Brown area of inlay fragment E.1764H, Dyn. VI, Abydos, Sixth Dynasty Temple	0.00	89.6	0.09	0.33	2.97	0.08	0.12	0.00	0.60	2.90	0.00	0.00	0.00	0.00	0.00	0.00	0.00	0.00	0.00	3.3
61-107-92	White body material, unglazed reverse side of inlay fragment E.1765F, Dyn. VI, Abydos, Sixth Dynasty Temple	0.00	95.0	0.00	0.00	0.24	0.04	0.09	0.00	0.14	0.00	0.07	0.00	0.00	0.00	0.00	0.00	0.00	0.00	0.00	4.4
61-107-92	Green stripe bordered by brown, fragment of inlay E.1765F, Dyn. VI, Abydos, Sixth Dynasty Temple	0.00	94.1	0.00	0.18	0.34	0.01	0.00	0.00	0.07	0.00	0.00	1.20	0.00	0.00	0.00	0.05	0.09	0.00	0.00	4.0
61-107-92	Another green stripe bordered by brown, fragment of inlay E.1765F, Dyn. VI, Abydos, Sixth Dynasty Temple	0.00	94.5	0.00	0.48	0.56	0.00	0.01	0.00	0.12	0.00	0.00	0.96	0.00	0.00	0.00	0.00	0.05	0.09	0.00	3.3
61-107-92	Brown stripe bordered by green, fragment of inlay E.1765F, Dyn. VI, Abydos, Sixth Dynasty Temple	0.00	83.3	0.00	0.80	2.32	0.19	0.09	0.00	3.85	0.00	0.00	0.37	0.00	0.00	0.00	0.00	0.00	0.00	0.06	5.2
61-107-92	Another brown stripe bordered by green, fragment of inlay E.1765F, Dyn. VI, Abydos, Sixth Dynasty Temple	0.00	80.9	0.00	0.82	8.06	0.09	0.00	0.00	1.37	1.89	0.00	0.23	0.00	0.00	0.00	0.03	0.00	0.00	0.18	6.5
61-107-93	White ground on the face of inlay fragment E.1766, Dyn. VI, Abydos, Sixth Dynasty Temple	0.00	98.6	0.00	0.09	0.17	0.00	0.06	0.00	0.12	0.00	0.24	0.02	0.04	0.01	0.00	0.00	0.00	0.00	0.00	0.6
61-107-93	Green hieroglyph, raised relief on fragment of inlay E.1766, Dyn. VI, Abydos, Sixth Dynasty Temple	0.43	91.0	0.00	0.70	2.11	0.00	0.00	0.10	0.00	0.12	0.00	1.66	0.00	0.00	0.00	0.00	0.00	0.04	0.10	3.8
61-107-94	White ground on the face of inlay fragment E.1767A, Dyn. VI, Abydos, Sixth Dynasty Temple	0.00	96.2	0.14	0.00	0.07	0.04	0.11	0.00	0.07	0.17	0.01	0.00	0.04	0.00	0.00	0.00	0.00	0.00	0.00	3.2
61-107-94	Green area on the face of inlay fragment E.1767A, Dyn. VI, Abydos, Sixth Dynasty Temple	0.00	92.7	0.00	0.42	1.27	0.00	0.00	0.00	0.26	0.01	0.00	2.06	0.00	0.00	0.00	0.00	0.02	0.12	0.00	3.1
61-107-94	Brown design on green fragment of inlay E.1767A, Dyn. VI, Abydos, Sixth Dynasty Temple	0.00	90.4	0.07	0.65	0.93	0.09	0.00	0.00	0.71	1.56	0.00	0.66	0.02	0.00	0.00	0.00	0.00	0.07	0.00	4.8
61-107-95	White body material, unglazed reverse side of inlay fragment E.1769C, Dyn. VI, Abydos, Sixth Dynasty Temple	0.00	96.7	0.05	0.00	0.21	0.10	0.07	0.00	0.08	0.22	0.02	0.00	0.03	0.00	0.00	0.00	0.00	0.00	0.00	2.5
61-107-95	Pale green face of inlay fragment E.1769C, Dyn. VI, Abydos, Sixth Dynasty Temple	0.27	94.7	0.00	0.50	0.59	0.01	0.05	0.00	0.05	0.28	0.00	0.99	0.00	0.00	0.00	0.00	0.00	0.02	0.14	2.4
61-107-96	Green stripe on white inlay fragment E.1770A, Dyn. VI, Abydos, Sixth Dynasty Temple	0.00	92.9	0.00	0.23	0.54	0.00	0.00	0.00	0.20	0.01	0.00	2.41	0.00	0.00	0.00	0.00	0.01	0.12	0.00	3.5
61-107-97	White intermediate layer, inlay E.A.526, Dyn. VI, Abydos, Sixth Dynasty Temple	0.00	95.9	0.00	0.00	0.28	0.03	0.09	0.00	0.20	0.00	0.00	0.00	0.00	0.00	0.00	0.00	0.00	0.00	0.00	3.5
61-107-97	Remains of pale green glaze on the face of inlay E.A.526, Dyn. VI, Abydos, Sixth Dynasty Temple	0.34	91.6	0.00	0.80	1.35	0.07	0.00	0.00	0.45	0.00	0.00	2.27	0.00	0.00	0.00	0.00	0.00	0.00	0.00	2.9
61-107-97	Brown spot on the face of green inlay E.A.526, Dyn. VI, Abydos, Sixth Dynasty Temple	0.00	87.7	0.06	1.01	1.59	0.20	0.16	0.00	1.33	3.79	0.00	0.00	0.31	0.00	0.00	0.00	0.00	0.06	0.13	3.9
78-74-131	Olive brown inlay 1932.933a, Dyn. VII-VIII, Matmar, tomb 1316	0.21	86.5	0.03	0.37	1.88	0.02	0.00	0.00	3.22	0.85	0.00	0.00	3.66	0.00	0.00	0.00	0.00	0.00	0.44	2.8

X-RAY FLUORESCENCE ANALYSES OF INDIVIDUAL OBJECTS ARRANGED CHRONOLOGICALLY

Chloride and oxides of:

ID	Description	Si	S	K	Ca	Ti	V	Cr	Mn	Fe	Co	Ni	Cu	Zn	As	Pb	Sr	Sn	Sb	Ba	Other
78-74-132	Remains of dark blue-green glaze,fragment of inlay 1932.933b,Dyn.VII-VIII,Matmar,tomb 1316	0.00	82.2	0.00	0.00	3.63	0.00	0.00	0.00	0.21	0.00	0.00	7.56	0.00	0.00	0.00	0.00	0.00	0.00	0.00	6.4
78-74-133	Black bead 1932.921A,Dyn.VII-VIII,Matmar,tomb 532	0.18	74.3	0.41	0.34	8.29	0.08	0.00	2.14	0.87	0.00	0.00	6.29	0.00	0.00	0.00	0.00	0.00	0.00	0.48	6.7
78-74-134	Black bead 1932.921B,Dyn.VII-VIII,Matmar,tomb 532	0.00	79.9	0.00	0.47	3.65	0.16	0.02	2.65	1.07	0.00	0.00	5.09	0.00	0.00	0.00	0.00	0.00	0.00	0.38	6.6
78-78-124	Small greyish green bead 1924.348A,Dyn.VII-VIII,Badari,grave 3306	0.00	78.3	0.00	3.28	3.27	0.00	0.00	3.32	1.42	0.00	0.00	7.25	0.00	0.00	0.00	0.00	0.00	0.00	0.68	2.4
78-78-125	Small black bead 1924.348B,Dyn.VII-VIII,Badari,grave 3306	0.00	86.3	0.00	1.70	2.58	0.05	0.00	2.09	0.37	0.02	0.00	3.28	0.02	0.00	0.00	0.00	0.02	0.00	0.25	3.3
78-78-126	Small green bead 1924.349A,Dyn.VII-VIII,Badari,grave 3306	0.00	88.7	0.00	1.45	3.60	0.07	0.01	0.09	0.31	0.00	0.00	2.21	0.00	0.00	0.00	0.00	0.00	0.00	0.00	3.6
78-78-127	Small dark green bead 1924.349B,Dyn.VII-VIII,Badari,grave 3306	0.12	87.5	0.00	0.89	4.36	0.00	0.00	0.00	0.30	0.00	0.00	3.87	0.00	0.00	0.00	0.00	0.00	0.00	0.00	3.0
78-78-128	Dark green two-hole disc bead 1924.351A,Dyn.VII-VIII,Badari,grave 3306	0.24	89.2	0.16	0.45	2.78	0.00	0.06	0.09	0.20	0.00	0.00	1.31	0.00	0.00	0.00	0.00	0.00	0.00	0.00	5.5
78-78-129	Green two-hole disc bead 1924.351B,Dyn.VII-VIII,Badari,grave 3306	0.00	93.0	0.00	0.48	1.77	0.00	0.09	0.00	0.15	0.00	0.00	1.59	0.01	0.00	0.00	0.00	0.00	0.00	0.00	2.9
78-79-138	Blue bead 1924.384A,Dyn.VII-VIII,Hammamiya,grave 2080	0.00	84.9	0.00	2.49	3.81	0.00	0.00	0.10	0.49	0.01	0.00	4.48	0.01	0.00	0.00	0.00	0.00	0.01	0.00	3.7
78-79-139	Blue bead 1924.384B,Dyn.VII-VIII,Hammamiya,grave 2080	0.00	89.6	0.00	0.72	2.94	0.06	0.09	0.10	0.51	0.01	0.00	1.72	0.02	0.00	0.00	0.00	0.00	0.00	0.00	4.3
78-79-140	Small brown bead 1924.387A,Dyn.VII-VIII,Hammamiya,grave 2080	0.57	89.2	0.00	1.83	3.19	0.13	0.06	0.15	0.43	0.00	0.00	0.00	0.04	0.00	0.00	0.00	0.00	0.00	0.00	4.4
78-79-141	Small blue-black bead 1924.387B,Dyn.VII-VIII,Hammamiya,grave 2080	0.00	84.2	0.00	3.73	0.73	0.06	0.00	1.58	0.42	0.01	0.00	6.71	0.05	0.00	0.00	0.07	0.00	0.00	0.00	2.4
78-74-132	Creamy body material,fragment of green inlay 1932.933b,Dyn.VII-VIII,Matmar,tomb 1316	0.00	88.7	0.00	0.00	6.31	0.12	0.05	0.06	0.57	0.01	0.00	0.88	0.02	0.00	0.00	0.00	0.00	0.00	0.00	3.3
80-106-102	Black bead E.E.458A,First I.P.,Mahasna M87	0.00	79.9	0.87	0.37	5.02	0.11	0.00	2.02	2.44	0.01	0.00	2.40	0.01	0.00	0.00	0.00	0.00	0.00	0.09	6.7
80-106-103	Black bead E.E.458B,First I.P.,Mahasna M87	0.00	85.1	0.77	0.91	2.76	0.06	0.00	1.77	1.86	0.00	0.00	2.52	0.00	0.00	0.00	0.00	0.00	0.00	0.15	4.1
80-106-104	Small dark green barrel bead E.E.102A,First I.P.,Mahasna,grave M23	0.00	85.6	0.00	0.00	3.65	0.01	0.00	1.74	1.03	0.00	0.00	3.29	0.00	0.00	0.00	0.00	0.00	0.00	0.22	4.4
80-106-105	Small black barrel bead E.E.102B,First I.P.,Mahasna,grave M23	0.00	83.6	0.00	2.01	2.43	0.03	0.00	2.46	1.56	0.00	0.00	2.75	0.00	0.00	0.00	0.00	0.00	0.00	0.17	5.0
80-106-106	Blue-green flat bead E.E.92(iii)A,First I.P.,Mahasna,grave M587	0.00	85.7	0.00	3.28	1.48	0.04	0.00	0.00	1.51	0.00	0.00	4.68	0.00	0.00	0.00	0.00	0.00	0.01	0.00	3.3

X-RAY FLUORESCENCE ANALYSES OF INDIVIDUAL OBJECTS ARRANGED CHRONOLOGICALLY

Chloride and oxides of:

Sample / Description	Si	S	K	Ca	Ti	V	Cr	Mn	Fe	Co	Ni	Cu	Zn	As	Pb	Sr	Sn	Sb	Ba	Other
80-106-107 Green edge of pendant E.E.92(iii)B,First I.P.,Mahasna,grave M587	0.22	86.2	0.00	2.71	2.12	0.06	0.00	0.00	0.35	0.00	0.00	4.93	0.03	0.00	0.00	0.00	0.00	0.00	0.00	3.4
80-106-107 Black band on the face of green pendant E.E.92(iii)B,First I.P.,Mahasna,grave M587	0.11	90.2	0.00	1.14	1.53	0.00	0.08	0.00	0.24	0.00	0.00	2.12	0.01	0.00	0.00	0.00	0.00	0.00	0.00	4.5
80-106-108 Small blue-green grooved bead E.E.92(ii)A,First I.P.,Mahasna,grave M587	0.00	87.6	0.00	2.87	3.08	0.00	0.00	0.00	0.22	0.00	0.00	2.09	0.54	0.00	0.00	0.01	0.01	0.01	0.00	3.6
80-106-109 Large blue-green ball bead E.E.92(ii)C,First I.P.,Mahasna,grave M587	0.00	89.9	0.00	0.79	1.32	0.00	0.00	0.00	0.10	0.01	0.00	4.62	0.00	0.00	0.00	0.00	0.00	0.00	0.00	3.3
80-106-110 Exposed grey body material,raised band around the middle of barrel bead E.E.92(ii)B,First I.P.,Mahasna,grave M587	0.00	82.1	0.12	1.19	2.45	0.19	0.00	0.00	0.62	1.09	0.00	1.46	0.02	0.00	0.00	0.00	0.00	0.00	0.00	10.8
80-106-110 Fragments of green glaze imbedded in a band about the middle of barrel bead E.E.92(ii)B,First I.P.,Mahasna,grave M587	0.00	91.4	0.00	1.04	1.19	0.00	0.00	0.00	0.15	0.32	0.01	2.61	0.00	0.00	0.00	0.00	0.00	0.00	0.02	3.3
80-106-110 Smooth dark blue tip of barrel bead E.E.92(ii)B,First I.P.,Mahasna,grave M587	0.30	86.4	0.00	2.96	1.31	0.01	0.00	0.00	0.71	0.64	0.00	4.30	0.00	0.00	0.00	0.00	0.00	0.03	0.28	3.0
80-106-111 Green streak bordered by black,biconical bead E.E.98A,First I.P.,Mahasna,grave M319	0.48	89.8	0.00	0.38	0.80	0.00	0.00	.0.13	0.21	0.01	0.00	4.11	0.00	0.00	0.00	0.00	0.00	0.00	0.08	4.0
80-106-111 Black streak bordered by green,biconical bead E.E.98A,First I.P.,Mahasna,grave M319	0.48	81.2	0.00	1.99	1.13	0.05	0.00	3.48	0.22	0.03	0.00	7.20	0.00	0.00	0.00	0.00	0.00	0.01	0.29	3.9
80-106-112 Brown body material,truncated end of green anthropoid pendant E.E.98B,First I.P.,Mahasna,grave M319	0.02	79.2	0.47	2.93	2.68	0.16	0.00	0.07	4.99	0.00	0.00	0.25	0.00	0.00	0.00	0.00	0.00	0.00	0.00	9.2
80-106-112 Green anthropoid pendant E.E.98B,First I.P.,Mahasna,grave M319	0.00	82.0	0.00	3.42	1.39	0.00	0.00	0.00	3.01	0.00	0.00	7.28	0.00	0.00	0.00	0.00	0.00	0.00	0.00	2.9
80-106-112 Black spot on top of green anthropoid pendant E.E.98B,First I.P.,Mahasna,grave M319	0.15	81.5	0.00	2.40	2.49	0.16	0.00	4.20	0.85	0.00	0.00	3.33	0.00	0.00	0.00	0.00	0.00	0.00	0.21	4.7
80-106-113 Yellowish body material,damaged glaze-free hip of blue model hippopotamus E.1784,First I.P.,Mahasna,grave M560	0.00	91.7	0.20	0.81	3.02	0.14	0.01	0.00	1.09	0.00	0.00	0.15	0.00	0.00	0.00	0.00	0.00	0.00	0.00	2.9
80-106-113 Dark blue model hippopotamus E.1784,First I.P.,Mahasna,grave M560	0.36	84.7	0.06	2.56	2.27	0.00	0.00	0.00	0.24	0.00	0.00	5.88	0.00	0.00	0.18	0.00	0.01	0.03	0.00	3.7
80-106-114 Very small dark green bead E.E.90A,First I.P.,Mahasna,grave M348	0.00	90.8	0.00	0.00	1.29	0.00	0.00	0.00	0.11	0.03	0.00	2.79	0.00	0.00	0.75	0.00	0.00	0.00	0.00	4.2
80-106-115 Very small green bead E.E.90B,First I.P.,Mahasna,grave M348	0.45	93.1	0.00	0.00	0.65	0.00	0.00	0.00	0.09	0.00	0.00	2.52	0.00	0.00	0.67	0.00	0.00	0.00	0.00	2.5
80-106-586 Very small pale green bead E.E.90C,First I.P.,Mahasna,grave M348	0.42	89.4	0.20	0.31	0.87	0.07	0.00	0.03	0.15	0.00	0.00	2.42	0.00	0.00	0.91	0.00	0.01	0.00	0.00	5.2
80-106-587 Very small dark green bead E.E.90D,First I.P.,Mahasna,grave M348	0.42	89.0	0.16	0.00	0.76	0.02	0.02	0.01	0.13	0.00	0.00	4.29	0.00	0.00	0.88	0.00	0.03	0.00	0.00	4.3
80-106-588 Very small dark green bead E.E.90E,First I.P.,Mahasna,grave M348	0.25	88.2	0.41	0.00	1.04	0.00	0.02	0.03	0.09	0.00	0.00	4.02	0.01	0.00	0.81	0.00	0.03	0.00	0.00	5.1

X-RAY FLUORESCENCE ANALYSES OF INDIVIDUAL OBJECTS ARRANGED CHRONOLOGICALLY

Chloride and oxides of:

Sample / Description	Si	S	K	Ca	Ti	V	Cr	Mn	Fe	Co	Ni	Cu	Zn	As	Pb	Sr	Sn	Sb	Ba	Other
80-106-589 Small brown-bodied black bead E.E.90F,First I.P.,Mahasna,grave M348	0.20	82.3	0.03	1.51	2.97	0.22	0.00	0.00	1.73	1.78	0.00	2.97	0.03	0.00	0.00	0.00	0.02	0.01	0.00	6.2
80-106-590 Small brown-bodied black bead E.E.90G,First I.P.,Mahasna,grave M348	0.19	86.9	0.10	2.00	2.40	0.21	0.00	0.00	0.89	0.39	0.00	2.85	0.08	0.00	0.00	0.07	0.00	0.00	0.00	3.9
80-106-591 Face of small brown-bodied black bead E.E.90H,First I.P.,Mahasna,grave M348	0.17	82.9	0.03	2.98	4.80	0.16	0.05	0.00	1.10	0.38	0.00	2.58	0.03	0.00	0.00	0.00	0.01	0.00	0.00	4.8
80-107-149 Very small green bead,Queens College Loan No.1280A,First I.P.,Abydos,grave 1736	0.00	92.5	0.12	0.00	2.08	0.02	0.05	0.00	0.14	0.01	0.01	2.14	0.06	0.00	0.00	0.00	0.00	0.00	0.00	2.9
80-107-150 Very small blue-green bead,Queens College Loan No.1280B,First I.P.,Abydos,grave 1736	0.00	86.3	0.06	0.75	1.19	0.00	0.00	0.00	0.23	0.00	0.00	5.85	0.01	0.00	0.00	0.00	0.02	0.04	0.00	5.6
90-56-146 Green flower pendant 1921.1345A,Dyn. IX-X,Sidmant,grave 1526	0.41	86.3	0.00	0.15	0.68	0.00	0.09	0.01	0.07	0.14	0.00	2.10	0.04	0.00	0.00	0.00	0.00	0.02	0.00	19.1
90-56-146 Black spot on top of green flower pendant 1921.1345A,Dyn. IX-X,Sidmant,grave 1526	0.24	83.4	0.00	0.25	0.77	0.12	0.00	4.28	0.29	0.01	0.00	4.19	0.03	0.00	0.00	0.14	0.00	0.01	0.26	6.1
90-56-147 Blue-green panel set in bronze pectoral 1921.1411,Dyn. IX-X,Sidmant,grave 2108	0.89	85.6	0.00	0.00	1.65	0.00	0.00	0.00	0.04	0.29	0.01	6.94	0.03	0.00	0.00	0.00	0.00	0.00	0.45	4.1
90-56-148 Blue panel set in bronze pectoral 1921.1411,Dyn. IX-X,Sidmant,grave 2108	1.09	81.2	0.00	0.00	1.19	0.00	0.00	0.18	0.34	0.01	0.00	8.27	0.00	0.00	0.00	0.00	0.00	0.00	0.72	7.0
90-56-156 Brown panel set in bronze pectoral 1921.1411,Dyn. IX-X,Sidmant,grave 2108	0.55	83.8	0.18	1.09	1.09	0.00	0.00	4.18	0.54	0.01	0.00	4.73	0.03	0.00	0.00	0.25	0.00	0.00	1.13	2.4
90-56-793 Another blue-green panel set in bronze pectoral 1921.1411,Dyn. IX-X,Sidmant,grave 2108	0.45	82.8	0.00	0.45	0.93	0.00	0.00	0.08	0.24	0.00	0.00	6.64	0.00	0.00	0.01	0.01	0.00	0.00	0.87	7.5
90-56-794 Second brown panel set in bronze pectoral 1921.1411,Dyn. IX-X,Sidmant,grave 2108	0.47	80.3	0.14	1.23	0.92	0.26	0.01	4.40	0.76	0.00	0.00	5.03	0.00	0.01	0.02	0.06	0.00	0.00	0.82	5.6
90-56-795 Third brown panel set in bronze pectoral 1921.1411,Dyn. IX-X,Sidmant,grave 2108	0.40	80.5	0.08	1.78	1.55	0.25	0.02	3.35	0.53	0.00	0.00	4.20	0.00	0.00	0.19	0.05	0.00	0.02	0.59	6.5
90-74-136 Blue flat fly-pendant 1931.256A,Dyn. IX-X,Matmar,tomb 306	0.00	81.7	0.00	3.11	0.75	0.11	0.00	0.00	1.93	0.00	0.00	8.80	0.00	0.00	0.00	0.00	0.00	0.00	0.00	3.6
90-74-137 Blue flat X-shaped bead 1931.258A,Dyn. IX-X,Matmar,tomb 306	0.00	78.1	0.00	4.36	2.14	0.06	0.00	1.95	0.06	0.01	0.00	9.64	0.05	0.00	0.00	0.00	0.00	0.00	0.00	3.7
90-79-142 Grey body material,hole in green vase 1923.489,Dyn. IX-X,Hammamiya,grave 1648	0.10	91.3	0.19	0.14	3.49	0.14	0.00	0.13	0.21	0.01	0.01	0.51	0.05	0.00	0.00	0.00	0.01	0.05	0.00	3.8
90-79-142 Blue-green vase 1923.489,Dyn. IX-X,Hammamiya,grave 1648	0.44	89.9	0.00	0.42	1.40	0.00	0.00	0.09	0.14	0.00	0.00	1.94	0.05	0.00	0.00	0.00	0.01	0.05	0.00	5.5
90-79-143 Grey body material,chipped lip of green vase 1923.557,Dyn. IX-X,Hammamiya,grave 1509	0.07	93.2	0.20	0.84	1.39	0.22	0.07	0.05	0.77	0.00	0.00	0.05	0.00	0.00	0.00	0.00	0.00	0.00	0.00	3.2
90-79-143 Exposed white intermediate layer,green vase 1923.557,Dyn. IX-X,Hammamiya,grave 1509	0.00	94.1	0.22	0.00	1.80	0.10	0.06	0.09	0.32	0.00	0.00	0.15	0.12	0.00	0.00	0.00	0.00	0.00	0.00	3.0

X-RAY FLUORESCENCE ANALYSES OF INDIVIDUAL OBJECTS ARRANGED CHRONOLOGICALLY

ID	Description	Si	S	K	Ca	Ti	V	Cr	Mn	Fe	Co	Ni	Cu	Zn	As	Pb	Sr	Sn	Sb	Ba	Other
90- 79-143	Remains of green glaze on vase 1923.557,Dyn. IX-X,Hammamiya,tomb 1509	0.00	92.3	0.32	0.29	1.65	0.03	0.15	0.00	0.17	0.01	0.00	0.79	0.35	0.00	0.00	0.00	0.02	0.04	0.04	3.8
90- 80-144	Blue side of small bead 1924.395A,Dyn. IX-X,Qau,grave 7311	0.18	82.6	0.12	0.44	5.44	0.16	0.03	1.88	1.23	0.00	0.00	1.21	0.03	0.00	0.00	0.00	0.00	0.00	0.13	6.5
90- 80-144	Blue-black side of bead 1924.395A,Dyn. IX-X,Qau,grave 7311	0.15	85.9	0.11	0.22	1.38	0.10	0.00	2.11	1.57	0.00	0.00	1.37	0.00	0.00	0.00	0.00	0.00	0.00	0.18	6.9
90- 80-145	Black(or very dark puple brown) bead 1924.395B,Dyn. IX-X,Qau,grave 7311	0.27	87.4	0.00	0.21	2.15	0.16	0.03	2.25	1.01	0.00	0.00	1.52	0.00	0.00	0.00	0.00	0.00	0.00	0.21	4.7
115- 55-192	Exposed yellow body material,damaged brown vase 1914.653,Dyn. XI,Haraga,grave 644	0.00	95.5	0.07	0.00	0.66	0.11	0.08	0.05	0.33	0.01	0.00	0.03	0.00	0.00	0.05	0.00	0.00	0.00	0.00	3.1
115- 55-192	Brown vase 1914.653,Dyn. XI,Haraga,grave 644	0.28	93.0	0.14	0.00	1.73	0.10	0.13	0.00	0.47	0.01	0.00	0.64	0.00	0.00	0.05	0.00	0.00	0.05	0.00	3.4
115- 55-193	White body material,fragment of blue model calf 1914.759,Dyn. XI,Haraga,house ruin 530	0.00	94.8	0.12	0.49	1.20	0.06	0.04	0.09	0.26	0.00	0.01	0.32	0.02	0.00	0.00	0.00	0.00	0.00	0.00	2.6
115- 55-193	Deep blue model calf 1914.759,Dyn. XI,Haraga,house ruin 530	0.00	90.5	0.00	1.10	1.24	0.00	0.00	0.00	0.12	0.01	0.00	3.99	0.01	0.00	0.00	0.00	0.02	0.02	0.00	3.0
115- 55-194	White body material,damaged glaze-free area of blue staff-head 1914.755,Dyn. XI,Haraga,house ruin 530	0.00	96.1	0.00	0.31	0.50	0.03	0.05	0.23	0.28	0.00	0.00	0.37	0.01	0.00	0.00	0.00	0.00	0.00	0.00	2.1
115- 55-194	Remains of blue glaze on staff-head 1914.755,Dyn. XI,Haraga,house ruin 530	0.41	87.0	0.00	0.58	1.42	0.00	0.00	0.09	0.10	0.00	0.00	4.65	0.00	0.00	0.00	0.00	0.03	0.01	0.01	5.7
115- 55-592	Dark green barrel bead 1914.762A,Dyn. XI,Haraga,house ruin 530	0.52	88.0	0.03	0.48	1.23	0.02	0.00	0.04	0.21	0.00	0.00	3.99	0.03	0.00	0.00	0.00	0.00	0.01	0.00	5.4
115- 55-593	Small dark blue barrel bead 1914.762B,Dyn. XI,Haraga,house ruin 530	0.02	88.7	0.14	0.42	1.13	0.03	0.02	0.04	0.32	0.00	0.00	3.92	0.00	0.00	0.00	0.01	0.01	0.01	0.00	5.2
119- 45-594	Blue four-lobed bead 1925.431A,Dyn. XI-XII,Qasr el Sagha,grave 13	0.51	87.9	0.06	0.12	1.97	0.06	0.04	0.04	0.26	0.00	0.00	4.25	0.00	0.00	0.14	0.00	0.12	0.02	0.00	4.5
119- 45-595	Blue four-lobed bead 1925.431B,Dyn. XI-XII,Qasr el Sagha,grave 13	0.32	90.9	0.00	0.10	0.81	0.00	0.02	0.02	0.17	0.00	0.00	4.69	0.00	0.00	0.09	0.00	0.11	0.00	0.00	2.8
119- 45-596	Very small blue bead 1925.432A,Dyn. XI-XII,Qasr el Sagha,grave 13	0.24	89.3	0.24	0.39	1.88	0.03	0.06	0.02	0.15	0.00	0.00	3.68	0.05	0.00	0.00	0.00	0.00	0.00	0.00	3.9
119- 45-597	Face of very small blue bead 1925.432B,Dyn. XI-XII,Qasr el Sagha,grave 13	0.00	89.6	0.29	0.04	0.64	0.04	0.01	0.02	0.06	0.00	0.00	4.69	0.02	0.00	0.00	0.00	0.01	0.00	0.00	4.5
119- 45-640	Very small blue bead 1925.432C,Dyn. XI-XII,Qasr el Sagha,grave 13	0.28	89.9	0.33	0.24	1.09	0.03	0.02	0.02	0.10	0.00	0.00	3.48	0.04	0.00	0.00	0.00	0.00	0.01	0.00	4.4
120- 55-196	White body material,large hole near the base of green vase,Newbury Loan No.94,Middle Kingdom,Haraga,grave 7	0.02	96.8	0.04	0.00	0.30	0.07	0.09	0.08	0.17	0.01	0.01	0.02	0.01	0.00	0.00	0.00	0.00	0.00	0.00	2.4
120- 55-196	Green exterior of decorated vase,Newbury Loan No.94,Middle Kingdom,Haraga,grave 7	0.23	87.6	0.03	0.00	1.11	0.00	0.04	0.04	0.09	0.01	0.00	3.88	0.00	0.00	0.00	0.07	0.00	0.01		

X-RAY FLUORESCENCE ANALYSES OF INDIVIDUAL OBJECTS ARRANGED CHRONOLOGICALLY

Chloride and oxides of:

	Si	S	K	Ca	Ti	V	Cr	Mn	Fe	Co	Ni	Cu	Zn	As	Pb	Sr	Sn	Sb	Ba	Other
120-55-196 Black interior surface near the mouth of green vase,Newbury Loan No.94,Middle Kingdom,Haraga,grave 7	0.20	74.3	0.03	0.00	12.62	0.00	0.00	2.54	0.07	0.00	0.00	4.31	0.00	0.00	0.10	0.00	0.00	0.00	0.00	5.9
120-62-190 White body material,chipped edge of blue bowl fragment E.2288,Middle Kingdom,Beni Hasan,tomb 294	0.08	94.0	0.47	0.24	1.14	0.00	0.05	0.05	0.17	0.00	0.00	0.12	0.03	0.00	0.00	0.00	0.00	0.00	0.00	3.6
120-62-190 Exterior of blue bowl fragment E.2288,Middle Kingdom,Beni Hasan,tomb 294	0.43	86.5	0.36	0.65	1.56	0.00	0.00	0.06	0.10	0.00	0.00	4.36	0.00	0.00	0.00	0.00	0.01	0.00	0.00	6.0
120-62-190 Black lotus design on blue fragment of bowl E.2288,Middle Kingdom,Beni Hasan,tomb 294	1.13	78.6	0.00	1.40	3.38	0.00	0.00	4.14	0.00	0.00	0.00	9.02	0.00	0.00	0.00	0.00	0.01	0.00	0.00	2.3
120-107-151 Remains of blue-black glaze on ball bead 1913.405A,Middle Kingdom,Abydos,tomb D166	0.00	87.9	0.28	0.00	0.93	0.00	0.04	2.68	0.14	0.02	0.00	3.84	0.04	0.00	0.00	0.00	0.06	0.01	0.17	3.9
120-107-152 Dark blue ball bead E.E.488A,Middle Kingdom,Abydos,tomb E2	0.24	84.3	0.22	0.53	0.65	0.00	0.00	0.08	0.14	0.02	0.00	7.44	0.07	0.00	0.00	0.00	0.05	0.08	0.00	6.2
120-107-153 Dark blue ball bead. E.E.488B,Middle Kingdom,Abydos,tomb E2	0.00	86.3	0.00	0.00	1.11	0.03	0.01	0.02	0.14	0.00	0.00	7.66	0.06	0.00	0.00	0.00	0.00	0.01	0.00	4.7
120-107-154 Small blue-green bead,Queens College Loan No.1284A,Middle Kingdom,Abydos,grave D2	0.54	84.4	0.00	0.80	3.94	0.00	0.00	0.11	0.52	0.00	0.00	3.99	0.08	0.00	0.17	0.00	0.31	0.00	0.00	5.1
120-107-155 Small blue-green bead,Queens College Loan No.1284B,Middle Kingdom,Abydos,grave D2	0.27	84.8	0.00	2.28	3.85	0.06	0.04	0.11	0.40	0.00	0.00	5.04	0.07	0.00	0.23	0.00	0.39	0.01	0.01	2.4
120-107-157 Pale green barrel bead E.E.487B,Middle Kingdom,Abydos,tomb E237	0.38	91.5	0.00	0.28	1.04	0.04	0.00	0.05	0.00	0.00	0.00	2.70	0.04	0.00	0.05	0.00	0.01	0.01	0.00	3.7
120-107-159 Green drop bead 1912.522B,Middle Kingdom,Abydos,grave S44	0.10	74.2	0.43	1.94	11.37	0.20	0.01	0.07	1.23	0.00	0.00	3.25	0.04	0.02	0.00	0.00	0.01	0.00	0.00	7.1
120-107-160 Blue stripe bordered by black,long tapered tubular bead 1912.524A,Middle Kingdom,Abydos,grave S44	0.48	85.3	0.16	1.57	0.73	0.00	0.02	0.00	0.10	0.00	0.00	6.13	0.04	0.00	0.00	0.00	0.04	0.00	0.00	5.4
120-107-160 Black stripe on blue tapered tubular bead 1912.524A,Middle Kingdom,Abydos,grave S44	0.41	77.2	0.00	4.41	1.47	0.00	0.00	4.06	0.18	0.00	0.00	8.56	0.12	0.00	0.00	0.00	0.05	0.00	0.00	3.5
120-107-161 White body material,truncated end of black and green striped cylinder E.1750,Middle Kingdom,Abydos,tomb E30	0.00	87.3	1.72	0.00	5.94	0.10	0.05	0.16	0.44	0.00	0.01	0.43	0.03	0.00	0.00	0.00	0.00	0.00	0.00	3.8
120-107-161 Remains of green stripe bordered by black,cylinder E.1750,Middle Kingdom,Abydos,tomb E30	0.00	85.0	0.55	0.32	3.02	0.01	0.00	0.08	0.12	0.00	0.00	7.19	0.01	0.00	0.00	0.00	0.01	0.01	0.03	3.6
120-107-161 Black stripe on green cylinder E.1750,Middle Kingdom,Abydos,tomb E30	0.00	69.4	0.35	0.00	10.45	0.00	0.00	5.52	0.18	0.01	0.00	8.98	0.03	0.00	0.00	0.00	0.01	0.02	0.02	5.0
120-107-162 Blue stripe bordered by black,long tapered tubular bead E.1751,Middle Kingdom,Abydos,tomb E30	0.11	82.6	0.16	0.00	2.57	0.00	0.02	0.00	0.09	0.02	0.00	7.41	0.00	0.00	0.00	0.00	0.00	0.01	0.00	7.0
120-107-162 Black stripe on blue tapered tubular bead E.1751,Middle Kingdom,Abydos,tomb E30	0.26	82.2	0.16	0.45	1.41	0.00	0.00	2.84	0.04	0.00	0.00	6.88	0.00	0.00	0.00	0.00	0.00	0.00	0.00	5.8
120-107-163 Green tubular bead E.E.633A,Middle Kingdom,Abydos,tomb 416	0.00	91.1	0.00	0.48	0.65	0.07	0.07	0.01	0.18	0.01	0.01	3.44	0.03	0.00	0.00	0.00	0.00	0.01	0.00	4.0

X-RAY FLUORESCENCE ANALYSES OF INDIVIDUAL OBJECTS ARRANGED CHRONOLOGICALLY

Chloride and oxides of:

Sample	Description	Si	S	K	Ca	Ti	V	Cr	Mn	Fe	Co	Ni	Cu	Zn	As	Pb	Sr	Sn	Sb	Ba	Other
120-107-164	Green drop bead E.E.633B, Middle Kingdom, Abydos, tomb 416	0.02	88.3	0.00	0.32	1.36	0.00	0.01	0.06	0.25	0.01	0.01	4.50	0.00	0.00	0.00	0.00	0.00	0.01	0.01	5.1
120-107-165	Black tubular bead E.E.633C, Middle Kingdom, Abydos, tomb 416	0.16	88.1	0.00	1.20	0.22	0.00	0.00	0.87	0.07	0.01	0.00	6.02	0.00	0.00	0.00	0.00	0.00	0.01	0.00	3.3
120-107-166	Brown body material, truncated end of black tubular bead E.E.633D, Middle Kingdom, Abydos, tomb 416	0.00	83.4	0.36	0.35	0.91	0.09	0.05	3.26	0.80	0.00	0.00	0.42	0.02	0.00	0.00	0.00	0.00	0.00	0.01	3.3
120-107-166	Black tubular bead E.E.633D, Middle Kingdom, Abydos, tomb 416	0.34	85.0	0.17	0.66	0.49	0.09	0.00	3.26	0.58	0.00	0.00	4.09	0.00	0.00	0.00	0.00	0.00	0.00	0.06	10.3
120-107-168	White body material, fragment of a white object E.3303, Middle Kingdom, Abydos, tomb 416	0.00	96.9	0.20	0.08	0.25	0.03	0.12	0.11	0.12	0.02	0.03	0.00	0.07	0.00	0.00	0.00	0.00	0.00	0.00	5.3
120-107-168	Bright white exterior of fragment of object E.3303, Middle Kingdom, Abydos, tomb 416	0.56	93.8	0.00	0.00	2.34	0.00	0.00	0.06	0.12	0.00	0.00	0.13	0.03	0.00	0.00	0.00	0.00	0.00	0.00	2.0
120-107-169	White body material, fragment of white vase E.3304Q, Middle Kingdom, Abydos, tomb 416	0.07	96.9	0.05	0.10	0.26	0.02	0.10	0.08	0.11	0.02	0.03	0.00	0.05	0.00	0.00	0.00	0.00	0.00	0.00	2.8
120-107-169	Bright white vase fragment E.3304Q, Middle Kingdom, Abydos, tomb 416	0.29	94.8	0.03	0.14	0.68	0.04	0.05	0.05	0.11	0.00	0.00	0.08	0.03	0.00	0.09	0.00	0.00	0.00	0.00	2.1
120-107-170	Bluish body material, fragment of a blue dwarf statuette E.3287, Middle Kingdom, Abydos, tomb 416	0.03	92.8	0.04	0.30	2.65	0.05	0.08	0.10	0.42	0.00	0.00	0.57	0.02	0.00	0.14	0.00	0.00	0.00	0.00	3.5
120-107-170	Another area of the exposed bluish body material of dwarf statuette E.3287, Middle Kingdom, Abydos, tomb 416	0.17	90.4	0.37	0.80	2.49	0.06	0.01	0.03	0.38	0.00	0.00	0.60	0.02	0.00	0.00	0.00	0.00	0.00	0.00	2.9
120-107-170	Right thigh of blue dwarf statuette E.3287, Middle Kingdom, Abydos, tomb 416	0.00	84.7	0.00	0.46	2.72	0.03	0.00	0.00	0.25	0.01	0.00	5.28	0.01	0.00	0.01	0.00	0.03	0.01	0.00	4.6
120-107-170	Black stripe on blue pedestal of dwarf statuette E.3287, Middle Kingdom, Abydos, tomb 416	0.63	82.1	0.12	1.96	2.80	0.00	0.00	1.34	0.42	0.02	0.00	6.51	0.00	0.00	0.00	0.00	0.00	0.00	0.09	6.5
120-107-171	Bluish body material, fragment of blue model leopard E.3302F, Middle Kingdom, Abydos, tomb 416	0.00	92.6	0.12	0.22	3.22	0.09	0.07	0.11	0.43	0.01	0.02	0.31	0.02	0.00	0.00	0.00	0.00	0.00	0.00	4.0
120-107-171	Blue fragment of model leopard E.3302F, Middle Kingdom, Abydos, tomb 416	0.52	84.1	0.00	0.85	3.69	0.00	0.00	0.25	0.07	0.00	0.00	6.51	0.01	0.00	0.00	0.00	0.03	0.01	0.00	2.8
120-107-172	White body material, speckled with black, fragment of black model grapes E.3289, Middle Kingdom, Abydos, tomb 416	0.00	93.7	0.25	0.73	1.08	0.11	0.07	0.25	0.47	0.00	0.00	0.13	0.01	0.00	0.00	0.00	0.00	0.01	0.00	4.2
120-107-172	Another area of white body material, speckled with black, fragment of model grapes E.3289, Middle Kingdom, Abydos, tomb 415	0.00	94.0	0.46	0.47	0.91	0.02	0.01	0.11	0.24	0.00	0.05	0.14	0.01	0.00	0.00	0.00	0.00	0.00	0.00	3.1
120-107-172	Another area of white body material, speckled with black, fragment of model grapes E.3289, Middle Kingdom, Abydos, tomb 415	0.05	94.0	0.27	0.39	0.70	0.02	0.01	0.13	0.20	0.00	0.00	0.18	0.03	0.00	0.00	0.00	0.00	0.00	0.00	3.5
120-107-172	Thick black unglazed intermediate layer, fragment of model grapes E.3289, Middle Kingdom, Abydos, tomb 416	0.16	85.7	0.25	0.77	1.41	0.05	0.10	4.61	0.22	0.00	0.00	0.25	0.00	0.00	0.00	0.00	0.00	0.00	0.02	4.1
120-107-172	Black outer layer of a model bunch of grapes E.3289, Middle Kingdom, Abydos, tomb 416	0.00	87.1	0.03	1.61	1.18	0.04	0.03	1.77	0.09	0.00	0.00	3.66	0.01	0.00	0.00	0.00	0.00	0.00	0.01	4.4

X-RAY FLUORESCENCE ANALYSES OF INDIVIDUAL OBJECTS ARRANGED CHRONOLOGICALLY

Chloride and oxides of:

Sample	Description	Cl	Si	S	K	Ca	Ti	V	Cr	Mn	Fe	Co	Ni	Cu	Zn	As	Pb	Sr	Sn	Sb	Ba	Other
120-107-173	Grey body material, fragment of blue vase E.3305, Middle Kingdom, Abydos, tomb 416	0.02	91.2	0.14	0.67	2.97	0.32	0.04	0.01	0.26	0.96	0.00	0.00	0.50	0.02	0.00	0.00	0.00	0.00	0.00	0.00	2.9
120-107-173	Blue fragment of vase E.3305, Middle Kingdom, Abydos, tomb 416	0.14	88.7	0.00	0.88	1.46	0.03	0.01	0.00	0.04	0.12	0.00	0.00	4.50	0.00	0.00	0.00	0.00	0.00	0.01	0.01	4.1
120-107-174	Grey body material, fragment of brown vase E.3306, Middle Kingdom, Abydos, tomb 416	0.00	96.1	0.10	0.00	0.19	0.05	0.07	0.00	1.17	0.25	0.02	0.01	0.00	0.00	0.00	0.00	0.00	0.00	0.00	0.00	2.0
120-107-174	Brown fragment of vase E.3306, Middle Kingdom, Abydos, tomb 416	0.48	85.9	0.00	2.34	0.00	0.00	0.00	0.00	1.80	0.32	0.00	0.00	0.18	0.16	0.00	0.00	0.00	0.00	0.01	0.00	8.8
120-107-175	Grey body material, fragment of blue pedestal E.3285, Middle Kingdom, Abydos, tomb 416	0.00	94.2	0.19	0.23	1.30	0.07	0.07	0.00	0.30	0.64	0.00	0.00	0.22	0.01	0.00	0.00	0.00	0.00	0.00	0.00	2.8
120-107-175	Dark blue upper surface of pedestal fragment E.3285, Middle Kingdom, Abydos, tomb 416	0.00	89.6	0.00	0.66	0.78	0.05	0.07	0.01	0.01	0.07	0.00	0.00	4.40	0.00	0.00	0.00	0.00	0.00	0.01	0.02	4.3
120-107-175	Black band along the edge of blue pedestal fragment E.3285, Middle Kingdom, Abydos, tomb 416	0.09	85.7	0.00	2.97	0.87	0.00	0.00	0.00	1.80	0.37	0.00	0.00	5.15	0.00	0.00	0.00	0.00	0.02	0.02	0.02	3.0
120-107-176	Grey body material, fragment of blue model leopard E.3281, Middle Kingdom, Abydos, tomb 416	0.00	94.9	0.00	1.17	1.23	0.08	0.14	0.00	0.28	0.57	0.00	0.00	0.59	0.02	0.00	0.00	0.00	0.00	0.00	0.01	1.0
120-107-176	Dark blue fragmentary model leopard E.3281, Middle Kingdom, Abydos, tomb 416	0.34	81.2	0.00	3.31	1.14	0.00	0.00	0.07	0.09	0.00	0.00	0.00	10.10	0.00	0.00	0.00	0.00	0.02	0.02	0.00	3.7
120-107-177	White body material, end-piece of partly restored blue bowl E.3288, Middle Kingdom, Abydos, tomb 416	0.00	94.1	0.21	0.15	1.72	0.11	0.04	0.00	0.08	0.45	0.00	0.02	0.12	0.03	0.00	0.00	0.00	0.00	0.00	0.00	3.0
120-107-177	Blue-green central piece of partly restored bowl E.3288, Middle Kingdom, Abydos, tomb 416	0.28	88.1	0.12	0.00	3.68	0.00	0.00	0.00	0.21	0.01	0.00	0.00	2.52	0.00	0.13	0.01	0.00	0.00	0.00	0.00	5.0
120-107-177	Pale blue end-piece of partly restored bowl E.3288, Middle Kingdom, Abydos, tomb 416	0.28	89.6	0.10	0.00	2.43	0.00	0.00	0.00	0.00	0.18	0.01	0.00	2.34	0.01	0.00	0.00	0.00	0.14	0.01	0.01	4.8
120-107-178	Bluish body material, fragment of blue model leopard E.3286, Middle Kingdom, Abydos, tomb 416	0.00	93.0	0.12	0.67	1.44	0.11	0.03	0.00	0.00	0.63	0.00	0.00	0.42	0.01	0.00	0.00	0.00	0.00	0.00	0.00	3.5
120-107-178	Dark blue fragment of model leopard E.3286, Middle Kingdom, Abydos, tomb 416	0.29	81.0	0.00	3.67	0.86	0.00	0.00	0.00	0.00	0.14	0.00	0.00	10.58	0.00	0.00	0.32	0.00	0.00	0.00	0.00	3.2
120-107-178	Black spot on blue fragment of model leopard E.3288, Middle Kingdom, Abydos, tomb 416	0.28	79.5	0.17	3.06	1.07	0.00	0.00	0.00	0.94	0.11	0.00	0.00	11.45	0.01	0.00	0.33	0.00	0.00	0.00	0.00	3.0
120-107-179	Grey body material, fragment of blue vase E.3278, Middle Kingdom, Abydos, tomb 416	0.00	91.8	0.00	0.42	3.19	0.14	0.06	0.00	0.18	0.68	0.00	0.00	0.25	0.02	0.00	0.00	0.00	0.00	0.00	0.00	3.2
120-107-179	Dark blue vase fragment E.3278, Middle Kingdom, Abydos, tomb 416	0.37	86.4	0.17	0.00	1.00	0.00	0.00	0.00	0.00	0.11	0.00	0.00	6.97	0.00	0.00	0.00	0.00	0.00	0.01	0.00	4.9
120-107-179	Black lotus design on fragment of blue vase E.3278, Middle Kingdom, Abydos, tomb 416	0.00	81.4	0.00	3.08	0.90	0.00	0.00	0.00	3.32	0.00	0.00	0.00	7.82	0.00	0.00	0.06	0.00	0.00	0.00	0.00	3.4
120-107-180	Brownish body material, fragment of blue vase E.3279, Middle Kingdom, Abydos, tomb 416	0.00	91.1	0.46	0.95	2.80	0.06	0.03	0.00	0.12	0.59	0.00	0.00	0.26	0.02	0.00	0.00	0.00	0.00	0.00	0.00	3.6

X-RAY FLUORESCENCE ANALYSES OF INDIVIDUAL OBJECTS ARRANGED CHRONOLOGICALLY

Chloride and oxides of:

Sample / description	Si	S	K	Ca	Ti	V	Cr	Mn	Fe	Co	Ni	Cu	Zn	As	Pb	Sr	Sn	Sb	Ba	Other
120-107-180 Thin white intermediate layer, fragment of blue vase E.3279, Middle Kingdom, Abydos, tomb 416	0.00	91.1	0.12	0.30	3.94	0.06	0.05	0.00	0.31	0.50	0.00	0.00	0.47	0.03	0.00	0.00	0.00	0.00	0.00	3.1
120-107-180 Right side of pale blue exterior of vase fragment E.3279, Middle Kingdom, Abydos, tomb 416	0.27	85.6	0.15	0.30	2.43	0.01	0.02	0.00	0.00	0.07	0.00	0.00	4.40	0.00	0.00	0.01	0.02	0.01		6.7
120-107-180 Left side of pale blue exterior of fragment of vase E.3279, Middle Kingdom, Abydos, tomb 416	0.50	87.9	0.13	0.49	2.39	0.02	0.00	0.00	0.14	0.00	0.00	3.65	0.04	0.01	0.01	0.02	0.00	0.01	0.01	4.6
120-107-180 Black lotus design on blue fragment of vase E.3279, Middle Kingdom, Abydos, tomb 416	0.00	82.2	0.00	0.00	3.38	0.00	0.00	0.00	3.46	0.03	0.00	4.43	0.01	0.00	0.00	0.02	0.03	0.01		5.4
120-107-181 White body material, fragment of blue plaque E.3282, Middle Kingdom, Abydos, tomb 416	0.00	94.5	0.25	0.00	1.20	0.07	0.07	0.00	0.10	0.35	0.01	0.02	0.20	0.02	0.00	0.00	0.00	0.00		3.2
120-107-181 Pale blue flat face of plaque fragment E.3282, Middle Kingdom, Abydos, tomb 416	0.20	87.8	0.13	0.29	1.60	0.03	0.06	0.01	0.06	0.09	0.01	0.00	3.30	0.00	0.00	0.02	0.03	0.01		6.4
120-107-181 Blue area in front of a leg in relief, fragment of plaque E.3282, Middle Kingdom, Abydos, tomb 416	0.61	90.9	0.22	0.41	1.48	0.02	0.00	0.00	0.02	0.10	0.00	0.00	2.98	0.09	0.00	0.01	0.02	0.03	0.02	3.1
120-107-182 Black band along the blue edge of plaque fragment E.3282, Middle Kingdom, Abydos, tomb 416	0.24	88.9	0.00	0.50	1.31	0.03	0.02	0.00	2.44	0.01	0.00	0.00	3.56	0.00	0.00	0.00	0.05	0.04		2.9
120-107-182 Brown body material, truncated blue tapered tubular bead E.E.486A, Middle Kingdom, Abydos	0.00	92.6	0.27	1.03	2.01	0.16	0.03	0.00	0.15	0.56	0.01	0.00	0.34	0.01	0.00	0.00	0.00	0.00		2.8
120-107-182 Dark blue stripe bordered by black, tapered tubular bead E.E.486A, Middle Kingdom, Abydos	0.16	80.8	0.00	5.29	1.52	0.00	0.00	0.00	0.06	0.19	0.02	0.00	8.47	0.09	0.00	0.00	0.00	0.00		3.4
120-107-183 Black stripe on blue tapered tubular bead E.E.486A, Middle Kingdom, Abydos	0.33	80.7	0.00	4.40	0.92	0.00	0.00	1.38	0.20	0.01	0.00	7.42	0.08	0.00	0.00	0.00	0.00			4.6
120-107-183 Green stripe bordered by black, elongated drop bead E.E.486B, Middle Kingdom, Abydos	0.31	89.1	0.24	0.00	1.27	0.07	0.02	0.00	0.10	0.34	0.02	0.00	3.97	0.05	0.00	0.00	0.00	0.00		4.3
120-107-184 Black stripe on green drop bead E.E.486B, Middle Kingdom, Abydos	0.00	84.8	0.21	1.25	1.23	0.08	0.00	3.28	0.53	0.00	0.00	0.00	4.49	0.05	0.03	0.04	0.00	0.00	0.11	3.9
120-107-184 Grey body material, chipped corner of green pedestal of Harpocrates statuette E.2199, Middle Kingdom, Abydos, tomb E303	0.00	93.0	0.33	0.60	2.30	0.11	0.07	0.00	0.71	0.00	0.00	0.10	0.00	0.00	0.00	0.00	0.00	0.00		2.7
120-107-184 Green left shoulder of Harpocrates statuette E.2199, Middle Kingdom, Abydos, tomb E303	0.23	88.5	0.00	0.62	1.09	0.00	0.00	0.00	0.12	0.00	0.00	4.06	0.00	0.00	0.00	0.00	0.00	0.00		5.4
120-107-185 Black hair of green Harpocrates statuette E.2199, Middle Kingdom, Abydos, tomb E303	0.48	78.3	0.29	2.11	1.64	0.20	0.03	0.00	4.85	0.16	0.01	0.00	7.93	0.00	0.00	0.11	0.00	0.00	0.00	3.9
120-107-185 Brown body material, chipped lip of black and blue cylinder vase E.2176, Middle Kingdom, Abydos, tomb E3	0.00	93.0	0.54	0.18	1.21	0.07	0.12	0.00	0.19	0.43	0.00	0.02	0.36	0.42	0.00	0.00	0.00	0.00		3.5
120-107-185 Dark blue streak bordered by black, side of cylinder vase E.2176, Middle Kingdom, Abydos, tomb E3	0.00	87.4	0.12	0.56	2.51	0.02	0.00	0.03	0.19	0.19	0.00	0.00	4.52	0.00	0.00	0.00	0.01	0.03	0.07	4.4
120-107-185 Dark blue streak bordered by black, lip of cylinder vase E.2176, Middle Kingdom, Abydos, tomb E3	0.84	87.8	0.22	0.89	2.22	0.00	0.00	0.01	0.06	0.13	0.00	0.00	4.76	0.06	0.00	0.04	0.02	0.01	0.03	2.9

X-RAY FLUORESCENCE ANALYSIS OF INDIVIDUAL OBJECTS ARRANGED CHRONOLOGICALLY

Chloride and oxides of:

No. / Description	Si	S	K	Ca	Ti	V	Cr	Mn	Fe	Co	Ni	Cu	Zn	As	Pb	Sr	Sn	Sb	Ba	Other
120-107-185 Black streak bordered by blue, side of cylinder vase E.2176, Middle Kingdom, Abydos, tomb E3	0.00	86.6	0.33	2.13	1.08	0.00	0.07	0.00	2.36	0.08	0.00	4.60	0.00	0.00	0.00	0.00	0.01	0.02	0.04	2.6
120-107-186 Dark olive green model lion E.2183, Middle Kingdom, Abydos, tomb E3	0.00	82.9	0.18	5.17	2.21	0.06	0.00	0.00	1.07	0.00	0.00	4.47	0.04	0.00	0.00	0.00	0.00	0.01	0.03	3.8
120-107-186 Red brown area on the left flank of olive green model lion E.2183, Middle Kingdom, Abydos, tomb E3	0.00	89.8	0.19	0.49	3.59	0.13	0.00	0.09	1.36	0.00	0.00	1.46	0.05	0.00	0.00	0.00	0.00	0.00	0.01	2.8
120-107-187 Grey body material, fragment of blue staff-head E.2172, Middle Kingdom, Abydos, tomb E3	0.00	94.5	0.28	0.75	1.18	0.05	0.18	0.14	0.22	0.00	0.01	0.46	0.01	0.00	0.00	0.00	0.00	0.01	0.01	2.2
120-107-187 Remains of dark blue glaze, staff-head fragment E.2172, Middle Kingdom, Abydos, tomb E3	0.44	81.1	0.22	6.27	2.35	0.00	0.00	0.08	0.17	0.01	0.00	10.79	0.02	0.00	0.00	0.07	0.02	0.03	0.01	-1.4
120-107-188 Black decoration on blue staff-head fragment E.2172, Middle Kingdom, Abydos, tomb E3	0.40	77.9	0.24	3.19	3.14	0.00	0.00	0.46	0.17	0.00	0.00	10.10	0.05	0.00	0.00	0.07	0.02	0.03	0.01	4.2
120-107-188 White body material, large hole at the bottom of green kohl pot E.2160, Middle Kingdom, Abydos, tomb E3	0.00	92.2	0.17	0.31	3.79	0.00	0.00	0.26	0.38	0.00	0.01	0.53	0.01	0.00	0.00	0.00	0.00	0.00	0.00	2.2
120-107-188 Remains of blue-green glaze at the bottom of kohl pot E.2160, Middle Kingdom, Abydos, tomb E3	0.00	87.7	0.23	0.47	2.53	0.00	0.00	0.08	0.30	0.00	0.00	2.18	0.00	0.00	0.00	0.00	0.00	0.03	0.04	6.4
120-107-746 Large green ball bead E.E.478A, Middle Kingdom, Abydos, tomb E3	1.11	89.9	0.10	0.41	1.40	0.02	0.00	0.01	0.26	0.00	0.00	3.74	0.00	0.00	0.02	0.02	0.00	0.00	0.00	3.0
120-107-747 Large green ball bead E.E.478B, Middle Kingdom, Abydos, tomb E3	0.90	90.4	0.10	0.33	1.26	0.03	0.00	0.01	0.21	0.00	0.00	2.92	0.03	0.00	0.02	0.00	0.00	0.00	0.00	3.8
120-107-748 Large green ball bead E.E.478C, Middle Kingdom, Abydos, tomb E3	0.84	90.3	0.07	0.39	0.69	0.02	0.00	0.00	0.15	0.00	0.00	3.00	0.00	0.00	0.02	0.00	0.01	0.03	0.00	4.5
120-107-750 Large blue ball bead E.E.480A, Middle Kingdom, Abydos, tomb E3	0.72	87.7	0.09	0.75	1.94	0.00	0.00	0.02	0.11	0.00	0.00	4.58	0.04	0.00	0.00	0.02	0.00	0.00	0.00	4.1
120-107-751 Large blue-green ball bead E.E.480B, Middle Kingdom, Abydos, tomb E3	0.61	89.0	0.03	0.33	0.86	0.00	0.00	0.00	0.09	0.00	0.00	5.16	0.04	0.00	0.01	0.01	0.00	0.00	0.00	3.8
120-107-752 Large green ball bead E.E.480C, Middle Kingdom, Abydos, tomb E3	0.43	87.7	0.56	1.46	0.63	0.01	0.00	0.00	0.12	0.00	0.00	4.23	0.11	0.00	0.02	0.01	0.00	0.00	0.00	4.7
120-107-754 Blue-green melon bead E.E.481A, Middle Kingdom, Abydos, tomb E3	0.48	89.0	0.25	1.25	1.61	0.04	0.00	0.01	0.19	0.00	0.00	3.16	0.05	0.00	0.01	0.03	0.01	0.03	0.00	4.0
120-107-755 Green melon bead E.E.481B, Middle Kingdom, Abydos, tomb E3	0.77	89.1	0.25	0.61	3.15	0.11	0.00	0.01	0.21	0.00	0.00	2.54	0.06	0.00	0.02	0.01	0.00	0.01	0.00	3.1
120-110-189 White body material, damaged corner of green necklace terminal E.1785, Middle Kingdom, Hu, grave Y176	0.00	96.0	0.28	0.00	0.66	0.08	0.10	0.08	0.19	0.01	0.00	0.13	0.00	0.00	0.00	0.00	0.00	0.00	0.00	2.5
120-110-189 Green rectangular necklace terminal E.1785, Middle Kingdom, Hu, grave Y176	0.00	89.7	0.94	0.00	1.17	0.07	0.09	0.11	0.39	0.00	0.00	3.21	0.01	0.00	0.00	0.00	0.00	0.04	0.00	4.2
120-110-598 Shiny deep blue cowroid E.E.164A, Middle Kingdom, Hu, grave Y52	0.37	84.4	0.06	1.72	2.52	0.08	0.00	0.25	0.34	0.00	0.00	6.48	0.03	0.00	0.00	0.00	0.00	0.00	0.00	3.7

X-RAY FLUORESCENCE ANALYSES OF INDIVIDUAL OBJECTS ARRANGED CHRONOLOGICALLY

Chloride and oxides of:

Object	Si	S	K	Ca	Ti	V	Cr	Mn	Fe	Co	Ni	Cu	Zn	As	Pb	Sr	Sn	Sb	Ba	Other
120-110-599 Dark blue-grey ball bead E.E.164B, Middle Kingdom, Hu, grave Y52	0.13	77.7	0.19	0.55	11.56	0.07	0.01	0.00	0.34	0.00	0.01	4.52	0.02	0.02	0.00	0.04	0.00	0.00	0.00	4.8
120-118-191 Flat black face of oval boss 1910.671H, Middle Kingdom, Dra Abu el Naga(Thebes)	0.39	82.3	0.00	3.22	0.69	0.00	0.00	3.35	0.00	0.00	0.00	5.51	0.00	0.00	0.00	0.00	0.00	0.00	0.44	4.0
120-200-197 White body material, hole in green ring stand 1971.950, Middle Kingdom, provenance unknown	0.00	94.5	0.14	0.52	0.33	0.07	0.07	0.00	0.87	0.00	0.00	0.34	0.00	0.00	0.09	0.00	0.00	0.00	0.00	3.1
120-200-197 Green inscribed ring stand 1971.950, Middle Kingdom, provenance unknown	0.62	87.6	0.00	0.60	0.71	0.06	0.00	0.01	0.09	0.00	0.00	6.45	0.00	0.03	0.15	0.00	0.02	0.01	0.03	3.6
121-133-198 Brown body material, chipped surface of green bracelet E.3789, Dyn. XII, el Kab, grave 1	0.00	88.5	0.79	0.00	5.81	0.00	0.00	0.00	0.44	0.00	0.00	0.40	0.03	0.00	0.19	0.01	0.00	0.00	0.00	3.7
121-133-198 Blue-green bracelet E.3789, Dyn. XII, el Kab, grave 1	0.00	81.3	1.53	0.00	3.96	0.00	0.00	0.02	0.10	0.01	0.00	3.61	0.00	0.00	4.35	0.02	0.00	0.09	0.00	5.0
121-133-199 Remains of green glaze, model cucumber E.3790, Dyn. XII, el Kab, grave 1	0.00	89.6	0.85	0.00	1.25	0.00	0.00	0.05	0.15	0.01	0.00	3.75	0.00	0.00	0.17	0.00	0.00	0.00	0.00	4.2
121-133-200 White body material, hole in forehead of green mummiform statuette E.3788, Dyn. XII, el Kab, grave 1	0.00	89.2	0.56	0.31	6.06	0.16	0.00	0.09	0.65	0.01	0.00	0.22	0.01	0.00	0.00	0.00	0.00	0.00	0.00	2.8
121-133-200 Pale green forehead of mummiform statuette E.3788, Dyn. XII, el Kab, grave 1	0.20	88.1	0.27	0.00	2.70	0.00	0.03	0.01	0.06	0.01	0.00	3.08	0.00	0.00	0.00	0.01	0.01	0.01	0.00	5.5
121-133-200 Black hair on the head of green mummiform statuette E.3788, Dyn. XII, el Kab, grave 1	0.25	73.6	0.33	0.48	3.27	0.15	0.00	8.15	0.30	0.01	0.00	2.47	0.01	0.00	0.04	0.00	0.01	0.16	0.00	10.7
122-133-201 Dark blue ball bead E.E.124C, Middle Kingdom, el Kab, grave 24	0.33	87.4	0.00	0.00	1.22	0.00	0.00	0.00	0.29	0.00	0.00	5.74	0.00	0.00	0.00	0.01	0.01	0.00	0.00	4.7
122-133-602 Dark blue ball bead E.E.124A, Middle Kingdom, el Kab, grave 24	0.29	86.8	0.02	0.12	1.31	0.05	0.04	0.02	0.09	0.00	0.00	6.55	0.00	0.00	0.00	0.00	0.00	0.00	0.00	4.7
122-133-637 Dark blue ball bead E.E.124B, Middle Kingdom, el Kab, grave 24	0.33	84.9	0.04	0.02	1.15	0.00	0.00	0.03	0.07	0.00	0.00	7.07	0.00	0.00	0.00	0.00	0.00	0.00	0.00	6.4
123-133-202 Large black-bodied black biconical bead E.E.125B, Dyn. XII, el Kab, grave 36	0.00	82.1	0.00	0.41	3.58	0.08	0.00	2.03	0.13	0.00	0.00	6.27	0.00	0.00	0.00	0.01	0.00	0.17	0.00	5.2
123-133-210 Green ball bead E.E.125A, Dyn. XII, el Kab, grave 36	0.32	88.5	0.24	0.30	1.34	0.03	0.02	0.09	0.19	0.01	0.00	3.02	0.03	0.00	0.12	0.00	0.00	0.00	0.00	5.8
123-133-211 Blue-green bead E.E.125C, Dyn. XII, el Kab, grave 36	0.42	89.4	0.22	0.10	0.83	0.02	0.00	0.05	1.07	0.00	0.00	3.63	0.01	0.01	0.15	0.00	0.00	0.00	0.00	4.1
123-133-756 Small green lozenge bead E.E.125D, Dyn. XII, el Kab, grave 36	0.37	90.4	0.09	0.22	1.03	0.00	0.00	0.00	0.07	0.00	0.00	3.09	0.00	0.00	0.00	0.00	0.01	0.00	0.00	4.7
123-133-757 small black ball bead E.E.125F, Dyn. XII, el Kab, grave 36	0.06	58.11	0.27	0.77	2.74	0.64	0.00	0.03	3.24	0.03	0.00	0.01	0.01	0.00	0.00	0.01	0.00	0.00	0.00	34.1
123-133-758 small black ball bead E.E.125E, Dyn. XII, el Kab, grave 36	0.34	75.3	0.22	1.15	3.21	0.73	0.00	0.01	0.82	4.02	0.00	2.38	0.00	0.00	0.05	0.02	0.00	0.00	0.15	11.6

X-RAY FLUORESCENCE ANALYSES OF INDIVIDUAL OBJECTS ARRANGED CHRONOLOGICALLY

Chloride and oxides of:

Object	Si	S	K	Ca	Ti	V	Cr	Mn	Fe	Co	Ni	Cu	Zn	As	Pb	Sr	Sn	Sb	Ba	Other
124-133-212 Blue-green ball bead E.E.131C, Dyn. XII, el Kab, grave 42	0.41	88.0	0.00	1.07	0.82	0.00	0.08	0.07	0.11	0.00	0.00	4.09	0.03	0.00	0.00	0.00	0.00	0.00	0.00	5.3
124-133-600 Pale blue-green ball bead E.E.131D, Dyn. XII, el Kab, grave 42	0.14	82.5	0.23	1.47	5.11	0.10	0.01	0.02	2.09	0.00	0.00	4.55	0.06	0.00	0.00	0.06	0.00	0.00	0.00	3.7
124-133-601 Pale olive-green ball bead E.E.131B, Dyn. XII, el Kab, grave 42	0.00	86.5	0.91	0.01	4.82	0.04	0.06	0.10	0.30	0.00	0.00	3.20	0.08	0.00	0.00	0.00	0.00	0.01	0.00	3.9
124-133-603 Blue-green side of ball bead E.E.131A, Dyn. XII, el Kab, grave 42	0.03	80.3	0.31	1.50	4.48	0.11	0.00	0.02	2.15	0.01	0.00	5.77	0.06	0.00	0.00	0.05	0.00	0.00	0.00	5.2
124-133-604 Small pale green bead E.E.106A, Dyn. XII, el Kab, grave 42	0.06	92.0	0.18	1.30	0.11	0.00	0.00	0.03	0.37	0.00	0.00	1.73	0.12	0.00	0.00	0.00	0.02	0.03	0.00	4.0
124-133-605 Very small pale green bead, E.E.106B, Dyn. XII, el Kab, grave 42	0.79	90.8	0.47	0.42	0.08	0.00	0.00	0.02	0.11	0.00	0.00	4.23	0.08	0.00	0.06	0.00	0.03	0.04	0.00	2.9
125-133-203 Small pale green bead E.E.133, Dyn. XII, el Kab, grave 60	0.64	79.5	0.96	0.48	3.34	0.00	0.00	0.00	0.34	0.00	0.00	11.51	0.00	0.00	0.00	0.00	0.00	0.00	0.00	3.2
125-133-204 White body material, chipped lip of green kohl jar E.2150A, Dyn. XII, el Kab, grave 60	0.00	94.2	0.68	0.00	0.50	0.08	0.09	0.00	0.40	0.00	0.00	0.60	0.01	0.00	0.49	0.00	0.00	0.00	0.00	2.6
125-133-204 Remains of pale green glaze near the mouth of kohl jar E.2150A, Dyn. XII, el Kab, grave 60	0.00	87.1	1.49	0.22	1.50	0.00	0.05	0.24	0.40	0.00	0.00	2.17	0.00	0.14	1.03	0.00	0.00	0.00	0.00	5.8
125-133-204 Remains of green glaze on the side of kohl jar E.2150A, Dyn. XII, el Kab, grave 60	0.22	79.4	1.06	0.43	6.35	0.15	0.00	0.37	0.56	0.00	0.00	5.59	0.17	0.00	0.36	0.01	0.00	0.02	0.00	5.3
125-133-759 White body material, broken edge of green jar-lid fragment E.2150B, Dyn. XII, el Kab, grave 60	0.00	95.8	0.63	0.00	0.41	0.00	0.00	0.03	0.12	0.00	0.00	0.30	0.02	0.00	0.00	0.00	0.00	0.00	0.00	2.7
125-133-759 Remains of green glaze, knob on top of jar-lid fragment E.2150B, Dyn. XII, el Kab, grave 60	1.24	77.6	1.09	0.51	1.76	0.04	0.00	0.00	0.26	0.00	0.00	4.71	0.08	0.00	0.79	0.01	0.01	0.02	0.00	11.7
126-133-219 Remnants of red coating over white core, spherical bead E.E.169A, Dyn. XII, el Kab, grave 85	0.00	88.0	0.44	0.24	1.89	0.11	0.00	0.07	5.10	0.00	0.00	0.54	0.06	0.00	0.00	0.00	0.00	0.00	0.00	3.6
126-133-760 Olive-green fluted barrel bead E.E.169B, Dyn. XII, el Kab, grave 85	0.12	85.1	11.59	1.36	0.12	0.00	0.00	0.00	1.10	0.00	0.00	5.96	0.00	0.00	0.01	0.01	0.00	0.02	0.00	4.5
127-133-205 Remains of olive-green glaze, flat four-hole pendant E.E.138D, Dyn. XII, el Kab, grave 202	0.00	90.2	0.26	1.85	0.10	0.02	0.00	0.00	0.83	0.00	0.00	2.22	0.51	0.00	0.18	0.00	0.00	0.00	0.00	3.8
127-133-206 Remains of green glaze, X-shaped bead E.E.138A, Dyn. XII, el Kab, grave 202	0.00	86.5	0.11	2.09	0.06	0.01	0.00	0.24	2.47	0.00	0.00	1.95	0.00	0.00	0.08	0.00	0.00	0.02	0.00	6.5
127-133-207 Remains of olive-green glaze, fragment of anthropoid pendant E.E.138B, Dyn. XII, el Kab, grave 202	0.00	86.5	0.00	5.01	0.10	0.05	0.00	0.00	0.37	0.00	0.00	4.58	0.92	0.00	1.27	0.00	0.00	0.02	0.00	3.4
127-133-208 Remains of flat olive-green glaze, P-shaped pendant E.E.138C, Dyn. XII, el Kab, grave 202	0.00	84.2	1.40	4.90	0.05	0.11	0.00	0.00	0.40	0.00	0.00	2.91	0.75	0.00	0.00	0.00	0.00	0.00	0.00	5.3
127-133-209 Remains of black glaze on a flat baboon amulet, pendant E.E.138E, Dyn. XII, el Kab, grave 202	0.00	84.0	1.72	2.59	0.03	0.25	0.03	1.03	1.83	0.00	0.00	2.16	0.68	0.00	0.91	0.00	0.00	0.00	0.00	4.6

X-RAY FLUORESCENCE ANALYSES OF INDIVIDUAL OBJECTS ARRANGED CHRONOLOGICALLY

Chloride and oxides of:	Si	S	K	Ca	Ti	V	Cr	Mn	Fe	Co	Ni	Cu	Zn	As	Pb	Sr	Sn	Sb	Ba	Other
127-133-763 Black bead fragment E.E.138G,Dyn. XII,el Kab,grave 202	0.00	87.1	0.96	0.16	0.90	0.24	0.00	2.30	1.19	0.00	0.00	0.44	0.03	0.00	0.03	0.01	0.00	0.00	0.02	6.6
127-133-764 Green baboon amulet,pendant E.E.138H,Dyn. XII,el Kab,grave 202	0.00	86.7	1.01	0.00	1.75	0.19	0.00	0.06	0.80	0.00	0.00	3.07	0.06	0.00	0.00	0.01	0.00	0.02	0.00	6.4
130-56-216 Dark green scarab seal 1921.1375A,Second I.P.,Sidmant,grave 1270	0.26	83.5	0.18	0.26	2.75	0.00	0.00	0.02	0.08	0.01	0.00	6.31	0.00	0.00	0.00	0.00	0.00	0.00	0.00	6.6
130-56-217 Grey body material,chipped lip of blue vase 1921.1373,Second I.P.,Sidmant,grave 1270	0.00	94.9	0.00	0.25	2.42	0.05	0.08	0.00	0.37	0.00	0.00	0.12	0.04	0.00	0.00	0.00	0.00	0.00	0.00	1.5
130-56-217 Dark blue decorated vase 1921.1373,Second I.P.,Sidmant,grave 1270	0.20	90.2	0.00	0.45	1.54	0.03	0.07	0.01	0.05	0.01	0.00	3.90	0.00	0.00	0.00	0.00	0.00	0.03	0.00	3.5
130-76-227 Green drop bead 1930.483A,Second I.P.,Mustagidda,pan grave 3113	0.63	86.8	0.00	1.12	1.04	0.00	0.00	0.00	2.67	0.03	0.00	3.92	0.01	0.00	0.10	0.00	0.00	0.00	0.00	3.7
130-76-228 Green drop bead 1930.483B,Second I.P.,Mustagidda,pan grave 3113	0.66	86.0	0.00	0.95	0.64	0.00	0.00	0.44	0.28	0.00	0.00	5.15	0.13	0.00	0.00	0.00	0.00	0.00	0.00	5.8
130-76-229 Very small black bead 1930.504A,Second I.P.,Mustagidda,pan grave 3170	0.23	86.3	0.00	3.51	1.58	0.00	0.00	2.42	0.74	0.00	0.00	3.19	0.03	0.00	0.00	0.00	0.00	0.00	0.00	2.0
130-76-230 Very small black bead 1930.504B,Second I.P.,Mustagidda,pan grave 3170	0.30	76.7	0.33	6.25	1.34	0.05	0.00	6.30	0.60	0.00	0.00	6.45	0.06	0.00	0.00	0.01	0.00	0.00	0.00	1.6
130-76-231 Small black bead 1930.507A,Second I.P.,Mustagidda,pan grave 3170	0.91	82.2	0.00	3.77	1.64	0.00	0.00	4.01	0.52	0.00	0.00	4.99	0.05	0.00	0.00	0.00	0.01	0.01	0.00	1.8
130-76-232 Small black bead 1930.507B,Second I.P.,Mustagidda,pan grave 3170	0.32	80.9	0.04	4.77	2.22	0.00	0.00	2.11	0.30	0.00	0.00	5.47	0.01	0.00	0.00	0.00	0.00	0.01	0.00	3.8
130-76-233 Small black bead 1930.508A,Second I.P.,Mustagidda,pan grave 3170	0.41	73.8	0.00	6.13	4.60	0.07	0.00	3.22	0.33	0.01	0.00	8.37	0.01	0.00	0.00	0.00	0.00	0.00	0.00	3.0
130-76-234 White bead 1930.508B,Second I.P.,Mustagidda,pan grave 3170	0.00	93.3	0.00	1.56	1.54	0.00	0.00	0.02	0.28	0.00	0.00	0.00	0.02	0.00	0.00	0.00	0.00	0.00	0.00	3.3
130-76-235 Small blue bead 1930.508C,Second I.P.,Mustagidda,pan grave 3170	0.00	90.9	0.17	1.28	0.47	0.00	0.03	0.00	0.09	0.00	0.00	3.34	0.00	0.00	0.00	0.00	0.00	0.00	0.00	3.7
130-76-612 Blue stripe bordered by black,long tapered tubular bead 1930.513A,Second I.P.,Mustagidda,pan grave 3170	0.74	77.7	0.04	5.46	1.91	0.05	0.00	0.11	0.45	0.00	0.00	9.46	0.00	0.00	0.09	0.04	0.09	0.03	0.00	3.8
130-76-612 Black stripe on blue tapered tubular bead 1930.513A,Second I.P.,Mustagidda,pan grave 3170	0.24	62.9	0.15	3.58	1.01	0.04	0.02	9.76	0.00	0.08	0.00	6.28	0.03	0.00	0.12	0.00	0.04	0.09	0.04	15.7
130-76-613 Blue double cylinder bead 1930.513B,Second I.P.,Mustagidda,pan grave 3170	0.02	80.9	0.03	1.90	1.00	0.00	0.01	0.01	0.18	0.01	0.00	4.05	0.04	0.00	0.02	0.00	0.00	0.00	0.00	11.8
130-76-638 Blue cylinder bead 1930.513C,Second I.P.,Mustagidda,pan grave 3170	0.31	81.3	0.07	1.83	0.71	0.05	0.00	0.02	0.15	0.00	0.00	4.25	0.03	0.00	0.00	0.00	0.00	0.00	0.00	11.3
131-76-225 Very small dark green bead 1930.468A,Second I.P.,Mustagidda,pan grave 3117	0.00	87.2	0.27	1.50	0.92	0.16	0.00	0.00	0.13	0.01	0.00	5.36	0.08	0.00	0.00	0.00	0.00	0.00	0.00	4.4

X-RAY FLUORESCENCE ANALYSES OF INDIVIDUAL OBJECTS ARRANGED CHRONOLOGICALLY

Chloride and oxides of:

Sample	Si	S	K	Ca	Ti	V	Cr	Mn	Fe	Co	Ni	Cu	Zn	As	Pb	Sr	Sn	Sb	Ba	Other
131- 76-226 Very small blue bead 1930.468B,Second I.P.,Mustagidda,pan grave 3117	0.00	89.3	0.00	1.69	1.31	0.06	0.00	0.00	0.03	1.23	0.00	3.88	0.00	0.00	0.00	0.00	0.01	0.00	0.00	2.5
131- 76-614 Small dark blue bead 1930.468C,Second I.P.,Mustagidda,pan grave 3117	0.00	85.6	0.14	1.13	1.29	0.03	0.08	0.00	0.00	0.26	0.01	3.90	0.07	0.00	0.01	0.00	0.00	0.00	0.00	7.4
131- 76-615 Small dark blue bead 1930.468D,Second I.P.,Mustagidda,pan grave 3117	0.20	86.6	0.18	1.46	1.67	0.08	0.03	0.01	0.03	0.39	0.00	3.51	0.05	0.00	0.00	0.00	0.00	0.00	0.00	5.8
131- 78-236 Grey body material,truncated end of green tubular bead 1925.493A,Second I.P.,Badari,pan grave 5478	0.00	94.8	0.21	0.30	1.75	0.06	0.09	0.00	0.08	0.24	0.00	0.18	0.00	0.00	0.00	0.00	0.00	0.00	0.00	2.3
131- 78-236 Green tubular bead fragment 1925.493A,Second I.P.,Badari,pan grave 5478	0.35	86.2	1.20	1.82	0.00	0.06	0.00	0.02	0.14	0.00	0.00	4.58	0.00	0.00	0.19	0.00	0.00	0.00	0.00	5.4
131- 78-237 Green stripe bordered by black,tubular bead fragment 1925.493B,Second I.P.,Badari,pan grave 5478	0.36	88.4	0.00	1.60	1.75	0.00	0.01	0.00	0.02	0.09	0.00	4.14	0.00	0.00	0.29	0.00	0.00	0.00	0.00	3.4
131- 78-238 Small green bead 1925.479A,Second I.P.,Badari,pan grave 5473	1.40	82.7	0.00	0.49	3.83	0.00	0.00	0.00	0.03	0.36	0.00	4.88	0.15	0.00	0.00	0.00	0.00	0.01	0.00	6.2
131- 78-239 Small blue bead 1925.479B,Second I.P.,Badari,pan grave 5473	0.85	85.4	0.00	2.44	1.53	0.07	0.03	0.00	0.00	0.22	0.00	6.47	0.00	0.00	0.00	0.00	0.01	0.00	0.00	3.0
131- 78-616 Small blue bead 1925.491A,Second I.P.,Badari,pan grave 5473	0.12	89.1	0.28	1.59	1.22	0.08	0.10	0.02	0.00	0.26	0.00	4.41	0.07	0.00	0.00	0.00	0.01	0.03	0.00	2.7
131- 78-617 Small blue bead 1925.491B,Second I.P.,Badari,pan grave 5473	0.36	85.8	0.14	1.39	1.40	0.06	0.01	0.02	0.00	0.54	0.00	5.88	0.05	0.00	0.06	0.00	0.01	0.04	0.00	4.2
131- 80-240 Dark brown tubular bead 1923.571A,Second I.P.,Qau,cemetery 1300	0.23	88.6	0.00	0.48	1.31	0.06	0.05	2.08	0.43	0.00	0.00	3.10	0.06	0.00	0.00	0.00	0.00	0.01	0.01	3.6
131- 80-241 Green tubular bead 1923.571B,Second I.P.,Qau,cemetery 1300	1.04	88.4	0.00	0.00	1.03	0.04	0.00	0.07	0.18	0.02	0.00	4.37	0.00	0.00	0.00	0.00	0.00	0.00	0.00	4.9
131-107-244 Dark blue decorated jar 1910.518,Second I.P.,Abydos,pan grave O4	0.42	85.7	0.00	1.62	2.01	0.00	0.02	0.16	0.27	0.00	0.00	4.69	0.00	0.00	0.00	0.00	0.00	0.00	0.00	5.1
131-107-244 Black decorations on the bottom of blue jar 1910.518,Second I.P.,Abydos,pan grave O4	0.46	84.9	0.20	2.38	1.94	0.06	0.00	3.38	0.40	0.00	0.00	2.53	0.00	0.00	0.00	0.00	0.00	0.00	0.00	3.8
131-107-245 Black bead E.E.492A,Second I.P.,Abydos,grave D79	0.38	86.0	0.00	2.97	1.11	0.05	0.00	1.40	0.64	0.00	0.00	4.40	0.00	0.00	0.07	0.00	0.05	0.03	0.00	2.8
131-107-246 Green bead E.E.492B,Second I.P.,Abydos,grave D79	0.00	86.6	0.00	0.22	0.43	0.00	0.00	0.00	0.11	0.00	0.00	3.71	0.00	0.00	0.14	0.00	0.00	0.00	0.00	8.8
131-107-606 Bright green ball bead E.E.492C,Second I.P.,Abydos,grave D79	0.15	89.1	0.13	1.18	2.33	0.07	0.05	0.04	0.22	0.00	0.00	2.19	0.03	0.00	0.11	0.00	0.01	0.01	0.00	4.4
131-107-607 Green ball bead E.E.492D,Second I.P.,Abydos,grave D79	0.36	87.7	0.08	0.21	1.03	0.03	0.01	0.04	0.29	0.00	0.00	4.08	0.05	0.00	0.00	0.00	0.00	0.00	0.00	6.1
131-107-608 Blue ball bead E.E.492E,Second I.P.,Abydos,grave D79	0.28	88.7	0.04	1.92	0.60	0.05	0.01	0.04	0.10	0.00	0.00	3.74	0.06	0.00	0.12	0.00	0.04	0.00	0.00	4.3

X-RAY FLUORESCENCE ANALYSES OF INDIVIDUAL OBJECTS ARRANGED CHRONOLOGICALLY

Chloride and oxides of:

Object / Description	Si	S	K	Ca	Ti	V	Cr	Mn	Fe	Co	Ni	Cu	Zn	As	Pb	Sr	Sn	Sb	Ba	Other
131-107-609 Blue ball bead E.E.492F,Second I.P.,Abydos,grave D79	0.18	87.3	2.43	1.24	0.03	0.04	0.00	0.04	0.16	0.00	0.00	3.71	0.06	0.00	0.09	0.00	0.01	0.00	0.00	4.5
131-110-252 White body material,hole in blue ring stand E.2217,Second I.P.,Hu,pan grave X46	0.07	92.1	0.40	0.23	3.24	0.11	0.06	0.00	0.35	0.55	0.00	0.60	0.05	0.00	0.02	0.00	0.00	0.00	0.00	2.2
131-110-252 Blue ring stand E.2217,Second I.P.,Hu,pan grave X46	0.59	88.9	0.06	0.22	0.62	0.03	0.05	0.05	0.07	0.00	0.00	3.68	0.01	0.00	0.17	0.00	0.01	0.02	0.00	5.6
131-110-253 Traces of brown on yellow and green drop bead E.E.163A,Second I.P.,Hu,pan grave X58	0.25	82.2	0.51	1.49	2.94	0.12	0.00	0.00	0.39	0.00	0.00	4.53	0.00	0.00	0.04	0.00	0.00	0.00	0.01	5.9
131-110-254 Blue melon bead E.E.163B,Second I.P.,Hu,pan grave X58	0.59	75.4	4.00	4.45	2.35	0.06	0.00	0.93	1.06	0.00	0.00	12.50	0.02	0.00	0.00	0.00	0.00	0.00	0.00	2.6
131-110-255 Blue-black tubular bead fragment E.E.165A,Second I.P.,Hu,pan grave W10	0.00	84.8	0.00	1.91	3.02	0.00	0.00	1.45	0.94	0.00	0.00	4.27	0.11	0.00	0.96	0.00	0.00	0.00	0.01	2.5
131-110-256 Blue biconical bead E.E.165B,Second I.P.,Hu,pan grave W10	0.00	85.4	4.14	0.79	0.67	0.03	0.05	0.07	0.11	0.00	0.00	3.44	0.00	0.00	0.00	0.00	0.00	0.00	0.00	5.3
131-112-250 Blue bead E.E.495A,Second I.P.,Abadiya,pan grave E2	0.47	87.5	0.00	0.56	0.75	0.04	0.07	0.00	0.23	0.00	0.00	5.00	0.00	0.00	0.00	0.00	0.02	0.01	0.00	5.4
131-112-251 Pale green bead E.E.495B,Second I.P.,Abadiya,pan grave E2	0.46	91.3	0.00	0.36	0.84	0.05	0.00	0.00	0.17	0.01	0.00	2.41	0.03	0.00	0.00	0.00	0.00	0.00	0.00	4.4
131-200-223 Brown body material,chipped section of blue-green kohl-pot 1956.954,Second I.P.,provenance unknown	0.26	89.7	0.78	0.91	1.34	0.06	0.19	0.00	0.26	0.00	0.01	0.21	0.08	0.00	0.49	0.00	0.00	0.00	0.00	5.2
131-200-223 Blue-green decorated kohl-pot 1956.954,Second I.P.,provenance unknown	0.14	90.8	0.13	0.89	0.88	0.04	0.09	0.00	0.07	0.30	0.00	3.12	0.00	0.00	0.39	0.00	0.00	0.00	0.02	3.1
131-200-224 Blue left ankle of a standing human figurine 1962.864,Second I.P.,provenance unknown	0.34	86.4	0.00	3.34	1.84	0.00	0.00	0.00	0.23	0.01	0.00	4.05	0.00	0.00	0.00	0.00	0.00	0.02	0.02	3.8
131-200-224 Black wig on blue head of figurine 1962.864,Second I.P.,provenance unknown	0.28	75.5	0.00	4.63	4.37	0.11	0.02	0.00	3.35	1.46	0.00	5.53	0.00	0.00	0.00	0.00	0.00	0.00	0.22	4.5
135-200-218 Edge of dark blue scarab seal 1892.262,Dyn. XIII-XIV,provenance unknown	0.00	87.3	0.00	4.21	0.64	0.00	0.02	0.00	0.16	0.00	0.00	4.62	0.03	0.00	0.00	0.00	0.00	0.00	0.00	2.8
141-107-243 Blue back of scarab seal E.A.1077,Dyn. XIV,Abydos,tomb E230	0.00	91.5	0.00	0.75	1.60	0.05	0.06	0.00	0.18	0.00	0.00	2.93	0.00	0.00	0.00	0.00	0.03	0.01	0.00	2.9
145-150-257 Pale green bead 1912.225A,Second I.P.,Faras,C-group cemetery 2,grave 219/3	0.58	91.2	0.00	0.00	0.48	0.06	0.00	0.02	0.14	0.00	0.00	2.59	0.03	0.00	0.00	0.00	0.01	0.00	0.00	4.8
145-150-258 Pale green bead 1912.225B,Second I.P.,Faras,C-group cemetery 2,grave 219/3	0.22	90.0	0.00	0.03	0.36	0.05	0.00	0.00	0.04	0.13	0.01	2.27	0.01	0.00	0.00	0.00	0.00	0.03	0.00	6.8
145-150-259 Black bead 1912.233A,Second I.P.,Faras,C-group cemetery 2,grave 229/4	0.18	92.6	0.00	0.07	0.66	0.00	0.05	0.00	1.22	0.33	0.02	1.79	0.01	0.00	0.00	0.00	0.01	0.03	0.20	2.8
145-150-260 Black bead 1912.233B,Second I.P.,Faras,C-group cemetery 2,grave 229/4	0.19	91.4	0.00	0.61	0.00	0.02	0.00	0.91	0.32	0.01	0.00	1.94	0.00	0.00	0.00	0.00	0.01	0.03	0.20	

X-RAY FLUORESCENCE ANALYSES OF INDIVIDUAL OBJECTS ARRANGED CHRONOLOGICALLY

Chloride and oxides of:

Object	Si	S	K	Ca	Ti	V	Cr	Mn	Fe	Co	Ni	Cu	Zn	As	Pb	Sr	Sn	Sb	Ba	Other
145-150-261 Base of green button seal 1912.726,Second I.P.,Faras,C-group cemetery 1,grave 716	0.00	90.3	0.00	0.30	0.88	0.19	0.00	0.06	2.81	0.03	0.00	0.89	0.00	0.01	0.00	0.00	0.00	0.00	0.00	4.5
151- 12-215 Back of dark green scarab seal E.3784,Dyn. XV-XVI(Hyksos period),Sinai(Petrie's 1904-5 expedition)	0.14	82.4	0.55	2.28	2.08	0.06	0.00	0.02	1.67	0.00	0.00	7.26	0.00	0.00	0.00	0.13	0.00	0.02	0.00	3.4
151- 20-213 Small black bead E.E.659A,Dyn. XV-XVI(Hyksos Period),Tell el-Yahudiya,grave 37	0.00	89.6	0.00	0.31	1.04	0.02	0.00	0.00	1.53	0.15	0.01	3.48	0.00	0.00	0.00	0.00	0.00	0.00	0.15	3.7
151- 20-214 Small black bead E.E.659B,Dyn. XV-XVI(Hyksos Period),Tell el-Yahudiya,grave 37	0.14	89.7	0.10	0.27	1.33	0.00	0.00	0.00	2.15	0.17	0.00	2.96	0.00	0.00	0.00	0.00	0.00	0.00	0.11	3.1
151- 20-618 Small white bead E.E.659D,Dyn. XV-XVI(Hyksos Period),Tell el-Yahudiya,grave 37	0.55	91.8	0.18	0.12	1.24	0.12	0.04	0.00	0.29	0.38	0.00	0.15	0.02	0.00	0.00	0.00	0.00	0.01	0.00	5.1
151- 20-619 Small black bead E.E.659C,Dyn. XV-XVI(Hyksos Period),Tell el-Yahudiya,grave 37	0.36	85.8	0.20	0.64	1.71	0.07	0.01	0.00	2.59	0.41	0.00	4.46	0.00	0.00	0.00	0.00	0.00	0.00	0.00	3.7
151- 20-620 Small black bead E.E.659E,Dyn. XV-XVI(Hyksos Period),Tell el-Yahudiya,grave 37	0.29	82.1	0.26	0.59	1.78	0.05	0.00	0.00	3.68	0.35	0.00	5.19	0.07	0.00	0.00	0.00	0.00	0.00	0.00	5.7
151- 20-621 White cowroid E.E. 657,Dyn. XV-XVI(Hyksos Period),Tell el-Yahudiya,grave 37	0.00	95.6	0.03	0.14	0.33	0.06	0.11	0.00	0.13	0.00	0.00	0.12	0.04	0.00	0.00	0.00	0.00	0.01	0.00	3.4
151- 20-622 Small white bead E.E.660B,Dyn. XV-XVI(Hyksos Period),Tell el-Yahudiya,grave 37	0.61	90.5	0.29	0.07	1.82	0.15	0.06	0.01	0.31	0.68	0.00	0.11	0.03	0.00	0.00	0.00	0.00	0.00	0.00	5.4
151- 20-623 Small white bead E.E.660A,Dyn. XV-XVI(Hyksos Period),Tell el-Yahudiya,grave 37	0.00	93.9	0.12	0.27	0.54	0.04	0.08	0.00	0.04	0.13	0.00	0.03	0.04	0.00	0.00	0.00	0.00	0.00	0.00	4.8
151- 20-624 Small white bead E.E.660C,Dyn. XV-XVI(Hyksos Period),Tell el-Yahudiya,grave 37	0.00	92.4	0.11	0.48	0.92	0.10	0.03	0.00	0.14	0.26	0.00	0.02	0.01	0.00	0.00	0.00	0.00	0.00	0.00	5.5
151-200-220 Base of pale green scarab seal 1890.406,Dyn. XV-XVI(Hyksos period),provenance unknown	0.11	78.8	0.17	1.07	11.51	0.11	0.00	0.00	0.67	0.00	0.00	2.45	0.00	0.00	0.00	0.11	0.00	0.00	0.00	5.0
178-107-248 Pale blue inlay (set in wood) E.3519,Dyn. XVII-XVIII,Abydos,grave D25	0.35	85.2	0.00	0.18	1.08	0.00	0.00	0.00	0.06	0.26	0.00	8.17	0.00	0.02	0.00	0.00	0.00	0.00	0.00	4.7
178-200-222 Back of pale green stamp-seal 1890.410,Dyn. XVII-XVIII,provenance unknown	0.00	78.5	0.09	0.68	11.16	0.00	0.00	0.00	1.10	0.00	0.00	2.35	0.00	0.00	0.00	0.00	0.00	0.00	0.03	6.1
179-200-262 Base of blue-green scarab seal 1892.273,Dyn. XVIII(cartouche of Ahmose I),provenance unknown	0.42	86.2	0.00	3.08	1.15	0.12	0.00	0.00	0.77	0.00	0.00	3.73	0.00	0.00	0.00	0.42	0.00	0.01	0.00	3.9
180-107-263 Grey body material,fragment of blue hippopotamus E.2205,Dyn. XVIII(Amenhotep I),Abydos E271	0.00	94.3	0.00	0.53	1.53	0.05	0.09	0.00	0.30	0.00	0.00	0.45	0.04	0.00	0.00	0.16	0.00	0.00	0.00	2.6
180-107-263 Dark blue fragment of hippopotamus E.2205,Dyn. XVIII(Amenhotep I) Abydos E271	0.00	90.4	0.00	0.32	0.28	0.00	0.00	0.00	0.04	0.00	0.00	5.27	0.00	0.00	0.00	0.00	0.00	0.00	0.00	3.7
180-107-263 Black lotus design on the rump of blue hippopotamus E.2205,Dyn. XVIII(Amenhotep I) Abydos E271	0 40	81.0	0.00	1.94	1.95	0.00	0.00	0.00	2.34	0.21	0.00	8.66	0.00	0.00	0.00	0.00	0.00	0.00	0.32	3.2
181- 54-304 Back of pale green scarab seal 1890.766,Dyn. XVIII(cartouche of Tuthmosis I),Lahun,tomb of Maket	0.00	84.3	0.00	2.61	1.02	0.09	0.03	0.00	0.50	0.01	0.00	5.43	0.00	0.00	0.00	0.00	0.00	0.00	0.00	6.0

X-RAY FLUORESCENCE ANALYSES OF INDIVIDUAL OBJECTS ARRANGED CHRONOLOGICALLY

Chloride and oxides of:

Object / Description	Si	S	K	Ca	Ti	V	Cr	Mn	Fe	Co	Ni	Cu	Zn	As	Pb	Sr	Sn	Sb	Ba	Other
181-200-291 Back of olive-green scarab seal 1889.101,Dyn. XVIII(cartouche of Tuthmosis I),provenance unknown	0.82	84.7	0.18	0.67	2.21	0.15	0.02	0.00	0.05	0.91	0.00	6.07	0.00	0.00	0.13	0.12	0.00	0.00	0.00	3.9
182-55-308 Grey body material,hole in green vase 1914.680,Early Dyn. XVIII,Haraga,grave 270	0.00	92.7	0.00	0.00	1.40	0.09	0.08	0.00	0.09	0.86	0.00	0.15	0.00	0.00	0.00	0.00	0.00	0.00	0.00	4.7
182-55-308 Small pale green vase 1914.680,Early Dyn. XVIII,Haraga,grave 270	0.83	90.0	0.09	0.79	1.03	0.03	0.03	0.00	0.05	1.09	0.00	2.58	0.00	0.00	0.00	0.02	0.02	0.12	0.00	3.4
182-107-242 Long dark blue segmented bead 1926.176B,Early Dyn. XVIII,Abydos,tomb 1806	0.00	87.8	0.00	1.41	0.86	0.06	0.03	0.00	0.18	0.00	0.00	4.28	0.00	0.00	0.00	0.28	0.12	0.00	0.00	5.0
182-107-247 Green socket on blue head of a Bes-pendant 1926.176A,Early Dyn. XVIII,Abydos,tomb 1806	0.00	91.9	0.00	0.00	1.25	0.05	0.03	0.00	0.05	0.17	0.00	1.37	0.00	0.00	0.22	0.00	0.14	0.00	0.00	4.9
182-107-247 Flat back of dark blue Bes-Pendant 1926.176A,Early Dyn. XVIII,Abydos,tomb 1806	0.00	89.0	0.00	1.62	0.77	0.05	0.07	0.00	0.11	0.13	0.00	4.62	0.00	0.00	0.14	0.00	0.39	0.01	0.00	3.1
182-107-610 Dark indigo-blue lenticular bead 1926.176C,Early Dyn. XVIII,Abydos,tomb 1806	0.00	92.7	0.03	0.73	0.79	0.04	0.02	0.00	0.18	0.23	0.11	1.97	0.07	0.01	0.00	0.00	0.00	0.00	0.00	3.1
182-107-611 Bright blue bead 1926.176D,Early Dyn. XVIII,Abydos,tomb 1806	0.15	87.7	0.00	0.18	0.98	0.03	0.01	0.00	0.01	0.12	0.01	4.21	0.00	0.00	0.05	0.00	0.32	0.00	0.00	6.2
182-107-625 Long yellow,highly vitrified,tubular bead E.E.489A,Early Dyn. XVIII,Abydos,tomb E266	0.01	83.6	1.27	0.48	0.74	0.03	0.00	0.00	0.59	0.01	0.00	0.31	0.06	0.00	7.46	0.00	0.56	0.00	0.00	4.8
182-107-626 Long yellow,highly vitrified,tubular bead E.E.489B,Early Dyn. XVIII,Abydos,tomb E266	0.04	82.3	1.10	0.60	1.84	0.02	0.00	0.00	0.75	0.00	0.00	0.29	0.05	0.00	7.97	0.00	0.61	0.00	0.00	4.5
182-107-627 Back of pale green scarab seal E.E.512A,Early Dyn. XVIII,Abydos,tomb E166(2)	0.18	85.9	0.05	0.75	4.38	0.10	0.00	0.00	0.26	0.00	0.00	4.46	0.00	0.00	0.00	0.03	0.16	0.03	0.00	3.7
182-118-286 Face of blue cowroid seal 1886.139a,Early Dyn. XVIII,Thebes	0.14	76.8	0.24	0.73	6.36	0.25	0.03	0.00	0.02	1.39	0.00	9.40	0.04	0.06	0.00	0.11	0.01	0.00	0.00	4.4
182-200-266 Blue-green back of scarab seal 1872.162,Early Dyn. XVIII,provenance unknown	0.41	78.1	1.00	1.90	0.64	0.00	0.00	0.00	0.78	0.02	0.05	11.91	0.00	0.09	0.07	0.00	1.24	0.00	0.00	4.7
182-200-269 Blue-green face of cowroid 1962.888,Early Dyn. XVIII,provenance unknown	0.29	89.6	0.00	1.64	0.52	0.10	0.08	0.00	0.00	0.25	0.01	4.86	0.00	0.00	0.00	0.00	0.00	0.00	0.00	2.7
182-200-270 Dark green edge of cowroid 1962.892,Early Dyn. XVIII,provenance unknown	0.26	87.4	0.00	0.41	0.94	0.09	0.05	0.00	0.08	0.32	0.01	3.15	0.01	0.00	0.12	0.00	0.72	0.01	0.00	6.4
182-200-271 Dark green back of round seal-plaque 1890.408,Early Dyn. XVIII,provenance unknown	0.59	89.8	0.08	0.46	1.56	0.09	0.11	0.00	0.08	0.38	0.00	2.25	0.11	0.00	0.12	0.00	0.00	0.04	0.00	4.3
183-38-273 Grey body material,fragment of green menat E.2644,Dyn. XVIII(cartouche of Hatshepsut),Serabit el Khadim,temple of Hathor	0.00	95.4	0.11	0.28	0.46	0.06	0.08	0.00	0.08	0.38	0.00	0.13	0.00	0.00	0.00	0.00	0.00	0.00	0.00	3.1
183-38-273 Pale green menat fragment E.2644,Dyn. XVIII(cartouche of Hatshepsut),Serabit el Khadim,temple of Hathor	0.00	91.4	0.00	0.00	1.13	0.06	0.07	0.00	0.05	0.52	0.00	0.86	0.00	0.00	0.00	0.02	0.05	0.02	0.00	5.8
183-38-310 Grey body material,fragment of green menat E.2643,Dyn. XVIII(cartouche of Tuthmosis III),Serabit el Khadim,temple of Hathor	0.00	94.1	0.00	0.00	0.15	0.07	0.20	0.00	0.06	0.03	0.00	0.06								

Chloride and oxides of:

Sample	Description	Si	S	K	Ca	Ti	V	Cr	Mn	Fe	Co	Ni	Cu	Zn	As	Pb	Sr	Sn	Sb	Ba	Other
183- 38-310	Green menat fragment E.2643,Dyn. XVIII(cartouche of Tuthmosis III),Serabit el Khadim,temple of Hathor	0.00	85.4	0.68	0.49	0.06	0.00	0.00	0.23	0.23	0.00	0.00	7.40	0.00	0.00	0.00	0.00	0.00	0.00	0.00	5.5
183- 38-310	Black hieroglyphs on green menat E.2643,Dyn. XVIII(cartouche of Tuthmosis III),Serabit el Khadim,temple of Hathor	0.00	83.0	0.84	1.03	0.05	0.06	0.00	2.88	0.31	0.02	0.00	7.19	0.00	0.00	0.00	0.00	0.00	0.00	0.00	4.3
183- 38-311	Grey body material,fragment of green sistrum E.4462a,Dyn. XVIII(cartouche of Tuthmosis III),Serabit el Khadim,temple of Hathor	0.00	96.4	0.00	0.23	0.04	0.04	0.00	0.05	0.25	0.00	0.00	0.15	0.00	0.00	0.00	0.00	0.00	0.00	0.00	2.8
183- 38-311	Pale green sistrum handle E.4462a,Dyn. XVIII(cartouche of Tuthmosis III),Serabit el Khadim,temple of Hathor	0.00	79.1	0.00	3.31	0.00	0.00	0.00	0.11	0.26	0.00	0.00	11.73	0.00	0.00	0.00	0.00	0.00	0.00	0.00	5.5
183- 54-295	Head of green scarab seal 1890.772,Early Dyn. XVIII,Lahun,tomb of Maket	0.00	70.2	7.73	1.91	0.00	0.00	0.00	0.00	3.85	0.00	0.00	11.58	0.00	0.00	0.00	0.92	0.00	0.00	0.00	3.8
183- 54-296	Base of blue-green scarab seal 1890.779,Early Dyn. XVIII,Lahun,tomb of Maket	0.00	90.1	0.00	0.33	1.27	0.00	0.00	0.05	0.20	0.01	0.00	4.94	0.00	0.02	0.00	0.19	0.00	0.00	0.00	2.9
183- 54-297	Back of blue scarab seal 1890.782,Early Dyn. XVIII,Lahun,tomb of Maket	0.53	86.0	1.35	1.16	0.13	0.03	0.00	0.00	0.67	0.01	0.00	7.18	0.00	0.00	0.00	0.02	0.02	0.00	0.00	2.9
183- 54-298	Edge of dark blue rectangular prism,seal-plaque 1890.777,Early Dyn. XVIII,Lahun,tomb of Maket	0.80	85.6	0.60	1.75	0.00	0.00	0.00	0.00	0.16	0.00	0.00	6.96	0.00	0.00	0.00	0.62	0.00	0.00	0.00	3.5
183- 54-299	Convex side of brown bead 1890.770,Early Dyn. XVIII,Lahun,tomb of Maket	0.82	69.9	0.00	15.29	0.00	0.00	0.00	0.00	0.86	0.00	0.00	8.49	0.00	0.00	0.00	0.12	0.08	0.00	0.00	4.4
183- 54-300	Flat uninscribed side of green scaraboid 1890.774,Early Dyn. XVIII,Lahun,tomb of Maket	0.00	90.7	2.27	0.85	0.06	0.05	0.00	0.02	0.14	0.00	0.00	3.67	0.00	0.00	0.00	0.00	0.00	0.00	0.00	2.2
183- 54-301	Forehead of green leopard,necklace-terminal 1890.785A,Early Dyn. XVIII,Lahun,tomb of Maket	0.39	79.6	0.00	9.31	0.09	0.00	0.00	0.00	0.93	0.00	0.00	5.94	0.03	0.02	0.00	0.12	0.00	0.00	0.00	3.6
183- 54-302	Green body material,glaze-free area near the mouth of green vase 1890.815,Early Dyn. XVIII,Lahun,tomb of Maket	0.00	88.3	0.66	2.29	0.04	0.03	0.00	0.06	0.72	0.00	0.00	2.90	0.02	0.00	0.00	0.00	0.00	0.00	0.00	5.0
183- 54-302	Remains of green glaze on vase 1890.815,Early Dyn. XVIII,Lahun,tomb of Maket	0.46	82.1	0.20	9.47	0.00	0.00	0.00	0.00	0.70	0.01	0.00	3.45	0.03	0.00	0.00	0.00	0.00	0.00	0.00	3.6
183- 54-303	Large olive-green vase 1890.821,Early Dyn. XVIII,Lahun,tomb of Maket	0.00	88.3	1.33	2.54	0.14	0.05	0.00	0.00	0.55	0.00	0.00	3.56	0.07	0.00	0.19	0.00	0.00	0.00	0.00	3.0
183- 54-305	Back of pale green scarab seal 1890.771,Dyn. XVIII(cartouche of Tuthmosis III),Lahun,tomb of Maket	0.00	87.2	1.92	0.71	0.23	0.00	0.00	0.00	2.83	0.03	0.03	4.37	0.00	0.00	0.00	0.00	0.00	0.00	0.00	2.7
183- 54-306	Back of pale green scarab seal 1890.776,Dyn. XVIII(cartouche of Tuthmosis III),Lahun,tomb of Maket	0.26	84.8	5.31	0.91	0.07	0.00	0.00	0.00	2.16	0.00	0.00	3.74	0.00	0.00	0.00	0.01	0.02	0.00	0.00	2.5
183- 54-307	Face of green cowroid seal 1890.769,Dyn. XVIII(cartouche of Tuthmosis III),Lahun,tomb of Maket	0.00	79.9	5.13	1.48	0.14	0.00	0.00	0.00	3.18	0.00	0.00	4.91	0.00	0.00	0.00	0.09	0.00	0.00	0.00	5.1
183- 58-293	White body materi...,fragment of Hathor-head amulet E.2645,Dyn. XVIII,Ihnasiya,temple of Tuthmosis III	0.00	95.1	0.18	0.60	0.06	0.06	0.00	0.00	0.61	0.00	0.00	0.15	0.00	0.00	0.00	0.00	0.00	0.00	0.00	3.2
183- 58-293	Remains of green glaze,reverse side of Hathor-head amulet E.2645,Dyn. XVIII,Ihnasiya,temple of Tuthmosis III	0.00	90.7	0.32	0.98	0.09	0.07	0.00	0.09	0.85	0.01	0.00	3.23	0.00	0.00	0.00	0.00	0.03	0.00	0.00	3.6

X-RAY FLUORESCENCE ANALYSES OF INDIVIDUAL OBJECTS ARRANGED CHRONOLOGICALLY

Chloride and oxides of:

No.	Description	Si	S	K	Ca	Ti	V	Cr	Mn	Fe	Co	Ni	Cu	Zn	As	Pb	Sr	Sn	Sb	Ba	Other
183-115-290	Body material of green model egg(?) E.4532,Dyn. XVIII,Qift(Coptos),temple of Tuthmosis III,foundation deposit No.3	0.00	93.2	0.00	0.56	0.06	0.10	0.00	0.09	0.17	0.00	0.00	0.41	0.02	0.00	0.00	0.00	0.00	0.00		5.4
183-115-628	Blue inlay fragment E.E.643A,Dyn. XVIII,Qift(Coptos),temple of Tuthmosis III,foundation deposit No.3	0.04	76.7	0.11	0.05	10.27	0.00	0.00	0.00	0.07	0.00	0.00	7.97	0.00	0.00	0.13	0.00	0.61	0.11	0.00	4.0
183-115-629	Olive-green back of scarab seal E.E.643B,Dyn. XVIII,Qift(Coptos),temple of Tuthmosis III,foundation deposit No.3	0.00	87.1	0.20	0.02	1.61	0.08	0.07	0.06	0.16	0.00	0.00	4.98	0.00	0.00	0.00	0.00	0.00	0.00		5.7
183-115-629	Pale green base of scarab seal E.E.643B,Dyn. XVIII,Qift(Coptos),temple of Tuthmosis III,foundation deposit No.3	0.00	83.5	0.21	0.10	0.97	0.08	0.08	0.05	0.19	0.01	0.00	5.10	0.00	0.00	0.00	0.00	0.00	0.00		9.7
183-115-772	Yellowish white tubular bead E.E.238A,Dyn. XVIII,Qift(Coptos),temple of Tuthmosis III,foundation deposit No.3	0.00	75.7	5.35	0.58	1.39	0.00	0.00	0.00	0.23	0.00	0.00	6.31	0.02	0.00	0.96	0.00				9.2
183-115-773	Bright white tubular bead E.E.238B,Dyn. XVIII,Qift(Coptos),temple of Tuthmosis III,foundation deposit No.3	0.00	95.9	0.31	0.33	0.50	0.01	0.00	0.00	0.16	0.00	0.00	0.03	0.00	0.00	0.00	0.00	0.00			2.7
183-115-774	Yellow segmented tubular bead E.E.238C,Dyn. XVIII,Qift(Coptos),temple of Tuthmosis III,foundation deposit No.3	0.00	80.2	3.25	0.44	2.65	0.02	0.00	0.00	0.26	0.00	0.00	4.50	0.02	0.00	0.78	0.00				7.5
183-115-775	Long yellow segmented tubular bead E.E.238D,Dyn. XVIII,Qift(Coptos),temple of Tuthmosis III,foundation deposit No.3	0.00	77.1	2.26	0.80	5.07	0.00	0.00	0.00	0.37	0.00	0.00	6.12	0.03	0.09	1.05	0.00				6.8
183-115-776	Green tubular bead E.E.238E,Dyn. XVIII,Qift(Coptos),temple of Tuthmosis III,foundation deposit No.3	0.57	88.1	0.50	0.26	1.61	0.00	0.00	0.00	0.08	0.00	0.00	4.56	0.00	0.00	0.03	0.00	0.10	0.00		4.2
183-115-777	Red segmented tubular bead E.E.238F,Dyn. XVIII,Qift(Coptos),temple of Tuthmosis III,foundation deposit No.3	0.00	87.3	2.30	1.26	0.96	0.05	0.00	0.00	2.97	0.01	0.00	1.08	0.01	0.04	0.00	0.00				3.9
183-115-785	Pale yellow long segmented tubular bead E.E.238I,Dyn. XVIII,Qift(Coptos),temple of Tuthmosis III,foundation deposit No.3	0.00	81.4	0.00	0.62	5.49	0.17	0.00	0.00	0.45	0.02	0.00	0.05	0.61	0.00	7.43	0.05	0.04	1.40	0.00	2.2
183-115-786	Short green segmented tubular bead E.E.238J,Dyn. XVIII,Qift(Coptos),temple of Tuthmosis III,foundation deposit No.3	0.44	84.5	0.00	0.40	0.64	0.04	0.04	0.01	0.05	0.00	0.01	2.21	0.00	0.00	0.02	0.00	0.13	0.00	0.00	11.5
183-115-787	Short apple-green tubular bead E.E.238K,Dyn. XVIII,Qift(Coptos),temple of Tuthmosis III,foundation deposit No.3	0.40	83.2	0.11	0.25	0.92	0.02	0.02	0.04	0.00	0.00	0.00	2.19	0.11	0.00	2.13	0.02	0.18	0.50	0.00	9.7
183-115-788	Second red segmented tubular bead E.E.238L,Dyn. XVIII,Qift(Coptos),temple of Tuthmosis III,foundation deposit No.3	0.00	89.4	0.00	0.55	2.20	0.04	0.00	0.00	2.55	0.00	0.00	0.04	0.01	0.00	0.68	0.00	0.00	0.00		4.5
183-115-789	Red body of red tubular bead E.E.238M,Dyn. XVIII,Qift(Coptos),temple of Tuthmosis III,foundation deposit No.3	0.00	88.0	0.00	2.37	1.81	0.09	0.00	0.00	5.85	0.00	0.00	0.06	0.00	0.00	1.07	0.00	0.00	0.00		0.7
183-115-790	Third red tubular bead E.E.238M,Dyn. XVIII,Qift(Coptos),temple of Tuthmosis III,foundation deposit No.3	0.00	82.0	0.00	1.88	1.60	0.08	0.00	0.00	4.46	0.00	0.00	0.06	0.03	0.00	1.02	0.01	0.00	0.00		8.8
183-115-792	Fourth red tubular bead E.E.238N,Dyn. XVIII,Qift(Coptos),temple of Tuthmosis III,foundation deposit No.3	0.00	83.7	0.00	0.92	0.53	0.02	0.00	0.00	2.90	0.00	0.00	0.04	0.05	0.00	1.27	0.01	0.00	0.00		10.6
183-115-798	Pale green tubular bead E.E.238G,Dyn. XVIII,Qift(Coptos),temple of Tuthmosis III,foundation deposit No.3	0.44	82.7	0.10	0.34	0.88	0.02	0.00	0.00	0.20	0.00	0.00	2.70	0.13	0.00	2.92	0.02	0.19	0.56	0.00	8.8
183-115-798	White tubular bead E.E.238H,Dyn. XVIII,Qift(Coptos),temple of Tuthmosis III,foundation deposit No.3	0.00	93.6	0.25	0.33	0.48	0.01	0.00	0.00	0.14	0.00										

X-RAY FLUORESCENCE ANALYSES OF INDIVIDUAL OBJECTS ARRANGED CHRONOLOGICALLY

Chloride and oxides of:

Object	Description	Si	S	K	Ca	Ti	V	Cr	Mn	Fe	Co	Ni	Cu	Zn	As	Pb	Sr	Sn	Sb	Ba	Other
183-119-288	White body material, blue menat E.2729, Dyn. XVIII (cartouche of Hatshepsut), Deir el Bahari, temple of Nebhepetre Mentuhotep	0.00	95.9	0.00	0.33	0.38	0.04	0.05	0.00	0.23	0.01	0.00	0.04	0.00	0.00	0.00	0.00	0.00	0.00	0.00	3.0
183-119-288	Dark blue menat fragment E.2729, Dyn. XVIII (cartouche of Hatshepsut), Deir el Bahari, temple of Nebhepetre Mentuhotep	0.44	87.8	0.00	2.89	0.45	0.03	0.00	0.06	0.26	0.00	0.00	5.40	0.00	0.00	0.00	0.00	0.00	0.02	0.00	2.7
183-119-288	Black hieroglyph on blue menat E.2729, Dyn. XVIII (cartouche of Hatshepsut), Deir el Bahari, temple of Nebhepetre Mentuhotep	0.56	81.0	0.00	4.72	1.06	0.00	0.00	1.01	0.78	0.00	0.00	7.09	0.00	0.00	0.00	0.00	0.00	0.00	0.00	3.8
183-200-272	Blue edge of menat fragment 1964.219, Dyn. XVIII (cartouche of Hatshepsut), provenance unknown	0.56	87.3	0.00	3.67	0.50	0.00	0.00	0.16	0.00	0.00	0.00	4.44	0.02	0.00	0.00	0.00	0.00	0.00	0.00	3.4
183-200-272	Black hieroglyph on blue menat fragment 1964.219, Dyn. XVIII (cartouche of Hatshepsut), provenance unknown	0.19	85.9	0.00	3.39	0.55	0.00	0.00	3.27	0.23	0.00	0.00	2.80	0.04	0.00	0.00	0.00	0.00	0.00	0.00	3.6
183-200-287	Pale green wedjat-eye, back of seal-amulet 1872.800, Dyn. XVIII (cartouche of Tuthmosis III), provenance unknown	0.00	90.8	0.00	0.98	0.00	0.00	0.00	0.27	0.23	0.00	0.00	2.89	0.00	0.00	0.00	0.00	0.03	0.04	0.00	4.7
183-200-309	Blue-green edge of seal-plaque 1957.215, Dyn. XVIII (cartouche of Tuthmosis III), provenance unknown	0.55	82.9	0.00	3.59	1.51	0.10	0.00	0.00	0.95	0.00	0.00	6.30	0.00	0.06	0.00	0.00	0.00	0.00	0.00	4.0
183-200-689	Blue-green scarab seal U.C.12221, Dyn. XVIII (cartouche of Amenhotep II), provenance unknown	0.68	90.0	0.18	0.56	0.51	0.03	0.00	0.00	0.19	0.00	0.00	3.33	0.00	0.00	0.00	0.00	0.10	0.01	0.00	4.4
183-200-690	Back of a green frog mounted on seal-amulet U.C.12229, Dyn. XVIII (cartouche of Amenhotep II), provenance unknown	0.66	88.0	0.28	0.58	0.63	0.03	0.00	0.20	0.00	0.00	0.00	4.99	0.06	0.00	0.04	0.01	0.87	0.10	0.00	3.6
183-200-690	Inscribed base of green frog-topped seal U.C.12229, Dyn. XVIII (cartouche of Amenhotep II), provenance unknown	0.66	85.9	0.18	0.93	1.23	0.04	0.00	0.00	0.33	0.00	0.01	5.17	0.00	0.01	0.00	0.00	0.87	0.10	0.00	4.5
184-118-691	Grey body material, diagonally broken blue torso of Hathor, sistrum handle U.C.29145, Dyn. XVIII, Thebes, temple of Tuthmosis IV	0.33	95.4	0.24	0.23	1.06	0.04	0.00	0.00	0.02	0.00	0.00	0.73	0.00	0.00	0.00	0.04	0.04	0.01	0.00	1.6
184-118-691	Greyish body material, damaged top of Hathor's blue wig, sistrum handle U.C.29145, Dyn. XVIII, Thebes, temple of Tuthmosis IV	0.59	95.0	0.04	0.17	0.91	0.13	0.00	0.00	0.00	0.16	0.01	0.66	0.00	0.01	0.00	0.01	0.03	0.01	0.03	2.3
184-118-691	Dark blue cheek of Hathor, sistrum handle U.C.29145, Dyn. XVIII, Thebes, temple of Tuthmosis IV	1.74	86.2	0.06	0.91	1.01	0.01	0.00	0.01	0.17	0.00	0.01	7.00	0.00	0.00	0.03	0.00	0.21	0.01	0.00	2.6
184-118-691	Pale blue left shoulder of Hathor, sistrum handle U.C.29145, Dyn. XVIII, Thebes, temple of Tuthmosis IV	2.05	82.8	0.88	0.63	3.46	0.04	0.00	0.01	0.22	0.00	0.01	6.61	0.00	0.00	0.05	0.01	0.20	0.01	0.00	3.1
184-118-691	Black stripe on blue wig of Hathor, sistrum handle U.C.29145, Dyn. XVIII, Thebes, temple of Tuthmosis IV	1.37	87.6	0.16	0.78	0.89	0.05	0.00	0.00	0.19	0.00	0.01	4.56	0.01	1.43	0.00	0.06	0.01	0.24	0.04	2.6
185-68-331	Greenish body material, fragment of green cylindrical kohl tube 1889.148, Dyn. XVIII (cartouche of Amenhotep III), Tell el-Amarna	0.00	79.8	0.06	2.03	3.86	0.39	0.02	0.00	0.14	2.40	0.00	1.13	0.43	0.00	7.53	0.00	0.07	0.93	0.01	1.2
185-68-331	Green cylindrical kohl tube fragment 1889.148, Dyn. XVIII (cartouche of Amenhotep III), Tell el-Amarna	0.00	77.6	2.25	1.76	1.14	0.03	0.00	0.00	0.07	0.33	0.03	2.34	0.29	0.00	8.80	0.00	0.11	0.88	0.00	4.3
185-68-331	Blue hieroglyphs, set in green cylindrical kohl tube fragment 1889.148, Dyn. XVIII (cartouche of Amenhotep III), Tell el-Amarna	0.00	81.2	2.37	1.33	1.10	0.05	0.00	0.00	0.28	0.36	0.14	1.69	0.11	0.00	7.97	0.00	0.07	0.58	0.00	2.6
185-68-333	Olive-green exterior of bowl fragment 1893.1-41(393), Dyn. XVIII (cartouche of Amenhotep III), Tell el-Amarna	0.00	85.9	0.57	0.50	1.81	0.11	0.00	0.00	0.39	0.34	0.00	6.77	0.00	0.00	0.00	0.00	0.01	0.09	0.00	3.5

X-RAY FLUORESCENCE ANALYSES OF INDIVIDUAL OBJECTS ARRANGED CHRONOLOGICALLY

Chloride and oxides of:

Object	Si	S	K	Ca	Ti	V	Cr	Mn	Fe	Co	Ni	Cu	Zn	As	Pb	Sr	Sn	Sb	Ba	Other
185-82-292 Violet-purple heel area of ushabti 1892.643(E3571),Dyn. XVIII(cartouche of Amenhotep III),Akhmim	0.49	90.2	0.00	1.12	0.82	0.00	0.00	0.28	0.29	0.10	0.03	3.28	0.20	0.00	0.00	0.00	0.01	0.02	0.00	3.1
185-115-332 Dull brown exterior of bowl fragment 1893.1-41(394),Dyn. XVIII(Amenhotep III),Coptos (or Amarna ?)	0.00	86.1	0.52	1.08	4.40	0.43	0.00	0.25	1.79	0.00	0.00	0.99	0.00	0.00	0.00	0.00	0.00	0.03	0.00	4.4
185-118-289 Bezel of apple-green signet ring,Fortnum R19,Dyn. XVIII(cartouche of Amenhotep III),Thebes	0.00	75.7	2.26	2.66	0.60	0.01	0.00	0.00	0.39	0.01	0.00	2.29	0.32	0.00	9.63	0.00	0.17	2.24	0.00	3.7
185-118-692 Grey body material,fragment of blue kohl tube U.C.587,Dyn. XVIII(cartouche of Amenhotep III),Thebes,temple of Amenhotep II	0.57	85.5	0.48	0.97	1.84	0.14	0.00	0.28	0.68	0.25	0.16	0.00	0.29	0.00	0.01	0.00	0.00	0.01	0.01	8.8
185-118-692 Indigo-blue inscribed kohl tube fragment U.C.587,Dyn. XVIII(cartouche of Amenhotep III),Thebes,temple of Amenhotep II	1.38	84.8	0.08	2.61	1.19	0.02	0.00	0.29	0.37	0.24	0.14	4.26	0.17	0.00	0.05	0.00	0.01	0.02	0.02	4.4
185-118-692 Turquoise blue hieroglyph on dark blue kohl tube U.C.587,Dyn. XVIII(cartouche of Amenhotep III),Thebes,temple of Amenhotep II	1.41	86.6	0.13	1.74	1.16	0.04	0.00	0.12	0.28	0.07	0.04	4.70	0.05	0.00	0.06	0.00	0.03	0.02	0.01	3.5
185-200-265 Dark green back of scarab seal 1879.356,Dyn. XVIII,provenance unknown	0.69	76.9	0.00	0.65	2.30	0.15	0.00	0.00	1.33	0.06	0.00	6.68	0.00	0.00	5.20	0.00	0.56	2.58	0.00	2.9
185-200-268 Dark brown back of scarab seal 1888.710,Dyn. XVIII,provenance unknown	0.23	87.0	0.00	2.66	2.69	0.14	0.03	0.08	1.20	0.01	0.00	0.45	0.06	0.00	1.64	0.00	0.52	0.00	0.00	3.3
185-200-274 White body material,fragment of blue signet ring 1872.813,Dyn. XVIII(cartouche of Amenhotep III),provenance unknown	0.00	89.0	0.00	1.10	3.01	0.30	0.08	0.11	0.94	0.00	0.00	0.88	0.00	0.00	0.00	0.00	0.00	0.00	0.00	4.5
185-200-274 Reverse side of pale blue bezel,signet ring 1872.813,Dyn. XVIII(cartouche of Amenhotep III),provenance unknown	1.06	86.0	0.00	0.00	1.19	0.06	0.00	0.06	0.17	0.00	0.00	4.40	0.00	0.00	0.18	0.00	0.85	0.49	0.00	5.5
185-200-275 Face of violet-purple bezel,signet ring 1889.125,Dyn. XVIII(cartouche of Amenhotep III),provenance unknown	0.00	91.2	0.00	1.36	1.87	0.13	0.00	0.65	0.72	0.42	0.26	0.38	0.56	0.00	0.03	0.00	0.00	0.13	0.00	2.3
185-200-276 Reverse side of violet-purple bezel,signet ring 1933.59,Dyn. XVIII(cartouche of Amenhotep III),provenance unknown	0.28	90.6	0.00	0.99	2.54	0.13	0.00	0.43	0.75	0.27	0.26	0.97	0.27	0.00	0.00	0.00	0.02	0.00	0.00	2.5
185-200-277 Face of violet-purple bezel,signet ring 1933.60,Dyn. XVIII(cartouche of Amenhotep III),provenance unknown	0.23	91.6	0.00	0.87	0.92	0.07	0.00	0.43	0.72	0.46	0.21	0.74	0.56	0.00	0.10	0.00	0.02	0.05	0.00	3.0
185-200-279 Base of green scarab seal 1889.110,Dyn. XVIII(cartouche of Amenhotep III),provenance unknown	0.00	79.1	2.47	1.91	0.27	0.00	0.00	0.22	0.01	0.00	0.00	2.03	0.18	0.00	8.09	0.00	0.44	2.31	0.00	2.9
185-200-280 Purple streaks on the back of green scarab seal 1892.226,Dyn. XVIII(cartouche of Queen Tiye),provenance unknown	0.00	90.4	0.42	0.71	0.84	0.34	0.06	0.08	0.43	0.00	0.00	2.43	0.06	0.00	0.61	0.00	0.98	0.02	0.08	2.5
185-200-282 Back of dark blue scarab seal 1933.675,Dyn. XVIII(cartouche of Amenhotep III),provenance unknown	0.50	88.6	0.13	0.81	0.59	0.05	0.07	0.00	0.19	0.00	0.00	3.79	0.00	0.00	0.00	0.00	0.25	0.00	0.00	5.0
185-200-283 Back of green scarab seal 1933.1462,Dyn. XVIII(cartouche of Amenhotep III),provenance unknown	0.00	90.8	0.00	0.90	0.83	0.06	0.05	0.00	0.08	0.26	0.00	2.95	0.11	0.00	0.00	0.00	0.34	0.00	0.00	3.6
185-200-284 Base of blue-green seal plaque 1890.412,Dyn. XVIII(cartouche of Amenhotep III),provenance unknown	0.00	86.3	0.00	6.94	1.21	0.07	0.00	0.02	0.43	0.02	0.00	1.75	0.07	0.03	0.00	0.00	0.33	0.02	0.00	2.8
185-200-285 White body material,fragment of green model coffin 1879.293,Dyn. XVIII(cartouche of Amenhotep III),provenance unknown	0.00	97.9	0.10	0.11	0.38	0.07	0.09	0.00	0.12											

X-RAY FLUORESCENCE ANALYSES OF INDIVIDUAL OBJECTS ARRANGED CHRONOLOGICALLY

Chloride and oxides of:

No. / Description	Si	S	K	Ca	Ti	V	Cr	Mn	Fe	Co	Ni	Cu	Zn	As	Pb	Sr	Sn	Sb	Ba	Other
185-200-285 — Greenish white model anthropoid coffin fragment 1879,293,Dyn. XVIII(cartouche of Amenhotep III),provenance unknown	0.42	95.3	0.00	0.69	0.71	0.02	0.03	0.08	0.06	0.00	0.00	0.10	0.04	0.00	0.00	0.00	0.02	0.00		2.5
185-200-285 — Violet hieroglyph on the base of pale green model coffin 1879,293,Dyn. XVIII(cartouche of Amenhotep III),provenance unknown	0.39	83.1	0.00	1.13	0.60	0.05	0.00	0.09	0.16	0.05	0.03	0.75	0.02	0.00	0.00	0.00	0.00	0.00		13.5
185-200-285 — Violet band on the edge of pale green model coffin 1879,293,Dyn. XVIII(cartouche of Amenhotep III),provenance unknown	0.35	82.3	0.00	1.75	1.51	0.02	0.00	0.07	0.37	0.05	0.02	0.47	0.00	0.00	0.00	0.00	0.00	0.00		13.1
186-68-334 — Blue body material,unglazed exterior of blue vase 1893.1-41(471),Dyn. XVIII(cartouche of Akhenaten),Tell el-Amarna	0.00	89.7	0.00	0.77	1.49	0.14	0.02	0.51	0.89	0.09	0.07	0.92	0.18	0.00	0.00	0.00	0.04	0.02		5.1
186-68-334 — Blue undecorated rim of vase fragment 1893.1-41(471),Dyn. XVIII(cartouche of Akhenaten),Tell el-Amarna	1.29	89.3	0.00	0.18	1.58	0.10	0.00	0.35	0.65	0.06	0.06	3.23	0.12	0.00	0.00	0.00	0.11	0.07		2.9
186-68-335 — Bluish body material,fragment of blue-green bowl 1893.1-41(472),Dyn. XVIII(cartouche of Akhenaten),Tell el-Amarna	0.00	94.5	0.25	0.34	1.02	0.07	0.11	0.04	0.16	0.08	0.01	0.09	0.00	0.00	0.00	0.00	0.00	0.00		2.8
186-68-335 — Blue-green hieroglyph set in indigo-blue fragment of bowl 1893.1-41(472),Dyn. XVIII(cartouche of Akhenaten),Tell el-Amarna	1.39	87.8	0.00	0.00	1.92	0.08	0.00	0.06	0.11	0.00	0.00	6.12	0.00	0.00	0.00	0.01	0.01	0.00		2.5
186-68-335 — Undecorated exterior of dark indigo-blue bowl fragment 1893.1-41(472),Dyn. XVIII(cartouche of Akhenaten),Tell el-Amarna	1.05	85.9	0.00	0.24	1.90	0.07	0.00	0.26	0.59	0.27	0.14	2.53	0.12	0.00	0.00	0.01	0.01	0.00		6.9
186-68-336 — White background,fragment of inscribed vase 1893.1-41(476),Dyn. XVIII(cartouche of Nefertiti),Tell el-Amarna	0.00	91.1	0.00	0.02	2.21	0.08	0.05	0.02	0.01	0.15	0.01	0.00	0.00	0.00	0.32	0.00	0.00	0.00		6.0
186-68-336 — Yellow decoration,set in white fragment of vase 1893.1-41(476),Dyn. XVIII(cartouche of Nefertiti),Tell el-Amarna	0.00	82.7	0.86	0.68	0.83	0.04	0.08	0.00	0.37	0.00	0.00	0.06	0.27	0.00	7.81	0.00	0.05	1.73	0.00	4.4
186-68-336 — Blue-grey decoration,set in white fragment of vase 1893.1-41(476),Dyn. XVIII(cartouche of Nefertiti),Tell el-Amarna	0.00	91.5	1.82	0.41	1.05	0.05	0.00	0.15	0.26	0.19	0.11	0.02	0.10	0.00	1.67	0.00	0.00	0.01	0.00	2.6
186-68-337 — White bezel of signet ring 1893.1-41(501),Dyn. XVIII(cartouche of Nefertiti),Tell el-Amarna	0.00	92.6	0.16	0.73	2.19	0.11	0.00	0.07	0.34	0.00	0.00	0.00	0.00	0.00	0.00	0.00	0.00	0.00	0.00	3.8
186-68-338 — Blue body material,unglazed side of green sistrum handle 1893.1-41(945),Dyn. XVIII(cartouche of Nefertiti),Tell el-Amarna	0.00	90.0	0.00	0.67	2.43	0.06	0.08	0.00	0.31	0.58	0.45	0.27	0.00	0.29	0.00	0.00	0.00	0.00	0.01	4.8
186-68-338 — Remains of green glaze on blue body of sistrum handle 1893.1-41(945),Dyn. XVIII(cartouche of Nefertiti),Tell el-Amarna	0.00	87.6	0.68	0.73	2.20	0.06	0.00	0.00	0.28	0.51	0.30	3.86	0.17	0.17	0.00	0.00	0.00	0.00	0.00	3.5
186-68-339 — White fragment of vase 1893.1-41(480),Dyn. XVIII(cartouche of Nefertiti),Tell el-Amarna	0.00	94.2	0.00	0.00	1.13	0.04	0.04	0.00	0.02	0.09	0.01	0.00	0.07	0.04	0.00	0.07	0.00	0.00	0.01	4.3
187-68-312 — Yellow-orange fragment of tile 1893.1-41(449D),Late Dyn. XVIII,Tell el-Amarna,Great Palace	0.00	81.4	2.41	0.70	1.17	0.00	0.03	0.00	0.08	0.27	0.00	0.00	0.18	0.43	6.25	0.00	0.02	1.17	0.00	5.9
187-68-312 — Brownish black stripe set in yellow fragment of tile 1893.1-41(449D),Late Dyn. XVIII,Tell el-Amarna,Great Palace	0.00	77.8	3.31	0.59	1.26	0.00	0.00	0.00	0.93	0.38	0.01	0.00	0.24	0.54	9.88	0.00	0.00	2.02	0.00	3.0
187-68-313 — White body material,fragment of green tile 1893.1-41(448F),Late Dyn. XVIII,Tell el-Amarna,Great Palace	0.00	95.4	0.00	0.22	0.92	0.06	0.06	0.00	0.11	0.30	0.00	0.00	0.00	0.00	0.00	0.00	0.00	0.00	0.00	2.9
187-68-313 — Green plant in relief,fragment of tile 1893.1-41(448F),Late Dyn. XVIII,Tell el-Amarna,Great Palace	0.00	84.6	1.68	0.58	1.29	0.00	0.00	0.00	0.16	0.00	0.00	1.62	0.21	0.00	5.46	0.00	0.17	0.97	0.00	3.3

X-RAY FLUORESCENCE ANALYSES OF INDIVIDUAL OBJECTS ARRANGED CHRONOLOGICALLY

Chloride and oxides of:

Object	Description	Si	S	K	Ca	Ti	V	Cr	Mn	Fe	Co	Ni	Cu	Zn	As	Pb	Sr	Sn	Sb	Ba	Other
187-68-314	Pale brown plant in relief,fragment of tile 1893.1-41(450C),Late Dyn. XVIII,Tell el-Amarna,Great Palace	0.00	88.0	0.41	0.00	3.38	0.07	0.05	0.00	0.50	0.38	0.00	0.05	0.00	0.00	0.08	0.00	0.00	0.01	0.01	7.1
187-68-315	White body material of polychrome tile 1936.637,Late Dyn. XVIII,Tell el-Amarna,Great Palace	0.00	95.8	0.00	0.17	0.46	0.05	0.05	0.00	0.09	0.27	0.00	0.00	0.03	0.00	0.00	0.00	0.00	0.00	0.00	3.1
187-68-315	White background,fragment of decorative tile 1936.637,Late Dyn. XVIII,Tell el-Amarna,Great Palace	0.17	92.9	0.16	0.00	1.66	0.04	0.06	0.00	0.09	0.14	0.00	0.00	0.00	0.00	0.31	0.00	0.00	0.01	0.00	4.5
187-68-315	Yellow tip of brown flower petal,raised relief on fragment of white tile 1936.637,Late Dyn. XVIII,Tell el-Amarna,Great Palace	0.00	89.9	0.00	0.39	1.28	0.18	0.00	0.06	1.93	0.00	0.00	0.22	0.00	0.00	1.90	0.00	0.00	0.46	0.00	3.7
187-68-315	Yellow tip of second brown flower petal,raised relief on white tile 1936.637,Late Dyn. XVIII,Tell el-Amarna,Great Palace	0.00	81.4	0.00	1.15	3.96	0.33	0.00	0.03	1.85	0.00	0.00	0.04	0.42	0.00	2.18	0.03	0.00	0.67	0.00	8.0
187-68-315	Purple stripe,set in white ground,fragment of tile 1936.637,Late Dyn. XVIII,Tell el-Amarna,Great Palace	0.47	89.1	0.46	0.03	4.15	0.12	0.00	0.00	0.26	0.91	0.09	0.03	0.00	0.15	0.00	0.42	0.00	0.00	0.00	3.8
187-68-316	Red decoration,raised relief on fragment of white tile 1936.637,Late Dyn. XVIII,Tell el-Amarna,Great Palace	0.00	89.9	0.00	0.24	0.80	0.00	0.00	0.00	4.04	0.02	0.00	0.02	0.00	0.00	0.19	0.00	0.00	0.00	0.00	4.8
187-68-317	Red design,surrounded by yellow,fragment of polychrome tile 1936.636,Late Dyn. XVIII,Tell el-Amarna,Great Palace	0.00	85.4	0.00	0.48	1.12	0.14	0.00	0.00	5.20	0.00	0.00	0.05	0.06	0.00	0.82	0.00	0.00	0.04	0.00	6.7
187-68-317	White background to design on fragment of polychrome tile 1924.75,Late Dyn. XVIII,Tell el-Amarna,house M50.32	0.39	93.4	0.00	0.00	1.57	0.00	0.00	0.00	0.08	0.00	0.00	0.07	0.01	0.00	0.23	0.00	0.06	0.00	0.00	4.2
187-68-317	Green leaf,part of design on fragment of polychrome tile 1924.75,Late Dyn. XVIII,Tell el-Amarna,house M50.32	0.00	85.5	1.14	0.39	0.89	0.00	0.00	0.00	0.15	0.00	0.00	3.03	0.11	0.00	4.61	0.00	0.28	1.20	0.00	2.6
187-68-318	Purple thistle,part of design on fragment of polychrome tile 1924.75,Late Dyn. XVIII,Tell el-Amarna,house M50.32	0.28	93.6	0.00	0.26	0.54	0.00	0.00	0.00	0.44	0.39	0.37	0.24	0.07	0.61	0.00	0.08	0.00	0.00	0.12	3.0
187-68-319	Indigo-blue Bes amulet 1924.112,Late Dyn. XVIII,Tell el-Amarna	0.66	87.3	0.00	2.08	1.44	0.05	0.00	0.65	0.64	0.19	0.04	3.61	0.22	0.00	0.00	0.00	0.14	0.00	0.00	3.0
187-68-319	Yellow area of flat mandrake,inlay 1924.115a,Late Dyn. XVIII,Tell el-Amarna	0.00	74.8	2.79	1.22	2.39	0.00	0.00	0.00	0.35	0.00	0.00	0.27	0.38	0.00	13.17	0.00	0.00	1.33	0.00	3.3
187-68-320	Green area of flat mandrake,inlay 1924.115a,Late Dyn. XVIII,Tell el-Amarna	0.00	66.2	2.05	0.95	8.68	0.00	0.00	0.00	0.32	0.00	0.00	3.62	0.11	0.00	12.20	0.00	0.44	1.65	0.00	3.7
187-68-320	White bottom section of a lotus flower,fragment of tile 1924.115b,Late Dyn. XVIII,Tell el-Amarna	0.27	91.3	0.08	0.12	1.58	0.00	0.04	0.00	0.06	0.00	0.00	0.05	0.00	0.00	0.31	0.00	0.00	0.01	0.00	6.2
187-68-320	Green edge of a lotus flower,fragment of tile 1924.115b,Late Dyn. XVIII,Tell el-Amarna	0.00	82.6	2.24	0.60	1.54	0.03	0.00	0.00	0.17	0.02	0.00	1.96	0.14	0.00	5.61	0.00	0.06	1.20	0.00	3.8
187-68-321	Dark blue tip of a lotus flower,fragment of tile 1924.115b,Late Dyn. XVIII,Tell el-Amarna	0.38	87.0	0.00	0.43	0.69	0.03	0.00	0.00	0.26	0.00	0.00	0.03	0.31	0.00	0.11	0.00	0.00	0.00	0.00	10.0
187-68-321	White background,fragment of decorative tile 1924.113c,Late Dyn. XVIII,Tell el-Amarna	0.27	92.3	0.26	0.00	2.53	0.04	0.00	0.00	0.05	0.16	0.00	0.00	0.03	0.00	0.00	0.00	0.00	0.00	0.00	4.4
187-68-321	Green bird-plumage,design on fragment of tile 1924.113c,Late Dyn. XVIII,Tell el-Amarna	0.00	90.8	1.37	0.30	1.19	0.03	0.14	0.00	0.27	0.01	0.00	0.46	0.12	0.00	2.53	0.00	0.03	0.37	0.00	2.3

X-RAY FLUORESCENCE ANALYSES OF INDIVIDUAL OBJECTS ARRANGED CHRONOLOGICALLY

Chloride and oxides of:

Object	Si	S	K	Ca	Ti	V	Cr	Mn	Fe	Co	Ni	Cu	Zn	As	Pb	Sr	Sn	Sb	Ba	Other
187-68-321 Black bird-plumage,design on fragment of tile 1924.113c,Late Dyn. XVIII,Tell el-Amarna	0.00	88.2	1.50	0.03	3.18	0.09	0.05	0.00	2.95	0.00	0.00	0.10	0.06	0.00	0.49	0.00	0.00	0.00	0.00	3.1
187-68-322 Creamy body material,fragment of polychrome inlay 1924.128,Late Dyn. XVIII,Tell el-Amarna	0.00	92.6	0.22	0.42	1.45	0.08	0.06	0.01	0.11	0.00	0.00	0.00	0.02	0.00	0.00	0.00	0.00	0.00	0.00	4.7
187-68-322 Red head of a duck,fragment of inlay 1924.128,Late Dyn. XVIII,Tell el-Amarna	0.48	85.0	0.00	1.95	3.08	0.09	0.00	0.00	2.87	0.01	0.00	0.18	0.00	0.00	0.66	0.01	0.05	0.00		5.6
187-68-323 Bluish grey body material,fragment of polychrome vase 1924.114,Late Dyn. XVIII,Tell el-Amarna,house M50.33	0.43	86.3	0.41	0.72	0.96	0.33	0.03	0.00	1.67	0.23	0.10	0.00	0.31	0.00	0.00	0.01	0.03	0.00		8.0
187-68-323 Violet blue exterior,fragment of polychrome vase 1924.114,Late Dyn. XVIII,Tell el-Amarna,house M50.33	0.37	89.1	0.00	0.89	2.82	0.08	0.00	0.00	0.82	0.29	0.10	1.80	0.23	0.00	0.00	0.06	0.20	0.00		2.7
187-68-324 Blue-grey body material,fragment of violet-blue model "Blue Crown" 1931.511,Late Dyn. XVIII,Tell el-Amarna,house T.34.1	0.00	92.9	0.00	0.26	0.50	0.06	0.08	0.00	0.24	0.37	0.15	0.00	0.14	0.00	0.00	0.00	0.00	0.00		5.2
187-68-324 Flat undecorated section of violet-blue model "Blue Crown" 1931.511,Late Dyn. XVIII,Tell el-Amarna,house T.34.1	0.62	88.1	0.00	0.59	1.29	0.07	0.00	0.00	0.32	0.35	0.23	2.68	0.20	0.00	0.08	0.00	0.04	0.00		5.3
187-68-325 White undecorated reverse side of fragment of tile 1929.407b,Late Dyn. XVIII,Tell el-Amarna,house U.35.24	0.29	90.1	0.00	0.02	4.35	0.02	0.02	0.00	0.14	0.00	0.00	0.19	0.04	0.00	0.46	0.00	0.01	0.11	0.11	4.1
187-68-325 Brown earth,part of design on fragment of polychrome tile 1929.407b,Late Dyn. XVIII,Tell el-Amarna,house U.35.24	0.75	85.9	0.05	0.72	1.12	0.01	0.01	0.00	2.94	0.32	0.19	1.00	0.27	0.00	0.26	0.00	0.05	0.13		6.1
187-68-326 Green plant,part of design on fragment of polychrome tile 1929.407a,Late Dyn. XVIII,Tell el-Amarna,house U.36.53	0.00	81.3	2.05	0.55	0.46	0.00	0.00	0.00	0.09	0.00	0.00	1.26	0.11	0.00	8.64	0.00	0.07	1.89	0.00	3.6
187-68-327 Yellow bezel of yellow finger ring 1934.265,Late Dyn. XVIII,Tell el-Amarna,houses Q42-3/50-2	0.00	61.6	5.23	2.05	3.10	0.00	0.00	0.00	0.42	0.00	0.00	0.18	0.62	0.00	19.29	0.00	0.03	2.98	0.00	4.4
187-68-328 Yellow finger ring 1934.264,Late Dyn. XVIII,Tell el-Amarna,houses Q42-3/50-2	0.00	72.8	4.21	1.96	0.61	0.00	0.00	0.00	0.12	0.00	0.00	0.07	0.28	0.00	7.87	0.00	1.15	0.00		10.9
187-68-328 Blue imitation gemstone mounted on yellow finger ring 1934.264,Late Dyn. XVIII,Tell el-Amarna,houses Q42-3/50-2	0.00	79.4	4.03	0.93	0.61	0.00	0.00	0.00	0.33	0.07	0.06	0.10	0.19	0.00	8.47	0.00	1.22	0.00		4.4
187-68-329 Back of green scarab seal 1932.1134b,Late Dyn. XVIII,Tell el-Amarna	0.00	83.2	2.49	0.47	0.68	0.00	0.00	0.00	0.41	0.02	0.00	3.87	0.39	0.00	4.85	0.00	0.45	1.91	0.00	1.3
187-68-330 Blue menat (inscribed in green) 1893.1-41(947),Late Dyn. XVIII,Tell el-Amarna	1.04	89.5	0.00	2.35	0.06	0.00	0.00	0.00	0.27	0.06	0.03	3.19	0.06	0.00	0.12	0.00	0.05	0.00		3.1
187-68-342 White body material,fragment of polychrome tile 1942.80,Late Dyn. XVIII,Tell el-Amarna	0.00	92.8	0.00	1.54	0.11	0.06	0.08	0.00	0.15	0.01	0.02	0.00	0.02	0.00	0.00	0.00	0.00	0.00		5.1
187-68-342 White glazed undecorated reverse side of polychrome tile 1942.80,Late Dyn. XVIII,Tell el-Amarna	0.79	89.4	0.20	3.70	0.00	0.00	0.00	0.00	0.02	0.13	0.00	0.06	0.06	0.00	0.00	0.00	0.03	0.03	0.00	5.6
187-68-342 Yellow square bordered by blue and green squares,fragment of polychrome tile 1942.80,Late Dyn. XVIII,Tell el-Amarna	0.00	84.1	11.51	0.82	2.10	0.15	0.00	0.00	0.89	0.09	0.00	0.34	0.30	0.00	4.27	0.00	0.00	0.52	0.00	4.9
187-68-342 Green square,part of checkered design on fragment of polychrome tile 1942.80,Late Dyn. XVIII,Tell el-Amarna	0.00	82.8	0.00	0.80	2.00	0.00	0.01	0.00	0.34	0.01	0.00	0.74	0.10	0.00	3.37	0.02	0.06	0.46	0.00	9.3

X-RAY FLUORESCENCE ANALYSES OF INDIVIDUAL OBJECTS ARRANGED CHRONOLOGICALLY

Chloride and oxides of:

Object	Si	S	K	Ca	Ti	V	Cr	Mn	Fe	Co	Ni	Cu	Zn	As	Pb	Sr	Sn	Sb	Ba	Other
187- 68-342 — Violet-blue hieroglyph (nb) on white area of polychrome tile 1942.80,Late Dyn. XVIII,Tell el-Amarna	0.39	81.6	0.00	2.28	3.71	0.08	0.00	0.15	0.61	0.15	0.05	0.08	0.23	0.00	0.24	0.02	0.04	0.13	0.39	9.8
187- 68-342 — Red square,part of checkered design on fragment of polychrome tile 1942.80,Late Dyn. XVIII,Tell el-Amarna	0.15	81.0	0.00	2.56	2.39	0.07	0.00	0.00	3.50	0.00	0.00	0.09	0.00	0.00	1.87	0.02	0.04	0.11	0.00	8.2
187- 68-343 — Another yellow square,part of checkered design on fragment of polychrome tile 1942.80,Late Dyn. XVIII,Tell el-Amarna	0.00	82.8	0.03	0.58	2.63	0.03	0.00	0.02	0.28	0.00	0.00	0.17	0.20	0.00	2.53	0.04	0.07	0.65	0.00	9.9
187- 68-344 — Indigo-blue fragment of vessel 1893.1-41(541),Late Dyn. XVIII,Tell el-Amarna	0.53	87.1	0.00	2.16	0.88	0.08	0.01	0.29	0.38	0.10	0.06	5.62	0.00	0.00	0.00	0.00	0.00	0.00	0.00	2.8
187- 68-345 — Grey body material of violet-blue jar-lid fragment 1893.1-41(481),Late Dyn. XVIII,Tell el-Amarna	0.20	93.4	0.00	1.19	1.21	0.11	0.01	0.40	0.65	0.17	0.09	0.03	0.20	0.00	0.00	0.00	0.00	0.00	0.00	2.4
187- 68-345 — Violet-blue jar-lid fragment 1893.1-41(481),Late Dyn. XVIII,Tell el-Amarna	0.58	86.7	0.00	1.60	2.83	0.12	0.01	0.50	0.63	0.26	0.21	1.13	0.21	0.00	0.00	0.00	0.01	0.00	0.00	5.2
187- 68-346 — Blue body material,fragment of violet statuette 1893.1-41(439),Late Dyn. XVIII,Tell el-Amarna	0.00	91.3	0.00	0.41	0.89	0.08	0.05	0.01	0.27	1.28	0.18	0.12	0.00	0.25	0.00	0.00	0.01	0.02	0.00	5.1
187- 68-346 — Violet hand,fragment of statuette 1893.1-41(439),Late Dyn. XVIII,Tell el-Amarna	0.45	88.5	0.16	1.45	2.16	0.09	0.02	0.22	0.54	0.22	0.16	0.59	0.30	0.01	0.00	0.00	0.00	0.00	0.00	5.1
187- 68-347 — Smooth ungranulated half of violet-blue model grapes 1931.509,Late Dyn. XVIII,Tell el-Amarna	0.84	88.7	0.00	1.37	1.05	0.08	0.00	0.49	0.83	0.38	0.14	2.09	0.23	0.00	0.13	0.00	0.53	0.04	0.00	3.1
187- 68-348 — Pale olive-green area of inlay fragment 1893.1-41(451),Late Dyn. XVIII,Tell el-Amarna	1.51	85.0	0.00	0.25	0.60	0.00	0.00	1.72	0.21	0.00	0.00	5.37	0.00	0.00	0.13	0.00	0.27	0.00	0.00	4.9
187- 68-348 — Dark olive-grey area of inlay fragment 1893.1-41(451),Late Dyn. XVIII,Tell el-Amarna	1.51	80.8	0.00	0.53	0.78	0.08	0.00	3.58	0.10	0.00	0.00	8.16	0.00	0.00	0.16	0.00	0.38	0.00	0.00	3.9
187- 68-349 — Smooth edge of dark blue-grey fragment of inlay 1921.1134,Late Dyn. XVIII,Tell el-Amarna	0.54	84.7	0.00	1.70	1.64	0.01	0.02	1.28	0.12	0.00	0.00	7.60	0.00	0.00	0.00	0.00	0.70	0.00	0.18	1.5
187- 68-350 — Greyish body material of dark blue model bundle of grapes 1921.1156,Late Dyn. XVIII,Tell el-Amarna	0.00	87.5	0.00	0.54	2.31	0.09	0.04	0.07	0.62	0.03	0.01	0.15	0.02	0.00	0.01	0.00	0.00	0.00	0.00	8.6
187- 68-350 — Dark-blue model bundle of grapes 1921.1156,Late Dyn. XVIII,Tell el-Amarna	0.94	87.6	0.13	0.44	0.92	0.04	0.00	0.37	0.44	0.18	0.05	5.09	0.09	0.00	0.13	0.00	0.32	0.00	0.00	3.2
187- 68-351 — Undecorated concave side of violet-blue bracelet fragment 1924.123,Late Dyn. XVIII,Tell el-Amarna	0.51	88.3	0.18	0.57	0.59	0.04	0.00	0.51	0.44	0.32	0.06	0.94	0.18	0.00	0.17	0.00	0.06	0.03	0.00	7.1
187- 58-353 — White body material of polychrome vase fragment 1942.77,Late Dyn. XVIII,Tell el-Amarna	0.00	95.1	0.00	0.55	0.48	0.01	0.02	0.01	0.13	0.00	0.01	0.36	0.02	0.00	0.00	0.00	0.00	0.00	0.00	3.3
187- 58-353 — Blue-green spot embedded in the body material of polychrome vase 1942.77,Late Dyn. XVIII,Tell el-Amarna	0.00	92.1	0.00	0.23	0.90	0.02	0.03	0.00	0.17	0.04	0.01	0.35	0.00	0.00	0.00	0.00	0.00	0.00	0.00	6.2
187- 68-353 — Pale blue rim of fragment of polychrome vase 1942.77,Late Dyn. XVIII,Tell el-Amarna	0.58	88.1	0.00	1.45	1.83	0.00	0.06	0.07	0.18	0.01	0.00	1.41	0.04	0.00	0.00	0.00	0.17	0.02	0.00	6.0
187- 68-353 — Violet-blue plant stem,set in pale blue ground,fragment of polychrome vase 1942.77,Late Dyn. XVIII,Tell el-Amarna	0.67	91.7	0.01	1.39	0.94	0.05	0.02	0.23	0.27	0.06	0.03	1.39	0.07	0.01	0.00	0.00	0.09	0.01	0.00	3.0

X-RAY FLUORESCENCE ANALYSES OF INDIVIDUAL OBJECTS ARRANGED CHRONOLOGICALLY

Chloride and oxides of:

187-68-353 — Red flowers,set in pale blue ground,fragment of polychrome vase 1942.77,Late Dyn. XVIII,Tell el-Amarna

187-68-354 — Red body of red inlay plaque 1935.590a,Late Dyn. XVIII,Tell el-Amarna

187-68-354 — Red circular inlay-plaque 1935.590a,Late Dyn. XVIII,Tell el-Amarna

187-68-355 — Blue exterior of bowl fragment 1893.1-41(482),Late Dyn. XVIII,Tell el-Amarna

187-68-356 — Dark green model flower-calyx,pendant 1931.510,Late Dyn. XVIII,Tell el-Amarna

187-68-357 — Green finger ring 1932.1132,Late Dyn. XVIII,Tell el-Amarna

187-68-357 — Violet bezel of green finger ring 1932.1132,Late Dyn. XVIII,Tell el-Amarna

187-68-357 — Red imitation gemstone,framed in violet and mounted on green finger ring 1932.1132,Late Dyn. XVIII,Tell el-Amarna

187-68-358 — Pale green wedjat-eye,bezel of finger ring 1924.109b,Late Dyn. XVIII,Tell el-Amarna

187-68-359 — Blue wedjat-eye,open-work bezel of finger ring 1924.109a,Late Dyn. XVIII,Tell el-Amarna

187-68-360 — Deep blue wedjat-eye,bezel of finger ring 1924.154,Late Dyn. XVIII,Tell el-Amarna

187-68-361 — White interior surface of bowl fragment 1929.406,Late Dyn. XVIII,Tell el-Amarna

187-68-361 — Brownish black design,exterior of white bowl fragment 1929.406,Late Dyn. XVIII,Tell el-Amarna

187-68-797 — Red body material of red inlay fragment 1936.635d,Late Dyn. XVIII,Tell el-Amarna

187-68-797 — Red exterior of red-bodied inlay fragment 1936.635d,Late Dyn. XVIII,Tell el-Amarna

188-200-401 — Reverse side of violet bezel,fragment of signet ring 1892.789,Dyn. XVIII(cartouche of Tutankhamun),provenance unknown

188-200-402 — Blue-green bezel,fragment of signet ring 1933.54,Dyn. XVIII(cartouche of Tutankhamun),provenance unknown

189-137-403 — Pale blue signet ring 1933.62,Dyn. XVIII(cartouche of Horemhab),Gebel el Silsila

189-200-404 — Dark blue bezel,fragment of signet ring 1933.56,Dyn. XVIII(cartouche of Horemhab),provenance unknown

Object	Si	S	K	Ca	Ti	V	Cr	Mn	Fe	Co	Ni	Cu	Zn	As	Pb	Sr	Sn	Sb	Ba	Other
187-68-353	0.65	83.7	0.10	4.28	1.22	0.11	0.00	0.00	5.49	0.06	0.00	0.95	0.03	0.00	0.00	0.00	0.02	0.00	0.00	3.4
187-68-354	0.07	90.3	0.00	0.81	1.66	0.16	0.02	0.01	5.44	0.06	0.00	0.06	0.02	0.00	0.01	0.00	0.00	0.00	0.00	1.4
187-68-354	0.38	86.6	0.16	0.60	0.59	0.07	0.00	0.00	4.85	0.04	0.00	0.03	0.00	0.00	0.05	0.00	0.00	0.01	0.00	6.7
187-68-355	0.50	90.4	0.00	0.27	0.28	0.00	0.05	0.00	0.08	0.01	0.00	4.18	0.00	0.00	0.00	0.00	0.46	0.00	0.00	3.8
187-68-356	0.00	79.8	1.40	1.14	1.15	0.00	0.00	0.07	0.20	0.01	0.00	4.36	0.24	0.00	6.43	0.00	0.32	1.68	0.00	3.2
187-68-357	0.00	85.3	2.33	0.56	0.67	0.00	0.04	0.00	0.09	0.00	0.00	2.15	0.19	0.00	5.03	0.00	0.08	0.94	0.00	2.6
187-68-357	0.00	85.6	2.27	0.40	1.49	0.04	0.00	0.68	0.52	0.25	0.17	0.95	0.17	0.00	3.30	0.00	0.02	0.00	0.00	4.2
187-68-357	0.00	85.2	1.42	0.35	0.82	0.07	0.00	0.00	4.87	0.03	0.00	0.46	0.04	0.00	1.77	0.00	0.00	0.01	0.00	5.0
187-68-358	0.00	80.7	2.40	0.59	1.04	0.00	0.00	0.00	0.20	0.00	0.00	2.69	0.16	0.00	6.79	0.00	0.35	1.09	0.00	4.0
187-68-359	0.00	91.0	0.00	0.48	0.43	0.00	0.04	0.00	0.04	0.00	0.00	4.98	0.00	0.00	0.00	0.00	0.24	0.00	0.00	2.8
187-68-360	0.71	87.3	0.00	1.42	0.76	0.00	0.00	0.00	0.04	0.00	0.00	6.19	0.00	0.00	0.00	0.00	0.16	0.00	0.00	3.4
187-68-361	0.65	92.6	0.20	0.08	2.68	0.02	0.00	0.02	0.07	0.01	0.00	0.08	0.03	0.00	0.10	0.00	0.00	0.03	0.00	3.4
187-68-361	0.38	92.7	0.00	0.17	1.54	0.00	0.02	1.08	0.09	0.01	0.00	0.13	0.09	0.03	0.05	0.00	0.02	0.00	0.00	3.6
187-68-797	0.00	84.5	0.00	1.44	1.68	0.20	0.00	0.00	6.00	0.00	0.00	0.00	0.00	0.00	0.00	0.00	0.00	0.00	0.00	6.1
187-68-797	0.10	86.5	0.00	0.81	1.80	0.09	0.00	0.01	4.82	0.00	0.00	0.04	0.00	0.00	0.00	0.01	0.00	0.00	0.00	5.8
188-200-401	0.18	93.1	0.14	1.89	0.53	0.07	0.05	0.20	0.45	0.13	0.09	0.28	0.17	0.00	0.00	0.03	0.03	0.02	0.00	2.7
188-200-402	0.45	90.3	0.00	0.17	0.32	0.04	0.00	0.00	0.24	0.00	0.00	4.70	0.00	0.00	0.10	0.00	0.35	0.06	0.00	3.3
189-137-403	0.00	92.9	0.14	0.41	0.64	0.10	0.07	0.22	0.00	0.00	0.00	2.44	0.00	0.00	0.08	0.00	0.29	0.03	0.00	2.6
189-200-404	0.68	88.7	0.00	0.45	0.67	0.07	0.02	0.00	0.06	0.00	0.00	5.00	0.00	0.00	0.00	0.00	0.39	0.00	0.00	4.0

X-RAY FLUORESCENCE ANALYSES OF INDIVIDUAL OBJECTS ARRANGED CHRONOLOGICALLY

Object	Chloride and oxides of:	Si	S	K	Ca	Ti	V	Cr	Mn	Fe	Co	Ni	Cu	Zn	As	Pb	Sr	Sn	Sb	Ba	Other
189-200-405	Dark blue bezel, fragment of signet ring 1968.111,Dyn. XVIII(cartouche of Horemhab),provenance unknown	0.66	86.1	0.00	1.28	1.00	0.00	0.00	0.00	0.05	0.00	0.00	6.81	0.00	0.00	0.00	0.00	0.49	0.00	0.00	3.6
190-53-377	Blue pilgrim flask 1890.897,Early Dyn. XIX,Medinet Ghurab,Petrie's "group of Amenhotep III"	0.36	87.7	0.00	0.00	2.12	0.00	0.03	0.00	0.07	0.14	0.00	2.61	0.00	0.00	0.11	0.00	0.33	0.00	0.00	6.5
190-53-378	Grey body material,fragment of blue dish 1890.898,Early Dyn. XIX,Medinet Ghurab,Petrie's "group of Amenhotep III"	0.14	92.0	0.00	0.30	0.87	0.07	0.05	0.01	0.80	0.00	0.00	0.15	0.00	0.00	0.09	0.00	0.00	0.00	0.00	5.6
190-53-378	Blue interior surface of dish fragment 1890.898,Early Dyn. XIX,Medinet Ghurab,Petrie's "group of Amenhotep III"	0.00	89.8	0.00	0.56	1.25	0.07	0.03	0.00	0.06	0.08	0.00	3.20	0.00	0.00	1.13	0.00	0.22	0.00	0.00	3.6
190-53-378	Black band along the rim of blue dish 1890.898,Early Dyn. XIX,Medinet Ghurab,Petrie's "group of Amenhotep III"	0.43	85.0	0.00	1.02	0.87	0.07	0.00	0.00	0.71	0.00	0.00	0.71	0.03	0.00	0.29	0.00	0.10	0.00	0.03	2.9
190-53-379	Reddish purple streaks on blue exterior of dish 1890.898,Early Dyn. XIX,Medinet Ghurab,Petrie's "group of Amenhotep III"	0.63	88.9	0.08	0.58	0.64	0.03	0.05	0.00	0.00	0.15	0.00	1.95	0.00	0.00	0.54	0.00	0.13	0.00	0.00	6.3
190-53-380	Pale blue cylindrical kohl-tube 1890.905,Early Dyn. XIX,Medinet Ghurab,Petrie's "group of Amenhotep III"	0.58	90.6	0.00	0.10	2.12	0.07	0.00	0.00	0.25	0.00	0.00	2.78	0.00	0.00	0.09	0.00	0.22	0.04	0.00	3.2
190-53-381	Pale blue vessel 1890.901,Early Dyn. XIX,Medinet Ghurab,Petrie's "group of Amenhotep III"	0.00	87.0	0.30	0.25	1.18	0.07	0.03	0.00	0.05	0.17	0.01	2.73	0.00	0.00	0.19	0.02	0.00	0.00	0.00	8.0
190-53-381	Grey body material,fragment of blue kohl-tube 1890.906,Early Dyn. XIX,Medinet Ghurab,Petrie's "group of Amenhotep III"	0.00	86.4	0.31	0.74	1.32	0.06	0.01	0.00	0.99	1.85	0.17	0.20	0.03	0.24	0.00	0.00	0.12	0.00	0.00	7.5
190-53-381	Blue interior surface of kohl-tube 1890.906,Early Dyn. XIX,Medinet Ghurab,Petrie's "group of Amenhotep III"	0.00	88.0	0.00	0.82	0.71	0.09	0.06	0.00	0.49	0.53	0.32	0.58	0.25	0.00	0.10	0.00	0.00	0.01	0.00	7.8
190-53-382	Black area on the exterior of blue kohl-tube 1890.906,Early Dyn. XIX,Medinet Ghurab,Petrie's "group of Amenhotep III"	0.48	90.6	0.35	1.89	1.56	0.13	0.02	0.00	0.71	0.29	0.22	0.29	0.25	0.00	0.10	0.00	0.01	0.01	0.00	2.6
190-53-382	Green finger ring 1890.925,Early Dyn. XIX,Medinet Ghurab,Petrie's "group of Amenhotep III"	0.00	86.4	0.24	0.05	4.88	0.00	0.00	0.00	0.06	0.00	0.00	3.77	0.00	0.00	0.00	0.30	0.00	0.00	0.00	4.3
190-53-693	Dark blue-green finger ring U.C.12361,Early Dyn. XIX,Medinet Ghurab,Petrie's "group of Amenhotep III"	0.34	87.7	0.01	0.74	1.10	0.02	0.00	0.00	0.11	0.00	0.00	5.52	0.05	0.00	0.75	0.00	0.66	0.01	0.00	2.9
190-53-694	Inscribed face of blue plaque U.C.12354,Early Dyn. XIX,Medinet Ghurab,Petrie's "group of Amenhotep III"	1.06	84.2	0.08	3.40	1.09	0.02	0.00	0.00	0.22	0.00	0.00	5.49	0.03	0.00	0.04	0.00	0.67	0.01	0.00	3.7
190-53-694	Smooth convex back of blue plaque U.C.12354,Early Dyn. XIX,Medinet Ghurab,Petrie's "group of Amenhotep III"	0.40	88.3	0.18	1.81	1.16	0.07	0.00	0.00	0.03	0.00	0.00	3.48	0.03	0.00	0.03	0.00	0.50	0.03	0.00	3.6
190-53-695	Yellow bead,first from string U.C.27901ii,Early Dyn. XIX,Medinet Ghurab,"burnt" deposit of Tutankhamun	0.34	81.5	1.67	0.91	1.31	0.00	0.00	0.01	0.32	0.00	0.00	0.02	0.42	0.00	2.10	0.01	0.05	0.59	0.00	10.8
190-53-696	Yellow bead,second from string U.C.27901ii,Early Dyn. XIX,Medinet Ghurab,"burnt" deposit of Tutankhamun	0.29	81.9	1.64	0.69	1.76	0.03	0.00	0.00	0.01	0.00	0.00	0.04	0.55	0.00	3.52	0.02	0.11	0.92	0.00	8.0
190-53-697	Red-brown bead,third from string U.C.27901ii,Early Dyn. XIX,Medinet Ghurab,"burnt" deposit of Tutankhamun	0.51	85.3	0.45	2.21	2.21	0.14	0.00	0.00	0.49	0.00	0.00	1.08	0.08	0.00	0.05	0.00	0.04	0.00	0.00	7.5
191-38-362	Remains of green glaze,model wand E.3320,Dyn. XIX(cartouche of Seti I),Serabit el Khadim,temple of Hathor	0.00	87.8	0.00	0.88	0.82	0.15	0.00	0.00	0.35	0.01	0.00	3.34	0.00	0.00	0.05	0.00	0.28	0.05	0.00	6.3

X-RAY FLUORESCENCE ANALYSES OF INDIVIDUAL OBJECTS ARRANGED CHRONOLOGICALLY

Chloride and oxides of:

ID	Description	Si	S	K	Ca	Ti	V	Cr	Mn	Fe	Co	Ni	Cu	Zn	As	Pb	Sr	Sn	Sb	Ba	Other
191-118-395	Dark blue right elbow of ushabti, Queens College Loan No. 44, Dyn. XIX, Thebes, tomb of Seti I	0.28	85.8	0.23	3.97	1.40	0.00	0.00	0.06	0.11	0.00	0.00	4.70	0.00	0.00	0.00	0.00	0.16	0.03	0.00	3.2
192-38-363	Undecorated concave side of green bracelet E.4458A, Dyn. XIX (cartouche of Ramesses II), Serabit el Khadim, temple of Hathor	0.00	85.0	0.00	0.06	1.98	0.04	0.05	0.00	0.16	0.01	0.00	1.93	0.00	0.00	0.00	0.00	0.97	0.03	0.00	9.8
192-53-383	Highly vitrified green finger ring 1890.1117, Dyn. XIX (Ramesses II), Medinet Ghurab, group 4	0.31	92.8	0.00	0.21	0.59	0.07	0.04	0.00	0.06	0.15	0.00	2.53	0.00	0.01	0.00	0.00	0.27	0.00	0.00	3.0
192-53-384	Grey body material, large gap in blue pilgrim flask 1890.953, Dyn. XIX (Ramesses II), Medinet Ghurab, group 4	0.27	87.7	1.38	3.39	1.77	0.12	0.05	0.00	0.98	0.00	0.00	1.65	0.03	0.01	0.00	0.00	0.00	0.00	0.00	2.6
192-53-384	Dark blue band below the neck of pilgrim flask 1890.953, Dyn. XIX (Ramesses II), Medinet Ghurob, group 4	0.49	86.1	0.00	2.72	0.61	0.08	0.00	0.11	0.31	0.00	0.00	5.69	0.00	0.03	0.00	0.00	0.60	0.00	0.00	3.2
192-118-396	Blue model flower E.3370, Dyn. XIX (Ramesses II), Thebes, Ramesseum, foundation deposit	0.75	86.7	0.00	0.79	0.94	0.00	0.00	0.00	0.16	0.00	0.00	4.03	0.00	0.00	0.07	0.00	0.30	0.03	0.00	6.3
192-120-397	Green model flower 1909.1069, Dyn. XIX (Ramesses II), Qurna, temple foundation deposit	0.00	90.4	0.00	0.17	0.80	0.06	0.05	0.00	0.25	0.01	0.00	2.40	0.00	0.00	0.00	0.00	1.20	0.09	0.00	4.6
193-26-660	Base of green seal amulet 1872.169, Dyn. XIX, Giza	0.12	91.3	0.11	0.81	1.52	0.10	0.04	0.04	0.65	0.00	0.00	1.60	0.03	0.00	0.00	0.00	0.10	0.05	0.07	3.5
193-38-650	Pale blue body material, chipped corner of blue jar lid E.2445, Dyn. XIX, Serabit el Khadim, temple of Hathor	0.00	82.4	0.07	0.99	3.87	0.19	0.02	0.00	0.45	0.00	0.00	0.86	0.03	0.00	0.00	0.00	0.00	0.00	0.00	10.2
193-38-650	Blue conical jar lid E.2445, Dyn. XIX, Serabit el Khadim, temple of Hathor	0.40	86.0	0.32	0.54	1.60	0.01	0.02	0.00	0.19	0.00	0.00	5.20	0.00	0.00	0.00	0.00	0.00	0.02	0.10	5.6
193-38-651	Fragment of green vase decorated in blue E.2656, Dyn. XIX, Serabit el Khadim, temple of Hathor	0.02	92.3	0.26	0.21	1.98	0.05	0.07	0.00	0.03	0.12	0.00	1.72	0.02	0.00	0.00	0.00	0.00	0.00	0.00	3.2
193-38-651	Violet-blue decoration on green vase fragment E.2656, Dyn. XIX, Serabit el Khadim, temple of Hathor	0.00	92.0	0.08	0.42	1.60	0.03	0.04	0.00	0.15	0.14	0.08	1.63	0.08	0.00	0.00	0.00	0.01	0.03	0.00	3.7
193-38-652	Fragment of blue-green bracelet E.3325, Dyn. XIX, Serabit el Khadim, temple of Hathor	0.00	89.6	0.26	0.02	1.15	0.07	0.07	0.00	0.04	0.25	0.00	1.88	0.00	0.00	0.00	0.00	0.58	0.08	0.03	6.0
193-38-655	Creamy body material, truncated head of blue cat 1911.614A, Dyn. XIX, Serabit el Khadim, temple of Hathor	0.11	92.5	0.22	0.33	1.51	0.12	0.07	0.00	0.05	0.00	0.00	0.88	0.04	0.00	0.00	0.00	0.09	0.01	0.00	3.5
193-38-655	Left cheek of dark blue head of model cat 1911.614A, Dyn. XIX, Serabit el Khadim, temple of Hathor	0.00	91.5	0.17	0.53	0.84	0.09	0.04	0.03	0.14	0.01	0.00	2.47	0.01	0.00	0.02	0.00	0.42	0.06	0.00	3.7
193-38-656	White body material, fragment of blue vase 1911.614B, Dyn. XIX, Serabit el Khadim, temple of Hathor	0.00	94.6	0.12	0.05	0.31	0.03	0.06	0.00	0.07	0.28	0.00	0.09	0.05	0.00	0.00	0.00	0.02	0.05	0.00	4.4
193-38-656	Fragment of pale blue vase 1911.614B, Dyn. XIX, Serabit el Khadim, temple of Hathor	0.02	90.0	0.01	0.63	0.87	0.07	0.05	0.00	0.05	0.18	0.00	2.40	0.00	0.00	0.00	0.00	0.02	0.05	0.00	5.7
193-38-656	Black decoration on blue fragment of vase 1911.614B, Dyn. XIX, Serabit el Khadim, temple of Hathor	0.19	85.0	0.31	1.68	2.05	0.08	0.03	0.00	1.31	0.00	0.00	3.28	0.00	0.00	0.00	0.00	0.02	0.02	0.08	5.4
193-80-391	Right elbow of white ushabti 1923.605, Dyn. XIX, Qau, grave 317	0.00	94.3	0.40	0.41	2.01	0.06	0.00	0.02	0.17	0.00	0.00	0.04	0.00	0.00	0.00	0.00	0.00	0.00	0.00	2.5

X-RAY FLUORESCENCE ANALYSES OF INDIVIDUAL OBJECTS ARRANGED CHRONOLOGICALLY

Object (Chloride and oxides of:)	Si	S	K	Ca	Ti	V	Cr	Mn	Fe	Co	Ni	Cu	Zn	As	Pb	Sr	Sn	Sb	Ba	Other
193- 80-391 Dark brown wig of white ushabti 1923.605,Dyn. XIX,Qau,grave 317	0.25	81.3	0.65	0.90	0.00	0.10	0.00	7.57	2.03	0.00	0.00	0.12	0.06	0.00	0.00	0.00	0.01	0.02	0.00	4.2
193- 80-391 Red crossed hands of white ushabti 1923.605,Dyn. XIX,Qau,grave 317	0.35	87.7	0.16	1.44	2.66	0.12	0.00	0.06	4.28	0.00	0.00	0.19	0.00	0.00	0.00	0.15	0.02	0.04	0.00	2.9
193-107-392 Deep blue right hip of ushabti E.3622,Dyn. XIX,Abydos,tomb D14	0.00	89.9	0.00	0.37	0.47	0.13	0.08	0.00	0.10	0.01	0.00	5.11	0.00	0.00	0.23	0.00	0.14	0.00	0.00	3.4
193-107-393 Pale blue-green right cheek of ushabti E.3595,Dyn. XIX,Abydos,grave E269	0.00	88.8	0.00	0.23	0.30	0.11	0.04	0.08	0.11	0.00	0.00	2.06	0.00	0.00	0.00	0.18	0.00	0.00	8.1	
194- 38-364 Green interior surface of vessel fragment E.3333,Dyn. XIX(cartouche of Merneptah),Serabit el Khadim,temple of Hathor	0.00	91.0	0.29	0.06	0.78	0.06	0.09	0.02	0.32	0.00	0.00	2.00	0.00	0.00	0.00	0.41	0.03	0.00		4.9
194- 38-364 Black hieroglyph on fragment of green vessel E.3333,Dyn. XIX(cartouche of Merneptah),Serabit el Khadim,temple of Hathor	0.40	88.6	0.28	0.30	0.96	0.07	0.06	0.02	0.54	0.00	0.00	1.76	0.00	0.00	0.00	0.00	0.00	0.00		5.8
194- 38-365 Pale green wand fragment E.3322,Dyn. XIX(cartouche of Merneptah),Serabit el Khadim,temple of Hathor	0.00	91.7	0.00	0.21	2.88	0.06	0.10	0.00	0.06	0.22	0.00	2.13	0.00	0.00	0.00	0.35	0.04	0.00		2.3
194- 38-366 Grey body material,fragment of green vase E.4455b,Dyn. XIX(cartouche of Merneptah),Serabit el Khadim,temple of Hathor	0.00	92.1	0.00	0.38	0.29	0.09	0.09	0.01	0.31	0.01	0.00	1.07	0.00	0.00	0.00	0.08	0.02	0.00		5.5
194- 38-366 Green undecorated rim of vase fragment E.4455b,Dyn. XIX(cartouche of Merneptah),Serabit el Khadim,temple of Hathor	0.00	89.5	0.92	0.42	1.82	0.09	0.07	0.00	0.17	0.00	0.01	2.82	0.00	0.00	0.41	0.12	0.00			3.5
194- 38-367 Blue-green interior surface of vessel fragment E.4455a,Dyn. XIX(cartouche of Merneptah),Serabit el Khadim,temple of Hathor	0.34	92.4	0.11	0.14	1.08	0.07	0.05	0.00	0.29	0.00	0.00	3.31	0.00	0.00	0.00	0.91	0.00	0.00		1.2
194- 38-653 Blue undecorated rim of vase fragment E.4455e,Dyn. XIX(cartouche of Merneptah),Serabit el Khadim,temple of Hathor	0.41	89.0	0.02	0.61	1.10	0.00	0.06	0.00	0.05	0.09	0.00	4.33	0.00	0.00	0.18	0.00	0.49	0.08	0.00	3.6
194- 38-653 Black band on blue rim of vase fragment E.4455e,Dyn. XIX(cartouche of Merneptah),Serabit el Khadim,temple of Hathor	0.31	87.7	0.03	0.81	1.17	0.04	0.01	0.00	0.10	0.00	0.00	4.65	0.00	0.01	0.00	0.49	0.07	0.00		4.3
195- 38-368 Undecorated concave side of blue bracelet E.3324,Dyn. XIX(cartouche of Seti II),Serabit el Khadim,temple of Hathor	0.00	86.2	0.00	0.00	5.64	0.05	0.07	0.00	0.32	0.10	0.00	4.25	0.00	0.02	0.00	0.52	0.04	0.00		3.0
195- 53-385 Dark blue neck area of pilgrim flask 1890.986,Dyn. XIX(Seti II),Medinet Ghurab,group 1	0.00	88.3	0.23	1.66	0.70	0.09	0.04	0.00	0.07	0.02	0.00	3.59	0.00	0.03	0.00	0.50	0.01	0.00		4.5
195- 53-386 Grey body material,unglazed flat side of jar lid 1890.1001,Dyn. XIX(Seti II),Medinet Ghurab,group 1	0.27	90.8	0.03	0.41	1.17	0.12	0.05	0.00	0.09	1.37	0.00	0.07	0.00	0.00	0.08	0.00	0.01	0.00		5.5
195- 53-386 Blue convex side of jar lid 1890.1001,Dyn. XIX(Seti II),Medinet Ghurab,group 1	0.49	86.2	0.17	2.49	2.15	0.08	0.00	0.43	0.63	0.13	0.16	1.96	0.10	0.00	0.14	0.00	0.06	0.04	0.00	4.7
195- 53-386 Blackened edge of blue jar lid 1890.1001,Dyn. XIX(Seti II),Medinet Ghurab,group 1	0.47	85.0	0.28	1.14	1.37	0.06	0.02	0.00	0.45	0.58	0.11	1.65	0.11	0.00	0.12	0.00	0.04	0.02	0.03	8.4
195- 53-387 Green wedjat-eye,bezel of finger ring 1890.1014,Dyn. XIX(Seti II),Medinet Ghurab,group 1	0.64	85.3	0.29	0.27	0.39	0.00	0.00	0.00	0.14	0.01	0.00	5.24	0.00	0.00	0.15	0.00	1.10	0.00	0.00	6.5
196-118-398 Green finger ring E.3391,Dyn. XIX(Siptah),Thebes,temple of Siptah,foundation deposit	0.00	88.0	0.32	0.00	0.96	0.00	0.00	0.00	0.07	0.00	0.00	5.78	0.00	0.00	0.00	0.00	0.58	0.00	0.00	4.3

X-RAY FLUORESCENCE ANALYSES OF INDIVIDUAL OBJECTS ARRANGED CHRONOLOGICALLY

Chloride and oxides of:	Si	S	K	Ca	Ti	V	Cr	Mn	Fe	Co	Ni	Cu	Zn	As	Pb	Sr	Sn	Sb	Ba	Other
196-118-399 — Blue model flower E.3384,Dyn. XIX,Thebes,temple of Tawosre,foundation deposit	0.00	80.9	0.40	7.90	0.07	0.00	0.00	0.00	0.08	0.00	0.00	7.09	0.00	0.02	0.00	0.00	0.45	0.00	0.00	3.1
200- 10-659 — Pale green body material,damaged base of green gaming piece 1888.266,New Kingdom,Tukh el Qaramus	0.00	98.2	0.14	0.00	0.17	0.07	0.10	0.00	0.24	0.00	0.00	0.21	0.00	0.00	0.00	0.00	0.05	0.00	0.00	0.8
200- 10-659 — Remains of pale green glaze,gaming piece 1888.266,New Kingdom,Tukh el Qaramus	0.00	92.0	0.35	0.15	1.00	0.06	0.16	0.00	0.22	0.00	0.00	0.59	0.05	0.00	0.00	0.00	1.09	0.06	0.00	4.2
200- 26-661 — Pale green wig of ushabti 1872.940,Dyn. XIX-XX,Giza	0.00	89.9	0.13	0.00	2.59	0.09	0.09	0.00	0.11	0.34	0.00	2.56	0.01	0.02	0.00	0.00	0.94	0.30	0.00	3.0
200- 53-388 — Green left buttock of ushabti E.3570,Dyn. XIX-XX,Medinet Ghurab,grave O4	0.00	87.1	0.00	0.04	0.45	0.03	0.07	0.00	0.05	0.21	0.00	2.14	0.00	0.00	0.00	0.00	1.43	0.05	0.00	8.4
200- 53-388 — Black wig of green ushabti E.3570,Dyn. XIX-XX,Medinet Ghurab,grave O4	0.27	89.2	0.00	0.03	0.67	0.05	0.00	0.00	1.66	0.19	0.00	1.55	0.00	0.00	0.00	0.00	0.79	0.02	0.00	5.6
200- 53-389 — Blue-green right knee of ushabti E.3585,Dyn. XIX-XX,Medinet Ghurab,grave O1	0.54	91.8	0.19	0.07	0.63	0.00	0.00	0.00	0.09	0.00	0.00	3.06	0.00	0.00	0.06	0.00	0.41	0.02	0.00	3.1
200-200-407 — White right arm of ushabti 1879.272,Dyn. XIX-XX,provenance unknown	0.15	94.5	0.00	0.78	0.92	0.03	0.02	0.00	0.02	0.03	0.00	0.12	0.02	0.00	0.00	0.00	0.00	0.02	0.02	3.4
200-200-407 — Brown wig of white ushabti 1879.272,Dyn. XIX-XX,provenance unknown	0.22	89.7	0.00	0.08	1.16	0.18	0.02	0.00	2.91	0.33	0.00	0.16	0.01	0.00	0.00	0.00	0.01	0.03	0.00	5.2
200-200-408 — Left side of protruding skirt of pale green ushabti 1889.852,Dyn. XIX-XX,provenance unknown	0.00	89.0	0.12	0.00	0.61	0.06	0.06	0.00	0.09	0.34	0.01	5.01	0.00	0.00	0.00	0.00	0.01	0.01	0.00	4.6
200-200-409 — Right side of skirt of white ushabti,Queens College Loan No.288,Dyn. XIX-XX,provenance unknown	0.25	93.9	0.00	0.14	1.10	0.04	0.02	0.00	0.26	0.01	0.00	0.04	0.05	0.00	0.00	0.00	0.00	0.00	0.00	4.1
201- 8-371 — Pale green right heel of ushabti 1887.2446,Dyn. XX,Nabesha,tomb 31	0.00	86.0	0.00	0.22	0.73	0.00	0.02	0.00	0.07	0.14	0.00	0.08	0.00	0.00	0.00	0.00	0.01	0.00	0.00	16.9
201- 8-372 — White body material,truncated torso of blue ushabti 1887.2447,Dyn. XX,Nabesha,tomb 3	0.00	93.1	0.00	0.00	0.59	0.07	0.05	0.00	0.09	0.15	0.01	0.16	0.01	0.04	0.00	0.00	0.02	0.03	0.00	5.6
201- 8-372 — Blue chest of fragmentary ushabti 1887.2447,Dyn. XX,Nabesha,tomb 3	0.00	90.3	0.00	0.00	0.57	0.03	0.05	0.01	0.14	0.17	0.00	1.70	0.00	0.00	0.00	0.00	0.41	0.69	0.00	5.9
201- 8-372 — Black wig of blue ushabti 1887.2447,Dyn. XX,Nabesha,tomb 3	0.00	88.8	0.00	0.00	0.62	0.00	0.06	0.00	1.20	0.73	0.00	1.18	0.00	0.00	0.00	0.00	0.29	0.42	0.00	6.7
201-107-394 — Pale green chest of ushabti E.3589,Dyn. XX,Abydos,grave D14E	0.00	91.7	0.11	0.00	0.67	0.03	0.00	0.00	0.19	0.00	0.00	3.49	0.00	0.01	0.00	0.00	0.41	0.03	0.00	3.3
203- 20-373 — Blue body material,fragment of blue model uraeus 1871.34A,Dyn. XX,Tell el-Yahudiya,palace of Ramesses III	0.00	91.7	0.00	0.39	1.96	0.14	0.08	0.00	0.73	1.32	0.00	1.13	0.07	0.00	0.00	0.00	0.14	0.01	0.06	2.3
203- 20-373 — Flat area of blue-grey fragment of model uraeus 1871.34A,Dyn. XX,Tell el-Yahudiya,palace of Ramesses III	0.44	91.5	0.00	0.62	1.23	0.05	0.00	0.00	0.47	0.40	0.00	2.54	0.00	0.00	0.00	0.00	0.15	0.00	0.02	2.6
203- 20-374 — White area on the reverse side of fragment of polychrome tile 1871.34C,Dyn. XX,Tell el-Yahudiya,palace of Ramesses III	0.18	94.2	0.15	0.25	0.94	0.03	0.00	0.00	0.05	0.09	0.00	0.07	0.00	0.00	0.00	0.00	0.00	0.03	0.01	3.9

X-RAY FLUORESCENCE ANALYSES OF INDIVIDUAL OBJECTS ARRANGED CHRONOLOGICALLY

Chloride and oxides of:

No.	Description	Si	S	K	Ca	Ti	V	Cr	Mn	Fe	Co	Ni	Cu	Zn	As	Pb	Sr	Sn	Sb	Ba	Other
203-20-374	Blue-green area on the reverse side of fragment of polychrome tile 1871.34C,Dyn. XX,Tell el-Yahudiya,palace of Ramesses III	0.09	90.6	0.29	1.90	0.01	0.00	0.00	0.05	0.12	0.00	0.00	1.54	0.21	0.00	0.17	0.55	0.00			2.8
203-20-374	Blue-grey lotus-petal fragment of polychrome tile 1871.34C,Dyn. XX,Tell el-Yahudiya,palace of Ramesses III	0.36	86.8	0.00	0.26	1.34	0.03	0.02	0.00	0.46	0.01	0.02	1.23	0.07	0.00	1.17	0.00	0.00	0.04	0.00	7.7
203-20-374	Red tip of lotus flower,fragment of polychrome tile 1871.34C,Dyn. XX,Tell el-Yahudiya,palace of Ramesses III	0.00	84.6	0.25	3.20	1.80	0.09	0.00	0.00	5.33	0.00	0.00	1.10	0.01	0.00	0.80	0.00	0.01	0.04	0.00	2.8
203-20-375	Creamy body material,break on the reverse side of tile 1871.34D,Dyn. XX,Tell el-Yahudiya,palace of Ramesses III	0.00	94.8	0.00	1.16	0.04	0.06	0.00	0.06	0.15	0.00	0.00	0.03	0.06	0.00	0.00	0.00	0.00	0.00	0.00	3.6
203-20-375	White glazed undecorated reverse side of polychrome tile 1871.34D,Dyn. XX,Tell el-Yahudiya,palace of Ramesses III	0.00	93.3	0.39	2.44	0.04	0.03	0.00	0.01	0.17	0.01	0.00	0.04	0.06	0.00	0.19	0.00	0.01	0.09	0.00	3.2
203-20-375	Ochre coloured lotus flower,left side of polychrome tile 1871.34D,Dyn. XX,Tell el-Yahudiya,palace of Ramesses III	0.32	87.3	0.00	1.62	0.07	0.11	0.00	0.10	1.44	0.00	0.00	0.64	0.00	0.00	3.02	0.00	0.00	1.10	0.00	3.7
203-20-375	Remains of ochre surface,central lotus flower,polychrome tile 1876.34D,Dyn. XX,Tell el-Yahudiya,palace of Ramesses III	0.00	85.6	1.00	3.01	0.03	0.03	0.00	0.07	1.41	0.00	0.01	0.01	0.49	0.00	2.73	0.01	0.00	1.48	0.04	4.0
203-20-375	Violet band along the bottom of polychrome tile 1876.34D,Dyn. XX,Tell el-Yahudiya,palace of Ramesses III	0.00	66.9	0.46	12.99	0.08	0.00	0.00	0.19	0.63	0.08	0.07	0.03	0.10	0.00	3.18	0.01	0.01	0.03	0.00	15.2
203-20-375	Red lotus leaf,polychrome tile 1871.34D,Dyn. XX,Tell el-Yahudiya,palace of Ramesses III	0.00	83.8	1.32	2.27	1.00	0.13	0.00	0.00	5.93	0.00	0.00	0.07	0.09	0.00	2.32	0.00	0.00	0.01	0.00	3.0
203-20-376	Undecorated white edge of fragment of polychrome tile 1871.34B,Dyn. XX,Tell el-Yahudiya,palace of Ramesses III	0.37	90.2	0.29	4.59	0.02	0.00	0.00	0.00	0.25	0.00	0.00	0.04	0.04	0.00	0.70	0.03	0.00	0.51	0.00	2.6
203-20-376	Yellow-green background,face of polychrome tile 1871.34B,Dyn. XX,Tell el-Yahudiya,palace of Ramesses III	0.00	89.7	0.12	2.39	0.04	0.00	0.00	0.50	0.00	0.00	0.00	0.13	0.25	0.00	2.55	0.00	0.01	0.91	0.00	2.5
203-20-376	Blue ring around white rosette on yellow-green tile fragment 1871.34B,Dyn. XX,Tell el-Yahudiya,palace of Ramesses III	0.00	90.8	0.07	2.48	0.04	0.02	0.00	0.27	0.49	0.06	0.03	0.07	0.04	0.00	1.28	0.00	0.01	0.37	0.00	3.5
203-20-639	Violet band dividing white petals,fragment of polychrome tile 1871.34E,Dyn. XX,Tell el-Yahudiya,palace of Ramesses III	0.20	80.9	0.98	7.75	0.04	0.00	0.00	0.23	0.44	0.05	0.02	0.09	0.06	0.00	1.74	0.02	0.02	0.60	0.00	6.0
203-20-657	Blue-grey edge around polychrome inlay disc 1871.34H,Dyn. XX,Tell el-Yahudiya,palace of Ramesses III	0.23	91.0	0.06	2.68	0.05	0.03	0.00	0.13	0.46	0.06	0.02	0.03	0.07	0.00	0.15	0.00	0.00	0.03	0.01	4.5
203-20-657	White petal bordered by grey,polychrome inlay disc 1871.34E,Dyn. XX,Tell el-Yahudiya,palace of Ramesses III	0.23	92.7	0.19	3.45	0.00	0.00	0.01	0.01	0.12	0.00	0.00	0.04	0.01	0.00	0.32	0.00	0.00	0.09	0.01	2.7
203-20-657	Yellow boss at the center of polychrome inlay disc 1871.34E,Dyn. XX,Tell el-Yahudiya,palace of Ramesses III	0.00	89.7	0.38	1.95	0.09	0.05	0.00	0.06	0.68	0.02	0.00	0.00	0.78	0.00	1.31	0.00	0.00	0.27	0.00	4.4
203-20-658	Blue-grey ground between white petals,polychrome inlay disc 1871.34F,Dyn. XX,Tell el-Yahudiya,palace of Ramesses III	0.85	88.6	0.50	2.82	0.03	0.00	0.00	0.10	0.44	0.05	0.03	0.03	0.04	0.00	0.29	0.01	0.00	0.07	0.01	5.9
203-20-658	White petal bordered by grey,polychrome inlay disc 1871.34F,Dyn. XX,Tell el-Yahudiya,palace of Ramesses III	0.30	93.3	0.24	1.69	0.00	0.04	0.00	0.02	0.06	0.00	0.00	0.03	0.03	0.00	0.28	0.00	0.00	0.21	0.04	3.8
203-20-658	Yellow boss at the center of polychrome inlay disc 1871.34F,Dyn. XX,Tell el-Yahudiya,palace of Ramesses III	0.02	92.4	0.17	1.20	0.14	0.00	0.00	0.04	0.44	0.01	0.00	0.05	0.35	0.00	1.52	0.00	0.00	0.46	0.01	3.2

X-RAY FLUORESCENCE ANALYSES OF INDIVIDUAL OBJECTS ARRANGED CHRONOLOGICALLY

Chloride and oxides of:

Object	Si	S	K	Ca	Ti	V	Cr	Mn	Fe	Co	Ni	Cu	Zn	As	Pb	Sr	Sn	Sb	Ba	Other
203- 20-658 Brown ground separating white petals, polychrome inlay disc 1871.34F, Dyn. XX, Tell el-Yahudiya, palace of Ramesses III	0.38	92.5	0.24	0.29	1.64	0.01	0.03	0.00	0.23	0.04	0.01	0.03	0.03	0.00	0.27	0.00	0.00	0.14	0.09	3.8
203- 20-765 White glazed undecorated reverse side of polychrome inlay disc 1871.34G, Dyn. XX, Tell el-Yahudiya, palace of Ramesses III	0.44	92.7	0.17	0.20	2.43	0.04	0.00	0.04	0.17	0.01	0.01	0.01	0.01	0.00	0.00	0.01	0.00	0.00	0.00	3.8
203- 20-765 Yellow boss at the center of polychrome inlay disc 1871.34G, Dyn. XX, Tell el-Yahudiya, palace of Ramesses III	0.25	89.3	0.40	0.15	2.33	0.01	0.00	0.03	0.43	0.00	0.00	0.02	1.03	0.00	1.35	0.00	0.00	0.33	0.00	4.4
203- 20-765 Violet-grey ground between white petals, polychrome inlay disc 1871.34G, Dyn. XX, Tell el-Yahudiya, palace of Ramesses III	0.71	89.6	0.20	0.18	5.02	0.08	0.00	0.18	0.44	0.10	0.07	0.02	0.24	0.00	0.09	0.01	0.00	0.01	0.00	3.0
203- 38-369 Fragment of green bracelet E.3327, Dyn. XX (cartouche of Ramesses III), Serabit el Khadim, temple of Hathor	0.00	85.5	0.00	0.00	5.24	0.04	0.03	0.05	0.24	0.00	0.00	2.71	0.00	0.00	0.00	1.27	0.00	0.01	0.00	4.9
203- 38-370 Pink body material, fragment of green vessel E.3410, Dyn. XX, Serabit el Khadim, temple of Hathor	0.00	90.2	0.00	0.20	1.42	0.11	0.03	0.12	2.04	0.02	0.00	0.11	0.00	0.00	0.00	0.01	0.01	0.01	0.00	5.7
203- 38-370 Olive green exterior of vessel fragment E.3410, Dyn. XX (cartouche of Ramesses III), Serabit el Khadim, temple of Hathor	1.04	86.4	0.00	0.95	0.90	0.05	0.00	0.14	0.23	0.00	0.00	6.03	0.00	0.00	0.75	0.11	0.00	0.00	0.00	3.3
204-119-400 Reverse side of olive-green ring bezel 1872.812, Dyn. XX (cartouche of Ramesses III), provenance unknown	0.51	85.3	0.00	0.11	1.00	0.06	0.06	0.07	0.16	0.00	0.00	3.29	0.00	0.02	0.00	0.85	0.01	0.00	0.00	8.6
209-118-410 Face of blue inscribed rectangular plaque 1913.513, Dyn. XX (Ramesses IV), Deir el Bahari, site 40, foundation deposit	0.40	87.6	0.00	0.19	0.21	0.00	0.00	0.05	0.12	0.00	0.00	6.35	0.00	0.01	0.00	0.00	0.86	0.32	0.00	3.9
209-118-411 Dark blue soles under the feet of ushabti 1964.706, Dyn. XX-XXI, Thebes, tomb of Amenemope	0.78	90.0	0.00	1.55	1.04	0.00	0.00	0.00	0.06	0.03	0.00	2.21	0.00	0.00	0.00	0.00	0.00	0.02	0.00	4.3
210-107-420 Bottom of dark blue ewer, Fortnum C2, Dyn. XX-XXI, Thebes, tomb of Amenemope	1.10	88.4	0.00	1.78	0.81	0.00	0.00	0.00	0.11	0.00	0.00	5.01	0.00	0.00	0.04	0.00	0.00	0.00	0.00	2.7
210-107-421 Green left knee of ushabti E.3405A, Dyn. XXI, Abydos, tomb D60	0.34	89.8	0.00	0.00	0.99	0.00	0.00	0.07	0.12	0.00	0.00	0.88	0.00	0.00	0.13	0.00	0.03	0.05	0.00	7.6
210-107-421 Blue area at the back of the left thigh of ushabti E.3588, Dyn. XXI, Abydos, tomb D22	0.00	88.6	0.27	0.66	0.69	0.00	0.03	0.10	0.54	0.00	0.00	6.91	0.00	0.00	0.14	0.00	0.13	0.10	0.00	1.8
210-200-437 Blue buttocks of ushabti 1879.277, Dyn. XXI, provenance unknown	0.76	92.5	0.00	0.29	0.39	0.04	0.05	0.07	0.13	0.00	0.00	3.20	0.00	0.00	0.07	0.00	0.51	0.04	0.00	1.9
210-200-438 Dark blue shoulder-blade of ushabti 1884.34, Dyn. XXI, provenance unknown	0.50	89.5	0.00	0.89	0.25	0.00	0.05	0.06	0.16	0.00	0.01	5.27	0.00	0.00	0.07	0.00	0.20	0.00	0.00	3.0
210-200-438 Black wig of blue ushabti 1884.34, Dyn. XXI, provenance unknown	1.18	81.4	0.13	2.74	1.33	0.01	0.00	4.54	0.26	0.00	0.00	3.97	0.00	0.00	0.04	0.00	0.08	0.00	0.02	4.3
210-200-439 Dark blue buttocks of ushabti 1884.54, Dyn. XXI, provenance unknown	0.72	87.1	0.00	2.99	0.64	0.00	0.00	0.08	0.20	0.01	0.01	5.35	0.00	0.00	0.29	0.00	0.09	0.07	0.00	2.4
210-200-440 Dark blue area between the shoulder-blades of ushabti 1884.35, Dyn. XXI, provenance unknown	0.78	85.8	0.00	3.81	0.77	0.03	0.00	0.00	0.18	0.01	0.00	5.95	0.00	0.00	0.18	0.00	0.03	0.01	0.00	2.5
210-200-440 Black wig of blue ushabti 1884.35, Dyn. XXI, provenance unknown	1.18	81.0	0.06	4.85	0.96	0.00	0.00	1.42	0.19	0.00	0.00	5.69	0.00	0.00	0.11	0.00	0.00	0.03	0.01	4.5

X-RAY FLUORESCENCE ANALYSES OF INDIVIDUAL OBJECTS ARRANGED CHRONOLOGICALLY

Chloride and oxides of:

Catalog No.	Description	Si	S	K	Ca	Ti	V	Cr	Mn	Fe	Co	Ni	Cu	Zn	As	Pb	Sr	Sn	Sb	Ba	Other
210-200-441	Dark blue buttocks of ushabti 1884.36,Dyn. XXI,provenance unknown	0.85	88.6	0.00	2.21	0.59	0.05	0.02	0.07	0.14	0.00	0.00	5.11	0.00	0.00	0.07	0.00	0.00	0.00	0.00	2.3
210-200-441	Black wig of blue ushabti 1884.36,Dyn. XXI,provenance unknown	0.00	84.6	1.83	2.55	0.49	0.00	0.00	2.75	0.14	0.00	0.00	4.35	0.00	0.00	0.02	0.00	0.02	0.02	0.00	3.2
210-200-442	Dark blue buttocks of ushabti 1884.48,Dyn. XXI,provenance unknown	0.88	85.5	0.00	2.58	1.17	0.00	0.03	0.00	0.22	0.00	0.00	6.59	0.00	0.00	0.04	0.00	0.05	0.00	0.00	2.9
214-26-662	Pale green wig of green ushabti 1872.944,Dyn. XXI-XXIV,Giza	0.00	89.8	0.17	0.59	2.76	0.11	0.05	0.08	0.59	0.02	0.00	1.10	0.03	0.00	0.00	0.00	0.08	0.04	0.06	4.5
214-26-663	Pale green wig at the back of ushabti 1872.946,Dyn. XXI-XXIV,Giza	0.05	88.1	0.03	0.25	1.02	0.02	0.12	0.06	0.16	0.01	0.00	0.88	0.02	0.02	0.00	0.10	0.08	0.03	0.00	9.0
214-33-664	Blue chest of ushabti 1872.939,Dyn. XXI-XXIV,Saqqara	0.01	89.7	0.10	0.66	0.06	0.08	0.00	0.04	0.15	0.00	0.00	2.16	0.01	0.00	0.17	0.00	0.14	0.05	0.00	6.7
214-33-665	Pale blue-green left shoulder of ushabti 1878.41,Dyn. XXI-XXIV,Saqqara	0.00	85.1	0.10	0.23	0.44	0.03	0.00	0.02	0.10	0.00	0.00	0.65	0.03	0.00	0.00	0.00	0.00	0.03	0.00	16.5
214-107-422	Dark blue left heel of ushabti E.3586,Dyn. XXI-XXIV,Abydos	0.00	86.1	0.41	0.16	2.89	0.04	0.00	0.00	0.44	0.00	0.00	5.87	0.00	0.00	0.00	0.00	0.00	0.00	0.00	4.1
214-107-422	Black wig of blue ushabti E.3586,Dyn. XXI-XXIV,Abydos	0.61	75.2	0.21	0.64	1.13	0.00	0.03	12.81	0.11	0.01	0.01	3.01	0.12	0.00	0.02	0.01	0.02	0.00	0.00	6.1
214-107-422	Brown whip over the right shoulder of blue ushabti E.3586,Dyn. XXI-XXIV,Abydos	0.00	73.4	0.78	1.54	3.39	0.24	0.00	0.08	12.53	0.00	0.00	2.24	0.00	0.00	0.00	0.00	0.00	0.00	0.00	5.8
214-107-423	Pale olive-green left thigh of ushabti E.3590,Dyn. XXI-XXIV,Abydos	0.34	88.1	0.29	0.23	1.39	0.00	0.03	0.00	0.53	0.00	0.00	1.21	0.00	0.00	0.00	0.00	0.02	0.03	0.00	7.7
214-107-424	Remains of pale green glaze behind the left ear of ushabti E.3591,Dyn. XXI-XXIV,Abydos	0.00	94.0	0.00	0.34	1.07	0.08	0.06	0.00	0.24	0.00	0.00	1.41	0.01	0.00	0.00	0.08	0.04	0.00	0.00	2.5
214-107-424	Black hair-ribbon on green wig of ushabti E.3591,Dyn. XXI-XXIV,Abydos	0.00	91.0	0.29	1.07	1.42	0.07	0.04	2.85	1.24	0.00	0.00	0.78	0.01	0.00	0.00	0.00	0.00	0.00	0.00	5.1
214-107-425	Remains of pale green glaze on the left elbow of ushabti E.3592,Dyn. XXI-XXIV,Abydos	0.00	88.0	0.47	1.07	0.65	0.30	0.06	0.00	1.14	0.00	0.02	1.68	0.00	0.00	0.00	0.00	0.31	0.05	0.00	3.3
214-107-425	Black hair-ribbon on green wig of ushabti E.3592,Dyn. XXI-XXIV,Abydos	0.00	44.6	0.18	1.05	0.78	0.22	0.00	36.06	4.78	0.00	0.00	1.97	0.00	0.00	0.00	0.00	0.00	0.00	0.00	10.4
214-107-426	Remains of olive green glaze on the right side of right knee of ushabti E.3593,Dyn. XXI-XXIV,Abydos	0.00	93.5	0.21	0.55	0.30	0.18	0.05	0.00	0.84	0.02	0.00	0.88	0.00	0.00	0.00	0.00	0.16	0.11	0.00	3.1
214-107-426	Dark brown hair-ribbon on green wig of ushabti E.3593,Dyn. XXI-XXIV,Abydos	0.00	89.3	0.16	0.86	0.67	0.14	0.04	0.00	1.25	0.00	0.00	0.43	0.00	0.00	0.00	0.00	0.00	0.00	0.00	6.4
214-107-427	White body material,glaze-free area under the feet of green ushabti E.3610,Dyn. XXI-XXIV,Abydos	0.00	95.0	0.00	0.14	0.40	0.08	0.11	0.00	0.28	0.00	0.00	0.03	0.05	0.00	0.00	0.00	0.00	0.00	0.00	3.8
214-107-427	Remains of green glaze on the left heel of ushabti E.3610,Dyn. XXI-XXIV,Abydos	0.00	90.3	0.33	0.03	1.21	0.10	0.10	0.00	0.73	0.00	0.00	3.23	0.10	0.00	0.00	0.00	0.45	0.00	0.00	3.3

X-RAY FLUORESCENCE ANALYSES OF INDIVIDUAL OBJECTS ARRANGED CHRONOLOGICALLY

Chloride and oxides of:

Object	Description	Si	S	K	Ca	Ti	V	Cr	Mn	Fe	Co	Ni	Cu	Zn	As	Pb	Sr	Sn	Sb	Ba	Other
214-107-427	Remains of blue-green glaze on the right temple of ushabti E.3610,Dyn. XXI-XXIV,Abydos	0.00	85.3	0.29	0.00	3.62	0.14	0.07	0.16	0.73	0.00	0.00	1.45	0.22	0.00	0.00	0.00	0.37	0.00	0.00	7.6
214-107-427	Brown hair-ribbon on green wig of ushabti E.3610,Dyn. XXI-XXIV,Abydos	0.00	80.9	0.38	0.11	5.38	0.18	0.01	0.00	1.60	0.00	0.00	3.78	0.25	0.00	0.03	0.02	0.32	0.03	0.38	4.2
214-107-428	Remains of pale green glaze on the left side of the left knee of ushabti E.3613,Dyn. XXI-XXIV,Abydos	0.00	93.4	0.12	0.15	2.01	0.07	0.08	0.17	0.41	0.00	0.00	0.61	0.04	0.00	0.00	0.00	0.12	0.01	0.00	2.8
214-107-428	Purplish brown inscription on the front of green ushabti E.3613,Dyn. XXI-XXIV,Abydos	0.00	81.5	0.11	0.27	0.31	0.07	0.03	7.66	1.81	0.00	0.00	1.19	0.05	0.00	0.00	0.00	0.00	0.00	0.00	7.0
214-107-429	Blue-green left calf of ushabti E.3616,Dyn. XXI-XXIV,Abydos	0.00	92.6	0.42	0.16	0.93	0.00	0.00	0.06	0.39	0.00	0.00	2.06	0.07	0.00	0.08	0.00	0.20	0.00	0.00	3.0
214-107-429	Black hair-ribbon on green wig of ushabti E.3616,Dyn. XXI-XXIV,Abydos	0.00	87.6	0.38	0.48	2.09	0.00	0.00	1.96	0.21	0.00	0.00	0.95	0.00	0.00	0.04	0.00	0.00	0.00	0.00	6.3
214-107-430	Remains of green glaze behind the right ear of ushabti 1889,851,Dyn. XXI-XXIV,Abydos	0.39	90.1	0.22	0.11	3.52	0.05	0.00	0.07	0.79	0.00	0.00	1.58	0.08	0.00	0.00	0.00	0.04	0.01	0.00	3.0
214-118-431	Dark blue area at the back of the right knee of ushabti 1884.44,Dyn. XXI-XXIV,Thebes	1.32	88.7	0.00	1.21	1.50	0.07	0.04	0.00	0.22	0.00	0.00	4.81	0.00	0.00	0.06	0.00	0.08	0.03	0.00	2.0
214-118-431	Black hair-ribbon on blue wig of ushabti 1884.44,Dyn. XXI-XXIV,Thebes	1.05	79.0	0.00	2.07	2.74	0.07	0.02	8.49	0.12	0.00	0.00	2.60	0.00	0.00	0.03	0.00	0.00	0.00	0.00	3.8
214-200-445	Remains of green glaze on the nose of ushabti,Queens College Loan No.271,Dyn. XXI-XXIV,provenance unknown	0.00	89.2	0.19	0.32	0.78	0.05	0.03	0.06	0.13	0.00	0.00	3.48	0.00	0.00	0.25	0.00	0.44	0.00	0.00	5.1
214-200-446	Remains of green glaze on the left heel of ushabti,Queens College Loan No.272,Dyn. XXI-XXIV,provenance unknown	0.00	87.7	0.21	0.22	0.53	0.13	0.06	0.06	0.12	0.00	0.00	3.35	0.00	0.00	0.23	0.00	0.35	0.00	0.00	7.0
214-200-447	Olive-green left thigh of ushabti 1958.346,Dyn. XXI-XXIV,provenance unknown	0.00	88.2	0.29	1.23	1.00	0.22	0.01	0.07	0.76	0.00	0.01	5.48	0.00	0.00	0.06	0.00	0.09	0.00	0.00	2.6
214-200-448	Greyish green left thigh of ushabti 1933.1503,Dyn. XXI-XXIV,provenance unknown	0.31	87.6	0.39	0.15	1.23	0.03	0.04	0.02	0.61	0.00	0.01	0.70	0.00	0.00	0.05	0.00	0.02	0.02	0.00	8.9
214-200-449	Blue left ear of ushabti 1891.84,Dyn. XXI-XXIV,provenance unknown	0.66	91.9	0.20	0.67	0.42	0.00	0.00	0.04	0.12	0.00	0.00	2.46	0.00	0.01	0.00	0.00	0.01	0.00	0.00	3.5
214-200-450	Creamy body material,footless fragment of blue ushabti,Queens College Loan No.283,Dyn. XXI-XXIV,provenance unknown	0.00	92.6	1.18	0.27	0.24	0.04	0.10	0.00	0.08	0.00	0.01	0.05	0.04	0.00	0.00	0.00	0.00	0.00	0.00	5.1
214-200-450	Blue area behind the right knee of ushabti,Queens College Loan No.283,Dyn. XXI-XXIV,provenance unknown	0.37	89.9	0.00	2.38	0.59	0.03	0.00	0.02	0.18	0.00	0.00	3.51	0.00	0.00	0.00	0.00	0.14	0.03	0.00	2.9
214-200-450	Violet-blue wig behind the right ear of blue ushabti,Queens College Loan No.283,Dyn. XXI-XXIV,provenance unknown	0.52	88.4	0.00	2.50	1.39	0.04	0.00	0.76	0.63	0.00	0.00	2.54	0.00	0.00	0.00	0.00	0.05	0.01	0.00	3.0
214-200-450	Violet-blue wig at the top of the head of blue ushabti,Queens College Loan No.283,Dyn. XXI-XXIV,provenance unknown	0.76	89.6	0.33	2.14	0.43	0.02	0.00	0.41	0.60	0.00	0.00	2.86	0.00	0.00	0.00	0.00	0.06	0.01	0.00	2.8
214-200-451	Pale blue area at the back of the knees of ushabti,Queens College Loan No.285,Dyn. XXI-XXIV,provenance unknown	0.33	89.7	0.00	2.83	1.51	0.05	0.00	0.08	0.18	0.00	0.00	2.53	0.00	0.00	0.00	0.00	0.08	0.01	0.00	2.7

X-RAY FLUORESCENCE ANALYSES OF INDIVIDUAL OBJECTS ARRANGED CHRONOLOGICALLY

Chloride and oxides of:

Sample	Si	S	K	Ca	Ti	V	Cr	Mn	Fe	Co	Ni	Cu	Zn	As	Pb	Sr	Sn	Sb	Ba	Other
214-200-451 Violet-blue wig of blue ushabti, Queens College Loan No.285, Dyn. XXI-XXIV, provenance unknown	0.50	89.2	0.00	2.61	0.97	0.03	0.00	1.06	0.28	0.02	0.00	2.61	0.00	0.00	0.00	0.00	0.03	0.00	0.00	2.7
214-200-452 Blue-grey right elbow of ushabti 1971.1413, Dyn. XXI-XXIV, provenance unknown	0.64	82.7	0.00	2.30	3.67	0.08	0.00	0.00	0.36	0.00	0.00	6.38	0.00	0.00	0.00	0.00	0.07	0.00	0.00	3.7
214-200-453 Blue-grey left shank of ushabti, Queens College Loan No.287, Dyn. XXI-XXIV, provenance unknown	0.44	85.6	0.20	1.07	0.72	0.05	0.05	0.00	0.07	0.24	0.01	0.01	1.20	0.08	0.00	0.00	0.04	0.03	0.00	10.2
214-200-454 Green center of the back of curly-haired ushabti 1968.776, Dyn. XXI-XXIV, provenance unknown	0.47	91.9	0.00	0.16	0.41	0.06	0.02	0.01	0.05	0.17	0.01	0.01	2.86	0.00	0.00	0.08	0.00	0.05	0.00	3.7
214-200-455 Blue mouth of ushabti 1971.1456, Dyn. XXI-XXIV, provenance unknown	0.77	89.0	0.09	1.28	1.26	0.07	0.01	0.00	0.02	0.43	0.01	0.01	3.27	0.13	0.04	0.59	0.00	0.12	0.06	2.8
214-200-456 Dark blue right cheek of ushabti 1971.1457, Dyn. XXI-XXIV, provenance unknown	0.29	90.8	0.16	1.14	0.49	0.08	0.04	0.00	0.02	0.20	0.01	0.00	3.05	0.00	0.00	0.32	0.00	0.47	0.02	2.9
214-200-457 Dark blue forehead of ushabti 1892.638, Dyn. XXI-XXIV, provenance unknown	0.77	88.5	0.02	0.44	0.23	0.02	0.04	0.00	0.05	0.11	0.01	0.00	4.72	0.00	0.00	0.56	0.00	0.61	0.00	3.9
214-200-766 Blue left hip of ushabti, Queens College Loan No.284, Dyn. XXI-XXIV, provenance unknown	0.57	88.6	0.11	1.99	1.36	0.00	0.00	0.04	0.25	0.00	0.00	3.01	0.00	0.00	0.02	0.01	0.05	0.02	0.03	4.0
214-200-766 Violet-blue wig of blue ushabti, Queens College Loan No.284, Dyn. XXI-XXIV, provenance unknown	0.62	87.2	0.13	2.65	1.56	0.01	0.01	0.00	0.76	0.24	0.00	0.00	2.22	0.00	0.00	0.02	0.00	0.05	0.02	4.6
220-54-412 Green wedjat-eye amulet 1914.725, Dyn. XXII, Lahun, grave 602	0.95	88.5	0.11	0.23	0.69	0.09	0.07	0.00	0.09	0.22	0.00	0.00	2.04	0.00	0.00	0.08	0.00	0.16	0.00	6.8
220-54-412 Black pupil of green wedjat-eye amulet 1914.725, Dyn. XXII, Lahun, grave 602	0.00	52.6	0.00	0.25	0.69	0.00	0.00	0.00	27.30	0.05	0.02	0.00	2.84	0.06	0.00	0.00	0.09	0.00	0.00	16.1
220-54-413 Green plinth of a standing Sekhmet figurine, amulet 1914.712A, Dyn. XXII, Lahun, grave 602	0.92	92.0	0.00	0.11	0.29	0.00	0.00	0.00	0.08	0.01	0.00	2.96	0.00	0.00	0.07	0.00	0.09	0.00	0.00	3.4
220-200-443 Blue shanks of ushabti 1933.606, Dyn. XXII, provenance unknown	0.41	88.5	0.00	1.14	4.27	0.00	0.00	0.06	0.11	0.00	0.00	2.28	0.02	0.00	0.00	0.00	0.24	0.02	0.00	2.9
220-200-444 White body material, fragment of greenish ushabti 1971.1355, Dyn. XXII, provenance unknown	0.00	92.8	0.00	0.06	0.22	0.10	0.07	0.00	0.13	0.59	0.01	0.03	0.05	0.07	0.01					5.9
220-200-444 Greyish green left calf of broken ushabti 1971.1355, Dyn. XXII, provenance unknown	0.00	91.7	0.00	0.23	2.52	0.00	0.00	0.00	0.16	0.65	0.00	0.00	1.02	0.00	0.00	0.00	0.05	0.02	0.00	3.6
225-32-666 White tubular bead (with traces of green) E.E.607A, Dyn. XXII-XXV, Memphis, palace of Merneptah	0.13	92.6	0.55	0.66	1.64	0.05	0.07	0.00	0.04	0.14	0.00	0.00	0.19	0.01	0.00	0.00	0.01	0.00	0.00	3.9
225-32-667 Pale green carinated barrel bead E.E.607B, Dyn. XXII-XXV, Memphis, palace of Merneptah	0.16	94.0	0.01	0.67	0.69	0.07	0.04	0.00	0.39	0.40	0.00	0.00	0.43	0.07	0.00	0.00	0.03	0.00	0.00	3.1
225-32-667 Black carination on green barrel bead E.E.607B, Dyn. XXII-XXV, Memphis, palace of Merneptah	0.26	90.5	0.10	1.21	0.91	0.06	0.00	0.00	1.26	0.58	0.00	0.00	0.41	0.01	0.00	0.00	0.04	0.03	0.06	4.6
225-32-668 Pale green tubular bead E.E.607C, Dyn. XXII-XXV, Memphis, palace of Merneptah	0.70	90.2	0.07	0.55	0.68	0.00	0.00	0.00	0.02	0.08	0.00		2.79							

X-RAY FLUORESCENCE ANALYSES OF INDIVIDUAL OBJECTS ARRANGED CHRONOLOGICALLY

Chloride and oxides of: Si S K Ca Ti V Cr Mn Fe Co Ni Cu Zn As Pb Sr Sn Sb Ba Other

225- 32-669 White body material,fragment of green multi-tubular bead E.E.611,Dyn. XXII-XXV,Memphis,palace of Merneptah

Si	S	K	Ca	Ti	V	Cr	Mn	Fe	Co	Ni	Cu	Zn	As	Pb	Sr	Sn	Sb	Ba	Other
0.00	96.6	0.07	0.12	0.39	0.08	0.08	0.04	0.14	0.00	0.00	0.16	0.03	0.00	0.00	0.00	0.00	0.00	0.00	2.3

225- 32-669 Remains of green glaze,fragment of multi-tubular bead E.E.611,Dyn. XXII-XXV,Memphis,palace of Merneptah

Si	S	K	Ca	Ti	V	Cr	Mn	Fe	Co	Ni	Cu	Zn	As	Pb	Sr	Sn	Sb	Ba	Other
0.00	93.0	0.04	0.07	0.44	0.07	0.06	0.00	0.04	0.14	0.01	0.00	0.61	0.07	0.00	0.00	0.00	0.00	0.00	5.4

225- 74-414 Blue-green eyelid of wedjat-eye amulet 1931.381,Dyn. XXII-XXV,Matmar,grave 1294

Si	S	K	Ca	Ti	V	Cr	Mn	Fe	Co	Ni	Cu	Zn	As	Pb	Sr	Sn	Sb	Ba	Other
0.33	87.9	0.00	0.33	2.65	0.00	0.06	0.00	0.07	0.16	0.01	0.00	4.65	0.00	0.00	0.12	0.00	0.00	0.01	3.7

225- 74-414 Black pupil of green wedjat-eye amulet 1931.381,Dyn. XXII-XXV,Matmar,grave 1294

Si	S	K	Ca	Ti	V	Cr	Mn	Fe	Co	Ni	Cu	Zn	As	Pb	Sr	Sn	Sb	Ba	Other
0.00	52.1	1.00	0.56	2.59	0.15	0.10	0.00	34.02	0.24	0.00	0.00	5.47	0.00	0.00	0.22	0.00	0.00	0.62	4.0

225- 74-416 Green top of the reverse side of aegis of Bastet 1931.304,Dyn. XXII-XXV,Matmar,grave 758

Si	S	K	Ca	Ti	V	Cr	Mn	Fe	Co	Ni	Cu	Zn	As	Pb	Sr	Sn	Sb	Ba	Other
0.28	88.4	0.03	0.48	1.89	0.00	0.03	0.00	0.12	0.12	0.00	0.00	3.61	0.00	0.00	0.22	0.00	0.36	0.00	4.5

225- 74-416 Blue bottom part of the reverse side of aegis of Bastet 1931.304,Dyn. XXII-XXV,Matmar,grave 758

Si	S	K	Ca	Ti	V	Cr	Mn	Fe	Co	Ni	Cu	Zn	As	Pb	Sr	Sn	Sb	Ba	Other
0.61	87.6	0.05	0.45	1.19	0.02	0.00	0.00	0.14	0.18	0.00	0.00	5.35	0.00	0.00	0.38	0.00	0.45	0.00	3.5

225- 74-416 Blue center of the reverse side of aegis of Bastet 1931.304,Dyn. XXII-XXV,Matmar,grave 758

Si	S	K	Ca	Ti	V	Cr	Mn	Fe	Co	Ni	Cu	Zn	As	Pb	Sr	Sn	Sb	Ba	Other
0.17	85.2	0.01	0.94	4.42	0.11	0.01	0.00	0.12	0.27	0.00	0.00	4.68	0.00	0.00	0.39	0.00	0.27	0.00	3.4

225- 74-417 Left side of dark blue throne,seated Nefertem amulet 1931.273,Dyn. XXII-XXV,Matmar,grave 721

Si	S	K	Ca	Ti	V	Cr	Mn	Fe	Co	Ni	Cu	Zn	As	Pb	Sr	Sn	Sb	Ba	Other
0.48	85.2	0.00	3.62	1.72	0.05	0.00	0.00	0.00	0.12	0.01	0.00	4.56	0.00	0.00	0.11	0.00	0.44	0.00	3.7

225- 74-418 Grey body material,stump of handle of blue bowl 1931.317,Dyn. XXII-XXV,Matmar,grave 772

Si	S	K	Ca	Ti	V	Cr	Mn	Fe	Co	Ni	Cu	Zn	As	Pb	Sr	Sn	Sb	Ba	Other
0.00	84.8	0.00	0.18	8.03	0.15	0.02	0.07	0.85	0.00	0.00	0.10	0.00	0.00	0.00	0.00	0.00	0.00	0.00	5.8

225- 74-418 Side of blue bowl 1931.317,Dyn. XXII-XXV,Matmar,grave 772

Si	S	K	Ca	Ti	V	Cr	Mn	Fe	Co	Ni	Cu	Zn	As	Pb	Sr	Sn	Sb	Ba	Other
0.83	88.7	0.14	0.16	2.50	0.00	0.00	0.00	0.13	0.00	0.00	2.96	0.00	0.00	0.19	0.00	0.01	0.05	0.00	4.4

225- 74-419 Front end of green plinth under a crowned falcon pendant 1931.322,Dyn. XXII-XXV,Matmar,grave 793

Si	S	K	Ca	Ti	V	Cr	Mn	Fe	Co	Ni	Cu	Zn	As	Pb	Sr	Sn	Sb	Ba	Other
1.49	89.5	0.08	0.57	0.92	0.05	0.00	0.00	0.21	0.00	0.00	5.12	0.00	0.00	0.54	0.00	0.23	0.00	0.00	1.1

225- 74-419 Green area on the right wing of crowned falcon pendant 1931.322,Dyn. XXII-XXV,Matmar,grave 793

Si	S	K	Ca	Ti	V	Cr	Mn	Fe	Co	Ni	Cu	Zn	As	Pb	Sr	Sn	Sb	Ba	Other
0.31	88.4	0.01	1.76	1.03	0.02	0.00	0.00	0.09	0.17	0.00	0.00	3.43	0.00	0.00	0.32	0.00	0.24	0.00	4.2

225- 74-419 Rear end of green plinth under a crowned falcon pendant 1931.322,Dyn. XXII-XXV,Matmar,grave 793

Si	S	K	Ca	Ti	V	Cr	Mn	Fe	Co	Ni	Cu	Zn	As	Pb	Sr	Sn	Sb	Ba	Other
0.83	91.8	0.05	0.77	1.12	0.02	0.00	0.00	0.03	0.13	0.01	0.00	2.89	0.00	0.00	0.29	0.00	0.22	0.00	1.8

225- 74-419 Black spot on the right breast of green crowned falcon pendant 1931.322,Dyn. XXII-XXV,Matmar,grave 793

Si	S	K	Ca	Ti	V	Cr	Mn	Fe	Co	Ni	Cu	Zn	As	Pb	Sr	Sn	Sb	Ba	Other
0.27	86.1	0.08	2.87	1.69	0.00	0.00	0.00	0.37	0.22	0.00	0.00	3.96	0.00	0.00	0.34	0.00	0.22	0.00	3.9

225- 74-670 Flat reverse side of deep blue Bes amulet 1931.323,Dyn. XXII-XXV,Matmar,grave 793

Si	S	K	Ca	Ti	V	Cr	Mn	Fe	Co	Ni	Cu	Zn	As	Pb	Sr	Sn	Sb	Ba	Other
0.52	88.3	0.05	0.75	1.05	0.02	0.04	0.00	0.02	0.13	0.00	0.00	3.61	0.00	0.00	0.15	0.00	0.27	0.01	5.1

225- 74-671 Flat undecorated side of green pendant 1931.281B,Dyn. XXII-XXV,Matmar,grave 740

Si	S	K	Ca	Ti	V	Cr	Mn	Fe	Co	Ni	Cu	Zn	As	Pb	Sr	Sn	Sb	Ba	Other
0.17	91.7	0.00	0.19	1.56	0.00	0.05	0.00	0.02	0.05	0.00	0.00	2.50	0.02	0.00	0.44	0.00	0.29	0.00	3.0

225- 74-672 Green rear-end of wedjat-eye amulet 1931.281A,Dyn. XXII-XXV,Matmar,grave 740

Si	S	K	Ca	Ti	V	Cr	Mn	Fe	Co	Ni	Cu	Zn	As	Pb	Sr	Sn	Sb	Ba	Other
0.22	89.3	0.04	0.24	1.81	0.00	0.05	0.00	0.03	0.07	0.00	0.00	3.90	0.04	0.00	0.18	0.00	0.16	0.02	3.9

225- 74-672 Black pupil of green wedjat-eye amulet 1931.281A,Dyn. XXII-XXV,Matmar,grave 740

Si	S	K	Ca	Ti	V	Cr	Mn	Fe	Co	Ni	Cu	Zn	As	Pb	Sr	Sn	Sb	Ba	Other
0.56	81.8	0.03	0.13	3.40	0.05	0.02	0.00	1.96	0.10	0.00	0.00	4.64	0.00	0.00	0.24	0.00	0.07	0.03	7.0

225- 74-675 Pale green face of offering-table,pendant 1931.352C,Dyn. XXII-XXV,Matmar,grave 1214

Si	S	K	Ca	Ti	V	Cr	Mn	Fe	Co	Ni	Cu	Zn	As	Pb	Sr	Sn	Sb	Ba	Other
0.14	90.6	0.11	0.36	2.02	0.11	0.06	0.00	0.07	0.38	0.01	0.00	1.25	0.05	0.00	0.06	0.00	0.02	0.03	4.7

X-RAY FLUORESCENCE ANALYSES OF INDIVIDUAL OBJECTS ARRANGED CHRONOLOGICALLY

Chloride and oxides of:

Object	Si	S	K	Ca	Ti	V	Cr	Mn	Fe	Co	Ni	Cu	Zn	As	Pb	Sr	Sn	Sb	Ba	Other
225-118-433 Blue scarab seal mounted on green finger ring,Fortnum R23,Dyn. XXII-XXV,Thebes	0.52	88.6	0.00	0.19	0.43	0.03	0.06	0.07	0.16	0.00	0.00	6.59	0.00	0.00	0.05	0.00	1.08	0.00	0.00	2.3
225-118-485 Clear blue-green section of finger ring 1872.330,Dyn. XXII-XXV,Thebes	0.36	86.3	0.07	0.43	1.10	0.06	0.02	0.06	0.31	0.01	0.01	3.21	0.00	0.00	0.58	0.00	0.49	0.00	0.00	7.0
225-118-485 Black decorative spots on green finger ring 1872.330,Dyn. XXII-XXV,Thebes	0.37	85.1	0.07	0.89	2.30	0.02	0.00	1.44	0.21	0.02	0.00	1.78	0.00	0.00	0.27	0.00	0.37	0.00	0.15	7.1
225-118-796 Another decorative black spot on green finger ring 1872.330,Dyn. XXII-XXV,Thebes	0.43	83.8	0.00	0.52	0.70	0.01	0.00	1.39	0.21	0.00	0.01	1.55	0.00	0.00	0.22	0.01	0.30	0.00	0.11	10.7
225-200-434 Right hip of blue figure of a seated king,mounted on a green finger ring,Fortnum R25,Dyn. XXII-XXV,provenance unknown	0.45	86.9	0.27	0.90	0.38	0.00	0.00	0.00	0.00	0.00	0.00	7.14	0.00	0.00	0.08	0.00	0.00	0.00	0.00	3.8
250- 39-436 Right shoulder-blade of green statuette 1912.607,Dyn. XXV,Kafr Ammar,temple fill	0.38	89.1	0.23	0.36	1.28	0.15	0.02	0.01	0.40	0.01	0.00	3.53	0.0U	0.00	0.74	0.00	0.22	0.08	0.00	3.4
250- 39-436 Dark blue wig of green statuette 1912.607,Dyn. XXV,Kafr Ammar,temple fill	0.00	80.9	0.25	0.33	6.37	0.05	0.00	0.10	0.52	0.00	0.00	4.75	0.00	0.00	1.41	0.00	0.17	0.04	0.03	5.1
250- 43-458 Creamy body material,chipped breast of blue goddess Tawert,theriomorphic vessel 1913.789,Dyn. XXV,Riqqa,cemetery B	0.53	88.5	0.81	0.36	3.26	0.04	0.03	0.00	0.01	0.24	0.01	0.01	0.52	0.00	0.00	0.00	0.00	0.00	0.00	5.6
250- 43-458 Left thigh of dark blue goddess Tawert,theriomorphic vessel 1913.789,Dyn. XXV,Riqqa,cemetery B	0.80	84.9	0.00	0.46	1.47	0.07	0.01	0.00	0.21	0.00	0.00	7.24	0.00	0.00	0.20	0.00	0.04	0.04	0.00	4.5
250-107-491 Blue wig of blue ushabti E.3574,Dyn. XXV,Abydos,tomb D16C	0.44	88.7	0.14	0.87	2.33	0.00	0.03	0.00	0.03	0.00	0.00	3.26	0.00	0.12	0.00	0.00	0.34	0.02	0.00	3.2
250-118-435 Green lentoid seal-plaque 1942.94,Dyn. XXV(cartouche of Shabaka),Thebes	0.79	89.0	0.00	0.49	1.11	0.09	0.00	0.07	0.30	0.00	0.00	4.64	0.00	0.00	0.08	0.00	0.80	0.00	0.00	2.7
250-200-504 Right hip of green ushabti (glassy faience) 1965.176,Dyn. XXV,provenance unknown	0.25	90.0	0.30	0.45	3.22	0.08	0.00	0.06	0.52	0.01	0.00	1.27	0.00	0.00	0.21	0.00	0.07	0.01	0.00	3.6
251-107-492 Left shoulder-blade of dark blue ushabti E.3615,Dyn. XXV,Abydos,tomb D3 of Esenkhebi,daughter of Shabaka	0.54	85.5	0.17	0.32	0.39	0.04	0.05	0.00	0.17	0.00	0.00	5.39	0.00	0.00	0.19	0.00	0.09	0.01	0.00	7.1
251-107-492 Black wig of blue ushabti E.3615,Dyn. XXV,Abydos,tomb D3 of Esenkhebi,daughter of Shabaka	1.59	85.5	0.09	1.06	1.76	0.02	0.00	2.14	0.25	0.00	0.00	4.56	0.00	0.00	0.10	0.01	0.01	0.01	0.00	2.9
252-151-459 Undecorated pale green bezel of finger ring 1914.476,Dyn. XXV,Sanam Abu Dom(Sudan),grave 1516	0.63	90.5	0.00	0.74	1.54	0.08	0.00	0.07	0.46	0.01	0.00	3.17	0.00	0.00	0.10	0.01	0.38	0.01	0.00	2.3
252-151-460 Top of blue-green back pillar of Tefnut pendant 1914.477,Dyn. XXV,Sanam Abu Dom(Sudan),grave 1516	0.14	89.1	0.00	0.23	0.72	0.07	0.07	0.00	0.08	0.31	0.00	1.25	0.00	0.00	0.00	0.00	0.46	0.05	0.00	7.5
252-151-461 Left side of blue-green throne under a figure of Isis nursing Horus 1914.471,Dyn. XXV,Sanam Abu Dom(Sudan),grave 1516	0.43	86.2	0.31	1.05	1.12	0.10	0.00	0.05	0.82	0.00	0.00	6.13	0.00	0.00	0.36	0.00	0.65	0.00	0.00	3.0
257- 32-475 Green segmented tubular bead E.E.608A,Dyn. XXV-XXVII,Memphis,temple of Merneptah	0.54	91.8	0.08	0.64	1.29	0.09	0.02	0.08	0.89	0.01	0.00	1.36	0.00	0.00	0.13	0.00	0.00	0.00	0.00	2.9
257- 32-564 Red segmented tubular bead E.E.608B,Dyn. XXV-XXVII,Memphis,temple of Merneptah	0.29	86.9	0.18	2.07	1.56	0.03	0.00	0.01	3.71	0.03	0.00	0.08	0.00	0.00	0.36	0.00	0.00	0.00	0.00	

X-RAY FLUORESCENCE ANALYSES OF INDIVIDUAL OBJECTS ARRANGED CHRONOLOGICALLY

Chloride and oxides of:

| Object | Cl | Si | S | K | Ca | Ti | V | Cr | Mn | Fe | Co | Ni | Cu | Zn | As | Pb | Sr | Sn | Sb | Ba | Other |
|---|
| 257-32-565 Another green segmented tubular bead E.E.608D, Dyn. XXV-XXVII, Memphis, temple of Merneptah | 0.42 | 92.0 | 0.06 | 0.53 | 1.13 | 0.08 | 0.03 | 0.00 | 0.07 | 0.88 | 0.00 | 0.00 | 1.45 | 0.00 | 0.00 | 0.29 | 0.00 | 0.01 | 0.00 | 0.00 | 3.0 |
| 257-32-566 Another red segmented tubular bead E.E.608E, Dyn. XXV-XXVII, Memphis, temple of Merneptah | 0.26 | 88.0 | 0.13 | 1.77 | 1.38 | 0.06 | 0.00 | 0.01 | 3.61 | 0.03 | 0.00 | 0.00 | 0.06 | 0.00 | 0.00 | 0.00 | 0.00 | 0.00 | 0.00 | 0.00 | 4.6 |
| 257-32-567 Red-brown segmented tubular bead E.E.608F, Dyn. XXV-XXVII, Memphis, temple of Merneptah | 0.23 | 89.3 | 0.12 | 1.73 | 1.50 | 0.05 | 0.00 | 0.00 | 2.97 | 0.00 | 0.00 | 0.00 | 0.06 | 0.00 | 0.00 | 0.00 | 0.00 | 0.00 | 0.00 | 0.00 | 3.9 |
| 257-32-762 Another white segmented tubular bead E.E.608G, Dyn. XXV-XXVII, Memphis, temple of Merneptah | 0.22 | 93.7 | 0.27 | 0.92 | 1.13 | 0.00 | 0.00 | 0.00 | 0.21 | 0.00 | 0.00 | 0.00 | 0.38 | 0.00 | 0.00 | 0.01 | 0.00 | 0.00 | 0.00 | 0.00 | 3.2 |
| 257-32-767 White segmented tubular bead E.E.608C, Dyn. XXV-XXVII, Memphis, temple of Merneptah | 0.33 | 94.4 | 0.34 | 0.93 | 1.03 | 0.00 | 0.00 | 0.00 | 0.23 | 0.00 | 0.00 | 0.00 | 0.42 | 0.01 | 0.00 | 0.01 | 0.00 | 0.00 | 0.00 | 0.00 | 2.3 |
| 257-33-481 Top of blue-green back pillar of ushabti 1872.933, Dyn. XXV-XXVII, Saqqara | 0.34 | 90.2 | 0.00 | 0.21 | 1.00 | 0.13 | 0.00 | 0.06 | 0.60 | 0.00 | 0.00 | 0.00 | 1.68 | 0.00 | 0.00 | 0.49 | 0.00 | 0.06 | 0.12 | 0.00 | 5.2 |
| 257-33-483 Yellow-green wig of ushabti 1878.193.o, Dyn. XXV-XXVII, Saqqara | 0.57 | 88.9 | 0.02 | 0.15 | 1.54 | 0.11 | 0.00 | 0.00 | 0.39 | 0.00 | 0.00 | 0.00 | 0.94 | 0.00 | 0.00 | 0.64 | 0.00 | 0.01 | 0.04 | 0.00 | 6.7 |
| 257-47-490 Pale green area behind the left elbow of ushabti 1891.297, Dyn. XXV-XXVII, Fayyum | 0.00 | 88.6 | 0.10 | 0.00 | 0.92 | 0.03 | 0.00 | 0.05 | 0.31 | 0.00 | 0.00 | 0.00 | 2.48 | 0.00 | 0.00 | 0.12 | 0.00 | 0.19 | 0.03 | 0.00 | 7.2 |
| 257-200-221 Brown body material, hole in green scaraboid 1872.186, Dyn. XXV-XXVII, provenance unknown | 0.07 | 88.8 | 0.05 | 2.10 | 4.08 | 0.09 | 0.04 | 0.10 | 0.93 | 0.00 | 0.00 | 0.00 | 0.45 | 0.00 | 0.00 | 1.19 | 0.00 | 0.00 | 0.09 | 0.00 | 2.1 |
| 257-200-221 Right ear of green human head mounted on scaraboid 1872.186, Dyn. XXV-XXVII, provenance unknown | 0.00 | 87.8 | 0.00 | 0.47 | 0.65 | 0.02 | 0.00 | 0.06 | 0.39 | 0.00 | 0.00 | 0.00 | 1.34 | 0.00 | 0.00 | 3.68 | 0.00 | 0.00 | 1.17 | 0.00 | 4.4 |
| 257-200-506 Blue spot on the left hip of green ushabti 1938.303, Dyn. XXV-XXVII, provenance unknown | 0.00 | 86.4 | 0.54 | 0.32 | 0.67 | 0.08 | 0.16 | 0.00 | 0.16 | 0.00 | 0.00 | 0.00 | 1.19 | 0.07 | 0.00 | 0.04 | 0.00 | 0.67 | 0.05 | 0.00 | 9.7 |
| 257-200-508 Pale green wig of ushabti 1874.230 Dyn. XXV-XXVII, provenance unknown | 0.61 | 91.2 | 0.31 | 0.08 | 1.50 | 0.06 | 0.03 | 0.06 | 0.38 | 0.00 | 0.00 | 0.00 | 1.32 | 0.00 | 0.00 | 0.15 | 0.00 | 0.67 | 0.02 | 0.00 | 3.6 |
| 257-200-509 Dark green wig of ushabti 1872.80, Dyn. XXV-XXVII, provenance unknown | 0.46 | 89.6 | 0.00 | 0.00 | 2.29 | 0.04 | 0.02 | 0.00 | 0.10 | 0.00 | 0.00 | 0.00 | 4.48 | 0.00 | 0.00 | 0.15 | 0.00 | 0.49 | 0.00 | 0.00 | 2.4 |
| 257-200-510 Blue area above the left elbow of ushabti 1874.233, Dyn. XXV-XXVII, provenance unknown | 1.02 | 90.9 | 0.00 | 0.06 | 0.92 | 0.05 | 0.00 | 0.06 | 0.25 | 0.01 | 0.00 | 0.00 | 2.37 | 0.00 | 0.00 | 0.16 | 0.00 | 0.44 | 0.06 | 0.00 | 3.7 |
| 260-51-489 Pale green right ankle of ushabti 1889.1073, Early Dyn. XXVI, Hawara, tomb of Horudja | 0.35 | 88.1 | 0.83 | 0.29 | 1.50 | 0.07 | 0.02 | 0.00 | 0.05 | 0.32 | 0.02 | 0.02 | 1.63 | 0.00 | 0.01 | 0.01 | 0.00 | 0.02 | 0.06 | 0.00 | 6.7 |
| 260-200-507 Creamy body material, fragment of green ushabti 1971.1357, Dyn. XXVI (cartouche of Psammetichus I), provenance unknown | 0.43 | 93.0 | 0.05 | 0.19 | 2.00 | 0.08 | 0.07 | 0.00 | 0.35 | 0.40 | 0.02 | 0.03 | 0.92 | 0.06 | 0.00 | 0.00 | 0.00 | 0.00 | 0.00 | 0.00 | 3.5 |
| 260-200-507 Pale green elbow, fragment of ushabti 1971.1357, Dyn. XXVI (cartouche of Psammetichus I), provenance unknown | 0.37 | 90.9 | 0.00 | 0.45 | 1.73 | 0.09 | 0.04 | 0.00 | 0.07 | 0.35 | 0.00 | 0.00 | 0.92 | 0.06 | 0.00 | 0.68 | 0.00 | 0.00 | 0.32 | 0.00 | 4.0 |
| 261-26-474 Greenish body material, fragment of green ushabti 1916.2, Dyn. XXVI (cartouche of Psammetichus II), Giza | 0.00 | 91.4 | 0.54 | 0.00 | 2.92 | 0.06 | 0.08 | 0.00 | 0.53 | 0.00 | 0.00 | 0.00 | 1.38 | 0.01 | 0.00 | 0.00 | 0.00 | 0.00 | 0.03 | 0.00 | 3.0 |
| 261-26-474 Green left elbow of truncated torso of ushabti 1916.2, Dyn. XXVI (cartouche of Psammetichus II), Giza | 0.48 | 85.2 | 0.14 | 0.33 | 1.10 | 0.03 | 0.03 | 0.01 | 0.02 | 0.10 | 0.00 | 0.00 | 2.50 | 0.00 | 0.00 | 0.07 | 0.00 | 0.03 | 0.12 | 0.00 | 19.1 |

X-RAY FLUORESCENCE ANALYSES OF INDIVIDUAL OBJECTS ARRANGED CHRONOLOGICALLY

Chloride and oxides of:

Object	Description	Si	S	K	Ca	Ti	V	Cr	Mn	Fe	Co	Ni	Cu	Zn	As	Pb	Sr	Sn	Sb	Ba	Other	
261- 33-482	Center of blue-green back pillar of ushabti 1872.936,Dyn. XXVI(cartouche of Psammetichus II),Saqqara	0.43	88.1	0.06	0.37	0.03	0.04	0.00	0.08	0.26	0.01	0.00	2.47	0.00	0.00	0.17	0.00	0.93	0.12	0.00	6.9	
262- 8-468	Yellow bead 1969.710A,Dyn. XXVI,Nabesha,grave in hosh 76	0.00	91.3	0.84	0.25	0.69	0.01	0.06	0.00	0.18	0.00	0.01	0.05	0.04	0.00	2.24	0.00	0.02	0.70	0.00	3.6	
262- 9-465	Upper end of pale green back pillar of ushabti 1887.2523,Dyn. XXVI,Defenneh(Daphnae)	0.22	90.1	0.13	0.06	2.39	0.17	0.06	0.00	0.68	0.01	0.00	1.87	0.05	0.00	0.00	0.00	0.65	0.02	0.00	3.6	
262- 32-476	White plinth of polychrome locust-vase 1910.784,Dyn. XXVI,Memphis	0.80	93.3	0.19	0.50	0.67	0.09	0.05	0.00	0.32	0.00	0.00	0.10	0.00	0.00	0.24	0.00	0.00	0.32	0.02	3.4	
262- 32-476	Yellow area on the right side of polychrome locust-vase 1910.784,Dyn. XXVI,Memphis	0.00	90.1	1.49	0.45	0.76	0.07	0.03	0.00	0.11	0.51	0.00	0.29	0.03	0.00	2.12	0.00	0.00	0.53	0.00	3.5	
262- 32-476	Blue-green band on top of polychrome locust-vase 1910.784,Dyn. XXVI,Memphis	0.75	86.0	0.75	0.53	1.84	0.10	0.00	0.02	2.05	0.04	0.00	2.21	0.00	0.00	0.88	0.00	0.05	0.71	0.01	4.0	
262- 32-476	Brownish black left eyeball of polychrome locust-vase 1910.784,Dyn. XXVI,Memphis	0.46	85.6	0.73	1.36	1.92	0.15	0.00	1.52	1.56	0.00	0.00	0.49	0.00	0.00	0.55	0.01	0.01	0.07	0.04	5.6	
262- 32-480	Smooth green bottom of green aryballos 1911.358,Dyn. XXVI,Memphis	0.39	87.3	0.11	0.48	0.73	0.05	0.05	0.02	0.47	0.01	0.00	1.81	0.00	0.00	2.06	0.00	0.35	2.04	0.00	4.1	
262- 32-480	Green band below the neck of aryballos 1911.358,Dyn. XXVI,Memphis	0.26	89.4	0.00	0.66	0.80	0.04	0.12	0.00	0.48	0.00	0.00	1.50	0.00	0.00	2.03	0.00	0.29	2.00	0.00	2.5	
262- 32-480	Smooth blue neck of green aryballos 1911.358,Dyn. XXVI,Memphis	0.31	82.0	0.00	1.20	4.44	0.23	0.02	0.00	7.05	0.36	0.00	1.70	0.00	0.00	0.18	0.00	0.30	0.15	0.00	2.1	
262- 32-480	Brown spot below the blue neck of green aryballos 1911.358,Dyn. XXVI,Memphis	0.20	68.1	1.02	0.72	1.46	0.52	0.10	0.00	2.13	18.82	0.00	1.53	0.00	0.00	0.70	0.03	0.29	1.37	0.04	3.8	
262- 32-799	Another decorative brown spot on the neck of green aryballos 1911.358,Dyn. XXVI,Memphis	0.14	60.5	0.05	1.42	4.67	0.67	0.13	0.00	19.92	0.16	0.01	1.08	1.35	0.00	0.24	0.03	0.14	0.88	0.05	8.6	
262-118-501	Grey body material,hole in the nose of blue and green hedgehog-vase 1872.298,Dyn. XXVI,Thebes	0.00	91.0	0.35	0.64	1.39	0.14	0.03	0.00	1.46	0.00	0.00	0.88	0.00	0.00	0.84	0.00	0.07	0.12	0.01	2.9	
262-118-501	The back of pale green handle on top of hedgehog-vase 1872.298,Dyn. XXVI,Thebes	0.00	85.9	1.43	0.77	3.15	0.08	0.03	0.00	0.05	0.47	0.01	1.97	0.00	0.00	1.55	0.00	0.23	0.44	0.02	3.9	
262-118-501	Greyish green tail area of hedgehog-vase 1872.298,Dyn. XXVI,Thebes	0.00	89.6	1.82	0.46	1.17	0.08	0.03	0.00	0.28	0.00	0.01	0.33	0.00	0.00	2.47	0.00	0.11	0.21	0.00	3.4	
262-118-501	Black left eyeball on green face of hedgehog-vase 1872.298,Dyn. XXVI,Thebes	0.68	85.8	0.13	0.92	1.75	0.05	0.00	0.00	3.69	0.19	0.00	1.62	0.00	0.00	0.96	0.01	0.13	0.26	0.04	3.8	
262-200-502	Green band along the edge of New Year flask 1947.291,Dyn. XXVI,provenance unknown	0.20	84.5	0.09	0.38	2.13	0.13	0.02	0.01	0.29	1.01	0.00	3.92	0.00	0.00	2.35	0.00	0.38	1.36	0.00	3.2	
262-200-505	Lower end of blue back pillar of ushabti 1961.410,Dyn. XXVI,provenance unknown	0.00	90.6	0.57	0.19	0.48	0.08	0.03	0.00	0.02	0.36	0.01	2.58	0.00	0.00	0.10	0.00	0.14	0.00	0.00	4.9	
263- 8-467	Pale green plaque 1887.2459,Dyn. XXVI(cartouche of Amasis),Nabesha,temple of Amasis,foundation deposit	0.38	88.4	0.34	0.18	2.37	0.07	0.07	0.09	0.30	0.02	0.00	0.55	0.00								

X-RAY FLUORESCENCE ANALYSES OF INDIVIDUAL OBJECTS ARRANGED CHRONOLOGICALLY

Chloride and oxides of:

No. / Description	Si	S	K	Ca	Ti	V	Cr	Mn	Fe	Co	Ni	Cu	Zn	As	Pb	Sr	Sn	Sb	Ba	Other
263-200-499 — Green plaque 1960.798,Late Dyn. XXVI(cartouche of Ankhnesneferibre,daughter of Psammetichus II),provenance unknown	0.00	78.5	3.53	0.26	0.77	0.10	0.90	0.04	0.91	0.00	0.00	8.43	0.00	0.00	0.97	0.00	0.48	0.02	0.00	5.1
265-33-484 — Green wig of ushabti 1965.175,Dyn. XXVI-XXVII,Saqqara,tomb of Tjanehebu	0.00	88.0	1.35	0.09	0.74	0.00	0.00	0.00	0.12	0.00	0.00	4.62	0.00	0.00	0.43	0.00	0.50	0.00	0.00	4.1
270-200-469 — Greyish green decorated base of Achaemenid seal 1892.1384,Dyn. XXVII,provenance unknown	0.30	87.8	0.27	0.11	1.24	0.03	0.00	0.01	1.20	0.27	0.00	0.61	0.00	0.02	0.38	0.00	0.01	0.04	0.04	7.6
270-200-472 — Green streak bordered by black,conical Achaemenid seal 1922.152,Dyn. XXVII,provenance unknown	0.37	83.5	1.84	1.81	6.50	0.20	0.00	0.33	0.81	0.00	0.00	1.22	0.00	0.00	0.00	0.00	0.04	0.00	0.01	3.3
275-7-466 — Upper end of pale blue back pillar of ushabti 1887.2527,Dyn. XXV-XXX,Gumaiyima	0.29	85.1	0.16	0.14	4.90	0.16	0.01	0.02	0.76	0.02	0.00	1.88	0.00	0.00	0.00	0.00	0.02	0.05	0.00	6.5
275-8-462 — Blue left calf (with patches of purple) of ushabti 1887.2443,Dyn. XXV-XXX,Nabesha	0.40	85.8	0.09	0.00	4.22	0.09	0.07	0.00	0.44	0.02	0.00	1.34	0.04	0.00	0.27	0.00	0.17	0.04	0.00	7.0
275-8-463 — Pale green right shoulder of ushabti 1887.2438,Dyn. XXV-XXX,Nabesha	0.66	88.4	0.00	0.00	1.60	0.13	0.00	0.02	0.63	0.01	0.00	2.04	0.00	0.00	0.09	0.00	0.60	0.05	0.00	5.8
275-8-464 — Pale green abdomen of ushabti 1887.2441,Dyn. XXV-XXX,Nabesha	0.07	87.9	0.11	0.12	1.83	0.17	0.02	0.00	0.71	0.01	0.01	2.05	0.09	0.00	0.00	0.00	0.93	0.03	0.00	6.0
277-32-477 — Green inlay (with Persian seal impression) 1910.533B,Dyn. XXVII,Memphis,palace of Apries	0.35	88.8	0.31	1.32	5.05	0.08	0.00	0.06	0.44	0.00	0.00	0.31	0.00	0.00	0.00	0.08	0.01	0.47	0.00	2.8
285-5-679 — Creamy uninscribed base of scarab seal E.A.905,Dyn. XXVI-XXX,Naucratis	0.00	82.8	0.00	0.25	0.24	0.09	0.06	0.01	0.59	0.00	0.00	0.03	0.00	0.00	1.72	0.00	0.07	1.22	0.00	12.8
285-5-680 — Green body material,fragment of green model coffin E.4548,Dyn. XXVI-XXX,Naucratis	0.00	78.6	0.01	0.72	1.96	0.31	0.03	0.00	1.53	0.01	0.00	1.16	0.04	0.00	0.23	0.00	0.13	0.06	0.01	15.2
285-5-680 — Remains of pale green glaze on the bottom of model coffin fragment E.4548,Dyn. XXVI-XXX,Naucratis	0.16	83.5	0.00	0.43	5.64	0.21	0.00	0.04	1.28	0.00	0.00	1.52	0.00	0.00	0.37	0.00	0.25	0.11	0.03	6.4
285-5-681 — Flat back of a green head of Bes,pendant E.A.555,Dyn. XXVI-XXX,Naucratis	0.33	92.3	0.06	0.54	0.87	0.03	0.00	0.06	0.06	0.00	0.00	1.21	0.01	0.00	0.10	0.00	0.07	0.03	0.04	4.3
285-5-682 — Left flank of a green "pregnant sow" pendant E.A.889,Dyn. XXVI-XXX,Naucratis	0.14	89.3	0.01	0.20	0.95	0.10	0.00	0.04	0.36	0.01	0.00	0.93	0.00	0.00	0.79	0.00	0.37	0.21	0.01	6.6
285-5-683 — Green model papyrus-sceptre,pendant E.A.898,Dyn. XXVI-XXX,Naucratis	0.24	88.6	0.04	0.01	0.68	0.04	0.02	0.00	0.12	0.00	0.00	1.78	0.01	0.00	0.31	0.00	0.92	0.08	0.00	7.1
285-5-683 — Dark-green spot on green model papyrus-sceptre,pendant E.A.898,Dyn. XXVI-XXX,Naucratis	0.45	89.2	0.17	0.18	1.59	0.09	0.02	0.05	0.22	0.01	0.00	2.07	0.00	0.00	0.38	0.00	0.87	0.07	0.00	4.7
285-5-685 — Deep blue base of scarab seal E.A.908,Dyn. XXVI-XXX,Naucratis	0.00	80.0	0.07	0.65	5.39	0.19	0.00	0.00	0.03	1.25	0.01	5.19	0.02	0.00	0.06	0.00	0.02	0.00	0.04	7.1
285-5-685 — Back of blue scarab seal E.A.908,Dyn. XXVI-XXX,Naucratis	0.05	78.0	0.14	0.20	6.39	0.15	0.00	0.00	0.04	1.09	0.00	6.25	0.01	0.00	0.08	0.00	0.02	0.00	0.05	7.6
285-5-686 — Remains of green glaze on white papyrus-head terminal E.E.670,Dyn. XXVI-XXX,Naucratis	0.00	88.9	0.35	0.42	2.01	0.10	0.07	0.00	0.33	0.00	0.00	0.12	0.04	0.00	0.19	0.00	1.05	0.04	0.01	6.4

X-RAY FLUORESCENCE ANALYSES OF INDIVIDUAL OBJECTS ARRANGED CHRONOLOGICALLY

Chloride and oxides of:

Object	Si	S	K	Ca	Ti	V	Cr	Mn	Fe	Co	Ni	Cu	Zn	As	Pb	Sr	Sn	Sb	Ba	Other
285-10-676 — Left breast, fragment of green statuette 1888.264, Dyn. XXVI-XXX, Tukh el Qaramus	0.68	87.9	0.23	0.65	1.39	0.02	0.00	0.00	0.13	0.00	0.00	2.36	0.00	0.01	0.00	0.00	0.42	0.02	0.04	6.1
285-10-676 — Black wig, fragment of green statuette 1888.264, Dyn. XXVI-XXX, Tukh el Qaramus	0.13	89.7	0.38	1.17	1.22	0.05	0.00	0.00	1.58	0.24	0.00	1.28	0.01	0.02	0.00	0.00	0.21	0.02	0.04	3.9
285-25-471 — Smooth undecorated side of green stamp-seal 1921.1203, Dyn. XXVI-XXX(Iron Age III), Cairo	0.00	85.9	0.92	0.67	0.61	0.07	0.04	0.00	0.06	0.79	0.00	2.67	0.00	0.00	3.42	0.00	0.43	0.97	0.00	3.4
285-32-503 — Green body material, truncated head of Hathor, sistrum handle 1909.1062, Dyn. XXVI-XXX, Memphis, palace of Apries	0.00	83.9	0.19	0.35	4.35	0.09	0.02	0.00	0.02	0.52	0.00	2.08	0.00	0.01	1.61	0.00	0.04	0.51	0.00	6.3
285-32-503 — Green forehead of Hathor, fragment of sistrum handle 1909.1062, Dyn. XXVI-XXX, Memphis, palace of Apries	0.00	86.6	0.29	0.46	3.26	0.05	0.01	0.00	0.08	0.57	0.00	2.77	0.00	0.01	1.89	0.00	0.03	0.81	0.00	3.1
285-42-488 — Dark green stem of chalice 1910.576, Dyn. XXVI-XXX, Medum	0.59	88.0	1.14	0.12	3.17	0.03	0.03	0.00	0.33	0.01	0.00	2.06	0.00	0.00	0.07	0.00	0.39	0.08	0.00	4.0
285-42-488 — Pale green side of chalice 1910.576, Dyn. XXVI-XXX, Medum	0.20	89.0	0.80	0.26	2.05	0.05	0.03	0.01	0.06	0.22	0.01	1.07	0.00	0.00	0.00	0.00	0.24	0.05	0.00	5.9
285-107-677 — Flat back of blue Harpocrates pendant E.A.521A, Dyn. XXVI-XXX, Abydos G3	0.22	87.6	0.13	1.98	2.40	0.04	0.00	0.02	0.19	0.00	0.00	4.49	0.00	0.00	0.00	0.00	0.10	0.00	0.00	2.8
285-107-678 — Flat back of green baboon, amulet E.A.521B, Dyn. XXVI-XXX, Abydos G3	0.29	85.5	0.19	0.77	1.97	0.07	0.00	0.04	0.39	0.01	0.00	2.42	0.14	0.00	2.81	0.00	0.33	0.72	0.00	4.4
285-118-500 — Side of small dark-beige jar 1933.798, Dyn. XXVI-XXX, Thebes	0.44	89.5	0.00	0.71	2.99	0.17	0.00	0.06	1.34	0.00	0.00	0.12	0.00	0.00	0.12	0.00	0.00	0.01	0.00	4.6
285-200-473 — Back of pale green Carian scarab seal 1895.105, Dyn. XXVI-XXX, provenance unknown	0.00	85.9	1.26	0.80	1.46	0.04	0.04	0.00	1.13	0.00	0.00	0.77	0.00	0.00	3.02	0.00	0.08	2.70	0.00	2.7
285-200-511 — Upper end of pale blue back pillar of ushabti 1892.641, Dyn. XXVI-XXX, provenance unknown	0.27	91.3	0.20	0.12	0.69	0.04	0.06	0.00	0.08	0.00	0.00	2.43	0.00	0.00	0.14	0.00	0.16	0.05	0.00	4.4
285-200-771 — Upper half of back pillar of black ushabti E.3577, Dyn. XXVI-XXX, provenance unknown	0.58	88.3	0.27	1.74	1.62	0.09	0.00	0.01	0.36	0.00	0.00	3.45	0.15	0.00	0.14	0.00	0.34	0.04	0.01	2.9
300-107-493 — Green chest of ushabti E.3580A, Dyn. XXX, Abydos G61	0.00	88.7	0.13	0.00	1.07	0.05	0.04	0.00	0.16	0.00	0.00	2.01	0.00	0.00	0.15	0.00	0.19	0.02	0.00	7.4
300-107-494 — Blue-grey right knee of ushabti E.3451A, Dyn. XXX, Abydos, tomb G50	1.19	84.1	0.03	0.41	2.74	0.39	0.00	0.06	2.03	0.02	0.00	2.21	0.00	0.00	0.31	0.00	0.36	0.02	0.00	6.1
300-107-495 — Dark blue wig of ushabti E.3451B, Dyn. XXX, Abydos, tomb G50	0.00	84.9	0.22	0.58	1.35	0.04	0.00	0.00	0.39	0.00	0.01	7.67	0.00	0.00	0.26	0.00	0.70	0.01	0.00	3.9
300-107-496 — Blue-green left elbow of ushabti E.3565, Dyn. XXX, Abydos, tomb G50	0.43	87.7	0.17	0.43	2.22	0.05	0.00	0.00	0.45	0.00	0.00	2.70	0.00	0.00	0.14	0.00	0.18	0.00	0.00	5.5
300-107-496 — Violet-blue wig of blue ushabti E.3565, Dyn. XXX, Abydos, tomb G50	0.73	86.9	0.13	1.67	3.56	0.05	0.00	0.00	0.99	0.11	0.00	2.45	0.00	0.00	0.14	0.00	0.12	0.00	0.00	3.2
300-107-769 — Blue abdomen of ushabti E.3566, Dyn. XXX, Abydos, tomb G50	0.62	83.7	0.25	0.46	7.65	0.04	0.00	0.00	0.01	0.45	0.00	2.86	0.00	0.00	0.16	0.01	0.18	0.04	0.01	3.5

X-RAY FLUORESCENCE ANALYSES OF INDIVIDUAL OBJECTS ARRANGED CHRONOLOGICALLY

Chloride and oxides of: Si, S, K, Ca, Ti, V, Cr, Mn, Fe, Co, Ni, Cu, Zn, As, Pb, Sr, Sn, Sb, Ba, Other

300-107-769 — Violet-blue wig, top of the head of blue ushabti E.3566, Dyn. XXX, Abydos, tomb G50

Si	S	K	Ca	Ti	V	Cr	Mn	Fe	Co	Ni	Cu	Zn	As	Pb	Sr	Sn	Sb	Ba	Other
0.81	85.2	0.53	0.59	3.82	0.07	0.00	0.01	0.78	0.07	0.00	3.73	0.00	0.00	0.19	0.01	0.27	0.05	0.00	3.9

300-107-769 — Violet-blue wig, right temple of blue ushabti E.3566, Dyn. XXX, Abydos, tomb G50

| 0.65 | 87.0 | 0.26 | 0.68 | 3.73 | 0.05 | 0.00 | 0.00 | 0.74 | 0.09 | 0.00 | 1.85 | 0.02 | 0.00 | 0.09 | 0.01 | 0.13 | 0.02 | 0.00 | 4.7 |

300-200-768 — Blue left ankle of ushabti 1956.19, Dyn. XXX, provenance unknown

| 1.08 | 82.3 | 0.22 | 2.05 | 6.97 | 0.12 | 0.00 | 0.02 | 0.71 | 0.00 | 0.00 | 3.68 | 0.00 | 0.00 | 0.12 | 0.01 | 0.14 | 0.05 | 0.04 | 2.5 |

300-200-768 — Violet-blue wig of blue ushabti 1956.19, Dyn. XXX, provenance unknown

| 1.22 | 82.4 | 0.15 | 2.45 | 6.29 | 0.09 | 0.00 | 0.23 | 1.04 | 0.21 | 0.00 | 2.35 | 0.01 | 0.00 | 0.06 | 0.01 | 0.09 | 0.03 | 0.03 | 3.3 |

300-200-770 — Blue left elbow of ushabti 1956.18, Dyn. XXX, provenance unknown

| 0.58 | 84.5 | 0.39 | 0.92 | 5.04 | 0.10 | 0.00 | 0.02 | 0.65 | 0.00 | 0.00 | 4.49 | 0.00 | 0.00 | 0.13 | 0.01 | 0.13 | 0.00 | 0.00 | 3.0 |

300-200-770 — Violet-blue wig of blue ushabti 1956.18, Dyn. XXX, provenance unknown

| 0.84 | 81.9 | 0.22 | 1.08 | 5.21 | 0.07 | 0.00 | 0.09 | 0.71 | 0.07 | 0.00 | 4.63 | 0.00 | 0.00 | 0.14 | 0.01 | 0.21 | 0.05 | 0.06 | 4.7 |

302-107-497 — Flat portion of the upper surface of dark-blue canopic jar lid E.3462, Dyn. XXX(Nectanebo II), Abydos, cemetery G

| 0.77 | 87.6 | 0.00 | 0.45 | 0.96 | 0.10 | 0.00 | 0.00 | 0.56 | 0.00 | 0.00 | 4.57 | 0.00 | 0.00 | 0.71 | 0.00 | 0.16 | 0.05 | 0.00 | 4.1 |

302-107-498 — Blue papyrus-sceptre amulet E.A.798A, Dyn. XXX(Nectanebo II), Abydos cemetery G

| 0.58 | 86.6 | 0.06 | 0.09 | 0.84 | 0.10 | 0.00 | 0.00 | 0.52 | 0.01 | 0.00 | 1.86 | 0.00 | 0.00 | 0.94 | 0.00 | 0.74 | 0.11 | 0.00 | 7.5 |

308-10-512 — Blue model cartouche, plaque 1888.239, Ptolemaic Period, Tukh el Qaramus, temple of Philip Arrhidaeus, foundation deposit

| 0.23 | 86.8 | 0.16 | 0.35 | 0.72 | 0.14 | 0.04 | 0.05 | 0.36 | 0.01 | 0.00 | 1.88 | 0.00 | 0.22 | 0.00 | 0.38 | 0.04 | 0.00 | — | 8.6 |

308-10-512 — Indigo hieroglyph on blue plaque 1888.239, Ptolemaic Period, Tukh el Qaramus, temple of Philip Arrhidaeus, foundation deposit

| 0.27 | 85.6 | 0.07 | 1.57 | 3.11 | 0.14 | 0.00 | 0.05 | 1.62 | 1.59 | 0.00 | 2.44 | 0.00 | 0.00 | 0.26 | 0.00 | 0.40 | 0.12 | 0.00 | 2.8 |

308-10-512 — Another indigo hieroglyph on plaque 1888.239, Ptolemaic Period, Tukh el Qaramus, temple of Philip Arrhidaeus, foundation deposit

| 0.00 | 76.8 | 0.00 | 0.99 | 4.37 | 0.12 | 0.03 | 0.04 | 1.32 | 1.52 | 0.00 | 1.32 | 0.16 | 0.00 | 0.15 | 0.01 | 0.32 | 0.09 | 0.00 | 12.8 |

308-10-687 — Blue rim of basin 1888.248, Ptolemaic Period, Tukh el Qaramus, temple of Philip Arrhidaeus, foundation deposit

| 0.04 | 85.1 | 0.25 | 0.00 | 4.70 | 0.08 | 0.00 | 0.04 | 0.57 | 0.00 | 0.00 | 4.03 | 0.00 | 0.00 | 0.26 | 0.05 | 0.30 | 0.02 | 0.00 | 4.6 |

308-10-688 — Green rectangular plaque 1888.256A, Ptolemaic Period, Tukh el Qaramus, temple of Philip Arrhidaeus, foundation deposit

| 0.03 | 88.5 | 0.13 | 0.22 | 1.12 | 0.13 | 0.00 | 0.04 | 0.32 | 0.01 | 0.00 | 1.90 | 0.04 | 0.00 | 0.16 | 0.00 | 0.58 | 0.12 | 0.01 | 6.6 |

309-200-542 — White body material, fragment of green "Royal oinochoe" 1892.1025, Ptolemaic Period, provenance unknown

| 0.18 | 85.4 | 2.36 | 0.83 | 6.71 | 0.07 | 0.00 | 0.00 | 0.65 | 0.00 | 0.00 | 0.34 | 0.01 | 0.00 | 0.00 | 0.00 | 0.00 | 0.00 | 0.00 | 3.4 |

309-200-542 — White left cheek of female head, raised relief on green "Royal oinochoe" 1892.1025, Ptolemaic Period, provenance unknown

| 0.14 | 89.0 | 1.90 | 0.86 | 3.55 | 0.05 | 0.00 | 0.02 | 0.53 | 0.00 | 0.00 | 0.14 | 0.03 | 0.01 | 0.00 | 0.04 | 0.02 | 0.00 | 0.00 | 3.7 |

309-200-542 — Smooth interior surface of green "Royal oinochoe" 1892.1025, Ptolemaic Period, provenance unknown

| 0.00 | 85.6 | 0.72 | 1.75 | 4.70 | 0.09 | 0.01 | 0.00 | 1.13 | 0.00 | 0.00 | 3.18 | 0.00 | 0.00 | 0.09 | 0.00 | 0.00 | 0.00 | 0.00 | 2.8 |

309-200-542 — Black hair on female head, raised relief on green "Royal oinochoe" 1892.1025, Ptolemaic Period, provenance unknown

| 0.26 | 71.5 | 0.64 | 3.03 | 3.56 | 0.32 | 0.00 | 0.11 | 15.01 | 0.64 | 0.00 | 1.35 | 0.07 | 0.00 | 0.00 | 0.00 | 0.02 | 0.00 | 0.00 | 3.5 |

310-1-541 — Green robe of female figure, raised relief on "Royal oinochoe" 1909.347, Ptolemaic Period, Alexandria

| 0.63 | 90.0 | 0.17 | 0.54 | 2.77 | 0.04 | 0.00 | 0.02 | 0.37 | 0.01 | 0.00 | 1.06 | 0.02 | 0.00 | 0.05 | 0.00 | 0.02 | 0.04 | 0.00 | 4.2 |

310-1-541 — Black hair on female head, raised relief on green "Royal oinochoe" 1909.347, Ptolemaic Period, Alexandria

| 0.00 | 75.0 | 1.46 | 2.08 | 6.37 | 0.18 | 0.00 | 0.02 | 9.53 | 0.40 | 0.00 | 2.49 | 0.05 | 0.00 | 0.56 | 0.00 | 0.26 | 0.00 | 0.00 | 1.6 |

X-RAY FLUORESCENCE ANALYSES OF INDIVIDUAL OBJECTS ARRANGED CHRONOLOGICALLY

Chloride and oxides of:

Sample	Description	Si	S	K	Ca	Ti	V	Cr	Mn	Fe	Co	Ni	Cu	Zn	As	Pb	Sr	Sn	Sb	Ba	Other	
310- 5-540	Smooth green interior surface of "Royal oinochoe" E.3720,Ptolemaic Period,Naucratis	0.00	84.8	0.62	0.68	1.89	0.05	0.03	0.02	0.60	0.01	0.00	1.20	0.00	0.00	2.97	0.00	0.00	1.26	0.00	5.9	
310- 25-519	White body material,trupcated female head 1892.1028,Ptolemaic Period,Cairo	0.13	90.3	0.61	0.38	5.45	0.04	0.00	0.01	0.40	0.00	0.00	0.00	0.01	0.01	0.00	0.03	0.02	0.00	0.00	2.6	
310- 25-519	Greyish white head-cover at the back of female head 1892.1028,Ptolemaic Period,Cairo	1.06	85.4	1.69	0.34	5.45	0.05	0.00	0.02	0.53	0.00	0.00	0.15	0.00	0.00	0.09	0.03	0.01	0.01	0.02	5.2	
310- 25-519	Yellow right cheek of female head 1892.1028,Ptolemaic Period,Cairo	0.00	78.2	1.42	1.72	4.99	0.05	0.00	0.00	1.18	0.02	0.00	0.05	0.00	0.00	7.57	0.00	0.00	1.14	0.00	3.7	
310- 25-519	Pale purple hair over the right temple of female head 1892.1028,Ptolemaic Period,Cairo	0.13	88.3	0.29	1.62	3.58	0.07	0.00	0.00	0.75	0.72	0.00	0.29	0.00	0.00	0.61	0.06	0.05	0.05	0.03	3.5	
310- 25-519	Purple-red hair on the left temple of female head 1892.1028,Ptolemaic Period,Cairo	0.27	88.6	0.83	0.40	3.32	0.05	0.00	0.43	0.38	0.00	0.00	0.03	0.00	0.00	0.71	0.07	0.00	0.07	0.03	4.8	
310- 32-524	Yellow background,interior surface of polychrome bowl fragment 1909.1042,Ptolemaic Period,Memphis	0.00	73.4	2.81	2.44	3.04	0.00	0.00	0.03	0.55	0.01	0.00	0.58	0.00	0.00	12.78	0.00	0.00	2.01	0.00	2.3	
310- 32-524	Blue decoration over yellow ground,exterior of polychrome bowl fragment 1909.1042,Ptolemaic Period,Memphis	0.00	77.2	1.76	1.56	1.32	0.06	0.00	0.00	0.86	0.10	0.00	1.45	0.00	0.00	9.08	0.00	0.14	1.37	0.00	5.1	
310- 32-525	Undecorated creamy interior surface of bowl fragment 1909.1044,Ptolemaic Period,Memphis	0.00	95.4	0.00	0.34	2.06	0.08	0.00	0.00	0.35	0.02	0.07	0.07	0.00	0.00	0.00	0.00	0.00	0.00	0.00	1.6	
310- 32-525	Brown decoration on white exterior of bowl fragment 1909.1044,Ptolemaic Period,Memphis	1.30	91.4	0.24	0.38	2.04	0.07	0.00	0.00	1.74	0.55	0.00	0.25	0.00	0.00	0.24	0.00	0.00	0.00	0.00	1.8	
310- 32-526	Dark-green triangle framed by blue,interior surface of bowl fragment 1909.1045,Ptolemaic Period,Memphis	0.00	78.2	1.52	1.57	3.23	0.10	0.00	0.00	0.64	0.02	0.00	3.34	0.00	0.00	5.90	0.00	0.77	0.00	0.00	4.7	
310- 32-526	Dark blue decoration on green exterior of bowl fragment 1909.1045,Ptolemaic Period,Memphis	0.00	81.9	1.70	2.28	1.30	0.04	0.00	0.00	1.02	0.14	0.00	2.33	0.00	0.00	3.44	0.00	1.11	0.00	0.00	3.1	
310- 32-527	Creamy body material,fragment of blue bowl 1909.1050,Ptolemaic Period,Memphis	0.00	97.5	0.00	0.37	0.71	0.07	0.07	0.08	0.44	0.01	0.02	0.16	0.02	0.00	0.00	0.00	0.00	0.00	0.01	0.5	
310- 32-527	Pale blue flower petals on dark-blue ground,interior surface of bowl fragment 1909.1050,Ptolemaic Period,Memphis	1.13	86.5	0.33	1.14	2.67	0.09	0.00	0.00	0.59	0.02	0.00	3.57	0.00	0.00	0.14	0.00	0.02	0.00	0.00	3.8	
310- 32-528	Bluish grey ground separating pale blue petals,interior surface of bowl fragment 1909.1050,Ptolemaic Period,Memphis	1.33	85.3	0.00	1.29	2.33	0.07	0.00	0.00	1.47	0.53	0.00	4.43	0.00	0.00	0.15	0.00	0.00	0.00	0.00	3.1	
310- 32-528	Yellow background to the reliefs on vase fragment 1909.1056,Ptolemaic Period,Memphis	0.00	83.7	1.41	0.96	3.77	0.02	0.00	0.06	0.42	0.00	0.00	0.10	0.00	0.00	4.68	0.00	0.60	0.00	0.00	4.2	
310- 32-529	Greyish green human figure,raised relief on yellow exterior of vase fragment 1909.1056,Ptolemaic Period,Memphis	0.00	84.6	1.03	0.64	3.40	0.07	0.00	0.00	1.24	0.13	0.00	0.67	0.00	0.00	1.81	0.00	0.13	0.32	0.00	5.9	
310- 32-529	Blue-green ground,interior surface of bowl fragment 1910.546(2),Ptolemaic Period,Memphis	0.00	80.7	1.34	1.08	1.80	0.08	0.00	0.00	0.56	0.01	0.00	2.76	0.00	0.00	6.78	0.00	0.11	1.33	0.00	3.5	
310-	Recessed dark-blue ground,exterior of blue-green bowl fragment 1910.546(2),Ptolemaic Period,Memphis	0.44	82.4	0.00	0.85	2.95	0.09	0.00	0.03	1.29	0.45	0.00	1.89	0.00	0.00	4.74						

X-RAY FLUORESCENCE ANALYSES OF INDIVIDUAL OBJECTS ARRANGED CHRONOLOGICALLY

Chloride and oxides of:

	Si	S	K	Ca	Ti	V	Cr	Mn	Fe	Co	Ni	Cu	Zn	As	Pb	Sr	Sn	Sb	Ba	Other
310- 32-530 Yellow body material of polychrome vase fragment 1910.551(1),Ptolemaic Period,Memphis	0.00	88.9	0.00	1.93	0.00	0.00	0.00	0.00	0.60	0.00	0.00	0.03	0.02	0.00	2.08	0.00	0.00	0.70	0.00	5.8
310- 32-530 Yellow-green ground,exterior of vase fragment 1910.551(1),Ptolemaic Period,Memphis	0.00	83.7	1.90	1.65	1.83	0.05	0.00	0.03	0.38	0.01	0.01	0.51	0.00	0.00	4.78	0.00	0.00	0.68	0.00	4.5
310- 32-530 Dark blue ground to green figures,interior surface of vase fragment 1910.551(1),Ptolemaic Period,Memphis	0.00	81.4	1.15	1.63	1.08	0.01	0.00	0.17	1.84	0.62	0.00	2.37	0.00	0.00	4.39	0.00	0.00	0.85	0.00	4.5
310- 32-531 Yellow body material of polychrome vase fragment 1910.551(2),Ptolemaic Period,Memphis	0.00	91.5	0.00	0.20	1.68	0.02	0.01	0.00	0.55	0.00	0.01	0.04	0.00	0.00	1.86	0.00	0.00	0.67	0.00	3.5
310- 32-531 Yellow-green ground for blue decorations,interior surface of vase fragment 1910.551(2),Ptolemaic Period,Memphis	0.00	81.6	1.76	1.38	2.73	0.04	0.00	0.00	0.36	0.00	0.00	0.35	0.00	0.00	7.61	0.00	0.00	0.77	0.00	3.4
310- 32-531 Dark blue ground bordered by yellow decorations,exterior of vase fragment 1910.551(2),Ptolemaic Period,Memphis	0.00	84.1	0.95	1.08	3.97	0.07	0.00	0.03	0.59	0.26	0.00	0.64	0.00	0.00	4.78	0.00	0.00	0.33	0.00	3.2
310- 32-532 White interior surface of bowl fragment 1910.549(1),Ptolemaic Period,Memphis	0.41	91.6	0.00	0.66	2.62	0.08	0.03	0.02	0.52	0.00	0.01	0.11	0.02	0.00	0.04	0.00	0.00	0.00	0.00	3.9
310- 32-532 Grey-black decorative frieze,exterior of bowl fragment 1910.549(1),Ptolemaic Period,Memphis	1.09	88.1	0.19	1.21	2.19	0.11	0.00	0.00	0.33	1.72	0.33	0.79	0.02	0.00	0.07	0.02	0.00	0.00	0.00	3.9
310- 32-532 Brown stripe,exterior of bowl fragment 1910.549(1),Ptolemaic Period,Memphis	1.23	88.8	0.33	0.98	2.56	0.12	0.00	0.08	2.05	0.57	0.00	0.19	0.00	0.00	0.05	0.04	0.00	0.00	0.00	3.1
310- 32-533 White interior surface of bowl fragment 1913.800A,Ptolemaic Period,Memphis	0.00	93.7	0.13	0.59	3.07	0.11	0.00	0.00	0.56	0.00	0.00	0.09	0.00	0.00	0.00	0.00	0.00	0.00	0.00	1.7
310- 32-533 Grey-black decorative pattern,exterior of bowl fragment 1913.800A,Ptolemaic Period,Memphis	0.57	87.0	0.26	0.87	2.06	0.08	0.00	0.37	0.92	0.11	0.00	1.11	0.00	0.00	0.08	0.02	0.00	0.00	0.00	6.6
310- 32-533 Brown decorative pattern,exterior of bowl fragment 1913.800A,Ptolemaic Period,Memphis	0.43	90.8	0.05	0.72	1.98	0.10	0.01	0.00	1.91	0.61	0.01	0.21	0.03	0.00	0.00	0.01	0.00	0.00	0.00	3.1
310- 32-534 Grey and green decorative frieze,exterior of bowl fragment 1913.799,Ptolemaic Period,Memphis	1.87	83.9	0.00	2.13	3.29	0.17	0.00	0.00	0.54	1.73	0.15	1.50	0.03	0.00	0.27	0.00	0.00	0.00	0.00	4.4
310- 32-534 Brown decorative frieze,interior surface of bowl fragment 1913.799,Ptolemaic Period,Memphis	1.28	86.8	0.06	0.98	3.29	0.16	0.00	0.00	1.87	1.09	0.00	0.50	0.00	0.00	0.16	0.00	0.00	0.00	0.00	3.8
310- 32-535 Creamy body material,fragment of polychrome bowl 1913.803C,Ptolemaic Period,Memphis	0.00	92.6	0.87	0.59	1.02	0.16	0.13	0.00	0.11	0.00	0.01	0.04	0.00	0.00	1.26	0.00	0.02	0.21	0.00	2.4
310- 32-535 Yellow green band,interior surface of bowl fragment 1913.803C,Ptolemaic Period,Memphis	0.42	87.6	1.05	0.35	1.73	0.06	0.00	0.00	0.45	0.02	0.00	0.46	0.00	0.00	3.03	0.00	0.04	0.36	0.00	4.5
310- 32-535 Blue-green ground separating green petals,exterior of bowl fragment 1913.803C,Ptolemaic Period,Memphis	0.00	84.4	1.10	1.82	1.90	0.17	0.00	0.00	2.09	0.46	0.00	1.57	0.02	0.00	3.57	0.00	0.10	0.44	0.00	2.4
310- 32-536 Clear greyish green bottom of bowl fragment 1913.808,Ptolemaic Period,Memphis	0.82	88.2	0.11	0.59	2.23	0.08	0.25	0.00	0.09	0.50	0.01	0.74	0.00	0.00	0.18	0.00	0.00	0.00	0.00	6.2
310- 32-536 Brown streak mixed with green,side of mottled bowl fragment 1913.808,Ptolemaic Period,Memphis	1.30	87.5	0.00	0.57	2.30	0.09	0.00	0.00	1.88	0.62	0.00	0.32	0.00	0.00	0.09	0.00	0.00	0.00	0.00	5.3

X-RAY FLUORESCENCE ANALYSES OF INDIVIDUAL OBJECTS ARRANGED CHRONOLOGICALLY

Chloride and oxides of:

Sample	Si	S	K	Ca	Ti	V	Cr	Mn	Fe	Co	Ni	Cu	Zn	As	Pb	Sr	Sn	Sb	Ba	Other
310- 32-537 — Exposed white streak, body material of marbled vase fragment 1913.804, Ptolemaic Period, Memphis	0.20	92.6	0.00	0.23	0.76	0.07	0.05	0.00	0.02	0.34	0.00	0.29	0.02	0.00	1.50	0.01	0.00	0.35	0.00	3.5
310- 32-537 — Exposed grey streak, body material of marbled vase fragment 1913.804, Ptolemaic Period, Memphis	0.22	64.2	0.06	0.63	3.95	0.28	0.00	0.00	9.81	0.68	0.00	2.97	0.11	0.00	8.37	0.01	0.09	0.13	0.00	8.4
310- 32-537 — Darkest grey streak on exposed body material of marbled vase fragment 1913.804, Ptolemaic Period, Memphis	0.19	66.8	0.06	1.00	3.55	0.19	0.00	0.04	8.88	0.62	0.00	2.71	0.20	0.00	7.24	0.01	0.08	0.13	0.00	8.3
310- 32-537 — Pale green irredescent spot, exterior of marbled vase fragment 1913.804, Ptolemaic Period, Memphis	0.49	88.0	0.10	1.53	1.81	0.10	0.00	0.00	1.01	0.03	0.00	1.20	0.00	0.00	2.62	0.00	0.00	0.14	0.00	3.0
310- 32-537 — Dark center of green spot on the exterior of marbled bowl fragment 1913.804, Ptolemaic Period, Memphis	0.56	81.0	0.00	1.32	3.13	0.02	0.00	0.03	0.53	0.04	0.00	1.80	0.00	0.00	4.49	0.01	0.00	0.30	0.00	6.7
310- 32-537 — Dark grey spot, exterior of marbled vase fragment 1913.804, Ptolemaic Period, Memphis	0.32	76.9	0.00	2.54	2.79	0.30	0.00	0.00	9.08	0.11	0.00	1.16	0.03	0.00	4.14	0.00	0.00	0.06	0.00	2.6
310- 33-517 — Grey spot on the bottom of marbled bowl fragment 1913.804, Ptolemaic Period, Memphis	0.37	74.7	0.00	1.55	3.11	0.37	0.00	0.00	9.89	0.33	0.00	1.24	0.07	0.00	5.27	0.02	0.04	0.11	0.00	3.0
310-107-513 — Pale blue base of model vase-stand 1971.69, Ptolemaic Period, Saqqara, area H5	0.00	74.4	1.37	0.24	13.65	0.08	0.00	0.10	0.57	0.00	0.00	2.23	0.00	0.00	2.63	0.00	0.00	0.00	0.00	4.8
310-107-513 — Undecorated lower half of blue model djed pillar, plaque 1912.529, Ptolemaic Period, Abydos, tomb E460	0.53	87.3	0.42	0.78	1.93	0.18	0.00	0.00	1.05	0.01	0.00	2.10	0.00	0.00	1.38	0.00	0.63	0.09	0.00	3.6
310-107-513 — Black ram's horns on top of blue model djed pillar, plaque 1912.529, Ptolemaic period, Abydos, tomb E460	0.60	77.2	0.69	1.03	3.97	0.15	0.00	0.00	2.81	2.69	0.00	1.34	0.00	0.00	0.64	0.02	0.20	0.04	0.00	8.7
310-107-513 — Violet-blue ostrich feathers, Atef crown on top of model djed pillar, plaque 1912.529, Ptolemaic Period, Abydos, tomb E460	0.90	83.7	1.06	1.07	4.14	0.15	0.00	0.33	1.52	0.14	0.00	2.24	0.00	0.00	1.63	0.01	0.40	0.05	0.00	2.7
310-107-513 — Inlaid violet-blue stripes in the middle of blue model djed pillar, plaque 1912.529, Ptolemaic Period, Abydos, tomb E460	0.91	86.2	0.56	0.91	2.96	0.11	0.00	0.06	1.13	0.34	0.00	2.15	0.00	0.00	1.51	0.00	0.40	0.05	0.00	2.7
310-107-514 — Undecorated side of flat detachable wings of scarab amulet 1912.533, Ptolemaic Period, Abydos, tomb E460	0.72	87.4	0.00	0.50	2.30	0.00	0.00	0.00	0.19	0.01	0.00	1.89	0.00	0.00	0.21	0.00	0.43	0.00	0.00	6.4
310-107-514 — Violet-blue lines outlining the feathers on blue scarab wing 1912.533, Ptolemaic Period, Abydos, tomb E460	1.66	83.0	0.06	0.23	4.83	0.02	0.00	0.01	0.47	0.18	0.00	2.13	0.00	0.00	0.18	0.00	0.27	0.01	0.01	7.0
310-107-515 — Dark blue beaker 1912.528, Ptolemaic Period, Abydos, tomb E460	0.59	88.3	0.04	0.64	2.09	0.10	0.03	0.00	0.00	0.00	0.00	2.24	0.00	0.00	0.47	0.00	0.28	0.00	0.00	4.3
310-135-516 — Dark brown surface on blue-green body, fragment of model hes-vase 1885.330, Ptolemaic Period, Edfu	0.32	80.9	0.22	3.41	4.62	0.39	0.00	0.13	2.05	0.00	0.00	3.42	0.00	0.00	0.28	0.00	0.53	0.07	0.00	3.7
310-200-538 — Yellow boss at the center of green rosette, polychrome vase 1924.45, Ptolemaic Period, provenance unknown	0.00	80.6	2.42	1.41	1.97	0.10	0.05	0.00	0.02	0.81	0.03	0.00	0.61	0.00	6.78	0.00	0.07	1.98	0.00	3.1
310-200-538 — Green forehead of Bes, affix on the exterior of polychrome vase 1924.45, Ptolemaic Period, provenance unknown	0.78	88.3	0.27	0.81	2.74	0.07	0.00	0.00	0.65	0.00	0.00	0.58	0.01	0.00	1.68	0.00	0.00	1.33	0.00	2.7
310-200-538 — Blue-grey background, exterior of polychrome vase 1924.45, Ptolemaic Period, provenance unknown	0.92	86.9	0.02	1.44	1.37	0.10	0.00	0.02	1.29	0.16	0.00	1.24	0.02	0.00	0.98	0.00	0.06			

X-RAY FLUORESCENCE ANALYSES OF INDIVIDUAL OBJECTS ARRANGED CHRONOLOGICALLY

Chloride and oxides of:

No. / Description	Si	S	K	Ca	Ti	V	Cr	Mn	Fe	Co	Ni	Cu	Zn	As	Pb	Sr	Sn	Sb	Ba	Other
310-200-539 Yellow-green winged lion within a dark-green panel,exterior of vessel 1888.1455,Ptolemaic Period,provenance unknown	0.00	81.1	2.51	1.68	3.04	0.04	0.00	0.00	0.79	0.02	0.00	0.32	0.00	5.28	0.00	0.08	1.16	0.00		4.0
310-200-539 Blue-green area surrounding the winged lion,exterior of vessel 1888.1455,Ptolemaic Period,provenance unknown	0.00	79.4	2.10	2.63	2.23	0.04	0.00	0.00	1.24	0.12	0.00	1.94	0.00	5.08	0.00	0.07	1.30	0.00		3.9
320-32-543 White body material,fragment of polychrome lamp 1910.555(2),Ptolemaic-Roman Period,Memphis,Kom Hellul kilns	0.00	94.0	0.00	0.24	4.88	0.09	0.07	0.05	0.07	0.42	0.02	0.00	0.12	0.02	0.00	0.05	0.00	0.01	0.00	-0.0
320-32-543 Green decorative button on blue lamp fragment 1910.555(2),Ptolemaic-Roman Period,Memphis,Kom Hellul kilns	0.58	81.2	0.00	1.67	4.17	0.27	0.00	0.00	1.41	0.00	0.00	3.63	0.00	0.00	2.85	0.00	0.66	0.31	0.00	3.2
320-32-543 Blue ground bordered by green design lines,lamp fragment 1910.555(2),Ptolemaic-Roman Period,Memphis,Kom Hellul kilns	1.07	82.9	0.07	1.21	3.98	0.13	0.00	0.00	0.13	1.02	0.00	4.16	0.03	0.00	1.18	0.02	0.44	0.02	0.01	3.6
320-32-543 Pale blue undecorated reverse side of lamp fragment 1910.555(2),Ptolemaic-Roman Period,Memphis,Kom Hellul kilns	0.96	80.0	2.66	1.51	5.49	0.22	0.00	0.00	0.04	1.09	0.00	2.41	0.05	0.00	0.58	0.02	0.18	0.01	0.01	4.8
320-32-544 Blue bottom,exterior of dish fragment E.3749A,Ptolemaic-Roman Period,Memphis,Kom Hellul kilns	0.00	84.1	0.31	0.48	5.07	0.14	0.00	0.00	0.06	0.75	0.00	2.39	0.00	0.00	0.22	0.00	0.32	0.00	0.00	6.2
320-32-544 Blue irredescent interior surface of dish fragment E.3749A,Ptolemaic-Roman Period,Memphis,Kom Hellul kilns	0.00	87.0	0.23	1.69	2.20	0.00	0.00	0.00	1.25	0.00	0.00	0.72	0.00	0.00	0.07	0.00	0.23	0.00	0.00	6.6
320-32-545 Blue interior surface of bowl fragment E.4620,Ptolemaic-Roman Period,Memphis,Kom Hellul kilns	0.22	86.6	0.06	1.26	2.64	0.12	0.00	0.00	0.05	0.88	0.00	2.01	0.00	0.00	0.09	0.00	0.22	0.00	0.00	5.9
320-32-546 Blue interior surface of vase fragment E.4621,Ptolemaic-Roman Period,Memphis,Kom Hellul kilns	0.09	85.3	0.19	0.90	4.08	0.24	0.00	0.00	0.02	1.11	0.00	2.45	0.01	0.00	0.10	0.00	0.30	0.03	0.00	5.2
320-32-547 Pale blue interior surface of bowl fragment E.4624,Ptolemaic-Roman Period,Memphis,Kom Hellul kilns	0.00	90.1	0.13	1.75	1.94	0.19	0.01	0.00	0.00	1.22	0.00	2.63	0.07	0.00	0.09	0.00	0.32	0.00	0.00	1.6
320-32-549 Blue exterior (mixed with green),vase fragment 1910.557(2),Ptolemaic-Roman Period,Memphis,Kom Hellul kilns	0.58	84.0	0.00	2.10	2.88	0.16	0.00	0.00	0.06	1.13	0.03	4.45	0.00	0.00	1.55	0.00	0.48	0.00	0.00	2.6
320-32-550 Blue exterior (mixed with green),vase fragment 1910.557(1),Ptolemaic-Roman Period,Memphis,Kom Hellul kilns	0.48	82.1	0.03	1.37	4.50	0.16	0.00	0.00	0.27	1.47	0.00	2.88	0.08	0.00	1.07	0.00	0.28	0.00	0.00	5.3
320-32-550 Black stripe on blue exterior of vase fragment 1910.557(1),Ptolemaic-Roman Period,Memphis	0.48	79.2	0.00	1.40	4.93	0.14	0.00	0.00	1.54	1.99	0.00	3.77	0.11	0.00	2.10	0.03	0.49	0.00	0.09	3.8
320-32-550 Black design line on blue exterior of vase fragment 1910.557(1),Ptolemaic Period,Memphis	0.78	78.0	0.00	1.74	4.67	0.00	0.00	0.00	1.45	1.83	0.00	2.89	0.33	0.00	2.39	0.00	0.53	0.00	0.05	5.3
320-32-551 Raised blue spot,bordered by green plants,bowl fragment 1910.560,Ptolemaic-Roman Period,Memphis,Kom Hellul kilns	0.12	86.0	0.11	1.32	2.90	0.15	0.00	0.00	0.09	1.27	0.00	2.92	0.10	0.00	1.08	0.00	0.45	0.00	0.00	3.5
320-32-551 Black band on green bowl fragment 1910.560,Ptolemaic-Roman Period,Memphis,Kom Hellul kilns	1.10	78.7	0.10	1.64	5.69	0.22	0.00	0.00	0.47	2.88	0.01	2.60	0.08	0.00	2.19	0.04	1.14	0.04	0.33	2.8
320-32-552 Dark blue area on the exterior of bowl fragment 1910.559(3),Ptolemaic-Roman Period,Memphis,Kom Hellul kilns	0.36	81.2	0.14	1.00	4.37	0.12	0.00	0.00	1.19	1.00	0.00	4.10	0.00	0.00	0.32	0.00	0.31	0.00	0.00	5.8
320-32-553 Greyish green donkey,raised relief on polychrome vase fragment 1910.544,Ptolemaic-Roman Period,Memphis,Kom Hellul kilns	0.47	84.9	0.00	1.45	5.39	0.21	0.00	0.00	0.99	1.53	0.00	0.80	0.00	0.00	0.80	0.00	0.08	0.01	0.00	3.4

X-RAY FLUORESCENCE ANALYSES OF INDIVIDUAL OBJECTS ARRANGED CHRONOLOGICALLY

Chloride and oxides of:

Object / Description	Si	S	K	Ca	Ti	V	Cr	Mn	Fe	Co	Ni	Cu	Zn	As	Pb	Sr	Sn	Sb	Ba	Other
320-32-553 Purple-red lotus bud,raised relief on polychrome vase fragment 1910.544,Ptolemaic-Roman Period,Memphis,Kom Hellul kilns	0.25	85.6	0.10	1.28	4.31	0.01	0.00	1.51	0.88	0.00	0.00	0.79	0.01	0.00	0.00	0.08	0.00	0.00		4.2
320-32-554 Yellow-green plant on brown exterior of bowl fragment 1910.559(1),Ptolemaic-Roman Period,Memphis,Kom Hellul kilns	0.00	77.1	0.49	0.90	7.87	0.07	0.00	0.19	0.72	0.00	0.00	1.20	0.00	0.00	4.13	0.00	0.48	1.13	0.00	5.8
320-32-554 Brown ground,exterior of bowl fragment 1910.559(1),Ptolemaic-Roman Period,Memphis,Kom Hellul kilns	0.00	82.6	0.74	0.49	7.90	0.08	0.00	2.52	0.80	0.00	0.00	1.38	0.02	0.00	0.30	0.00	0.04	0.00	0.00	3.2
320-32-556 Dark green thigh of a lion,raised relief on vase fragment 1910.545,Ptolemaic-Roman Period,Memphis,Kom Hellul kilns	0.78	82.4	0.00	0.59	2.08	0.14	0.00	0.06	2.68	0.02	0.00	4.45	0.03	0.00	0.42	0.00	0.22	0.00	0.00	6.1
320-32-557 Yellow-green band under a bird,raised relief on vase fragment 1910.553,Ptolemaic-Roman Period,Memphis,Kom Hellul kilns	0.00	80.2	1.07	1.80	1.88	0.02	0.00	0.03	0.51	0.01	0.00	5.22	0.21	0.00	4.53	0.00	0.24	1.32	0.00	3.0
320-32-558 White plant-design on purple exterior of vase fragment 1910.554,Ptolemaic-Roman Period,Memphis,Kom Hellul kilns	0.00	88.1	0.00	1.66	5.03	0.17	0.00	0.37	0.98	0.00	0.00	0.35	0.00	0.00	0.51	0.00	0.12	0.00	0.00	2.7
320-32-558 Purple plant-design,exterior of vase fragment 1910.554,Ptolemaic-Roman Period,Memphis,Kom Hellul kilns	0.26	85.2	0.38	1.49	3.93	0.12	0.00	0.00	1.97	0.00	0.00	0.23	0.01	0.00	0.30	0.00	0.14	0.00	0.00	5.1
320-32-559 Blue head-cloth by the right cheek of sphinx fragment E.4611,Ptolemaic-Roman Period,Memphis,Kom Hellul kilns	0.00	86.0	0.44	2.01	2.40	0.18	0.00	0.05	1.16	0.01	0.00	4.67	0.08	0.00	0.13	0.00	0.20	0.00	0.00	2.6
320-32-560 Blue-green left side of sphinx(?) fragment E.4614A,Ptolemaic-Roman Period,Memphis,Kom Hellul kilns	0.00	86.7	0.00	0.48	2.74	0.16	0.01	0.00	0.82	0.00	0.00	2.55	0.05	0.00	0.09	0.00	0.18	0.00	0.00	6.2
320-116-699 Fragment of green model lettuce,U.C.34696,Ptolemaic-Roman Period,Qift(Coptos),temple of Min	0.06	85.7	0.64	0.93	5.53	0.11	0.00	0.01	0.87	0.00	0.00	1.94	0.00	0.00	0.18	0.02	0.09	0.09	0.00	3.8
320-116-699 Blue decoration on fragment of green model lettuce,U.C.34696,Ptolemaic-Roman Period,Qift(Coptos),temple of Min	0.09	80.9	0.59	1.29	5.20	0.17	0.00	0.04	2.31	0.50	0.00	2.75	0.00	0.00	0.31	0.02	0.09	0.09	0.00	5.6
320-200-548 Dark blue spot on the breast of pale blue bird,raised relief on vase fragment 1949.748,Ptolemaic-Roman Period,provenance unknown	0.29	83.2	0.00	0.67	3.10	0.15	0.01	0.02	0.23	0.00	0.00	6.20	0.03	0.00	0.09	0.00	0.33	0.00	0.00	4.8
320-200-555 Yellow neck of female head 1968.104,Ptolemaic-Roman Period,provenance unknown	0.00	78.1	0.88	3.06	4.33	0.03	0.00	0.07	0.48	0.01	0.00	0.59	0.00	0.00	9.19	0.00	0.09	1.35	0.00	1.8
320-200-555 Blue hair over yellow skin,left side of female head 1968.104,Ptolemaic-Roman Period,provenance unknown	0.00	71.7	1.03	4.01	4.94	0.14	0.00	0.71	1.50	0.01	0.00	1.63	0.00	0.00	9.32	0.00	0.29	0.83	0.00	3.9
320-200-555 Purple skin below the right ear of female head 1968.104,Ptolemaic-Roman Period,provenance unknown	0.10	77.7	0.89	3.19	3.74	0.08	0.00	0.30	0.93	0.01	0.01	1.20	0.02	0.00	8.45	0.01	0.30	1.07	0.00	2.0
325-68-352 White body material of indigo bowl fragment 1924.119,probably Roman Period,Tell el-Amarna	0.07	93.7	0.00	0.69	1.70	0.20	0.00	0.00	0.17	0.00	0.00	0.00	0.02	0.00	0.00	0.01	0.00	0.00	0.07	3.4
325-68-352 Fluted exterior of indigo bowl fragment 1924.119,probably Roman Period,Tell el-Amarna	0.00	80.3	0.88	2.30	2.85	0.00	0.00	0.00	1.87	1.35	0.00	1.88	0.00	0.00	3.09	0.00	0.00	0.39	0.00	4.9
325-68-352 Exterior surface near the rim of indigo bowl fragment 1924.119,probably Roman Period,Tell el-Amarna	0.00	79.8	0.00	2.85	4.88	0.09	0.00	0.00	1.22	0.75	0.00	1.03	0.00	0.00	1.91	0.02	0.00	0.49	0.00	6.8
325-68-352 Smooth interior surface of indigo bowl fragment 1924.119,probably Roman Period,Tell el-Amarna	0.17	75.3	0.00	2.79	5.00	0.10			1.36			1.93								

CODE NUMBERS OF ANALYSED OBJECTS LISTED ACCORDING TO RECOVERY SITE

Abadiya
 Second Intermediate Period
 pan grave E2: 131-112-250,-251
Abydos
 Dyn. I
 tomb O(Djer): 14-107- 29,- 30
 tomb Z(Djet): 15-107- 22
 tomb T(Udimu): 16-107- 27,- 28
 tomb X(Anedjib): 17-107- 44
 tomb X53(Anedjib): 17-107- 24
 tomb X84(Anedjib): 17-107- 25
 tomb U(Semerkhet): 18-07- 1,- 2,
 - 3,- 4,- 5,- 6,- 7,- 8,- 9
 tomb Q(Ka´a): 19-107- 23
 Dyn. I-II
 tomb M16: 20-107- 33
 chamber M69: 20-107- 38,- 39,
 - 40,- 41,- 42
 tomb W9: 20-107- 32
 tomb W37: 20-107- 31
 temple area: 20-107- 34,- 35,
 - 36,- 37
 Dyn. II
 tomb P(Peribsen): 28-107- 26
 tomb V(Kha-Sekhemwy): 29-107- 19,
 - 20,- 21
 Dyn. VI
 Sixth Dynasty Temple: 61-107- 91,
 - 92,- 93,- 94,- 95,- 96,- 97
 First Intermediate Period
 grave 1736: 80-107-149,-150
 Middle Kingdom: 120-107-182,-183
 tomb 416: 120-107-163,-164,-165,
 -166,-168,-169,-170,-171,-172,
 -173,-174,-175,-176,-177,-178,
 -179,-180,-181
 grave D2: 120-107-154,-155
 tomb D166: 120-107-151
 tomb E2: 120-107-152,-153
 tomb E3: 120-107-185,-186,-187,
 -188,-746,-747,-748,-750,-751,
 -752,-754,-755
 tomb E30: 120-107-161,-162
 tomb E237: 120-107-157
 tomb E303: 120-107-184
 grave S44: 120-107-159,-160
 Second Intermediate Period
 grave D79: 131-107-245,-246,
 -606,-607,-608,-609
 pan grave O4: 131-107-244
 Dyn. XIV
 tomb E230: 141-107-243
 Dyn. XVII-XVIII
 grave D25: 178-107-248
 Early Dyn. XVIII
 tomb 1806: 182-107-242,-247,
 -610,-611

 tomb E166(2): 182-107-627
 tomb E266: 182-107-625,-626
 tomb E271: 180-107-263
Dyn. XIX
 tomb D14: 193-107-392
 grave E269: 193-107-393
Dyn. XX
 grave D14E: 201-107-394
Dyn. XXI
 tomb D22: 210-107-421
 tomb D60: 210-107-420
Dyn. XXI-XXIV: 214-107-422,-423,-424,
 -425,-426,-427,-428,-429,-430
Dyn. XXV
 tomb D16C: 250-107-491
 tomb D3: 251-107-492
Dyn. XXVI-XXX
 tomb G3: 285-107-677,-678
Dyn. XXX
 cemetery G: 302-107-497,-498
 tomb G50: 300-107-494,-495,-496,-769
 tomb G61: 300-107-493
Ptolemaic Period
 tomb E460: 310-107-513,-514,-515
Akhmim
 Late Dyn. XVIII: 185- 82-292
Alexandria
 Ptolemaic Period: 310- 1-541
Tell el-Amarna
 Late Dyn. XVIII: 185- 68-331,-333
 186- 68-334,-335,-336,-337,-338,-339
 187- 68-318,-319,-320,-321,
 -322,-329,-330,-342,-343,-344,
 -345,-346,-347,-348,-349,-350,
 -351,-353,-354,-355,-356,-357,
 -358,-359,-360,-361,-797
 Great Palace: 187- 68-312,-313,
 -314,-315,-316
 house M50.32: 187- 68-317
 house M50.33: 187- 68-323
 house T.34.1: 187- 68-324
 house U.35.24: 187- 68-325
 house U.36.53: 187- 68-326
 houses Q42-3/50-2: 187- 68-327,-328
 Roman Period: 325- 68-352
Armant
 Dyn.I(S.D.80)
 grave 1208: 11-124- 47
 Dyn. IV
 grave 1310N: 41-124- 98,- 99,
 -584,-585
Badari
 Old Kingdom
 grave 5433: 46- 78- 85,- 86
 Dyn. V-VI
 grave 3236: 56- 78- 78,-578,-579
 Dyn. VI

CODE NUMBERS OF ANALYSED OBJECTS LISTED ACCORDING TO RECOVERY SITE

grave 5535: 61- 78- 79,- 80,
 - 81,- 82,- 83
grave 5543: 61- 78- 84
Dyn. VII-VIII
 grave 3306: 78- 78-124,-125,
 -126,-127,-128,-129
Second Intermediate Period
 pan grave 5473: 131- 78-238,-239,
 -616,-617
 pan grave 5478: 131- 78-236,-237
Beit Khallaf
 Dyn. III
 tomb K1: 31-104- 53,- 54,-582,-583
Beni Hasan
 Middle Kingdom
 tomb 294: 120- 62-190
Cairo
 Dyn. XXVI-XXX: 285- 25-471
 Ptolemaic Period: 310- 25-519
Coptos, see Qift
Defenneh(Daphnae)
 Dyn. XXVI: 262- 9-465
Deir el Bahari
 Dyn. XVIII,Reign of Hatshepsut
 temple of Mentuhotep: 183-119-288
 Dyn. XX,Reign of Ramesses IV
 site 40,foundation deposit:
 204-119-400
Dishasha
 Dyn. V
 tomb 22: 51- 60- 76
Dra Abu el Naga(Thebes)
 Middle Kingdom: 120-118-191
Edfu
 Ptolemaic Period: 310-135-516
Faras
 Second Intermediate Period
 C-group cemetery 1,grave 716:
 145-150-261
 C-group cemetery 2,grave 219/3:
 145-150-257,-258
 C-group cemetery 2,grave 229/4:
 145-150-259,-260
Fayyum
 Dyn. XXV-XXVII: 257- 47-490
Gebel el Silsila
 Dyn. XVIII(Horemhab): 189-137-403
Giza
 Dyn. XIX: 193- 26-660
 Dyn. XIX-XX: 200- 26-661
 Dyn. XXI-XXIV: 214- 26-662,-663
 Dyn. XXVI: 261- 26-474
Gumaiyima
 Dyn. XXV-XXX: 275- 7-466
Hammamiya
 Dyn. VII-VIII
 grave 2080: 78- 79-138,-139,

-140,-141
Dyn. IX-X
 grave 1509: 90- 79-143
 grave 1648: 90- 79-142
Haraga
 Dyn. XI
 house ruin 530: 115- 55-193,-194
 -592,-593
 grave 644: 115- 55-192
 Middle Kingdom
 grave 7: 120- 55-196
 Early Dyn. XVIII
 grave 270: 182- 55-308
Hawara
 Dyn. XXVI
 tomb of Horudja: 260- 51-489
Hierakonpolis(Kom el-Ahmar)
 Dyn. I-II
 Main Deposit: 20-134- 11,- 12,
 - 13,- 14,- 15,- 16,- 17,- 18
 grave 30: 20-134-633,-634
 group 61: 20-134-631,-632
 house 144: 20-134- 48
 grave 206: 20-134-635,-636
Hu
 Dyn. I
 grave R208(S.D.77): 11-110- 45
 Middle Kingdom
 grave Y52: 120-110-598,-599
 grave Y176: 120-110-189
 Second Intermediate Period
 pan grave W10: 131-110-255,-256
 pan grave X46: 131-110-252
 pan grave X58: 131-110-253,-254
Ihnasiya
 Dyn. XVIII
 temple of Tuthmosis III:
 183- 58-293
el Kab
 Old Kingdom: 46-133- 57
 tomb C: 41-133- 55,- 56
 tomb 166: 46-133- 59,-574,-575
 Middle Kingdom
 grave 1: 121-133-198,-199,-200
 grave 24: 122-133-201,-602,-637
 grave 36: 123-133-202,-210,-211,
 -756,-757,-758
 grave 42: 124-133-212,-600,-601,
 -603,-604,-605
 grave 60: 125-133-203,-204,-759
 grave 85: 126-133-219,-760
 grave 202: 127-133-205,-206,-207,
 -208,-209,-763,-764
Kafr Ammar
 Dyn. XXV
 temple fill: 250- 39-436
Lahun

CODE NUMBERS OF ANALYSED OBJECTS LISTED ACCORDING TO RECOVERY SITE

Early Dyn. XVIII
 tomb of Maket: 181- 54-304;
 183- 54-295,183- 54-296,-297,
 -298,-299,-300,-301,-302,-303,
 -305,-306,-307
Dyn. XXII
 grave 602: 220- 54-412,-413
Mahasna
 Old Kingdom
 tomb M114: 46-106- 60,- 61,- 62,
 -580,-581
 First Intermediate Period
 grave M23: 80-106-104,-105
 grave M87: 80-106-102,-103
 grave M319: 80-106-111,-112
 grave M348: 80-106-114,-115,
 -586,-587,-588,-589,-590,-591
 grave M560: 80-106-113
 grave M587: 80-106-106,-107,
 -108,-109,-110
Matmar
 Dyn. I(S.D.78)
 grave 220: 11- 74- 46
 Dyn. I-II
 grave 2001: 20- 74-571,-572,-573
 Dyn. VI
 grave 838: 61- 74- 87
 Dyn. VII-VIII
 tomb 532: 78- 74-133,-134
 tomb 1316: 78- 74-131,-132,-132
 Dyn. IX-X
 tomb 306: 90- 74-136,-137
 Dyn. XXII-XXV
 grave 721: 225- 74-417
 grave 740: 225- 74-671,-672
 grave 758: 225- 74-416
 grave 772: 225- 74-418
 grave 793: 225- 74-419,-670
 grave 1214: 225- 74-675
 grave 1294: 225- 74-414
Medinet Ghurab
 Early Dyn. XIX
 group of Amenhotep III:
 190- 53-377,-378,-379,-380,
 -381,-382,-693,-694
 burnt deposit of Tutankhamun:
 190- 53-695,-696,-697
 Dyn. XIX
 group 4: 192- 53-383,-384
 group 1: 195- 53-385,-386,-387
 Dyn. XIX-XX
 grave O1: 200- 53-389
 grave O4: 200- 53-388
Medum
 Dyn. XXVI-XXX: 285- 42-488
Memphis
 Dyn. XXII-XXV

 palace of Merneptah: 225- 32-666,
 -667,-668,-669
 Dyn. XXVI: 262- 32-476,-480,-799
 Dyn. XXVI-XXVII
 temple of Merneptah: 257- 32-475,
 -564,-565,-566,-567,-762,-767
 Dyn. XXVI-XXX
 palace of Apries: 277- 32-477,-503
 Ptolemaic Period: 310- 32-524,-525,
 -526,-527,-528,-529,-530,-531,
 -532,-533,-534,-535,-536,-537
 Late Ptolemaic-Roman Period
 Kom Hellul kilns: 320- 32-543,
 -544,-545,-546,-547,-549,-550,
 -551,-552,-553,-554,-556,-557,
 -558,-559,-560
Mustagidda
 Dyn. V
 grave 3540: 51- 76- 77
 Second Intermediate Period
 pan grave 3113: 130- 76-227,-228
 pan grave 3117: 131- 76-225,-226,
 -614,-615
 pan grave 3170: 130- 76-229,-230,
 -231,-232,-233,-234,-235,
 -612,-613,-638
Nabesha
 Dyn. XX
 tomb 3: 201- 8-372
 tomb 31: 201- 8-371
 Dyn. XXVI
 grave in hosh 76: 262- 8-468
 temple of Amasis,foundation
 deposit: 263- 8-467
 Dyn. XXV-XXX: 275- 8-462,-463,-464
Naqada
 Amratian Period(Naqada I)
 grave 1774(S.D.31): 3-117- 10
 grave 1752: 3-117-700,-701,-702
 grave 1783: 3-117-741,-742,-743
 grave 1567: 4-117-703
 Gerzean Period(Naqada II)
 grave 1330(S.D.35-43): 5-117-705
 grave 13: 6-117-724 ,-737
 grave 343: 5-117-704
 grave 630: 5-117-706
 grave 661: 6-117-725,-726,-727,
 -728,-736
 grave 667: 6-117-721,-722,-723
 grave 704: 6-117-738,-739,-740,
 -744,-753,-783,-784,-796
 grave 804: 7-117-729,-730,-731,
 -732,-733,-734,-735,-778,-779,
 -780,-781
 grave 869: 6-117-714,-715,-716,
 -717,-718,-719,-720
 grave 1248: 9-117-707,-708,-709,-791

CODE NUMBERS OF ANALYSED OBJECTS LISTED ACCORDING TO RECOVERY SITE

Naucratis
 Dyn. XXVI-XXX: 285- 5-679,-680,
 -681,-682,-683,-685,-686
 Ptolemaic Period: 310- 5-540
Qasr el Sagha
 Dyn. XI-XII
 grave 13: 119- 45-594,-595,-596,
 -597,-640
Qau
 Dyn. IV-V
 grave 677: 45- 80- 63,-576,-577
 Dyn. VI
 grave 557: 61- 80- 70,- 71
 grave 613: 61- 80- 69
 grave 676: 61- 80- 67,- 68
 grave 7317: 61- 80- 73
 Dyn. IX-X
 grave 7311: 90- 80-144,-145
 Second Intermediate Period
 cemetery 1300: 131- 80-240,-241
 Dyn. XIX
 grave 317: 193- 80-391
Qift(Coptos)
 Early Dyn. XVIII
 temple of Tuthmosis III,foundation
 deposit: 183-115-290,-628,-629,
 -772,-773,-774,-775,-776,-777,-785
 -786,-787,-788,-789,-790,-792,-798
 Late Dyn. XVIII: 185-115-332
 Ptolemaic-Roman Period
 temple of Min: 320-116-699
Qurna
 Dyn. XIX, Reign of Ramesses II
 temple foundation deposit:
 192-120-397
Riqqa
 Dyn. XXV
 cemetery B: 250- 43-458
Sanam Abu Dom(Sudan)
 Dyn. XXV
 grave 1516: 252-151-459,-460,-461
Saqqara
 Dyn. III
 Pyramid of Djoser: 31- 33- 50,- 51
 Heb Sed Temple of Djoser:
 31- 33- 52
 tomb of Djoser: 31- 33- 65
 Dyn. XXI-XXIV: 214- 33-664,-665
 Dyn. XXV-XXVII: 257- 33-481,-483
 Dyn. XXVI: 261- 33-482
 Dyn. XXVI-XXVII
 tomb of Tjanehebu: 265- 33-484
 Ptolemaic Period
 area H5: 310- 33-517
Serabit el Khadim,temple of Hathor
 Dyn. XVIII
 Reign of Hatshepsut: 183- 38-273

 Reign of Tuthmosis III: 183- 38-310
 -311
 Dyn. XIX: 193- 38-650,-651,-652,
 -655,-656
 Reign of Seti I: 191- 38-362
 Reign of Ramesses II: 192- 38-363
 Reign of Merneptah: 194- 38-364,
 -365,-366,-367,-653
 Reign of Seti II: 195- 38-368
 Dyn. XX, Reign of Ramesses III:
 203- 38-369,-370
Sidmant
 Dyn. IX-X
 grave 1526: 90- 56-146
 grave 2108: 90- 56-147,-148,-156,
 -793,-794,-795
 Second Intermediate Period
 grave 1270: 130- 56-216,-217
Sinai(Petrie's 1904-5 expedition)
 Dyn. XV-XVI: 151- 12-215
Tarkhan
 Dyn. I-II
 grave 678: 20- 40-569,-570,-636,-74?
Tell el-Yahudiya
 Dyn. XV(Hyksos Period)
 grave 37: 151- 20-213,-214,-618,
 -619,-620,-621,-622,-623,-624
 Dyn. XX
 palace of Ramesses III: 203- 20-373,
 -374,-375,-376,-639,-657,-658,-765
Thebes
 Dyn. XVIII: 185-118-289
 temple of Tuthmosis IV: 184-118-691
 temple of Amenhotep II: 185-118-692
 Dyn. XIX
 tomb of Seti I: 191-118-395
 Ramesseum,foundation deposit:
 192-118-396
 temple of Siptah,foundation
 deposit: 196-118-398
 temple of Tawosre,foundation
 deposit: 196-118-399
 Dyn. XX-XXI
 tomb of Amenemope: 209-118-410,-411
 Dyn. XXI-XXIV: 214-118-431
 Dyn. XXII-XXV: 225-118-433,-485,-796
 Dyn. XXV(Shabaka): 250-118-435
 Dyn. XXVI: 262-118-501
 Dyn. XXVI-XXX: 285-118-500
Tukh el Qaramus
 New Kingdom: 200- 10-659
 Dyn. XXVI-XXX: 285- 10-676
 Macedonian Period
 temple of Philip Arrhidaeus,
 foundation deposit:
 308- 10-512,-687,-688
Yahudiya, see Tell el-Yahudiya

BIBLIOGRAPHY

LIST OF BIBLIOGRAPHICAL ABBREVIATIONS

- Lucas = A. Lucas and J.R. Harris, **Ancient Egyptian Materials and Industries**, 4th Ed., Edward Arnold Ltd., London, 1962.

- **AGT = Advances in Glass Technology, Part** 2 (Historical papers presented at the 6th International Congress on Glass), F.A.Matson and G.E.Rindone, Editors,Plenum Press, New York, 1963.

- **BMOP** = **British Museum Occasional Paper**, published by the British Museum, London.

- **JEA** = Journal of Egyptian Archaeology

- **CAH = Cambridge Ancient History**, Cambridge University Press, 3rd Edition, 1971-1975.

- **RAS** = **Revue d'Archéometrie, supplement** 1981,Vol.3 (20eme symposium international d'archeometrie, Paris, May 26-29, 1980).

- **RASTM = Recent Advances in Science and Technology** of **Materials**, Vol.3, A.Bishay Ed.,Plenum Press, New York, 1974.

- **SAT = The Search for Ancient Tin** (a seminar organized by T.A.Wertime, the Smithsonian Institution, March 14-15, 1977), U.S. Government Printing Office, Washington, D.C.,1978.

REFERENCES

1. Lucas, pp.155-178 and 474-75 (faience analyses).

2. K. Kühne, "Äegyptische Fayencen", Part I, in St. Wenig, **Grabungen der deutschen Orient-Gesellschaft**, 1969, pp. 5-27.

3. J.F.S. Stone and L.C. Thomas, "The Use and Distribution of Faience in the Ancient East and Prehistoric Europe", **Proceedings of the Prehistoric Society, 22** (1956), 37-84.

4. A. Aspinall, S.E. Warren, J.G. Crummett and R.G. Newton, "Neutron Activation Analysis of Faience Beads", **Archaeometry, 14** (1972), 27-40.

5. H. McKerrell, "On the Origins of British Faience Beads and Some Aspects of the Wessex-Mycenae Relationship", **Proceedings of the Prehistoric Society, 38** (1972), 286-293.

6. J.E. Dayton and A. Dayton, **Minerals, Metals, Glazing, and Man**, London, 1978.

7. J.V. Noble, "The Technique of Egyptian Faience", **American Journal of Archaeology, 73** (1969), 435-39.

8. C.F. Binns, M. Klein and H. Mott, "An Experiment in Egyptian Blue Glaze", **Journal of the American Ceramic Society, 15** (1932), 271-272.

9. C. Kiefer and A. Allibert, "Pharaonic Blue Ceramics: the Process of Self-Glazing", **Archaeology, 24** (1971), 107-117.

10. H.E. Wulff, H.S. Wulff and L. Koch, "Egyptian Faience: a Possible Survival in Iran", **Archaeology, 21** (1968), 98-107.

11. K. Kühne, "Frühegeschichtliche Werkstoffe auf silikatischer Basis", **Das Altertum, 20** (1974), 67-80.

12. P. Vandiver, "Technological Change in Egyptian Faience", **Archaeological Ceramics** (Seminar on Ceramics as Archaeological Material, The National Bureau of Standards, Washington, D.C., Sept. 29-Oct. 1, 1980), A.D. Franklin and J.S. Olin, Eds., The Smithsonian Institution Press, Washington, D.C., 1982.

13. E.T. Hall, F. Schweizer and P.A. Toller, "X-Ray Fluorescence Analysis of Museum Objects", **Archaeometry, 15** (1973), 53-78.

14. R.H. Brill, "Interlaboratory Comparison Experiments on the Analysis of Ancient Glass", **Proceedings of the 7th International Congress on Glass**, Preliminary Papers, Sec. B, Brussels: International Congress on Glass, 1965, pp.1-4; R.H. Brill, "A

REFERENCES

Chemical Analytical Round-Robin on Four Synthetic Ancient Glasses", The 9th International Congress on Glass, Versailles,Sep.1971, Artistic and Historical Communications, Paris, l'Institut du Verre, 1972, pp. 93-110.

15. (a) R. Jenkins and J.L. DeVries, Practical X-Ray Spectrometry, Springer-Verlag, New York, 1967, Chap. 7; (b) E.P. Bertin, Introduction to X-Ray Spectrometric Analysis, Plenum Press, New York, 1978, Chapter 9, Section 9.

16. G.A. Cox and A.M. Pollard, "X-ray Fluorescence Analysis of Ancient Glass. The Importance of Sample Preparation", Archaeometry, 19 (1977), 45-54.

17. W.E.S. Turner, "The Precision Attainable in the Chemical Analysis of Ancient Glasses", AGT, 1963, pp. 384-387.

18. Lucas, Chap. X and pp. 476-480 (glass analyses).

19. M. Farnsworth and P.D. Ritchie, "Spectrographic Studies on Ancient Glass", Technical Studies in the Field of Fine Arts, 6 (1938), 155-168.

20. E.R. Caley, Analyses of Ancient Glasses, 1790-1957, The Corning Museum of Glass, Corning, New York, 1962.

21. W.E.S. Turner, "Studies in Ancient Glasses and Glassmaking Processes. Part IV. The Chemical Composition of Ancient Glasses", Journal of the Society of Glass Technology, 40 (1956), 162-186.

22. E.V. Sayre and R.W. Smith, "Analytical Studies of Ancient Egyptian Glass", RASTM, 1974, pp. 47-70.

23. E.V. Sayre, "The Intentional Use of Antimony and Manganese in Ancient Glasses", AGT, 1963, pp. 263-282.

24. E.V. Sayre, private communication; some of the communicated data have appeared in a research report from the Brookhaven National Laboratory: E.V. Sayre, Some Ancient Glass Specimens with Compositions of Particular Archaeological Significance, Brookhaven National Laboratory, Upton, New York, July 1964.

25. R.H. Brill and S. Moll, "The Electron-Beam Probe Microanalysis of Ancient Glass", Recent Advances in Conservation, Contributions to the IIC Rome Conference, 1961, Butterworth, London, 1963, pp. 145-151.

26. W.E.S. Turner, "Studies in Ancient Glasses and Glassmaking Processes. Part V. Raw Materials and Melting Processes", Journal of the Society of Glass Technology, 40 (1956), 277-300.

27. Lucas, p. 481 (analyses of Egyptian sands).

28. A. Leo Oppenheim, R.H. Brill, D. Barag, and A. von Saldern, **Glass and Glassmaking in Ancient Mesopotamia**, The Corning Museum of Glass, Corning, New York, 1970, pp. 114-128.

29. Lucas, pp. 493-494 (natron analyses).

30. W.T. Chase, "Egyptian Blue as a Pigment and Ceramic Material", in **Science and Archaeology**, R.H. Brill, Ed., MIT Press, Cambridge (Mass) 1968, pp. 80-90.

31. M.S. Tite, M. Bimson and N.D. Meeks, "Technological Characterisation of Egyptian Blue", **RAS, 3** (1981), pp. 245-301.

32. J.D. Cooney, "Glass Sculpture in Ancient Egypt", **Journal of Glass Studies, 2** (1960), 32-29.

33. W.A. Weyl, **Coloured Glasses**, The Society for Glass Technology, Sheffield, England, 1951 (reprinted in 1978).

34. W. Geilmann, "Beitnege zur Kenntnis alter Glaser III", **Glastechnische Berichte, 28** (1955), 146-156.

35. S.K. Tobia and E.V. Sayre, "An Analytical Comparison of Various Egyptian Soils, Clays, Shales, and Some Ancient Egyptian Pottery by Neutron Activation", **RASTM**, 1974, pp. 99-128.

36. W. Noll, "Mineralogy and Technique of the Painted Ceramics of Ancient Egypt" (in German), **Neue Jahrbuch für Mineralogie. Abhandlungen, 133** (1978), 227-290.

37. W. Noll, R. Holm, and L. Born, "Painting of Ancient Ceramics", **Angewandte Chemie, International Edition, 14** (1975), 602-613.

38. W.F. Hume, **The Geology of Egypt**, Vol. 2, Part III, Egyptian Government Press, Cairo, 1937.

39. R. Said, **The Geology of Egypt**, Elsevier, Amsterdam, 1962.

40. E.M. El Shazly and G.S. Saleeb, "Contributions to the Mineralogy of Egyptian Manganese Deposits", **Economic Geology, 54** (1959), 873-888.

41. Lucas, Chap. XI ("Metals and Alloys: Minerals"), pp. 195-269.

42. W.M.F. Petrie, **Ancient Egyptians**, in book No. 11 of **Descriptive Sociology**, Williams and Norgate, Ltd., London, 1925, p. 49.

43. Lucas, pp. 81-84.

44. P. Ramdohr, **The Ore Minerals and Their Intergrowths**, Pergamon

Press, Oxford, 1969.

45. R.W. Andrews, **Cobalt**, Overseas Geological Surveys, Mineral Resources Division, HMS Publication, London, 1962.

46. (a) H.J.L. Beadnell, **An Egyptian Oasis**, J. Murray and Co., London, 1909, p. 222; (b) "Dakhla Oasis: Its Topography and Geology", **Geological Survey Report, 1899**, Part IV, National Printing Department, Cairo, 1901, p. 130.

47. F.W. Moon, **Preliminary Geographical Report on St. John's Island**, Government Press, Cairo, 1923, p. 16.

48. H. Droop Richmond and H. Off, "Indications of a Possible New Element in an Egyptian Mineral", **Journal of the Chemical Society**, 61 (1892), 491-495.

49. Lucas, pp. 482-492 (analyses of metals and alloys).

50. J. Riederer, "Recently Identified Egyptian Pigments", **Archaeometry**, 16 (1974), 102-109.

51. (a) W. Noll and K. Hangst, "Contributions to the Knowledge of Ancient Egyptian Blue Pigments" (in German), **Neue Jahrbuch für Mineralogie. Monatshafte**, 1975, 209-214; (b) W. Noll, "Kaltbemallung antiker Gefasskeramik", **Naturwissenschaften**, 63 (1976), 385.

52. W. Noll, "Mineralogy and Technology of the Painted Ceramics of Ancient Egypt", in **Scientific Studies in Ancient Ceramics**, M.J. Hughes, Ed., **BMOP No. 19**, London, 1981, pp. 143-152.

53. H.G. Bachmann, H. Everts and C.A. Hope, "Cobalt-Blue Pigment on 18th Dynasty Egyptian Pottery", **Mitteilungen des deutschen archaeologischen Instituts, Abteilung Kairo**, 36 (1980), 33-37.

54. N. Barakat and E.M. El Shazly, "Spectrographic Distribution of Chemical Elements in Egyptian Minerals from Lead, Zinc, Copper and Gold Deposits", **Bulletin de l'institut d'Egypte**, 57 (1956), 31-46.

55. (a) J.E. Dayton, "Cobalt, Silver and Nickel in Late Bronze Age Glazes, Pigments and Bronzes, and the Identification of Silver Sources for the Aegean and the Near East", in **Scientific Studies in Ancient Ceramics**, M.J. Hughes, Ed., **BMOP No. 19**, London, 1981, pp. 129-142. (b) J.E. Dayton, "Geological Evidence for the Discovery of Cobalt Blue Glass in Mycenean Times as a By-Product of Silver Smelting in the Schneeberg Area of the Bohemian Erzgebirge", **RAS**, 3(1981), pp. 57-61.

56. R. Cottevieille-Giraudet, "La verrerie-les graffiti", **Raport sur les Fouilles du Medamud,1930** (FIFAO,VIII), Cairo, 1931, pp. 5-9.

57. (a) A.H. Schindler, **Eastern Persian Irak**, Royal Geographical Society, London, 1896, p. 114. (b) G. Ladame, "Les resources metalliferes de l'Iran", **Schweizerische mineralogische und petrographische Mitteilungen, XXV** (1945), 195-97.

58. J.W. Allan, "Abu'l-Qasim's Treatise on Ceramics", **Iran, 11** (1973), 111-120.

59. W.J. Young, "Discussion of Some Analyses of Chinese Underglaze Blue and Underglaze Red", **Far Eastern Ceramic Bulletin, 2** (1949), 19-26.

60. H. Garner and S. Young, "An Analysis of Chinese Blue-and-White", **Oriental Art, N.S. 2** (1956), 43-47.

61. M.S. Banks and J.M. Merrick, "Further Analysis of Chinese Blue-and-White", **Archaeometry, 10** (1968), 101-103.

62. J.C.Y. Watt, "Notes on the Use of Cobalt in Later Chinese Ceramics", **Ars Orientalis, 11** (1979), 63-83.

63. G. L. Nassim, "The Discovery of Nickel in Egypt", **Economic Geology, 44** (1949), 143-150.

64. B. Rothenberg, **Timna**, London, 1972.

65. J.R. Harris, **Lexicographical Studies in Ancient Egyptian Minerals**, Akademie-Verlag GmbH, Berlin, 1961, p. 57.

66. A.L. Oppenheim, **Letters from Mesopotamia**, The University of Chicago Press, Chicago, 1967, p. 120; Letter EA 35 in J.A. Knudtzon, **Die El-Amarna-Tafeln**, Leipzig, 1910.

67. W.E.S. Turner and H.P. Rooksby, "A Study of the Opalising Agents in Ancient Glass Throughout Three Thousand Four Hundreds Years, Part. I", **Glastechnische Berichte, 32K**, Part VIII, special supplement (1959), 17-28.

68. H.P. Rooksby, "Opacifiers in Opal Glasses", **General Electric Company Journal, 29** (1962), 20-26.

69. E.M. El Shazly and M.S. Afia, "Geology of Samiuki Deposit, Eastern Desert", **Egyptian Journal of Geology, 2** (1958), 25-42.

70. R. Said, Paper 61, **Geological Survey of Egypt**, Cairo, 1974.

71. E.J. Baumgartel, **The Cultures of Prehistoric Egypt**, Vol. II, Oxford University Press, Oxford, 1960, p. 18.

72. T.C.F. Hall, **Lead Ores**, J. Murray and Co., London, 1921, p. 65.

73. A.M. Bateman, **Economical Mineral Deposits**, Wiley, New York,

1955, p. 527.

74. W. Lindgren, **Mineral Deposits**, McGraw-Hill, New York, 1933, pp. 423-426.

75. A.E. Werner and M. Bimson, "Some Opacifying Agents in Oriental Glass", **AGT**, 1963, pp. 303-305.

76. Lucas, pp. 348-350.

77. H.G. Wiedemann and G. Bayer, "The Bust of Nefertiti", **Analytical Chemistry, 54** (1982), 619-628.

78. E.M. El Shazly, S. Abdel Nasser and B. Shukri, "Contributions to the Mineralogy of the Copper Deposits in Sinai", Paper 1, **Geological Survey of Egypt**, Cairo, 1955.

79. Z. Stos-Gale and N.H. Gale, "Sources of Galena, Lead and Silver in Predynastic Egypt", **RAS, 3** (1981), pp. 285-295.

80. J.A. Charles, "Early Arsenical Bronzes--a Metallurgical View", **American Journal of Archaeology, 71** (1967), 21-26.

81. J.A. Charles, "The Development of the Usage of Tin and Tin-Bronze: Some Problems", **SAT**, Chapter 3, pp. 25-32.

82. H. McKerrell and R.F. Tylecote, "The Working of Copper-Arsenic Alloys in the Early Bronze Age, and the Effect on Determination of Provenance", **Proceedings of the Prehistoric Society, 38** (1972), 209-218.

83. P.R.S. Moorey and F. Schweizer, "Copper and Copper Alloys in Ancient Iraq, Syria and Palestine: Some New Analyses", **Archaeometry, 14** (1972), 177-198.

84. P. Bar-Adon, **The Cave of the Treasure. The Finds from the Caves in Nahal Mishmar** (in Hebrew), Judean Desert Studies, Jerusalem, 1971, Table 1.(An English translation is in preparation)

85. R.J. Braidwood, J.E. Burke and N.H. Nachtrieb, "Ancient Syrian Coppers and Bronzes", **Journal of Chemical Education, 28** (1951), 87-97.

86. R.J. Braidwood and L.S. Braidwood, **Excavations in the Plain of Antioch**, The University of Chicago, Oriental Institute Publication No. 61, Chicago, 1960.

87. **CAH**, Vol. I, Part 2, pp. 333-343.

88. P.R.S. Moorey and F. Schweizer, "Copper and Copper Alloys in Ancient Turkey: Some New Analyses", **Archaeometry, 16** (1974), 112-115.

89. E.R. Eaton and H. McKerrell, "Near Eastern Alloying and Some Textual Evidence for the Early Use of Arsenical Copper", **World Archaeology,** 8 (1976), 169-191.

90. H. McKerrell, "The Use of Tin-Bronze in Britain and the Comparative Relationship with the Near East", **SAT,** Chapter 2, pp. 7-24

91. Unpublished data, courtesy of the Department of Antiquities, Ashmolean Museum.

92. M. Cowell, British Museum Laboratory, private communication.

93. W.E.S. Turner and H.P. Rooksby, "A Study of the Opalising Agents in Ancient Glasses Throughout 3400 Years, Part II", **AGT,** 1963, pp. 306-307.

94. W.E.S. Turner and H.P. Rooksby, "Further Historical Studies Based on the X-Ray Diffraction Methods of the Reagents Employed in Making Opal and Opaque Glasses", **Jahrbuch des roemisch-germanischen Zentralmuseums,** Mainz, VIII annual (1961), pp. 1-6.

95. J.W. Allan, L.R. Llewellyn, and F. Schweizer, "The History of So-called Egyptian Faience in Islamic Persia: Investigations into Abu'l-Qasim's Treatise", **Archaeometry,** 15 (1973), 165-173.

96. H.E. Wulff, **The Traditional Crafts of Persia,** MIT Press, Cambridge (Mass), 1966.

97. S.A. Saleh, Z. Iskander, A.A. El Masry and F.M. Helmi, "Some Ancient Egyptian Pigments", **RASTM,** 1974, pp. 141-155.

98. H.P. Rooksby, "A Yellow Cubic Lead Tin Oxide Opacifier in Ancient Glasses", **Physics and Chemistry of Glasses,** 5 (1964), 20-25.

99. J. Brailsford, **Early British Masterpieces from the British Museum,** British Museum Publications, London, 1975, pp. 75 and 81.

100. I.M. Stead, "A LaTene III Burial at Welwyn Garden City", **Archaeologia,** 101 (1967), 16-17.

101. T.A. Wertime, "The Search for Ancient Tin: the Geographic and Historic Boundaries", **SAT,** Chapter 1, pp. 1-6.

102. P.S. De Jesus, "Considerations on the Occurrence and Exploitation of Tin Sources in the Ancient Near East", **SAT,** Chapter 4, pp.33-38.

103. J.D. Muhly, "New Evidence for Sources of and Trade in Bronze Age Tin", **SAT,** Chapter 6, pp.43-48.

REFERENCES

104. J.D. Muhly, "COPPER AND TIN, The Distribution of Mineral Resources and the Nature of the Metals Trade in the Bronze Age", **Transactions of the Connecticut Academy of Arts and Sciences, 43** (1973), Chapter IV, published by Archon Books, Hamden, Connecticut.

105. G.A. Wainright, "The Occurence of Copper and Tin Near Byblos", **JEA, 20** (1934), 29-32.

106. G.A. Wainright, "Egyptian Bronze-Making", **Antiquity, 17** (1943), 96-98; "Egyptian Bronze-Making Again", **ibid, 18** (1944), 100-102.

107. N. Azer, "Remarks on the Origin of Precambrian Mineral Deposits in Egypt(U.A.R.)", **Tschermaks mineralogische und petrographische Mitteilungen**, Drittefolge 11 (1966), 41-64.

108. M.S. Amin, "A Tin-Tungsten Deposit in Egypt", **Economic Geology, 42** (1947), 637-671.

109. A.H. Sabet, V. Chabanenko and V. Tsogoev, "Tin-Tungsten and Rare Metal Mineralization in the Central Eastern Desert of Egypt", **Annals of the Geological Survey of Egypt", 3** (1973), 75-86.

110. H. Kees, **Ancient Egypt, A Cultural Topography**, University of Chicago Press, Chicago, 1961, Chapter IVA, and pp. 117,136,164.

111. W.M.F. Petrie, **Researches in Sinai**, J. Murray and Co., London, 1906, p. 51.

112. A.H. Gardiner, T.E. Peet, and J. Cerny, **Inscriptions of Sinai, part I**, 2nd Edition, Egypt Exploration Society, 1952, pp. 9-19.

113. A.R. Gindy, "Radioactivity and Tertiary Volcanic Activity in Egypt", **Economic Geology, 56** (1961), 557-568.

114. J.H. Breasted, **Ancient Records of Egypt**, Russell and Russell, New York, 1906, Vol. II, sections: 460, 462, 471, 491, 493, 509, 521, 534.

115. R. Schwabe and K. Slusallek, "Application of the Cluster Analysis on Element Concentrations of Archaeological Bronzes and Ceramics, **RAS, 3** (1981).

116. C.F.A. Schaeffer, "La contribution de la Syrie ancienne à l'invention du bronze", **JEA, 31** (1945), 92-95.

117. R.E.M. Hedges and P.R.S. Moorey, "Pre-Islamic Ceramic Glazes at Kish and Nineveh in Iraq", **Archaeometry, 17** (1975), 25-43.

118. V.V. Vargin, **Technology of Enamels**, Hart Publishing Co., New York, 1968.

119. C.G. Fink andan A.H. Kopp, "Ancient Egyptian Antimony Plating of Copper Objects", **Metropolitan Museum Studies**, 4 (1933), 163-167; **Chemistry and Industry**, 53 (1934), 216-220; **Industrial and Engineering Chemistry**, 26 (1934), 236.

120. C.S. Smith, "An Examination of the Arsenic-Rich Coating on a Bronze Horse from Horoztepe", in **Applications of Science in Examination of Works of Art** (1970 Seminar), W.J. Young, Ed., Boston, Museum of Fine Arts, 1970, note 5, p. 102.

121. R.H. Brill and S. Moll, "The Electron Beam Probe Microanalysis of Ancient Glass", **AGT**, 1963, pp. 293-302.

122. R.F. Tylecote and P.J. Boydel, "Experiments of Copper Smelting Based on Early Furnaces Found at Timna", in **Chalcolithic Copper Smelting, Archaeo-Metallurgy**, Institute for Archaeo-Metallurgical Studies, Monograph No. 1, London, 1977, pp. 27-49.

123. R. Maddin, J.D. Muhly and T.S. Wheeler, **Metalworking at Atheniou**, 1977, p. 12; T.S. Wheeler, R. Maddin and J.D. Muhly, "Ingots and the Bronze Age Trade in the Mediterranean: A Progress Report", **Expedition**, 1975, p. 35.

124. G.A. Mustafa, M.I.A. Kabesh, and A.M. Abdalla, Geology of Gebel el-Ineigi District", **Egyptian Geological Survey**, Report No. 40 (1954).

125. M.F. El Ramly, Egyptian Geological Survey, Cairo, private communication to N.H. Gale, Department of Geology, Oxford University.

126. A.M. Bateman, **op. cit.**, pp. 607-609; W. Lindgren, **op. cit.**, pp. 473-475, 876-877.

127. H.C. Beck and C.G. Seligman, "Barium in Ancient Glass", **Nature**, 133 (1934), 982.

128. C.G. Seligman, P.D. Ritchie and H.C. Beck, "Early Chinese Glass from pre-Han to T'ang Times", **Nature**, 138 (1936), 721; see also ref. 20, pp. 38-45.

129. V. Vikentief, "26th Dynasty Inscriptions", **Annales du service des antiquités de l'Egypte** , 54 (1957), 179-189.

130. R. Doremus, **Glass Science**, John Wiley, New York, 1972, pp. 102-103.

131. R.H. Brill, I.L. Barnes and B. Adams, "Lead Isotopes in Some Ancient Egyptian Objects", **RASTM**, 1974, pp. 9-27.

132. Z.A. Stos-Fertner and N.H. Gale, "Chemical and Lead Isotope Analysis of Ancient Egyptian Gold, Silver and Lead", **Archaeo**

Physica, 10 (1979), 219-314.

33. N.H. Gale and Z.A. Stos-Gale, "Ancient Egyptian Silver", JEA, 67 (1981), 103-115.

34. A.A. Hassan and F.A. Hassan, "Source of Galena in Predynastic Egypt", Archaeometry, 23 (1981), 77-82.

35. G. Dykmans, Histoire économique et sociale de l'ancien Egypte, vol. I, Picard, Paris, 1936, p. 201.

36. W.M.F. Petrie, Arts and Crafts of Ancient Egypt, 2nd edition, London, 1910, p. 103,107-119.

37. P.E. Newberry, Beni Hassan I, The Egypt Exploration Society, London, 1893 (reprinted in 1975); see also ref.14, vol. I, p. 281, note d.

38. J.M. Ogden, "The So-Called Platinum Inclusions in Egyptian Goldwork", JEA, 62 (1976), 138-144.

39. W.E.S. Turner, "Studies of Ancient Glass and Glass-Making Processes. Part I. Crucibles and Melting Temperatures Employed in Ancient Egypt at about 1370 B.C.", Journal of the Society of Glass Technology, 38 (1954), 436-444.

40. C.E. Hayward, An Outline of Metallurgical Practice, 3rd Edition, Van Nostrand, New York, 1952, p. 12.

41. F.R. Matson, "The Composition and Working Properties of Ancient Glasses", Journal of Chemical Education, 28 (1951), 82-87.

42. Pliny the Elder, Natural History, Book XXXI, Chapter 46, Loeb Classical Library, W.Heinemann, Ltd.,London, 1963.

43. O. Popp, "Ueber das Nilwasser", Liebigs Annalen, 155 (1870), 344-348.

144. Lucas, pp. 267-268.

145. H.C. Beck, "Glass Before 1500 B.C.", Ancient Egypt and the East, June 1934, part I, pp. 7-20.

146. D.P. Barag, "The Origin of Glass", The 9th International Congress on Glass, Versailles, Sep. 1971. Artistic and Historical Communications. Compte rendu des travaux, Paris, l'Institut du Verre,1972, pp.183-196.

147. W.A. Weyl and E.C. Marboe, The Constitution of Glasses: a Dynamic Interpretation, Vol. I, Interscience Publishers, New York, 1962.

148. G.R. McCarthy, **American Journal of Science, 12** (1926), 16-36.

149. A. Chambers and J.F. Rigg, "Notes on Antimony Yellows, Part I", **Transactions of the Ceramics Society, 25** (1925-26), 101-107.

150. C. Aldred, **Akhenaten and Nefertiti**, New York, 1973, pp. 212-218; see also **CAH**, Vol. II, Part 2, p. 97.

151. W.M.F. Petrie, **Illahun, Kahun and Gurob**, D. Nutt, London, 1891, pp. 16-17.

152. W.B. Emery, **Archaic Egypt**, Penguin Books Ltd., Hammondsworth, Middlesex, 1967, p. 97; A. Gardiner, **Egypt of the Pharaohs**, Oxford University Press, Oxford, 1961, p.414.

153. H. Whitehouse, Ashmolean Museum, private communication.

154. C.A. Hope, University College, London, private communication.

155. A. Muan and S. Somiya, "The System Iron Oxide-Manganese Oxide in Air", **American Journal of Science, 260** (1962), 230-240.

156. Lucas, pp. 372-381.

157. N.A. Eissa, H.A. Sallam, S.A. Saleh, F.M. Taiel, and L. Kesthelyi, "Mossabauer Effect Study of Ancient Egyptian Pottery and the Origin of the Colour in Black Ware", **RASTM**, 1974, pp. 85-98.

158. W.E.S. Turner, "Studies of Ancient Glasses and Glass-Making Processes. Part II. The Composition,Weathering Characteristics and Historical Significance of Some Assyrian Glasses of the Eight to Sixth Centuries B.C. from Nimrud", **Journal of the Society of Glass Technology, 38** (1954), 445-456.

159. W.E.S. Turner, "Glass Fragments from Nimrud of the Eight to Sixth Century B.C.", **Iraq, 17**(1955),57-68.

160. J.E. Quibell, **Hierakonpolis**, 4th and 5th Memoirs, parts I and II, B. Quaritch for the Egyptian Research Account, London, 1900, 1902; B. Adams, **Ancient Hierakonpolis**, Aris and Phillips, Warminster, England, 1974.

161. W.C. Hayes, **The Scepter of Egypt**, Part II, The Metropolitan Museum of Art, New York, 1959, p. 368 and Fig. 232.

162. J. Baines and J. Malek, **Atlas of Ancient Egypt**, Phaidon Press, Oxford, 1980, p. 174.

163. V. Webb, **Archaic Greek Faience**, Aris and Phillips, Warminister, England, 1978.

REFERENCES

164. D.B. Thompson, **Ptolemaic Oinochai and Portraits in Faience:
Aspects of the Ruler Cult,** Oxford University Press,Oxford, 1973.

165. Lucas, pp. 161-164.

166. H. Le Chatelier, "Sur les poteries égyptiennes", **Comptes Rendus
de l'Academie des Sciences,** 129 (1899), 477-480.

167. J. Llorens i Artigas, **Les pastes ceramiques i els esmalts blaus
de l'antic Egipte** (in Catalan), Barcelona, 1922, pp. 40-45.

168. H. Le Chatelier "Sur la procelaine égyptienne", **Comptes Rendus
de l'Academie des Sciences,** 129 (1899), 377-378.

169. J. Llorens i Artigas, op. cit., pp. 33-34.

170. Lucas, pp. 340-352, 362-363.

171. Ibid, pp. 186-191.

172. Ibid, p. 495.

173. C. Lahanier, Research Laboratory, Louvre Museum, Paris, personal
communication; some of the analyses appeared in ref. 6.

174. R. Kasser, "Dialectologie", **Textes et Langages de l'Egypte
Pharaonique,** Institut francais d'archéologie orientale du Caire,
Cairo, 1972, pp. 107-115.

175. W.F. Edgerton, "Early Egyptian Dialect Interrelationships",
Bulletin of the American Schools of Oriental Research, 122
(1951), 9-12.

176. W. Stevenson Smith, **The Art and Architecture of Ancient Egypt,**
Penguin Books, Baltimore, 1958, pp. 60-63; **A History of Egyptian
Sculpture and Painting** in the Old Kingdom, Oxford University
Press, Oxford, 1946, pp.33-44.

177. J. Riederer, "Metal Analysis of Egyptian Bronzes", **RAS, 3**
(1981), 239-243.

178. J.D. Cooney, **Glass,** Vol. IV of the **Catalogue of Egyptian
Antiquities in the British Museum,** British Museum Publications,
Ltd., London, 1976, pp. 141 and xv-xvi.

179. K.W. Butzer, **Early Hydraulic Civilization in Egypt,** University
of Chicago Press, Chicago, 1976, pp. 57-80.

180. M.F. El Ramly, T.A. Wertime, G. Rapp and J.D. Muhly, **Expedition**
(forthcoming article).

181. R.H. Brill, "Scientific Investigation of Ancient Glasses",

Proceedings of the 8th International Congress on Glass, London, 1968, The Society of Glass Technology, Sheffield, England, 1969, pp. 47-68.

182. B. Rothenberg, "Excavations at Timna Site 39, a Chalcolithic Copper Smelting Site and Furnace and its Metallurgy", in Chalcolithic Copper Smelting,Archaeo-Metallurgy, Institute for Archaeo-Metallurgical Studies, Monograph No.1, London, 1977, pp.1-23.

183. Lucas, p.209.

184. W.M.F. Petrie, The Royal Tombs of the Earliest Dynasties,Part II, The Egypt Exploration Society, London, 1901, p.40.

185. W.M.F. Petrie and J.E. Quibell, Naqada and Ballas,1895, B.Quaritch, London, 1896, p.54.

186. A. Rowe, "Three New Stelae from the Southeastern Desert", Annales du service des antiquites de l'Egypte, 39 (1939),188-191.

187. G.W. Murray, "New Empire Copper Mine in the Wadi Araba", Annales du service des antiquites de l'Egypte, 39 (1939), 217-218.

188. Petronius Arbiter, The Satyricon, Modern Library Edition, Random House, New York, pp. 75-76.

189. E.J. Peltenburg, "Some Early Developments of Vitreous Materials", World Archaelogy, 3 (1971), 6-12.

190. U. Zwicker,"Investigations on the Extractive Metallurgy of Cu/Sb/As Ore and Excavated Smelting Products from Norsun-Tepe (Keban) on the Upper Euphrates (3500-2800 BC)",in Aspects of Early Metallurgy, W.A. Oddy, Ed., BMOP No. 17, London, 1980, pp.13-24.

191. J. Weinstein, Foundation Deposits in Ancient Egypt, Doctoral Dissertation, University of Pennsylvania,1973, p.180. Copies available from University Microfilms, Ann Arbor, Mich., USA.

192. B. Adams, "Petrie's Manuscript Notes on the Koptos Foundation Deposits of Tuthmosis III", JEA, 61 (1975), 102-113.

193. M.G. Daressy, "Fouilles de la vallée des rois 1898-99" (Catalogue général des antiquitees égyptiennes du musée du Caire), Cairo, 1902, p.301, Mus.No. 24981.

194. H.E. Winlock,"Notes on the Reburial of Tuthmosis I", JEA, 15 (1929), 56-68.

195. D. Barag, "Mesopotamian Glass Vessels of the Second Millennium

B.C.", **Journal of Glass Studies, 4** (1962), 9-27.

196. P. Fossing, **Glass Vessels Before Glass Blowing,** Copenhagen, 1940.

197. B. Nolte, **Die Glasgefasse im alten Äegypten,** Muncher äegyptologische Studien 14,Verlag Hessling, Berlin, 1968.

198. R.G. Newton, "Recent Views on Ancient Glasses",**Glass Technology, 21** (1980), 173-183.

199. A.L. Oppenheim, "Towards a History of Glass in the Ancient Near East", **Journal of the American Oriental Society, 93** (1973),259-266.

200. R.H. Brill and J.M. Wampler, "Isotopic Ratios in Archaeological Objects of Lead", **Applications of Science in Examination of Works of Art** (1965 seminar), W.J. Young, Ed., Museum of Fine arts, Boston, 1967, pp. 155-166; "Isotope Studies of Ancient Lead", **Archaeology, 71** (1967), 63-77.

201. R.H. Brill, " Lead and Oxygen Isotopes in Ancient Objects", **Philosophical Transactions of the Royal Society of London, A269** (1970),143-164.

202. M.S. Amin,"Geological Features of Some Mineral Deposits in Egypt", **Bulletin de l'institut de désert d'Egypte,** 5 (1955), 209-239.

203. S. El Akkad and A. Alif Dardir,Paper 35, **Geological Survey of Egypt,** Cairo, 1966.

204. R.H. Brill, "Lead Isotopes in Ancient Glass",**Annales du 4ème congres des journées internationales du verre, Ravenne-Venise 1967,** International Association for the History of Glass, Liege,1969, pp.255-261.

205. M.E.L. Mallowan, **Nimrud and its Remains I,** 1966, pp.209-210 and note 17 on p.344.

206. R.H.Brill, "Some Miniature Glass Plaques from Fort Shalmanaser,Nimrud", **Iraq, 40** (1978), 23-39.

207. **CAH,** Vol. II, Part 1, pp.483-493 and Part 2, pp. 81-85.

208. K. Kitchen, **The Third Intermediate Period in Egypt,** Aris and Phillips, Warminster, England, 1973.

209. "The Report of Wenamun", in M. Lichtheim, **Ancient Egyptian Literature,** Vol.II, University of California Press, Los Angeles, 1976, pp.224-230.

210. H.W.F. Saggs, **The Greatness that was Babylon**, Hawthorn Books,Inc.,New York, 1962, pp.83-104.

211. **ibid**, p.108; H.W.F. Saggs, "The Nimrud Letters, 1952--Part II", **Iraq, 17** (1955), 128, 150.

212. Louvre stela C.256; ref.110, p.282.

213. A.H. Gardiner, "The Dakhleh Stela", **JEA, 19** (1933),19-30.

214. J.J. Janssen, "The Smaller Dakhla Stela", **JEA, 54** (1968),165-172.

215. J. Yoyotte, "Les principautes du Delta au temps de l'anarchie libyenne", **Mélanges Maspero, I:4** (Mémoires publies par les membres de mission archéologique francaise au Caire),1961, pp.141 and 150.

216. Louvre Stela A.90; ref.110, p.326.

217. G. Posener, "Le canal du Nil à la Mer Rouge avant les Ptolemées", Chronique d'Egypte, 13 (1938), 259.

218. J. Boardman, **The Greeks Overseas**,Thames and Hudson, London, 1980, Chapter 4.

219. Herodotus, **The Persian Wars**, Book II, Chapters 154 and 178-179, The Modern Library Edition, Random House, New York, 1942.

220. W.M.F. Petrie, **Naucratis, Part I**, 2nd Edition, The Egypt Exploration Society, London, 1888.

221. P.R. Fields, J. Milsted, E. Henrickson and R. Ramette, "Trace Impurity Patterns in Copper Ores and Artifacts", in **Science and Archaeology**, R.H. Brill, Ed., MIT Press, Cambridge (Mass),1968, pp. 131-142.

222. I.M. Toller, "The Mineral Resources of Syria", **Engineering and Mining Journal, 112** (1921), 846-852.

223. **Diodorus of Sicily**, Book III, Chapters 12-14, Loeb Classical Library, W.Heinemann Ltd., London, 1968.

224. S.A. Saleh, A.W. George and F.M. Helmi, "Study of Glass and Glass-making Processes at Wadi el-Natrun, Egypt in the Roman Period 30 B.C. to 359 A.D. Part I. Fritting Crucibles, their Technical Features and Temperature Employed", **Studies in Conservation, 17** (1972), 143-172.

225. J.F.S. Stone and L.C. Thomas, **op. cit.**, pp.41 and 44.

226. (a) M.E.L. Mallowan, **Early Mesopotamia and Iran**, McGraw Hill

REFERENCES

Co., New York, 1965, p.12; (b) J. Melaart, **Earliest Civilizations of the Near East**, McGraw Hill Co., New York, 1974, p.12.

27. M.E.L. Mallowan, "Excavations at Brak", **Iraq, 9** (1947), 33.

28. **Chronologies in Old World Archaeology**, R.W. Ehrich, Ed., Chicago University Press, Chicago, 1965; P.R.S. Moorey, **Iraq, 28** (1966), 40; also "Abu Salabih, Kish, Mari and Ebla: Mid-Third Millennium Archaeological Interconnections", **American Journal of Archaeology, 85** (1981), 448.

229. (a) I.E.S. Edwards, "Absolute dating from Egyptian records and comparison with carbon-14 dating", **Philosophical Transactions of the Royal Society of London, A269** (1970), 11-18; (b) R.M. Derricourt, "Radiocarbon Chronology for Egypt and North Africa", **Journal of Near Eastern Studies, 30** (1971), 271-292; (c) F.A. Hassan, "Radiocarbon Chronology of Archaic Egypt", **Journal of Near Eastern Studies, 39** (1980), 203-207.

230. L. Biek and J. Bailey, "Glass and other Vitreous Materials", **World Archaeology, 11** (1979), 3.

231. **CAH**, Vol. I, Part 2, pp.45-47.

232. W.A. Ward, **Egypt and the East Mediterranean World 2200-1900 B.C.**, American University of Beirut, Lebanon, 1971, pp.49-69.

233. W.A. Ward, "Egypt and the East Mediterranean from the Predynastic Times to the End of the Old Kingdom", **Journal of the Economic and Social History of the Orient, 6** (1963), 1-57.

234. A. Ben-Tor, "The Relations Between Egypt and the Land of Canaan During the Third Millennium B.C.", **American Journal of Archaeology, 85** (1981), 449-452.

235. H. Garner, "An Early Piece of Glass from Eridu", **Iraq, 18** (1956), 147-149.

236. **CAH**, Vol. I, Part 2, p. 998 (Chronological Table B).

237. R.F.S. Starr, **Nuzi: Report on the Excavation at Yorgan Tepe Near Kirkuk, Iraq, 1927-1931**, Vols. I and II, Harvard University Press, Cambridge (Mass), 1937-39.

238. P. Vandiver, "Soda-Lime-Silicate Technology at the Mid-Second Millennium Site of Nuzi (Iraq)", in **Early Pyrotechnology: The Evolution of the First Fire Using Industries**, T.A. Wertime and S. Wertime, Eds., The Smithsonian Institution Press, Washington, D.C., 1982.

239. **CAH**, Vol. II, Part 1, pp.436 and 820 (Chronological Table B).

240. A.M. Pollard and P.R.S. Moorey, "Some Analyses of Middl Assyrian Faience and Related Materials from Tell al-Rimah i Iraq", **Archaeometry, 24** (1982), 45-60.

241. H. Carter, "Excavations at Tell al-Rimah, 1964", **Bulletin of th American Schools of Oriental Research, 178** (1965), 40-69.

242. R.W. Smith, "Archaeological Evaluation of analyses of Ancien Glass", **AGT**, 1963, pp.283-290.

243. E.J. Peltenburg, "Al Mina Glazed Pottery and its Relations", **Levant, 1** (1969), 82-83; J. du Plat Taylor, "The Cypriote an(Syrian Pottery from al Mina, Syria", **Iraq, 21** (1959), 91.

244. A. Blanco and J.M. Luzon, "Pre-Roman Silver Miners at Ri(Tinto", **Antiquity, 43** (1969), 124-131.

245. B.H. Warmington, **Carthage**, Penguin Books Ltd., Hammondsworth, Middlesex, England, Chapter 1, pp.13-38.

246. P.D. Ritchie, "Spectrographic Studies in Ancient Glass, Chinese Glass from pre-Han to T'ang Times", **Technical Studies in the Field of Fine Arts, 5** (1937), 209-220; see also ref. 20, p.46.

247. K.P. Foster, **Aegean Faience of the Bronze Age**, Yale University Press, 1979.

248. K.P. Foster and A. Kaczmarczyk, "X-ray Fluorescence Analysis of Some Minoan Faience", **Archaeometry, 24** (1982).

249. P.P. Betancourt and G.A. Weinstein, "Carbon-14 and the Beginnings of the Late Bronze Age in the Aegean", **American Journal of Archaeology, 80** (1976), 329-348.

250. G. Cadogan, "Dating the Aegean Bronze Age without Radiocarbon", **Archaeometry, 20** (1978), 209-214.

251. W. Noll, R. Holm and L. Born, "Chemie und Technik altkretischer Vasenmalerei von Kamares-Typ, **Naturwissenschaften, 58** (1971), 615-618; Z. Stos-Fertner, R.E.M. Hedges and R.D.G. Evely, "The Application of the XRF-XRD Method to the Analysis of the Pigments of Minoan Painted Pottery", **Archaeometry, 21** (1979), 187-194.

252. R.E. Jones, M.S. Tite and N.D. Meeks, "An Analytical Investigation of Some Unusual Late Minoan Jewellery from Crete", **Proceedings of the 19th International Symposium on Archaeometry**, London, 1979.

253. H. Schliemann, **Mycenae**, J. Murray, London, 1878, pp.157-158; **Tiryns**, London, 1886, pp. 82-83 (reprinted in 1967 by B. Blom, New York).

54. A. Kaczmarczyk, unpublished results.

55. E.J. Peltenburg, "The Glazed Wares", Appendix I in **Excavations at Kition** by V. Karageorgis, Department of Antiquities, Cyprus, 1974.

56. E.J. Peltenburg, page 9 of ref.189.

57. G.A. Reisner, **Excavations at Kerma, IV-V**, in **Harvard African Studies**, Vol.6, Cambridge (Mass),1923, pp.134-175.

58. H.C. Beck, "Notes on Glazed Stones", **Ancient Egypt and the East:** Part I, "Glazed Steatite", June 1934, 64-83; **Part II:** "Glazed Quartz" Dec. 1934, 19-37; and "Report on Qau and Badari Beads", in G. Brunton, **Qau and Badari, II,** London: British School of Archaeology in Egypt, 1928, pp.22-25,27,29.

59. F.A. Bannister and H.J. Plenderleith, "Physico-Chemical Examination of a Scarab of Thuthmosis III Bearing the Name of the God Aten", **JEA, 22** (1936), 2-6.

60. W.D. Kingery, "Plausible Inferences from Ceramic Artifacts", **Journal of Field Archaeology, 4** (1981), 457-468.

61. (a)A. Shepard, **Ceramics for the Archaeologist,** Carnegie Institution Press, Washington, D.C., 1964, pp.31,44; (b) C.W. Parmerlee and C.G. Harmon, **Ceramic Glazes,** Cahners, Boston, 1973, pp.1-2,386-387,478-479.

262. G. Bayer and H.G. Wiedemann, "Le bleu, pigment synthétique examine sous l'angle scientifique", **Bulletin Sandoz, 40** (1976), 19-40.

263. W.T. Russell, "Egyptian Colours", in W.M.F. Petrie, **Medum,** D. Nutt, London, 1892, pp.44-47.

264. W. Burton, "Ancient Egyptian Ceramics", **Journal of the Royal Society of Arts, 60** (1912), 594-599.

265. **Egypt's Golden Age: The Art of Living in the New Kingdom, 1558-1085 B.C.,** E. Brovarski, Ed.,Museum of Fine Arts, Boston, 1982, pp. 41,115,147,148.

266. P.B. Vandiver, unpublished analyses.

267. W.M.F. Petrie, **Tell el Amarna,** Methuen and Co., London, 1894.

268. W.D. Kingery, H.K. Bowen and D.R. Uhlmann, **Introduction to Ceramics,** J. Wiley and Sons, New York, 1976, pp.85-87.

269. Janine Bourriau, to be published.

270. Peter Lacovara, to be published.

271. W.O. Williamson, "The Scientific Challenge of Ancient Glazing Techniques", **Earth and Mineral Sciences, 44** (1974), 17-22.

272. C.S. Smith, "Structural Hierarchy in Science, Art and History", in J. Welchsler, **On Aesthetics in Science,** MIT Press, Cambridge (Mass), 1978; "The Interpretation of Microstructures of Metallic Artifacts", in **Application of Science in The Examination of Works of Art** (1965 seminar), W.J. Young, Ed., Museum of Fine Arts, Boston, 1967, pp. 20-52; and "The Techniques of the Luristan Smith", in **Science and Archaeology,** R.H. Brill, Ed., MIT Press, Cambridge (Mass), 1968, pp.32-54.

273. J.R. Gettens, **The Freer Chinese Bronzes, Vol.2: Technical Studies,** The Smithsonian Institution, Washington, D.C.,1969.

274. G. Brunton and G. Caton-Thompson, **The Badarian Civilization and Predynastic Remains,** London: British of Archaeology in Egypt, 1928, pp. 7-15,27,39.

275. P.L. Kohl, G. Harbottle and E.V. Sayre "Physical and Chemical Analyses of Soft Stone Vessels from Southwest Asia", **Archaeometry,** 21 (1979), 131-160.

276. J. Boardman, **Greek Gems and Finger Rings,** Thames and Hudson, London, 1970, p. 373-383.

277. D. Randall-McIver, A.C. Mace and F.Ll. Griffith, **El Amrah and Abydos,** Egypt Exploration Society, London, 1902, pp.36-39.

278. E.M. Levin, C.R. Robbins and H.F. McMurdie, **Phase Diagrams for Ceramicists,** Vol.1, American Ceramics Society, Columbus (Ohio), 1964, pp.174-176.

279. W.M.F. Petrie, **Prehistoric Egypt,** London: British School of Archaeology in Egypt, 1920, p.42.

280. J.-P. Lauer, **Saqqara, The Royal Cemetery of Memphis,** Thames and Hudson, London, 1976, pp.90-136; "Fouilles du service des antiquites a Saqqara", **Annales du service des antiquites de l'Egypte,** 38 (1938), 551-565.

281. H. Yamamoto and S. Isobe, "Compositional Change During the Electron Microprobe Analysis of Glasses", **Proceedings of the 10th International Congress on Glass,** Part 2 (1974), 9-1 to 9-6.

282. H.Beck, "Classification and Nomenclature of Beads and Pendants", **Archaeologia,** 77 (1929), 1-124.

283. H.D. Schneider, **Shabtis,** Rijksmuseum van oudhen, Leiden, 1977, Part I, pp.233-238 and Part III, pp.37-38.

INDEX OF AUTHORS
(The numbers denote citations)

INDEX OF AUTHORS
(The numbers denote citations)

INDEX OF AUTHORS
(The numbers denote citations)